James Hall is the Author of

The World as Sculpture: the Changing Status of Sculpture from the
Renaissance to the Present Day

Michelangelo and the Re-invention of the Human Body

Coffee with Michelangelo

The Sinister Side

How left-right symbolism shaped Western art

THE SINISTER SIDE

How left-right symbolism shaped Western art

James Hall

OXFORD
UNIVERSITY PRESS

OXFORD
UNIVERSITY PRESS

Great Clarendon Street, Oxford OX2 6DP

Oxford University Press is a department of the University of Oxford.
It furthers the University's objective of excellence in research, scholarship,
and education by publishing worldwide in

Oxford New York

Auckland Cape Town Dar es Salaam Hong Kong Karachi
Kuala Lumpur Madrid Melbourne Mexico City Nairobi
New Delhi Shanghai Taipei Toronto

With offices in

Argentina Austria Brazil Chile Czech Republic France Greece
Guatemala Hungary Italy Japan Poland Portugal Singapore
South Korea Switzerland Thailand Turkey Ukraine Vietnam

Oxford is a registered trade mark of Oxford University Press
in the UK and in certain other countries

Published in the United States
by Oxford University Press Inc., New York

© James Hall 2008

British Library Cataloguing in Publication Data

Data available

Library of Congress Cataloging in Publication Data

Data available

Typeset by SPI Publisher Services, Pondicherry, India
Printed in Great Britain
on acid-free paper by
CPI Antony Rowe Ltd., Chippenham, Wiltshire

ISBN 978–0–19–923086–0

1 3 5 7 9 10 8 6 4 2

To my mother Françoise Carter
And in memory of my father
Philip Hall (1932–2007)

Contents

MODERNITY

Part 5. Rethinking Left and Right

CODA

List of Illustrations

Acknowledgements

MANY PEOPLE HAVE BEEN extremely generous with their time and knowledge. The following have read and commented on one or more chapters: Lorne Campbell, Elizabeth Cowling, Jennifer Fletcher, Felicity Harley, Paul Hills, Jules Lubbock, Paul Taylor. Chris McManus, whose own book on left and right I have found invaluable, read the entire text. The following answered specific questions or made specific suggestions: Phil Baker, John Birtwhistle, Alan Bowness, Emma Barker, Paul Bernard, Liz Brooks, Beverly Louise Brown, Charles Burnett, Daniel Chandler, Fran Dolans, Nigel Foxall, Dorian Gieseler Greenbaum, Jeffrey Hamburger, Hugh Honour, James McConnachie, Elizabeth McGrath, Dirk Van Miert, Jennifer Montagu, Nigel Palmer, the late Thomas Puttfarken, Pat Rubin, Marjorie Trusted. This list is bound to be incomplete as most people I meet have some observation to make on this topic: my apologies to any I have omitted. All other intellectual debts are, I hope, fully acknowledged in the notes.

I am very grateful to the librarians of the Warburg Institute (especially Paul Taylor); British Library; London Library; Winchester School of Art; National Art Library. I have been invited to lecture on left-right symbolism at Birkbeck College, the Courtauld Institute, and Southampton University's Centre for Medieval and Renaissance Studies, of which I am a Visiting Fellow.

At Oxford University Press, I would especially like to thank Latha Menon, who commissioned and edited the book; Alice Jacobs, Claire Thompson, and Debbie Sutcliffe. My agent Caroline Dawnay set the wheels in motion.

As always, my immediate family has been a constant source of inspiration and consolation—my wife Emma Clery and our sons, Benjamin and

Joshua; my sister Charlotte Hall and her daughter Alice; my step–mother Joy Cameron-Hall. The book is dedicated to my mother Françoise Carter, who read and commented on the whole text, and who inspired the sections on dance; and to my late father Philip Hall who, in his inimitable way, made so many good things happen.

Introduction

Matters of no more seeming consequence in themselves than, *Whether my father should have taken off his wig with his right hand or with his left*,—have divided the greatest kingdoms, and made the crowns of the monarchs who governed them, to totter upon their heads.

Laurence Sterne, *Tristram Shandy* (1758)[1]

Even the parts of the genitals have their special beauty. Of the testicles, the left one is always larger, as it is found in nature: it has [also] been remarked that the left eye sees things more sharply than the right.

Johann Joachim Winckelmann, *History of the Art of Antiquity* (1764)[2]

IN RECENT YEARS, THERE has been a deluge of books, exhibitions, films and live performances centrally concerned with what is referred to as 'the body'. It is not as if bodies did not previously exist (though some theorists and abstract artists in the last century did claim to have banished or transcended the human form). It is more that the new approaches to 'the body' (fuelled by a heady cocktail of psychoanalysis, phenomenology, issues of gender and latterly race) have claimed to be breaking age-old taboos.

In theory and practice, no holes are barred, and all five senses (especially touch and sight) have been reclaimed and cross-examined.[3]

1

It is thus an offshoot from what was dubbed in the 1960s 'history from below', which sought to put 'ordinary' lives centre stage: it is history from below the belt, from beneath the skin. It has been said, with tongue only partly in cheek, that few texts now make it into the literary canon 'unless they contain at least one mutilated body'.[4] To say that an artwork is 'disturbing' is the highest form of praise, and luridly confessional art forms are all the rage.

But in the headlong dash to map 'the body' in the humanities, at least one crucial aspect of it has been conspicuous by its near total absence: any mention of the distinction between left and right.[5] This distinction is important on several counts. Anthropologically, because we are almost all either left-handed or right-handed, and usually with a 'dominant' eye and foot to match; scientifically, because the left and right sides of the brain have very different functions; politically, socially, and culturally, because every society has its own symbolism of left and right.

I think there are three main reasons for this lacuna.

The first reason is that the creative industries of our era have been predicated on a metaphor that makes the mind's eye move vertically up and down—the distinction between high and low. If one's mission is to apotheosize 'low' cultural forms and manifestations, and only to venerate those icons of 'high' culture that engage with the low (either by absorption or repression), then issues of left and right—which make the mind's eye move back and forth horizontally—are harder to get one's head around.[6] Psychoanalysis has also encouraged this tendency to think 'vertically'. The *sub*-conscious suggests something lying below, and when Freud compared psychoanalysis to an archaeological dig, he imagined himself digging *down* through different layers, rather than working his way across laterally. Freud looked *down* on his patients as they lay on his famous couch. One of his patients, the Wolf Man, recalled Freud telling him: 'The psychoanalyst, like the archaeologist in his excavations, must uncover layer after layer of the patient's psyche, before coming to the deepest, most valuable treasures.'[7] But width is depth too.[8]

Another aspect of modern culture that militates against an interest in left-right distinctions is its totalizing nature. Modern cultural forms frequently aspire to 'immerse' and 'envelop' the viewer/reader/auditor in the experience; and that experience is expected to be 'in your

face'; 'gob-smacking'; 'cutting edge', etc. Even Clement Greenberg, the great apologist for post-war American abstract painting, was adamant that every modern picture should have a quality of 'at-onceness', and should be taken in at a glance.[9] More recently we have had to endure the following extreme but not untypical remarks from an Ivy League Professor: 'Great Art has dreadful manners. The hushed reverence of the gallery can fool you into believing masterpieces are polite things, visions that soothe, charm and beguile, but actually they are thugs. Merciless and wily, the greatest paintings grab you in a headlock, rough up your composure and then proceed in short order to rearrange your sense of reality.'[10] There is not much room here for nuance, foreplay or differentiation, the softly-spoken or sidelong.

The final reason for the almost complete silence with regard to left and right is the assumption that, as a cultural concept or tool, it is banal, limited, and obsolete—all too easily summed up in the equation: right = good; left = bad. This modern reductiveness is a legacy of the Victorian age, and above all, perhaps, of Madame Blavatsky's theosophy, where the 'left hand path' is the source of all evil and black magic, and the 'right hand path' the source of all good.[11] Freud, too, only had a few Blavatsky-ite things to say about left and right that were derived second-hand from his follower Wilhelm Stekel.

This last point deserves further consideration for even those who have been professionally concerned with the concept have tended to come to the same overly schematic conclusions. The essay that is credited with founding the sociological study of left-right symbolism is Robert Hertz's 'The Pre-eminence of the Right Hand: A Study in Religious Polarity'. It was first published in France in 1909, but had most influence on being republished in English translation in 1960, when it prompted an upsurge of anthropological and scientific interest in the issue that continues unabated.[12]

Hertz (1881–1915) was a star student of the celebrated sociologist Émile Durkheim, and he tried to show that in every culture a dualism of left and right exists, with the right hand invariably pre-eminent, and the left hand demonized. Just as Maori tribesmen believe that the right is the 'side of life' (and of strength), while the left is the 'side of death' (and of weakness), so too Christians situate the good thief in Crucifixions, and the saved in Last Judgements, on Christ's right side, while the bad thief and the damned are on Christ's left side. The same

left–right distinctions are embodied in most languages, with the word for left having negative and inauspicious connotations. Hertz's conclusions verge on the apocalyptic:

> Thus, from one end to the other of the world of humanity, in the sacred places from where the worshipper meets his god, in the cursed places where devilish pacts are made, on the throne as well as in the witness-box, on the battlefield and in the peaceful workroom of the weaver, everywhere *one unchangeable law* governs the functions of the two hands.[13]

[my italics]

It is scarcely surprising if Marcel Mauss, Durkheim's nephew, assumed that Hertz's essay was solely a study of the 'impurity' of the left side and of 'the dark side of humanity'.[14] Much of Hertz's research was done in the British Museum, which then housed the British Library, and none of it was derived from anthropological study in the field. At one point he says that the right hand 'is still called good and beautiful, and the left bad and ugly'—on the basis of an entry in a German dictionary published in 1818.[15] The one example he cites that contradicts his paradigm is dismissed as a 'secondary development'—or an exception to prove the rule. This was the apparently peace-loving Zuni, a Native American tribe located in western New Mexico, for whom the two sides of the body are brother Gods, with the left being the elder and 'reflective, wise, and of sound judgement'; while the right is 'impetuous, impulsive, and made for action'.[16] On first being translated into English, Hertz's essay was given the suitably lugubrious title, 'Death and the Right Hand', and his over-emphatic conclusions have usually been endorsed.

The most sophisticated, wide-ranging, and lucid survey of this subject, the psychologist Chris McManus' *Right Hand, Left Hand: The Origins of Asymmetry in Brains, Bodies, Atoms and Cultures* (2002), comes to broadly similar conclusions even though the ample evidence he presents does not always support it: 'Wherever one looks, on any continent, in any historical period or in any culture, right and left have their symbolic associates and always it is right that is good and left that is bad.'[17] One need only point to modern international politics (which McManus does), where the 'left' have frequently been feted, and the 'right' denounced. Indeed, in the standard work on this topic, the term

'left' is said to be 'the anchor term of the political polarity', with political right taking on the connotations of 'sinister'.[18]

Another significant recent study, Pierre-Michel Bertrand's *Histoire des Gauchers* (2001), is a history of Western attitudes to left-handers and to the left side. At one point Bertrand claims that the Middle Ages were a golden age for left-handers, but largely on the basis of a single piece of evidence—analysis of eighty skeletons from a medieval cemetery in Wharram Percy, Yorkshire, where an unusually high proportion— 16 per cent—appeared to be left-handers.[19] But the bulk of the book implies that it is only in the post-war period that the anti-left prejudices have changed.

I draw repeatedly on all these studies and am hugely indebted to them, yet the essentially Blavatsky-ite mindset which they have perpetuated is deeply flawed. As a result, modern editors and interpreters of historical texts in which the left hand/side is venerated tend to pass over the relevant passages in silence—or assume that they say the opposite. The situation is pretty much the same with visual images and aesthetics.

* * *

I FIRST STARTED TO think about left-right distinctions a few years ago when reading the five volumes of Charles de Tolnay's *Michelangelo* (1947–60). Although this is the cornerstone of modern Michelangelo studies, it is marred by its nebulous neo-platonic and Nietzschean theorizing, and by its banal approach to left-right symbolism: so, for example, the different orientations of Christ's hands in a crucifixion drawing (right hand pointing up; left down) supposedly allude to the traditional belief in 'the right side as the side of good and the left as the side of evil'.[20] Tolnay conveniently ignored the fact that in this image Christ turns his head to his left—as the dead and dying Christ does in so many of Michelangelo's other works. This was a radical innovation as the crucified Christ traditionally looked or faced to his right. Nonetheless, I was intrigued as to where Tolnay derived this idea, and the confidence to state it so boldly and baldly—especially when Michelangelo was reputedly a natural left-hander, who had learned to draw and paint with his right hand.[21]

From then on I kept half an eye open for references to left and right, and to my surprise I found that in the Middle Ages and the Renaissance left-right symbolism was an exceptionally important, versatile, and subtle

expressive device that permeated all sectors of society. Michelangelo himself exploits it in his poems, and in a pair of poetic epitaphs (which have hitherto been completely misunderstood) he even celebrates the spiritual and aesthetic beauty of 'left-handedness'—something which I later learned he would have derived from Lorenzo de' Medici's courtly cult of the left hand. For many mystics, too, from St Bernard of Clairvaux to St Teresa of Avila, Christ's left hand offered the most marvellous evidence of his incarnation, and of his love for humanity.

One aim of my book is to show the variety of left-right distinctions in Western culture, and how these are far from being universally hostile to the left. Where the Bible is concerned, most commentators on this subject have been misled by confining themselves to a few selective quotations from the New Testament of the 'right = good; left = bad' variety, and they have not mined the far richer and more nuanced harvest offered by the Old Testament.[22] This subject was broached by Ursula Deitmaring in a pioneering survey essay published in 1969, but her plea for a more nuanced reading of left-right distinctions has scarcely been heeded, and her essay is hardly ever cited.[23] The relevant Old Testament passages underpin a revaluation of the left side by mystics and courtly lovers during the Middle Ages, and its transmutation into the 'heart' side—the side of the most intense and authentic feelings. In the modern period, it would become the domain of the unconscious and subconscious, and of the unfettered imagination. Left-right symbolism has clearly played a vital and varied role in Western culture—one that is now seriously underrated and misunderstood.

Left-right symbolism became a 'live' issue during the Renaissance precisely because the traditional supremacy of the right was being challenged by the cultural elite. This is part of what has been called the 'civilizing process'.[24] In the visual arts, the left-right dichotomy was internalized and its effects manifested in individual faces and bodies, creating radical asymmetries. From then on, left-right symbolism was a creative catalyst of huge importance. It was increasingly used to express different but equally valid experiences, and responses to those experiences, with the left side of the body often representing emotional disturbance of some kind. The left side, which signified things such as human love, the passage of time, and the feminine, was given its own validity. It marks the beginning of modern consciousness and self-dramatization.

Such psychic compartmentalization occurs in many works that have been traditionally admired primarily for their naturalism. We can note in passing that the symmetry of Leonardo's drawing of *Vitruvian Man* is broken by the sharp 'left turn' of his lower body and feet, and that the sitters in all but one of his portraits turn to their left. This 'left-turn' is one of the most distinctive revolutions in Western culture, and although aspects of it are presaged in classical antiquity, it is only now that it really comes to the fore. Some of the greatest works by Leonardo, Michelangelo, Titian, Velazquez, Rembrandt, and finally Picasso are predicated on the various symbolisms of left and right—and this is why I believe it to be a 'lost key' to Western art.

In this book, I draw on a wide range of sources—literary, theological, anthropological, and scientific, as well as in ritual and the performing arts (especially dance). However, although this is a broadly based cultural history, my main focus is on the visual arts, for these are the most important and natural domain for left-right symbolism.

This needs further explanation. It is, of course, self-evident that most works of visual art in which there is a human figure and/or man-made object have necessarily to make left-right distinctions of some sort. Whereas the Book of Genesis can say that Eve 'took of the fruit thereof, and did eat, and gave also unto her husband with her; and he did eat', visual artists have to select a left or a right hand, and position Eve in relation to Adam, the tree, and the serpent. The difficulty is in deciding whether a left-right distinction is meaningful. Thus whereas there seems to be little consistency among artists concerning which hand Eve uses to take the apple, there is far more consistency in Eve's position relative to Adam: she usually stands to his left, in the traditional manner for husbands and wives—and she continues to do so when they are expelled from the Garden of Eden. What I have endeavoured to do throughout is to limit myself to the identification of conventions, and of the meaningfully unconventional. Thus in the chapters dedicated to the 'left-turn' in Western culture, I tend to focus on clusters of work by particular artists, and on relevant/accessible texts, in order to demonstrate that artists and patrons were actively interested in such issues.

Of course, any cultural history that ranges over a millennium and more is, in certain respects, going to be a blunt instrument. But I do not feel any need to apologize. I have tried to write an introduction to a subject that has been unjustly neglected, drawing attention to what

I believe to be the main issues, texts, and images. My book will have served its purpose if it prompts further reflection and research.

* * *

THE SINISTER SIDE IS divided into five parts made up of thematic chapters that are broadly chronological. Some of these chapters focus on particular artists, or particular historical moments, while others cover more ground.

In Part 1, *Turning Right*, I will briefly sketch out some of the basic classical and Biblical left-right conventions that underpin the 'right = good; left = bad' school of thought, and scientific explanations for the pre-eminence of the right hand. *Heraldic Images* explains how most pre-modern images were arranged heraldically, with left being organized in relation to the protagonists of the artwork, rather than in relation to the viewer, and with right being the privileged location. In *Fair Game*, I look in detail at how the simultaneous belief that the left side of the human body is the weak side, and that bad things usually come from the left (devils, disease, death, etc.), radically complicates our response to images of physical and sexual assault. *Sun and Moon* proposes that the tendency to illuminate portraits from the sitter's right is influenced by the astrological belief that the right eye is the domain of the sun, and the left eye the domain of the moon.

In Part 2, *Contesting Left and Right*, I will explore how from the Renaissance left-right symbolism is deployed in images depicting stark moral alternatives. *Darkened Eyes* shows how the radical occlusion of the left or right eye, whether by cast shadow or by other means, can indicate the spiritual state of the subject.

In Part 3, *Balancing Left and Right*, I show various ways in which Renaissance and Baroque artists create a dynamic equilibrium between left and right. *The Choice of Hercules* argues that the popularity of pictures on this theme, in which the fate of the hero is dependent on whether Hercules turns to his left or right, stems from the fact that the 'choice' is rarely made. *Double Vision* looks at some celebrated portraits in which the sitter only smiles with the left side of the mouth, and in which a balance is achieved between spirituality and worldliness. *Rembrandt's Eyes* argues that in the late self-portraits radically different aspects of left-right symbolism are explored, but that this culminates in the wonderfully calibrated Kenwood self-portrait.

Part 4, *Turning Left*, argues that from the Renaissance there is a 'left turn' in European culture that validates the left side of the body and puts it centre stage. *The Death of Christ* looks at the way in which artists begin to portray the crucified Christ from the left, and leaning to his left, in order to emphasize his incarnation and his love of humanity. *Courtly Love* looks at the aesthetic cult of the left hand and side, from its origins in medieval mysticism, courtly love and dance: a key figure here is Lorenzo de' Medici. *Fragile Beauty* shows how this cult of the left side has a major impact on the visual arts, and on Winckelmann's theories of beauty. *Leonardo and the Look of Love* explores the 'left-turn' in Leonardo's portraits, and how this is central to their allure and vivacity.

Prisoners of Love explores various visual manifestations of Petrarch's conception of the modern lover as being 'lame' in the left leg, and how this notional paralysis is essential to the fulfilment of their love. *Lovelocks* looks at the late sixteenth- and seventeenth-century aristocratic hairstyle in which long locks of hair were allowed to cascade over the left shoulder: these 'lovelocks' became the most ostentatious symbols of love. *Honourary Left-Handers* centres on three works by Michelangelo featuring left-handed archers which are predicated on a politics of love rather than war.

Part 5, *Rethinking Left and Right*, looks at the fate of left–right symbolism in the art and culture of the nineteenth and twentieth centuries. In general, its artistic importance declines thanks to Enlightenment attacks on religion and astrology. The rise of sublime landscape as a genre in the late eighteenth century is also crucial. It diminished the role of left–right distinctions, by breaking down the barrier between viewer and depicted nature.

But some great artists do revive left–right distinctions, seeing it as a radical tool that can imbue their work with awesome primitive power. 'To Err Forever' argues that Caspar David Friedrich re-introduces left–right symbolism into landscape, thereby re-sacralizing it and partially excluding the viewer.

In the late nineteenth century, an upsurge of interest in the occult and in Satanism, in which the 'liberated' left hand is pre-eminent, together with scientific awareness of the different functions of the two sides of the brain, leads to a revival of interest in left–right symbolism. So too does the new political terminology of left and right.

Two chapters on Picasso argue that he exploits subversive notions of left-handedness in his most ambitious early paintings, such as the *Demoiselles d'Avignon*. In *Modern Primitives*, I show how the left hand becomes increasingly associated with the unconscious, and becomes both a symbol and tool of automatist art. Finally, in *God Save the Queen*, I explore how the lighting and mood of Annie Liebowitz's recent portraits of the Queen of England were influenced by traditional ideas about left and right.

ANTIQUITY AND AFTER

Part 1
Turning Right

1. Avoiding the Beer-Cellar: Left-Right Conventions

...some influence from without seems to bring [the] murmuring sound [of a discussion] to my ear... If this discussion be fair, the sound seems to come to rest on the right side... when evil is spoken, the noise rests in the left ear.

Girolamo Cardano, *The Book of My Life*, mid-sixteenth century[1]

In a specific spatial relation to myself, on my left-hand side, I saw a dark space out of which there glimmered a number of grotesque sandstone figures. A faint recollection, which I was unwilling to credit, told me it was the entrance to a beer-cellar.

Sigmund Freud, *The Interpretation of Dreams* (1909 edn.)[2]

IN THIS OPENING CHAPTER, I will very briefly outline the history of some of the standard left-right conventions which have asserted the pre-eminence of the right. I have not included some significant counter-examples from antiquity in which the left hand is given priority—such as the Roman practice of wearing wedding rings on the left hand—because these 'exceptions' will be discussed at relevant points in subsequent chapters. I will conclude by outlining the main explanations—scientific and anthropological—that have been given for the supremacy of the right hand.

* * *

NUMEROUS LEFT-RIGHT DISTINCTIONS occur in every culture, but they were first systematized by the Ancient Greeks. Aristotle (384–322 BC) gave one of the most comprehensive, succinct and enduring accounts in the *Metaphysics*, when he drew up a table of opposites derived from Pythagorean philosophy.

The Pythagoreans believed that numbers were the primary components of the universe, and the source of all cosmic order and harmony. Ten was their ideal number, and by claiming the moon as a planet, they were able to say there were ten heavenly bodies. Their philosophy was also dualistic, and so everything could be broken down into a series of contrasting pairs. According to Aristotle, Pythagorean philosophy was encapsulated in the following table of ten 'opposites':[3]

Limited	Unlimited
Even	Odd
One	Many
Right	Left
Male	Female
Still	Moving
Straight	Bent
Light	Darkness
Good	Bad
Square	Oblong

Right and Left are the first 'opposites' that are not in any obvious sense numerical. It is clear that Left—aligned with Female, Bent and Darkness—is 'unlimited' in a chaotic rather than in a sublime or transcendent way. Two archetypal opposites that are surprisingly omitted from the Pythagoreans' list are Up (with Right) and Down (with Left). Aristotle's teacher Plato incorporated them into his most famous left-right distinction (which I will discuss in a moment), but the Pythagoreans presumably omitted this pair to keep the number of opposites to the magic figure of ten. With the addition of Down, we are already practically in the realm of Freud's diabolical beer-cellar.

Left-right distinctions pervaded Greek culture, and especially the human sciences. Greek physicians believed that in the womb, males lay on the right and females on the left; that sperm from the right testicle

produces boys, and so on: in *The Essentials of Conception* (1891), Mrs. Ida Ellis could still claim that 'it is the male who can progenate a male or female child at will; by putting an elastic band round the testicle not required'.[4]

At one point in *On the Generation of Animals*, Aristotle rejects both these theories, the first on the basis of knowledge gained from anatomical dissections, and the second on the basis of removing either the right or left testicle from an animal and finding that the gender of the offspring could still not be predicted. But this clear-sightedness in relation to right and left is a mere blip when the totality of Aristotle's writings is considered. The discussion of his predecessors' theories in *On the Generation of Animals* concludes with him backtracking. He believes the right side of the human body is warmer than the left, its blood purer, with more spirit and less water. Thus semen produced by the right testicle will also be hotter—something which makes it more fertile and therefore more likely to produce males.

Most of Aristotle's theories supported the primacy of the right side. Thus in animals and men, locomotion begins on the right side: 'all animals naturally tend to use their right limbs more in their activities'. This is untrue: animals such as cats often prefer to use specifically the front left or the front right paw for, say, taking food out of a tin, but roughly half use the left.[5] Aristotle counters this sort of argument by confining himself to the example of a lobster: the fact that it is only a matter of chance whether the right or left claw of a lobster is bigger only goes to show that they are a deformed and inferior species. He even believed that Heaven was a superior sort of animal, and that it therefore has a right and left side: the east (the bright, warm domain of the rising sun) is the right half of Heaven while the darker and colder west is the left half. So right is naturally and essentially superior to left, and man (by which he means the male of the species) is the 'most right-sided' of all living creatures.[6] The position of the heart, the principle internal organ, on the left side of the chest would seem to undermine this thesis, but Aristotle took this anomaly in his stride. The heart was only positioned on the left side of the chest to 'counterbalance the chilliness of the left side'; even so, the right hand chamber of the heart was still the largest and hottest, thus maintaining the right side's superior temperature.[7]

During the Middle Ages, these theories would come to underpin the depiction of animals in heraldry. With single animals, or several animals

16

stacked in a single vertical column, the right paw is usually raised—as in the English 'three lions', introduced in around 1195 during the reign of Richard the Lionheart[8]—and heraldic animals generally move to their right.[9] Thus when St Francis of Assisi pacifies a wolf that has been terrorizing a community, the following interchange takes place: ' "Friar wolf, I desire that thou pledge thy faith to me" . . . And when St Francis held forth his hand to receive this pledge, the wolf lifted up his right paw and gently laid it in the hand of St Francis, giving him thereby such token of good faith as he could.'[10]

For similar reasons, almost all Christian hand and arm reliquaries show the right arm or hand, often in the act of blessing: of the twenty-eight medieval arm reliquaries catalogued in the standard book on this subject, only two are left arms.[11] While two is probably not such a bad total if we were to assume the left arms belonged to left-handed saints (that comes out as an average of 7 per cent being left-handed), the more likely proposal (considering the low esteem of left-handers) is that the left arms and hands of saints were usually thrown away.

These theories about the body's interior influenced ideas about its appearance, character and 'orientation'. The astronomer and geographer Claudius Ptolemaeus (*c.* AD 100–178), known as Ptolemy, wrote a celebrated treatise on astrology, the *Tetrabiblos*, in which, following Aristotle, he aligns the right side of the body with the east, the zone of the rising sun:

> Those towards the east have more courage and act openly in everything, for this is according to the nature of the Sun, viz. oriental, diurnal, masculine and on the right hand (and we find in animals that the parts on the right are the strongest). This therefore is the reason, why those eastward are more courageous; but those who live westward, are more tender, effeminate and secret in their ways, for the west is lunar, because the Moon always first appears rising in the west after the conjunction, and renders that climate effeminate, nocturnal and left-handed.[12]

An anonymous *Book of Physiognomy* (late fourth century AD), which was traditionally attributed to Apuleius, the celebrated Roman author of *The Golden Ass*, is even more precise. 'Apuleius' informs us that in both men and women:

17

if some part on the right is larger, in whatever body, be it eye or hand or breast or testicle or foot . . . all these indications are assigned to the masculine type. If some part on the left is found to be larger, it is assigned by these indications to the feminine type.[13]

In most men the right testicle is slightly larger—and higher—than the left, but apart from this, there is no anatomical truth in this asymmetrical ideal in which the perfect male must be literally 'right-sided', and the woman 'left-sided'.[14] Nonetheless, a right-hander is likely to have slightly more developed muscles on the right side, especially in the arm.

A comparable biological imperative operates in relation to the creation of Eve. In the Jewish mystical book, the Cabala, Eve represents the left side of Adam, having been created from a rib taken from Adam's left side.[15] In Milton's *Paradise Lost* (1667/74) the rib itself is bent to the left—and Milton uses the Anglicized latin word for left, 'sinister', exploiting its creepy associations. Immediately after tasting the forbidden fruit, Adam describes Eve as:

> all but a rib
> Crooked by nature—bent, as now appears,
> More to the part sinister—from me drawn.
> [Bk. X:884–6]

Whereas Aristotle believed that right-handedness was the natural state, Plato, writing in the *Laws*, assumed it was a cultural imposition, blaming the fact that the left hand effectively 'limps' on 'the folly of nurses and mothers': for Plato, ambidextrousness would appear to be the ideal state.[16] Yet even though Plato seems not entirely hostile to the left hand, in *The Republic* he relied on standard left-right distinctions when he offered an influential vision of the afterlife. Here the souls of men are divided into two groups by their judges: the just travel upwards and to the right, carrying tokens of their judgement on their fronts, while the unjust travel downwards to the left, with tokens on their backs.[17] During the Middle Ages Lady Fortune would push her wheel down with her left hand, and up with her right,[18] and a similar division would reappear in the Christian 'Day of Judgement', where the damned fall away to God's left, and the blessed rise to God's right. In the Koran, the elect are on the right of the Lord and damned on the left.[19] In Buddhism, the path to Nirvana divides into two: 'The left-hand one is to be avoided, the one to the right is to be followed.'[20]

Formal seating arrangements followed similar patterns, with the most honoured guest sitting to the right of the King or host. Being seated on the left of the host was sometimes regarded as a political snub.[21] In Notker's *Life of Charlemagne* (AD 829–36), we find a wonderful example of how these hierarchies could be exploited to devastating effect. After a long campaign, the Emperor returns to Gaul, his 'invincible right hand' having given him a series of great victories. He asks to see some boys to whom he had been providing schooling, and orders them to show him their writings in prose and poetry:

> Those of middle-class parentage and from very poor homes brought excellent compositions, adorned more than he could even have hoped with all the subtle refinements of knowledge; but the children of noble parents presented work which was poor and full of stupidity. Then Charlemagne, imitating in his great wisdom the justice of the eternal Judge, placed those who had worked well on his right hand and said to them: 'My children, I am grateful to you, for you have tried your very hardest to carry out my commands....' Then he turned with great severity to those on his left, with a frown and a fiery glance which seemed to pierce their consciences, and scornfully thundered out these frightening words: 'But you young nobles, you, the pleasure-loving and dandified sons of my leaders...care not a straw for my command...' When he had said this, he turned his august head and raised his unconquered right hand towards the heavens, and thundered forth an oath against them.[22]

But no man—not even Charlemagne—could escape the bad things located on the left for ever: 'as [the Emperor] was setting out from his camp and was beginning the day's march, he suddenly saw a meteor flash down from right to left with a great blaze of light.'[23] This causes Charlemagne's horse to fall. As a devoted student of the ancients, he would have known that in Greek augury, auspicious signs appear on the right, or travel from left to right (i.e. birds or comets), while inauspicious signs appear on the left, or travel from right to left. These conventions were followed by the Romans under the Empire, and were adopted by Christians. Thus Charlemagne knew his days were numbered when the meteor crossed his path and crash-landed on his left. He died soon after—no doubt making a sign of the cross by moving his right hand 'auspiciously' from left to right across his chest.

Left–right distinctions are also enshrined in language. In most lan-
guages around the world, the word for left has negative and inauspi-
cious connotations (sinister, gauche etc.). The Indo-European group of
languages (which include Hebrew, Arabic and English) have been traced
back to a 'proto-Indo-European' language that was spoken before about
3000BC, and it seems that although they had a word for right, which
was something like *deks(i)-* or *deksinos* (and thus not so far from the
Ancient Greek *deksios*), they had no word for left. The reason for this
is thought to be its tabooing and partial replacement by euphemisms in
individual dialects. As a word, left is less stable than right. This is why
so many languages have several words for left (Latin: sinister, laevus,
scaevus; Italian: sinistro, mancino; Spanish: izquierdo, zurdo, siniestro),
and one basic word for right which remains in use for long periods and
over a wide area.[24]

In many Indo-European languages the words for right and south are
virtually interchangeable, probably because northern hemisphere people
tended to look east when worshipping, and so the sun would be on their
right during the course of the day. Thus sun worship is usually combined
with reverence for the right side, and its close association with the south
and east. Conversely, the left side tends to be associated with the much
colder west and north.[25] In Christian churches, the worshipper enters
from the west end and the altar is situated at the east end, and so the
sun shines from the worshipper's right—the south side.[26] Corpses were
buried with their feet towards the east, so that on the Day of Judgement
they could sit up in their tombs and face God. Conversely, the devil –
the Prince of Darkness—was believed to reside in the west (and some-
times the north). In Baptism ceremonies of non-infants in the early
Church, the convert had to turn to the west and say 'I renounce you,
Satan'; in Milan, they also had to spit in this same direction.[27] In a
marriage song (*c.*1613) by the English poet John Donne, who elsewhere
aligns east with right and west with left, the benediction of the happy
couple concludes ominously:

May never age, or error overthwart
With any west, these radiant eyes, with any north, this heart.[28]

A corollary to this is the prejudice against entering buildings with the
left foot. The term 'footman' derives from the slave positioned by the
Romans next to the front door whose job it was to check that guests and
visitors entered with their right foot first, for it was deemed inauspicious

to lead with the left.[29] This protocol was observed in relation to the Scala Sancta next to St Peter's in Rome,[30] and is observed today when entering a Greek Orthodox Church.[31] The writer Dr Samuel Johnson (1709–84) would never enter a house with his left foot first, because it 'brings down evil on the inmates',[32] while his contemporary, Lord Chesterfield, in letters to his Godson written in the 1760s, urges him to improve his posture and deportment by putting his right foot forward:

> You will give me leave to inquire how your right foot does, has it taken a righter turn of late than it had formerly? It would be more pardonable in your left foot, for when you have a mind to put the best foot foremost, it would be very awkward to present your left; not to mention that it would be (I know you love a pun) a *sinister* omen of your carriage.[33]

* * *

VARIOUS EXPLANATIONS HAVE BEEN offered for the pre-eminence of the right hand and side. The Victorian sage Thomas Carlyle speculated that right-handedness 'probably arose in fighting; most important to protect your heart and its adjacencies, and to carry the shield in that hand'.[34] Appealing as this explanation might be, it has been shown that the first shields were invented well after right-handedness became the human norm. In certain kinds of hand-to-hand fighting being left-handed may bring advantages, insofar as a right-hander will be less experienced fighting a left-hander than the left-hander will be fighting a right-hander.

Carlyle thought a great deal about handedness after he had lost the use of his own right hand in the 1860s, probably due to Parkinson's Disease. He came up with another theory after seeing three mowers at work—one left-handed, two right-handed—along Chelsea Embankment: 'He that has seen three mowers, one of whom is left-handed, trying to work together, and how impossible it is, has witnessed the simplest form of an impossibility, which but for the distinction of a "right hand" would have pervaded all human beings.'[35] Carlyle's contention is that for any kind of co-ordinated activity (especially one involving a razor-sharp implement such as a scythe), a certain level of consistency and uniformity is desirable.

An element of specialization certainly does seem to increase efficiency—chimpanzees who fish for termites with the same hand

collect 36 per cent more.[36] In large organisms becoming more efficient also means becoming asymmetric internally.[37] Thus in a human being internal organs are distributed asymmetrically, and blood flows in a spiral movement. The same is true at the molecular level, where sugar molecules rotate polarized light to the right, while amino-acids rotate it to the left.[38] The most dramatic—and counter-intuitive—modern discovery is that the left hemisphere of the human brain performs different functions to the right hemisphere, and controls the movements of the right side of the body.

From antiquity until the mid-nineteenth century, it was generally assumed that the human brain was symmetrical in a way that broadly matched the shape of the human skull—i.e. laterally, from side to side (with the line of the nose forming the dividing line), but not from back to front. Thus the main way of dividing the brain was into anterior, middle and posterior parts, with the anterior portion directly behind the forehead. The last major manifestation of this view occurred in phrenology, the basic principles of which were laid down at the beginning of the nineteenth century.

Phrenology claimed that brain function was localized, and that the surface of the skull was shaped and marked according to the kind of brain activity taking place below the surface; as the various brain faculties developed, they not only produced their own 'bump' on the skull, but these bumps could be developed through massage. By the mid-nineteenth century, anything up to forty-two different faculties were identified, and some phrenologists even claimed there were bumps for things like political affiliations. One phrenologist inscribed on a skull, 'Each little hillock hath a tongue'.[39] The left brain hemisphere was the exact mirror image of the right, so there could be anything up to a total of eighty-four 'bumps' on the head, with the bad ones— such as 'destructiveness', 'secretiveness', 'defiance' and 'love of sex'— located towards the back, on either side. Because of this hemispherical symmetry, phrenological treatises were mostly illustrated with profile silhouettes.

The phrenological consensus started to break down in the 1860s when a French surgeon, Paul Broca, having studied the brains of patients with both language problems and paralysis on the right side of the body, concluded that the left hemisphere of the brain contained the language faculty, and controlled the movements of the right side of the body. Analysis of the brain of his patients after death showed damage to the

left cerebral hemisphere. Broca's discoveries prompted the publication in 1865 of a paper originally given by Dr Marc Dax at a medical conference in Montpellier in 1836, which had come to similar conclusions. In 1800, because Dax had been reading about phrenology, he had asked a cavalry officer with a head-wound who had difficulty remembering words where exactly he had been wounded: it turned out to be in the parietal region on the left side of the head. Dax subsequently saw more patients with a similar combination of left-sided brain damage and language loss. At the time, Dax's paper had generated scant interest, and it was only published thirty years later thanks to the efforts of his son.[40]

Modern research has supported these results, and has also elaborated on the different functions of the hemispheres. The left hemisphere is generally believed to process language, which includes speech, reading, writing and spelling. Some think that the 'nimbleness' and 'speed' required to process language gets transferred to the right hand, thus making it more adept.[41] Conversely, the right hemisphere is believed to carry out 'non-verbal' tasks, including the 'highly parallel, holistic analyses needed to understand visual images and make sense of three-dimensional space'.[42] The right hemisphere also deals with sensory perception and, in relation to language, provides emotion, emphasis, metaphor and humour.[43]

This was, of course, a body blow to phrenology, though these insights did ultimately derive from phrenology's own insistence on the localization of brain functions. There does seem to have been a half-hearted attempt to respond to these ideas in the phrenological ceramic busts that were produced in vast quantities in the late nineteenth century. The most successful were produced by the American Fowler brothers, and they can still be bought in junk and antique shops today. They are glazed uniformly white, like a neo-classical marble bust, but with black texts inscribed on them.

I have one which is drastically asymmetrical, with far more texts inscribed on the left side of the head than on the right. Every single brain function is inscribed on the left side, so that this side is a dense forest of different words: around the left eye, for example, we find 'Verbal Memory', 'Verbal Expression', 'Language', 'Estimates', 'Figures', 'System', 'Neatness', 'Colour', 'Weight', 'Size', 'Form'. However, the right side is far more sparsely covered with a few summarizing inscriptions in upper case, some with unfathomable punctuation: 'MORAL AND RELIGIOUS SENTIMENTS'; 'PERFECTING GROUP'; 'INTUITIVE,

REASONING. REFLECTIVE. FACULTIES.' There are no words at all around the right eye. Visually, this gives the impression that the left brain hemisphere is indeed the extremely busy linguistic side, akin to a computer, while the right is the more laid-back, conceptual, generalizing side.

In many cases, these revelations about the different functions of the brain hemispheres only served to give further credence to the 'pre-eminence' of the right hand. The literate and numerate left hemisphere, which controlled the right hand, was frequently regarded as the 'dominant' hemisphere, while the right hemisphere was seen as less sophisticated—a mere 'vestige', according to a neuroscientist writing in 1961.[44]

This still doesn't answer the question of why in around 90 per cent of human beings the right-hand is the preferred hand, or why the left brain hemisphere is more developed in linguistic and mathematical abilities: people who have had strokes in their left hemispheres often regress to the linguistic ability of a young child, but many can re-learn adult speech with their remaining right hemispheres.[45] So the right hemisphere *can* do it. Indeed, just to make matters more complicated, 5 per cent of right-handers and 30 per cent of left-handers have their language faculty located in their right brain hemisphere![46]

Still, 'division of labour', and a certain amount of dualism, is a fact of the human body and brain, and what will concern us here is the creative exploitation of those divisions.

2. Heraldic Images

But the right side that faces us is, from our perspective, the left side, just as, if a person turns his face in my direction, his right side is on the left from my perspective.

Bartolo da Sassoferrato, *On Insignia and Coat of Arms* (publ.1358)[1]

WHEN DISCUSSING LEFT AND right in relation to artworks, for the most part I shall be doing so in relation to the subject's viewpoint. The standard art historical terminology for this is 'proper left' and 'proper right', but to minimise confusion with portraits, I have opted to use 'the sitter's left' and 'the sitter's right'—or equivalent words with non-portraits, such as 'subject' or 'protagonist'.

This is an important point because in most pre-modern artworks it was taken for granted that the mise-en-scene of the picture is set up in relation to its protagonists, and especially to its leading protagonist, rather than to the viewer. The reason for this is that the protagonists of an artwork are usually assumed to be more important than the viewer, and in certain respects separate—Gods, heroes, saints, kings, queens, aristocrats, statesmen, religious leaders. This is most easily discernible in a centralized, frontal composition. Thus in a crucifixion scene, for example, the bad thief will be on Christ's left, and the good thief on Christ's right—rather than on our left and right. In a double portrait of a husband and wife, as in a wedding ceremony, the wife will usually stand to the left of her husband, rather than to the viewer's right, thus reflecting her social subservience.[2] Similarly, in the theatre, the terms 'stage left' and 'stage right' are judged from the actors' point of view, as they face the audience.

The hierarchical way in which viewers 'read' images is movingly illustrated by a passage in the memoirs of the Florentine merchant Giovanni di Pagolo Morelli.[3] His eldest son, the nine-year-old Alberto, died in June 1406 after a painful illness and without receiving the last sacrament. A year later, still grief-sticken, Giovanni devised an elaborate ritual of prayer and penance. With bare head and knees, and with a leather strap around his neck, he prayed before the same image that his son had had brought before him during his illness. The panel showed Christ on the cross flanked by Mary (on his right) and St John the Evangelist (on his left).

Giovanni first fixed his gaze on Christ, meditating for some time on his suffering, then asked for God's mercy for himself and his son. After a while, when 'my heart and mind had calmed down, I turned my eyes to the right side of the true Cross, where, looking at the foot of the cross I saw the pure and holy and blessed mother'. Having meditated on her sufferings, he asked her to make him and his son part of her own prayers. He then picks up the panel, kisses it, replaces it, says the Creed and recites the Book of St John the Evangelist: 'As I said this, my eyes came to rest on his figure, depicted on the left hand of the precious cross with as much sadness as it is possible to show in a human body.' Giovanni promptly bursts into floods of tears that create a pool on the floor, then makes a long prayer to St John (his name saint: Giovanni is Italian for John). Finally he kisses them all in order—first Christ, then Mary, and finally John.

It would be impious for Giovanni to say that he had turned to Mary who was standing 'to my left': the order has to be the one determined by Christ himself, who was presumably facing to his right. Although he kisses them, Giovanni accepts that he is outside that order and subordinate to it when he says that he turned his eyes 'to the right side of the true Cross'. One of the most important truths that the 'true' Cross lays down is in relation to left and right. Indeed, in descriptions of the crucifixion, Christ's right hand is nailed to the cross before the left, and the right hand is un-nailed first too.[4] This decorum is a discrete 'alienation effect' that imposes a limit to the intimacy that any worshipper can assume with the image. A recent experiment in cognitive psychology concluded that in making left-right judgements about another person's body parts, the observer implicitly mentally rotates into the observed body, but it seems likely that the decorum of the past made people more cautious about doing so. Inhabiting another person's

body—and especially the 'imitation of Christ'—was hedged in with protocols.[5]

An almost identical approach is found in the thirteenth-century cabbalistic *Book of Faith and Religion*, written by Rabbi Jacob ben Sheschet of Gerona. The Rabbi urges those who are praying to do the following: 'Then one proclaims "shalom" as if one were a student departing from one's master. First one greets the left—which is the right side of the Holy One, blessed be He—and then the right, which is His left side.'[6] Thus a similar spatial hierachy is adopted in a religion that does not anthropomorphize its God, and that outlaws visual images of the Divine. Modern experiments in perceptual psychology have shown that most people attend more carefully to the space to their left than to their right—something which makes people more likely to bump into things on their right.[7] This may well derive from a primitive requirement to be especially vigilant to the gestures—whether friendly or hostile—made by the right hand of the person standing in front.

So ingrained were such procedures that even the famous antique sculpture of *Laocoon* (see Fig. 3, p. 49), rediscovered in Rome in 1506, could be looked at in this way. The Venetian ambassadors, in their diplomatic report of their visit to the Vatican on 28 April 1523, observe that the sculpture was placed on a base 'the same height from the ground as an altar'. They begin by describing the central figure of Laocoon: 'only breath is lacking', and then move on to describing his two sons, first the one on Laocoon's right, and then the one on his left: 'we see one of the boys on the right side, twice wrapped around very tightly by the serpent, and one of these [coils] crosses his breast and constricts his heart so much that he is on the point of dying; the other boy on the left hand side, also wrapped around by another serpent, wanting to pull the rabid serpent from his leg with his small arm, but with no one else being able to help, stands with his face covered in tears, shouting towards his father, and holds his father's left arm with his other hand.'[8] The ambassadors stick to the standard procedure even though the boy on Laocoon's right is younger, smaller and more pathetic than his brother. The same running order had been followed in the most celebrated and influential description of the sculpture, Jacopo Sadoleto's poem *On the Statue of Laocoon* (1506).[9]

These conventions must have influenced the development of heraldry during the Middle Ages, for heraldry is orchestrated in a similar way—with heraldic dexter on a shield being the right half of the shield in

relation to the knight who bears the shield, rather than in relation to the viewer—or opponent—looking at it; similarly, heraldic sinister is the left half in relation to the bearer. There was a further gendered hierarchy within heraldry whereby when a man and woman from noble families were married, the woman combined her husband's heraldic emblem with that of her own family, with her own being relegated to the position of heraldic sinister.

In a manuscript illumination from *c.*1483 to 1485 (British Library, London), the Countess of Salisbury is shown standing to the left of her fully armed husband, who looks away to his right. She wears a full-length cloak decorated on the 'dexter' half with her husband's arms—a lion rampant (erect) with right paw raised—and with her own arms on the 'sinister' half—vertical lozenges and stripes.[10] Shakespeare was evidently versed in these subtleties, and so when the Trojan warrior Hector says in *Troilus and Cressida* that he doesn't want to fight his Greek cousin Ajax any more because they are related through his mother, the dramatist deliberately reverses heraldic convention to show that Hector's 'dexter' hand has succumbed to a 'womanly' pacifism: 'my mother's blood / Runs on the dexter cheek, and this sinister /Bounds in my father's' (4:5:144–6).

The reason why this point needs to be belaboured is because there is a tendency for modern viewers to assume that pictures are designed to be 'read' in the same way that westerners read (or write) a line of text—that is, from left to right. Rudolf Arnheim, in his hugely influential *Art and Visual Perception* (first edition 1954), insists that 'a picture is "read" from left to right', despite noting in his next paragraph that tracings of eye movements show that 'viewers explore a visual scene by roaming about irregularly and concentrating on the centres of major interest'.[11] Arnheim further believes that the left side of any picture is emphasized 'by the viewer's identification with it', and thus in 'Grünewald's Crucifixion of the Isenheim altar, the group of Mary and the Evangelist to the [viewer's] left assumes greatest importance next to Christ, who holds the centre, whereas John the Baptist to the [viewer's] right is the conspicuous herald, pointing to the scene' (Fig. 1).[12] Arnheim writes about the crucifixion scene as if it is set up entirely to satisfy the viewer's need to empathize with the 'left' side of the picture, where Mary and John the Evangelist are located. This theory hardly supports Arnheim's prior contention that we 'read' a picture from left to right, for in a sentence the first word or phrase is not necessarily more 'weighty' than the last.

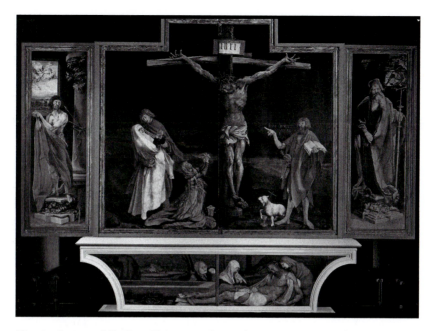

Fig. 1: Grünewald's Crucifixion, Isenheim altarpiece

Grünewald is unlikely to have intended his picture to have been 'read' from left to right. Mary is the most important person after Christ, and the contemporary viewer would probably have looked over to her after gazing at the astonishing image of Christ. But their eyes are more likely to dwell on the figure of John the Baptist, who stands to Christ's left. The Baptist points at Christ while facing us, and so he is our main entry point to the picture: he mediates directly between us and Christ. By way of contrast, the heavily clothed Virgin is far more remote: she seems totally absorbed in her own grief, and her face is partially veiled. The Baptist's importance is shown by the fact that he is the second largest figure in the picture, after Christ.[13] He was of course dead by the time of the crucifixion, but is included and given such prominence because he is the archetype for anyone who preaches the Gospel.

Other aspects of the Baptist encourage us to dwell on him. Contemporary viewers (especially those who could read Latin) would have been especially curious about the inscription shoe-horned into the triangular space formed by John's raised arm—the only inscription to be found in the panel. The usual inscription would have been: 'Beholde the Lambe

of God, which taketh away the sinne of the world' (John 1:29). Instead, we find a different text arranged in a higgledy-piggledy pile:

ILLUM OPORTET
 CRESCERE
 ME AUTEM
 MINUI

'Ye must encrease but I must decrease'(John 3:30). This is probably a reference to the respective feast days of Christ and John: Christ's birth is celebrated on the darkest day of the year, after which the world becomes progressively lighter—hence he will increase.[14] Viewers would also have been interested in the Baptist's wonderfully extended index finger, for it was believed that this finger did not decay after the Baptist's death.

The fact that our main entry point to this picture is located on the left side of Christ would also remind us of our lowly existence in the world—and of the amount of spiritual 'work' we are going to have to do before we can occupy the more privileged right side of the cross where the somewhat occluded Virgin stands. This, I believe, is why Giovanni Morelli bursts into tears when he focuses on St John the Evangelist, standing to the left of Christ: he thinks to himself that if a man as good and great as St John still has to stand to the left of the cross, where does that leave my son and me?

<p style="text-align:center">* * *</p>

THE TENDENCY TO WANT to 'read' a picture smoothly from left to right has drawn much impetus from a celebrated and frequently quoted letter written by Pope Gregory the Great (590–604) to the Bishop of Marseilles. The Bishop had destroyed the images in his church when he found his congregation paying homage to them. Pope Gregory underlines the educative advantage of images:

> It is one thing to offer homage to a picture, and quite another to learn, by a story told in a picture, to what homage ought to be offered. For that which a written document is to those who can read, so a picture is to the unlettered who look at it. Even the unlearned see in that what course they ought to follow, even those who do not know the alphabet can read there.[15]

A recent study of around 100 surviving Italian mural cycles from 400–1600 is extremely instructive.[16] In the period 500–1000, it does indeed

seem that there was a tendency to arrange scenes of mural cycles to be read from left to right. The 'Double Parallel', devised for early Christian basilicas, requires the viewer to 'read' from their left to their right. But from then on—in other words, at a time of rapidly increasing literacy— the most popular form by far is the 'Wraparound Pattern'. The best known examples are the two fresco cycles on the walls of the Sistine Chapel, painted by Tuscan artists in the 1480s. If we look towards the altar, on our right we find key episodes from the life of Christ, and on our left from the life of Moses. But both these cycles start from the altar end, meaning that while we 'read' the life of Christ from left to right, we 'read' the life of Moses from right to left. Here, one might assume that the right-left direction of the Moses cycle is an allusion to the right-left direction of Hebrew writing, but 'Wraparound' cycles devoted to Christian narratives do exactly the same.

In the period 1500–1600—that is, in the first century after the Gutenberg revolution—there are proportionally fewer 'left-to-right' cycles than ever before. By far the most common patterns are the 'Wraparound' and the 'Counterclockwise Wraparound' in which the fresco cycles on *both* walls are 'read' from right to left. The next most common is the 'X'-shaped 'Cat's Cradle' pattern which jumps about diagonally from side to side: these usually progress from top right to bottom left, then across to bottom right and finally finishing at top left.

The most common place where one might find a left to right arrange-ment of paintings was in the predella of an altarpiece. The predella was a series of small narrative panels placed right at the bottom of the altarpiece, below the main panel. Perhaps the first and certainly the most influential example appears in Duccio's *Maestà* (*c.*1308–11), by far the most important and ambitious Italian altarpiece.[17] It is sixteen feet high and fifteen feet wide, and is painted on both sides. The predella on the front depicts seven key episodes from the early life of Christ below the main panel of the *Virgin and Christ Child Enthroned with Saints and Angels*. Each panel is separated by standing figures of prophets. On the back, the predella comprises nine scenes from the ministry of Christ, and the predella is surmounted not by a single large panel, but by twenty-six scenes from the Passion and from Christ's appearances after the Resurrection.

While the predellas are clearly meant to be read from left to right, it is in no way comparable to reading a book, for the earliest scene

on the front of the altarpiece—*The Annunciation*—is at the bottom left of the predella, while the latest scene—*The Death of the Virgin*—is at the top right, above the main panel. Thus we read from bottom left to top right. However, the Virgin's death is not the end of the story: it is only the last scene of the Virgin's life on earth. Missing panels in the top centre would have depicted her *Assumption* and *Coronation* in heaven. So right at the end we go left, and double back on ourselves.[18] But they would anyway have most likely been read like that relatively modern invention, the footnote, as amplifications of the main event—the large panel of the enthroned Virgin—with the viewer's eye passing vertically up and down.

The scenes above the predella panel on the back of Duccio's altarpiece are also read from bottom left to top right, but they are structured in a far more complicated way. Some panels are double-sized, and we read the whole by zigzagging up, across, down and across, through the two lower registers, and this trajectory, the so-called 'boustrophedon', is repeated in the upper register. Unity is preserved by devices such as having the figures on the same scale, light falling from the viewer's left, and buildings shown slightly from the left. Individual scenes, however, are still orientated internally in the normal way, with the angel Gabriel arriving from the Virgin's right, and the central, double-height image of the crucified Christ facing to his right at a group that includes the fainting Virgin.[19]

The term boustrophedon is a Greek word that describes the way in which oxen plough a field, and it is also used to describe a possible phase in the development of writing in the Mediterranean: early Phoenician was written from right to left, but classical Greek from left to right, and it has been conjectured that there may have been an intermediate 'boustrophedon' phase, in which the letters in the 'right-to-left' line were written as reverse mirror images.[20] Where the visual arts are concerned, the structure of the boustrophedon may have seemed quite natural in societies in which activities such as ploughing and weaving loom large.

If viewers were expected to 'read' pictures from left to right, there would be more consistency about the way in which inscriptions are applied to artworks. But in paintings and tapestries they tend to be fitted around the images (as in the *Isenheim Altarpiece*), and are often not even horizontal (the only inscription in the *Maestà* is wrapped around three sides of the base of the Virgin's throne). The names of holy figures are

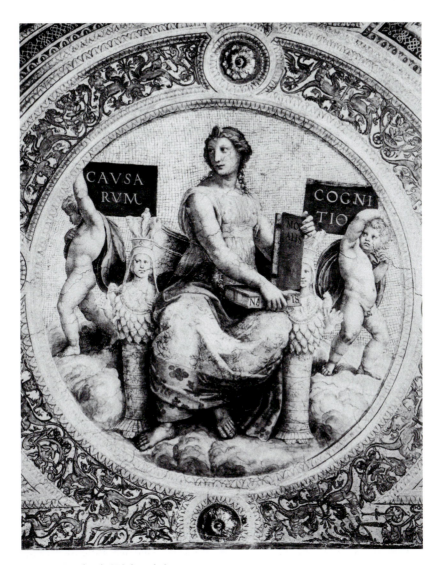

Fig. 2: Raphael, '*Philosophy*'

often inserted into their circular haloes, and texts are often inscribed on long trailing scrolls—but this hardly means we are meant to 'read' the image in a clockwise or curvilinear fashion.[21] When saints hold books out so that a text is legible, words are often unnaturalistically enlarged and 'stacked', so that we read more from top to bottom than from left to right.

Raphael's allegorical depiction of Philosophy (Fig. 2) on the ceiling of the Stanza della Segnatura (*c*.1508–9), holds up a book whose back cover is inscribed:

MOR
ALIS

She rests this book on another book which she holds horizontally in such a way that only NAT and IS are visible—NATURALIS. Morality is clearly superior to 'horizontal' nature, and has to be comprehended in a top-down vertical manner, since its origin is God.

She is flanked on either side by two putti who hold inscribed tablets. That on her right says:

CAUSA
RUM

This means 'of the causes of things'. The inscription on her left says:

COGNI
TIO

This means 'knowledge', 'cognition'. Here again we are being invited to read from top to bottom.

But Philosophy, the colours of whose dress are those of the four elements, looks to her right, which shows that she values 'causarum' most highly of all.[22] Thus our 'reading' of the image is carefully directed, with our ultimate destination being above Philosophy's right shoulder. A similar hierarchy is adopted in the fresco below of *The School of Athens*. In the centre stand Plato and, to his left, Aristotle. The former, in the honorific position, gestures vertically upwards while the latter gestures horizontally downwards. They each hold books and these reflect the same hierarchy. Plato's book is held vertically, and is raised slightly higher than Aristotle's which is propped horizontally on his left thigh.

* * *

THE IMPORTANCE OF ORIENTATING images in relation to the protagonists, rather than in relation to the viewer is given further support in a fascinating discussion of writing by Bartolo da Sassoferrato (1314–57) in the first learned treatise on heraldry, *On Insignia and Coat of Arms* (publ. 1358). For Bartolo, the fact that Europeans write and read from left to right required explanation.

While he was learning Hebrew, Bartolo had a discussion with some Jews: 'They said that our method of writing is not rational: we begin writing from the left side, drawing the letters toward the right side, and thus what should be the source of motion [according to Aristotle, the right side is the source of motion] becomes the end and what should be the end becomes the beginning.' The Jews then claimed that their method of writing is much more rational 'because they begin writing on the right side and move to the left'.

But Bartolo counters with an ingenious defense of left-to-right script that is predicated on the heraldic notions of left and right.

> Writing is made to be read; to be read is to be seen by the eyes, and therefore reading is performed through sight. To see is a passive operation, as the philosophers say. The image of scripture as perceived by our eyes acts on them, so that the eyes become the recipient of an action, which is evident also because they can be injured by reading.

Here, the writing is active, animate even, and it works on the passive eye of the reader. Bartolo imagines someone, as it were, both creating and inhabiting the writing from the other side—from behind the piece of parchment. He goes on:

> In order that writing might effect our eyes, this action must begin on the right side of the writing, because that side is the source of motion and action. But the right side that faces us is, from our perspective, the left side, just as, if a person turns his face in my direction, his right side is on the left from my perspective. And so it appears that we in our writing operate more rationally, since we consider the end, namely, that writing may begin from the right side, while according to Jewish custom it begins from the left side.[23]

Alcuin of York (*c.*735–804) was the first to observe that the writing of holy men is dictated by God,[24] and Bartolo implies that God is the ultimate author of all Christian writing. From God's perspective, sitting opposite the human scribe guiding their pen, Christian writers do start on the right (or heraldic dexter). Thus our own writing is actually God's mirror-writing—the same form of writing that the omniscient Leonardo would learn to do.

Bartolo's theory, or something very like it, must have had an influence on Fra Angelico when he painted his two great altarpieces of *The Annunciation* (*c.*1425–6; *c.*1430–1), each of which exhibits a radically

different approach to inscriptions. The main panel of each altarpiece is arranged in a similar way, like a triptych with three main 'scenes'. On our left, Adam and Eve are shown being expelled from the garden of Eden. This garden abuts a portico, which has two arches framing, respectively, the Angel Gabriel and the Virgin.

In the earlier of the two altarpieces, from San Domenico, Fiesole,[25] a Latin inscription runs horizontally below the main panel for its full length. It contains the words of the Angel, beginning with: AVE MARIA GRATIA PLENA DOMINUS TECUM [Hail Mary full of grace. The Lord is with you (Luke 1:28)]. However, they are not really placed there to encourage us to 'read' the main panel from left to right. The main purpose is to have 'AVE', the angel's famous greeting, directly below Eve or EVA, to demonstrate how the Virgin 'reversed'— or cancelled out—the sin of Eve. The AVE/EVA verbal mirroring was one of the most famous bits of theological wordplay. Thus the first word of the inscription directs our eye upwards to Eve at the top of the picture, and asks us to read the word AVE from *right to left*, rather than immediately encouraging us to travel along the rest of the inscription. The Annunciation scene itself is orchestrated in relation to the Virgin, as was standard practice. Thus the angel, and the light of the Holy Spirit, come from the Virgin's right (our left) because this is the traditional location of all things Divine.

For the second altarpiece, painted for the church of San Domenico in Cortona, Fra Angelico intensified the interaction between the angel and the virgin by having the words seem to emanate from the angel's mouth in two streams, the first of which curls up and round the Virgin's halo, as if caressing it, and the second of which aims directly at her womb. The Virgin's reply is amazing: it is written in reverse with mirror-letters, as in a boustrophedon, so that the text seems to start at the Virgin's lips, and move from right to left. Van Eyck did exactly the same in his *Annunciation*, now in Washington, and it has been said of both pictures that this has been done so that God, lurking in the background, can read what the Virgin says. But this is only part of the story. While God is ultimately the 'author' of the Virgin's words, she also happens to be *the* woman—pace AVE/EVA—who reverses everything.[26]

* * *

WHY, THEN, HAVE SO many twentieth-century viewers ignored the heraldic principles governing so much pre-modern art?

It is largely due to the modern tendency to prioritize the viewpoint and subjectivity of the viewer. The treatment of left and right by the erudite papal archaeologist Giovanni Ciampini (1633–98) has been seen as symptomatic of the decline in the heraldic perception of artworks, and of a shift towards seeing left and right in relation to the viewer.[27] In the first volume of his pioneering book on medieval christian mosaic, *Vetera Monimenta* (1690), Ciampini describes a mosaic in Rome's Santa Maria Maggiore in which St Peter and St Paul flank a crucifix placed before the Holy Shroud—Peter is to the crucifix's right, Paul to its left. Ciampini merely says that 'St Peter is to the left, and St Paul to the right in relation to the viewer' [respectu aspicientis].[28] This may well be the first time in which such a phrase had been used to describe left and right in a religious image.[29]

In the second volume of *Vetera Monimenta* (1699), Ciampini describes another mosaic in the Roman church of Santa Cecilia in which St Paul is now positioned to Christ's right, and St Peter to Christ's left (there were disputes during the Middle Ages and the Reformation over whether Peter or Paul should occupy the supreme position on Christ's right).[30] Ciampini says that St Paul 'is placed to the right of the Saviour in a position on the [viewer's] left'.[31] This inelegant acknowledgement of the viewer's viewpoint can be seen as the first step before left-right distinctions are ignored altogether, for as soon as we think we can read a picture like a text, left-right distinctions diminish in importance, for there is no clear positional hierarchy among the words in a particular sentence: the words at the beginning (i.e. on our left) are no more likely to be more significant than any of the others.

One could propose a number of reasons for this historical shift, but among the most plausible are the following. The ascendency of the printed book illustrated with engravings (Ciampini's own book was very well illustrated) may have made people more likely to associate reading and looking—something that was anyway encouraged by comparisons that had been made since the mid-sixteenth century between poetry and painting.[32] Prints were increasingly produced with captions, and this too may have encouraged the tendency to 'read' images, and to think increasingly of left and right in relation to themselves.

A far more significant challenge to heraldic modes of vision was made by aesthetic theories that paid close attention not just to the viewpoint of the beholder but to the viewer's subjectivity. A key milestone in this process was the publication in 1674 in a French translation of the

treatise *On the Sublime*, attributed to Longinus, a Greek rhetorician of the third century AD Longinus claimed that the effect of the sublime was to transport the spectator and to take him out of himself. For Longinus, the sublime could only be found in the untamed vastness of nature and in literature. But during the course of the eighteenth century, beginning in England, the visual arts became a key catalyst for feelings of the sublime. Landscape gardens and landscape painting were both eminently capable of giving the spectator sensations of boundlessness and immensity. In the theory of the sublime, the viewer is free both to enter the object of sight and to be overwhelmed by it. There is a kind of total mystical fusion—whether positive or negative—that has no room for 'alienating' and divisive heraldic notions of left and right.[33] In the art criticism of the period, especially in France, critics frequently imagine themselves as participants in a depicted scene, or going for walkabouts in a painted landscape.[34]

The new emphasis on the viewer—and the related 'decline of heraldry'—is most clearly signalled by changes in the design of tomb monuments, especially in mid-eighteenth-century England. In earlier English tombs, it was standard practice in what has been called the 'chivalric tradition' to surround the effigy of the deceased with an elaborate set of heraldic armorials, which stressed their fixed place in a vast family tree. During the eighteenth century it became fashionable to present a single neo-Roman image of the deceased beneath a single heraldic escutcheon. These were often 'skied', and small-scale, so they were relatively inconspicuous. The connection of the deceased with their ancestral past was celebrated less than their relationship to the living. Long inscriptions on the tomb emphasized what the deceased had left to his heirs, and the fact that the heirs had (more than) fulfilled their part of the bargain by constructing a fine tomb: 'Monuments passed from representing the virtue of the dead to recording the virtuous connection between the living and the dead.'[35] In many cases, the living upstaged the dead in the actual monument for statues of 'live' mourners were included. Thus the mournful 'viewer', who was sometimes shown in the act of writing the inscription, became the main protagonist in the monument.

But we are running ahead of ourselves: we will return to modern ideas about left and right in the final part.

3. Fair Game

...when he is entangled in the toils of temptation, when he is inflamed with the heat of desire for carnal lusts...then he knows that he is attacked on the left hand.

St John Cassian (*c*.360–*c*.435), *Conferences*[1]

Once when I was in the oratory the Devil appeared on my left side in hideous form...There was some holy water near by, some drops of which I threw in his direction.

St Teresa of Avila, *Autobiography* (*c*.1561)[2]

HAVING SKETCHED IN SOME of the basic left-right conventions, I would now like to explore in more detail an issue that informs our response to some of the most highly-charged visual images—those that are centrally concerned with physical and/or sexual assault. In most of the images I have chosen, the assailant comes from the victim's left.

In all such images, there was (and still is, to a great extent) an underlying moral hierarchy relating to the direction of the attack. A wound sustained on the right side of an unshielded body is more likely to count as an outrage, the archetypal example being the spear thrust by the Roman centurion Longinus into the right side of Christ's body.[3] At the very least, if the victim turns the right side of their body to the assailant, it implies that they intend to resist, or at least want to give the impression they do not welcome the intruder. The right side is akin to a cold shoulder, and any wound is a violation. In Christ's case, the wound in his right side emphasizes the extent of the sacrifice he has made for humanity.

Conversely, if an aggressor is offered the 'impure' left side, and that side is violated, the moral issues seem to be less clearcut. Historical evidence suggests that viewers were less likely to be outraged, more likely (especially if the victim is a beautiful woman) to be titillated. Pictorial and cultural convention suggests that those who expose their left side (which is also the 'heart' side) are at some level either complicit or culpable—they are 'asking for it'. This is why an assault on the left side tends to appear more acceptable and exciting.

This dichotomy is neatly exemplified by an image which is credited with inaugurating that great theme of Venetian and then European art, the reclining female nude. The image is a woodcut illustration from the *Hypnerotomachia Poliphili* (Venice, 1499), one of the most beautiful printed books of the Renaissance. The author is generally thought to be Francesco Colonna, a Dominican friar from Treviso who gravitated to Padua and then Venice. The woodcuts are by an unknown artist who was probably in the circle of Andrea Mantegna.

The text is a first-person account by a young lover called Poliphilo of a dream in which he searches for his lost love in a landscape strewn with astonishing ruins of antique buildings and sculptures. At one point Poliphilo discovers a fountain carved in marble, with the water issuing from a relief carving of a naked nymph sleeping outdoors under an arbutus tree:

> This beautiful nymph lay sleeping comfortably on an outspread drapery... She lay on her right side, with the lower arm bent and its open hand beneath her cheek, lazily supporting her head. The other arm was free and extended along the left side with its hand open halfway down her plump thigh. The nipples of her small breasts were like a virgin's, and from them spurted streams of water, cold from the right hand one and hot from the left. At her feet there stood a satyr, all aroused in prurient lust...[4]

In the woodcut image, the satyr draws back a flimsy curtain that has been suspended from a branch of the arbutus tree, and stands over her with a substantial erection, feeding his eyes on her left side.

Here Colonna reverses the Aristotelian convention that the left side of the body is colder than the right by having hot water spurting from her left breast. The medieval *Book of Secrets*, a highly popular conduct book supposedly sent by Aristotle to his pupil Alexander the Great, recommends that sleepers lie on their left side, because it needs to be

kept warmer than the right.[5] Perhaps the nymph's 'unnatural' heating system is what allows her to sleep on her right side, and thus expose her left side to all-comers.

Colonna's basic idea seems to be that the left side of this nymph, which is completely exposed, is her 'hot' and even 'steamy' side. The cold water that runs out of the right nipple seems purely functional: it is drinking water. However, one could potentially bathe one's whole body in the hot water gushing from the left nipple. The fact that the nymph's left hand lies 'open half way down her plump thigh' only seems to confirm the hospitable voluptuousness of that whole side. By only leaving her 'weaker' left arm free we may assume she has little thought of defending herself—and little desire to do so.

This woodcut suggests that the left-right orientation of a depicted body in relation to the onlooker (whether it be another protagonist or the viewer) may have a significant impact on our response to that body. Titian certainly seems to have thought so: when he painted his most sexually explicit reclining nudes, the two versions of *Danae* (both 1540s; the first painted for Cardinal Alessandro Farnese, the second for the future King Philip II of Spain), in which the courtesan-style princess lies naked on her bed and is raped by Jupiter in the form of a shower of gold coins, the shower angles in from her left like driving rain. Danae's head falls languidly leftwards towards it, and her left arm and leg sprawl motionless and wholly unresisting. We, the viewers, are confronted by her less languid right side, with which she creates far more of a barrier. Her powerful right leg is raised and bent sharply at the knee, shielding her sex from us, while her right arm is more active. It is pushed towards us and bent sharply at the elbow, while her fingers ruffle the sheets.[6] The same is true of Titian's similarly orientated *Venus of Urbino* (1538), if we believe—as many do—that her strategically placed left hand is fondling rather than merely concealing her sex. As Mark Twain wrote in 1880: 'It isn't that she is naked and stretched out on a bed—no, it is the attitude of one of her arms and hand. If I ventured to describe that attitude, there would be a fine howl.'[7]

* * *

WE NOW NEED TO explore the cultural reasons why the left side may have been typecast as both more accessible and complicit.

Historically, for about 90 per cent of the population, the left arm and leg are less strong and agile than the right, and there has been a

corresponding tendency to believe that things that are physically and morally most dangerous will launch their attacks on our weaker side. Our left side is, as it were, our Achilles heel. Thus when I was a child in the 1960s my aunt initiated me into the traditional practice of throwing salt over one's left shoulder to ward off the Devil: in the past, this must have been a profoundly serious gesture, as salt was an extremely expensive commodity, and the 'salt-cellar' (pace Cellini) was the costliest item of table furniture.[8] Similarly, in pantomime, the good Fairy Queen has always entered from stage right (the audience's left) while the Demon King entered from stage left.

The perceived weakness of the left side was once believed to have a physiological basis. Ptolemy claimed in the *Tetrabiblos* that evil spirits, when they are located in the east (which Ptolemy, following the Greek system, regarded as on our right), only cause superficial blemishes, but when they are in the west, they cause serious diseases: 'Maleficent planets when Oriental, generally produce blemishes and hurts, but when Occidental, they cause diseases. There is a difference between a hurt and a disease, because the pain of the former is but short, whereas a disease is either continual or returns at intervals.'[9] In the astrologically influenced science of metoposcopy—reading the marks and lines on the forehead—a bad mark on the left side is catastrophically bad, whereas a bad mark on the right side is only moderately bad.[10] Similarly, a right eye that twitches is a favourable omen, and a humming in a person's right ear means nice things are being said about them somewhere in their absence. A left eye that twitches or humming in the left ear is a bad sign.[11]

The Ptolemeian theorem is vividly expressed by the great preacher St Bernardino, in a sermon that he gave in the Campo of Siena, in 1427, but which would have been repeated elsewhere. The soul is a city with doors on all four sides. The first door is on the eastern side and this signifies the joy that comes from knowing that every happiness comes from God rather than from the world. The second door is on the west, and this signifies pain, and when the devil enters through the western door 'he gives infirmities to the body, and kills children'.[12]

Astrology was central to medical practice until at least the eighteenth century, and so these kinds of belief were widely held. Ptolemy's theory is clearly based on cultural prejudice rather than on medical fact, for it is only really true if the heart gets injured, and for most people

(whether warriors or writers) damage to the right hand or arm has more debilitating consequences than damage to the left. This is why a standard punishment for defeated enemies and criminals was—and still is under Sharia law—to cut off their right hand.

The intrinsic physical and moral weakness of the left side meant that special precautions needed to be taken to protect it from harm. It has always been standard Jewish practice to attach protective amulets to the left side of the body, especially the left arm. The most elaborate of these amulets was the *teffilin*, worn during prayer. Old Testament passages written on leather made from the skin of ritually pure animals were fastened to a strap tied round the left arm. The practice was inspired by a selective reading of Deuteronomy 6:8: 'And thou shalt bind [these words] for a sign upon thine hand, and they shall be as frontlets between thine eyes.' Although no hand (or arm) is specified, the left was invariably selected. The texts were rolled up and fixed to a leather strap of about $1^1/_2$ times the length of the arm. This was then wound three times round the middle finger, before criss-crossing the back of the hand, and then wound seven times round the forearm, and tied in an elaborate knot.[13]

Because of the greater weakness of the left side, the ability to ward off an ambush by the Devil from the left is a sure sign of divine favour and proof that appropriate precautions have been taken. A key text here is a chapter in one of St John Cassian's *Conferences*, 'Of the excellence of the perfect man who is figuratively spoken of as ambidextrous'. The 'desert father' Cassian (*c*.370–*c*.435) can claim to be the father of the monastic movement in western Europe, for the monastery of St Victor which he founded near Marseilles, and the rules he drew up for its organization, were to be hugely influential. While Cassian's *Institutes* deal with practical matters relating to monastic life, his *Conferences* are concerned with the training of the inner man. Numerous manuscript versions survive, and both treatises were frequently printed and translated throughout the sixteenth and seventeenth centuries.[14]

Cassian's starting point is the biblical figure of Ehud, who in the Book of Judges delivers the Israelites from the evil (and obese) King Eglon by stabbing him in the stomach with a dagger held in his left hand. In the Septuagint, the oldest Greek version of the Old Testament, Ehud is described as ambidextrous—a man who 'used either hand as the right hand' (he is left-handed in all the other versions). Cassian believes the perfect man needs to be *spiritually* ambidextrous:

And this power we also can spiritually acquire, if by making a right and proper use of those things which are fortunate, and which seem to be 'on the right hand', as well as those which are unfortunate and as we call it 'on the left hand', we make them both belong to the right side, so that whatever turns up proves in our case, to use the words of the Apostle, 'the armour of righteousness'.

The right hand here represents that indomitable spiritual strength by which a good christian 'gets the better of his desires and passions, when he is free from all attacks of the devil, and without any effort or difficulty rejects and cuts off all carnal sins, when he is exalted above the earth and regards all things present and earthly as light smoke or vain shadows'.
But he also needs to keep an eye on his left hand:

He has also a left hand, when he is entangled in the toils of temptation, when he is inflamed with the heat of desire for carnal lusts, when he is set on fire by emotion towards rage and anger, when he is overcome by being puffed up with pride or vainglory, when he is oppressed by a sorrow that worketh death, when he is shaken to pieces by the contrivances and attacks of accidie, and when he has lost all spiritual warmth . . . when a monk is troubled in this way, then he knows he is attacked 'on the left hand'.

The good man 'struggles manfully' against these 'left-sided' temptations and 'seizes the armour of patience', using 'both hands as right hands'. The key example of this is Job, who took fortune and misfortune in his stride, never falling into despair or blasphemy.[15]
Cassian's theory of spiritual ambidextrousness implies that there is no reason why the (metaphorical) left hand cannot be as effective as the right in warding off evil and temptation, so long as it is given the appropriate spiritual training (sadly, though, Cassian's own followers would still only preserve his *right* hand, together with his head, as relics in the Monastery of St Victor). There is no real suggestion here that the training should involve drastic physical interventions and restraints, such as the application of something like a *teffilin*. Yet by the later Middle Ages, with classical antiquity's basic respect for the human body becoming more alien than it had been for Cassian, who wrote and spoke in Greek, the education of the human soul had indeed expanded to include the castigation of the human body.

But there was nothing joyless about it. Far from it: the great medieval text on bodily repudiation is ecstatic. It was written by the founder of the Cistercians and the leading advocate of the disastrous second crusade, St Bernard of Clairvaux (1090–1153). His *Sermon on Psalm xc: 'Qui habitet'*, advocates a crusade against the left side. Taking his cue from a line in Psalm 16:8—'The Lord always provided for me, for he is on my right side, to make me stand firm'—St Bernard says:

> May God grant that you, good Jesus, be always on my right side! May God grant that you always hold my right hand! I am sure that no adversary will harm me if no injustice rules. Meanwhile let the left side be shorn and cut, let it be struck with insults and bound with disgrace! Willingly do I set forth the word, while I am guarded by you, since you are my defense on my right hand.[16]

The Jewish *teffilin* functions in a similar way, for the left arm is 'bound with disgrace' in order that the wearer can be saved. The amulets make the person as a whole spiritually stronger, while the tightly bound strap physically disables the troublesome left side, putting it into bondage and rendering it physically weaker than it was before. You save your soul by further disarming your left arm. Bernardino of Siena says that when pain enters through the western door of the human soul (i.e. the left side) 'the soul should never grieve about anything that happens unless it comes from God, and unless this rule is followed things will turn out badly'.[17] In other words, all left-sided pain should be accepted, whether with joy or penitential grief.

St Bernard's statement must have been influenced by practical as well as by moral considerations. Until the eleventh century flagellation had tended to be used solely as a form of punishment, inflicted in public by one person on the back of another. But St Peter Damian (1007–72) seems to have turned it into a regular form of penance that could be carried out in private by one's own hand.[18] For right-handed self-flagellants, it is easier to whip the left side of their body, and they can get far more power in the stroke.[19] The German monk and mystic Heinrich Suso (*c.*1295–1366), a follower of Meister Eckhart who was famous for gouging Christ's monogram (IHS) into the skin over his heart, describes the consequences of just such a practice in his spiritual autobiography:

> On St Benedict's Day, on which he was born into this wretched world, he went into his chapel during the collation. He closed the

door and undressed as before. He took out his scourge [with the sharp thorns] and began to strike himself. A blow chanced to fall upon his left arm, and struck the median vein or another one. The blood sprang out, and flowed in a stream over his foot, through his toes down onto the floor, forming a pool there. His arm swelled up greatly at once, and became bluish. He was too frightened to strike any more.[20]

His whole left side is bathed in blood, and his left foot stands in a pool of blood. Suso's writings were heavily influenced by chivalric culture and courtly love, with God rather than a Lady the object of his affections. He was known as 'Sweet Suso', and adopted the name of Amandus—the Latin for 'lovable'. There must have been a powerful element of machismo behind this frenzy of self-mutilation, and a desire to be a frontline Christian soldier. This gruesome scourging scene is comparable to an act of self-mutilation perpetrated by Sir Perceval in the French romance, *The Quest for the Holy Grail* (c.1225). The devil disguised as a beautiful damsel has attempted to deflower this flower of chivalry, and brings him 'to the brink of losing what is irredeemable, namely virginity'. On coming to his senses, Sir Perceval yearns for death, and in atonement draws his sword and 'stabbed himself so savagely that he drove the point through his left thigh and the blood spurted out in a rain'.[21] He has been too much in love with his 'worldly' left side and so now he must repudiate it. In this case, we can adapt the motto of the United States Marine Corps, and say 'Pain is weakness leaving [the left side of] the body'.

Medical theory further encouraged flagellants to assume that mutilation of the left side would produce a more satisfying spectacle, for it was said to be more full of blood than the right side. In Isidore of Seville's *Etymologies* (c.615–630), the bestselling encyclopedia for a thousand years (there were a dozen *printed* editions even before 1500), we are told—pace Aristotle—that the heart has two arteries, 'of which the left one has more blood, the right one more air—for this reason we examine the pulse on the right arm'.[22] It is a contrast between spirit and flesh. Not surprisingly, the veins of the left side were more likely to be opened up for blood-letting, or to play host to a leech.

The visions of St Gertrude of Helfta (1256–1301/2) offer perhaps the most imaginative and exhaustive exploration of spiritual ambidextrousness, with her left side coming under regular attack from disease and the

Devil. Having entered a monastery near Magdeburg at the age of five in 1261, Gertrude suffered numerous ailments throughout her life due in no small part to severe penitential practices, though she still lived to what was then the ripe old age of forty-five. Her spiritual autobiography was compiled in the early 1280s, and St Teresa of Avila is one of many to have known and admired St Gertrude's writings.[23] Christ repeatedly appears to her, and on one occasion he visits her when she was so ill and dried up that she could not even cry. He gave her a gold cup, whereupon her heart was filled with a sweet sensation and hot tears flowed.

But then, 'on my left, a disgusting creature appeared who surreptitiously slipped into my hand a grain of bitter poison. And he secretly and firmly encouraged me to throw it into the cup to corrupt the liquid'.[24] Here the Devil is effectively 'throwing' his own grain of salt at Gertrude's left side, thereby trying to disable the gold cup that protects her. But she sees through the trickery of the 'old enemy', and he is repulsed. She doesn't say how the Devil is sent packing, but we assume she brandished the cup in her left hand, and either threw or threatened to throw some of the divine liquid over him. Here she would have been not just spiritually ambidextrous, but physically too.

Gertrude's contempt for all things carnal—which Cassian located on the 'left hand'—explains why, when she is unfortunate enough to lose the sight in her left eye, she can console herself by seeing her affliction as divinely inspired:

> In a short prayer, she offered to the Lord all the sufferings, both corporal and spiritual, that weighed her down, and all the joy, both bodily and spiritual, of which she had been deprived. The Lord appeared to her with these two gifts, suffering and joy, which resembled two jewel-encrusted rings which he carried like jewellery on each hand. Seeing this, Gertrude repeated the same prayer and after a while she felt the Lord Jesus with his left hand, which she understood to be that of bodily suffering, rub her left eye. And from that day, the same eye that she saw touched in spirit by the Lord experienced so great a physical pain that, ever since, it has never fully recovered.[25]

Immediately after being roughed up by the divine knuckle-duster, Gertrude experiences an excruciating pain in her side, but she fails to note whether it is the left or right. From her silence on this matter, we

presume it must have been the right side: mention of this inconvenient medical fact would interfere with the notion that for good Christians it is the left side which should suffer. In this respect, Christ leads by example. He subsequently appears to Gertrude with the right side of his body 'magnificently clothed in royal robes', while his left side is completely covered in supporating wounds. His ostensible purpose is to symbolize the good and bad elements in the Church, but this dualism of the body applies to every Christian.[26]

This whole theme is elegantly encapsulated in a celebrated vision of Christ experienced by the French nun Marguerite Marie Alacocque on the 27th December 1673—a vision that would inspire the catholic Cult of the Sacred Heart. The vision involves a mystic marriage between Christ and Alacocque in which they exchange burning hearts. The flames not only express the intensity of their love; they also perform the useful function of purging what must predominantly be the left side of their body:

> [Christ] asked me for my heart. I begged him to take it; he did and placed it in his own divine heart. He let me see it there—a tiny atom being completely burned up in that fiery furnace. Then lifting it out—now a little heart shaped flame—he put it back where he had found it. 'There my well beloved', I heard him saying, 'that's a precious spark from its hottest flames. That will be your heart from now on, it will burn you up to your very last breath, its intense heat will never diminish—only blood letting will cool it slightly.'[27]

Christ is presumably referring to blood letting on the left arm, for an ancient belief had it that a vein or nerve passed from the heart directly to the ring-finger of the left hand.

<p style="text-align:center">* * *</p>

THE COMPLEX ARRAY OF attitudes towards the left side would have influenced both the creation and the reception of the *Laocoon* (Fig. 3). After its rediscovery in Rome in 1506, it prompted an extraordinarily rich catalogue of literary and artistic responses.[28] The most celebrated antique image of violent death, the sculpture was immediately acquired by Pope Julius II and given pride of place in the Belvedere sculpture court of the Vatican. The Roman writer Pliny the Elder said it was carved by Hagesandrus, Polydorus and Athenodorus of Rhodes for the palace of the Emperor Titus in Rome, adding that it was 'of all paintings

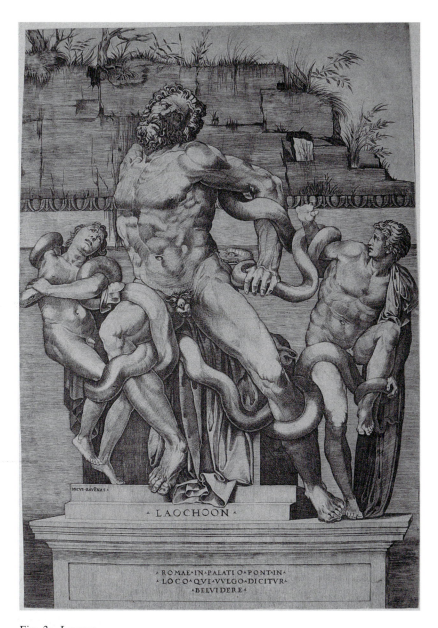

Fig. 3: *Laocoon*

and sculptures, the most worthy of admiration'. It is still revered today, and is one of very few antique statues to be lodged in the popular consciousness.

Laocoon was a Trojan priest who warned his compatriots not to take the wooden horse of the Greeks inside the city. Soon after, as he was officiating at the altar of Neptune, aided by his two sons, two sea-snakes came ashore and killed all three. The Trojans took this to be a sign of divine displeasure, and so dragged the wooden horse into the city, with disastrous consequences. Laocoon is shown perched naked on his altar, heroically muscled and bearded, flanked by his two sons, who are also naked. All three are writhing in agony and/or terror as they are enveloped by the sea-snakes. The eye of this convulsive sculptural storm is the head of the sea-snake poised to bite the left flank of the naked priest, its huge jaws agape. Laocoon grips the snake's body with his left hand, but is clearly powerless to resist. No doubt the sculptors were influenced by the Greek belief that the worst things come from the left. So that nothing could detract from the horror of this snake bite, the sculptors reduced the impact of the other snake's head by half-hiding it under the right hand of the boy standing to Laocoon's right.

What is particularly interesting about the ensuing discussions of the statue is how many of them revolve around the issue of whether Laocoon deserved to die, and these debates were, I believe, intensified by the location of the sea-snake's attack. For some, Laocoon was a forerunner of innumerable Christian saints and martyrs. The priest Giovanni Andrea Gilio, writing in his fiery handbook for Counter-Reformation painters, *Due Dialogi* (1564), urged artists to use Laocoon as an inspiration for their crucified Christs and scenes of martyrdom, for 'the anguish, grief and torment that he feels' is brilliantly expressed.[29]

But while some considered Laocoon an ideal prototype for a saint, there were others who regarded him as a traitor and a heretic. One Roman poet compared the fate of Laocoon's family to that of the disgraced Bentivoglio, rulers of Bologna who were exiled after Pope Julius captured the city in 1506: the statue was a warning to all those who would cross swords with God's earthly vicar. Modern political cartoonists have regularly turned floundering and disgraced politicians into latter-day Laocoons: Richard Nixon, at the height of the Watergate affair, was depicted perched atop a tape recorder, tangled in coils of tape.[30]

Laocoon's role as a father was contentious too. An alternative version of his story, popular in antiquity, had it that he was punished precisely because he was a father, for priests were expected to be celibate. The scabrous Venetian writer Pietro Aretino exploited Laocoon's reputation for immorality in a dialogue between prostitutes and their clients published in 1534. The ecstatic visage of a prostitute involved in a ménage-à-trois is compared to the 'frowning expression which that marble figure in the Belvedere makes at the serpents which kill him in the midst of his sons'.[31] Aretino transforms the serpent that pounces from the left into a sado-masochistic phallic symbol, and implies that Laocoon—no less than a flagellant—is ecstatic at the 'rape' of his left side.

No doubt if the sculpture had been made in reverse, with the snake poised at his right side, it would have prompted at least some of these reactions. But their very extravagance and variety is due to the complexity of people's attitude to the left side, and their strong sense of its moral as well as its physical weakness. This is borne out by looking at how the left side is treated in the most influential of all iconographic handbooks, Cesare Ripa's *Iconologia*, which was first published in Rome in 1593, and then in 1603 in an illustrated edition, with figures derived from drawings by the Cavalier d'Arpino. It was consulted by artists well into the eighteenth century.

Ripa's 'DOLORE' [pain, grief] has long been recognized as having been inspired by the Laocoon—as well as by Gilio's advocacy of the statue as a model for suffering saints. DOLORE is described as follows: 'A semi-naked man with chained hands and feet, his body entwined by a serpent which ferociously bites his left side, will look very sad [malinconioso].'[32] He is a mixture of Prometheus and Laocoon, both of whom were severely punished by the Gods. The former was chained to a rock and had his liver (also on the left side) pecked at by an eagle. However, Ripa leaves it unclear whether his allegorical figure is pitiable or contemptible. He explains that the serpent is the (unspecified) evil that brings destruction, but can also be the devil, 'cause of all the imperfections in man'.[33]

Indeed, several other allegorical figures representing vices are attacked by snakes from the left. INVIDIA [envy] 'will have the left breast bare and bitten by a serpent which winds round the same breast in many coils';[34] PECCATO [sin] is 'a young man, blind, naked and black, who is shown walking through precipitous and crooked paths; a serpent is coiled round him and a worm, having penetrated his left side, gnaws his

heart'; QUERELA A DIO [dispute with God] has her left hand 'eaten by fierce and poisonous serpents'.[35] These descriptions recall the Jewish cabalistic 'serpent of death', an allegorical interpretation of the serpent in the Garden of Eden: 'The serpent is death of the world, penetrating a person's blind gut. He is on the left, while another, of life, is on the right, both accompanying each human.'[36]

There can be little doubt that Ripa believed most punishments were merited, and that most victims were guilty: his allegorical figure of AMICITIA [friendship] 'has her left shoulder and chest bare, and points to her heart'.[37] There is thus a suspicion in which those who open up their 'vulnerable' left side to evil may be hospitable to it. Cristoforo Stati's charming naked statue of *Friendship* (first decade of seventeenth century; Paris, Louvre) probably made for Villa Mattei in Rome, went even further: she meekly looked to her left and, with her right hand, cups her left breast so she can squeeze milk from it—a thirst-quenching drink from the heart. A recent conduct book, Nicholas Boothman's *How to Make People Like You in 90 Seconds or Less* (2001), ploughs exactly the same furrow: 'Keep your heart aimed directly at the person you're meeting. Don't cover your heart with your hands or arms and, when possible, unbutton your jacket or coat.'[38] Thus an exposed left side constitutes an open invitation—and it is the individual's responsibility to make sure that this invitation is wisely extended. Get it wrong, and you end up dancing with the Devil.

The most ambitious and intricate demonstration of 'DOLORE' and its cognates is undoubtedly Poussin's *Landscape with a Man Killed by a Snake* (1648) (Fig. 4), celebrated for its ricocheting zigzag of anxiously glancing figures.[39] In the foreground at stage right we see, more or less in left profile, a man's body slumped face down on the bank of a murky river or pool, with a giant snake coiled around him.[40] The snake's head is poised near the man's left flank. At the moment of death, the victim was trying to crawl away. His naked left arm and leg lie in the water. The ground rises immediately behind the man, cutting out the light and casting the corpse into inky darkness, but another man, positioned further along the river bank to the victim's left, has seen the body and the snake (and perhaps the snake has seen him too). He stares at it over his left shoulder and has broken into a run. He brings his left arm up, seemingly to shield himself from the sight. The nakedness of his left arm, shoulder and torso only emphasizes his vulnerability. He is slowed down by the reflection of his legs in the water. They resemble stony fragments

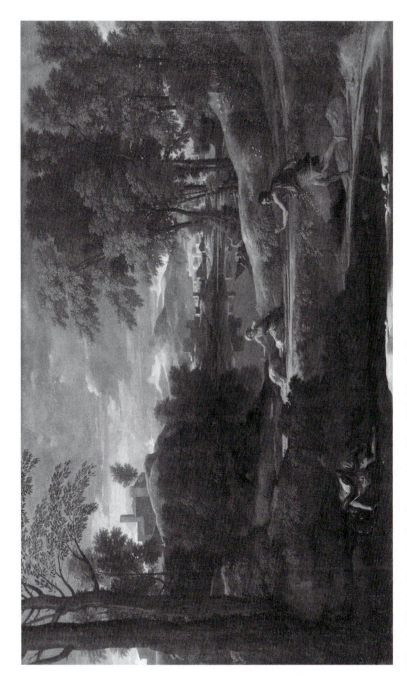

Fig. 4: Nicolas Poussin, *Landscape with a Man Killed by a Snake*

of a statue, and this sunken wreck of a reflection tells of the watery grave he is desperately trying to escape.

The running man is in his turn observed by a laundress positioned further back in the dead centre of the composition, on a path at the top of the bank. She is sitting on the ground and glances to her left with both arms held up with the palms visible. She and the running man have some of the qualities of Ripa's definition of the figure signifying 'Meraviglia'[Amazement]: 'A young woman who has the right arm quite high with the hand open, and the left arm held low with the hand equally open, but with the palm of that hand facing the ground; and with one leg behind the other, she will have her head somewhat turned towards her left shoulder.'[41]

What makes these physical and visual assaults from the left side even more disturbing is the doubt Poussin's figures raise about the moral status of the victims. The laundress' central position gives her a pivotal judicial role, akin to that of the enthroned King in Poussin's *The Judgement of Solomon* (1649), painted the following year for the same patron. Both of Solomon's arms are outstretched, but his left hand, positioned directly above the head of the woman who falsely claims to be the baby's mother, seems to push her down and away. It is structured like a Last Judgement, with the bad imposter to Solomon's left, and the good real mother to his right. Similarly, the laundress' left hand seems to be pushing away the running man—and the horror he brings with him. She is trying to prevent him destroying the calm that prevails to her right and behind her. Her being a laundress is also in direct, and rather mordent counterpoint to the dead man whom she cannot see, for his clothes must be in need of a good wash. But we suspect that her attempt to keep death—and dirt—at bay will fail.

In Poussin's earlier and much less dramatic snake painting, *Landscape with a Man Recoiling from a Snake* (late 1630s?), a long thin snake slithers along the ground from the man's right, and we feel pretty sure he will be able to escape by running away.[42] A mysterious veiled woman stands statuesquely nearby, and here one almost feels this snake is the cabalistic 'snake of life'—it is the only thing that injects some movement into the otherwise rather inert composition. Whereas the snake from the left immobilizes and destroys, the snake from the right energizes and brings to life.

* * *

THUS FAR, I HAVE primarily been discussing what we might call the internal operations of artworks. I would now like to widen the discussion and explore how the orientation of bodies in artworks demands different responses from viewers, depending on whether their left or right side is exposed to us. The starting point for this discussion is an interpretation of a Dutch seventeenth-century genre painting found in Heinrich Wölfflin's pioneering essay, *Ueber das Rechts und Links im Bilde* [On Left and Right in Pictures, 1928].[43] Wölfflin, a Swiss national who inherited Jacob Burckhardt's Chair at Basel University, was one of the most influential art historians of the twentieth century. In his essay, which is the transcription of a lecture, Wölfflin wanted to demonstrate how artworks are transformed if they are shown in reverse, whether they be Raphael's *Sistine Madonna* or a landscape print by Rembrandt.

An obvious enough point, one might assume, but Wölfflin had pioneered the simultaneous use of two lantern-slide projectors for public lectures. This new technique made possible the 'dualistic' compare-and-contrast methods that are now taken for granted by art historians. The initial idea may have come to him after inserting slides the wrong way round. Although his basic point is entirely convincing (the impact of a reversed Old Master image is very different), his explanations for this phenomenon are far less impressive. They are based on little more than intuition, subjective formalist analysis, and vague, unsupported appeals to 'psychology'. Nonetheless, Wölfflin's views were very influential and they informed the section devoted to 'Right and Left' in Rudolf Arnheim's *Art and Visual Perception*.

The genre scene which Wölfflin discusses is by the seventeenth-century Dutch painter, Pieter Janssens Elinga (1623–before 1682), *Woman Reading* (Fig. 5). Janssens was a follower of Pieter de Hooch, and their work has sometimes been confused. We see a young woman obliquely from the back and from the right, seated before a partially shuttered window in a cosy interior, with an open book in her lap. A white bonnet sheathes her head and conceals her face. Shards of bright light fall onto the floor and wall to her right, but the room as a whole is bathed in a warm honeyed glow. For Wölfflin, the picture has a compelling atmosphere:

> The atmosphere is one of composure, and everyone agrees that it is caused by the room, not by the figure of the woman itself. Although the room is clean, light and tidy, it is not creating the

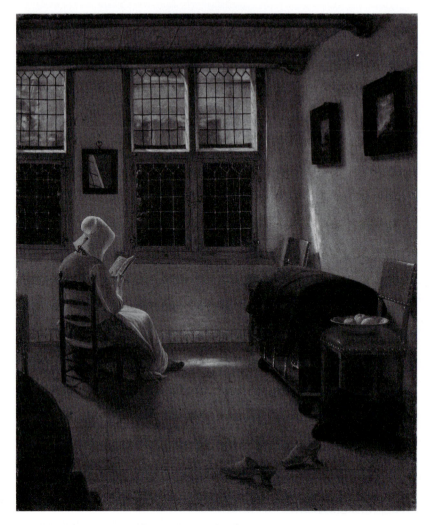

Fig. 5a: Peter Janssens Elinga, *Woman Reading*

composure alone, because as soon as the picture is reversed, the 'Sunday' atmosphere is lost and the reader is sitting uncomfortably, as if lost in her chamber.[44]

Wölfflin claims to be reading the picture like a text, from left to right, though it is never clear what sort of literary model he is applying to the picture. He insists that the 'sunspots' and the 'rich colour that begins to burn' have to be on the viewer's right. Once this opulent visual feast is switched to the viewer's left, it is as though one were reading over

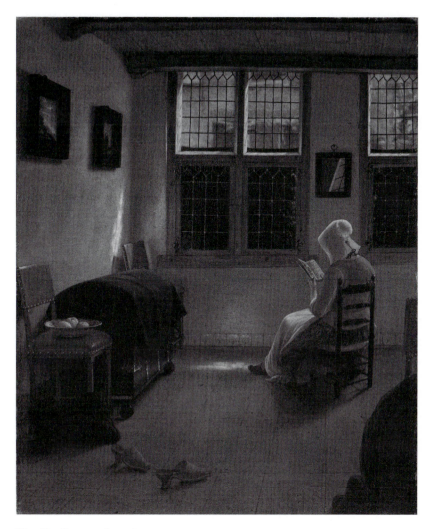

Fig. 5b: Reversed version

'a more or less immaterial introduction'. If the expansive warm dappled area is placed on the left, and the narrow empty 'void' on the right, the picture is ruined: 'the unfilled right end of the picture . . . is enough to spoil the atmosphere of the whole scene.'

Because Wölfflin only deploys the tools of formalist analysis—colour, light, form and composition—he fails to notice the central role played by the seated woman in the pictorial drama. Indeed, he actually claims that the figure of the woman contributes nothing to the overall atmosphere

of the picture: 'everyone agrees that it is caused by the room, not by the figure of the woman itself'. The idea that 'everyone' who has ever seen the picture has immediately insisted on the woman's redundancy, is of course absurd. Only Wölfflinian formalists can do this because the woman's colour, form and central positioning is little altered by her reversal. This would have been even more the case with lantern slides, which still only reproduced images in black and white.

Wölfflin clearly protests too much about the woman's invisibility—because at some level he must have known this to be untrue. When he says that the 'Sunday' atmosphere is lost when the picture is reversed, this involves an implicit moral judgement that can only apply to the woman—whether directly (in relation to her sitting position) or indirectly (in relation to the state and style of her home). He thereby suggests that something less contemplative and more worldly is being presented to us. Seeing the woman from her left side involves a shift (to adapt some recently coined critical terms) from 'absorption' to 'theatricality'—from her being totally self-contained and insulated from the outside world (including that of the viewer), to being conscious of self and of others.[45] The final sentence of Wölfflin's essay suggests he may mean that the difference between the original and reversed image is as extreme as the difference between the sacred and the profane, or the conscious and the subconscious: he writes portentously that the left-right problem 'obviously has deep roots, roots, which are reaching down into the lowest depths of our sensory nature'.

Wölfflin's judgement about this picture and its reversed 'double' must in part have been influenced by other artworks, past and present. He spent much of his professional life in Basel, and would have been very familiar with that favourite theme of German Renaissance art, *Death and the Maiden*. The artist who made this theme his own, and painted dozens of pictures, Hans Baldung Grien (1484/5–1545), spent most of his working life in Strasbourg, and the Basel Kunstmuseum had acquired two of his *Death and the Maiden* images in 1923.[46] Almost invariably Grien's naked classical lovelies are assailed murderously and vampirically from their left. In one of the Basel images, which is the most famous *Death and the Maiden* image of all, the decomposing figure of Death stands behind the girl and leans over her left shoulder to bite her left cheek and mouth (Fig. 6). His left hand claws at her left breast. She turns petrified towards her nemesis, and they almost seem to kiss. She might well ask the same question about this moment as the poet Pierre

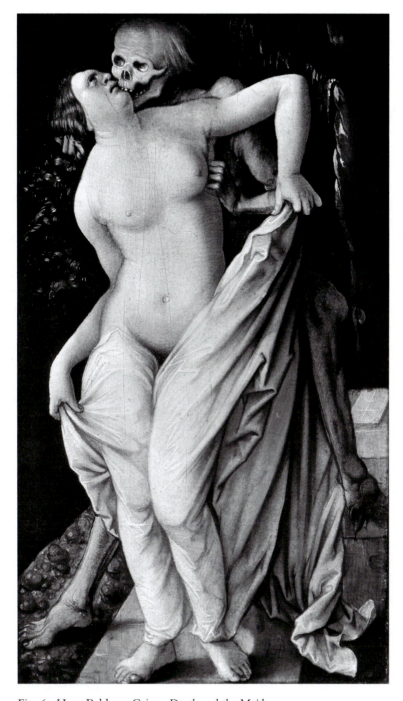

Fig. 6: Hans Baldung Grien, *Death and the Maiden*

de Ronsard did in relation to his whole life in *Les Amours* (1552): 'Et quell demon d'une senestre main / Berça mon corps quant le ciel me fit naistre?' [And what devil cradled my body with a left hand when heaven had me born?][47]

The unmistakeable frisson of these works is that the viewer is invited simultaneously to revel in these girls' nubile nudity, and to despise them for their presumed shamelessness and vanity—and for the desperation that makes them cling on to their lives. The maidens are located outside, in gloomy forests, as if they were witches waiting at night for their consort the Devil (the witch hunts were then in full swing, and Grien made several images of witches). So Death catches the maiden out in more senses than one.

In Barthel Behem's *Death and the Maiden* (1540; Hamburg Kunsthalle), the theme is dressed up in a thin veneer of Christian probity. Here a naked beauty stands upright before us on a stone pedestal placed in a summery landscape. She is completely unflustered both by a skeletal grim reaper who peers over her left shoulder, holding a scythe in his outstretched left hand, and by a naked female corpse which is stretched out on the ground behind her and to her left. This is because she looks straight ahead (at us) and firmly grasps with her right hand a long iris stem, symbol of divine mercy and eternal life, that rises up like a sceptre out of a tall metal vase situated to her right. Thus symbols of mortality are located to her left, and it is her duty not to worry about them: one look (like Orpheus glancing back at Eurydice as they leave the Underworld) and all will be lost. She is prepared to relinquish her left side serenely and without a struggle so that her right side can gain eternal life.

Behem's maiden might almost be the adolescent referred to in Marsilio Ficino's popular life-style and health guide, *The Three Books of Life* (1489): 'Why not then have our own old people—who have no other hope—suck the blood of an adolescent—of a willing adolescent. I mean one who is clean, happy, temperate, and whose blood is excellent but perhaps a little excessive? They could suck it in the way leeches do, an ounce or two from a vein on the left arm barely opened. Afterwards, they should take an equal amount of sugar and wine, and they should do the sucking while hungry and thirsty and with the Moon rising'.[48] Ficino's excitement is palpable as he puts forward his recipe for the resurrection of the near-dead, and one gets a strong sense of how the potentially vampiric practice of blood-letting could have been a catalyst for *Death and the Maiden* imagery.

Grien and Behan were both pupils of Dürer (on whom Wölfflin published a book in 1905), and it must have been from Dürer that they first came across the subject, for Dürer made two prints in which a woman is ambushed from the left by a skeletal lecher.[49] However, in relation to the 'reversed' *Woman Reading* by Janssens (and to Wölfflin's reading of it) another print by Dürer, *The Temptation of the Idler (or The Dream of the Doctor)* (c.1498), may be even more relevant. A scholar, who we see in left profile, has fallen asleep at his desk while reading. The 'Sunday' atmosphere (if there ever was one) is irredeemably lost for he is now in double trouble. Not only does the Devil fly over his left shoulder and blow his bellows into his left ear but Venus and her filial side-kick Cupid wait at his side to pounce. There is literally no escape from this 'sinister' duo because the right side of the desk is next to a dark wall, and the right side of his head is propped against a pillow. Directly in front of the sleeper is a stove, that both suggests the heated atmosphere and the fires of hell: Venus points to the stove as if to say 'I'm hot too'. The scholar is undone because he has shut off his right side, leaving his left side open and hospitable to all comers. He is, as it were, 'all left side'. This scholar bears out something that Isidore of Seville said about the left hand in his *Etymologies*: Isidore believes the left hand is so called 'as if it "permitted" something to happen, because *sinextra* is derived from "permitting" [*sinere*]'.[50] Here, the left hand is the hand that always gives permission—even and especially unto sin and death.

By way of complete contrast, in Dürer's celebrated engraving *Knight, Death and the Devil* (1513), we know the Knight is safe because he keeps Death and the Devil to his right. The mounted knight impassively trots past the supremely grotesque figures of Death and the Devil. They are on his right, and he is going to their right. It is clearly meant to show how 'Christian soldiers', aided by their faith (symbolized by his dog, positioned between the knight and the diabolical duo) will triumph over all odds. The knight on horseback was probably inspired by Verrocchio's swaggering monument in Venice to the condottieri Bartolommeo Colleoni, but whereas Colleoni's torso twists sharply to the right, and his head, and that of his horse, look slightly to the left, Dürer's knight is bolt upright, and both he and his horse keep 'eyes front' like heraldic symbols. The rider's unflinching attitude recalls the verse from the Psalms so beloved of St Bernard: 'I have set the Lord always before me: because he is at my right hand, I shall not be moved' (16:8).

For Wölfflin, the change wrought to Janssens' picture by reversing it has the quality of a fairytale—in which a dream scenario becomes a nightmare, and where the woman seems to belong to time (and to us) rather than to eternity. Instead of being confronted by a 'resolute' right hand and side, we are offered the more 'pliable' left side and hand. It is not that a mirror image can intrinsically be any more 'responsive' than the original; it is the cultural and psychological baggage that we bring to it that makes it so.[51]

* * *

WÖLFFLIN'S CULTURAL BAGGAGE MAY also have included *The Nightmare* (1782, Detroit Institute of Arts), by the Swiss-born painter Henri Fuseli (Fig. 7). Fuseli had studied German prints from an early age, and *The Nightmare* is an exuberant merging of the *Death and the Maiden* theme with the Venetian tradition of the reclining female nude. In the 1920s, Fuseli had come back into fashion, providing inspiration for both the Expressionists and Surrealists. The climactic moments in horror films such as *Nosferatu* (Germany 1922) and *The Cabinet of Doctor Caligari*

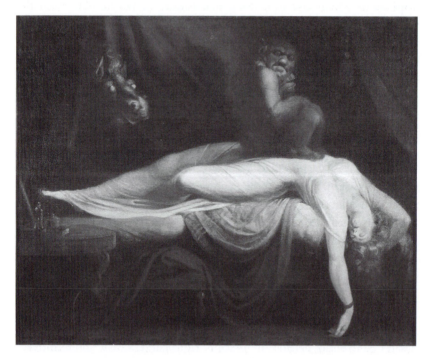

Fig. 7: Henri Fuseli, *The Nightmare*

(Germany 1919) were modeled on Fuseli. Sigmund Freud had an engraving of the picture hanging in his office in Vienna in the 1920s—next to another engraving of Rembrandt's *Anatomy Lesson*.

What is particularly pertinent about Fuseli's *The Nightmare* in relation to Wölfflin's discussion of Janssens' *Woman Reading* is that there are two versions of this painting, the second a reverse mirror image of the other—but with significant differences. The first and most famous version was exhibited at the Royal Academy Summer Exhibition in London in 1782, causing a succes-de-scandale.[52] Fuseli was classed among the 'libertines of painting', and dubbed 'Painter in ordinary to the Devil'.[53] The painting was engraved in January 1783, and was soon exploited ad nauseam by political cartoonists. Unlike Fuseli's previous paintings, it had no literary source, and uncertainty about the precise subject only added to its allure. The second version (Goethe Museum, Frankfurt-am-Main) was painted at an unknown date, probably not long after the first, for an unknown patron. In both pictures, however, it is the lady's left side that is being offered up, and that is more 'accessible' than the right.

In the first version, the lady is stretched out on a couch in a diaphanous white dress with her left side towards the viewer, and with her right leg placed over her left leg, so that her 'sexual centre'[54] tilts up towards us. It is the more 'natural' side for her to turn to, for her bedside table, with its various potions, is placed here. Her left breast seems to be sliding down her arm so that it faces us. The impish incubus who crouches on her stomach stares directly out at us, pulling us even more into the picture, almost as though he is acting as a pimp with the viewer as client.

In the second 'reversed' version, where the lady's right side is closest to us, we are much more excluded. As in Titian's *Danae*, her right leg is now jack-knifed up, bent at the knee, forming an impassible barrier between us and her (invisible) sex. The fabric of her white dress is much thicker and opaque, as if made from marble that has only been crudely blocked out. Her breasts remain firmly anchored to the bed, because a large bolster under her shoulders pushes them up and away: far from sliding down her arm, they have retreated to the bottom of her rib-cage. It sounds odd to talk about chastity in relation to the picture, but the right side of her body is effectively its own stony chastity belt.

The imp busily plays a flute and does not ogle us so directly. If anything, he is laughing at us, because we have lost her: it is the phallus-headed horse on her left who has the best view of and access to her sex.

He is much closer to her and more central than in the first picture. Her bedside table has now moved over to that side too, making it the side of first resort. In the earlier picture, we seem to be the preferred 'client'; in the second picture, the horse is in full possession.

* * *

WÖLFFLIN'S APPEAL TO 'PSYCHOLOGY' suggests he may have been aware of recent theories about the left side—though the formalist in him cannot openly examine them.

A significant text in this respect was Wilhelm Stekel's *Die Sprache des Traumes* (1911, The Language of Dreams). The theosophical stigmatization of the left hand path heavily influenced the Austrian psychologist—or at least, it seems to have influenced the dreams of Stekel's patients. Stekel was one of the earliest followers of Freud, and Freud derived his own ideas about left and right from him. In later editions of *The Interpretation of Dreams* (first edition 1900) Freud quotes a passage from Stekel's chapter on left and right:

> According to Stekel, 'right' and 'left' in dreams have an ethical sense. 'The right-hand path always means the path of righteousness and the left-hand one that of crime. Thus "left" may represent homosexuality, incest or perversion, and "right" may represent marriage, intercourse with a prostitute and so on, always looked at from the subject's individual moral standpoint'.[55]

Stekel is seeing things very much from the 'individual moral standpoint' of a heterosexual, non-religious Austrian male, and this is why visiting prostitutes counts as a 'normal' thing to do, rather than as a 'perversion'. Presumably a catholic priest would situate intercourse with any woman in the left hand path, and would consider intercourse a 'perversion'.

Looking at Janssens' original picture from the 'individual moral standpoint' of the woman, we might say that by seating herself with her left side near to the wall and shuttered windows, she is rejecting wholeheartedly the 'left-hand path'—for the space to her left is effectively blocked off and shielded. Conversely, the area to her right opens up for her to occupy spiritually. When the image is reversed, the 'right-hand path' is shut off, and she opens her body up to the 'path of perversion'.

Too late for Wölfflin's essay, but an optical trick which might have interested him, is William E. Benton's 'Reality mirror', which was patented in 1930. This enabled one to look at a portrait photograph

and see how they would look with two right halves to their face, or two left halves. This basic technique had first been used in psychological research in 1912, but by using two identical photographs of the same facial half, with one reversed so that a 'complete' face could be made.[56] Benton tested his device on photographs of the famous, including the writer Edgar Allen Poe. Benton explains how the right side of Poe's face reveals 'the conscious or obvious side of Poe's face and nature was honest, direct, reserved, dependable and business-like', whereas the left side shows: 'the subconscious or hidden side of Poe's face and nature was tragic, creative, plotting, cruel, sensual'. This only goes to show that there is 'a little of Dr. Jekyll and Mr Hyde in each of us'.[57]

The depth psychologist Werner Wolff came to similar conclusions after conducting some experiments in Berlin whose results were first reported at a conference in 1932. Wolff showed photographs of the left and right sides of the face to a selection of students, criminals and 'sexual deviants', and he concluded that the left side represents our underlying wishes and desires, and is our 'wish face': 'The most remarkable finding was that wishful tendencies appeared more frequently in the Left-Left than in the Right-Right faces.' The right side bears the individual expression which the person exhibits in their daily life—their 'public face'.[58]

The poster for the classic 1931 film of *Dracula*, directed by Tod Browning with Bela Lugosi in the title role, and Helen Chandler as Mina Seward, his chosen bride, would offer a text-book example of a 'wish face'. It shows the Count in a standard 'Death and the Maiden' clinch, standing to the left of the girl, enveloping her in his cloak; but she barely seems to resist, and with the left side of her face raised to her assailant and with her eyes shut, seems to be experiencing a *petit mort* in her sleep. The Count must have already known what was only recently shown by psychological researchers—that the left ear is better than the right ear at detecting and recalling emotional words like 'love', 'kiss' and 'passion'.[59] Andy Warhol's screenprint *The Kiss (Bela Lugosi)* (1963) was derived from another still in which Dracula bites a swooning Helen Chandler on the left side of the neck having approached from behind.

Things are rather different in the film itself, but the left side of the neck and face very much seem to be the 'wish face'. The two leading ladies are Mina and her friend Lucy Weston, who seems to be attracted to the elderly Count on first meeting him. Lucy defends him to the skeptical Mina: 'Laugh all you like. I think he's fascinating.' Mina prefers

her 'normal' boyfriend John Harker. That night, we know something is afoot because the camera lovingly lingers over the sleeping Lucy, filming her from the left in soft focus. Her 'wish face' and neck are voluptuously exposed, and her left arm is hidden under the bedclothes, making her seem even more defenceless. Count Dracula then creeps up on the left side of Lucy's bed and bites the left side of her neck. The first bite from the left is a sign of great intimacy and (subconscious) complicity, because in every other case the Count's victims are unwilling (Mina, Mr Renfield, the Flowergirl) and he first bites them on the right side of the neck. These scenes tend to be much more perfunctory. Thus in the posters, Mina is merged with Lucy—or else she is shown once she has become a blissful Bride of Dracula.

Two paintings by Picasso of young girls from 1932 are far more radical and original examples of a 'wish face'. The 'model' for both was his mistress Marie-Thérèse Walter, who was nearly thirty years younger. In *Girl before a Mirror* (1932), disparate profile and frontal images of the girl's face jockey for position. The right profile of the girl's face is severely serene, almost expressionless, and the skin has a limpid creamy complexion. By contrast, the left side is a heavily impastoed amalgam of Van Gogh yellow, scruffily scarred with red for the cheek and lips which have the hint of a sardonic smile. She reaches out to hold a mirror, and the mirror-image (which, under normal circumstances, should represent the left side) is eminently sinister: a gloomy, edgy mosaic of purple, ochre, brown and deep red. To adapt Milton, this new Eve is distorted 'more to the part sinister'. But now it probably represents the most glamorous of faculties—her unconscious.

Picasso's *Dream*, painted on 24th January 1932, depicts an even more voluptuous beauty asleep in an armchair. We see her from the front, but her left side is the most revealing and eroticized. Her head rests on her right shoulder, and Picasso invests her with a double face. The 'right' face, which is shown in profile, has an impervious porcelain perfection. The left side of her face is a tumescent lilac penis that hovers over her, ingeniously joined at its base to her mouth and chin. The libidinousness of her left side is further emphasized by her exposed left breast, and by the fact that the fingers of both hands are joined together and seem to be rubbing the area at the top of her left thigh, as though her sex has been displaced leftwards. One thinks of Goya's engraving *The Sleep of Reason Breeds Monsters* (1797–8), where the diabolical winged creatures seem to

both fly up from and fly down to the exposed left side of the sleeper's body, leaving it unclear whether he is their master or slave.

Marie-Thérèse's wet dream is a long way from Christ thrusting his jewel-encrusted ring into Gertrude's left eye, but they both belong to a culture that loves to locate transgressive desires on the left side of the human body.

4. Sun and Moon

THE SKY: A young man of very noble appearance . . . with the Sun depicted on his right breast, and the Moon on his left.

Cesare Ripa, *Iconologia* (1603), allegorical figure of the Sky[1]

VERY LITTLE ATTENTION HAD been paid to the possible symbolic significance of cast shadows in Renaissance easel painting. One of the main reasons is that when art historians have defined the key characteristics of Renaissance art, they have traditionally insisted on its heightened naturalism, a key component being illumination from a single light source, and consistent deployment of shading and cast shadow.

The idea that the illumination is naturalistic might seem to be undermined by the fact that the vast majority of easel paintings, from the Renaissance onwards, whether by Van Eyck, Titian or Rembrandt, are in fact illuminated from the protagonist's right. Yet the proponents of Renaissance (and post-Renaissance) 'naturalism' insist that this idiosyncratic phenomenon actually serves to confirm the pragmatic, empirical basis of Renaissance art.

Ernst Gombrich is the major spokesman for this view. In his classic book on the psychology of perception, *Art and Illusion* (first edition 1960), he offered a single explanation for illumination from the sitter's right, and he believed that this accounted not just for the illumination in easel paintings, but for paintings in other formats too: 'Psychologists have found that in the absence of other clues, Western observers have settled for the probability that the light falls from high up and from the left-hand side. It is the position most convenient for drawing and writing with the right hand, and it therefore applies to most paintings.'[2]

68

This argument—which is frequently encountered—has it that if the light falls from high on the (right-handed) artist's left, the shadow from the drawing or painting hand is less likely to fall onto the area on which one is working. However, it is not clear why it should make such a huge difference to the artistic process, for unless the artist draws and paints with his hand tucked in and curled round (as most young children do), or the light source is very low down, the mark-making will take place above the hand, well away from any major shadows. The use of a mahlstick by painters, a stick on which they rest the painting hand, also reduces the problem of shadows. This is precisely what we find in Vermeer's so-called *Allegory of Painting* (c.1666–7; Vienna, Kunsthistorisches Museum) (Fig. 8), the classic image of the painter working 'from life'— and one, incidentally, which Gombrich would have known from his youth in Vienna.

The painter sits with his back towards us, and light streams in from his left; conversely, the light strikes the right side of the face of his female model who has turned towards him, dressed up as Clio, the classical Muse of History. The right-handed painter has begun his picture from the top by painting the garland that crowns the woman's head. He has been painting the wreath from left to right. However, his painting hand, resting on a mahlstick, seems to cast no proximate or obvious shadow onto the canvas, while the top end of the mahlstick casts shadows that seem implausibly wide and deep. These shadows merge with other shadows that fall onto the whole of the bottom two-thirds of the canvas. Clearly, the shadows are symbolic, and the illumination of this picture is far from naturalistic. The light is artificially pooled around the area that is being painted. Vermeer seems to be proposing that paintings—and painters—create their own light. It thus alludes to the familiar idea that God was a painter, painting the world into existence. Vermeer evidently had no difficulty painting with the light coming from the sitter's left: one of his greatest works, *The Lacemaker* (1669–70), is strongly lit in just this way, and so are three others.

Nonetheless, Gombrich's theory appears to receive some significant historical support from a passage in Cennino Cennini's influential technical handbook, *Il Libro dell'Arte*, which was probably written in Padua in around 1400. When learning how to draw Cennini advises the artist to 'arrange to have the light diffused when you are drawing, and have the sun fall on your left side'.[3] However, a second, very 'garbled'[4] passage concerned with lighting in buildings shows that every artist must

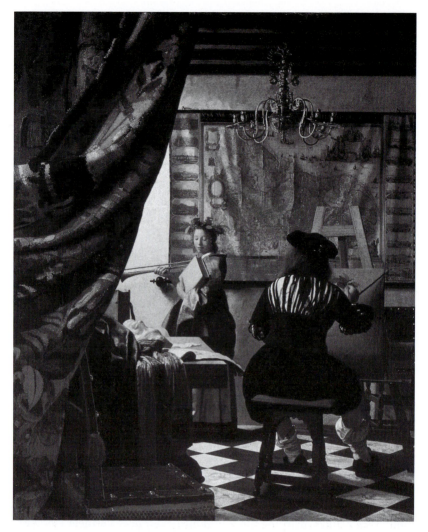

Fig. 8: Jan Vermeer, *Allegory of Painting*

also be able to depict light falling from different directions. It deals with the study of paintings in situ, usually in a church:

> If, by chance, when you are drawing or copying in chapels, or paint-ing in other adverse situations, you happen not to be able to get the light off your hand, or the way you want it, proceed to give the relief to your figures, or rather, drawing, according to the arrangement of

70

the windows which you find in these places, for they have to give you the lighting. And so, following the lighting, whichever side it comes from, apply your relief and shadow, according to this system. And if it happens that the light comes or shines through the centre straight ahead, or in full glory, apply your relief in the same way, light and dark, by this system. And if the light shines from one window larger than the others in these places, always follow the dominant lighting; and make it your careful duty to analyze it, and follow it through, because, if it failed in this respect, your work would be lacking in relief, and would come out a shallow thing, of little mastery.[5]

Cennini is saying—or trying to say—that if the artist is copying a picture in a chapel, and the light from the main window in the chapel, which he calls the 'dominant lighting', comes from his right, hitting the back of his drawing hand, the artist has to accept this, and come to terms with it.[6] However, in most settings there was no obvious main window and so artists were forced to improvise. Lack of light was usually the main problem: the interiors of churches were generally rather dim, and so the main lighting came from candles and (especially in the case of altarpieces) permanently lit oil lamps that were hung overhead. During the course of the fifteenth century an 'unwritten convention' arose whereby altarpieces positioned in chapels or on wall altars in the nave nearest the west door (the main entrance) tended to show the light falling from that direction, and vice versa.[7] For the would-be professional painter, 'adverse' situations were the rule rather than the exception, and a further stage in the learning process is evidently getting used to working with the light coming from all angles.

The key point is that drawing with the light coming from the artist's right wasn't a serious problem for professional artists in the fifteenth, sixteenth and seventeenth centuries. This is evident from one of the most famous images of a Florentine artist at work, a pen and ink drawing on paper which is attributed to the workshop of the goldsmith and master draftsman Maso Finiguerra (1426–64). Here a right-handed teenage apprentice sits straddling a bench facing us, drawing intently with a stylus on a wooden tablet. The surface has probably been prepared with a thin layer of ground bone, which can be scraped down and reused.[8] He has set himself up in Cellini's ideal 'Position A', with the light streaming in from his left. Yet the artist who has drawn his

portrait has to adopt Cellini's 'adverse' 'Position B', for the light comes from his right. He does a perfectly good job of it too, delineating the deep cast shadows very convincingly. And by doing so, the draughtsman shows his own technical superiority to the draftsman he is drawing.

Thus you would not have got very far as a professional artist in the Renaissance if you could only paint or draw with the light coming from the left side, even if it may have been regarded as the ideal. This must be why Vasari says nothing about the direction of light in the technical introduction to the *Lives of the Artists* (1550), and in his allegorical depiction of *Pittura* (1542) on the wall of his house in Arezzo, Pittura actually paints into a big shadow cast by her own right arm.[9] The direction of light is here determined by the position of the windows in the room, and comes from behind and to the right of the female painter. However, when Vasari made his two independent 'ruler' portraits of Lorenzo and Alessandro de' Medici, he made the light fall from the sitter's right.[10]

Gombrich's argument seems anachronistic, for it is predicated on the 'romantic' idea that the artist's convenience could dictate the appearance of an artwork. Indeed, the lighting system in a painting which Gombrich cites as an example of light falling 'from high up and from [our] left-hand side' would not have been determined by the artist, but by the 'dominant lighting' in its intended setting. It is the central panel of a very elaborate polyptych by Carlo Crivelli, a *Madonna and Child with Donor* (c.1470), made for the high altar of the parish church of Porto San Giorgio on the Adriatic coast near Fermo.[11] Other altarpieces by Crivelli show him equally adept at depicting light falling the other way. Like all competent artists, he was evidently able to make altarpieces for any location in a church.

* * *

So IF PRACTICAL CONSIDERATIONS are relatively unimportant, what might be the cultural reasons for preferring light that falls from the sitter's right in easel paintings? I believe the most compelling answer is that it was influenced by ancient astrological beliefs relating to the idea of 'man as microcosm'. Seen in this wider context, Renaissance 'naturalism', and the mastery of light and shade, do not mark a revolutionary break with the art of the so-called 'Dark Ages', but a brilliant refinement.

Astrological ideas were ubiquitous, and virtually everyone at all levels of society was keenly interested, since astrology performed a crucial role in all health matters, in determining things such as diet, when to perform blood-letting, or to conceive. The appeal of astrology has been compared to that of psychoanalysis, but astrology penetrated far more deeply into all sectors of society, and endured far longer, its influence amongst the intelligentsia lasting almost unbroken from antiquity to around 1700, when the scientific revolution discredited many of its basic principles.[12] It was probably most influential at the highest levels of society, among those same people who commissioned works of art, for affluence permitted regular consultation of astrologers, and the scope to respond to their admonitions. Thus most courts had resident astrologers who cast horoscopes, made predictions, and determined the best time for going to war, getting married, and even the kinds of clothes one should wear: Lionello d'Este, Duke of Ferrara, wore different coloured clothes on each day of the week, according to elaborate astrological calculations.

Renaissance artists and architects had the sanction of the Roman architect Vitruvius for knowing some basic astrological conventions.[13] Vitruvius urged aspiring architects to be 'educated, skilful with the pencil, instructed in geometry, know much history, have followed the philosophers with attention, understand music, have some knowledge of music, know the opinions of the jurists, and be acquainted with astrology and the theory of the heavens'.[14] These stipulations are, of course, preposterous, and Leon Battista Alberti would dismiss many of them in his treatise on architecture, but while Alberti rejects music and law out of hand, he merely says the architect does not have to have 'an *exact* knowledge of the stars, simply because it is best to make libraries face the north and baths the west'.[15] He is not ruling out some knowledge of the heavens, and since astrology required expertise in mathematics, geometry, optics and even history, it is hardly surprising. Alberti himself was an expert astrologer, making astrological predictions and exchanging letters on the future of the papacy with the celebrated astrologer Paolo Toscanelli.

At the beginning of his treatise on painting, Alberti regrets that, until the arrival on the scene of Brunelleschi, Ghiberti, Donatello and Luca della Robbia, nature no longer seemed to produce 'painters, sculptors, architects, musicians, geometers, rhetoricians, and augurs'.[16] Artists were augurs insofar as they needed to 'predict' both the outcome

of building or working in a certain way, and the exact interraction between an artefact and its location. They also had to predict taste in general, and their prospective patron's in particular. Portraits were expected not simply to record the physical appearance, but to penetrate beneath the surface and reveal the state of the sitter's soul.[17]

The sculptor Lorenzo Ghiberti followed Vitruvius in his auto-biographical treatise in urging the artist to learn about astrology, and included his own self-portrait alongside those of Old Testament prophets and sybils on the two sets of bronze doors for the Baptistery in Florence. Alberti's own emblem was a single eye with wings, which suggested that he could penetrate the mysteries of creation, and see the future. In his treatise On Architecture (1480–5), Alberti credited changes in architectural fashion to the stars:

I cannot comprehend the mania prevalent two hundred years ago for building towers even in the smallest towns. It seemed that no head of a family could be without a tower; as a result, forests of towers sprouted up everywhere. Some think the movement of a star may influence men's minds. Thus between three and four hundred years ago there raged such religious fervour that man seemed to have been born for no other purpose than to construct religious buildings.[18]

For most people, the key issue was the influence of the planets on the human body. Different temperaments were ascribed to those born under different planets. In antiquity, the human body was believed to comprise four humours or fluid substances: blood, phlegm, yellow bile, and black bile, with health being dependent on a good balance between them. An excess of blood engendered sanguine types; of phlegm, phlegmatic types; of yellow bile, choleric types; of black bile, melancholic types. One's temperament—or 'excess'—was determined by the planet that one had been born under. Marsilio Ficino, in his De Vita Triplici (1482–9), revived Aristotle's notion that 'all extraordinary men distinguished in philosophy, politics, poetry and the arts' are melan-cholic, adding that they are born under the brooding, remote planet Saturn. This challenged the prevailing view that artists were born under Mercury, the 'industrious' god of commerce and inventor of the arts and sciences.[19]

Michelangelo, the most celebrated artist of the sixteenth century, was frequently the subject of astrological speculation, and his 'temperament' was variously interpreted. In Sigismondo's Fanti's astrological lottery

book, *Trionfo di Fortuna* (1527), a woodcut illustration purporting to show Michelangelo in action appears in the domain of Jupiter the sanguine temperament. Michelangelo's own version of his horoscope, relayed to his biographer Asconio Condivi, and published in 1553, gave Mercury a leading role. The great man was born:

> in the year of our salvation 1474, on the sixth of March, four hours before daybreak, on a Monday. A fine birth, certainly, and one which showed already how great the boy was to be and how great his genius; because the fact of having received Mercury and Venus in the second house, the house ruled by Jupiter, and with benign aspect, promised what later followed: that such a birth must be of a noble and lofty genius, destined to succeed universally in any undertaking, but principally in those arts which delight the senses, such as painting, sculpture and architecture.[20]

The horoscope is in fact a year out, for Michelangelo was born in 1475, but no doubt he would have retrospectively imposed a similar horoscope on any birth date. Condivi granted the great man prophetic powers: he foresees the Sack of Rome three years early in 1524, and so leaves for Florence, and in 1529 warned the Florentine Signoria about the danger to which the city was exposed—if only the Gonfaloniere Francesco Carducci had listened, he would not have had his head chopped off in 1530.[21] To posterity, however, Michelangelo would be known as the key 'saturnine' artist, solitary and melancholy. It was Giovanni Paolo Lomazzo who offered the most elaborate formulation in his *Idea del Tempio della Pittura* (1590). Here the 'ascetic' Michelangelo is one of the seven 'governors' of art, and is associated with the planet Saturn.

Unlike most astrological theory and practice, which is fiendishly complex, the idea that might have influenced the fashion for illumination from the sitter's right is relatively straightforward both to understand and to visualize. It is known as 'planetary melothesia'. There are two types of melothesia—zodiacal and planetary. The Roman poet Marcus Manilius, in his *Astronomica* (AD 15–20), had devised the standard schema for zodiacal melothesia in which the twelve zodiac signs are arranged from top to bottom in a standing figure, with Aries located in the head, and Pisces at the feet.[22] Planetary melothesia made a further distinction between the left and right sides of the body.

Ptolemy, in the *Tetrabiblos* (second century AD), claimed that the seven openings in the head were connected with particular planets. So

whereas Saturn is 'lord of the right ear, the spleen, the bladder, the phlegm, and the bones', Mars controls 'the left ear, kidneys, veins, and genitals'. The Sun controls (among many other things) the eyes, and 'all the right hand parts', whereas Mercury controls the tongue and 'all the left-hand parts'.[23] By giving the Sun control of both eyes, Ptolemy adhered to the ancient idea that the eyes are the noblest organs ('windows of the soul') by virtue of their function and their elevated position above the ground. The association of the sun with both eyes would become a standard trope in love poetry, and one that would eventually be satirized by Shakespeare: 'My mistress's eyes are nothing like the sun . . .'

By distinguishing between left and right in relation to the ears and the sides of the body, Ptolemy opened the door to more refinements. Demophilus (tenth century AD) took the momentous step of giving the right eye in the man to the Sun, and the left to the Moon; conversely, the right eye in the woman was given to the Moon, and the left eye to the Sun.[26] Demophilus was not being especially original. In ancient Egyptian religion, the right eye of the god Horus and of the goddess Osiris was the domain of the sun, while the left eye was the domain of the moon.[24] Unlike the Egyptians, however, Demophilus distinguished between the genders, by reversing the position of the sun and moon for women.[25]

Demophilus's schema for the eyes, and its Egyptian ancestor (which was transmitted via Hermetic texts), were both influential during the Middle Ages and the Renaissance, featuring regularly in astrological treatises, and in texts influenced by astrology. One of the earliest surviving post-classical depictions of 'man as microcosm' is entirely orthodox in its assignment of the eyes. A miniature in a manuscript from Regensburg in Germany (c.1165) features a symmetrical standing figure with outstretched arms. Thick ray-like strips bearing explanatory inscriptions abut his body, anchoring it in space and turning it into a kind of cosmic railway junction. Each of the seven openings in the head is governed by a particular planet, and the inscribed rays are arranged like the spokes in a wheel. A ray marked 'sol' goes to the right eye, and a ray marked 'luna' to the left. The man's body below the head is aligned with the four elements, each one of which is domiciled in a corner of the page. The association of the upper right side with light is emphasized by fire's placement in that same corner, with its 'ray' descending onto the man's right shoulder. The right side is also the more

masculine side, since the right nostril is given to Mars, and the left to Venus.

This microcosmic man is eminently Christ-like, and bears more than a passing resemblance to contemporary images of Christ the Redeemer, and of crucifixion images in which Christ looks straight ahead with open eyes. The 'wheel' around his head is clearly meant to resemble a halo. Crucifixion images did indeed have an important planetary component: at least since the sixth century, when crucifixion images first begin to be made, the sun and moon are frequently depicted, at top right and left of Christ; and from around the twelfth century these planets are furnished with faces.[27] This is nominally a reference to the eclipse of the sun that is supposed to have occurred at Christ's death, but the symmetrical placement of the two planets on either side of Christ, when they should rightly be next to each other or overlapping, is clearly informed by these ancient astrological beliefs.

The crucifixion was downplayed by early Christians, because the idea that the son of God might die on the cross, one of the most shameful forms of execution in the Roman world, almost beggared belief, and was probably deemed unlikely to attract converts. In early Christian art, the cross is depicted without Christ, and it is only in the sixth century that the crucified Christ starts to appear, albeit rarely. It became a central subject of Christian art in the Carolingian era.[28] The fact that the sun and moon feature in some of the earliest crucifixion images suggests that this was regarded as a good way of alerting the viewer to Christ's divinity. Roman emperors were depicted on coins with the sun and moon, and both planets also appear in some of the earliest Christian images of the Baptism, the Good Shepherd and Christ in Majesty. Even if the presence of the sun and the moon at the crucifixion was taken to signify the moment of the eclipse, this too demonstrated Christ's intimate relationship with the planets. Indeed, as early as the first century AD, Ignatius of Antioch described Christ as the brightest star in the firmament: 'The other stars and the sun and moon gathered round it in chorus, but this star outshone them all.'[29]

Nonetheless, the idea that the sun and moon were analogous to the eyes, whether of Christ, God or man, appears to have been controversial, no doubt because of its pagan origins, and because it might suggest an element of astrological determinism. In the popular fourteenth-century French prose romance *Perceforest*, in which the legends of Alexander the Great and King Arthur are combined, the defeated 'Fairy Queen'

renounces her pagan beliefs, and confesses her sins to an ancient pious hermit:

> All those who believe in other gods are deceived as I was by my foolish sense. For I held that the sun, which gives nourishment and light to every human being, was the right eye of the Sovereign God, and that with this eye he observed, nourished and warmed every creature; I also believed that the moon was his left eye, that by night in its simplicity gave to every creature moisture and relief from the heat of the day, by which every creature could find repose. But your speech has destroyed all my foolish ideas.[30]

The need to ridicule such ideas only goes to show how popular they were. Crucifixions with sun and moon imagery do indeed start to become less common in the fifteenth century, but this cannot be because such notions were discredited: astrology was as popular as ever. It has more to do with the fact that once artists start to depict light and shade, and illumination from a single light source, the presence of the sun and moon becomes less important. There is a certain redundancy in depicting the sun and moon if the light strikes the right side of Christ's body.

It is thus scarcely surprising if, as soon as artists concerned themselves with depicting light and shade, they were more likely to illuminate their sitters from their right, the time-honoured domain of the sun. As the sun was traditionally associated with the right side of Gods, Emperors and Kings, showing that the sun 'ruled over' the right eye could be regarded as intensely flattering. In his extremely popular *Books of Occult Philosophy* (1510/33), which reprised traditional astrological lore, Henry Cornelius Agrippa of Nettesheim says that the Sun 'rules over the right eye and the spirit', and that those in the domain of the sun are granted 'glory, victory and courage'; the 'solary mind', he continues, is 'magnaminous, courageous, ambitious of victory and renown: as the Lion, King of beasts . . . '.[31] When Lomazzo, in the passage we cited earlier, claims that the right eye is 'dedicated to the sun' and signifies intelligence and justice—he is making a variation of the same theme.[32] Conversely, Agrippa says that those under the jurisdiction of the Moon are condemned 'to a common life' that is always changeable. Women, dogs, chameleons and dung-beetles are all 'lunary' creatures.[33] He doesn't specifically mention that the left eye is dedicated to the moon, presumably because it was unnecessary, but the 'lunary' eye is

generally regarded as the eye that looks on 'sublunary' matters—either with, or without, the necessary skepticism and judiciousness.

Microcosmic man was no longer simply accompanied by inscriptions or depictions of the sun and moon, he could also be subject to light and shade. A good example is the title page illustration in Robert Flood's *Utrisque Cosmi* (1617), which has a naked man, surmounted by the sun and moon, but now with the whole of his left side in shadow. It expresses the same sort of idea that could be found in Giambattista della Porta's treatise *On Celestial Physiognomy*. Della Porta recapitulates the sun-moon theories of the ancient authorities, but this time applying the sun-moon distinction to the whole body: 'Ptolemy says that the Sun dominates the right side of the body and the Moon the left side.'[34] Ptolemy had actually said that Mercury dominates the left side of the body, but it obviously made more sense to hand the whole of the left side over to the Moon if the Sun dominated the right side. These same ideas inform Federico Zuccari, in his *Idea de' Pittori, Scultori et Architetti* (1607), when he insists that the human body, the principal object of 'disegno' (meaning design/drawing), is governed by the planets, and that the eyes are the province of the sun and moon.[35]

With a bit of ingenuity, and some knowledge of Roman religion, these conventions could even reinforce the notion of the painter as an augur. Etruscan augurs—in marked contrast to the Greeks—had favoured the left side in their religion, and augurs in Republican Rome had followed Etruscan practice. Etruscan augurs would face south, and so the bright and auspicious light of the east was to their left.[36] Plutarch, in *The Roman Questions* (no. 78), had tried to explain this very un-Greek orientation, and his final proposal is that the Roman augur takes up a position whereby he can face the gods, and so those things which are on the augur's left are actually on the gods' right. Thus pictorial illumination from the sitter's right could not only underpin the sitter's quasi-divine power and importance, it also establishes the painter as a sooth-sayer of the Etruscan school. The 'Tuscan' Alberti would surely have known this.

* * *

WHAT I WOULD LIKE to do now is to explore some of the ways in which these 'solar' conventions were exploited in paintings that tend to be regarded as triumphs of naturalism. I want to begin by looking at some of the earliest independent portraits: that is, 'portable' portraits that

were probably not made with a specific location—such as a church or palace—in mind. This is because the artist and/or sitter would have been freer to choose the kind and direction of lighting within the picture. The most important surviving group of early independent portraits is by the great Netherlandish painter Jan van Eyck, who was active from around 1422 until his death in 1441. During his own lifetime and ever since, he is credited with being the 'inventor' of oil painting, and although this is patently untrue (it had been used since the eighth century for painting on stone and glass), he took oil painting to unparalleled heights in his meticulous depiction of the fall of light on different surface textures.

Van Eyck's surviving altarpieces show that he was eminently capable of depicting light falling from the protagonists' left, even when he inserted donor portraits which must have been drawn from life. However, all of his surviving half-length portraits of individuals (around seven, at current estimates) are lit from the sitters' right. All but one depict the head and shoulders of the sitter, turned slightly to their right, against a dark, monochrome background. Although there is a distinct privileging of the sitter's right side, the light hits them full in the face, so that each eye is equally illuminated: in terms of planetary melothesia, these portraits are eminently Ptolomeian, with both eyes (and the whole face) 'controlled' and blessed by the sun. Like sunflowers, these sitters seem to turn towards the sun. This format of portrait was to be one of the most popular.

The lighting of Van Eyck's most ambitious portrait, the *Portrait of Giovanni Arnolfini and his Wife* (1434) (Fig. 9), is much more elaborate.[37] It is probably the earliest surviving portrait on panel of two people who were not rulers, and it is the earliest known portrait on panel where the subjects are seen in a domestic setting. Indeed, only in the sixteenth century did this type of portrait become widespread.[38] The Arnolfinis are depicted in a reception room filled with many painstakingly delineated props, including a bed, an item of furniture that was often found in reception rooms.

The focal point of the picture is not actually the Arnolfinis, but a convex circular mirror hung on the back wall at dead centre of the composition. The Arnolfinis stand either side of the mirror (Giovanni to its right; his wife to its left) and their left and right hands respectively touch just beneath it. The mirror has an elaborate frame featuring ten scenes from Christ's passion, with the Crucifixion at the top. The lighting system of the picture seems to take its cue from this, for the area

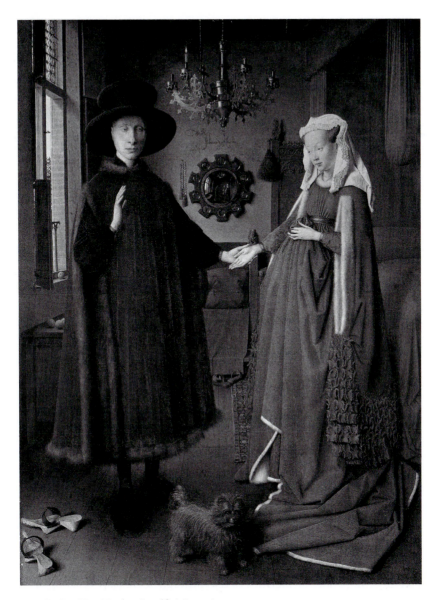

Fig. 9: Jan Van Eyck, *Arnolfini Portrait*

to Christ's right is indeed the sunny side, with light flooding in from a window that is reflected in the mirror. The emphasis on right-sided illumination is reinforced by the candelabra that hangs from the middle of the ceiling, and is perfectly aligned with the mirror. It has a single

candle which, despite it being broad daylight in high summer, has been mysteriously lit, and this is to the right of the mirror. Burning a luxury item such as a candle may have been a way of honouring a guest,[39] but here it takes on a decidedly spiritual function—not least because it is perfectly aligned with a golden rosary bead that hangs on the wall to the right of the mirror. We know that van Eyck was well versed in the sun-moon imagery of the crucifixion because a carefully observed moon appears in a *Crucifixion* (1425–30). It is placed just to the left of the bad thief, who arcs his body into a crescent shape.

Giovanni Arnolfini, who is placed to the right of the mirror and of his wife, has a priestly demeanour. His right hand is raised in a gesture that is both blessing and welcoming—both to his wife, and to the two visitors whose reflection we see in the mirror. The position of his right hand, strongly illuminated on the window side, creates a vertical division that neatly matches the division of his face into light and dark along the bridge of the nose. His shadowed but still clearly visible left eye seems slightly more closed than his illuminated right, a sort of crescent moon to the right eye's sun. He almost seems to be looking out of his left eye warily. Yet he is gathering his wife in (probably an unrecorded second wife, about whom we know nothing) rather than distancing himself from her, for he has reached across with his left hand so that she may lay her right hand over his palm. And she, having turned towards her husband and to the light, appears to glow with an inner light, as though transfigured by his touch. We shall say more about the importance of Arnolfini's gesture, and how it subtly re-orientates the picture, in a later chapter.

In this great portrait, Giovanni seems to have the full measure of his 'solar' and 'lunar' selves—in the same way as Christ and microcosmic man achieved a perfect balance between the divine and the human. Even Arnolfini's extravagant hat, made from plaited straw dyed or painted black, with its huge brim and planetary rotundity, starts to looks like a cosmic halo. The artificiality of the mise-en-scene can be compared with that found in van Eyck's *Madonna in a Church* (*c.*1426–8), in which a giant Madonna, holding the Christ Child, stands in a Gothic church, with her back towards the choir screen that is surmounted by a crucifix, and, beyond that, the altar. As the altar end of a church is traditionally the east end, light should fall from the Madonna's left (the southern side), but once again the light seems to take its cue from the position of the

crucified Christ, and it falls from his right.[40] The status of the right side as the side of light is further emphasized by the presence of two lighted candles on an altar to the right of the choir screen.

The lighting system in Van Eyck's Arnolfini portrait is crucial insofar as it gives a moral authority and structure to what might otherwise just be a random inventory of the worldly goods of a rich Italian merchant living in Bruges. This was an eminently portable picture, 82 × 60 cm, probably furnished with shutters to protect it, and so the light gives it a moral anchorage wherever it might be in the world. The artist signed his work on the wall over the mirror: 'Jan van Eyck was here / 1434.' This has often been adduced to prove that the picture was painted to bear witness to a legal contract of some sort, such as a marriage, but other portraits by Van Eyck are signed with the day as well as the year.[41] By just giving the year, Van Eyck gives the portrait a quality of timelessness, like a lavishly illuminated book of hours that gives prayers and pictures for a whole year. So too does the candle burning during broad daylight, and the fact that the Arnolfinis are wearing warm clothing during what seems to be summer (there are oranges from southern Europe on the window-sill and a tree with fruit can be glimpsed through the window). It is a synthetic 'supra-seasonal' picture.

My next portrait depicts another Tuscan and was painted—astrologers please note!—exactly a hundred years later. Jacopo da Pontormo's portrait of *Duke Alessandro de'Medici* (1534), who was then the ruler of Florence, is particularly germane to the argument of this chapter because not only does it exploit astrological symbolism, but Alessandro is portrayed in the act of drawing an idealized female head on a sheet of paper. The portrait's very elaborateness shows how the Medici, a recently ennobled family with merchant origins, was striving to aggrandize itself, and develop a new form of ruler portraiture of the greatest gravitas.

Alessandro, who stands before us wearing a somber black robe and cap, looks up at us momentarily, while leaving his right 'drawing' hand resting on the paper. The priority here has evidently been to light the sitter from his right, in order to illuminate the right side of his face, and so the light hits the back of his drawing hand. Once again, though, it is only the lower part of the drawing, below the sharpened tip of the charcoal, that is in shadow. Having the light hit the back of his drawing hand is evidently not a problem, even for an amateur artist such as Alessandro.

From Vasari onwards, Pontormo has been characterized as a melancholy artist, who was both neurotic and secretive.[42] Works such as this portrait are regarded as pretty accurate reflections of his personality. However, its austerity has nothing to do with melancholy, fashionable or felt: it underscores Alessandro's quasi-divine, high-priestly power. He was the first Medici Duke of Florence, ruling from 1532 until his little lamented assassination in 1537, and is 'best known as a tyrant-libertine'.[43] If anything, he is portrayed as a kind of magus. There is a certain informality about the fact that we have interrupted him in the act of drawing, and this is underscored by the casual foregrounding of his languid, long-fingered left hand. He is drawing a female head in profile, probably that of his latest flame, Taddea Malespina, and this too gives the picture an undertow of eroticism. Having said that, Alessandro's elongated and broadened trunk, in unrelieved black, and unerring gaze, are intensely hieratic and imperious.

The classicizing style of the drawing, and the fact that it is a profile image, like an empress on a Roman coin, actually underscores the imperial theme. There is no doubt about who is in control. Indeed, it may be an allusion to Alessandro's namesake, Alexander the Great, and his famous commission to Apelles to paint his mistress Campaspe. Alexander, on seeing the beauty of Apelles's portrait, realized that the painter had fallen in love with her, and gave her to him. Here, however, Alessandro is an Alexander also endowed with the skills of Apelles, and so he triples up as great Emperor, Lover and Artist.

It is the lighting system that completes the apotheosis. Alessandro is lit from his right, and the illumination of the right side of his face is universalized by the peculiar semi-circle of light that strikes the wooden paneling behind, giving it a golden 'solar' glow. The left side of his face is in dark smoky shadow. Through the open door over his left shoulder we see, in the gap between the edge of the door and the doorpost, a rectangular strip of cool grey 'lunar' light. Pontormo implies that on this earth, the power of the sun and the moon are directly and exclusively channeled through this priestly potentate.

* * *

I'D LIKE NOW TO return to Vermeer, and to his deployment of light. In the *Art of Painting*, Clio is very much a mediator between heaven and earth, between (sublunary) time and eternity. On the wall behind her extends a large, slightly crumpled map of the Netherlands: it signifies

passing and indeed past time for it is an old map, long since obsolete, dating from 1618. Clio is very exactly aligned with it, for the map's thick vertical edge seems to pass through the middle of her head, while its lower horizontal edge is aligned with her neck. Clio marks a border crossing, between past, present and future.

Clio holds out the trumpet of Fame almost horizontally, like a jousting lance, with her right hand located at the picture's central vanishing point. The line of the trumpet is a near perfect continuation of the map's lower horizontal edge, and it projects into the realm of brightest light, an 'unmapped' zone between the tied back curtain and the wall. The trumpet is set against an off-white, upright isosceles triangle of wall. The distinctive diagonal shape of this section of wall is created by the drawing back of the curtain in the foreground. The wall becomes a high triangle of light that seems to rise up from the body of the trumpet like a sail above a ship (the trumpet is a symbol of fame, and ships were indeed the bedrock of Holland's own fame, for they were essential to its security and prosperity: many ships are depicted on the map). Both of Clio's eyes are closed, but it seems more likely that she is peering down at the big yellow book (probably a roll of fame) which she holds up to her breast like a dazzling shield; and perhaps, too, she glimpses the painter out of the corner of her left eye.

Was any of this informed by astrological conventions? Judging by Vermeer's contemporaneous *The Astronomer* (1668) and *The Geographer* (*c.*1668–9), the chances are it was. These similarly sized pictures were probably made as a pair and, judging by auction records, were known as 'Astrologers' for about the first hundred years of their existence. Both are dressed in standard scholarly garb, a blue robe with red trim and long hair pulled behind his ears. In Vermeer's day, there was no clear distinction between the professions of geographer, astonomer and astrologer, and geographers needed to know about the stars in order to plot latitude.[44]

We see the geographer from the front, leaning over his desk which is placed next to the window. He holds a pair of dividers in his right hand. His desk is a surrogate landscape, for the blue, brown and green patterned rug that acts as a tablecloth is rucked up into a range of 'hilly' folds. His papers too contribute to the desk's undulating topography. However, we cannot see anything on the paper over which he and his dividers hover, for it is an inchoate, blinding white void. It seems as though the sun has broken through the cloud and has struck the paper

with its full force. The geographer seems to have looked up suddenly to gaze out of the window towards the light, which bleaches the right side of his face.

A tell-tale sign that this is no ordinary pause for thought is the terrestrial globe strangely placed on the top of the wardrobe behind him, above his head. The globe, mounted in a four-legged stand, was first made by Jocodus Hondius in 1618, as a pair with a celestial globe that has a starring-role in *The Astronomer*. It has been said that Vermeer treats the globe as a scientific object because instead of showing the attractive decorative cartouches with which it was adorned, Vermeer chose to reveal the empty expanse of the Indian Ocean—identified as the 'Orientalis Oceanus'.[45] But anyone with an understanding of Christian and astrological symbolism, would realize that Vermeer probably had no particular interest in the Indian Ocean. What interested him above all was that it incorporated the magical word 'orientalis', meaning the east, and the rising sun; what makes it even better is that the 'Orientalis Oceanus' is empty, bright and immaterial. We may thus take it that our geographer is having a moment of spiritual revelation, and that the globe, improbably located on top of the wardrobe, is being rather clumsily apotheosized. If any further evidence is needed to prove that he is no ordinary geographer, we need only note that his pose is adapted (in reverse) from Rembrandt's mysterious print of an astrologer-magus in mid-revelation, the so-called *Faust* (*c.*1652).

The Astronomer is not nearly such a dramatic picture, perhaps because a star-gazer is less likely than a geographer to need to have his gaze suddenly torn from the earth, but it tells a basically similar story—that science should always be in the service of spirituality. The mise-en-scene is very similar, except that the astronomer sits facing the window and reaches out his right hand across his desk to adjust the celestial globe, decorated with 'animal' constellations. The globe is implausibly placed just in front of the window so that the astronomer can only ever look at the shaded side, and could only with difficulty adjust the brass dials on the top. But this seems to be the point, to have the hemisphere closest the window bathed in light, and the other half nearest the astronomer bathed in shadow.[46] The astronomer already seems to have worked all these things out for himself and even has a painting of the *Finding of Moses* hanging on his wall as a kind of alibi. Moses was a key figure for astrologers, and the biblical contention that he was 'learned in all the wisdom of the ancients' (Acts, 7:22) was taken to mean that he was

a magician. So strong was the belief that Calvin had had to reject the aspersion that he was a mere wizard.[47]

Vermeer painted four pictures, all late works, in which the light strikes the main protagonist from the left, and which he would have had to paint with the light coming from his right. They are all dramatic cropped close-ups of solitary women in interiors, so they might be said to conform to the Demophilan schema whereby women have the sun presiding over their left eye. Two of these pictures—*The Guitar-Player* (*c.*1672) and *The Lacemaker* (*c.*1669–70)—show women using their hands in quite a vigorous way. *Girl with a Flute* and *Girl with a Red Hat* (*c.*1666–7) are more lubricious, and both girls look at us with parted and very moist lips. The light seems to emanate from low down, below the horizon line. For better or for worse, it illuminates women who are (to adapt Cornelius Agrippa) sublunary creatures dedicated to the common life.[48]

<p style="text-align:center">* * *</p>

THUS FAR WE HAVE not mentioned Holbein, most of whose portraits are lit from the left. As he was a left-hander, we might assume that in this case Gombrich was right, and that Holbein did this purely to suit himself. However, it is likely that he did this precisely because of the type of portrait he wanted to paint: it makes his portraits intensely down to earth. His light is clinical, forensic and horizontal; it does not come from above. Its purpose is to materialize rather than to dematerialize; to make people seem to arrive rather than to depart; ready to occupy rather than to vacate space. It validates 'sublunary' existence. At the same time, however, Holbein minimizes the impact by only occasionally casting the right side of the sitter's face into strong shadow: all of the important facial features tend to be evenly lit, and it is usually only the area behind the sitter's right cheekbone that is ever actually dark.

Conversely, those that are lit from the right include three portraits of the religious reformer and scholar Erasmus (all 1523), and another of his patron William Warham, Archbishop of Canterbury (1527). Holbein (and Erasmus) clearly wanted to infuse these portraits with a powerful spiritual dimension. In all of these the sitters face and/or look to their right. Two of the portraits of Erasmus show him writing in left profile like St Jerome. The third must have been sent to the Archbishop: in a letter Erasmus says that Warham should have it as a tribute in case God takes him away.[49] It shows the scholar in three-quarter face with

<p style="text-align:center">87</p>

both hands resting on a closed book, and Holbein closely imitated its composition for the later portrait of Warham, a version of which may have been sent to Erasmus.

In 1532–3, Holbein painted a number of portraits of German Hanseatic merchants based in London,[50] some of which suggest that he was fully aware of the astrological symbolism that related to the eyes, and that he exploited this to infuse a spiritual dimension to these portraits of wealthy businessmen. Around seven of these portraits survive, and they were probably painted as momentoes to be sent home to their families. It has been observed that in three of these portraits—*A Man Aged Thirty-Nine (?Hermann Hillebrandt Wedigh)*; *Hermann von Wedigh*; and *Cyriacus Kale*—the right eye is larger than the left. In the case of Cyriacus Kale, it is 'disconcertingly large'.[51]

These portraits are among the earliest examples of the use of a frontal pose in Holbein's work, and as such they seem to evoke images of Christ as Salvator Mundi.[52] The Hanseatic merchants had come under suspicion from the English authorities for importing Protestant literature, and so these frontal images may have been a defiant assertion of their religious identity. The portrait of Kale carries two Latin inscriptions that run either side of the sitter's neck, just above the shoulders, bearing down on him like a yoke: 'In all things be patient', says the one to Kale's right; the other announces the sitter's age—32—and the date of the portrait—1533. In Germany, reaching the age of 30, or reaching what was considered to be the 'ideal' age of 33, the age at which Christ was crucified, was traditionally regarded as a major milestone, and Kale may therefore be offering his thanks for having survived this far.[53]

The dramatic distinction between the size of his eyes is likely to be an allusion to the fact that the sun (which controls the right eye) is much larger than the moon; by so doing, Holbein implies that the spiritual side of these successful merchants is more powerful than their worldly side. At about the time Holbein was painting these portraits, he designed a woodcut illustration depicting eclipses of the sun and moon, the frontispiece to Sebastian Münster's guide to the movements of these bodies, *Canones Super Novum Instrumentum Luminarum* (Basel 1534). This features two magus-like men holding astronomical instruments looking up to their right at the sky filled with a series of circular sun and moon 'faces' in various stages of eclipse, each 'face' sporting a different expression. The woodcut suggests that Holbein's interest in scientific

instruments, which are so lovingly delineated in his pictures, did not rule out astrological sympathies.

Perhaps too, with these Protestant merchants caught up in the thick of the Reformation, their strangely intense portraits could imply the co-existence of a 'larger' spiritual joy alongside a 'smaller' worldly sorrow. I have in mind the joy-in-sorrow that is expressed by Paulina in Shakespeare's *Winter's Tale* (1610/11) when she learns simultaneously that her husband is dead, and that the King's wife and daughter are alive. This is one of the few occasions when ocular disparity is revered rather than despised:

> *Third Gentleman*: 'But O, the noble combat that "twixt joy and sorrow was fought in Paulina! She had one eye declined for the loss of her husband, another elevated that the Oracle was fulfilled"'. [V, II, 72–6][54]

Where oracles and portents are concerned, the 'auspicious' side is usually the right side.

RENAISSANCE TO ENLIGHTENMENT

Part 2
Contesting Left and Right

In Part 2, I will be looking at the way in which, from around 1500, left-right distinctions are dramatized in the visual arts by radically occluding one side of the sitter's face. This apocalyptic style of portraiture emerges, I believe, at a moment when left-right distinctions had become a particularly contentious issue. An increasing amount of secular art was being produced for patrons who did not automatically subscribe to the prevailing 'right-leaning' prejudices; conversely, the protestant reformation and catholic counter-reformation both stressed the importance of spiritual rebirth which necessitated the 'purging' of the left side.

5. Darkened Eyes

Pastor: 'Thou shalt not be angry with any man until he wants to put out thy right eye.'

<div align="right">Heinrich Suso (<i>c.</i>1295–1366), <i>The Life of the Servant</i>[1]</div>

Some that but looke into Divinitie
with their left Eye, with their left Hand do write
What they observe, to wrong Posteritie,
That by this Ignis fatuis [foolish fire] roame by Night.

<div align="right">John Davies, <i>The Muses Sacrifice</i> (1612)[2]</div>

WE HAVE ALREADY SEEN that Aristotle saw light as properly belonging to the right hand side, and darkness to the left. A more specific interpretation of this same theme occurs in the eleventh chapter of the Old Testament Book of Zechariah. The Book consists of a series of visions, prophecies and moral allegories, with Chapters 1–8 probably written by Zechariah, and Chapters 9–14 later additions. The latter are now thought to have been written around 450 BC, though suggested dates range from 750 to 150 BC.[3] Zechariah is the most frequently cited of the Old Testament prophets in the New Testament Passion Gospels and, because much of this book is apocalyptic in tone, it had a great influence on the author of the Book of Revelation, who was traditionally regarded as the Apostle St John.[4]

In Zechariah Chapter 11, an intricate allegory is developed, centring on the distinction between the true and false shepherd, which enables the prophet to express God's anger at the people of Israel, and above all at their rulers and priests. Zechariah has a vision in which the Lord

dares him—with taunting irony—to 'take unto thee yet the instruments of a foolish shepherd'. This is because the Lord is about to send a good vigilante shepherd, who will 'eat the flesh of the fat, and tear their claws to pieces'. The chapter ends with a stern warning:

> Woe to the idle shepherd that leaveth the flock! The sword shall be upon his arm, and upon his right eye: his [right] arm shall be clean dried up, and his right eye shall be utterly darkened [11:17].

This is a radical and apocalyptic version of the astrological theme which we discussed in the previous chapter. For a basic interpretation of this influential passage,[5] we can turn to a short treatise by Peter of Limoges, *De oculo morali et spirituali* (*On the Moral and Spiritual Eye*), which was written in Paris some time between 1276 and 1289.[6] Peter's treatise is worth highlighting both because of its accessibility and enduring popularity, and the visual nature of many of its *exempla*. Peter was a famous astronomer, and his treatise features moralizing discussions of optics, optical illusions and perspective—exactly the kinds of thing that would have been of interest to artists, especially in the Renaissance. The writing is very vivid and anecdotal, with allegorical interpretations of why, for example, you see two fingers if you hold up a finger in front of a lighted candle; why if you stand opposite a circular concave mirror, with your eye positioned in the middle, you only see your eye reflected in the mirror.

The treatise seems to have been aimed primarily at preachers who wove Peter's various exempla into their sermons, thus giving them a very wide currency. It was evidently extremely popular, and its popularity was long-lasting. Many manuscript copies survive from almost every European region. Peter moralizes the eye largely in terms of left-right distinctions, and twice cites the passage from Zechariah, regretting that 'in many men the left eye is illuminated while the right is obscured'. Whoever has an 'obscured' right eye is blind to spiritual matters, and the devil particularly prizes this eye because once it is taken and put out of action, the spiritual battle is over. Peter interprets an episode from the first book of Samuel, Chapter 11, in a similar light: Nahash the Ammonite besieges the city of Jabesh in Israel, and says he will only make a treaty on condition that he can 'thrust out all your right eyes, and lay it for a reproach upon all Israel'. For Peter, Nahash is the 'serpent who desires to make a pact whereby he leaves them with their left eye, which perceives temporal things, and takes their right eye,

which signifies the desire for eternal things'.[7] Fortunately for the people of Jabesh, Saul comes to the rescue and massacres all the Ammonites.

The hierarchy envisaged by Zechariah was clearly a consolation to St Gertrude of Helfta, a contemporary of Peter of Limoges, and enabled her to come to terms with the ailment to her left eye.[8] This 'left-sided' darkening of her eye ennobles her, and it inspires gratitude and joy, which allows her to ascend towards God and to enter into spiritual marriage with him. Purged of her left eye, she can channel all her energies into seeing with her spiritual right eye.

The Zecharian schema also seems to inform a depiction of the brain included in an extraordinary anthology of fifty-five texts that was compiled in England in around 1330, probably in an important monastic centre.[9] Most of the texts are written in Anglo-Norman, with a few in Latin and one in English. They include all manner of text—devotional, political, historical, literary, scientific, medical and cosmological. It may be one of those books which monks read when they were in the infirmary for the periodical bleedings which they underwent.[10] The depiction of the brain accompanies a short text entitled 'description on the head of a man'. It shows the basic contours, interior as well as exterior, of the head of a bearded man. The structuring of the brain follows the theories of the great Islamic physician and philosopher Ibn Sina, better known by his Latin name Avicenna (c.980–1037). There are five 'cells', each with a different function, arrayed in the anterior, middle, and posterior parts of the brain. For Avicenna, the brain is structured from back to front, rather than from left to right. The middle part of the brain is the most important, and contains three cells that interpret and evaluate: 'imagination or the power of shaping', 'estimation' and 'the power of cogitating or imagining'. The anterior part of the brain houses the purely sensory cell—'the common or imaging sense'—and the memory cell is at the back, level with the ears. Insofar as it is connected by arterial 'feeder pipes' to three other cells, the most important cell is 'imagination or the power of shaping'.

However, the artist has given the brain a decided left-right emphasis. A fourth, extremely long feeder pipe is also connected to 'imagination or the power of shaping', and this pipe stretches all the way across from it to the figure's right eye, like a giant optical nerve. The more lowly 'common or imaging sense' is connected to the left eye by a shorter feeder pipe, which passes underneath the one going to the right eye. Here the right eye is a seeker after truth—active rather than passive,

central to the brain's function rather than marginal. Two other factors suggest that the author of this image has decided Zecharian sympathies, and is less interested in what the left eye has to offer. Not only is the right eye located higher on the face than the left eye; but the head is shown in three-quarters profile, looking to his right.

Why should the artist have tampered with Avicenna's five-cell version of the brain? The most likely answer is that many of the texts in the anthology are concerned with prophecy, revelation and prognostication.[11] The texts even include an illustrated version of the Apocalypse of St John, which is the medieval title of the Book of Revelation, which was heavily influenced by the Book of Zechariah. Two other similar drawings of the brain survive from the fifteenth century, with crossed feeder tubes leading to the eyes, and these too may have been produced to satisfy a patron's interest in prophecy.[12] Even images of the brain that make no distinction between the eyes tend to have the head facing to the right, as if to show that the supreme function of the brain is to focus on spiritual matters.

In general, however, medieval artists seem to have had scant interest in tampering with the symmetry of the face, whether by re-configuring it or by occluding parts of it. Indeed, facial and especially ocular asymmetry has traditionally been seen as deeply disturbing. The asymmetrical eyes of Holbein's Hanseatic merchants and of Shakespeare's Paulina are very much the exception to prove the rule. Physiognomists are scathing about pairs of eyes that are not uniform in their appearance and actions, and proverbial wisdom has it that the false man looks up with one eye and down with the other.[13] In *Hamlet*, we smell a rat as soon as Claudius claims to have an 'auspicious and a dropping eye' on marrying Hamlet's mother, the widow of the man he has just poisoned. The basic idea lives on in a sardonic description of the French President Georges Pompidou (1911–74) given by his second mother-in-law: 'One eye a vicar's, the other a rascal's!'[14] Although we are not told which is the left and which the right eye, it is probable that the 'auspicious' or 'vicar's' eye would be located on the right, and would be bigger, brighter and more elevated than the left eye.

In medieval art a right-sided 'spiritual' orientation tends to be signaled by allegorical props held in the right hand (bishops' croziers); by blessings made with the right hand; or by the orientation of the body, as in the case of the crucified Christ, turned to his right. In medieval tombs, the main concern seems to have been with contrasting the 'before'

and 'after' state of the deceased's body, rather than with depicting their daily struggles during their life with virtue and vice. In medieval 'transi' tombs, a reclining effigy of the deceased in all their worldly splendour would often be contrasted with an effigy of a rotting corpse, placed directly below. This 'before' and 'after' scenario is undoubtedly gruesome—but it is also rather impersonal.

This changes dramatically in around 1500, when the first authentically Zecharian images start to appear. The first printed edition of Peter of Limoges' *De oculo morali et spirituali* was published in Augsburg in 1475, attributed to John Peckham (1230s–1294), the Archbishop of Canterbury who had written one of the greatest medieval treatises on optics. The misattribution may well have boosted sales, but it was probably inadvertent, and so attests to the prestige of Peter's work.

An early self-portrait drawing by Dürer, made in Nuremberg in *c.*1491–2 when he was around twenty, only makes real sense if it is understood in relation to these ideas. It is the most urgent and turbulent self-portrait that had yet been made, and is of a 'romantic' type that would become increasingly common. It must have been produced by looking into a convex mirror, but there is no reason to believe that the artist wanted us to think that we are seeing a 'mirror' image, and to read it accordingly. The right hand in the drawing is the most active, and this suggests that Dürer wanted us to treat it as an authentic right hand, rather than the mirror image of a left hand.

The young artist stares out at us intently, but his right eye is distorted and partially occluded by his sharply tapering fingers of the right hand which is pressed up hard against that side of his face. The light falls from the sitter's right, so the hand blocks the light as well as covering the eye. We cannot be sure whether the hand is about to conceal or reveal the eye, or is just highlighting it. The intensity of the image— and of the confrontation between the head and the hand—is made all the greater because only they are delineated with hatching. This is a young man who is not just playing with his physical appearance—as it were, pressing the human clay—the status of his soul is in the balance. This moral method-acting also involves a consideration of what kind of artist the twenty-year-old wants to be: should he be a purely naturalistic artist, governed by the 'common or imaging sense' of his left eye—or should the imaginative and contemplative right eye have a say too?[15] This drawing is Dürer's most original piece of auto-analysis, and his most dynamic self-portrait. His moral and religious status would later be

explored in the famous self-portrait painted in the Jubilee year of 1500, where Dürer depicts himself as a hieratic, Christ-like figure.

The first explicit illustration of the ocular metaphor in Zechariah 11: 17 appears in two Venetian editions of Peter of Limoges' text. In 1496, a Latin version and an Italian translation, *Libro del occhio morale,* were simultaneously printed in Venice—now correctly credited to Peter of Limoges; the Latin version was reprinted in 1502. The Venetian publisher evidently regarded the Zechariah passage as the most important because the frontispiece woodcut demonstrates the primacy of the right eye in no uncertain terms. It shows a priest standing in a pulpit giving a sermon at a moment when he theatrically lifts his head up high and points to his right eye with the index finger of his right hand. It is a version of what anthropologists call the 'eyelid pull', a gesture still widely used in Mediterranean countries whereby the extended forefinger is used to pull down the lower eyelid, thereby opening the eye wider. It denotes superior wisdom of some sort, and now tends to mean either 'I am alert' or 'be alert'.[16] As if to underline the importance of the gesture, the priest raises his left hand and points with his index finger to his right hand, as though he is completely denying his left side. It is not clear whether his left eye is closed, but the pupil is largely inked in. The impact of the gesture is intensified by the fact that the priest is depicted in profile from the left, thus implying that we, like the bad thief, are firmly located on the left side, and have a long way to go to reach the privileged right side.[17]

The prophet Zechariah is relatively rarely depicted in the visual arts in his own right, but as he is often conflated with Zacharias, the father of St John the Baptist, he makes numerous surrogate appearances. The conflation is facilitated by the fact that in the Vulgate Bible, and in Italian, both are called Zacharias.[18] This must have increased the sense in which Zechariah pervades the New Testament—not just textually, through citations, but physically, through his namesake. Interest in him seems to have been boosted around 1500 because of his apocalyptic visions and castigation of errant priests: he suited a period of religious, political and social turmoil. This was especially so in Italy, which was the main theatre of war in Europe from 1494, when the French invaded, to around 1430. The charismatic Dominican reformer Girolamo Savonarola gave a series of sermons inspired by passages from Zechariah in Santa Maria del Fiore, Florence, in 1495, and this was his first entire cycle of sermons (along with those on Amos) to be published in 1497.[19]

Savonarola makes many traditional left-right distinctions throughout his sermons. He does not specifically mention the Zecharian topos in the sermons on Zechariah, though he gets quite close in an elaborate allegory of the crucifixion in which the worst sinners, who are Christians from the papal city of Rome, stand on the left side of the cross: 'some cover up [their view of] the cross which they have before them, some with their cap [berretta], some with their hood [cappuccio], some with their hands ... '.[20] Savonarola does not specify precisely how this occlusion is done, whether these 'bad shepherds' cover one or two eyes, but during the sixteenth century caps, hoods and hands are used to cover up one eye or the other in several 'Zecharian' images. In the following year, the second half of another sermon is given over to a discussion of Nahash's attempt to take the right eye of the people of Jabesh: this demonstrates that while the Devil always wants to take the eye of 'good living and of faith', he is quite content to leave us with the left eye of 'reason' and of 'natural light', for he knows that 'the natural sciences never bear any fruit'.[21]

Zechariah's 'topicality' helps explain why he presides over Michelangelo's ceiling fresco in the Sistine Chapel (1508–12), being directly above the entrance, and thus the first prophet to be painted. His position is usually explained because of his supposed predictions of the coming of Christ, and also of the religious patronage of Pope Julius II and his family, whose name was Rovere, meaning oak-tree. This is because of the passage in which Zechariah talks of 'a man named the Branch' who will 'shoot up from the ground where he is and will build the temple of the Lord' [6:12]. The Sistine Chapel had been built by Pope Julius' Rovere uncle, Pope Sixtus IV. However, Zechariah also happens to be the only prophet to be depicted in complete (right) profile. He flicks through his book looking for some passage. The right side of his face is in semi-shadow: perhaps the shadows will completely disperse when he finds his place, and is 'enlightened' by the holy writ.

Medieval theologians and mystics had devised a vast array of 'eye' metaphors with which to express man's relationship with God and the world. We find inner and outer eye/s; the eye/s of feeling, spirit, reason, knowledge; the eye of the heart and the eye/s of the soul.[22] But it is those eye metaphors that involve or imply a left-right distinction that are most amenable to visual representation, either through the orientation of the head (as in the crucified Christ), or a different emphasis on the left and right sides of the head.

In the first decade of the sixteenth century, we begin to find visual counterparts in Italian art for Zechariah's 'idol shepherd' with his 'darkened eye'. The earliest examples, two paintings of a *Shepherd with a Flute*, are the product of Giorgione's circle. One has recently been attributed to Giorgione (Villa Borghese),[23] while the other, which is poorly preserved, now tends to be attributed to Sebastiano del Piombo (*c.*1508–10, Wilton House) (Fig. 10). Both shepherds look at us conspiratorially over their left shoulder, and the right side of their face is cast into deep shadow by their flamboyantly tilted caps: they inaugurate an era in the visual arts in which hats are aggressively tilted, and cast portentous shadows.

The darkness of the right side of the face is intensified by the fact that both sitters are illuminated from their left. Each shepherd holds up his flute in a blatantly phallic manner. Both of these shepherds—especially

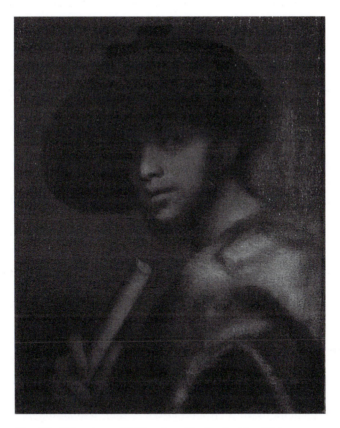

Fig. 10: Sebastiano del Piombo, *Shepherd with a Flute*

the Borghese flute-player, in his slashed silk top—are far too well dressed to be rustics. Real shepherds would have worn threadbare, undyed cotton clothes. The uncouth, grinning demeanour and sun-burnt complexion of the Borghese shepherd suggests that these elegant clothes may be recent acquisitions, possibly gained unlawfully; or else he is a middle-class youth playing at being a country bumpkin. The dramatic and even aggressive way in which his red cap flops down over the right side of his face, swallowing it up, is particularly striking. The left arm is the 'active' one, holding up the flute.

In both these shepherd pictures it is as though, as Zechariah would have it, the right arm has been 'clean dried up'; while the brim of the hat is like the metaphorical 'knife' above the right eye: it throws a shadow that cuts across the right side of the face, 'utterly darkening' it. Sebastiano del Piombo, who was reputed to be a natural left-hander who had trained himself to use his right,[24] used similar lighting effects in his 'machiavellian' portrait of *Baccio Valori* (1530), the ruthless governor of Florence under the Medici. The portrait is now displayed in Palazzo Pitti in such a way that his left eye seems to be coldly appraising the naked left side of Canova's justifiably startled *Venus Italica* (1804–14).

In Ludovico Ariosto's crusader romance epic, *Orlando Furioso* (1516; revised edns. 1521 and 1532), we find a counterpart to these rude rustics in the 'mean-faced' leader of a band of brigands who has been previously blinded in his right eye in a fight. He has imprisoned the gentle maiden Isabel for eight months in a remote cave, when the hero Orlando comes to the rescue and smashes him in the face with a burning brand: 'Neither eye escaped the brand, but it did more damage to the left one: it deprived him of his last source of light, and, not content with blinding him, the savage blow dispatched him to join the spirits whom Chiron and his crew guard in the fiery swamps.'[25] This is a rather circuitous and pedantic way of saying that the blow was fatal, but Ariosto seems to be insisting that spiritual death preceded physical death. His 'last source of light' was, we infer, a very depraved one because it was his left eye; in addition, the light that had entered this eye was 'weak' because he was a frequenter of gloomy caves.

Sebastiano's *Shepherd with a Flute* (*c*.1508–10) was hugely influential, and because of its originality and popularity, is sometimes claimed to be a copy of a lost Giorgione.[26] Two saucily conspiratorial portraits of would-be lovers glancing with their left eyes over their left shoulders, Lorenzo Lotto's *Portrait of a Youth with a Book* (*c*.1526)[27] and Andrea del Sarto's

Portrait of the Artist's Stepdaughter (*c.*1528), are brilliant variations on the theme. In the former, the youth holds a book—presumably of love poetry—while in the latter the girl points to some lines in a manuscript copy of Petrarch's poetry. But the most exuberant reworking has to be Giovanni Paolo Lomazzo's *Self-Portrait as the Abbot of the Accademia di Val di Blenio*, (1568) in which the artist depicts himself as a dissolute shepherd or lapsed priest who is a devotee of Bacchus.[28]

The Accademia di Val di Blenio, founded in 1560, was a literary academy dedicated to promoting a fabricated dialect that was claimed to be the ancient language of Swiss wine porters working in Lombardy (its correct dialect title was the Accademiglia dra vall d'Bregn). The 160 members wrote burlesque literature in the dialect, and wined and dined each other. In 1568 Lomazzo was appointed 'Abbot'—or 'Nabad'—of the Accademiglia, and in the following year he published some of his own 'dialect' writings as 'Rabisch dra Accademiglia dor compà Zavargna, Nabad dra Vall d'Bregn'—with 'Zavargna' being his dialect name. In the portrait he leers at us over his left shoulder, with light streaming in from his left. He holds up a pair of dividers in his right hand, but as a spear rests on his left shoulder, he seems just as likely to use them as a double-bladed stiletto as for artistic purposes—a mixture of Swiss wine porter and Swiss mercenary.

The sight in both Lomazzo 's eyes failed in the 1570s, and he turned increasingly to writing elaborate and often arcane art theoretical treatises, in which aesthetics are informed by astrological considerations. From these we know he was indeed fascinated by left-right symbolism. In the midst of a pioneering discussion of portraits in his *Trattato dell'Arte della Pittura* (Milan, 1584), Lomazzo says that 'the right eye, because it signifies intelligence and that nothing is hidden from it, is dedicated to the sun, which means justice'.[29] He doesn't go on to say what the left eye signifies, but one assumes he regards it as less respectable, unerring and exalted. Not long afterwards Cesare Ripa's iconographical handbook would define the allegorical figure of 'Injustice' as blind in the right eye.[30] Lomazzo's self-portrait romanticizes the idea of a world turned upside down, of the unruly mob 'rule' that often occurred during times of Carnival.

The Zecharian shepherd would take on a new lease of life in Dutch seventeeth-century art, frequently aided and abetted by the fashion for wide brimmed hats. Rembrandt's ribald *Self-Portrait as the Prodigal Son* and *Self-Portrait as Zeuxis*, are outstanding examples (we will be returning

to these in a subsequent chapter). In Vermeer's *The Procuress* (1656), two male clients alternate with two women (a grotesquely smiling procuress, and a brightly attired whore) behind a carpeted table in a claustrophobic interior. The man who stands behind the whore, his left hand placed on her breast and his right offering her a coin, wears a wide-brimmed hat tilted at forty-five degrees so that the right side of his face is bathed in smoky shadows. His companion wears his hat in a similar way. Logically, in this stifling interior, they should have removed their hats, but it adds to the airlessness and menace of Vermeer's most claustrophobic and disturbing painting. From the eighteenth century, we have Joshua Reynolds' *A Nymph and Cupid or, 'The Snake in the Grass'* (1784), where a reclining, bare-breasted nymph, seen from the left, uses her bent right forearm and hand to cover up the right side of her face: she ogles us mischievously with her left eye.

In all these examples (except perhaps the Reynolds), there is a clear class distinction at work. The occluded right eye of the 'bad' shepherds is associated with the peasantry and the urban proletariat—or with middle class men who are, as it were, deliberately dumbing down, and imagining themselves as wine porters, peasants and all kinds of rough trade. It is the badge of the lowest of the three feudal estates; as such, their exuberant renunciation of their elevated class status is almost a parody of the classic Christian form of renunciation whereby someone like Francis of Assisi renounces his inheritance and takes on the trappings of the poor.

* * *

An occluded right eye doesn't invariably mean, however, that the wearer of this particular badge is a moral basket-case, permanently beyond the pale. It may sometimes mean that the person is unfulfilled or lacking in some way, and covers their eye temporarily to advertise their shameful benighted state. This is how we should read the so-called 'vow of the heron', undertaken in the late 1340s by English knights on the eve of Edward III's military campaign to pursue his claim to the French throne—a campaign that inaugurated what came to be known as the Hundred Years War. A French exile, Robert of Artois, seems to have devised the 'vow of the heron' to shame the English knights into invading France: the heron was a symbol of cowardice as it was believed to be afraid of its own shadow. He had a dead heron brought in on a pair of silver platters and presented to the King. According to the rather

fanciful poem *The Vow of the Heron*, written later in the century, Robert leapt over the banqueting table and began canvassing for volunteers:[31]

> He went first to the Earl of Salisbury, who was seated by his mistress, the object of great love [the daughter of the Earl of Derby]; she was appealing and courtly and of fair countenance...And Robert said graciously to him, 'Good sir, you who are so bold, in the name of Jesus Christ, to whom the world belongs, make a vow of support on our heron without delay, I humbly pray you'. Salisbury answered him: 'Why and how could I put myself at great risk in order to accomplish any vow perfectly? For I serve the most beautiful woman in the world according to what I have, and love instructs me. If the Virgin Mary were here and her divinity—nothing more—were taken away, I could not distinguish the two. I have asked her for her love, but she resists; but gracious hope makes me believe that she will yet have mercy on me, if I live long enough. I devoutly ask the maiden to lend me just a finger of her hand and simply place it on my right eye.'
>
> 'By my faith', saith the maiden, 'it would be ignoble for a lady who wants to command all the strength of her lover's body to refuse to touch him with one finger! I will lend him two; I agree to do that'. She immediately placed two fingers on his right eye and firmly closed the eye. He asked her graciously: 'My lady, is it completely closed? 'Yes indeed.' Then his mouth spoke the thought in his heart: 'I vow and promise to God almighty and to his sweet Mother, resplendent with beauty, that my eye will never open, for storm or wind, for evil or pain or disaster, and yet I will be in France...I will set fire everywhere, and fight with great force...' Then the beautiful maiden took away her finger, and the others saw that his eye remained closed.

This entire performance (which must have been planned out well in advance, and which was accompanied by girls singing 'I am going into the wood, as love instructs me') is an exquisitely calibrated mixture of 'real politik', romance, and religion. Despite all the appeals to the Virgin Mary and to Christ and God, the eroticism of his mistress' action is all too evident. Her two-fingered gesture is deliciously paradoxical. When Salisbury's right eye is 'darkened'—and it apparently remained closed throughout the war, no doubt with the help of an eye patch—he effectively becomes ashamed of the 'shadow' that is cast across his face

(in contrast to the heron which is afraid of its shadow). This implies he is not yet spiritually fulfilled, or worthy to gaze at those things that are most perfect.[32]

When Salisbury returned in triumph from France, and was permitted by his virginal fiancé to open his right eye, he would have considered it a form of spiritual rebirth. Others would no doubt have considered it an impious parody of spiritual rebirth, and there is anyway no suggestion that his fiancé then put two fingers over his left eye, to close that eye instead.

* * *

THE ALTERNATIVE CONVENTION—ILLUMINATED right eye and darkened left eye—was also to be explored by visual artists in the period around 1500. Those sitters who opt for it either are, or appear to be, churchmen and members of the secular religious orders—crusaders and 'christian soldiers'. The first major example, however, is a self-portrait in the guise of the Old Testament prophet David by Giorgione, the artist who is perhaps the key figure in the evolution of the Zecharian portrait.

Giorgione's works, which were all produced in the first decade of the sixteenth century, suggest he had a profound personal interest in left-right symbolism. We have already noted that the two half-length pictures of a *Shepherd with a Flute* have been attributed to artists in his circle, and the Wilton House painting has even been thought of as a copy of a lost picture by Giorgione. But perhaps the strongest evidence is that the compositions of his two most celebrated allegories are predicated on left-right distinctions. Neither is a Zecharian image, but the radical asymmetry of each composition seems designed to demonstrate the very different moral orders that lie—to cite John Cassian—'on the left hand' and on the right.[33]

In the *Tempesta*, virtually everything takes place to the left of the man—an idealized shepherd holding a staff—who stands in the foreground. Positioned at the edge of the composition, he glances over his left shoulder across a stream and sees a voluptuous image of a semi-naked woman sitting on the ground suckling a child with her left breast, and two images suggestive of imminent and/or ultimate death (two broken columns and a bolt of lightning flashing through storm clouds above a town).

This enchanting picture could easily be an illustration of some of the elements allied with 'left' in the Pythagorean table of

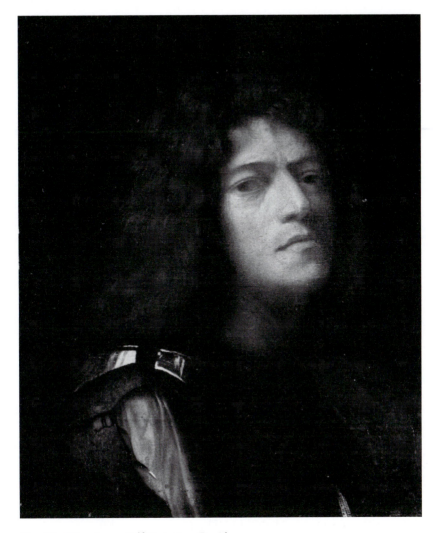

Fig. 11: Giorgione, *Self-Portrait as David*

opposites—'female', 'moving', 'bent', 'dark', and 'bad'.[34] It is always being seen in the context of pastoral poetry, and the most celebrated example, Jacobo Sannazaro's *Arcadia* (1504), utilizes standard left–right symbolism, including the idea that auspicious portents are located on the right, and vice versa.[35] There has been much speculation as to why Giorgione placed the 'carro' symbol of the Carrara family, rulers of Padua in the fourteenth century, over the entrance to the town.[36]

107

It is surely further evidence that the area to the left of the shepherd is a zone of moral and spiritual weakness, for the last Carrara ruler of Padua had been judicially strangled, with his two sons, by the Venetians in 1405, when they had captured the city. In the following years, the rest of the family were hunted down. A further indication is that a heron, symbol of cowardice, sits on the roof of the main turret.[37]

A similar scenario can be found in the still very popular allegorical love poem *The Romance of the Rose* (thirteenth century). The 'pilgrim lover' is told that if he wants to take the castle of the deceitful Fair Welcome, he has to turn left, and 'before you have walked more than a bowshot's length along the beaten track, and without wearing out your shoes in the least, you will see the walls tremble and the towers and turrets sway, however strong and fair they are, and all the gates will open by themselves, better than if the people had been dead. On that side the castle is so weak that it is harder to divide a toasted cake into four than to knock down the walls.'[38]

The allegory of the *Tempesta* is comparable, with the world to the shepherd's left being a domain of instability and weakness—and he will certainly get a 'Fair Welcome' from the fecund lady, who is clearly no virgin. However, as there is no indication, or possibility of an alternative world to the shepherd's right (he is positioned at the edge of the picture), it is a moot point whether any real alternative is being offered here: our lot, as human beings, is to be immersed in the transitory.[39] By way of contrast to this shepherd, Giorgione's *Three Philosophers* are positioned on the far right of the composition and can look to their right for inspiration and for knowledge of eternal verities. They are located in a landscape too, but theirs is much more permanent and reassuring. They stand on rocky ground, and a rocky precipice looms up before them, with the sun rising behind it. The pictures are a different size, and probably of different dates, but they still feel like a contrasting diptych.

In Giorgione's *Self-Portrait as David with the Head of Goliath* (Fig. 11), the drama occurs in the faces. David was of course a shepherd boy when he defeated Goliath, and here he is the archetypal 'good shepherd' at his moment of greatest triumph. The painting survives as a fragment that shows David's head and shoulders. However, we have a good idea of what the original looked like from painted copies and an engraving by Wenzel Hollar (it seems relatively faithful, though the chiaroscuro is softened, and the print is in reverse). Here, the virtuous shepherd boy David appears to be wearing the armour he was given after defeating

Goliath, his right eye boldly illuminated. He rests his left hand on the severed head of Goliath, which he has placed on a parapet. By way of visual and moral contrast, the left side of Goliath's face is illuminated, and the right side in deep shadow. Some of the psychological tension of the picture is generated by the fact that we seem to have two different lighting systems for each head, for it seems implausible that the light which strikes David would leave the left side of Goliath's face almost devoid of shadow. The contrivance of the mise-en-scene suggests that an important point is being made.

The strong contrast between light and dark recalls a passage from the *Song of Songs*, an Old Testament book which was then attributed to King Solomon, the son of David, because he is mentioned several times in the text. It consists of a series of rhapsodic erotic exchanges between a man and a woman, and at one point the latter says that she is black, crediting this state of affairs to the sun: 'Look not at me for that I am darkened; for the sun hath looked down on me'. This biblical passage was interpreted moralistically by theologians, with the Christian father Origen (*c.* AD 185–254) setting the general tenor:

> ...the sun is seen as having twofold power: by one it gives light, and by the other it scorches; but according to the nature of objects and substances lying immediately under it, it either illuminates a thing with light, or darkens and hardens it with heat... God is light without a doubt to the just; and He is fire to the sinful, that He may consume in them every trace of weakness and corruption that He finds in their soul.[40]

In Giorgione's self-portrait, the sun appears to have illuminated David's right side, and to have partially consumed his left. There is a certain 'look not at me' quality to his expression, as though he is slightly embarrassed or alarmed at the frank exposure of the state of his soul to scrutiny— and the artist must also have been aware of the sheer novelty of his radical deployment of chiaroscuro. In his self-portrait, Giorgione seems to be inviting us to witness the moment of his spiritual rebirth—though the fact that it is signalled by something as transitory as light may make us wonder how long he will remain the 'good shepherd' (David was famous for his chequered career).

* * *

ZECHARIAH'S OCULAR 'EITHER-OR' WAS to play an increasingly significant part in the Reformation, and the Reformation was in turn to be a catalyst for some of the most dramatic and extreme Zecharian images. In 1516 Martin Luther had found the manuscript of an anonymous spiritual tract written in German which he assumed had been written by the great German mystic John Tauler (c.1300–61), though it is now thought to come from someone in Tauler's circle. Luther immediately had it published in Wittenberg. This had the distinction of being Luther's first publication, and one of his most popular. He wrote a foreword in which he said that 'next to the Bible and Saint Augustine no other book has come to my attention from which I have learned—and desired to learn—more concerning God, Christ, man, and what all things are'.[41] Two years later he discovered and published a more complete manuscript of the same text, and it appeared in twenty more editions during Luther's lifetime, becoming known as the *Theologica Germanica*. It became a symbol to the anti-ecclesiastical forces of the Reformation because at various points salvation is ascribed to God alone, and the sacraments are only mentioned in Chapter 23.[42] A Latin translation by the protestant humanist Sebastian Castellio was published in 1557. The Pope banned the work officially in 1612, but until that time it was available in Catholic as well as Protestant countries. The relevant passage is very prominent: it occurs at the start of the first chapter of the first edition, and the seventh chapter of the second edition. Having explained that the 'soul of Christ has two eyes, a right eye and a left eye', with each eye able to work in harmony, the writer draws a stark contrast with the soul of man, where the two eyes can only operate one at a time, and never in tandem:

> Now, the created soul of man also has two eyes. One represents the power to peer into the eternal. The other gazes into time and the created world, enabling us to distinguish between the lofty and the less lofty, as I said above. But these two eyes, which are parts of man's soul, cannot carry out their functions simultaneously. If the soul is looking into eternity through its right eye, the left eye must cease all its undertakings and act as if it were dead. If the left eye were to concentrate on things of this outer world (that is to say, be absorbed by time and created beings), it would hinder the musing of the right eye.[43]

The sitter in Parmigianino's haunting half-length *Portrait of a Man with a Book* (early to mid-1520s, York, City Art Gallery) is trying very hard to make his left eye 'cease all undertakings and act as if it were dead'. This is one of a number of hugely impressive, intellectually ambitious portraits, of which the ultra-cerebral *Self-Portrait in a Convex Mirror* (*c*.1520) is the most celebrated. The Parmese artist, who would have been well versed in recent developments in Venetian art, depicts a youthful bearded man seated in an armchair with a book, its cover decorated with a pattern of green leaves. Often assumed to be a poet, he may just be a discerning bookworm who appears to have had a sudden revelation. The opulence of his clothes and surroundings suggests he is a man of some means and culture, but he is not entirely at ease with his worldly success. Indeed, he is its prisoner. He is uncomfortably wedged between the curved arm of his chair, draped in an exotic patterned carpet, which sweeps across the foreground, and the ornamented vertical gilt band of what may be a curtain in the background.

An abbreviated inscription on the cover of the book—I/E/Ultra—has been interpreted as meaning 'In Aeternum et Ultra' (To Eternity and Beyond),[44] which suggests the reader's mind is turning away from the trap of worldly pleasures. The lighting and the position of his black cap also reinforce this reading. The composition is almost impossibly claustraphobic and gloomy, with the light playing an inquisitorial role, spot-lighting some areas while leaving others in unrelieved darkness. The light-levels are hardly conducive for reading, but the illumination is symbolic rather than realistic, for the light picks out the area round his right eye, which stares out fixedly. The left side of his face is correspondingly dark, and his black cap slips down the left side of his face, deepening the darkness of that side still further.

The left eye is so swallowed up in shadow that an art historian recently tried to explain the anomaly away: 'The impression that he has only one eye is probably a result of the fact that part of the paint surface has suffered losses.'[45] It is unlikely that paint losses alone are responsible for the 'absence' of the eye for Parmigianino has not even left enough room for an open eye. A seventeenth-century description of the portrait—'ha l'aria ignobile e traditore' [he has an ignoble and treacherous air][46]—suggests that this side of the face was already considered disturbingly dark. The writer was presumably not a fan of the dramatic chiaroscuro made fashionable by Caravaggio and his followers,

but of which Parmigianino was an early pioneer. Parmigianino seems to have well understood that whenever one eye in a portrait is cast into extreme shadow, we do not necessarily assume that it is 'secretly' observing us, especially if the other is brightly lit: it is just as likely to appear inoperative, whether temporarily or permanently.

The portrait has been energized by the young artist's encounter with Michelangelo.[47] The sitter's constriction by a curved and straight element, and the air of foreboding, makes one think of the Ancestors of Christ on the Sistine Ceiling. Parmigianino may have seen sketches of the Ceiling, or perhaps he made an unrecorded visit to Rome. The curve of the chair arm falls away to the sitter's left, and the open book is tilted in the same direction. There seems to be a choice, mirroring that of a *Last Judgement*, between falling away to the left, or 'rising' to the right. That said, this spatial dynamic is subsumed into the bristling, spring-loaded tautness of the composition as a whole: even the sitter's white shirt collar, peaking through his dark jacket, is shaped like an arrow head.

The controlled aggression of the composition culminates in the far-away yet shark-like stare of his right eye. As a result, there is no sense that we are witnessing a spiritual crisis; rather we are witnessing the triumphant birth of a militant Christian soldier. One thinks of a simile used by the Spanish poet Juan de Padilla in his *Retablo de la vida de Cristo* (Painting of the Life of Christ, 1505) when he describes the conversion of Mary Magdalene. He says that spiritual rebirth is like shooting a cross-bow: if you want to hit the target you have to open your right eye and place it behind the sighting mechanism, and close the left eye.[48] Many artists had direct experience of such devices in the studio because 'sighting mechanisms' were often used by artists when making perspectival drawings, and these too required the closing of one eye (usually the left, for right-handed artists).[49] Padilla posits spiritual rebirth as a quasi-militaristic affair which necessitates the re-armament of the penitent: this is why Parmigianino's portrait is as alarming as it is seductive. We see fanatical determination and tunnel-vision rather than fear: he evidently aspires to the condition of a knight from one of those crusading military orders, the Templars and the Knights of St John.

The York portrait can be usefully compared with Parmigianino's *Portrait of a Collector* (*c*.1523, London National Gallery), which is sharply lit from the sitter's left. Although the sitter's right eye is only in half-shadow, the picture is far more grounded and horizontal. To the sitter's

left is a lush, twilit landscape, and to his right a bulky marble relief of a seated Venus and Mars. Before him on a table, a bronze statuette lies flat on its back. The lighting seems coolly lunar, and the main compositional lines are horizontal. The pursed-lipped sitter is clinically appraising someone or something located just to our left.[50]

Parmigianino seems to have been interested in the prophet Zechariah, because he subsequently included him in the right foreground of the magnificent *Madonna di San Zaccaria* (*c.*1530), which he dominates. The Madonna is seated in the middle ground in a turbulent landscape with the Christ child on her lap being vigorously embraced by John the Baptist. In the background, seen in right profile, Mary Magdalene looks on. The presence of the Baptist might suggest that the inspired elderly prophet, dressed in priestly robes, and positioned to the Madonna's left, is his father, but he actually holds a book which is inscribed with a line from Zechariah 2:13, 'Be silent, O all flesh, before the Lord'.[51] His brooding muscular grandeur is influenced by Michelangelo's Sistine Ceiling prophets and sybils (especially Daniel and Cumaea), and the statue of *Moses*. His position, seen in left profile, further suggests the Old Testament prophet, for the sacred quartet are within the purview of his right eye, while we lesser mortals are in the purview of his left eye. At the very least, Parmigianino suggests that the father of the Baptist strove to model himself on his Old Testament namesake.

During the 1530s Michelangelo became increasingly interested in left-right distinctions, and explored many of their ramifications—in part, perhaps, because he was naturally left-handed but had trained himself to draw and paint right-handed. He wrote several penitential poems that feature punning variations of the word 'manco' [lacking/left], and made a number of works (which we will discuss shortly) in which left-handedness and left-sidedness are key issues. Michelangelo is responsible for two of the most extraordinary depictions of exposed right eyes, and occluded left eyes.

The first appears in a dramatic pen drawing of a seated woman in right profile that has been dated to around 1520 (Oxford, Ashmolean).[52] She is usually assumed to be a study for a sibyl, and is a vibrant reprise of the prophets and sibyls of the Sistine Ceiling: her pose borrows aspects of Zechariah and of the Perisan Sibyl (in reverse). She appears to have been startled, and twists her turbaned head round sharply to look over her right shoulder. We clearly see that some of the fabric from the turban hangs loose over the left side of her face, either because she wears it this

way, or because her sudden movement has caused it to fall down. At any rate, the left side of her face is now completely covered—as well as being in dense shadow.[53] With her (illuminated) right eye she looks up at what appears to be an airborne snake, that was heading towards her but is now frantically doubling back on itself. This is one of those evil, Nahash-style serpents who want to take her right eye, but as soon as it sees that her left eye is occluded, and that she must be an indomitable 'good shepherdess', seems to have realized it hasn't got a hope in hell: virtue creates its own forcefield. A few years later Michelangelo would return to the topic of an attack by airborne serpents, and salvation from serpents, in a drawing based on the story recounted in Numbers 21:4–9.[54]

The second and most high-profile instance occurs in Michelangelo's *Last Judgement* (1536–41). At this time, he befriended the devout noble-woman and poet Vittoria Colonna, and she was equally fascinated by left-right distinctions. Colonna sympathized with many aspects of Lutheranism, and hoped that an accommodation might be reached between Catholics and Protestants. In one of her *Rime Spirituali*, published in 1546 but probably written much earlier, she writes of her left eye being closed, and her right eye being open at the moment of spiritual revelation:

> L'occhio sinistro chiuso, il destro aperto,
> l'ale de la spearanza e de la fede
> fan volar alto l'amoroso mente . . . [55]

['The left eye closed, the right open, / the wings of hope and of faith / make the loving mind fly high']. One of the possible catalysts for Colonna's interest in left-right eye symbolism may have been the writings of Gertrude d'Helfta, for they became increasingly popular (especially among educated women) after a Latin edition of her writings was published in Cologne in 1536.[56]

In one of the most celebrated poses in art, a Damned Man in Michelangelo's *Last Judgement* covers the left side of his face with his left hand as he is dragged down into hell. The occluded left side of the face may indicate his shame at having being dominated by carnal and material concerns. Donatello had used a similar motif in two reliefs of *The Feast of Herod*: in each a horrified bystander covers, respectively, the right and left side of their face with their hand so they can avoid seeing the severed head of John the Baptist. For Donatello, this was a 'functional'

motif of horror, and it clearly made no symbolic difference which eye was covered—it was determined by the position of the severed head.

That Michelangelo is not simply borrowing Donatello's motif, but is using it to make a particular moral point is confirmed by the fact that the sinner's left leg is being bitten by a monstrous demon. His 'weaker' left leg is presumably the one he preferred to stand on during his lifetime. His punishment appears to fit the crime—of loving worldly things too much.[57] It is almost a reprise of Sir Perceval's punishment in *The Quest for the Holy Grail*, when he stabs himself in his left thigh. Michelangelo may well have known St Bernard's great text on bodily repudiation, and here we see the left side being effectively 'shorn and cut . . . struck with insults and bound with disgrace'.

The Damned Man shows no sign of wanting or being able to defend himself, and to this end his right hand has completely disappeared behind his left arm. Indeed, despite his powerful physique, he is the only one of the Damned to offer no resistance. The covered left eye, and the bug-eyed right eye, suggest not just terror, but a belated dawning of consciousness, and a tragic desire for spiritual rebirth. Just above the damned man and to his right is the flayed skin of St Bartholomew, being held out in the saint's left hand, and the flayed face seems to observe him. This is often considered to be a self-portrait of Michelangelo who, like many of his contemporaries, regarded 'flaying' as a metaphor for spiritual rebirth. Thus the belated desire of the Damned Man for spiritual rebirth finds a cruel echo in the flayed skin of St Batholomew.

* * *

THE MOST ELABORATE AND theatrical instance in a Renaissance portrait of pictorial concealment of the left side of the body has to be Titian's *Portrait of Cardinal Filippo Archinto* (mid- to late 1550s) (Fig. 12). Archinto and/or Titian may even have been influenced by Michelangelo's fresco. Born into a wealthy and powerful family in Milan in around 1500, Archinto came to Rome in 1536 to join the court of Pope Paul III, and he subsequently became vicar-general of Rome. Thus he arrived when Michelangelo was starting to paint the *Last Judgement*, and he could have known Vittoria Colonna, though he was not in sympathy with her desire to reconcile the Catholic and Protestant churches. Archinto was an important protagonist at the Council of Trent (1545–7), a belated attempt to reform the church in the aftermath of the protestant schism, and he was a supporter of Ignatius of Loyola, founder of the Jesuits.

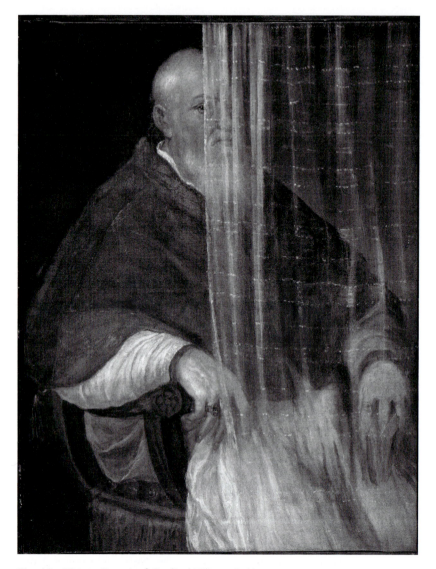

Fig. 12: Titian, *Portrait of Cardinal Filippo Archinto*

In 1553, he became papal nuncio to Venice, and then in 1556 was appointed Archbishop of Milan, but never took up the post due to local opposition to his plans to purge the curia. He retired to Bergamo, where he died in 1558.

Titian painted two seated portraits of the Cardinal which are almost identical except in one startling respect. While one portrait offers a

116

conventional, unimpeded view, the other features a transparent, rippling curtain that hangs across the front of the Cardinal, veiling the left side of his body, and making it appear ghostly and withered. It is so idiosyncratic that it has hardly ever been included in modern exhibitions of Titian's work. It may also have suffered indirectly as a consequence of a derogatory comment made by a leading art historian about shadows in Titian's portraits: 'Directed lighting involves the corollary of shadows, and in portraits the use of shadows is an evasion; it is not depiction, but a refusal to depict.'[58] If shadows can be dismissed as a time-saving short-cut, what hope can there be for a portrait in which most of the face is hidden by a curtain? Its main claim to fame has come since an art critic in 1963 said it had influenced the vertical striated veilings in Francis Bacon's Pope pictures, though Bacon's are placed seemingly at random across the entire figure.[59]

It is usually assumed that the veiled portrait was painted after Archinto's setback in Milan, and that he is veiled because he is unable to exercise his authority. As such, the portrait has been dated to 1558, when Archinto was obliged to retire to Bergamo.[60] But it would be very surprising—and very banal—if a great Cardinal of the Church commissioned the world's greatest portrait painter to immortalize a particular episode of this kind. While his rejection by the Milanese elite and his retirement to Bergamo may have been the immediate catalysts for these portraits, their frame of reference is much larger than any specific incident. The fact that the portraits are virtually identical in appearance and size, and that they both remained in the family collection in Palazzo Archinto in Milan, suggests they were painted at or around the same time, and probably as a pair. They would then relate to each other like the two sides of a medal, or like a painted portrait and its emblematic cover, offering representations of the 'outer' and 'inner' man.

In the veiled portrait Archinto's 'sinister' side is being repudiated and buried. Only the right, 'spiritual' side is left intact. Not all his right eye is visible, however, as the curtain cuts across the corner of the inner eye. To the Cardinal's contemporaries, all this would have been as disconcerting as the severed eyeball scene in Dali and Bunuel's film *Un Chien Andalou* is to modern viewers (a woman has her *left* eye cut by a razor). It emphasizes the extent to which the Cardinal is being purged (about two-thirds of his body mass) while simultaneously preventing us, the viewers, from flattering ourselves that we could ever, in our present

spiritual state, see 'eye to eye' with someone who is now in a state of grace. If his right, 'good' eye had been fully visible, we might assume that he could see us in our entirety, and that we were thus being admitted to his newly virtuous presence without the need for purification. If we want to see him 'eye to eye', the implication is that we would have to move even further to his right. We too are being judged and found wanting.

The portrait is effectively the last visual rites of an elderly man preparing to meet his maker, and Archinto would have known that Titian was the man for the job from his brutal and decidedly left-sided altarpiece of *The Crowning with Thorns* (1540–2; Paris Louvre), painted for Santa Maria della Grazia in Milan. The church had been given a thorn from Christ's crown in 1497, and Titian showed a Laocoon-style seated Christ assailed from his left by four muscle-men who use their sticks to bang in the thorns, which they wield like giant thorns. A fifth tormentor, the only one to be located on Christ's right, still reaches his stick round to the opposite side to bang in the thorns on the left side of Christ's head: the altarpiece is showing worshippers (of which Archinto must have been one) the sort of left-sided punishment they should ideally mete out on their own bodies.[61]

Archinto's participation in the Council of Trent would have stoked his appetite for such things, as spiritual rebirth had been an important theme, and in relation to this the story of the New Testament figure of Nicodemus was cited. Nicodemus was a Pharisee who came secretly by night to receive teaching from Christ, and who assisted at his burial. In the Bible, when Nicodemus first visits Christ, he is told that a man can only see the kingdom of God if he is born again spiritually. Nicodemus then asks how a man can be born again when he is old, whereupon Christ insists that he must believe this is possible (John 3). In a *Decree on Original Sin* promulgated by the Council of Trent in June 1546, Christ's words to Nicodemus are cited: 'For, *unless one is born again of water and of the holy Spirit, he cannot enter the kingdom of God*' (John 3:5). The Council went on to affirm that 'God hates nothing in the reborn, because there is no condemnation for those who are truly buried with Christ by baptism into death, *who do not walk according to the flesh* but, putting off the old person, and putting on the new person created according to God, become innocent, stainless, pure, blameless and beloved children of God, *heirs indeed of God and fellow heirs of Christ*, so that nothing at all impedes their entrance into heaven'.[62] John 3:5 was cited again in a

Decree on Justification published in January 1547.[63] Another major theme was the reform of the priesthood, to ensure that priests carried out their duties correctly, and were 'good shepherds' to their flock.

These Decrees are very suggestive in relation to Titian's portrait, for Archinto's left side is indeed being submerged, buried, and even washed away. The body parts behind the curtain, in their smeary grotesqueness, do look slightly bestial, above all the left hand which bears an uncanny resemblance to the flayed face of St Bartholomew in Michelangelo's *Last Judgement*. At the same time, the portrait may also reflect a form of public penance that was meted out by Church courts. In 1511, part of the punishment of seven English heretics sentenced by Archbishop Warham consisted of having to wear an image of a faggot surrounded by red flames on the left upper arm of their outer garment.[64] One wonders whether Cardinal Archinto ever meted out a similar punishment to Italian heretics.

A possible problem with this interpretation is the book that the Cardinal holds in his left hand, with his index finger inserted in the middle to mark his place. If this is a religious text, then why would it need to be 'purged'? The answer is that while books, such as the Bible, were a crucial foundation for faith, the final stage of spiritual ascent involved a renunciation of all such props, and a surrender to contemplation and 'pure faith'.[65] The only 'prop' that remains fully visible is the large ring of office on the fourth finger on his right hand: the curtain occludes the rest of the hand, leaving his ring to glint out at us like another right eye. In 590, Pope Gregory the Great had stipulated that bishops should wear a ring on the second finger of the right hand to signify their spiritual 'marriage' to God and the Church, and this practice continues to this day with bishops, cardinals and abbots.[66]

We are presumably also meant to assume that the Cardinal has pulled the curtain across himself, for the edge of the curtain is just in front of his right hand, occluding some of the fingers, but leaving his ring visible. The implication is that he has pulled the curtain across his body, from left to right, with this hand. If he has just pulled it, this movement was in accord with the way in which the sign of the cross was made, with the 'horizontal' section being indicated by a movement from left to right. The Jesuit Father Francis Coster explained why this was in his *Liber sodalitaties* (Antwerp 1588): '...the remission of sins and the celestial glory is shown when the hand is passed, not from the right shoulder to the left, but, on the contrary, from the left to the right. Because we who

were with the goats on the left side, stinking from the filth of our sins, are by the Cross and the Passion of Our Lord transported to the right side with the sheep, reconciled to the eternal Father, having received the remission of our sins and the promise and guarantee of the Celestial Kingdom.'[67]

I have suggested that Titian's Milan *Flagellation* can be seen as a precursor to the Archinto portrait; a clear secular counterpart is Titian's contemporaneous *Venus with a Mirror* (also mid–1550s; Washington, National Gallery of Art) (Fig. 13), for it too includes a strategically

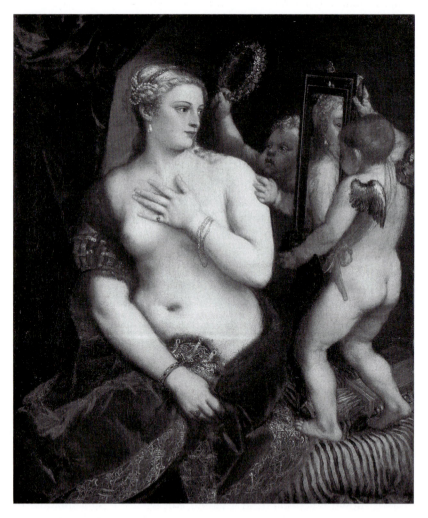

Fig. 13: Titian, *Venus with a Mirror*

cropped eye. It could almost be a humanist riposte to the Archinto portrait, and was one of his most commercially successful pictures, with several studio copies being made. The gorgeous goddess perches on the side of a bed, wrapped in a man's fur-lined robe, and turns to her left to look into a rectangular mirror held up by a winged boy. The left side of her face is reflected in the mirror, and the single eye seems to scrutinize us. It is the reflection of the left side of her face, but as the mirror image is in reverse it looks as though the goddess is looking through her right eye. Because the goddess' left eye is anyway occluded by the turn of her head, we end up seeing a Venus with two right eyes.

Here Titian seems to want to have it both ways, and he leaves it open to the viewer to choose which 'eye' is being revealed in the mirror—the sacred (right) or the profane (left). The fact that Venus' pose, with the left hand covering her left breast, and the right hand over her lap, derives from the antique statue of the so-called *Venus Pudica* ('modest Venus'), adds to the moral mix. We can still feast our eyes on the woman's body (which is lit from the sitter's left), and can take or leave the radical moral editing provided by the image in the mirror.

Petrarch (1304–74), in a poem that may have influenced Colonna's winged eye image, offers an approximate template for a 'spiritually correct' viewing of this kind of image. When his beloved Laura is first struck down by the illness that was to lead to her early death, Petrarch writes a sonnet in which he claims that their eyes are transfigured by the pain. He celebrates his good fortune at being struck by the virtuous power emanating from 'one of the two loveliest eyes that ever were':

> Ché dal destr' occhio—anzi dal destro sole–
> De la mia donna al mio destr' occhio venne
> Il mal che mi diletta et non mi dole;
>
> Et pur com'intelletto avesse et penne,
> passò quasi una stella che'n ciel vole;
> et Natura et Pietate il corso tenne [no. 233, ll. 9–14]

[For from my lady's right eye—rather her right sun—to my right / eye came the illness that delights me and does not pain me; / and, just as if it had intellect and wings, it passed into me like a star flying through the heavens; and Nature and Pity held their course.][68]

The illness that supposedly 'delights' the poet is the purging of his left side—meaning carnal and worldly desires. When we look at Titian's

picture, our right eye is indeed closer to the 'right' eye that stares out at us from the mirror. And this eye does, in a sense, have 'intellect and wings', for not only does it drill into us, the mirror is carried by a winged boy.[69]

After Archinto's death in 1558, both of the Titian portraits were probably taken from Bergamo to Palazzo Archinto in Milan. It seems highly likely that the veiled portrait would have influenced a statue of Zechariah carved by Annibale Fontana for the façade of the Milanese church of S. Maria presso Celso (late 1570s). Here the prophet pulls the voluminous hood of his robes across the left side of his face, trying to occlude it—and perhaps also trying to avoid seeing the spiritual descendants of those same people who had repudiated Cardinal Archinto. In turn, both works are likely to have influenced Caravaggio, who was apprenticed in Milan to a former student of Titian from 1584 to c.1588.

Caravaggio's only two surviving portraits were painted in Malta, and their sitters are two senior Knights of the Order of Saint John, the Grand Master Alof de Wignacourt and Fra Antonio Martelli.[70] The Knights were the archetypal Christian soldiers, a powerful crusading order that had moved to Malta from Rhodes in 1530. Many came from aristocratic families. They were dedicated to fighting against the Ottoman Empire, and to defending the weak and ill. Wignacourt wears full armour; Martelli is in the black habit of a *miles conventualis*, adorned with a while eight-pointed star. Both look to their left, and the left side of each face is swallowed up in pitch darkness. Their right eyes glow incandescently. It has been said that Martelli, 'ageing, with sagging neck and brooding eyes, is deeply melancholic'.[71] As only one eye is properly visible, it is technically incorrect to say that he has 'brooding *eyes*'. Martelli may be old and slightly tired, but the corner of his right eye glints through the gloom, and his right hand seems on the point of drawing the sword cradled in his left: he, no less than the armed Wignacourt, peers inquisitorially into the heart of darkness where the infidel lurks. This is his moment of awakening.

* * *

AN APPROPRIATE CONCLUSION TO this chapter is a contrasting pair of half-length pictures by the 'Dutch Caravaggist' Hendrick ter Brugghen (1588–1629) which are both known as the *Flute-Player* (1621; Kassel, Gemäledegalerie).[72] At first sight, their poses seem to be almost mirror-images of each other, but there are important differences. One is seen

from a similar viewpoint to that of Janssens' *Woman Reading*—that is, from just behind his right shoulder. He is dressed in military outfit, with blue and white stripes on his sleeves. His broad brimmed hat, with its blue feather, is tilted over the left side of his face, and although the right side of his face is in shadow, there is an atmosphere of spiritual solemnity and solitude to the image. He plays a fife, which was a military instrument, and faces a wall which has a huge hole in the top corner. There is a feeling this may be taking place around the time of a battle, and that he is meditating on death.

In the companion picture, we see an almost identical boy from the left. He plays a recorder, and this together with his casually *deshabille* costume, which has fallen off his left shoulder leaving much of his left breast bare, is more closely associated with pastoral settings. His hat is very similar, but is tilted over the right side of his face, and is adorned with an ochre red feather that picks up the deep red of his robe. The left side of his (expressionless) face is illuminated. His bared left hand and wrist are in the foreground (the fife-player's cuff reaches his knuckles). There are no holes in the bare wall behind him, making it much more of a grounded picture. It would be going too far to say that ter Brugghen is drawing a contrast between 'Christian soldier' and 'pagan sybarite', but something along these lines is being stated in terms of right and left. And one final point: the former plays his flute as a right-hander and the latter, as a left-hander.

Part 3
Balancing Left and Right

In Part 3, I shall be exploring the ways in which Renaissance and Baroque artists incorporated left-right distinctions into the physiognomy and body-language of their subjects, creating a dynamic equilibrium between the two sides. Typical of this whole period is the prevarication and uncertainty of Hercules in so many depictions of his choice between Virtue and Vice/Pleasure.

6. The Choice of Hercules

Parlan bellezza e Virtù a l'intelletto,
E fan question come un cor puote stare
Intra due donne con amor perfetto.

[Beauty and Virtue speak to my intellect, debating the question of how a heart can be divided between two ladies with perfect love]

Dante Alighieri, *Rime*, c.1300[1]

THE MOST FAMOUS CLASSICAL myth relating to a clear moral choice between virtue and vice is the so-called 'choice of Hercules'.[2] The story was the invention of the sophist Prodicus, who was a friend of Socrates and Plato, and is related at length by Xenophon in his recollections of Socrates, the *Memorabilia* (*c*.381 BC): when Hercules was an adolescent, he went and sat down in a quiet spot and debated with himself which of two paths he should follow—that of virtue or vice/pleasure. While he mused, two women came up to him, one fair but modest, of sober gait and dressed in white; the other wearing revealing clothes and make-up, and glancing around. The latter—who is called Happiness by her friends, Vice by her enemies—promises to lead him along the short and easy path to a life of pleasure. The former—Virtue—promises to lead him along the harder path of noble and generous deeds that ultimately gain the gods' favour (bk 2:1: 22 ff).

There were other variations on this theme. A less sedentary version of Hercules' 'choice' was 'Hercules at the Crossroads', in which the youthful hero comes to a fork in the road, with Virtue and Vice standing on each path. The 'crossroads' version was symbolized by the

Pythagorean letter 'Y', in which the wider/thicker of the raised forks represents the path of Vice and the other the path of Virtue.[3] This must have influenced the passage in St Matthew's gospel about the narrow and broad gates and paths. Whereas the wide gate and broad path 'leadeth to destruction, and many there be which go in thereat'; the narrow gate and path 'leadeth unto life, and few there be that find it'. (7:13–14)

These stories and metaphors were popular throughout the Middle Ages, and left was decisively associated with the path of vice, and right with virtue. The outcome of knightly quests in chivalric literature sometimes depends on whether a knight turns left or right at a fork in the road.[4] Thus near the beginning of *The Quest for the Holy Grail* (early thirteenth century), Galahad and Melias ride off from King Arthur's court into the forest for several days until they come to a fork in the road with a cross inscribed with the following rather cryptic warning:

GIVE HEED, THOU KNIGHT THAT GOEST ABOUT SEEK-ING ADVENTURE: BEHOLD TWO ROADS, ONE TO THY LEFT, THE OTHER TO THY RIGHT. THE LEFT-HAND ROAD THOU SHALT NOT TAKE, FOR HE THAT ENTERS THEREIN MUST BE SECOND TO NONE IF HE WOULD FOLLOW IT TO THE END: AND IF THOU TAKE THE RIGHT-HAND ROAD, HAPLY THOU MAYEST SOON PERISH.[5]

Melias takes the left-hand road, and is punished for the proud presumption that he is a peerless knight—a mysterious knight suddenly rides towards him and defeats him in battle, mortally wounding him. The saintly Galahad, who judiciously took the right-hand path, eventually comes across the dying Melias and takes him to a monastery where his life is saved. A monk elaborates on the meaning of the inscription on the cross: 'For the right-hand road you must read the way of Jesus Christ, the way of compassion, in which the knights of Our Lord travel by night and by day, in the darkness of the body, and in the soul's light. In the left-hand road you perceive the way of sinners, which holds dire perils for those who choose it.'[6]

In antiquity, the subject of the 'choice of Hercules' never seems to have been tackled by visual artists. This may be because Hercules was a popular figure not for his psychological complexity, but for his bold

exploits as a man of action, the Twelve Labours of Hercules. In the visual arts, he is always identified by props from his Labours, such as the lion skin and club. This is not to say that a fragment like the *Belvedere Torso*, in which a heroically muscled figure sits on an animal skin and turns his torso to the left, could not be a ruminating Hercules assessing the two cases. But it is scarcely surprising that the neo-platonic philosopher Plotinus (AD 204–70) should write of the great man: 'Hercules was a hero of practical virtue. By his noble serviceableness he was worthy to be a God. On the other hand, his merit was action and not the Contemplation which would place him unreservedly in the higher realm.'[7] Evidently the path he treads is not sufficiently to the right.

Another related issue is that the visual arts may not have been regarded as ideally equipped to depict a story centrally concerned with moral choice. Aristotle had complained about the inability of the painter to depict moral worth,[8] in contrast to those who use words: whereas in a text, it is simple enough to narrate the whole story from beginning to end, starting with Hercules retiring to a quiet spot, and concluding with his choice of the 'virtuous' path, a visual artist, usually confined to a single image, is more likely to depict the 'central' and most informative part of the story—the debate between Virtue and Pleasure. Thus in a visual depiction, Hercules' final choice is going to remain indeterminate, even if the artist can allude to it. The 'problem' of making visual images that are unambiguous has been addressed by Ernst Gombrich: 'Images apparently occupy a curious position somewhere between the statements of language, which are intended to convey a meaning, and the things of nature, to which we only can give a meaning.'[9]

It is only during the fifteenth century that the antique 'choice' theme starts to be tackled by visual artists, with a big increase in interest around 1500. There has been some controversy as to why this might be the case. Erwin Panofsky, writing in 1930, saw it as a triumphant expression of Renaissance 'individualism', a 'profound confirmation that in the centre of the universe stood the free man—free, not any longer because of the aid of heavenly grace but because of his innate virtues'.[10] However, Panofsky's contention that visual depictions of the 'choice' are symptomatic of a radical break between the Middle Ages and the Renaissance has been at least partially discredited because it rested on his erroneous belief that the 'choice of Hercules' and the Pythagorean 'Y' were scarcely mentioned in medieval literature.[11]

An alternative explanation—in addition to the obvious one that classical subject-matter was now in vogue—is that people became interested in the depiction of such choices because they were less inclined to a moral absolutism. Or, to put it another way, they were not so convinced that the 'right' road was always the best. And this sort of subject matter—moral uncertainty, moral prevarication—was where the visual arts came into their own. Many of the earliest Renaissance depictions of the subject were printed book illustrations, so the accompanying text could supplement the image and direct the viewer, but the earliest independent painted versions are reliably inconclusive (and this is why I have placed this chapter here rather than in one of the previous two sections).

Dürer's engraving of *The Choice of Hercules* (1498) is the first depiction of this subject to have been made by a major artist. Many of the mythological prints that Dürer made between 1496 and 1505 have obscure subjects, probably selected by humanists associated with his close friend Willibald Pirkheimer, but this mythological print is also *morally* obscure. Earlier versions of this subject had placed Hercules in between Virtue and Vice, with all three in a line facing the viewer; here a well-clothed Virtue stands in the middle of the composition before a pivotal clump of trees—leafy branches to the right, bare to the left.

The landscape to Virtue's right is dominated by a walled path leading up to a castle, while to her left the landscape falls away to a lake and a verdant valley. She raises a heavy stick over her left shoulder and is about to bring it down on the head of a naked maiden who is lying on the ground next to a satyr. The maiden is clearly Vice/Pleasure, and she looks up over her left shoulder in alarm and raises her left arm to block the blow. The unbroken, brightly lit contour that runs from her left ankle to her left armpit is one of Dürer's most voluptuous, and it is this at which Virtue aims. This section of the composition could almost be a version of 'Death and the Maiden'.

Hercules stands in the foreground with his back towards us, naked except for a fantastic headdress. Pleasure is more or less to his left, and Virtue to his right, but it is almost impossible to read his pose. He stands stock still with legs apart, holding his club up horizontally before his eyes, grasping it with both hands about a foot apart like a weight-lifter. His left foot touches the sheet on which Pleasure lies and is only separated from the satyr's right foot by Dürer's monogram signature. What can Hercules be doing? This is both a defensive and a neutral

position. He seems to be protecting himself from Virtue (in case she decides to set about him as well), and he may also be playing for time. He is not allying himself with Virtue in her attack on Pleasure, but could easily join in: the base of his club hovers over Pleasure's left arm.

His club seems to express his mental state, in so far as it is perfectly balanced. Not only is it horizontal, his hands divide it into three symmetrical portions, and his body is aligned with the central one. In Shakespeare's *Winter's Tale* (1610/11), Leontes' unjust attack on Camillo could with more justice be directed by Virtue at Hercules. Camillo is:

> ... a hovering temporizer that
> Canst with thine eyes at once see good and evil,
> Inclining to them both [I,II, 300–4][12]

* * *

THE FIRST PAINTING OF a 'choice' is just as deliciously and even tantalizingly poised. Raphael's *Allegory ('Vision of a Knight')* (17.5 × 17.5 cm; *c*.1504) (Fig. 14) is inspired by a passage in an epic poem about the Second Punic War by the Roman poet Silius Italicus (AD 25–101).[13] While relaxing in the shade of a laurel tree, the young soldier Scipio has a vision of two ladies, Virtue and Pleasure, who fly out of the sky and stand to his right and left. The story derives from the 'Choice of Hercules', but in the poem Virtue is a mannish figure who offers Scipio honour and fame through victory in war, and this is the path he chooses.

In Raphael's square panel, his earliest secular picture, Scipio is shown lying asleep on the ground in full armour, using his large red shield as a pillow. Virtue approaches him from behind and to his right, holding a sword in her right hand and a closed book in her left. She is modestly dressed, and her brown hair is covered by a white cloth. She stands before a hilly landscape presided over by a large outcrop of rock, flanked by a palace-cum-castle. Pleasure approaches from Scipio's left, and holds out a white flower to him. She is more elegantly dressed, her torso and head draped in red coral beads, her blond tresses uncovered. She stands before a lake surrounded by gentle hills. The architectural component of her landscape is lower and more 'horizontal': villas with terracotta tiles and a pier that juts out into the lake.

These contrasts are not boldly drawn. The 'virtuous' landscape elides seamlessly into the 'pleasurable' landscape and the allegorical women are virtual mirror images of each other—and they both smile decorously.

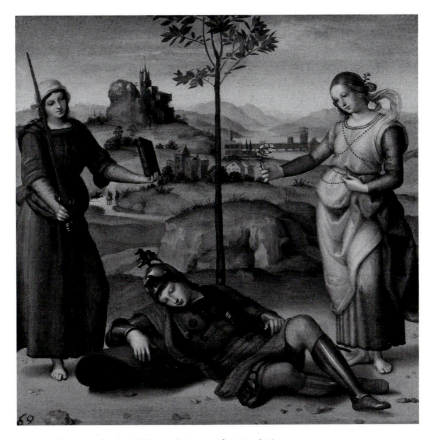

Fig. 14: Raphael, *An Allegory* ('*Vision of a Knight*')

The ideal knight is not expected to choose *either* the sword and book *or* the flower, but to embody all three. As Marsilio Ficino wrote to Lorenzo de' Medici: 'No reasonable being doubts that there are three kinds of life: the contemplative, the active, and the pleasurable. And three roads to felicity have been chosen by men: wisdom, power and pleasure.' To pursue any one at the expense of the others is wrong, Ficino claims. Paris chose pleasure, Hercules heroic virtue, and Socrates wisdom—and all three were punished by the deities they had spurned.[14]

A further comparison can be made with a sonnet by Dante:

> Due donne in cima de la mente mia
> Venute sono a ragionar d'amore:
> L'una ha in sé cortesia e valore,
> Prudenza e onestà in compagnia;

131

L'altra ha bellezza e vaga leggiadria,
Adorna gentilezza le fa onore:
E io, merzé del dolce mio signore,
Mi sto a piè de la lor signoria.

Parlan bellezza e Virtù a l'intelletto,
E fan question come un cor puote stare
Intra due donne con amor perfetto.

Risponde il fonte del gentil parlare
Ch'amar si può bellezza per diletto,
E puossi amar virtù per operare.

[Two women have come to the summit of my mind to speak of love. One is accompanied by courtesy and goodness, moral wisdom and decorum; the other has beauty and lovely charm, and fair nobility does her honour. And I—thanks to my dear Lord—I kneel at their ladyships' feet. Beauty and Virtue speak to my intellect, debating the question of how a heart can be divided between two ladies with perfect love. The source of noble speech pronounces thus: beauty can be loved for delight and virtue for the sake of action].[15]

Because Scipio is immobile and asleep, there can be no clear or conscious sense in which he is making a choice. Even so, his slumbering body is very carefully positioned. While his head is placed much closer to Virtue, his heart is located at the dead centre of the panel, and thereby becomes his 'moral centre'. The heart's importance is underscored because the tall, slim trunk of a laurel tree rises vertically from behind his left shoulder, dividing the picture down the middle. As such, the tree seems to rise directly from the zone of his heart, just as the biblical Tree of Jesse rose from the loins of the sleeping Jesse. The laurel traditionally signifies love as well as fame, and by being rooted in Scipio's heart, suggests he is bold as well as loving. The size of his heart is surely further alluded to by his enormous and very curvaceous red shield.

Raphael suggests that only the heart can 'reconcile' Virtue and Pleasure, and a marriage may have been the catalyst for the picture's production. It has been suggested it was painted to celebrate the marriage of a young member of the Sienese Borghese family called Scipione. It would then be an image of an ideal bridegroom or spouse. Another panel showing *The Three Graces*, nearly identical in size (17 × 17 cm),

must have been painted as its pair, to symbolize the qualities—Chastity, Beauty and Love—epitomized by the ideal bride. Two of the Graces wear coral necklaces similar to those worn by Pleasure.

Titian's so-called *Sacred and Profane Love* (*c.*1514), whose subject is one of the most hotly debated in Renaissance art, is surely another 'choice' picture.[16] A clothed beauty sits to the right of a naked beauty, with each perched at either end of a rectangular stone water trough. The similarity in facial features and hair suggest they may be the same model. Cupid stands between them, behind the trough, stirring the waters with his hand. The title derives from the belief that the picture is an exposition of neo-platonic ideas, and that the two women represented the two Venuses, with the nude woman representing sacred love because the truth is unadorned. But this theory has fallen from favour, in part because no precedent existed for a picture on this theme. Currently, the most popular explanation of the picture argues that it is a marriage portrait, with the bride being the clothed lady, and Venus her nude muse. Yet the absence of the groom prompted one scholar to quip that if it was a marriage portrait it must celebrate a lesbian marriage.[17]

Whatever the precise meaning, it is structured very much like a 'choice' picture. The background landscapes are comparable to those in Raphael's picture, with a low-lying bucolic lake scene, with lovers and hunters, behind the naked beauty, and a hill-top castle behind her clothed counterpart. The foreground components of the complex narrative relief carved on the front of the sarcophagus reinforce our reading of it as a 'choice'. Alongside the clothed woman a magnificent horse, seen in right profile, trots with all the composure of a highly trained thoroughbred; alongside the naked beauty is a scene of a man beating a naked woman with a stick as she lies on the ground, and a man chasing a woman.

Of course, a vital component is missing: a man making a choice. But he is doubly present. The patron's escutcheon is carved into the middle of the front of the sarcophagus, just above a pipe through which water runs—an amusing and unmistakeable phallic symbol. But the patron, a high-ranking Venetian civil servant Niccolò Aurelio, was even more vitally present in front of the picture, since it is usually assumed that a panel of this type would have been displayed in his bed-chamber, inserted into the wooden panelling. My guess is that it would have been directly above his bed, and so when he slept, he would have been a

'sleeping Scipio', in between Virtue and Pleasure; and when he was awake—depending on whether he was in bed with a wife or a mistress—he would be in the domain of, respectively, the clothed or the naked beauty. Although the relief carving suggests that the clothed beauty triumphs, while the naked beauty gets a sort of flagellatory comeuppance, the picture as a whole suggests supremely civil cohabitation between the two women and the particular qualities they represent.

The relaxed, urbane atmosphere of Raphael and Titian's 'choice' pictures is found again in Ariosto's crusader romance *Orlando Furioso* (1516; revised edns. 1521 and 32), where a choice of route is presented to some youthful crusaders, without either path seeming particularly difficult, or more morally perilous than the other, even though the right path is 'higher' than the left. Indeed, Ariosto appears to be parodying the literary topos of the hero at the crossroads. Two noble brothers are called back from fighting—and flirting—in the East, but before they go they pay a visit to the Holy Land, taking with them the magical horse Astolfo and the defeated giant Caligorant:

> So Grifon and Aquilant each took leave of his lady, and the ladies, much though it grieved them, could not stand in their way. Leaving with Astolfo, they turned to their right, proposing to pay their respects to the holy places where God lived as man, before they made towards France. They could have taken a road to their left, which was pleasanter and smoother going, and hugged the sea-coast, but they took the right-hand way, a weird, wild road which shortened the journey to the lofty city of Jerusalem by six days. Water and grass was to be found along the way, but it was totally lacking in all else. So before they set out they assembled everything they needed for their journey and loaded their baggage and provisions onto the giant—who could still have carried a whole tower on his shoulders. At the end of the rough and rugged road, from a high mountain they set eyes on the holy land where the Supreme Love washed away our sins in His blood.[18]

An Arthurian knight would scarcely see any difference between the journeys along the left- and right-hand paths (the latter is actually a short-cut!) This is the 'Choice of Hercules' turned into a kind of off-road tourism. Today's equivalent of the giant would be a hulking

Sports Utility Vehicle, filled to overflowing with supplies from the local supermarket.

* * *

THE SUBJECT-MATTER OF all these images is resolutely secular. Insofar as the Raphael panel was probably commissioned for a marriage, this may seem surprising. However, marriage was a civil ceremony, with a priest usually only giving a blessing long after the couple had exchanged vows in a domestic setting. Thus the 'even-handedness' which we find in relation to left and right may not be quite so strange. Yet even a great 'choice' picture commissioned by a north Italian Bishop shows little sign that the Bishop is, as it were, 'turning right'.

Lorenzo Lotto's *Allegory of Virtue and Vice* (1505), seems morally cut and dried when viewed in isolation; but it was made as a cover for a portrait of *Bishop Bernardo de' Rossi*, which tells a rather different story.[19] A standard way for painters to moralize a portrait was to attach wooden or canvas protective covers or shutters decorated with suitable inscriptions, heraldic devices, and even maps.[20] These covers were usually either hinged in place or slid across the painting in channels carved into the frame. Lotto's *Allegory*, with its brilliant atmospheric effects, is one of the finest covers in existence and is especially unusual because the compelling portrait also survives, albeit in a different collection.

The scene is set in a turbulent landscape divided in half by a broken tree-trunk that sprouts a new branch on its right. This may be a reference to a verse in the Book of Job (14:7): 'For there is hope of a tree, if it be cut down, that it will sprout again, and that the tender branch thereof will not cease.'[21] The blasted side of the tree is presided over by a transparent vitreous shield decorated with a gorgon's head that is suspended from the tree. To the left is a drunken satyr slumped on the ground, staring blearily into a large golden jug, surrounded by the debris of his debauched picnic. The vegetation is lush. Behind him three fir trees loom up, claustrophobically close together, an image of wild forest, and beyond that lies a stormy seascape with a sinking ship.

Bishop's Rossi's heraldic shield with a rampant lion (its right paw raised) is propped up against the trunk, turned to face to its right. This is the more difficult but ultimately more rewarding path to take. A naked putto kneels down in a stony clearing, poring assiduously over mathematical and musical instruments, and books. Beyond a rocky and

thorny ridge, we see a future image of the putto, winged and climbing up an extremely steep narrow path towards a brightly lit hilltop shrouded in evanescent clouds.

Now we are ready to slide back the cover, to view the half-length portrait beneath. We might expect the Bishop to be facing to his right, and to a degree he is—his upper torso is angled to the right, and like the heraldic lion his right 'paw' is raised (his right hand clutches a scroll in front of his midriff). But he looks sharply to his left, confronting the viewer 'with a stare that is at once defensive and somewhat aggressive'.[22] He is not yet disappearing off to the sunlit hills, but is still very much of this world.

In order to interpret the portrait, it helps to know something about the sitter. Bishop Rossi, who was extremely cultured, belonged to a noble family from Parma, and had been appointed Bishop of Treviso in 1499. He immediately antagonized the Venetian secular authorities by appointing several of his compatriots to key posts in the cathedral chapter. The hostility culminated in September 1503, when the Venetian *podestà* and some local noblemen attempted to murder him. If nothing else, the portrait broadcasts the fact that he has survived.

The right side of Rossi's face is shadowless and unruffled. The contour line from his jaw to his temple has an almost geometric clarity and rectilinearity; the skin is drum-tight; his gaze unerring. The left side—to which our attention and gaze are primarily drawn—is rather different. The eyelid hangs lower over the eye, and the line of the lips is slightly lower than on the right hand side. The shadows are intensified because of the puffiness of the skin, while the depiction of two moles on the jaw line makes the surface of his face almost lunar. The roughness of the area between the eyebrow, cheekbone, and the jawbone suggests scarring. The messy feel is reinforced by the knot of curling hair that hangs in front of Rossi's prominent ear (no ear disturbs the smooth contour of the right hand side); and the crumpled hood of his cape.[23] Thus the portrait suggests that while he may be damaged, like the blasted tree, he is not a sinking ship. He is a reformer who has Vice in his sights. He is not finished with the world yet.

The Rossi portrait and its allegorical cover point to a fundamental problem with the basic iconography of 'choice' pictures. For if there was virtue in performing great deeds in the world, then why did Virtue climb a cloud-clad mountain to the right, with all its associations of religious retreats and ivory towers? Indeed, the first sinner to be singled

out by Dante in the *Inferno* is the shade 'che fece per viltà il gran rifiuto' ['who made through cowardice the great refusal'; Canto 3:60]. This was widely assumed to be a reference to Pope Celestine V, who renounced the papacy in 1294, five months after being elected, because he did not consider himself to be up to the job, and returned to his life as a hermit. The Earl of Shaftesbury, in his important essay of 1713 on the choice of Hercules (about which I will say more in a moment), explicitly rejects the idea of having 'the Fortress, or Palace of Virtue, rising above the Clouds', because 'this wou'd immediately give the enigmatical mysterious Air to our Picture, and of necessity destroy its persuasive Simplicity and natural Appearance'.[24] Shaftesbury believed that virtue promotes 'the interest of the whole world',[25] and so there can be no doubt that Hercules and his equivalents do their best 'labour' on earth: this is why Plotinus, in the passage I quoted earlier, implies that Hercules takes a path that is effectively to the left of the path of Contemplation.

One of the most ambitious paintings of *The Choice of Hercules* (1635, Florence, Uffizi), probably painted by Jan van den Hoecke, an associate of Rubens, seems to tackle this issue head on.[26] Virtue has been replaced by Minerva, the Goddess of War, and she has been positioned to Hercules's *left*. She points downwards with her left hand towards a horse that is very much on flat ground. A simpering figure of Vice/Pleasure is situated to Hercules's right, and he looks up to her with longing in his eyes. Indeed, there is much more feeling of uplift on her side, not least because of the presence above her of an airborne Cupid. It is as though 'up' and 'right' are now associated with sybaritic living. To turn right is to cut oneself off from the world solepcistically.[27]

No doubt the bewildering range of possibilities that the subject had thrown up—few of which gave a decisive indication of Virtue's eventual triumph—was partly what inspired the most painstaking attempt yet known to micromanage the production of a painting. The English political philosopher and aesthetician Anthony Ashley Cooper, Third Earl of Shaftesbury (1671–1713), wrote his essay *A Notion of the Historical Draught or Tablature of the Judgement of Hercules* (1713) in the form of detailed instructions for the Neapolitan painter Paolo de Matteis, from whom Shaftesbury had commissioned a large picture of *Hercules at the Crossroads Between Virtue and Vice*, of which three versions are known. Shaftesbury also commissioned an engraving from Simon Gribelin which was reproduced on the title page of his essay (Fig. 15).[28]

Fig. 15: Simon Gribelin, *Hercules at the Crossroads*

The essay was originally published in a French journal in 1712, and a stand-alone English edition was published the following year.

For Shaftesbury, who had lived in Italy for many years, it was essential for the painter to depict a single 'pregnant moment' that both recalls the past and prophecies the future—a point that was later developed by Lessing in his more famous treatise *Laocoon*. The selection of the appropriate moment is vital, and with this particular subject there are four possibilities to choose from:

> Either in the instant when the two Goddesses (*Virtue* and *Pleasure*) accost HERCULES.
> Or when they are enter'd on their Disputes.
> Or when their Dispute is already far advanc'd and *Virtue* seems to gain her Cause...
> The same History may be represented yet according to a *fourth* Date or period, as at the time when HERCULES is intirely won by *Virtue*.

Shaftesbury thinks the third is best because Hercules 'is wrought, agitated, and torn by contrary Passions. 'Tis the last Effort of the vicious one, striving for possession over him. He agonizes, and with all his

strength of Reason endeavours to overcome himself'. Shaftesbury goes on to describe in detail what Hercules does during this key third period, and he gives him the role of attentive listener:

> HERCULES being Auditor, and attentive, speaks not, *Pleasure* has spoken, *Virtue* is still speaking. She is about the middle, or towards the end of her Discourse; in the place where, according to just Rhetorick, the highest Tone of Voice, and strongest Action are employ'd.

Hercules needs to be a good listener because of the ever more detailed instructions that Shaftesbury dishes out, relating to the hero's 'rising' and 'declining' passions, and the 'much slower' movements of the body than the mind. Just when we think Shaftesbury must have exhausted his subject, he refines his demands even further, and diminishes the sense whereby '*Virtue* seems to gain her Cause':

> it shou'd appear by the very Turn, or Position of the Body alone, that this young hero had not wholly quitted the balancing or pondering part. For in the manner of his turn towards the worthier of these Goddesses, he shou'd by no means appear so averse or separate from the other, as not to suffer it to be conceiv'd of him, that he had ever any inclination for her, or had ever hearken'd to her voice. On the contrary, there ought to be some hopes yet remaining for this latter Goddess *Pleasure*, and some regret apparent in HERCULES. Otherwise we shou'd pass immediately from the *third* to the *fourth* period; or at least confound one with the other.

As Shaftesbury's minutely nuanced prescriptions pile up—'if he looks on *Pleasure*, it shou'd be faintly, and as turning his eyes back with pity'— his hero starts to resemble Sisyphus, forever rolling his big club up Virtue's hill, only for it to roll back down again into Pleasure's vale. Indeed, one passage in particular suggests that Shaftesbury does not really believe that painting can point to a single outcome, for after criticizing those artists who contravene the 'Law of [temporal] *Unity* and *Simplicity*', he says that this fault 'particularly shews it-self in a Picture, when one is necessarily left in doubt, and unable to determine readily, *which* of the distant successive parts of the History or Action is that *very one* represented in the Design'. That 'necessarily' begs the question of whether the 'pregnant moment' in painting is not really a 'promiscuous moment'. There may have been an autobiographical element too, for ill health curtailed Shaftesbury's political career, and he

must have been only too aware of the private 'pleasures' to be enjoyed in places like Italy, where he spent some of his time recovering: his picture was commissioned in Naples.

Matteis' picture is indeed delicately poised. The central figure of Hercules is modelled on the colossal Farnese Hercules in Naples, one of the few classical images of the hero to show him in repose: he stands leaning on his club which is slotted under his left armpit like a crutch. Matteis has him tilt even further to the left by making him lean his left elbow on the base of the club. In fact, he rests his elbow on his right hand, which he has pulled across his body to rest on the club. Thus his fighting hand is pinioned. Pleasure sits close by on the ground to his left, practically touching the base of his club with the little finger of her right hand. She sits in a bower decked with draperies, an elaborately carved urn and a goblet. There is a kinship between her and Hercules, because both are scantily and loosely clad—he in a lion skin, she in white muslin. Hercules looks across quizzically at Virtue who stands to his right, heavily clad in classical robes, like a representative of a sartorially more advanced yet colder civilisation. Shaftesbury recommended a helmet as an appropriate prop for Virtue, and a plumed Greek helmet lies behind her.[29]

Amazingly, in his depiction of Hercules and Pleasure, Matteis seems to have incorporated elements of the story of Hercules and Omphale, Queen of Lydia, to whom the hero was sold as a slave for three years for murdering his friend Iphitus. They became lovers, and Hercules grew so effeminate that they exchanged attributes and clothes. The fact that Pleasure seems to touch his club alludes to this exchange, and in Gribelin's monochrome engraving, which prefaced Shaftesbury's essay, their clothes are barely distinguishable: they do very much seem like an item. Pleasure's bower, furnished following Shaftesbury's instructions with vases, embossed plate and draperies,[30] gives her an even greater appearance of permanence.

This iconographic innovation puts Virtue at a distinct disadvantage, and implies that she is intruding on them and will have her work cut out to prise the long-since seduced Hercules away. Pleasure does not appear to be pleading with Hercules to come with her. Rather, she implores him not to *leave* her. The moral of this particular picture (if there is a single moral) seems to be that Virtue comes *long after* Pleasure. Indeed, even the plumed helmet next to Virtue is ambiguous, because it is primarily associated with Alexander the Great, who was both a

great warrior and lover (Shaftesbury briefly mentions Alexander when he discusses 'martial pieces').[31]

Shaftesbury's instruction manual shows how visual depictions of the 'choice' of Hercules almost inevitably tend to focus on and even exalt the 'hovering temporiser'. As we shall soon see, this was hardly surprising in an era when even Christ would be depicted taking a decisive left turn.

7. Double Vision

The right eye is the counselor which shows the way in divine things;
the left eye shows the way in worldly things.

St Augustine of Hippo (354–430), *On the Lord's Sermon
on the Mount*[1]

THE MORAL FUNDAMENTALISM OF Zecharian physiognomics was bound to
have a limited appeal. While it could undoubtedly be exciting artistically
and intellectually, it would take a brave patron to be portrayed with half
their face brutally suppressed. Cardinal Archinto, patron of the most
striking Zecharian image of all, hedged his bets, and commissioned
a two-eyed portrait from Titian as well. Of course, only half a face
was depicted in traditional profile images, but although Aristophanes
in Plato's *Symposium* had complained that people represented in profile
were 'sawn in two vertically down the line of [their] noses',[2] most
fifteenth-century patrons seem to have admired the elegance and conci-
sion of profiles.

A more common type of two-eyed portrait was one that gave an
almost equal if still distinct weighting to left and right, and to body
and soul. In this respect, one of the key biblical passages was Proverbs
3:16, where we are given an allegorical definition of wisdom: 'Length
of life is in her [Wisdom's] right hand, and in her left hand riches and
glory.' One might assume it meant that true wisdom lies in living for as
long as possible, with as much wealth and fame as possible. But it was
usually taken to mean that Eternal Life is in Wisdom's right hand, and
worldly success in the left, and that one's fate in the after life depended
on one's conduct in this life. Images of Christ the redeemer often show
him frontally in the 'even-handed' guise of Wisdom, blessing with his
right hand, and holding a terrestrial globe in his left, and medieval ruler

portraits are often structured in a similar way. The *Enseignement de la vraye noblesse* (early to mid-fifteenth century) says that the ideal Prince is a 'good carter' driving the two horses which draw the wagon of his commonwealth—the right horse signifying the clergy, the left the nobility.[3]

This gave rise to a crucial variation on the Zecharian theme—that, rather than closing the left eye, one used it to observe worldly things with shrewd understanding and appreciation as well as with contempt. This is clearly expressed by Thomas à Kempis in his meditation manual, *The Imitation of Christ*, which was issued anonymously in 1418, and has been the most popular and reprinted book of its kind ever since. Thomas' short treatise was written while he was in a monastery in Deventer, not far from Amsterdam, and was aimed at those in Holy Orders, but it found a wide readership because of its straightforward language, and its emphasis on the worshipper's direct experience of God. In the section entitled 'Of ruling oneself well in outward things and of hastening to God in danger', Thomas writes:

> ...you should aim earnestly at this, that in every matter and outward action or business you may be inwardly free and master of yourself: so that all things may be under you, and not you under them: that you may be lord and ruler of your actions, not a slave or hireling, but rather a free and true Hebrew going on to the destiny and freedom of sons of God who stand upon the present and look towards the eternal: with the left eye seeing the transitory and with the right the heavenly: whom things of time draw not to dwell upon, but are themselves drawn to a better service: as they were meant by God to be, and planned by the prime maker, who left nothing purposeless in his creation.[4]

Everything in creation has a purpose, and we need to be aware of transitory things if we are to fully appreciate the eternal. If we 'stand upon the present', it is in some respects our foundation. Van Eyck's *Portrait of Giovanni Arnolfini and his Wife* (1434) (see Fig. 9, p. 81), can be better understood if we think in these kinds of terms. Among other things, a chain of golden rosary beads hangs to the right of the mirror, and a brush to the left. The right is clearly demarcated as the side of worship; the left that of worldly toil. Giovanni Arnolfini's body language, with his right hand making a 'devotional' gesture, and his left hand a 'marital' gesture, together with the bipartite way his face is illuminated, suggests he is very

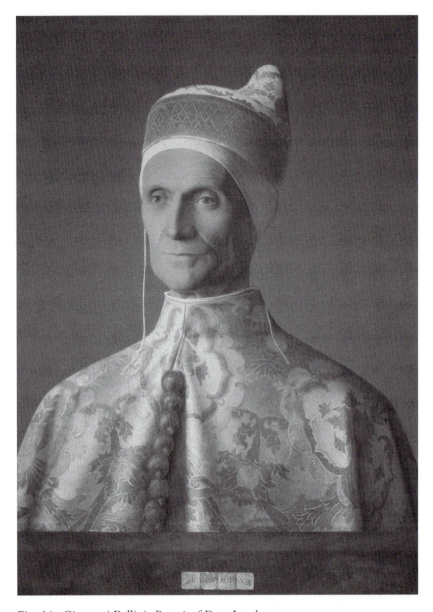

Fig. 16: Giovanni Bellini, *Portrait of Doge Loredan*

much one of those sons of God 'who stand upon the present and look towards the eternal'.

It is only really towards the end of the century that Italian artists, having come to terms with the Netherlandish painters' mastery of oil painting technique and their ability to describe minute variations in light and texture, were able to invest their own portraits with a comparable subtlety and semantic richness. These developments culminate in two portraits above all, both painted in the first decade of the sixteenth century: Giovanni Bellini's *Portrait of Doge Loredan* (1501) (Fig. 16) and Leonardo's *Mona Lisa* (1504–10) both of which exploit left–right symbolism to create a dynamic equilibrium between the two sides of the figure—that is, between the transitory and the eternal. Both artists were certainly aware of each other's work. Leonardo is believed to have visited Venice in 1500, and he is likely to have met Bellini, the city's leading painter. In 1498, Isabella d'Este had borrowed for a month from Cecilia Gallerani Leonardo's great portrait of her so Isabella could compare it with 'certain portraits by hand of Giovanni Bellini'.[5] This too must have piqued Leonardo's curiosity and even rivalry. The outcome was a commission for a portrait of Isabella from Leonardo, which resulted in a preparatory drawing.

Giovanni Bellini was not only the leading painter of religious works in Venice; his male portraits were also in much demand. He was one of the first Venetian painters to specialize in two-eyed rather than profile portraits. He usually painted the sitter's head and shoulders from the front, with the torso and/or head turned slightly to the sitter's right, and lit from the right: this was the basic format first established by Van Eyck. He used a similar format for the portrait of Doge Loredan, while showing rather more of the body. This format was unusual, as Doges were usually represented in profile: another portrait of Doge Loredan, attributed to Vittore Carpaccio, shows him in right profile.[6] The best description of Bellini's painting is by Lorne Campbell, in a section of his book *Renaissance Portraits* (1990) concerned with facial asymmetry in art.[7] It is well worth quoting in its entirety:

Giovanni Bellini's portrait of Leonardo Loredan, probably painted shortly after the sitter became Doge of Venice in 1501, is a static official image with the armless rigidity of a Roman bust. Yet the expression seems to change, for the lit [right] side of the sitter's face is more severe, the shadowed [left] side more benign. This is to be

explained partly in terms of the painter's manipulation of the sitter's features and partly in terms of his use of light. The Doge's right eyebrow contracts and is intense and the upper lid is raised well clear of the pupil, to suggest a glare. The eyes are very widely spaced. Above the sitter's left eye, the eyebrow lies easily in its natural place, the catchlight in this eye is weaker, the upper lid is closer to the pupil and the corner of the eye is raised. The lines running from the cheeks towards the corners of the mouth differ: on the sitter's right the line is straight and suggests a set, stern expression; while on the sitter's left, the line curves, giving a more relaxed impression and appearing to attract into the arc of its curve the centre line of the mouth, which as a result seems to rise upwards. An incipient smile may be suggested by this small area of the face. The strings of the hat, hanging untidily when all else is immaculately ordered, are brought forward in impossible perspective. The string on the sitter's right is assertively straight and vertical and is strongly lit; on the sitter's left, the string is in shadow and falls away from the vertical in a more broken, gentler line. The strings consequently play a secondary part in echoing the contrasts between the two sides of the face.[8]

These asymmetries seem systematic, and they conform to at least some of the Pythagorean opposites—'at rest', 'straight', and 'light' on the right; 'in motion', 'bent', and 'darkness' on the left. However, Campbell is reluctant to interpret the portrait symbolically. He regards all facial asymmetry as a formal device that gives the illusion the sitter is alive.[9] In addition, he believes that much of the contemporary writing on gestures and expressions 'is wildly subjective and vague'.[10] As such, we must assume that each idiosyncratic detail is an unnaturalistic expressive distortion that merely intensifies the overall naturalism of the figure. This kind of interpretation would seem to be supported by contemporary praise of Bellini's portraits. The humanist Raffaele Zovenzoni, whose portrait Bellini painted in 1474, hailed him as follows: 'O fine man who makes the faces in your paintings breathe, you were a painter worthy of Prince Alexander.'[11] Nonetheless, more was at stake than verisimilitiude, for otherwise the profile portrait would not have held sway for so long. Bellini wants to show not just that the Doge is physically alive, but spiritually, emotionally, and intellectually.

In order to understand what Bellini is doing, it helps to look at a sermon given by Savonarola in Santa Maria del Fiore, Florence, on

8 February 1496. The sermon is a richly allegorical reading of the 144th Psalm of David which begins: 'Blessed be the Lord my strength, which teacheth my hands to war...' Savonarola says that love of truth always brings victory, and that whoever 'goes in truth' is similar to God, because God is truth. He then claims that he and the Florentines have been fighting for truth for the previous seven years—that is, from the moment he first came to live and work in Florence. The God of Truth has made Savonarola invincible because he has armed both his left and right sides:

> My God has taught me to fight with my right, that is with the truth that strikes: so he has taught me to strike the devil and his allies with the just life and with the works of truth. He has also taught me to fight with my left. The left is that which conceals, and signifies patience and good humour during tribulations. If something abusive is said to you, you should have patience: you will laugh because the blows will hit your shield and rebound into the face of your adversary.[12]

Savonarola had closely read St John Cassian's *Conferences* (a printed edition of 1491, with Cassian's *Institutes*, survives in the British Library with his annotations), and he too associates the left side with 'the armour of patience'. But there is far more gusto and joy in Savonarola's account of it, for he associates the left side with good humour and laughter.

Using Savonarola's formulation, we can interpret Doge Loredan's stern, unblinking and brightly lit right side as signifying 'the truth that strikes'. It is the Doge's forthright and resolute side. More generally, it suggests the virtue of Fortitude. The left side is both shadowy and smiling, and is the one which 'conceals, and signifies patience and good humour during tribulations'. Patience is one of the key Christian virtues, associated above all with Christ and his Passion.[13] That Savonarola makes the left side the locus of suffering and feeling is, of course, because the heart is located there and because it is the most vulnerable side. The sermon on Psalm 144 was not published until 1515, but Savonarola's ideas and prophecies were discussed throughout Italy.

Smiling and laughing were disapproved of by some theologians, both because Christ is never seen to laugh in the New Testament, and because Paul outlawed 'foolish talking' and 'jesting' in Ephesians 5:4. However, the antique ideal of dignified smiling or laughter (an ability which Aristotle believed distinguished us from animals) was also respected. The Florentine Gainnozzo Manetti wrote in 1438 that 'man by his nature

is a social and civic animal, capable of smiling, born for doing and acting, even to be a certain type of mortal god'.[14] Sardonic humour looms large in many saint's lives. It both suggests the saints' disdain for their persecutors, and their joy at the prospect of eternal life.[15] Patient laughing and smiling can often disarm aggressors, and defeat the Devil. In Shakespeare's *Pericles*, the King tells his daughter Marina:

> Thou dost look
> Like Patience gazing on kings' graves and smiling
> Extremity out of act... [5, 1, 137–9]

Doge Loredan christened his first son Lorenzo,[16] and his son's name saint, San Lorenzo (Saint Lawrence), was one of the most urbane of christian martyrs. When the Emperor Decius ordered Lawrence to be beaten with scorpions, 'Lawrence smiled, gave thanks, and prayed for those who stood by'. His sense of humour stayed with him when he is roasted on burning coals: 'And with a cheerful countenance he said to Decius: "Look, wretch, you have me well done on one side, turn me over and eat!" '[17]

Equally pertinent is the fact that the Loredan family claimed descent from the Roman hero Caius Mucius Scaevola.[18] Mucius was a young Roman noble who entered the enemy camp in disguise in order to try and kill Lars Porsenna, an Etruscan king who was besieging Rome in 509 BC. Having mistakenly killed the King's secretary, Mucius was seized, but he instantly thrust his right hand into the flames of a burning altar, saying: 'Look, that you may see how cheap they hold their bodies whose eyes are fixed upon renown!'[19] He kept his hand in the flames until it was consumed. We are not told whether he did all this with a smile on his face. Porsena was so impressed by Mucius' bravery that he released him, and thereafter he was called 'scaevola', meaning left-handed. He became a symbol of patience and constancy, and the Loredans were evidently proud of their ancestry, and happy to exploit it. In 1523 Jacopo di Giovanni Loredan commissioned a portrait medal whose reverse showed Scaevola, his left hand placed over his heart, his right over a burning brazier.[20] Bellini's portrait, 'with the armless rigidity of a Roman bust', could almost be called a 'scaevola' portrait, for just as Mucius had to start using his left hand, and so activate the left side of his body, movement has been transferred from the right side, which 'burns' brightly but impassively, to the left side, which is mobilized.

The 'two-faced' nature of Bellini's portrait does indeed recall and rival portrait medals, which had a low-relief profile portrait on one side, surrounded by an inscription, and a personal emblem extolling the sitter's virtues on the other. It has been argued that the Renaissance revival of the portrait medal by Pisanello may have been influenced by the various criticisms levelled at the visual arts by the humanist Guarino of Verona. Guarino complained that, unlike literature, paintings and statues are ineffective vehicles for transmitting personal fame because they are *sine litteris*, unlabelled, and not easily portable. Underlying the first point was his Aristotelian insistence on the inability of the painter to depict moral worth.[21] As we have previously mentioned, one of the most common ways for painters to 'moralize' a portrait was to attach wooden or canvas protective covers or shutters decorated with suitable inscriptions, heraldic devices, and even maps. A Bellini portrait is recorded in the collection of Gabriele Vendramin with a cover painted by one of his assistants.[22]

We can see the *Portrait of Doge Loredan*, with its two distinct 'profiles', as an attempt to make a more compact kind of moral portraiture which 'speaks for itself'.[23] Bellini's image might best be thought of as a 'double-profile' portrait that maintains the formality of the profile, while achieving the vividness of the frontal portrait and the semantic richness of the medal. As such, the Doge exists in a uniquely privileged state of wholeness.

Leonardo Loredan became Doge three years into a savage and costly war with the Turks, and so in its entirety we might see Bellini's portrait as an emblem of a model leader who is—according to the Virgilian tag—'In utrium paratus', prepared for both peace and war.[24] The diarist Sanudo emphasized that Loredan became Doge on account of his political skills, rather than his wealth, which was relatively modest,[25] and this portrait deftly suggests his intrinsic virtues. Soon after Bellini's portrait was painted Giorgione painted frescoes of female allegories of Diligence and Prudence flanking the Grand Canal entrance to Palazzo Loredan.[26]

The strong light which illuminates the right side of Doge Loredan is quite low down, and its source has been assumed to be a sun that is on the point of setting, thus imbuing the portrait of the elderly Doge with a sense of passing time: we are supposed to think of the old comparison between the span of a life and the passing of a day, with the inevitable onset of night.[27] This is a common Renaissance trope, but here the interpretation seems inappropriate and even anachronistic,

perhaps inspired by romantic notions of the decaying 'Serenissima', gradually sinking into the sea. But Doge Loredan is no Gustav von Aschenbach from *Death in Venice*. The right hand side was traditionally associated with the east and with the rising sun (the direction from which Venice's wealth came), and in this respect the picture is about the irresistible rise of the Loredans—and of Venice. At the very least, we might say that the sun is abasing itself before the father of the Venetian Republic, and the holder of an office that has been in unbroken existence for nearly a thousand years. Some of his contemporaries did indeed see him and his family as being 'on the make'. In 1505, a satire on the Doge and his nepotism was attached to a column at S. Giacomo di Rialto: 'I don't care if I and my son Lorenzo get fat.'[28] After his death his heirs were forced to return some money he had embezzled from the State.

* * *

MODERN CRITICS HAVE BEEN united in the belief that the smile of Leonardo's *Mona Lisa* (begun 1503–6) is enigmatic. Ernst Gombrich, who regarded the smile in art as a universal symbol of animation, thought that such expressions were 'ambiguous and multi-valent'—with the *Mona Lisa* being the most famous example.[29] However, early commentators do not seem to have found anything enigmatic about her smile. Like the Bellini portrait, it was meant to be a tour-de-force of sophisticated facial heraldry.

Vasari never saw Leonardo's portrait. But he concluded (perhaps after speaking to descendents of the sitter) that her 'smile' came about because Leonardo painted the portrait with musicians, singers and jesters in attendance 'in order to take away that melancholy which painters are often wont to give to the portraits that they paint'.[30] Vasari painted portraits himself, and would have known all about the melancholy induced in the sitters' by the boredom of having to sit for one. But his charmingly pragmatic explanation (the equivalent of getting the sitter to say 'cheese') is unlikely to be correct, for if this were the case, we might expect to find a smile in most of Leonardo's other portraits. In fact, the smile is an essential aspect of Mona Lisa's being. It records her status as the wife of Francesco del Giocondo, for 'giocondo' means cheerful. The portrait was known as 'La Gioconda' from very early on. The emblematic status of the smile must be why Leonardo felt he could dispense with conventional identifying props such as wedding rings and

jewellery, and the emblematic props he included in some of his earlier portraits of women.

Although this explanation of the smile may sound disappointingly frivolous to modern ears, names were taken with the utmost seriousness: in Jacobus de Voragine's *Golden Legend* (*c.*1275), the most widely used collection of saints' lives, each life is prefaced by an allegorical exegesis of the meaning of the saint's name. Particularly pertinent to Leonardo's portrait would be the contemporaneous punning word-play on the name of Erasmus' patron in the dedication to *In Praise of Folly* (1511). Erasmus explains that the name 'More' is 'as close to the Greek word for folly as you are far from the meaning of the word'. Moreover, because More enjoys jokes 'that are not unlearned' and yet 'not at all dull' he compares him to Democritus, the 'laughing philosopher' who had an ethical ideal of cheerfulness, and who laughed at the folly of mankind.[31] Holbein's portraits of More show him unsmiling, but his 1523 portrait of Erasmus, in which he rests his hands on a book inscribed with his pseudonym—that of Hercules—in Greek letters, furnishes the scholar's face with a beguiling left-sided smile. Leonardo punned in identical fashion on the name of his Milanese patron Ludovico Sforza il Moro, but like most courtiers, he avoided all mention of folly, and restricted himself to Italian puns: 'O *moro*, io *moro* se con tua *mora*lità non mi a*mori* tanto il vivere m'é a*maro*' ['O Moro, I shall die if with your goodness you will not love me, so bitter will my existence be'].[32]

The *Mona Lisa*'s smile would attest to her own and her husband's Democritean wisdom. Leonardo also belonged to the laughter party, judging by his caricatures and his riddling 'prophecies' which so amused his contemporaries. But to say that the *Mona Lisa* smiles sagely is only half of the story. Just as in the *Portrait of Doge Loredan*, she smiles only on the left side of her mouth; the right side is severe and unsmiling (Marcel Duchamp accentuated this in his moustachioed Mona Lisa, for the left 'handlebar' is at least twice as long as the right). The picture is also lit from high on the sitter's right, albeit with a more diffused light. Although we have to be cautious with any close reading of such a heavily varnished and dirt-encrusted picture, the left side of her head is marginally more veiled in shadow, particularly in the area around the mouth.

The left-sided smile seems to have conformed to social etiquette, and been regarded as one of the most powerful facial expressions. In Agnolo Firenzuola's *Della perfetta bellezza d'una donna* (Florence, 1541), women are urged, on occasion, to close their mouth 'with a sweet movement or

with a certain grace on the right side, in order to open it on the left, as if with a hidden smile, or sometimes biting the lower lip in an unaffected way, nonchalantly'. These are gestures 'which open, which throw wide open a paradise of delights and flood with an incomparable sweetness the heart of the man who gazes at them with yearning'.[33] If women really want to touch the hearts of men, it seems they must 'open' their mouths on the 'heart' side.

Firenzuola was clearly alert to left-right distinctions—but he was no social anthropologist. Just before this passage, he observes that people 'generally sleep more on their right side' and so the hair on this side is pressed down more. As a result men's beards 'are always thinner on the right than the left', and women put flowers on the right side of their hair to balance the two sides.[34] In sleep, too, Venetians left their left side 'open' and exposed. It seems inconceivable that Firenzuola had actually made an empirical study of sleep patterns: it is more likely to be wishful thinking prompted by traditional ideas about left and right.

The same is probably true of Leonardo in his adoption of a left-sided smile for the portrait of *Mona Lisa*, though her smile was hardly meant to be merely flirtatious: it is a highly alluring armour for soul as well as body. The landscape background to her left is both higher and heavier than that on her right, and it may allude to her wifely patience and powers of endurance. It is composed of a series of horizontal geological layers, densely sandwiched together, with a mountain lake at the top, then a thick band of rock, a long bridge across a turbulent river, and finally a hill at the bottom which seems to merge with the spiraling arc of drapery gathered over her left shoulder. All these layers directly abut her head, neck, and shoulders, as if impaling and weighing her down: the way in which the icy sliver of mountain lake abuts the left side of her head feels almost as menacing as the bellows which the devil thrusts into the left ear of the sleeper in Dürer's *Temptation of the Idler* (*c.*1498). Leonardo was fascinated by high mountain lakes, and although he rejected the traditional belief that they were evidence of the biblical flood, there is a strong suspicion here that the water might burst its banks and cause a deluge.[35]

But this young woman remains unmoved, impervious to the vexations caused by nature and the world. She recalls Isidore of Seville's etymological explanation of the two sides of the human body, with the left side doing the donkey work: 'The movement of the right side is more readily controlled, while the left [laeva] is stronger and better

suited to carrying heavy loads. Whence the left side is also so called because it is more apt at lifting [levare] something and carrying it. This same left side carries the shield, the sword, the quiver, and the remaining load, so that the right side may be unhampered for action.'[36] The 'loads' that are attached to Lisa seem far heavier and more momentous than mere weaponry. This evocation of Lisa's indomitable strength may be connected with the fact that Francesco del Giocondo had already been married twice, to women who died within a year of marriage, probably from complications in childbirth. Lisa was evidently flourishing, and had already provided her husband with two male heirs (a third child, a daughter, died shortly after her third birthday).[37]

Her right side is indeed, as Isidore puts it, 'unhampered': not only is her right hand placed on top of the left hand but the hair and veil on the right side seem looser and the landscape less oppressive, hectic, and constricting. It is more spatious, airy, and ethereal, with a meandering path, and much lower water levels. We are less aware of the passage of time here: or at least, its passing feels far less urgent and potentially catastrophic. The increased airiness makes Lisa seem more elevated on the right side than the left—an allusion, no doubt, to her spirituality. The landscape thus echoes the Aristotelian idea that the right side of the human body has more air and spirit, and the left more water and matter.

The *Mona Lisa* is the culmination of Leonardo's fascination with complementary contrasts. This interest most frequently manifests itself in his drawings of an old man juxtaposed with a young man, with both seen in profile. During the 1480s, while a member of the court of Ludovico Sforza, Duke of Milan, he devised allegorical emblems in which two figures share the same pair of legs or body. An 'Allegory of Statecraft' features a figure of Prudence with a double head and body, male on the viewer's left, female on the right.[38] No less 'joined at the hip' are Virtue and Envy (a young and an old woman), and Pleasure and Pain (a young and an old man).[39] Inscriptions on the drawings show that Leonardo believed these opposites to be inextricably linked: where one is found, so inevitably will the other. He illustrates the Socratic idea, expounded in Plato's *Philebus*, that pleasure and pain always co-exist, even in comic situations, for laughter involves a certain amount of malice.[40] The 'double-faced' *Mona Lisa* can be seen as the culmination of these allegorical figures, signifying the two virtues—Solemn Piety and Smiling Patience—that are 'twinned' in Lisa Gherardini del Giocondo. Leonardo's fascination with mapping complementary contrasts would

also help explain why he made a nude version of the *Mona Lisa*, which is known from numerous copies.[41] It may have signified Virtue's Shadow, Vice or Pleasure.

* * *

IT SEEMS HIGHLY LIKELY that the Florentine painter and poet Agnolo Bronzino would have read Firenzuola's treatise, for he specialized in chillingly exquisite male and female portraits. His *Portrait of a Lady* (*c.*1550) would be a perfect illustration for Firenzuola's section on the female smile. The identity of the sitter is unknown, but her sumptuous clothes and jewellery show that she belongs to the highest social echelon. It has been pointed out that the striped draperies behind her chair 'spring from her shoulders like angels' wings'.[42] That on her right rises almost vertically, suggesting spiritual uplift, while that on her left is lower and more scrunched up, suggesting a slightly disheveled immersion in the world. The expression on the lady's face is similarly structured: the brightly lit right side is a mask of dour solemnity, while the shadowy left side breaks into a grin. Her left shoulder and arm are nearer the viewer, with the left hand casually draped over the scrolled arm of a wooden chair. Carved into the arm just below her wrist is a grotesque head with a beaming smile: it must be the messenger of her heart side, and because it is so dark, of her carnal nocturnal self. In her right hand she holds a small book which is expensively bound: I would imagine that this is a prayer book.[43] As the Florentine writer Anton Francesco Doni (1513–74) would say: 'The world has always had two parts: the spiritual and the temporal. The former we associate with the right side and with daylight; the latter with the left side and with night.'[44]

8. *Rembrandt's Eyes*

FEW WOULD DISAGREE THAT Rembrandt is unsurpassed as a painter of the human face. Regardless of age, gender, station situation, or expression, he is able to distil from each face its own peculiar intensity, and it is hard not to be moved by Rembrandt's faith in faces.

Despite the ceaseless inventiveness of Rembrandt's face-painting, there is at least one important compositional component that remains fairly consistent—his tendency to brightly illuminate his sitters/protagonists from their right. This convention helps anchor and structure their faces, and lends them a certain gravitas and 'spiritual' depth. Those few portraits (mostly etchings) in which the sitters/protagonists are illuminated from the left, and/or turn to their left, usually have a rather different feel. They are more urgently and even indecorously intimate. This dichotomy would suggest that Rembrandt was well versed in the symbolism of left and right. The fact that it is exploited most radically—and creatively—in his late self-portraits shows, I think, that he regarded it as one of the most powerful weapons in the painter's armoury. These explorations culminate in the great synthesis of the Kenwood *Self-Portrait* (*c*.1665), where left and right are held together in dynamic equilibrium.

* * *

IN THREE OF REMBRANDT'S painted self-portraits light falls from the sitter's left. Two of these self-portraits are classic Zecharian images.[1] Light falls from the sitter's left in the *Self-Portrait as the Prodigal Son in the Tavern* (*c*.1635) (Fig. 17), an updated version of the biblical story with Rembrandt playing the part of the prodigal son carousing drunkenly in an inn, his outsized left hand spread across the lower back of his

155

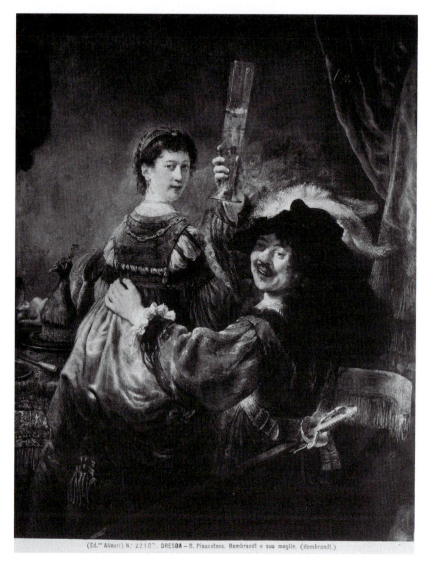

Fig. 17: Rembrandt, *Self-Portrait as the Prodigal Son in the Tavern*

wife Saskia, who plays a woman of easy virtue perched on his lap.[2] 'Rembrandt' is seated with his back towards the viewer, and so although light falls in the conventional manner from our left, it also falls from the prodigal son's left. He turns his head sharply to look at us over his left shoulder, but even now the left eye is privileged for the wide brim of

his tilted hat casts the right eye into shadow, while leaving the left eye brightly illuminated.

In *Self-Portrait as Zeuxis* (*c.*1662), Rembrandt in the guise of the great Greek painter Zeuxis paints the portrait of an old lady.[3] Although Zeuxis was famed for his portrait of the supremely beautiful Helen of Troy, he had reputedly died by suffocating with laughter while making a portrait of a wrinkled, droll old lady. The story was popular in Rembrandt's circle, for his pupil Samuel von Hoogstraten mentions it twice in his *Introduction to the Art of Painting* (1678), and another pupil, Arent de Gelder, painted this same subject in 1685, depicting himself as Zeuxis. Old women were standard buts for derision, and the basic mise-en-scene of Rembrandt's picture is similar to that of a painting by Sofonisba Anguissola (*c.*1550) which, when reproduced in a print by the Netherlandish artist Jacob Bos, carried an explanatory inscription: 'The beffudled old woman [who is trying to learn the alphabet] moves the young girl to laughter.'[4]

Rembrandt/Zeuxis looks out at us over his left shoulder, and the light, streaming in from his left, illuminates the left side of his face, with its open-mouthed grin, screwed up eye, and extravagantly jack-knifed eyebrow. Girolamo Cardano, in an illustrated treatise on metoposcopy—the science of reading the marks and lines on the forehead—first published in Paris in 1658, interpreted an extravagantly arched line above the left eye as signifying 'a man who burns intensely with lust...affected by the vice of avarice and lacking in humanity'.[5] The painter's mahlstick rises up from his midriff towards the bolt-upright image of the old lady in a suggestive manner. The painting technique is appropriately coarse, and Zeuxis has rugged, bark-like skin.

The pose is a reprise of a sketch made in 1644, which has been given the title *Satire on Art Criticism* (Fig. 18), in which a critic furnished with asses ears, and with a snake coiled round his right arm, sits on a barrel pontificating about a painting held up before him.[6] The critic occupies the same 'laughing-stock' role as the old woman for just behind the picture that is being judged lurks a man who could well be Rembrandt's alter-ego: he crouches down to defecate, and smirks conspiratorially at us over his left shoulder. Only his left eye has been depicted—a big black inky blob that has something of the 'evil eye' about it.

The *Self-Portrait as Zeuxis* recalls Rembrandt's early series of expressive self-portrait etchings such as '*Self-Portrait*', *Open-Mouthed* (1630) and '*Self-Portrait*', *Smiling* (1630).[7] The portrait etchings are usually lit from

Fig. 18: Rembrandt, *Satire on Art Criticism*

the left, and this seems to chime with the more 'informal' nature of all his prints: the sitters for his portrait etchings tend to be 'relations, friends, colleagues or people with whom the artist had some personal contact'.[8] Where a drawing or oil-sketch survives (lit from the sitter's right) for a portrait that was subsequently made into an etching ('reversed' and lit from the left) the etching often feels more spontaneous.[9] Rembrandt's prints—both of religious and secular subjects—are perhaps his most 'sublunary' images.

The third painted self-portrait lit from the sitter's left, *Self-Portrait with Beret and Turned-Up Collar* (1659), is in some respects the exception to prove the rule. For although Rembrandt peers at us over his left shoulder, and the painting of the face is unusually free, the expression is neither especially indecorous nor conspiratorial. However, Rembrandt softens the chiaroscuro by illuminating the face from high up and in front so that both sides of his face are almost equally brightly lit. With this self-portrait Rembrandt was, it seems, after heightened immediacy, not outrage.[10]

<p style="text-align:center">* * *</p>

THE PAINTED SELF-PORTRAITS OF the 1660s are unprecedented in the regularity with which they depict the painter with the tools of his trade. Only once before, in *The Painter in his Studio* (*c.*1629), had he painted himself *in medias res*, but in this very small painting he is a far-off, diminutive figure at the back of his studio, observing his canvas from a distance.[11] From the 1660s, we have the *Self-Portrait as Zeuxis* and two other 'close-up' half-lengths, both lit from the sitter's right. In the first, the hieratic *Self-Portrait at the Easel* (1660), the focus is principally on Rembrandt's head,[12] but the second, the celebrated Kenwood *Self-Portrait* (*c.*1665), constitutes Rembrandt's most ambitious and moving statement about his status and purpose as an artist, and as such it can be paired with the *Self-Portrait as Zeuxis*. Rembrandt had been declared bankrupt, and his house and extensive art collection sold off in 1657: it is hard not to feel in these self-portraits showing the artist busy at work that the elderly Rembrandt was taking stock and laying claim to his own artistic territory at a time when his commercial star was on the wane.[13]

In the 'Kenwood' *Self-Portrait* (*c.*1665) (Fig. 19) the painter stands before a canvas inscribed with two geometrical forms.[14] Away to his left is a segment of a circle, truncated by the edge of the canvas, and behind his head, rising to his right, and continuing past his right elbow, is the

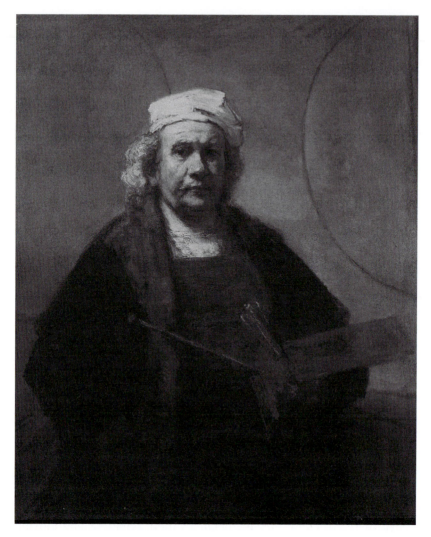

Fig. 19: Rembrandt, The *'Kenwood' Self-Portrait*

circumference of another circle. His right hand appears to be tucked into the pocket of his fur-lined robe, and his left hand holds a palette, brushes and maulstick. As can be seen from X-rays, Rembrandt had originally depicted himself standing before an easel, with his brush in his left hand. It is usually assumed that he did this because he was looking in a mirror, and on realizing his mistake, reworked the left hand. Yet he seems to have been smiling, in which case it may have been a more restrained

160

reprise of the *Self-Portrait as Zeuxis,* this time as a deliberately 'gauche' artist. The revised version which we see today offers a far more balanced image of the artist.

Various explanations have been given for the geometrical forms, none of which have gained universal assent.[15] One theory argues that they relate to the circles drawn by calligraphers to demonstrate their skill in drawing freehand—but this is weakened by the fact that they are not complete circles. Another suggestion—that they echo the shapes of world maps that were hung on the walls of Dutch houses—is doubtful for several reasons: the circles are widely separated; the one to Rembrandt's left has a slightly smaller radius; both 'circles' are incomplete and empty. In addition, it is hard to see why Rembrandt would depict himself making a painting that only featured part of such a map. If he wanted to suggest that during his long career he had painted and could paint the entire visible world, why didn't he just show an actual map on the wall of his studio—as Vermeer did in his *Allegory of Painting*? An even less convincing explanation is that they are a purely decorative background.

The most interesting proposal thus far is that the portrait depicts the Aristotelian trio of qualities that are essential for the artist: *ingenium* (inborn talent), *ars* (theory), and *exercitatio* (practice).[16] Rembrandt, as the embodiment of *ingenium*, stands between symbols (derived from Cesare Ripa's *Iconologia*) of theory and practice: the circle on Rembrandt's right would symbolize theory, while the segmented circle, with its 'ruled' edge, would symbolize practice.[17]

I am quite sure the circles are meant to be antithetical, but in a rather different way. What doesn't seem to have been noticed is that if the arc of the 'circle' behind Rembrandt's head were continued downwards, it would pass through the painter's right eye. This suggests that the self-portrait is a visualization of a credo attributed to Michelangelo by Vasari, and which was well known in the Netherlands, which stressed that it was necessary 'to have compasses in the eyes and not in the hand'.[18] Michelangelo seems to have been attacking the academic notion that it was sufficient for the artist to follow proscribed rules of proportion and geometry, as Dürer had sought to do in his treatise on human proportion; while these 'rules' had to be absorbed, it was the eye that had the final say in making the figure appear to breathe, move, and feel: the artist had to be able to visualize it in the mind's eye. The most

detailed formulation of this idea occurs in Lomazzo's *Trattato dell'arte de la pittura* (1584):

> Michelangelo, that greatest of sculptors, painters and architects, used to say that all the reasons—of geometry, or arithmetic, or proofs of perspective—were no use to men without the training of the eye in knowing how to see and in making the hand do. And this he said, adding that, however much the eye may be trained in these reasons, it is only in its seeing—never mind angles or lines or distances—that one may render properly and make the hand show everything he wishes in the figure, and not differently from what he might expect to see with perspective. So by the habit of training, founded on [the study of] perfect art, one shows in the figure what ever so many deep perspectives may not show. But whoever is trained neither in geometry or drawing, may not reach, or penetrate, or express with his speculations, divisions, proofs, segments and similar things. Because this whole art, to say it in a word, and its whole end, is to draw all that is seen with the same reasons that one sees.[19]

The '*Kenwood*' *Self-Portrait* seems to be a declaration that while Rembrandt has mastered the basic skills in art, it is the 'judgement of the eye' that has the final say. He makes this point through a bold left-right distinction. The circle on the painter's left, painstakingly and pedantically drawn, is rather brutally terminated and segmented by a dark line just inside the rough edge of the (depicted) canvas; this line is at an angle to the edge of the picture, and tapers in, so that the segment seems to be tilting over and falling into the picture. The segment, together with the rectilinear implements held up like dividers in his left hand, allude to the practical and material basis of art. This side of his face is in deep shadow and his left eye appears to be squinting if not closed (it could almost be a bruised black eye). Complete vision evidently does not reside here.

By contrast, the right side of his face is brightly lit and the eye more fully open. The artist's hair explodes around his right ear like a puff of white smoke. Because the arc of the circle passes directly *behind* the painter's head, it feels as though it has been thoroughly internalized: the compass is *in* his eye, *in* his head.[20] Here vision becomes visionary. He has in fact used his own 'judgement' to paint the arc of the circle just above his right elbow, for it doesn't quite align with the higher arc.

But we scarcely feel that the circle is incomplete because both arcs seem to emanate from his head and his upper arm like an angel's wing (in Rembrandt's paintings, angels usually appear at the subject's right shoulder, as in his recent *St Matthew and the Angel* (1661)). Thus Rembrandt's 'winged' eye recalls Vittoria Colonna's conceit that with the right eye open, and the left closed, 'the wings of hope and of faith / make the loving mind fly high'. By contrast, the thicker segmented circle is both more material and more marginal, by being placed well to his left and at the left edge of the canvas. It is also slightly darker than the other circle. The truncated segment to Rembrandt's left is akin to a half-moon, while the open circle to his right is akin to a sun.[21]

Equipped with his 'flying' eye, did Rembrandt think of himself as having almost prophetic powers? If he did, it was certainly a topical subject. During this period the role of prophecy was a central issue in Dutch society. In part this was a legacy of the Reformation, for the abolition of mediators and the stress on the individual conscience meant that God was supposed to speak directly to his elect. As a result, ordinary people felt fewer qualms about claiming that God had spoken to them.[22] In England, the revolutionary decades of the 1640s and 50s (King Charles I was executed in 1649) gave rise to 'what was almost a new profession— the prophet, whether as interpreter of the stars, or of traditional popular myths, or of the Bible'.[23] Similar tendencies have been discerned in Holland, which was anyway much influenced by religious currents from England, and the practice of 'free prophecy' became prevalent. Competing religious sects debated the role of reason in spiritual life, with radical spiritualists such as the Quakers being extremely hostile to it.[24] The controversial German mystic Jacob Boehme (1575–1624), whose works were almost all published in Amsterdam and who was extremely influential throughout northern Europe, believed that through faith man could attain a state of 'supersensual' harmony and thus merge with God. In *The Way to Christ* (1623) he writes of the two eyes of the soul in a way which is loosely analogous to Rembrandt's self-portrait: 'Thou perceivest too, doubtless, that it is according to the Right Eye that the Wheel of the superior Will is moved; and that it is according to the Motion of the Left Eye, that the contrary Wheel in the lower is turned about.'[25]

Rembrandt was intensely involved with the Old Testament prophets in the 1660s. In 1659, he had painted a large, turbulent canvas of *Moses* holding the tablets of the law menacingly above his head, with only his

right eye picked out by the light. In the early 1660s, he painted a series of brooding Apostles and Evangelists, culminating in a *Self-Portrait as Saint Paul*, which is almost Zeuxis in reverse, minus the grin.[26] In 1661, Rembrandt's Jewish friend and patron Menasseh ben Israel published a book about the Old Testament prophets, which contained numerous apocalyptic references to Zechariah (though not to 11:17).[27] Rembrandt supplied him with four illustrations of convoluted allegories.[28]

Above all, perhaps, he had painted a great mural for Amsterdam's new town hall, *The Oath of Claudius Civilis* (1661), which had been sent back to Rembrandt for modifications but never returned.[29] The subject of the painting was the oath sworn by the Germanic tribe of the Batavians with their leader Claudius Civilis to unite and rise against the Roman invaders in AD 69, as recounted by Tacitus.[30] The story of this heroic uprising was treated as a historical precursor to the union of the Dutch provinces in their rebellion against Spain, which ended successfully in 1648. Tacitus reported that Civilis had lost an (unspecified) eye in battle. Rembrandt chose to show him with a missing left eye, and staring out with a far-away look in the general direction of the viewer with his right. This charismatic Cyclops thus appears to absent himself from his co-conspirators at the very moment that they unite. He could almost be a practitioner of 'free prophecy'.

Yet despite the spectacular right-sidedness of the Kenwood self-portrait, our abiding impression of the whole is one of balance and poise—an accommodation has been reached between the spiritual and the rational. Only after we have done a complete tour of inspection of the 'sublunary' side of the picture do we finally home in on the painter's right eye, with its intimations of a realm beyond the canvas that we are not privileged to see or gauge. Rembrandt's static, monumental frontal pose, and the background arcs, mean that we scan across the totality of this self-portrait more thoroughly than any other from this period.

As such, the picture recalls the opening of a verse letter by the English poet John Donne (1572–1631), who was obsessed by the relationship between faith and reason, and both alarmed and relieved by the immeasurability of the universe ('nor can the sun / Perfect a circle, or maintain his way / One inch direct').[31] Some of Donne's love poems had been translated into Dutch by the politician, scientist, poet and art lover Constantijn Huygens (1596–1687), who had given Rembrandt

qualified support in the early stages of his career.[32] The verse letter, written between 1609 and 1614, was addressed to the 'angelic' Countess of Bedford. The poet insists that although 'right' is superior to 'left', they are in fact mutually self-sustaining:

Madam,
Reason is our soul's left hand, Faith her right,
By these we reach divinity, that's you;
Their loves, who have the blessing of your sight,
Grew from their reason, mine from fair faith grew.

But as, although a squint lefthandedness [a distorted adherence to
 reason]
Be ungracious, yet we cannot want that hand,
So would I, not to increase, but to express
My faith, as I believe, so understand.

Therefore I study you first in your Saints,
Those friends, whom your election glorifies,
Then in your deeds, accesses, and restraints,
And what you read, and what yourself devise.

But soon, the reasons why you are loved by all,
Grow infinite, and so pass reason's reach,
Then back again to implicit faith I fall,
And rest on what the catholic voice doth teach . . . [33]

Donne's conceit ultimately derives from an idea developed by the Cistercian mystic William of St Thierry (1085–1148). In *The Nature and Dignity of Love*, William argued that the soul has two eyes, love of God and reason, which are complementary: 'When one makes an effort without the other, it doesn't get very far. When they help each other, they accomplish much.'[34] Like Donne, Rembrandt allies himself more closely with his right hand than with his left (he stands to right of centre), and thereby seems to disdain a 'squint lefthandedness', as exemplified by the truncated circle, and by his own squinting and shadowy left eye. Yet at the same time, he realizes we cannot do without reason, 'the soul's left hand'; it is only when reasons 'grow infinite, and so pass reason's reach', that 'implicit faith' is born. Here the 'doubleness' of the human condition is a boon, and is something that deepens rather than dissipates our power. No other self-portrait has such amplitude.

Part 4
Turning Left

9. *The Death of Christ 1: Crossing Over*

...in His left hand is the remembrance of that love, than which is
none greater, whereby he laid down His life for His friends...
St Bernard of Clairvaux (1090–1153), *On the Love of God*[1]

IN THE SECOND TO last chapter of St Teresa of Avila's spiritual autobi-
ography (*c.*1561), Christ appears after she has been praying to Him to
restore the sight of a person who is almost blind: 'He appeared to me
as on previous occasions, and began to show me the wound in His left
hand [mano izquierda]. Then with His other [con la otra] He drew out
a long nail that had been driven through it, and as He pulled it, He
seemed to tear His flesh. It was clear how painful this must be, and it
distressed me greatly. ' "Seeing that I have done this for you", He said,
"you need have no doubt that I will even more readily do what you
have asked Me".'[2]

Teresa's vision of Christ is astonishingly vivid, but what makes it
particularly remarkable is the emphasis it places on the wound in Christ's
left hand. Here the 'long nail' driven into this particular hand looms
as large as does Longinus's spear in traditional narratives and depic-
tions. Longinus, a Roman centurion, appears standing on the right
side of Christ in a seminal illumination in the Syrian Rabbula Gospels
(AD 586), and this is the first time he is identified by name, in an
inscription. He is shown driving his spear into Christ's *right* side, just
under the armpit, to give him the coup de grace. The right side is clearly
favoured—as it would be for centuries. Christ looks to his right, which
is where the good thief, and his mother, are also located. The wound in
his side was believed to be a fountain from which flowed the redemptive
blood of Christ, and from which the sacramental wine would be made.[3]

Teresa is evidently trying to make an important point because Christ's right hand, which pulls the nail out, remains more or less anonymous. It is not even specified, but is referred to in a seemingly off-hand manner as 'the other' [la otra]. This gruesome performance is evidently meant to be a climactic moment in the narrative for it is the third and last of Teresa's visions in which the left side of the body is centre stage. It is preceded chronologically by the appearance of a monstrous Devil at Teresa's left side (in an unsuccessful bid to tempt her); and of a beautiful Angel at her left side who thrusts a golden spear into her heart.[4] In a book of forty chapters these three left-sided spiritual crises come, respectively, in the twenty-ninth, thirty-first, and thirty-ninth chapters.

The leftsidedness of all three of Teresa's visions reflects an important cultural shift whereby the 'sinister' side is revalued and becomes the domain of the most important and intense experiences. The left side becomes not just the side of feeling, but of authentic and true feeling. It is now ever more firmly and conspicuously established as the domain of the heart, and the heart itself is pushed ever further leftwards, expanding out into every cranny of the body's left side.

This displacement and revaluation implicitly contradicts the folk wisdom expressed in the Old Testament book of Ecclesiastes that 'a wise man's heart is at his right hand; but a fool's heart at his left.' (10:2). We have already seen how Aristotle, despite believing that the heart was the seat of the emotions, assumed it was only positioned on the left side of the chest by charitable default. It was there to 'counterbalance the chilliness of the left side'; and what was more, the heart's own anatomy privileged the right side: its right-hand chamber was the largest and hottest.[5] Aristotle's great medieval follower, Albertus Magnus, insisted that the heart, despite being on the left side of the body, pours out its influence to the right, and this is why the right side is so much more powerful and agile.[6]

But now, the human heart is less likely to be regarded as biology's most prominent internal exile, banished, as it were, to the body's Siberia. Instead of apologizing for the heart's location, or being embarrassed about it, one can revel in it. The left-leaning heart may certainly be characterized by its vulnerability and susceptibility, but its exposure can be heroic. Where the vision of Christ is concerned, every reader of St Teresa's spiritual autobiography would have known of the popular belief, deriving from ancient Egypt and the Romans, that a nerve or vein passed all the way from the heart directly to the fourth finger of

the left hand.[7] The vein was identified as the 'salvatella', and drawing blood from it was supposed to cure the heart of excessive grief.[8] So Christ is effectively pulling out a nail that is impaled in his own heart, and by enabling more blood to flow, becoming stronger. No wonder he expects Teresa to be impressed—and to believe.

But her vision of Christ makes a specific and deeper point too, which would have been clear to anyone who had a passing acquaintance with theology and art. Let us attend more closely to what she actually sees, and to what Christ says and does. He pulls the long nail out and as he does so 'He seemed to tear His flesh'. I have no experience of pulling nails out of hands, but nails are not like barbed arrow heads, and it seems unlikely that they would tear that much flesh, unless they were very badly twisted. The gruesomeness seems to be insisted on precisely because Teresa wants us to pay attention to Christ's flesh—in other words, to his incarnation. Thus when Christ says to her—'Seeing that I have done this for you . . . you need have no doubt that I will even more readily do what you have asked Me'—'this' refers to his incarnation as much as it does to the removal of the nail.

And this is precisely where the left hand comes in. For nothing attests more to the sacrifice made by God than the fact that he allowed his only son to become a being who was the proud possessor of a left hand. For a divinity, this is the ultimate humiliation, and in sixteenth-century Spain the left hand was just as marginalized as everywhere else. A few decades later Cervantes has Don Quixote tell Sancho Panza: 'for a man not to know how to read, or to be left-handed, implies one of these two things; either that he sprung from very mean and low parents, or that he himself was so untoward and perverse, that no good could be beaten into him'.[9] And in Francisco de Quevedo's *Seuño del Infierno* (1608), there is a place in Hell specially reserved for left-handers.[10]

But the whole point about Christ is that by virtue of being incarnated, he 'crossed over'. He went from heaven to earth, from a glorious throne at the right hand of God to a stable in Bethlehem and thence to a degrading death on a cross—about as far 'left' as you can possibly go. And on earth he was the son of 'exceedingly mean and lowly parents'. The medieval Church had devised a special ceremony to symbolize Christ's 'crossing over', whereby the Greek and Latin alphabets were drawn crosswise on the floor in the middle of the church with dust, ashes or sand.[11] The Greek letter *chi*—X—also happened to be the first letter of Christ's name.

This ceremony is described in a chapter on the 'Dedication of a Church' from Jacobus de Voragine's standard book of saints lives, the *Golden Legend* (c.1275). Jacobus explains that since Christ, by means of the cross, unified the faiths of the Gentiles and Jews: 'Therefore the cross is drawn from the eastern corner [of the floor of the church] obliquely to the western corner (in the shape of an X) to signify that he who at first was on the right has gone over to the left, and that he who was at the head has been put at the tail, and vice versa.'[12] Here Christ's ability to 'cross-over' attests to his ability to unify, and to reach the parts that other deities could not. No wonder if so many Christian pictorial cycles use complex criss-crossing narrative schema such as the boustrophedon and the cat's cradle: Piero della Francesca's fresco cycle of *The Legend of the True Cross* (c.1452–66) uses both.[13]

Where St Teresa's Christ is concerned, the mutilated left hand is a badge of honour, and his ostentatious pride in showing it off—and the necessity of looking over to his left to do so—shows the extent to which he overturned established hierarchies. Traditionally, the only time when the left hand of God was specifically mentioned by theologians was on Judgement Day, when he was popularly believed to have gestured with his left hand to curse the damned who were located to his left. Thus the left hand came into its own at the last possible moment, and with unrelenting ruthlessness. This is strangely similar to its function in warfare, for the left hand often held the fine-pointed, thin-bladed dagger, sardonically known as the 'misericorde' (after the Latin 'misericordia', meaning mercy), with which fallen enemies were given the coup de grace.

In St Teresa's vision, however, Christ's left hand is the slow, wounded, temporal hand of redeeming love. It is also a truthful hand, because palm-readers considered it a more reliable source of information, both because it was less intensively used (by right-handers) and because of its direct connection with and proximity to the heart.[14] The implication is that the wound on the left hand is more revealing than any of the others, even the one in his (right) side. In Teresa's vision, God's left hand is the bearer of sweet, rather than bitter truths.

Teresa's vision of Christ is not conjured out of thin air. It ultimately depends on a passage in the Old Testament *Song of Songs* in which a subtle but crucial distinction is made between a left and a right hand. The *Song of Songs* (so-called because it is the supreme song in the sacred scriptures)[15] was a prime inspiration both for mystics, and for secular

love poets, and Teresa actually wrote a very brief commentary on it.[16] As I explained in an earlier chapter, it consists of a rhapsodic dialogue in which a man and a woman give ecstatic accounts of each other and of their mutual desire for, and pleasure in, one another. It is far and away the most erotic book in the Bible—'My beloved put in his hand by the hole of the door, and my bowels were moved for him'; 'Thy two breasts are like two young roes that are twins, which feed among the lilies'. Its impact and popularity was also helped by its being one of the shortest books in the Bible (it comprises only eight chapters). St Bernard of Clairvaux was particularly impressed by the kaleidoscopic range of imagery and the use of short sentences with staccato rhythms.

The speakers were usually assumed to be a Bridegroom and a Bride, but the question of who precisely these 'newlyweds' were, and of whether their infatuation with each other could be interpreted allegorically, lead to controversy over the book's canonicity, and it was one of the last to be admitted to the Old Testament. During the Middle Ages and the Renaissance the Bridegroom was generally regarded as a prophetic evocation of Christ, while the Bride variously signified the Church, the Virgin Mary, or the human soul. Because it offered such a strong female protagonist, the *Song of Songs* had a particular appeal to female mystics as they could easily imagine themselves in the role of the Bride.

During the Reformation, although the major Reformers were little interested in allegorical exegesis and in anything that smacked of mysticism, the Song of Songs was, for the most part, regarded as a 'special case', with Calvin insisting that it spoke of the mutual love between Christ and the Church.[17] Luther published a commentary on the *Song of Songs* in 1539,[18] and it influenced the Italian reformist treatise *Beneficio di Cristo* (1543), especially the section dealing with 'the union of the soul with Christ'.[19] In both Catholic and Protestant countries, it became if anything more popular, because it seemed to answer the reformers' insistence that the believer should meditate exclusively and directly on Christ, rather than using intermediaries, whether priests or saints. As such, it provided the most important biblical model for a worshipper's direct encounter with God. It was especially popular in Spain, with several commentaries being written on it, including those by Luis de León and St John of the Cross.

The passage that informs St Teresa's own vision of Christ is spoken by the Bride, and comes immediately after a series of erotic gustatory metaphors:

> I sat down under his shadow with great delight, and his fruit *was* sweet to my taste. / He brought me to the banqueting house, and his banner over me *was* love. / Stay me with flagons, comfort me with apples: for I *am* sick of love. / His left hand *is* under my head, and His right hand shall embrace me. [2:3–6]

In the last chapter of the *Song of Songs*, the sentence concerning his left and right hands is repeated, but the auxiliary verbs are changed to conditionals, casting a shadow of doubt over whether the Bridegroom will ever actually embrace the Bride, while at the same time asserting the necessity: 'His left hand *should* be under my head, and his right hand should embrace me.' [8:3]

Jewish commentators tended to ignore the variations in tense, and see it as signifying the tightest of two-armed clinches—'single unification, single bond'.[20] As such the passage seemed to reinforce the Old Testament's obsession with the procreative powers that were necessary to produce the Jewish people: 'Isaac, being [Rebeccah's] husband, grasped her—laying his arm under her head, as is written: "His left hand beneath my head, his right embracing me". Later, Jacob [their second son] came and performed in bed, engendering twelve tribes, all fittingly.'[21]

Christian commentators, for whom the main significance of the Jewish Old Testament was that it prophesied the New (thus Jacob and David are ancestors of Christ), could not be satisfied with an interpretation that was so exclusively predicated on the present, and on uber-fertility within a real rather than a mystic marriage. Instead, they homed in on 2:6, and used it to turn the Jewish 'single bond' into a double bond. They could prise it apart because it made a clear temporal distinction between the act of putting the left hand under the Bride's head (present tense) and the embrace by the right hand (future). For the influential Christian father Origen (*c.* AD 185–*c.* AD) the Bridegroom's two hands had different but equally necessary functions. The left hand signified faith in Christ's incarnation and passion, and in the salvation that it brought to humanity; while the right hand signified the (future) splendour and glory of eternal life: 'For we must think of all "right-hand" things as being where there is included nothing of the grief of sinners, nor of the fall of weakness; and

the "left-hand" things as being of that time when He Who was Himself made sin and made a curse for us, healed our wounds and bore our sin'.[22] The ultimate 'left-hand' thing was Christ's sacrifice on the cross, which was both agonizing and humiliating, for he allowed himself to be taunted, derided, and killed as a common criminal.

The most eloquent and rapturous interpretation of this passage was made by St Bernard of Clairvaux. In his treatise *On the Love of God*, Bernard says that 'in His left hand is the remembrance of that love, than which is none greater, whereby he laid down His life for His friends...Justly in the left hand is placed that wondrous remembered and ever remembered love, for, until iniquity shall pass away, the bride shall lean and rest upon it...'[23] In his 52nd *Sermon on the Song of Solomon*, St Bernard is again enchanted by the Bridegroom's gesture with his left hand: 'I cannot contain myself for joy that that Majesty, with such familiar and sweet association, does not disdain to stoop to our infirmity, and the supreme Deity does not shun giving its affection in a wonderful way, as in a marriage with the expelled soul, and taking it as bride with most ardent love.'[24]

St Teresa's contemporaries evidently understood her vision of Christ's left hand in relation to the *Song of Songs*. The illustrated biography that contributed greatly to her canonization, Adrian Collaert and Cornelis Galle's *Vita B. Virginis Theresiae* (Antwerp 1613), showed Christ holding the extracted nail in his right hand, and clasping with his left hand the raised left hand of the kneeling Teresa. This is clearly meant to be a mystic marriage between Christ and Teresa for an inscribed scroll emerges from his mouth saying that she is his true and chaste bride.[25] Teresa's body had been exhumed in 1583 and found to be incorrupt, whereupon her heart and both arms were placed in golden reliquaries on the main altar of the Discalced Carmelites at Alba de Tormes: it was an effective demonstration of her spiritual and emotional ambidextrousness.

* * *

ST TERESA'S FASCINATION WITH Christ's left hand, and in his ability to 'cross over', is paralleled in the visual arts. Where the *Song of Songs* is concerned, one could immediately cite Leonardo's two most energetic and acrobatic images of the Christ child, the Uffizi *Adoration* and the London cartoon, *The Virgin and Child with Saints Anne and John the Baptist*. In both, He cantilevers himself sharply leftwards, using His mother's lap as a launchpad, and stretches out his left hand to grasp,

respectively, a gift offered by one of the Three Kings, and to caress the chin of St John the Baptist. The London cartoon comes closest to the spirit of the *Song of Songs*: not only does Christ's outstretched left hand affectionately hold the chin of the eminently Bridal Baptist, he also points his right hand heavenwards.[26]

It also makes sense to read the gestures of Giovanni Arnolfini's left and right hands in Van Eyck's portrait in relation to the *Song of Songs*. Arnolfini's wife 'rests' her right hand on his lovingly outstretched left hand, while his right hand points upwards, hinting at eternal values. The fact that the 'crossing' of their hands takes place just below the circular mirror with images of Christ's passion implies that they may be modern versions of the biblical Bridegroom and Bride. The mirror itself, with its 'reversed' reflections of the Arnolfinis and of two visitors, was a common symbol of Christ. First and foremost, Christ was a 'mirror' of all virtue, but for a fourteenth-century theologian like Peter of Limoges, whose treatise *On the Moral and Spiritual Eye* we discussed earlier, the crucifixion was a miraculous 'mirror' which not only reverses left and right, but top and bottom.[27]

Although Van Eyck's great portrait appears to be centrally concerned with christian 'crossing over', the tiny image of the crucified Christ that surmounts the mirror is still a conventional one, for Christ's head tilts slightly to the right, and there is no privileging of his left side. However, this radical possibility was also starting to be envisaged. The first indisputable and deliberate example I have found is a manuscript illumination from around 1370 (Fig. 20) illustrating a vision experienced by the German mystic Heinrich Suso (*c.*1295–1366),[28] who we referred to earlier in relation to self-flagellation. Suso belonged to the nobility, but he entered the Dominican friary at Constance when he was eighteen and, shocked by the laxity of the regime, mortified himself mercilessly for the next sixteen years, and had many visionary experiences—all of which are recounted in his spiritual autobiography, the *Exemplar*. Suso wore nailed clothes and gloves, strapped a nailed cross to his back, and cut the monogram of Jesus (IHS) into the skin over his heart (this last was the subject of a compelling altarpiece painted by the Spanish artist Francisco de Zurbaran for a Dominican church in Seville in around 1640). Suso eventually threw all these instruments of self-torture into a river, after a host of angels appeared to him and told him God did not wish him to continue his penitential practices. He then became an itinerant preacher. All his writings are informed by the tradition of

courtly love, with God rather than a Lady the object of his affections. He was known as 'Sweet Suso', and adopted the name of Amandus—the Latin for 'lovable'.

The manuscript illumination appears alongside a text of Suso's *Exemplar*.[29] The illumination ostensibly illustrates 'how Christ appeared to him in the form of a seraph and taught him how to suffer'. The six-winged seraph in the guise of the crucified Christ is what appeared to St Francis of Assisi, and from which issued the rays that formed his stigmata. The Christ-seraph is surrounded by inscriptions which match those which Suso saw inscribed on the wings: 'Receive suffering willingly'; 'Bear suffering patiently'; 'Learn to suffer as Christ did'. We see Christ

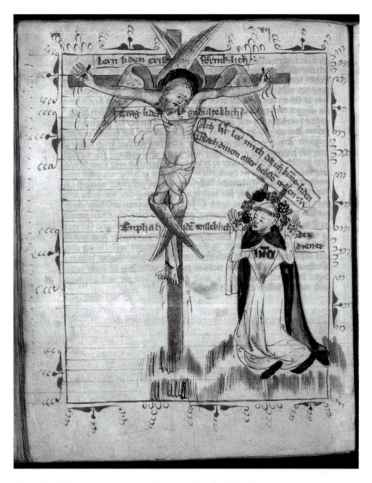

Fig. 20: Illumination from Henry Suso's *The Exemplar*

from the front, with Suso kneeling to his left, with chest bared to reveal the 'IHS' monogram. His head is haloed by a lover's chaplet of roses, thus claiming for Suso the role of Christ's Bride. However, the artist seems to have conflated this image with another of Suso's visions in which he invited Christ to dine with him:

> When he sat at table, he placed the beloved guest of pure souls just in front of him as his neighbour, and looked at him in a very friendly fashion; at times he leaned towards the side of his heart.[30]

Modern translations tend to assume that it is Suso who leans towards Christ's heart side. This would make Suso a successor to the unnamed disciple referred to solely in St John's Gospel who rests his head on Christ's breast during the Last Supper, and who is singled out as one 'whom Jesus loved' [John 14: 23]. He was traditionally assumed to be St John the Evangelist, author of the Gospel, and in Giotto's depiction of the Last Supper in the Scrovegni Chapel, Padua (c.1303–5), is shown sitting to Christ's left and leaning on Christ's heart. But the German is unclear about precisely who is leaning, and towards whose heart.[31] In another vision Suso sees inside his own heart and there finds the allegorical figure of Eternal Wisdom 'leaning lovingly at the side of God', being embraced by God's arms and pressed to God's heart[32]—so Eternal Wisdom must be at God's 'heart' side, and God must be leaning over to his left if he is to press her to his heart. What really mattered to Suso was a communion of hearts, and immersion in the heart. To this end, the artist places Suso on Christ's heart side, and makes Christ lean towards his left, the side of his own heart.[33]

The first major works of art in which the crucified Christ not only looks to his left, but is actually viewed from the left, were created in northern Italy by the court artist Pisanello. Pisanello (c.1394–1455) was no less enamoured of 'worldly' anecdotal detail than his northern contemporaries (such as van Eyck), and he was to become the most celebrated Italian artist of his day. His exquisitely miniaturist *The Vision of St Eustace* (c.1438–42) is one of only four surviving panel paintings by the artist, and was probably made for an aristocratic patron.[34] The story is told in the *Golden Legend* of a benevolent Roman soldier Placidus who, while out hunting, had a vision of a stag with a radiant crucifix between its antlers. Christ spoke to him, and said that having heard of his good deeds, he had decided to hunt him down. Placidus immediately converted to Christianity, and changed his name to Eustace.

177

In Pisanello's picture Placidus is riding through a verdant landscape on a horse, sumptuously dressed in the very latest in court fashions. He has just noticed Christ and he has started to turn his horse to the left. The picture is liberally peppered with all kinds of animals—dogs, rabbits, birds, two other deer, and a bear. We see Christ's body sharply from the left, and his haloed head tilts forward and turns to face the left. He should by rights be dead, as blood streams from the wound in his right side, but his eyes seem to be ever so slightly open, scrutinizing the passing huntsman. Indeed, we assume he must be alive because in previous crucifixions, his death is usually indicated by his facing to his right.

Christ's right arm is hidden by his head and golden halo, and only the fingertips of his right hand are visible; his raised left arm, and the ribs on the left side of his chest, are completely visible and quite brightly illuminated. A similar lateral contrast occurs with the deer: the right antler is barely visible, while the left antler seems to billow ecstatically upwards like brown flames. A surviving drawing, with various sketches for Christ on the cross, show how hard Pisanello worked on this part of the composition, and how long it took him to develop his radical new motif. Initially, he seems to have intended to give a clear view of Christ's right hand, for a fully worked up drawing of it appears on the page. Other sketches at the bottom of the page show Christ's head hanging down, so that he seems dead. In the painting, Christ's feet are placed side by side, thus eschewing the convention that his right foot should be placed over his left.

Were it not for the presence of Christ on the cross, the setting would be an earthly paradise, and the picture offers no simple repudiation of worldly pleasures such as hunting. Indeed, in the *Golden Legend* Christ himself becomes a hunter, hunting down those ripe for conversion. The leftward orientation of Christ reminds us forcibly of his immersion in the world, and the picture revels equally in the wonders of the natural world and of the fashion world. A saint's vision of the crucified Christ had frequently been depicted, but this seems to be the first 'action' image in which the saint is shown approaching from Christ's left[35] and where Christ looks/faces over to his left. The movement in this composition— of Christ, Eustace, and his horse, and of the surrounding animals—give the encounter a shockingly transient feel, but in this it is responding to the acceptance of temporal existence that is also manifested by Christ's glance to the left. It is a picture about 'is' and 'now' rather than about a

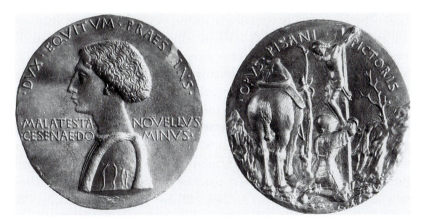

Fig. 21: Pisanello, *Portrait Medal of Domenico Malatesta Novello*

promised future. Any aristocrat contemplating this picture would have had no qualms about immediately setting off for a hunt.

A few years later Pisanello's returned to the theme in his influential and far more moving *Portrait Medal of Domenico Malatesta Novello* (*c.*1446–52) (Fig. 21).[36] Domenico was the third illegitimate son of Pandolfo III Malatesta, a highly successful *condottiere*, who became lord of Rimini and its surrounding territories. Domenico was legitimated by Pope Martin V in 1428, and became ruler of Cesena, but by all accounts he was extremely quiet and studious, with an important library. In 1435 he married Violante da Montefeltro, but she had already taken a vow of chastity and remained chaste throughout the marriage. The inspiration for the medal was a vow made at the battle of Montolmo in 1444, where Domenico, in danger of capture by Francesco Sforza's forces, promised that if he escaped he would build a hospital dedicated to the Holy Crucifix, and this was done in 1452. The front of the medal features a (left) profile portrait of Domenico, while the reverse shows a knight in full armour kneeling at the foot of a cross in a barren landscape. He seems to embrace the cross, and tries to kiss Christ's left foot. Christ is shown pretty much as in the St Eustace panel, with a few subtle but important differences. He now lacks a halo, but despite its absence from around his head, not even the finger tips of his right hand are visible. No blood spurts from his right side, but as a kind of visual compensation, the ends of his loin cloth billow out to his left, as if asking to be grasped. Christ looks down benevolently at the knight, who is a little to the left of the cross, kneeling in what appears to be a mixture of stones and

mud. The landscape is completely barren, with a couple of dead and shattered trees. The knight's horse is tethered to a tree slightly to the left, and is seen from behind, his rump brilliantly foreshortened. The horse's head turns to the left so that we see its left eye, thus reinforcing the left-leaning orientation of the image.

In chivalric romances, when someone passes a wayside cross (or chapel or hermitage), and the cross's position is given, it is usually on the right, the 'auspicious' and 'blessed' side.[37] In an anonymous biography of Ramón Lull (written *c.*1311), who was the author of the standard guide to chivalry, we get a real sense of the trauma of having Christ on one's left side. Earlier in his life, Lull had had visions of Christ on his right-hand side, but when the bedridden Lull believes he is dying, things have become desperate: 'a priest brought him the precious Body of Jesus Christ [the sacrament], and, standing before him, desired to deliver it to him; the said reverend master [Lull] felt that his head was being turned by force to [his] right hand, and likewise it seemed to him that the precious Body of Jesus Christ passed to [his] left hand, saying to him these words: "Thou shalt suffer condign punishment if thou desirest in thy present state to receive me".'[38] When Lull again feels his head being pushed to his right, he throws himself off the bed to prostrate himself at the feet of the priest.

The position of Domenico and of his horse suggests he has actually approached the cross from the left. By being situated on the less favoured left side, it suggests that his parlous state in the Battle of Montolmo was a punishment for his sins; by the same token, however, by approaching from the left, Domenico demonstrates his humility—and this was of course manifest in his promise to build a hospital if he survived.

These iconographic innovations in relation to the crucified Christ were extraordinarily daring, but we can reconstruct an approximate cultural context for it by looking at discussions of necks that lean to the right or left in Graeco-Roman physiognomic treatises that remained influential throughout the Middle Ages and into the Renaissance. Necks leaning to the left were thought to show a propensity in their owner to love. The most famous historical possessor of a left-leaning neck was Alexander the Great, an inspirational historical figure at the court of Pisanello's greatest patron, Leonello d'Este, Marquis of Ferrara.[39] A drawing by Pisanello survives in which he has copied a Macedonian coin with a profile image of Alexander the Great (*c.*1434–8).[40]

The Greek historian Plutarch gives the most detailed descriptions of Alexander's appearance, and his *Life of Alexander the Great* (c. AD 110) was translated into Latin by Guarino of Verona, a humanist patronized by Leonello d'Este.[41] Plutarch implied that Alexander was a man of feeling as well as an invincible conqueror. Plutarch praises the sculptor Lysippus for being the only artist who portrayed him correctly: '[Alexander's] outward appearance is best conveyed by the portraits of Lysippos, the only sculptor whom the king thought was good enough to represent him. For those peculiarities that many of his successors and friends afterwards tried to imitate, namely, the poise of his neck, which was tilted slightly to the left, and the melting glance of his eyes, the artist accurately observed'.[42] Modern scholars still argue over whether Plutarch was conveying information gained from reliable sources, or was just describing a convention found in Lysippus's portraits. In the middle ages, this seems to have given rise to a Jewish legend that during Alexander's campaigns in the east, he came across a people whose kings were left-handers. The story is told in *The Book of Josippon*, which was erroneously attributed to Josephus, but was probably compiled in tenth-century Italy: 'And [Alexander] asked another one: "Which is better, the right or the left side?" And he answered: "The left, because the woman nurses her son on the left side first. And kings stemming from the tribe of kings are left handed".'[43] In the twentieth century this gave rise to a further mutation—that Alexander was himself a left-hander.[44]

Plutarch's positive interpretation of Alexander's left-leaning neck and melting glance flies in the face of contemporary physiognomic theory, which tends to see this orientation in wholly negative terms: instead of being a loving glance, it is a lascivious glance. Marcus Antonius Polemon (c. AD 88–144), who was the first to try to codify current theories of physiognomy, believed a left-leaning neck was a 'sign of stupidity and love of adultery'.[45] For Adamantius the Sophist, who lived some time after the third century AD, eyes turned to the left signify 'lewdness',[46] and a neck 'which looks to the left belongs to a lewd and mindless man'.[47] In another treatise on physiognomy which was then attributed to Aristotle, we are informed that 'all tender melting glances' are characteristics of fops and women.[48] They were in fact associated with a particular woman—the goddess Venus, who was depicted by the sculptor Praxiteles with her head tilted and turned to her left.[49] Some physiognomists disapproved equally of a neck that leans to the

right—the pseudo-Aristotle believed that anyone whose head hangs on their right shoulder was a deviant. But there was much less consensus here. Adamantius argued that a neck 'looking to the right belongs to an orderly, thoughtful, and moral man'.[50]

These beliefs may have informed the third-century parody of a crucifixion crudely scratched into plaster on a wall of the Imperial Palace on the Palatine Hill in Rome, and which was rediscovered in 1856. A crucified man, with the head of an ass, is shown from the rear (his fleshy buttocks are exuberantly delineated). His enormous head and long neck tilt to his left, towards a male bystander. The accompanying Greek inscription reads 'Alexamenos, worship God!'[51] Although the bystander looks to his right, the similarity of his name to that of Alexander may not be wholly fortuitous.

The same clichés were repeated by physiognomists well into the Renaissance,[52] but Giambattista della Porta was clearly so disturbed by the idea that Alexander's neck tilted to the left that in his *Della Fisionomia dell'Uomo* (1601/10) he claimed that Plutarch had said Alexander's neck tilted to the right![53] Shakespeare seems to have been poking fun at this kind of wilful misreading during the play scene in *Love's Labour's Lost* (early 1590s), when the curate Sir Nathaniel announces that he is Alexander the Great, and is met with the withering response: 'Your nose says, no, you are not; for it stands too right.'[54]

Of course, the physiognomists are talking about a permanent deformity, and this is not the same as a pose adopted *in extremis*. But there is nothing especially natural or impermanent about the way in which the crucified Christ's head is depicted: his head almost always tilts to the right when the most 'natural' position would be for the head to flop forwards. We can reasonably infer that the position of Christ's head— made eternal through art—was informed, at whatever distance, by physiognomic theory. For Suso and doubtless also for Pisanello, Christ's orientation to the left certainly did demonstrate that he was a great lover, but only insofar as he loved all humanity, and was prepared to die for them—and, in Suso's case, to dine with them.

* * *

PISANELLO'S EXTRAORDINARY MOTIF OF a left-sided, left-looking Christ did not immediately bear fruit, presumably because it was too radical. His Venetian contemporary Jacopo Bellini made three drawings of the vision of St Eustace which must have been inspired by Pisanello's painting

(*c.*1445–60), but in none of these does Christ look to his left. In the most faithful version of the composition, Christ on the cross has been entirely omitted, while in the other two his head tilts to the right.[55] Bellini was clearly uncomfortable both with the idea that Christ looked to his left, and that his head might tilt to the left. In the two drawings in which Christ is included, his body is seen from the front and right, and his right foot is carefully positioned over his left.

Judging by surviving impressions, Pisanello's medal of Domenico Malatesta Novello was one of his most popular.[56] But it wasn't until the sixteenth century and the Reformation that artists really built directly on Pisanello's legacy, and showed the crucified Christ from the left. Lucas Cranach the Elder revisits Pisanello in his print *The Law and the Gospels*, *c.*1529, a key Lutheran image from the Reformation, and he repeated the motif with minor variations in several paintings. It seems to have established the motif of Christ on the Cross viewed from the left, or looking to his left, as a viable alternative. It can be found in the work of—among others—Pordenone, Veronese, Titian, Tintoretto, Rubens, Jordaens, Rembrandt, Vermeer, Poussin, and Bernini.

Cranach's composition is a diptych that hinges on a tree in the central foreground. To the left of the tree (our right), stands a naked 'Everyman'. The tree has lush foliage on this side, but is bare on the other side. This is because the man is being shown the redemptive crucified Christ by the pointing John the Baptist, and below it, the resurrection, with Christ stepping out of the tomb. On the other side of the tree—under bare foliage—we are shown the temptation and expulsion of Adam and Eve; a naked man being prodded towards a bonfire by a spear-carrying skeleton; and Moses, holding the Ten Commandments ('The Law'). This indicates that before Christ, the law could not be fulfilled, and brought only sin, death, and damnation.[57] The placing of the Old Testament scenes on the central protagonist's right, and the New Testament on his left is a traditional alignment, as explained by Origen: 'There are in Him some dispensations wrought before the Incarnation, and some wrought by the Incarnation. That part of the Word of God which in the divine economy was exercised before he took flesh, can be regarded as His right hand; and that which functioned through the Incarnation can be called His left.'[58]

Here the crucifixion is depicted pretty much as in Pisanello's medal, which Cranach probably knew (it was known in Germany and a drawn copy was made that was formerly attributed to Altdorfer). The cross

is seen obliquely from the left with Christ looking towards us. But — in a spectacular 'reversal'—a fountain of redemptive blood spurts leftwards from a wound located in the centre of Christ's torso towards a naked penitent man in the foreground. It bears a superficial similarity with traditional images of stigmatization. During the stigmatization of St Francis rays passed from Christ's five wounds to the corresponding points on the saint's body: accordingly, the ray from the wound in Christ's right side has to 'cross over' his body in order to reach the right side of St Francis. Here, though, we don't have a discrete laser light, but a fireman's hose deluge, and there is no sense that the blood is aimed at the right side of 'Everyman'. Cranach would repeat the deluge in other painted versions of the composition, and most dramatically in the *Weimar Altarpiece* (1555), where Cranach depicts himself standing to the left of Christ, with the stream of blood landing on his head like a baptismal waterfall.[59]

Martin Luther's publication of the *Theologica Germanica* (1516/18) may well have encouraged Cranach, who was god-father to Luther's son, to develop such daring images of the crucified Christ. The relevant passage occurs immediately before the discussion of the left and right eyes of the human soul. Indeed, it was the opening section of the first edition of the text. Whereas man can only operate one eye at a time, and is thus either good or evil, Jesus Christ is able to operate both eyes simultaneously:

Remember how it is written that the soul of Christ has two eyes, a right eye and a left eye. In the beginning, when these were created, Christ's soul turned its right eye toward eternity and the Godhead and therefore immovably beheld and participated in divine Being and divine Wholeness. This vision continued unmoved and unhampered by all vicissitudes, travail, agitation, suffering, torment, agony—tribulations surpassing anything ever experienced in a person's outer life.

But at the same time the left eye of Christ's soul, his other spiritual vision, penetrated the world of created beings and there discerned distinctions among us, saw which ones were better and which ones were less good, nobler or less noble. Christ's outer being was structured in accordance with such inner discrimination . . . the outer man, the left eye of His soul, was involved in a full measure of suffering, distress, and travail.[60]

Holbein's *Body of the Dead Christ in the Tomb* (1521–2), in which Christ's corpse is stretched out before us in right profile, with his head tilted to his right and the right eye still eerily open, as if peering up 'toward eternity', seems to exemplify the first of these paragraphs.[61] But Cranach is more concerned with the second. The blood of Cranach's Christ, in its sharp leftwards trajectory, truly penetrates 'the world of created beings', and shows just how fully Christ is 'involved in a full measure of suffering, distress, and travail'.[62]

* * *

CRANACH'S SHIFTING OF THE wound to the centre of Christ's torso is vital, and not simply from a practical point of view (it would be hard for the jet of blood to reach us if the wound was further round to the right). What Cranach is doing is moving the wound from the right side closer to the heart. Indeed, we are surely meant to appreciate that the force and volume of the jet of blood is solely due to the fact that it is being pumped directly from Christ's heart. The position of the wound was moved to facilitate the worshipper's union with Christ, a logical development that is already implied in this passage from a meditation manual by the Dominican contemporary of Eckhardt and Suso, John Tauler (1294–1361): 'The Side of Christ was pierced *not far from* his Heart, that an entrance to his Heart might be opened to us.'[63]

Cranach is one of the most conspicuous examples of a growing trend to privilege the 'heart' side of the dead and dying Christ. During the fifteenth century Fra Angelico had given the wound a more central position, and in his San Marco *Lamentation over the Dead Christ*, he had even depicted Christ's stretched out corpse from the left. Very occasionally medieval artists had depicted Christ from the left in entombments, but the body was usually kept fairly distant from the viewer. Donatello made a small bronze relief of the *Lamentation* (*c.*1460) and Rogier van der Weyden painted a *Pietà* (the central panel of the *Miraflores Triptych*) in which Christ's body is seen from the left in the foreground. However, the most spectacular and emphatic reversals occur in the 1490s. In the mid-1490s, Botticelli painted two major altarpieces of the *Lamentation over the Dead Christ* (*c.*1490 and *c.*1495). Here, Christ's body is depicted with the left side facing the viewer, and the wound in the side either moved to the centre or scarcely visible, while his 'heart' side is fully exposed to us.[64] The flaunting of the left side in the Botticelli

paintings goes hand in hand with an extraordinary outpouring of grief from the bystanders—amongst the most moving in all Renaissance art.[65]

Iconographically, Dürer is even more daring. His woodcut of the *Deposition of Christ* (*c*.1497–1500), from his *Large Passion* series, not only shows Christ's body from the left, but also depicts the wound on the same side, just below the heart. This is thought to be the first depiction since late antiquity of the wound on the 'heart' side.[66] It is no slip of the burin, as no other side wound in the *Large Passion* looms so large or emphatic. Christ's body slumps down in the bottom right hand corner of the composition, and is twisted round into an almost impossible position. In relation to the cross, Christ has fallen as far left and down as it is possible to go. In other woodcuts from this same series depicting the *Crucifixion*, *Lamentation* and *Resurrection*, we also see Christ from the left though his wound does not seem to have been switched to that side. By the same token, on the relatively few occasions when Dürer does depict Christ's right side, he barely delineates the wound.

A wound in the left side, and a damaged body seen from the left, may have had a particular meaning for the artist. In a later self-portrait drawing, *The Sick Dürer*, he makes himself look very similar to the Christ of the *Deposition*, with long straggly hair and spindly body, and he points to a 'wound' in a similar location in his left side, which has been circled. This is the area of his spleen, gall bladder, and liver, the traditional seat of melancholia. By relocating Christ's wound to a similar position in his print, Dürer may have been trying to intensify the feeling of pathos experienced both by the protagonists and the viewers. With both Christ and Mary slumped in the bottom right-hand corner, the *Deposition of Christ* may be regarded as the forerunner of *Melencolia I*, where the sufferer is seen from the left crouching in a similar position, and looks up to his right for spiritual solace which does not seem to be forthcoming.

Dürer's prints may well have influenced Grünewald's radical decision to give the exterior panels of the *Isenheim Altarpiece* (finished 1515) (see Fig. 1, p. 29) a powerfully left-sided orientation. It was made for the Hospital Order of St Anthony in Isenheim, and is the largest crucifixion altarpiece ever made. Despite the fact that the gaping wound in Christ's side is located in the conventional position on the right, the crucified Christ in the main panel hangs far to the left of the central vertical of the cross, with the footrest, and his feet, powerfully twisted in the

same direction. The cross itself is not in the centre, but is pushed to the protagonists' left. This is unprecedented in an altarpiece. Practical considerations partly dictated this compositional innovation, because otherwise Christ's head and torso would have lain on the vertical gap which runs vertically down the centre of the image, allowing the panels to be opened out, revealing an image of the resurrected Christ below.

But Christ's dramatic leftward lurch seems to have suited Grünewald and his patrons, and is further emphasized in the predella panel of the *Entombment* positioned directly below. This shows Christ's stretched out corpse visible from the 'heart' side, with his head and torso filling the right side of the panel: in other words, the Christ of the Entombment is placed to the left of the crucified Christ. Although the head of the crucified Christ tilts to the right, his eyes seem to look down to the left at his future dead self, and also at the bleeding lamb which is directly to his left. The lamb (which is seen in left profile) is a symbol of Christ: it props up a small wooden cross, and blood flows from a wound in the centre of its chest into a golden chalice.

By turning left, Grünewald's Christ does not simply express his love for humanity, he also confronts his own death. This is a nocturnal crucifixion and entombment—or at any rate, they both occur when the sky is dark. But it is not necessarily an allusion to the solar eclipse that was supposed to have occurred at the moment of Christ's death. The altarpiece is brightly but coolly lit from the left, which was the north side of the monastery church,[67] and Christ's right side is cast into deep shadow. Grünewald thus gives the illumination a wholly supernatural resonance. His altarpiece is not lit by the sun. His light from the left is a chilling and forensic lunar light that speaks of nothing but suffering and death in a cold sublunary world.

10. The Death of Christ 2: 'Not Idle'

The Servant not only [stood by the left side], but suddenly he starteth,
and runneth in great haste, for love to do his Lord's will.
> Julian of Norwich, *Revelations of Divine Love* (*c.*1400)[1]

ONE POSSIBILITY WE DID not really consider in the last chapter is that
Pisanello's and Cranach's images of Christ on the cross simply depict
earlier phases of the crucifixion story, when Christ was still alive. As
such, they are simply exploring narrative possibilities that are mentioned
in the Bible, but which had not hitherto been much explored by visual
artists. Until then, the standard way of showing Christ on the cross
when he was still alive was to have him looking straight ahead, with his
eyes wide open, like a soldier standing to attention, but this type only
had currency during the early middle ages, and even then remained a
relative rarity. No doubt this was because of the unengaging stiffness of
the image, which seems to bypass Christ's humanity and suffering, and
to resurrect him in triumph before he has even died on the cross. It is
certainly hard to relate this type of the crucified Christ with any of the
events mentioned in the Bible.

Those images that privilege the left side are uniquely adept at alluding
to Christ's awareness of his own suffering and death, and to the ghastly
duration of the crucifixion. There is an uncanny sense in which Christ
seems more conscious in images that privilege the left side than in those
traditional ones that privilege the right: the feet of Grünewald's Christ,
for example, seem to stretch out leftwards with the same urgency that
John the Baptist points his telescopic index finger at Christ's left side. It
is almost as though a leftwards orientation provides a life-support system
that not only keeps Christ alive for longer than seems really possible;

it also demonstrates his desperation to remain among us and not to 'go gentle into that good night'.

This leftwards shift comes about in part because of frustration with an over-emphasis on the dead, right-leaning Christ. This is already implicit in the late-thirteenth century *Meditations on the Life of Christ*, one of the most popular religious texts of the late Middle Ages. Essentially a biography of Christ, with allegorical readings of the various episodes usually taken verbatim from the sermons of Saint Bernard, the *Meditations* did for the life of Christ what the *Golden Legend* did for the lives of the saints. As a source book, it was used by artists as well as by writers of mystery plays. Adding to its attraction were homely details not found in the Gospels such as the claim that Christ preferred His mother's cooking to that of the Angels. Until the eighteenth century the book was considered to be by the leading Franciscan theologian, St Bonaventura, but it is now regarded as the work of a Franciscan monk living in Tuscany.

Christ's utterances on the cross are conveniently enumerated and, for the author, they attest to his hyper-active alertness on the cross: 'While he was hanging on the cross, however, until the departure of His spirit, the Lord was not idle, but did and taught useful things for us. From there He spoke the seven words that are found written in the Gospel.'[2] For the Romans, a 'good death' always featured a fine speech or a memorable phrase from the dying man, and Christian martyrs had to keep the homilies flying right until the end. Christ's seven pronouncements offer mightily impressive food for thought, and the list is worth quoting extensively, because later artists would work their way through it:

> The first was during the act of His Crucifixion, when he prayed for His crucifyers, saying, 'Father, forgive them, for they do not know what they are doing' (Luke xxiii, 34), which word gives a token of great patience and great love, and indeed came of indescribable charity.
>
> The second was to the mother, when He said, 'Woman, behold your son,' and to John, 'Behold your mother' (John xix, 26, 27). He did not call [the Virgin Mary] 'mother', in order that the tenderness of vehement love might not grieve her the more.
>
> The third was to the penitent thief, when He said, 'Today you shall be with me in Paradise' (Luke xxiii, 43).

The fourth was, 'Eli, Eli, lamma sabacthani?' This is, 'My God, my God, why have you forsaken me?' (Matt. xxvii, 46), as if He said, 'Father, you loved the world so much that, while you delivered me up for it, you seem to have forsaken me.'

The fifth was when He said, 'I am thirsty' (John xix, 28) . . . Now one could show that he was thirsty for the salvation of souls; yet in truth he thirsted because He was inwardly drained by loss of blood, and was dried out. And when those wretches were unable to think how they could injure Him further, they found a new manner of ill-treating Him and gave Him vinegar mixed with gall to drink . . .

The sixth word was, 'It is consummated' (John xix, 30), as if He said, 'Father, I have completed perfectly the obedience that you imposed on me . . . all that is written about me is consummated. If it please you, father, call me back to you now.' And the father said to Him, 'Come, my most beloved Son. You have done everything well. I do not wish you to be troubled any further. Come, for I will receive you to my breast and embrace you.' And from that time on, He began to weaken, in the manner of the dying, now closing His eyes, now opening them, and bowing His head, now to one side, now to the other, all His strength failing.

At length He added the seventh word, with a loud cry and tears, saying, 'Father, into your hands I commend my spirit' (Luke xxiii, 46). And saying this, He sent forth His spirit: with His head bowed on His breast toward the Father, as though giving thanks that He had called Him back. He gave up His spirit. At this cry, the Centurion that was there [Longinus] was converted, and said, 'Truly this was the Son of God' (Matt. xxvii, 54).[3]

The idea that anyone who has just been crucified could be accused of being 'idle' seems more than a little heartless, but the author seems to be showing impatience with all those (especially artists) who imagine Christ inert and silent on the cross—to all intents and purposes, prematurely dead to the world. In other words, they show him, 'with His head bowed on His breast toward the Father'—or facing to his right. The author wants him to be a hive of activity, 'now closing His eyes, now opening them, and bowing His head, now to one side, now to the other'.

An early attempt to depict a more proactive Christ can be found in the chapel of Saint John in the Papal Palace in Avignon, southern France.

Pope Clement V had moved to Avignon in 1309 because factional fighting had made Rome unsafe, and the Papacy resided there for most of the fourteenth century. The chapel of St John, which was reserved for high dignitaries of the Church, was devoted to St John the Baptist and St John the Evangelist, Christ's first apostle. The Sienese painter Matteo Giovanetti decorated the chapel between 1346 and 1348 with two fresco cycles recording the lives of the two saints. A Crucifixion scene above the entrance door depicts the moment when Christ says to St John the Evangelist 'Behold your mother'. The Virgin takes up her traditional position, standing just to the right of the cross, and she stands taller than any other bystander: Christ's knees are angled towards her. Just beneath her, Mary Magdalene grasps the foot of the cross. As John is situated some way to the left of the cross, and stands on lower ground than Mary, before a bunch of devilish looking creatures huddled round a cave, Christ has to strain his neck to his left to see him.

The novelty of the subject is perhaps shown by the fact that Giovanetti has inscribed the relevant Latin text on the fresco—ECCE MATER TUA. The inscription is 'aimed' at John's head, where his ears and eyes are located, but it is not aligned with Christ's mouth and seems instead to emanate from the shadowy region of Christ's heart. In some respects, this left-sided 'message from the heart' has replaced Longinus' spear, and the wine and water that traditionally flowed from the wound in Christ's side: the soldiers with their spears stand far away to Christ's right, and there is no wound in his side. No doubt the Popes, in their hour of need, were keen to emphasize Christ's continued keen involvement with the world and with evangelism.

From the fifteenth century onwards, artists seem especially keen to keep Christ conscious of us as long as possible. If you want to imply that he is still conscious, the best option is for him to keep eyes left, for whenever he has eyes right, we assume he is close to death, or that his soul is already winging its way up to his throne at the right hand of God. In Pisanello's medal, Christ is triply alive, for not only is he seen from the left, looking to his left; there is also no blood dripping from his side, suggesting that we are pre-Longinus. In Cranach's version, the blood is certainly there, but its force and volume give no sense of finality: it suggests that Christ's heart is still pumping vigorously and is literally bursting with love for humanity. No doubt too, all these 'left-sided' Christs on the cross take us back to Christ's infancy, and to those Madonna and Child images where he is generally situated on the left

side of the Virgin's lap.[4] They rejuvenate him. He is like the drowning man who relives his life in an instant.

* * *

NO SIXTEENTH-CENTURY ARTIST was more vitally concerned with keeping Christ *conscious* than Michelangelo—and no artist took more drastic measures to give him a leftwards orientation. In the unfinished panel of the *Entombment* (1500–1), Christ's head tilts to his left, towards his kneeling mother, and while his left arm projects forward, and the left side of his naked body forms an almost unbroken languid contour that compels our eye to trace it, his right arm is thrust back, concealed behind an attendant, and the right side of his body is bunched up, as if shrinking into itself, and thus visually less inviting.

It was almost unprecedented to place the Virgin at Christ's left, but the Franciscan preacher Bernardinus de Busti of Milan (died 1513), who was famous for formulating the office for the feast of the Immaculate Conception, had recently proposed just this iconographic innovation. In a popular book of 63 Latin sermons on the Virgin Mary, *Mariale*, first published in 1492, and published frequently thereafter,[5] Bernardinus cited Psalm 142:4, in which David believes he has been abandoned by God: 'I looked on *my* right hand, and beheld, but *there was* no man that would know me.' The implication is that Christ then looks to his left, where his mother is located. She patiently positions herself in this benighted 'northern' location, full of tribulation and persecution, so that she can be closer to sinners, and be a shining star who shows them the way and intercedes with Christ on their behalf.[6] The fact that Michelangelo's Christ leans over to his left where his mother is located proves that he continues—even in death—to love the world with all his heart.

Something even more radical occurs in the circular marble relief, *Madonna and Child with the Infant St John* ('Taddei Tondo', 1504–5), in which the Christ Child, positioned to the left of the seated Virgin, is apparently alarmed by two symbols of his future passion (a bird and a crown of thorns) held up by his elder cousin St John the Baptist, standing to the Virgin's right. In fact, St John presents three symbols of the passion, for his own forearms cross over, just below the wrists.[7]

This is an allusion to an episode in the 48th book of Genesis which is the first positive reference in the Bible to the left side. Joseph brings his

two sons to be blessed by his dying father Jacob, and having positioned the youngest Ephraim on Jacob's left, and the oldest Manasseh on his right, he is dismayed when Jacob crosses his arms so that he can bless Ephraim with the honorific right hand. When Joseph tries to remove his father's hand from Ephraim's head and transfer it to that of Manasseh, his firstborn, Jacob explains: 'truly his younger brother shall be greater than he, and his seed shall become a multitude of nations' [48:19]. Christians interpreted this ceremonial inversion as a symbol of the way in which the 'younger' Christianity had superseded the 'firstborn' Judaism, with Jacob's crossed arms prophesying the key moment of supersession: Christ's death on the cross.[8] In Michelangelo's relief, John the Baptist takes on the role of Jacob not only because he crosses his arms but also because he did actually 'bless' Christ by baptising him. At the same time he is Manasseh—spatially, because he stands to the right of the Virgin; and temporally, because he was regarded as the 'forerunner' of Christ. Christ takes on Ephraim's role because he is positioned to the left of the Virgin, and because he was greater than anyone who preceded him.

Yet this Christ child actually throws himself to his left, thrusting out his left leg and arm. It is the first time that the Christ child is shown practically running, and his mother does not raise her left hand to cradle or catch Him. The helter-skelter scene recalls an allegorical account of Christ's incarnation and Passion by the English mystic Julian of Norwich in her *Revelations of Divine Love* (*c.*1400). It is possible that Michelangelo knew of something similar. Julian's allegory centres on a Lord and a Servant. The Lord is God the Father, and the Servant is a combination of Christ and Adam. The Servant stands to the left of the Lord: 'The standing of the Servant betokeneth travail...and that he stood by the left side [betokeneth] that the Father left His own Son, willingly, in the Manhood to suffer all man's pains, without sparing of Him.' But not only does Julian's Servant stand to the left, he runs to the left, and then falls: 'The Servant not only goeth, but suddenly he starteth, and runneth in great haste, for love to do his Lord's will. And anon he falleth into a glade, and taketh full great hurt. And then he groaneth and moaneth and waileth and struggleth, but he neither may rise nor help himself by no manner of way...'[9] Christ's 'fall' will cancel out that of Adam, but what makes Michelangelo's relief so moving is that the Christ-child seems to be not so much running away from his destiny, as running into it.[10]

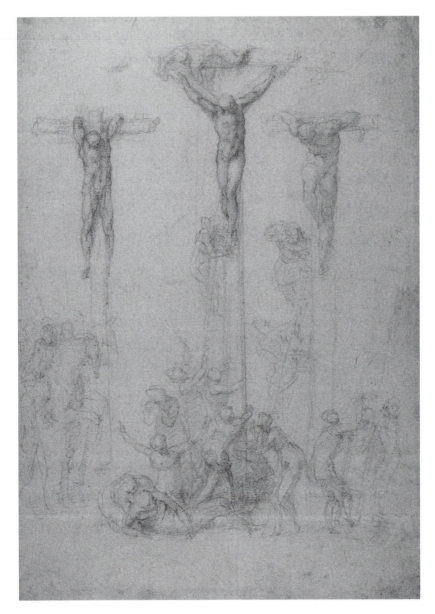

Fig. 22: Michelangelo, *Three Crosses*

The first time that Michelangelo makes the crucified Christ look to his left is in a magnificent and unusually large red chalk drawing of the *Three Crosses* (1520s) (Fig. 22), which has so far defeated attempts by

scholars to explain what is taking place.[11] Indeed, Michelangelo seems to want to rewrite the crucifixion story. As two men finish off fixing Christ to a high 'Y'-shaped cross, he twists athletically to look up over his left shoulder. It had traditionally been the bad thief who had been shown in this kind of pose. Christ observes a scene that has been barely sketched in: an angel taking the soul of the thief on his left up to heaven.[12] This is disconcerting because the bad thief is traditionally placed on Christ's left, so it should be a devil taking his soul down to hell. Unlike the thief to Christ's right, whose body hangs down slack and inert, this one is still very much alive: his legs have not yet been broken, and his head is turned towards Christ. If he were the bad thief, he would be more likely to look away from Christ. Another untraditional feature is that the 'bad' thief's cross is much closer to Christ's cross and further forward than that of the thief to Christ's right, who already appears dead, and is thus incapable of hearing that he will join Christ in Paradise.[13] Last but certainly not least, Christ's left foot has been nailed above his right, and the cross is not in the centre of the paper, but has been nudged leftwards, even closer to the 'bad' thief. The drawing is systematically unorthodox.

Most of the anomalies disappear if the drawing is reversed, either by making a tracing of it or by looking at it in a mirror. I have argued elsewhere that when Michelangelo was making his so-called presentation drawings, he was interested in print-making, and so may have experimented with making images in reverse.[14] The development of print-making, as much as the increasing availability of glass mirrors, must have drawn artists' attention to the narrative implications of image-reversal: Parmigianino exploited image reversal to brilliant effect in the two versions of his most ambitious etching, the *Entombment* (mid-1520s), altering the props depending on whether Christ's body is seen from the left or right side, and thus making a clear contrast between flesh and spirit, time and eternity.[15]

We know that Michelangelo was interested in moralizing reversals. A presentation drawing made for Tommaso de' Cavalieri depicting the punishment of the giant *Tityus* (*c.*1532) is a case in point. Tityus' punishment for having raped Leto, mother of Apollo, was for a vulture to gnaw his liver (thought to be the seat of lust). Having drawn him lying horizontally on a rocky outcrop in Hades, with his extended right arm chained, Michelangelo turned over the sheet of paper, and revolved it ninety degrees. He then traced the outline of the giant and,

by making a few subtle changes and editing out the vulture, transformed him into a resurrected Christ, leaping out of the tomb, leading with his (unchained) right arm. At the turn of a page, Tityus is a free and saintly man. Through this ingenious sleight of hand pagan becomes Christian, horizontal becomes vertical, and left becomes right.[16]

What moralizing purpose could be served, however, by putting the 'good' thief on Christ's left, in addition to having a left-leaning Christ? In Michelangelo's drawing, Christ edges leftwards, and the 'good' thief, like Julian of Norwich's humble servant, initially takes up a position on the left. It may express an idea that was articulated later in the century by the Dutch humanist Adrianus Junius (1511–75): in his poem on the passion, *Anastaurosis* (1565), Junius proposed that in Crucifixion scenes the good thief should be placed on Christ's left, in the same way that Jacob's favoured grandson Ephraim stood to his left.[17] If the orientation of Michelangelo's drawing is subsequently reversed by holding it up to a mirror, or by tracing over the back, we will get a more complete sense of what Christ is about—the totality of his journey. For then the 'good' thief and Christ will have edged a little bit closer to their ultimate position at God's right hand. What is more, Christ's right foot will now be placed above the left.

This, I think, is why Vittoria Colonna looked at a highly finished drawing, *Christ on the Cross* (*c*.1540), which Michelangelo made specially for her, with the help of a mirror. She tells him this in the first of three letters that refer to this drawing.[18] Christ gazes up to his left, as though desperately searching for a token of love or sympathy from God the Father: perhaps he has just looked to his right and—in the words of the Psalm—found that '*there was* no man that would no know me'.[19] Michelangelo's image is made especially moving because one suspects Christ is not looking for God in the correct place, and so feels doubly abandoned, gazing into a void that is more usually occupied by Death and the Devil. Later artists who borrowed the basic pose, such as Giambologna, reversed the position of the head, so that Christ looks up to his right,[20] and it was not until Rembrandt's *Christ on the Cross* (1631; La Mas d'Agenais, Parish Church) that Christ would again be depicted looking up to his left.

Michelangelo's reply to Colonna's first letter included an auto-biographical poem which analysed his moral state in terms of left and right:

Ora in sul destro, ora in sul manco piede
variando, cerco della mia salute.
Fra 'l vizio e la virtute
Il cor confuso mi travaglia e stanca,
Come chi 'l ciel non vede,
Che per ogni sentier si perde e manca.

[Sometimes on my right foot, sometimes on my left, shifting from one to the other, I go in search of my salvation. Moving between vice and virtue, my confused heart troubles and wearies me, like one who does not see heaven, which along every path becomes lost from view and disappears.][21] This is a fidgety version of Hercules' choice between Virtue and Vice.

The drawing which best exemplifies this moral shuffle is one of the late crucifixion drawings, from *c*.1550 to 1564, in which Christ hangs on a 'Y'-shaped cross, and is flanked by two figures. Michelangelo probably made these drawings for his own devotional purposes—and in most of them Christ looks to his left.[22] The flanking figures are usually assumed to be the Virgin and St John the Evangelist, but the drawing technique is so smudged, tremulous and full of 'corrections' that it is impossible to be certain who they are: indeed, they are just as likely to be 'Everyman' and 'Everywoman'. Each figure appears to be advancing from a starting position behind the cross, and St John, to Christ's left, is especially animated, almost a series of 'after-images'. We seem to see them at the moment when they realize who is on the cross. Flanking figures of this importance had never been shown pacing around or walking next to the cross: in Fra Angelico's extended series of Crucifixion frescoes at San Marco, for example, all the figures kneel or stand still. Michelangelo's figures, and especially St John, who we could easily regard as the artist's alter ego, appear to be people who are constantly 'shifting' from one foot to the other. The woman on Christ's right has crossed her arms over her chest, though whether she is making the sign of the cross, or just pulling a cape around her shoulders is unclear. The multitude of 'corrections' both mirrors and intensifies their uncertainty: Michelangelo is no more sure where to position his figures than they are sure where to go. Indeed, for anyone viewing the drawing, it is hard to keep our bearings, for every line 'becomes lost from view and disappears'.

This 'shifting' culminates in the extraordinary image of the crucified Christ. The cross seems unsteady, and Michelangelo has re-ruled the lines at the base of the cross so that it appears to be wobbling violently from side to side: in the 'final' position it lurches to Christ's left. The 'Y' shape of the cross, which Condivi associated with a cross placed in Santa Croce, Florence, which was carried in procession at the time of the Black Death by some flagellants,[23] here recalls the Pythagorean 'Y',[24] and Christ's head, because of the nebulous technique and flurry of revisions, resembles one of those comic-strip images of a head rocking from side to side, like a punch bag. Now it is Christ who is at the crossroads, desperately trying to reconcile his commitment to man and God, 'bowing His head, now to one side, now to the other'.

* * *

THE STRONGEST EVIDENCE FOR Michelangelo's devotion to a left-leaning Christ is not his drawings, however, but the two marble *Pietàs* which he made for his own tomb. Christ's head leans over sharply to the left, and the Virgin Mary also takes up a position to his left. In the first and most ambitious *Pietà* (*c.*1547–55), the Virgin Mary places her hand under Christ's left armpit, with the fingers spread out over his heart, and his head lies on the right side of her face; in the second (*c.*1550/64) her whole hand is laid over his heart. The basic idea is similar to that which is expressed in one of Vittoria Colonna's *Rime Spirituali* (1546):

> Parea più certa prova al manco lato
> tentar se'l Signor nostro avea più vita
> alor che fece al destra ampia ferita
> sul morto corpo in croce il braccio irato.[25]

['A more certain proof of whether our Lord is still alive would appear to be to test him from the left hand side [manco lato], seeing that the enraged arm [of Longinus] gravely wounded his dead body on the cross from the right hand side.']

A literal reading of these lines makes little sense—after all, why should one be able to tell whether Christ is still alive by examining him from the opposite side to his wound; and if Longinus 'wounded his *dead* body', why does anyone need to examine him at all? It seems to be an elaborate way of drawing attention to the fact that Christ had a heart, and a 'manco lato'. Like St Teresa, Colonna is underlining the extent of his sacrifice, his humiliation—and his love. By insisting that Christ's heart really was

on the left, this showed that Christ had been fully incarnated and was authentically human.

Like St Teresa, Colonna may have been influenced by the writings of St Gertrude, which had been 'rediscovered' after a Latin edition of her revelations had been published in Cologne in 1536. During the course of a vision, Christ tells Gertrude that if she wants to relieve his burden, she should stand on his left and let him lean over and lie on her breast: 'when I lean over to my left', Christ continues, 'I lie on my heart, which is a great solace for my tiredness, and from there I can also look directly into your heart and enjoy the melodious call of your desires'. Few of these sensory intimacies would be possible if Gertrude positioned herself on Christ's right side—the side of '[eternal] prosperity' where hearing is the dominant sense: 'I would then be deprived of all these sweet things: in the domain where the ear holds sway, the eyes could not easily be delighted, the nostrils could not breathe in, nor the hands grasp'.[26] This is Gertrude's only unreservedly enthusiastic passage in relation to the left side,[27] but it shows how greatly the cult of the heart could challenge traditional hierarchies, and redeem the sensory realm.[28]

In Michelangelo's *Pietà*, Christ does not lie on his mother's breast, but he does 'look' down towards her heart, and she does grasp his heart with her hand. Because Christ's head, with its long dangling locks of thick hair, rests directly on her face, she really does seem to be breathing him in through her nostrils. Conversely, the kneeling female figure on Christ's right is very detached. She must be Mary Magdalene, but she is restrained to the point of unrecognizability. She pulls her head away from Christ's body and does not look: it's almost as if she just wants to *listen*. There is very little sensuality about her and her position. This Christ has swung so far left that he is actually located to the left of Michelangelo himself, for Nicodemus, the towering figure who presides over the whole composition, and who supports Christ's right arm, is a self-portrait of the artist. Here Christ has travelled so far left that even a 'mere' artist seems to lord it over him.

An emphatically left-sided presentation of Christ can be disturbing as well as reassuring. Its sheer novelty makes it seem more aggressively one-sided than the traditional emphasis on the right side. Rather than consoling ourselves with our proximity to Christ's heart, we may despair at our distance from his soul and his 'spiritual' side. We may fear we are as removed from his right side as the bad thief. When Colonna looked at her crucifixion drawing through a mirror, Christ could be made to

face the 'right' way, but this optical trick is not feasible with a huge sculpture.

Michelangelo was dissatisfied with the first marble *Pietà*, and attacked it with a hammer, with most of the damage being sustained by the left side of Christ's body. He broke off Christ's left arm and leg, and shattered the area round his left nipple and the Virgin's left hand. The arm was patched together again, but the left leg was never repaired, leaving what looks like a sawn off stump.[29] As far as we know, this was unprecedented: there is no other record of his having damaged a sculpture with which he was dissatisfied; or of his having damaged a sculpture before giving it away.

But there may have been spiritual method in Michelangelo's madness. On the one hand, he was intensifying the debilitation and pathos of the left side, making it demonstrably the 'weaker' side; on the other, he was hacking his way through to the other, more spiritual side, and in the process purging Christ of his weaker human side. Christ himself had said: 'If thy leg offend thee, cut it off...for it is more expedient to you to enter the kingdom of God with one foot, than to enter into eternal fire with two' [Matthew 18:8]. There can be little doubt which leg he imagined being cut off. And then there was always Saint Bernard: 'let the left side be shorn and cut, let it be struck with insults and bound with disgrace!...'

* * *

DURING THE SEVENTEENTH CENTURY, viewing Christ on the cross from the left became commonplace, and it became more acceptable to place the side wound on the left. The new iconography was to be acknowledged and endorsed by Sir Thomas Browne in *Pseudodoxia Epidemica* (1645), an anthology of essays attacking 'vulgar errors'. In his essay 'Of the heart', one of several exploring prejudices concerning left and right, Sir Thomas observes: 'epithems or cordial applications are justly applied to the left brest, and the wounds under the fifth rib may bee more suddenly destructive if made on the sinister side; and the speare of the souldier that pierced our Saviour, is not improperly described when Painters direct it a little towards the left.'[30]

The most interesting and original images of the crucified Christ appear in Spain, and in the Netherlands, which had until recently been a Spanish dominion. The most remarkable of all is a drawing by a

follower of St Teresa, St John of the Cross (1542–91).[31] It is said to have been sketched in the 1570s when John was confessor of the Convent of the Incarnation at Avilá, of which Teresa was Prioress. He is said to have had a vision of Christ on the cross while praying in a loft overlooking the sanctuary, and he sketched what he had seen on a piece of rough parchment less than four inches across. John gave the drawing to a nun at the Convent, and at her death, she passed it on to another nun who subsequently became prioress. In 1641, at the prioress' death, it was placed in a small, elliptical monstrance and preserved as a relic.

We have a vertiginous bird's eye view of the cross, with Christ seen from the front left,[32] his hugely inflated upper torso literally hanging off the cross, his dislocated arms seemingly pulling away from it. It has the crude, brutal quality of a northern European medieval woodcut. We cannot discern Christ's face because of the tangle of long matted hair that flows leftwards over the back of his neck and the left shoulder. The main focus of attention is his torso, which has been distended—we are surely meant to believe—because of the frantic beating-to-bursting-point of his outsized heart.

Because the sketch has no background and the paper has been cut into an oval shape, there is no consensus over which way up it should be placed. It was sent for conservation in the late 1960s, and was shown to the painter José Maria Sert, who thought it should be shown on its side, with the arms of the cross vertical, and Christ's left side thrust downwards. This certainly seems to suit the direction in which the drops of blood are dripping from Christ's wounds and the drastic foreshortening of Christ's right arm and the right arm of the cross. As such, it complements Teresa's own vision of Christ rather well, for Christ's left hand, with a huge nail sticking out of it, and the left arm of the cross, are thrust into the foreground.[33] The drawing also implies the extent of Christ's leftwards 'fall' into the world. At the same time, however, the fact that John of the Cross gives so few pointers to the drawing's orientation shows the extent to which Christ's death on the cross changed left and right, top and bottom. The drawing is almost endlessly reversible.

In the following decade, John of the Cross wrote his own poetic version of the *Song of Songs*, called the *Spiritual Canticle*, and the most relevant passage for the drawing is that in verse 23 of his own poem.

Even though He communicates many other mysteries to her, the Bridegroom in the following stanza mentions only the Incarnation, as the most important. In speaking of the soul He says:

Beneath the apple tree:
There I took you for My own,
There I offered you my hand,
And restored you,
Where your mother [Eve] was corrupted[34]

John does not single out the left hand, but the fact that a verse in which the Bridegroom offers his hand to the Bride refers to the incarnation, is clearly a reference to the traditional reading of *Song of Songs* 2:4 proposed by Origen and St Bernard. John goes on to explain that 'as human nature through Adam was ruined and corrupted by means of the forbidden tree in the Garden of paradise, so on the tree of the cross it was redeemed and restored when He gave it there, through His Passion and death, the hand of His favour and mercy, and broke down the barriers between God and man which were built up through original sin.'[35] He then paraphrases the Bridegroom's words: 'there I offered you My kind regard and help by raising you from your low state to be My companion and spouse.'[36] The drawing supremely enacts that lowering, for as we look down on Christ, it is as though he were prostrating himself before us, pulling himself down to the most inauspicious piece of ground, and there stretching out his left arm to us.[37]

This same mystical tradition must have informed Velázquez' two most moving paintings, *Christ on the Cross* (Fig. 23) and *Christ after the Flagellation Contemplated by the Christian Soul*. Both are radically left-sided, and they are his largest and most beautiful depictions of Christ. Here we will focus on *Christ on the Cross*, which is thought to have been made in the 1630s for a convent of Benedictine nuns in Madrid, which had recently been investigated for hysterical and heterodox religious practices. It may have been commissioned by the powerful royal official Jerónimo de Villanueva, who had been engaged to marry the head of the convent, Sor Teresa Valle de la Cerda, before she took her vows. Villaneuva, who had founded the convent in 1623, was suspected of direct involvement in these practices by the Inquisition, and in 1632 was ordered to perform some act of penitence. It is thought he may have commissioned the picture at that time.[38]

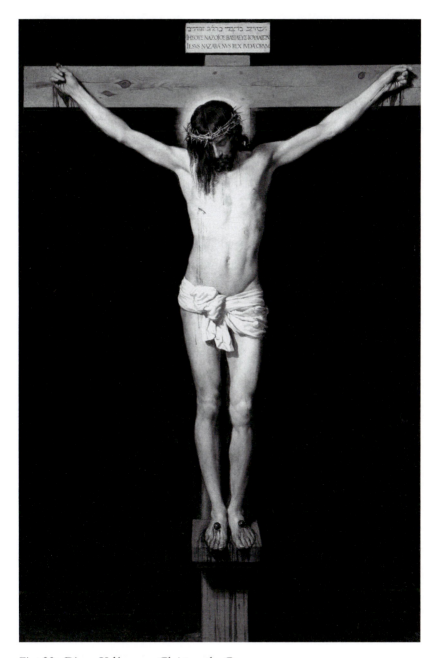

Fig. 23: Diego Velázquez, *Christ on the Cross*

Velázquez' picture is so original and so sensual—and so left-sided—that it is unlikely to have been produced in such delicate circumstances, and may have been commissioned earlier in more carefree times by Villaneuva, perhaps as a tribute to Sor Teresa and her recently canonized name saint. Christ is depicted frontally, with the wound on the right side of his chest, but it is upstaged by the long, wavy locks of dark brown hair that fall over the right side of his face, completely obscuring it. This unprecedented motif might be explained in formal terms: the hair falls in rippling rivulets that echo the streams of blood falling from his wounds, especially from that in his side, which Velázquez exquisitely delineates.

Christ's hair had never previously been a leading protagonist of a crucifixion image, though the contemporary male fashion for long hair had made it more prominent in religious as well as secular art. Usually it was only Mary Magdalene's beautiful locks that had a key role at crucifixions, for she is sometimes shown embracing the cross and wiping the blood off Christ's feet with her hair. This was a reprise of the occasion when she had washed his feet with oil of myrrh and dried them with her hair in the house of Simon the Pharisee. One can only imagine how the participatory 'hysteria' of the nuns would have been inflamed and endorsed by Christ's own Magdalene-like hair.

The emotional and theological orbit within which the picture operates is similar to that of a long poem by Lope de Vega that concludes his *Rimas Sacras* (1614), 'Las Lágrimas de la Madalena' [The Tears of the Magdalene].[39] Here it is Christ's hair that causes the Magdalene to fall in love with him ['Cuando me enamoró vuestro cabello', l. 237], and she never imagines that a Roman soldier would seize his hair with an impudent hand (ll. 273ff). She hopes that Christ's experience of her own hair being rubbed against his feet will cause him to fall in love with her (ll. 265ff), and as she rubs his feet with her hair, the hair is transformed into the roots of the tree of life (ll. 73–88). The tears of the Magdalene wash her Beloved's crucified body, and rise to his mouth to satisfy his thirst (ll. 521ff.). In Velázquez's picture, the blood caresses Christ's body with the delicacy of a tear, and there seems to be a visual interchangeability between blood, hair, and tears—all designed to inflame the spirit of the Benedictine nuns. In another poem from the *Rimas Sacras*, the 'disobedient' hair of Absalom (killed when his hair caught in the branches of a tree) is contrasted with the 'obedient' hair of Christ during his passion; in the very same verse Christ's betrayal is compared with that of Samson, whose strength-giving hair was cut off.[40]

Vega's poetry gives a context for Velázquez's fetishization of Christ's hair, but this still does not explain the total occlusion of the whole of the right side of his face. It seems to cut Christ off absolutely from the realm of the Blessed and of God the Father—and from his seat at the right hand of God. The light falls from his right, but he is doubly dead to it. At this point even his own godliness seems on the point of disappearing: the halo around his head can only muster a dim glow, like the last smouldering embers of a fire. The left side of Christ's body is both more naked and more visible: it is revealed rather than concealed by shadow. It is neither shrouded in thick hair nor in streams of blood: the few drops of blood that trickle here are miniaturized versions of the torrents on the right, individual threads rather than cords. The top of Christ's loin cloth is lower on his left side, movingly and erotically revealing the join between hip and torso, which is deep and dark as a chasm. Such things were noticed at the time: the low-slung loin-cloth of Guido Reni's *Saint Sebastian* (*c.*1620, Madrid Prado) was subsequently repainted to make it less revealing.

In a sonnet in the *Rimas Sacras*, an astounded Lope de Vega asks of the crucified Christ: 'tieni tu Dios abierto el lado izquierdo?' [Do you God keep your left side open?].[41] We too are meant to be astounded by this revelation of the heart side in Velázquez's painting.[42] He follows the local custom of showing Christ crucified with four nails rather than three, and this enables him to push the left knee slightly forward of the right, bringing the left side that bit closer to us. Velázquez draws further attention to the left kneecap by trailing a single hair of blood down and across it. In addition, the left foot is much closer to the side of the wooden footrest than the right, for the feet have been nudged leftwards. The same is true of Christ's hands, for his left hand is closer to the end of the horizontal beam than the right hand, and the left half of the beam is slightly shorter than the right. Finally, the cross itself is not in dead centre of the picture, but slightly to the left (our right).

An old tradition has it that the motif of the falling hair came about when Velázquez lost his temper while painting the hair, and threw his brush at the canvas, striking the right side of Christ's face: so it was understood from the start as a violation and a blinding, with Velázquez effectively participating in the mocking of Christ. It's a sort of Longinus moment, and the 'missing' eye is evoked by the large eye-shaped knot in the horizontal beam of the cross, just above Christ's right forearm. The motif is as shocking as an idea that had been put forward by

Meister Eckhart (*c*.1260–*c*.1328), the great German mystic. In one of his sermons, Eckhart tried to explain the incarnation using a story about a 'rich husband and his wife', using the conjugal language of the *Song of Songs*. The woman has the misfortune to lose an eye, and she fears her husband will no longer love her. But he insists he does still love her: 'Not long after that he gouged out one of his own eyes and came to his wife and said: "Madam, to make you believe that I love you, I have made myself like you; now I too have only one eye". This stands for the man, who could scarcely believe that God loved him so much, until God gouged out one of his own eyes and took upon himself human nature.'[43] In Velázquez' painting, Christ's incarnation is symbolized by the fact that the 'godly' right side of his face is both blinded and occluded: even the crown of thorns is lower on the right side, with a particularly large thorn hanging down over the right eye. Conversely, the 'worldly' left side remains fully visible, and nakedly incarnate.

* * *

MANY OF THE ISSUES we have been talking about come to a head in Vermeer's *Allegory of Faith* (*c*.1671–4) (Fig. 24). The painter's contemporaries seem to have valued it more highly than his other works: when it was sold in Amsterdam in 1699 at an auction of twenty-one of his paintings, it fetched 400 guilders, twice the amount paid for the next most expensive picture. For modern viewers, however, it can claim to be the least loved work of Vermeer's maturity.[44] It was probably made for a Catholic patron, or for the Jesuit order in Delft, and it represents the most elaborate response to the theme of this chapter. Vermeer was always fascinated by light, perspective and optical illusions: but here we have his most ambitious moralization of vision.

The young female allegory of Faith is seated in an interior dominated by a large painting hung on the back wall in which the crucified Christ is viewed from his left. To her left, on a table/altar is a chalice and, beyond that, an ebony crucifix with a gilt bronze figure of Christ who looks to his left and projects his knees far out to his left. Faith herself leans far over to her left, with her right hand clasped to her heart, her left hand resting limply on the table. Her right foot is propped up on a giant terrestrial globe, which suggests the earthly and human foundations of Faith. On the marble floor in front of her left foot is an apple (a reminder of original sin) and in front of her right foot is a serpent crushed under

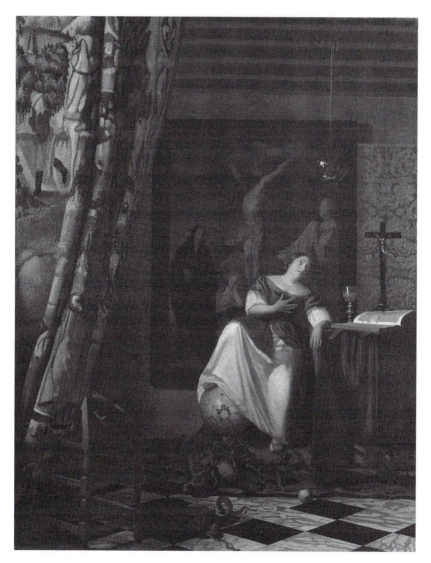

Fig. 24: Jan Vermeer, *Allegory of Faith*

a stone (symbolic of Christ). The overwhelmingly left-sided orientation of Faith's body is counterbalanced by the way in which she looks up with her brightly illuminated right eye at a glass sphere suspended from the ceiling: the chiaroscuro is the most intense in Vermeer's work, and the left side of her face is in deep shadow, as are broad expanses of her white dress.[45]

Although many still-life features of the room, including the mullioned windows, are reflected in the sphere, none of the human protagonists are, whether painted or 'real'.[46] This may be because the 'human' implications of the glass sphere are only accessible to the truly faithful. In the glass sphere Faith should be able to see the reflection of the painting which hangs behind her, but its orientation would be reversed so that Christ would appear to be seen from his right. Thus Vermeer's picture suggests that at the moment of maximum immersion in the world—when we lean farthest to the left—the 'mirror' of Faith simultaneously catapaults us back to the right, giving us a glimpse of eternal life. The pose of the figure of Faith has been compared to the description and illustration of 'Theology' in Cesare Ripa's *Iconologia*, and Ripa's female allegory looks in two directions as well: she is Janus-faced, with her 'young' face looking towards heaven, and her 'old' face looking towards the earth.[47]

Vermeer's figure of Faith evokes aspects of the Bride of the *Song of Songs*, especially in her allegorical function as the Church. The strong chiaroscuro throws deep black triangles of shadow onto Faith's white dress, and these shadows recall the bride's outburst: 'I *am* black, but comely, O ye daughters of Jerusalem, as the tents of Kedar, as the curtains of Solomon' [1:5]. The luxurious pastoral idyll depicted in the *Song of Songs*—'Let my beloved come into his garden, and eat his pleasant fruits' [4:16]—may be evoked by the tied-back tapestry curtain decorated with fruit and flowers and an idyllic pastoral scene in which an unseen figure on a white horse is led by a page through the countryside. Perhaps too the reflection of the mullioned window in the glass sphere is meant to evoke the lines: 'he standeth behind our wall, he looketh forth at the windows, shewing himself through the lattice' [2:9].

* * *

IT WOULD BE ONLY appropriate if Vermeer's painting had been commissioned by the Jesuits, for they would be most closely associated with the Cult of the Sacred Heart of Jesus. Devotion to the Sacred Heart had been practiced during the Middle Ages (St Catherine of Siena, for example, had a vision in which she exchanged her own heart with that of Jesus) but it really took off in the late seventeenth century, when there was a vogue for mystical revelation and ecstatic religious experience.[48] The

visionary experiences of the French nun, Marguerite-Marie Alacoque, who was mentioned in a previous chapter, gave huge impetus to the cult. These visions were experienced after she entered a convent in 1671. She claimed that Christ had showed her his heart, and said: 'Behold this heart which has so loved men, that it has spared nothing, even to the exhausting and wearing itself out, to manifest to them its love.'[49]

The Jesuits were the most vociferous supporters of the cult, not least because it was a key weapon in the fight against the rationalism of the Jansenists, who denied the validity of mystical visions and revelations. The Jesuit Jean de Gallifet published an exhaustive treatise advocating the cult of the Sacred Heart, initially in Latin in 1726, and then again in an expanded French version in 1733. Early editions had a frontispiece illustration by Charles Natoire of an anatomically realistic heart, with a crown of thorns wrapped round it, and a cross emerging from the aorta.[50] For Gallifet, the heart is not just the 'principle of the natural life', it is the part of the body 'which participates most intimately in the holiness of the soul'.[51] The heart had been central to the experiences of many saints.[52] Whether the soul 'is enjoying heavenly sweetness in its holy intercourse with its Divine Spouse, or under supernatural trials is being purified by a thousand interior sufferings, the heart feels all these effects one after the other'.[53] From the heart come 'sobs and sighs', and one only has to think 'of the feelings of a wife at the sight of the heart of a well-beloved husband, who dying far away from her, has let it be sent to her as a pledge of his love'.[54]

Finally, in 1765, as part of a campaign to increase support for the Jesuits, who were now increasingly embattled, Pope Clement XIII ratified the decree of the Congregation of Rites in favour of the cult of the Sacred Heart.[55] Sacred Heart images showing Jesus holding his heart, encircled by a crown of thorns, surmounted by a small cross and radiating light, started to proliferate in Catholic Europe and the colonies. The 'archetypal' image, Pompeo Batoni's *The Sacred Heart of Jesus* (c.1765–7), was painted for the Roman mother church of the Jesuits, Il Gesù, and became perhaps the most venerated of all eighteenth-century religious images. Today, few Catholic churches do not possess a copy or variant.[56] Its oval format cacoons a half-length image of Christ proffering his flaming heart in his left hand and pointing to it with his right.[57] Christ's left shoulder, caressed by luxuriant locks of long hair, is pushed forward and upwards, and his head tilts languidly down towards it. Even the

flames rising from the heart lean to the left. Painted in smouldering soft-focus, we may justly say of Batoni's 'portrait' of Christ what Plutarch said of Lysippus' portrait of Alexander the Great: the artist has 'accurately observed' the 'poise of his neck ... tilted slightly to the left, and the melting glance of his eyes'.

11. Courtly Love

My left hand, on the contrary, is truly beautiful...
Girolamo Cardano (1501–76), *The Book of My Life*[1]

WHEN CHRIST SHOWED HIS left hand to St Teresa, He was showing her the hand of truth, because of his wounded left hand's direct line to the heart. But He was also showing her the hand of beauty. The superior beauty of the left hand was an important component of the courtly love tradition. The Countess of Champagne offers an explanation for the left hand's allure in Andreas Capellanus' classic conduct book, the *Art of Courtly Love* (late twelfth century):

> I should like individual knights of love to be informed that if a lover has accepted a ring from his partner as love-symbol, he should place it on the little finger of his left hand, and always keep the stone of the ring hidden on the inside of the hand. The reason for this is that the left hand normally refrains from all dishonourable and base acts of touch, and in the little finger a man's life and death are said to reside more than in all the others: and all lovers are bound to keep their love hidden.[2]

The Countess' contention is that since right-handers use the left hand less intensively (and not, it would seem, for acts of hygiene), it is unlikely to be worn, cut or dirty (especially, perhaps, the finger nails). By remaining in a pristine state, the left hand maintains a sort of pre-lapsarian purity. It virtually represents a non-utilitarian kind of beauty, akin to the male nipples which St Augustine singled out as being created for aesthetic reasons alone since they perform no practical function.[3]

211

When the Countess of Champagne says that a man's 'life and death' are located in the little finger, she means that one's fate can be read from it: illustrated treatises on chiromancy (palm-reading) show a cross—'+'—near the outer edge of the palm level with the little finger, and the distance of this cross from the base of the little finger determines the length of one's life.[4] Now the weakest finger on the weaker hand is capable of expressing the most powerful truths.

The left hand has often been favoured in chiromancy both because the lines (in right-handers) are less likely to be obfuscated by use, and because of its hotline to the heart.[5] However, in chiromantic diagrams, a left and a right hand are frequently shown side by side, with the former being assigned to women and the latter to men, thus denoting the male's monopoly of power and 'righteousness'.[6] Thus the Countess's activation of the left hand for men as well as for women suggests a 'feminizing' agenda—or, at least, it implies that men should get in touch with their more feminine side.

Similar considerations inform the life-like statue of Isolde in Thomas' *Tristan* (c.1165). Tristan commissions a statue of his lost beloved which he erects in a cave in the forest.[7] In its left hand the statue holds out a ring on which are inscribed the words which Isolde had uttered at their parting: 'Tristan and Isolde shall forever remain one and undivided'.[8] Tristan often 'looks at Ysolde's hand. She is about to give him the ring of gold. He sees the expression on her face as she looks on her lover at their parting, and recalls the covenant that he made at their farewell. At this he weeps...he made this image so that he might tell it what is in his heart'.[9] The ring proffered in the left hand (we are not told where it was worn, but we might assume it was on the little finger of the left hand) triggers off the most powerful feelings.[10]

Much later Dürer would furnish the little finger of Venus' left hand with such a ring in *The Temptation of the Idler* (c.1498), and Titian usually follows suit in his images of Venus: the *Venus of Urbino* keeps her sex secret—and/or fondles it—with her ringed left hand.[11] In Francesco Salviati's *Portrait of a Young Man with a Doe* (1540s), the doe licks the youth's beautifully proffered left hand, its snout strategically positioned above a ring worn on the little finger.[12] This hand hangs before the man's midriff, so the eroticism of this act is as clear as the lady's identity is mysterious. The sculptor in Bronzino's *Portrait of a Young Sculptor* (1540s) cradles a statuette of a crouching Venus or nymph with a supremely elegant left hand, with a signet ring on the little finger.[13]

When Parmigianino created his celebrated *Self-Portrait in a Convex Mirror* (1524), painted on a convex circular wooden panel, the 21-year-old artist pressed his left hand and its flamboyantly ruffled white cuff up against the mirror, massively magnifying it and making the fingers even longer.[14] The artist was noted for his beauty, and here we see him with flawlessly pale skin, flowing chestnut hair, and a perfect oval face. The gold signet ring on his little finger implies he may already be as expert in the art of love as he self-evidently is in the art of painting. There is an element of secrecy about his disclosure—'all lovers are bound to keep their love hidden'—because the signet is tucked under so we cannot read it; adding to the secrecy is the fact that what we see is a mirror-image, and so the hand appears to be his right hand. A more accurate title for this jewel of a picture would be *Self-Portrait of My Lovely and Loving Left Hand*. This sort of ring seems to have been the ideal first ring (no other rings are visible in all these portraits), and one particularly favoured by unmarried youths.

In medical discourse, it was standard practice to say that the frailest parts of the body were the noblest, regardless of their function within the body as a whole. This applied above all to the eyes. As the encyclopedist Bartholomew of England wrote in the early thirteenth century: 'The nobler the complexion of the members the more they suffer when injured, as with the eye which, because of its noblility, is hurt worse by a little dust than the hand or foot would be by a great wound'.[15] However, the Countess of Champagne grants the 'frailest' finger on the left hand, and by extension the whole of the 'heart' side of the body, much of the dignity traditionally accorded to the eye. The little finger, adorned with a dazzling ring, has in fact usurped the eyes in being the 'window of the soul'. Eyes were often compared to jewels, so in this case the lover's hand performs the function of an eye-lid in concealing the dazzling gem.

The most common way for lovers to keep those truths 'secret', however, was not to keep the stone on the inside of the hand, which was perhaps rather painful and impractical, but to have an inscription engraved on the flat inner side of the ring. Tristan and Isolde's ring is presumably a ring of this kind. In England they were called 'posy-rings' (as in poesy or poetry). According to John Lyly, writing in the second part of his *Euphues: the Anatomy of Wit* (1578/80), they were the most secret items of jewellery, 'not to be seene of him that holdeth you by the hand, and yet knowne by you that weare them on your hands'.[16]

In the fifteenth century, the beautiful left hand of the elite was likely to be set off by a dazzling embroidered sleeve. Throughout the Middle Ages, sleeves were usually detachable, and the most elaborate and costly embroidered motifs were usually confined to one arm—invariably the left. This is why we find so many entries for single sleeves in contemporary wardrobe accounts, and they are usually the most opulent.[17] One of the most famous single sleeves belonged to Bona of Savoy and was embroidered with a jewel-encrusted phoenix. The jewels were a mixture of balsases, diamonds, and pearls, and in 1468 the sleeve was valued at 18,000 ducats.[18] Shoulder brooches were also placed on the left side,[19] and this was where protective charms and amulets were usually worn.[20] Albertus Magnus, in his influential *Book of Minerals* (*c.*1260), recommends wearing stones with special powers such as diamonds on the left arm, while Orthodox Jews also traditionally tied amulets to the left arm.[21] In Francesco Colonna's prose romance *Hypnerotomachia Polophili* (1499), we learn that 'Ethiopian chrysolith, flecked with flaming gold... is lucky when worn on the left hand'.[22] No wonder one's eye was drawn to the left side. Most Florentine profile portraits of women show them looking to our left, which not only permitted them to face the profile portrait of their husband, it also meant that the woman's adorned left shoulder is visible.[23]

The mythologizing of the left hand/side reached a peak of refinement and intensity in the fifteenth century. During this period, the Burgundian court, peripatetic but principally based at Bruges, was culturally the most influential in Europe, and it had exceptionally complex and arcane codes of etiquette, particularly relating to seating and standing positions, and one's position in a group or retinue.[24] Here, issues of left and right, before and after, and of physical contact, were of crucial importance. One of the key things that courtiers needed to be versed in was the 'huche'—an invitation, whether with a wave or a call, to hold or touch hands. Only certain people could hold or touch hands, and there were precise rules over who could take the initiative.

It is extremely difficult to reconstruct the history of gesture and movement for any period before the invention of film, both because of the lack of sufficiently detailed sources, and our uncertainty as to the extent that stated ideals of comportment and behaviour were put into practice. The visual arts are only a very partial guide because 'still' images—like those publicizing a film or play—are often staged in a very different way from continuous 'live' action.[25] With the Burgundian

court we have an unusually detailed source, Aliénor de Poitiers' *Les honneurs de la cour* (1484–91), but even this account of court etiquette is frequently opaque.

Aliénor, the widowed Viscountess of Veurne, was the daughter of Isabel de Sousa, lady-in-waiting to Isabella of Portugal, the third wife of Philip the Good, Duke of Burgundy. Aliénor records that in the 1440s, when the Burgundian court was residing in Lille, Madame de Nevers and Madame d'Eu vied over who should have precedence when walking with the Duke. Madame de Nevers appeared to have precedence because 'he always positioned Madame de Nevers below him [au dessous] and Madame d'Eu above [au dessus]'. It seems that being *below* was in this case the position of honour, because it was to the Duke's *left*, and just in front of him, so that he looked in her direction. The fact that the Duke had offered her his left hand, and that she was situated on his heart side, implied greater intimacy. Aliénor explains: 'I have been told by very old people [anciens] who knew about these things that she who walked below the Duke was more honoured than she who walked above. The Duke guided them in this same position when they went somewhere with him.'[26] From this it would also appear that the 'huche' was a gesture made by the left hand.

This change in the status of positional 'high' and 'low' seems counter-intuitive, for although Madame d'Eu literally holds the 'upper hand', she is disadvantaged socially. It was clearly a reversal of traditional hierarchies, for in a threesome (such as Christ on the cross flanked by the two thieves) the most important person was traditionally positioned in the middle, and the next most honoured person to their right. Similarly, in a cortege the VIPs were at the back, not in front. The role reversal presumably only took place if one was standing or walking while holding or touching hands—that is, in an affectionate or amorous context—rather than sitting at a formal banquet.[27] Indeed, seating arrangements at the Burgundian court conformed to the traditional hierarchy, with the most honoured male guest placed on the Duke's right. Descriptions of seating plans at Burgundian feasts always begin by naming the person seated on the Duke's right.[28]

The protocol for this new positional hierarchy is most likely to have been inspired by the *carole*, a dance that seems to have been in fashion from the twelfth century until around 1400. In the *carole*, the dancers formed themselves either into a circle or a line, holding hands with their immediate neighbours, and then moving to their left. For moralists such

215

as the anonymous author of the *Mireour du monde* (1270s; The Mirror of the World), this movement proved that dancing was evil: 'That caroles are processions of the Devil is obvious, because they turn to the left. Of which Holy Scripture says "God knows the ways that turn to the right; those that turn to the left are perverse and bad, and God hates them".' Nicole Oresme, in his *Le Livre du Ciel et du Monde* (1370s; The Book of the Heavens and the World), compared the movement of the planets around the sun to the dancers in a *carole*, and he later explained that 'each member of the dance goes ahead of the person on his right, and behind the person on his left'.[29] It is almost as though the Duke and the two ladies are dancers extracted from a *carole*, moving forwards but turning their bodies and faces to their left.

At the Burgundian court the unrivalled ability of the left hand to make loving gestures—and to take the initiative—is taken for granted. The most recent editor of *Les honneurs du cour* has said that none of the gestures there described were depicted in contemporary visual arts, but this may only be true in relation to depictions of ceremonial life at court. Jan van Eyck was Philip the Good's court painter, and the elaborate gesture made by Giovanni Arnolfini in relation to his wife in their portrait could well be a version of the 'huche'. Arnolfini made his fortune supplying textiles and luxury goods to the Burgundian court, so he would have been as familiar with court etiquette as Van Eyck. He was certainly aware of Philip the Good's sartorial tastes: muddy wooden clogs are conspicuously placed near his feet, and the wearing of clogs—both indoors as well as outdoors—had been made ultra-fashionable by the Duke.

The oblique position of Arnolfini's feet means that his wife is in front of him—'devant' and 'au dessous'. The fact that he does not grasp her right hand with his outstretched left, but places it beneath hers, and that she lays her hand on his with the palm facing upwards, suggests we are in the realm of exquisite courtly gestures—gestures that could just as easily belong in a dance. Aliénor does not specify how the courtiers held hands, but it seems likely that something more sophisticated than a potentially clammy hand lock would have been performed. We know that in contemporary dance the lightest of touches was prized. In *Le Roman de la Rose*, dancers of a carole intertwine their little fingers: 'Sir Mirthe hir by the finger hadde / Daunsyng, and she hym also' (Chaucer's translation).[30] An illustration in a dance treatise by the great Italian dance master Guglielmo Ebreo (1463) shows that the finger hold

was still standard practice. Three supremely elegant dancers—a young man flanked by two women—advance with little fingers intertwined. A dancer's life and death hung by their little finger.[31]

Arnolfini stretches out his left hand to his wife with honorific intent, and she responds with absolute trust: her upturned palm is the courtly equivalent of a cat or dog that rolls over so that its tummy can be stroked by a beloved owner (a pet dog stands at her feet). In the mirror, we see the reflection of a man in blue costume entering the room, with another man (probably a servant) behind him. This is often assumed to be a self-portrait of the artist, who was probably a friend of Arnolfini as he painted a second portrait of him in later years. Whoever he is, he too appears to be performing a 'huche', for he is raising his left arm (the right in the mirror), as well as taking a step forward with his left foot.[32]

It may well be that the 'huche' was influenced by the Bridegroom's gesture in the *Song of Songs* when he reaches out his left hand to the Bride. In the case of Arnolfini, his left hand is under his bride's right hand. An illuminated manuscript commissioned by Margaret of York, the wife of Charles the Bold, Duke of Burgundy, may be relevant here. Her copy of Nicholas Finet's *Dialogue between the Duchess of Burgundy and Jesus Christ* (shortly after 1468) contains an image of Christ appearing to her which has been attributed to the Master of Guillebert de Lannoy.[33] The Duchess kneels, with both hands raised before her to chest height, in front of a bed in a room that is comparable to that featured in the Arnolfini portrait. Christ stands before her and elegantly stretches out his left hand (the little finger is slightly raised) so that she can see the nail wound; his left foot is pushed forward in an equally graceful manner. In his raised right hand, he holds a crozier. A 'faithful' dog—a greyhound—lies on the floor in the foreground. Burgundian court etiquette was inherited by the Hapsburgs, and exported by them to Austria and Spain, so it is quite possible that the gesture of St Teresa's Christ was also influenced by it—with Teresa put in the same 'au dessous' position in relation to Christ that was occupied by Madame de Nevers in relation to the Duke of Burgundy. The precedent of the *Song of Songs* no doubt helped the 'huche's' spread.

* * *

LORENZO DE' MEDICI (1449–92) had extensive financial, political, and social contacts with the Burgundians, since the Medici bank had its most important foreign branch in Bruges. He is the high priest of the

Renaissance cult of the left hand, and it is he who sets it on the grandest of moral and cultural pedestals. For Lorenzo, an accomplished poet as well as de facto ruler of Florence, the left hand reigns supreme, and puts the right hand firmly in the shade. The ultimate privilege is to be offered the left hand of his lady, as happens in this sonnet:

> La mi porgea la sua sinistra mano,
> Dicendo:—Or non conosci el loco? Questo
> È il loco ove Amor pria dar mi ti volle!—[34]

[She offered me her left hand, saying:—Do you still not know this place? This is the place where Amor begs me to do your will!] He is presumably referring to the left hand of his 'platonic' love, Lucrezia Donati. By offering her left hand, the lady signals both that she is favouring him, and that she trusts he will treat her with due respect. Lorenzo explains in detail what the left hand means to him in an extended commentary on three consecutive sonnets in which the hand of his beloved is praised. The commentary, which was left unfinished at his death in 1492, was a literary exercise comparable to Dante's *Vita Nuova*. In the first of these sonnets he extols the 'candida, bella e dilicata mano' [white, beautiful, and delicate hand] which she uses to draw his heart out of his chest, tying it with a thousand knots and refashioning it anew so that it is disposed to love her. In the commentary he insists he is referring to her left hand, which implies that they are standing not so much face to face, as heart to heart, so that each could reach out their left hand to the other. The left hand is that which:

> originates in the heart, and so appears as a more reliable messenger and witness of the intentions of my lady's heart: this is because it is said that in the ring finger, which is next to the finger commonly called the little finger, is a vein that comes directly from the heart, as if a messenger of the heart's intention.[35]

Lorenzo's interest in this charming biological myth would have been fuelled by the fact that he knew its antique origins. The standard explanation for this practice, which derived from the Egyptians, is given by a doctor in Macrobius' educational dialogue the *Saturnalia* (c. AD 400): 'there is a certain nerve which has its origin in the heart and runs from there to the little finger of the left hand, where it ends entwined with the rest of the nerves of that finger; and that this is the reason

why it seemed good to men of old to encircle that finger with a ring, as though to honour it with a crown'.[36] This was repeated by the great etymologist Isidore of Seville (*c*.560–636), with a subtle but momentous change. Isidore said that a vein rather than a nerve lead directly to the heart.[37]

Lorenzo's championing of the left hand could therefore be seen as a further manifestation of his love of classical antiquity. In fact, interest in Roman ring lore amongst the Medici may have started earlier. A classicizing treatise on marriage by the Venetian humanist Francesco Barbaro, *De Re Uxori* (*c*.1415–16; first published 1513), was written to celebrate the marriage of Lorenzo's eponymous ancestor Lorenzo di Giovanni de' Medici (1394–1440), brother of Cosimo de' Medici. Barbaro cites the Roman convention, and their belief in the nerve leading to the heart, adding that the ring was placed on this finger 'so that it might be a perpetual monument before their eyes of their great love for their husbands'.[38] In the fifteenth and early sixteenth centuries several Florentine paintings of *The Marriage of the Virgin* and *The Mystic Marriage of St Catherine* by artists associated with the Medici took the unprecedented step of showing the ring being placed on the bride's left hand. Here, archaeological exactitude (the Virgin and Catherine were all subjects of the Roman Empire) went hand in hand with an intensification of 'heartfelt' feeling.[39]

There was probably one more crucial component in Lorenzo's cult of the left hand, which involved an element of 'Tuscan' nationalism. As we have previously noted, the Etruscans—in marked contrast to the Greeks—had favoured the left side in their religion: Etruscan augurs would face south, and so the 'auspicious' east was to their left.[40] Signs that appeared on their left—whether the flight of birds or dramatic meteorological conditions—were usually considered favourable. Republican Rome followed Etruscan practice, and it was only under the Emperors that the Greek system, which involved the augur facing north, prevailed. It was then that 'laevus', the Roman word for left, acquired the meaning 'clumsy' and 'inauspicious'—an association that would be perpetuated with great enthusiasm and resourcefulness by the early Christian Church. Lorenzo was redeeming 'laevus', taking it back to its unsullied Etruscan origins.[41]

* * *

ACCORDING TO ALIÉNOR DE Poitiers' account of the Burgundian court, when a woman walked hand in hand with a man, and he was positioned in front of her and to her left, this merely denoted her superior status, and had no special honorific significance for the man, even if she offered her left hand to him.[42] For Lorenzo, however, any proactive proffering

Fig. 25: Netherlandish Artist, portrait of *Lysbeth van Duvenvoorde*

of the left hand, whether by a man or by a woman, brings honour to the recipient of that gesture.

One of the earliest surviving Netherlandish portraits suggests that this view may have been quite widespread. The full-length standing portrait of *Lysbeth van Duvenvoorde* (c.1430) (Fig. 25) originally had a pendant portrait of her husband Simon van Adrichen that was lost during the last century.[43] It is one of the earliest individual portraits in European painting. Lysbeth belonged to one of the most important noble families in Holland, and so presumably had some knowledge of Burgundian court protocol. Decked in a sumptuous red loose gown with voluminous sleeves known as a houppelande, and with an elaborate hair-do, she faces to her left, and with the dainty fingers of her raised left hand clasps an S-shaped scroll that bears an inscription: 'I have long yearned with hope; who is he who will open his heart?' The left hand is here literally the 'messenger' of her heart's desire. The 'S' presumably stands for Simon, whose portrait would have been to her left. The ring finger and the little finger of the left hand are both elegantly outstretched and each bears two substantial rings. The flaunting of her left hand contrasts with the total supression of the right, which is concealed under the voluminous sleeves of her dress.

Her husband is known to have held a scroll inscribed: 'I am greatly troubled; who is she who will honour me with her love?' The diptych must have been commissioned to celebrate their marriage in 1430, but the air of exquisite amorous uncertainty, with both teetering on the edge of erotic 'life and death', suggests it is a retrospective evocation of the first efflorescence of their love.[44] The privileged positioning of the woman on the heraldic dexter is unlikely to have been due to the superior status of her family, for the fathers of Lysbeth and Simon were both high-ranking administrators at the court of Count William VI, and Simon also held an important administrative post. Although it is her husband who talks about being honoured, any notional superiority is forgotten in the mutual expressions of affection: they seem equals in love.

A comparable scenario is depicted on the front of a late-fifteenth-century Flemish parade shield (London, British Museum), made from wood, leather, and painted gesso.[45] It is a long vertical lozenge, divided down the middle like a diptych. On the heraldic dexter portion (our left) stands a beautiful lady who looks over to her left, and dangles in her outstretched left hand a long gold chain that is fastened at one end

to her waist. She is being serenaded by a kneeling knight in full armour, depicted opposite her in the heraldic sinister portion of the shield. A scroll floats above him inscribed with the legend VOUS OU LA MORT [You or death], and to this end a skeletal figure of death stands over his left shoulder and reaches out his arms towards the knight. The basic idea is that if she doesn't open her heart to him, by offering him as a favour her gold chain (which is itself an 'emissary' of her own heart), then death will claim him instead.

During the Renaissance, the apotheosis of the left hand plays a significant part in what has been called the 'civilizing process', and the claims of the left hand were sometimes made at the expense of the right hand: Lorenzo de' Medici overtly disdains the right hand because it is more aggressive, the one that usually strikes enemies and holds weapons. The aesthetic and moral superiority of the left hand was to be dramatically asserted by the hypochondriac astrologer-cum-philosopher Girolamo Cardano (1501–76) in his self-mythologizing autobiography, *The Book of My Life*: 'The thickly fashioned [right] hand has dangling fingers, so that chiromantists have declared me a rustic; it embarrasses them to know the truth. The line of life upon the palm is short while the line called Saturn's is extended and deep. My left hand, on the contrary, is truly beautiful with long, tapering well-formed fingers and shining nails.'[46] The palm-readers are clearly rather 'old school', and have made the mistake of reading his right hand rather than his left. It may be that Cardano's left hand was markedly more beautiful than his right, but his high opinion of it is evidently influenced by fashionable cultural mores. Cardano fondly believes his left hand is the truest mirror of his heart and soul: he refers to it with the possessive—'*my* left hand'—while the right hand is referred to with an alien *the*—'the thickly fashioned hand'.[47] In his treatise on *Metoposcopy*, Cardano adds a further dimension to his belief in the superior beauty of the left side, for here he implies that the left side of the body is actually much *younger* than the right. The marks on the forehead are divided into three zones:

The zone on the left relates to the first period of life (up to thirty years of age), because it is under the jurisdiction of the Moon, which presides over infancy.

The zone in the middle of the forehead is that of adult life up to the age of sixty.

The zone of the right of the forehead extends up to ninety years of age, or to the end of life.[48]

Michelangelo is likely to have been exposed to Lorenzo's cult of the left hand in his early years when he was a member of Lorenzo's household between 1489 and 1492 (Lorenzo died in 1492). The most complete and reliable early transcriptions of Lorenzo's sonnets and prose commentary have been dated to 1492–3, so Lorenzo had probably been trying to put them in order at this time.[49] There is an interesting dichotomy in the depiction of hands in Michelangelo's *Creation of Adam* on the Sistine Ceiling (1508–12). Despite being closest to God's animating finger, Adam's raised left hand remains a miracle of languid grace, whereas his own right arm, on which he leans, is more energized: it appears 'thickly fashioned' and the clenched hand has a tense, rocky obduracy. Similarly, God's right hand, with its extended index finger, is sublimely purposeful and instrumental, whereas the impossibly long index finger of his left hand is double-jointed and unfurls itself luxuriantly over the shoulder and neck of an attendant boy. To us it looks rather grotesque and tentacular; but it is clearly meant to be the epitome of craggy elegance. Where portraiture is concerned, Cardano could not have done better than to be painted by his contemporary Bronzino (1503–72), for the Florentine artist almost always foregrounds the left hand and side of his male and female sitters; he would undoubtedly have done justice to the 'long, tapering well-formed fingers and shining nails' of Cardano's left hand.

One of the main reasons for Lorenzo de' Medici's apotheosis of his lady's left hand is because he perceives it to have a vital role in couple dances. He says that although the lady's eyes made the first 'wound' in his heart, 'then, as often happens, either while dancing or in another equally honest way I was again made worthy to touch her left hand'.[50] When a man danced side by side with a woman in a couple dance, he stood to her left, and so held her left hand.[51] In a romantic reversal of the convention for married couples, the man was effectively the woman's servant and supplicant (even if he used his right arm to guide his partner). In a deeply segregated society it is not hard to imagine the lightning strike that could occur when a man and woman touched for the first, and perhaps only time, during the course of a dance—and this was, of course, the reason why so many moralists wanted dancing to be banned.

The diptych of Lysbeth van Duvenvoorde and her husband might be inelegantly described as a static 'invitation to dance' portrait.

A rumbustuous illustration of a dancing couple occurs in a series of Florentine engravings on secular subjects from the 1470s attributed to Baccio Baldini.[52] The engraving is circular and was probably made to be glued to the lid of a toilet- or work-box, and perhaps given to a woman as a love token or marriage gift. A circular image of a young couple dancing in a meadow is encircled by a wreath that incorporates music-making cupids and, at the bottom, a reclining couple. The dancers and the reclining couple are, as Hogarth might say, 'before' and 'after' images. The man dances to the left of the woman, holding her left hand, and on his left sleeve is an elaborate embroidered inscription in french: 'AMEDROIT'—'to me the right [to love this lady?]'.

The 'after' couple in Baldini's print recline full length on the ground, with the man stretched out behind and to the left of the woman. She is naked but he remains clothed. She reaches her left arm across to grasp his right which has been raised to offer her a flower. The print suggests that her nakedness is the inevitable consequence of her prior offering of her left side to him in the dance: it constitutes an open invitation, and by doing so, she effectively denudes herself first.

When Lorenzo de' Medici says that 'while dancing or *in another equally honest way* I was again made worthy to touch her left hand', he is obviously concerned to allay skepticism about the 'chastity' of his motives. He hopes that his apotheosis of his lady's left hand will be seen as an honourable attempt to transcend what we might term the genital fixation of courtly love. In most Arthurian romance, and in courtly love, sexual intercourse is central—and the more illicit the better. King Arthur, a bastard, is cuckolded by his best knight, Sir Lancelot (another bastard), and there is little sense that either Lancelot or Guenevere think their behaviour wrong or shameful.[53] Not surprisingly, Dante's adulterous lovers Paolo and Francesca stole their first kiss while reading the story of Lancelot and Guenevere's first tryst, arranged by Galehot.[54] The hugely popular allegorical poem the *Roman de la Rose* (2nd pt: *c.*1275–80) charts the journey of a male lover in search of his beloved 'rose', and by the end the rose has become a clear metaphor for the female genitals: when the lover eventually forces his way into the rose garden, he none too subtly impales and shakes the rose with a long stick attached to a bulbous leather bag. The goal of chivalric romance is perfectly illustrated

by a twelve-sided panel painted by the so-called Master of San Martino, *The Round Table Knights Worshipping Venus* (*c.*1450). Six knights kneel in a semi-circle before the naked standing figure of Venus, and golden rays travel from the eyes of each knight straight towards the goddess' *mons veneris*.[55]

Lorenzo tries to shift the centre of attention and desire from the lower middle to the upper left, and for those who remain unconvinced he immediately adds an explanatory coda: he was again made worthy to touch his lady's left hand 'because one climbs the ladder of love step by step'.[56] He is here conflating the left/right passage in the *Song of Songs*, with the neo-platonic doctrine that a love of visible beauty is the first step on a journey that culminates in love of the divine. Lorenzo wants to assure us that the touch of her left hand will culminate in a spiritual embrace—in other words, he would have us believe that her left hand is the bottom rung of a ladder that leads upwards and rightwards to purely spiritual delights, rather than the head of a snake down which he slides to her nether regions.

The beautiful left hand of the Virgin in Michelangelo's St Peter's *Pietà* (1498–9), which was made for the funerary chapel of a French Cardinal, functions like the first rung of a ladder of love. Whereas the right hand supports Christ's body, its fingers purposefully splayed to the point of dislocation beneath his armpit, the left hand floats free, as if testing the air. The Virgin gestures almost unconsciously towards the viewer who would have first seen the sculpture from the left as he entered the chapel. The gesture is a double invitation—to come closer, and to gaze on her son's body. It is a divine 'huche'—an irresistible honorific invitation to touch and be touched by God.

The most emphatic illustration of this conception of an elevated and elevating left hand was painted nearly a century later, in Elizabethan England. It is an enchanting head-and-shoulders portrait miniature by Nicholas Hilliard which is usually titled *Man Clasping a Hand from a Cloud* (1588): a dapper young man raises his right hand up to head height in order to clasp a dainty female left hand that pops out from the base of a fluffy cloud. A mysterious explanatory inscription—'Attici amoris ergo'—floats up between the clasped hands and the man's head. If it were translated as 'Athenians on account of love', it could be a lapidary reference to platonic love.[57] The miniature was presumably given to the lady and worn suspended from her neck, protected by a cover, or fixed

over the heart. When she wanted to gaze on her beloved, she very likely (if she was right-handed) held it in her left hand, opening the lid with her right.[58] Thus the lady's *real* left hand and her *painted* left hand hold the image of her suitor.

* * *

THE SIGNIFICANCE OF THE dance to Lorenzo and his contemporaries did not reside solely in the fact that the man held the woman's left hand when dancing as a couple. Of equal relevance was the convention that all dancers, male as well as female, led off with their left foot, and so seemed to open up the whole left side of their bodies, especially when standing opposite their partner. They also finished the dance with a movement of their left foot, and paid 'reverence' to their female partner by standing next to her and sliding their right foot behind the left, so that the left leg ended up pointing towards her.[59] Indeed, what singles out the Renaissance above all is that the entire left side of the body takes on the beauty, truth and fragility that the Countess of Champagne accorded to the lover's little-finger. Lorenzo himself wrote a 'Bassa danza called Venus, for three persons' in the 1460s, and this begins with a 'slow sidestep, and then they together move with two pairs of forward steps, beginning with the left foot'.[60] The slow forward step would have opened up the left side: in a 'Canzoni a ballo' [Chi non e inamorata], Lorenzo orders anyone who is not in love to leave the dance and no longer 'stare in sì bel lato' [be positioned next to such a beautiful side].[61]

Evidently the thoughts of dancers didn't always fly high, and such exposure was frequently regarded as supremely erotic: in a conduct book for would-be lovers published in Florence in 1547, lady dancers are advised to 'find a dark or quiet part of the room, always keeping an eye out to make sure you are not seen, and then take his hand and force him to touch your left thigh'.[62] Presumably while holding his hand during the dance she 'accidentally-on-purpose' brushes her thigh with it. In a similar vein Veronica Franco (1546–91), the Venetian courtesan and poet, in a verse letter replying to her favourite lover, the leading politician and poet Marco Venier, says that her own beauty will be dedicated to making him happy, and she will make him taste the delights of love, 'when he is close to my left side' [quand'egli e ben apreso al lato manco].[63]

This position must be what the bald, grey-bearded lecher hopes to take up in Tintoretto's *Susanna and the Elders* (*c*.1555; Vienna Kunsthistorishes Museum). We see a supremely voluptuous and naked Susanna in left profile as she sits drying herself before a mirror propped up against a tree trunk in the foreground. It is evident that we occupy the prime position, because the elder, with his shiny dome-like pate, is manoeuvring himself round the back of the tree to take up a position next to us; another elder in the distant background has a good view of Susanna's right side, but does not or cannot bring himself to look at it: he looks down at the ground rather bashfully instead of across.[64] Similarly in Giorgione/Titian's *Fête Champêtre* (*c*.1511), the left sides of the two naked women are fully exposed to us, and one of the women holds a glistening glass jug in her left hand, and pours water out of it into a well, which emphasizes the refreshing 'purity' of the left hand and side.[65] Our visual claim on both women's left side is not challenged by the two clothed men for they chat amongst themselves, seemingly oblivious to their presence, and it is we who occupy the privileged viewing position.

The grandest 'left-sided' picture of all is Botticelli's *Primavera* (*c*.1482). (Fig. 26). This was first owned by Lorenzo de' Medici's cousin twice removed, Lorenzo di Pierfrancesco de Medici, and some scholars believe it was commissioned by Lorenzo de' Medici for his cousin's wedding. Here eight of the nine protagonists—Zephyrus, Chloris, Flora, Venus, Cupid, Mercury, and two of the three Graces dancing clockwise in a circle, incline their left side towards the viewer. Their left hands are not held out, but the implication is that in Spring, one's thoughts turn to love, and that one flourishes one's left side in the same way that plants unfurl their flowers and petals. The closest to us is Flora, who pushes a dainty and naked left leg almost to the front edge of the picture. It is practically an invitation to dance.

The French cleric Thoinot Arbeau, in his important illustrated dance manual *Orchesographie* (1588), claimed that dancers set off on the left foot because 'the left foot is weaker, and if it should chance to stumble for any reason, the right would be straightway ready to succour it'.[66] But to aspiring or actual lovers this weakness was a strength: the presentation of the left side allowed the total exposure of the dancer's sensitive 'heart' side. The Venetian petrarchan poet Pietro Bembo (1470–1547) exploited just this dance convention in a sonnet written before 1503. The poet compares himself to a young hart that comes out in springtime

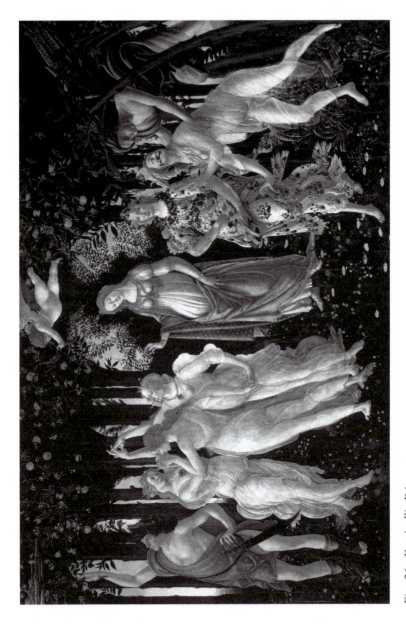

Fig. 26: Botticelli, *Primavera*

to graze 'far from houses and shepherds', and he does not fear 'an arrow or other treachery' until the very moment when he is shot at by a concealed archer. The poem concludes:

> tal io senza temer vicino affanno
> moss' il pied equal dì, che I be' vostr'occhi
> me 'mpiagar, Donna, tutto 'l lato manco[67]

[in the same way did I without any fear move my foot so that your beautiful eyes, my Lady, could feast on my whole left side]. Bembo thinks of himself as the man in the *Song of Songs*, who in springtime comes 'leaping upon the mountains' and 'skipping upon the hills' like a 'roe or a young hart' [2:8–9]. Here, love is manifested by instinctively or unconsciously moving one's body so that the 'left side' is totally exposed to the beloved. But by revealing that he does this 'without any fear' Bembo imparts an exquisite ambiguity to the gesture. On the one hand, it implies that Bembo is an innocent 'virgin' who is totally unaware of what is about to happen (that he is going to be shot by Cupid's arrow); on the other hand, it suggests he is all too experienced and knows exactly who she is and what is about to happen. The very mention of fear implies he has suffered before in love, possibly even at her hands. But by stating that he has complete faith in her, he is insisting she should not mistreat him. It is thus passive-aggressive: having come 'naked' into her presence, he now expects to triumph.

These conventions still inform what must be the most famous 'dance-step' image of all, Hyacinthe Rigaud's resplendent state portrait of *King Louis XIV* (1701), where the strutting French peacock strikes a ballet pose in his robes of state, daintily pushing forward his left foot and white-stockinged left leg. The hilt of Louis' sword also projects forward from his left hip, as if inviting his notional dance partner to 'draw' his sword. Louis was a celebrated dancer, but here his dance partner is evidently meant to be 'la France'. He is surrendering himself, body and soul, to the French nation, which he serves. Political propaganda has rarely been so charismatically preposterous.

Much further into the future, these same conventions would inform a compliment beloved of contemporary soccer commentators, that a great player has 'a cultured left foot'. The right foot is never described in such elevated terms, and according to a recent pundit this is an accurate description of the 'unique elegance' of 'great left-footers such as Jim Baxter, Liam Brady and Georghe Hagi'.[68] Fittingly, a website dedicated

to Arsenal FC, a club justly celebrated for being the world's most elegant passers of a ball, is called 'A Cultured Left Foot' . . .

* * *

A KEY MOMENT IN the aesthetic education of the ruling and warrior classes was the founding by King Edward III of England of The Order of the Garter in around 1348. The device of this quasi-chivalric Order was a garter worn below the left knee whenever the companions of the Order appeared in public. The garter was a beautiful luxury item, made from light-blue cloth, with the motto 'Honi soit qui mal y pense' [Shame on whoever thinks badly of this] embroidered in gold thread. The motto must have referred at least in part to Edward's claim to the French throne, the pursuit of which inaugurated the Hundred Years' War. Those who wore the garter were advertising their heartfelt loyalty to their King and to their fellow companions.[69] It is the only one of Edward III's recorded mottoes to be in French, and almost all the first Knights of the Garter had fought at Crécy.[70]

Although its origins may be primarily military and political, the garter must always have had a frankly erotic frisson, not least because its position meant that companions of the Order were encouraged to keep their left leg uncovered and even foregrounded. One imagines that this flaunting would have been done very elegantly, even by the most hard-bitten professional soldier. The penitential devotional memoirs of one of the founding members of the Order of the Garter, Henry, Duke of Lancaster (c.1310–61), give us a strong sense of the delight that such accessories could give. Looking back over his life in Le Livre de Seyntz Medicines (1354; The Book of the Holy Doctors), Henry regrets his misplaced pride in the way his feet looked in stirrups, shoes, or armour, his light-footed display of dancing and the garters he had worn that were 'beyond compare'.[71] It is scarcely surprising if by the mid-fifteenth century, the garter was being interpreted in continental Europe as a love token. It was said that the idea for the Order came to Edward after he picked up a garter that had fallen from the stocking of a lady in his court, and when some knights began to jeer, he declared that they would soon hold the same garter in the highest honour. Ever since the first historian of the Order, Elias Ashmole, writing in 1672, dismissed this as the scurrilous invention of a French courtier, there has been some skepticism about this genealogy, and it does seem unlikely that anyone would have had the temerity to laugh at King Edward III to his face.[72]

But the idea that a knight's left leg should bear witness to his love, even if—and especially if—this invited derision, and that he should then go to war to expiate his shame and win his lady, was certainly something that King Edward and his romance-reading contemporaries could have understood. Indeed, the use of French for the motto might equally have been because this was the language of the most celebrated Arthurian romances, from Chrétien de Troyes onwards. The Order of the Garter had, after all, been intended to emulate King Arthur's Round Table. The adoption of a garter as a device, and its placement on the left leg, invites and even demands such stories.

This reading gains credence from the fact that by 1348 garters, having been a relatively popular item of male apparel in the early fourteenth century, were no longer being worn by men of fashion.[73] It is certainly possible that their démodé status now gave garters a quaint antiquarian allure. But a more plausible explanation may be that since women continued to wear garters, a garter with a laconic inscription concerning 'shame' could not be mistaken as anything other than a love token given by their lady love. In Chaucer's *Canterbury Tales*, written at the end of the century, the libidinous Wife of Bath wears hose of 'fine scarlet redde / Ful staite y-teyed'—in other words, tied with a garter.[74] As such, the garters would have given the King's hard-nosed French adventure an eminently romantic gloss. In this respect it is interesting to note that Order of the Garter is one of only two monarchical orders to admit women members, and they had to wear the garter over their left sleeve above the elbow—that is, next to their heart.[75] The garter also, of course, helped confirm the superior beauty of the left side of the body.

* * *

EVERY KNIGHT NEEDED A good horse, and Lorenzo de' Medici, in a discussion of nobility that directly precedes his praise of his lady's left hand, imagined a horse that might have been designed with a Knight of the Garter in mind. This is not so surprising as Lorenzo was an expert horseman and organized regular jousting tournaments in Florence. He argues (following Dante, Andreas Capellanus and others) that nobility is not confined to those who are born into aristocratic or wealthy families: 'a certain thing is "noble" that is well adapted and disposed to perform perfectly the office to which it is well suited, accompanied by grace that is a gift of God.' A 'noble' race horse is one that 'runs faster than the others' and is 'pleasing to the eyes'. Lorenzo then gives a

detailed description of the proportions and appearance of his ideal horse. Giving a precise account of a horse's colour and markings was standard practice in household accounts and inventories,[76] for they were believed to determine the horse's character, but Lorenzo's ideal horse exhibits one striking asymmetry. It has to have 'a coat pleasing to the eyes with some good marking—as a nearly all black horse would be, for example, with a white band on the left back foot [col piè di drieto sinistro balzano] and a little star on its forehead'.[77] This white band is the equine equivalent of a garter, or a lover's ring.

12. Fragile Beauty

> Ask anyone who has knowledge of the most beautiful living human
> beings, whether they have ever seen a flank to compare with the left
> flank [of the Belvedere Torso].
>
> Johann Joachim Winckelmann, *Description of the Belvedere*
> *Torso in Rome* (1759)[1]

THE BEAUTY OF THE left side is at its most intense when the left side
is in imminent danger. It is at these moments of heightened expo-
sure that it seems to be most intensely because vulnerably alive, with
heart pumping and blood coursing through the veins. That archetypal
antique image of female beauty, *Venus Pudica* [modest Venus], of which
innumerable copies were made, shows the goddess turning sharply to
her left, suddenly startled by an unseen intruder. The implication is
that the 'intruder' has found the ideal vantage point from which to
spy on the goddess, and that her being startled heightens her already
considerable attractions because it stimulates movement and a supremely
elegant 'contrapposto' pose.

Hans Baldung Grien's doomed maidens are partly inspired by antique
sculpture, and their own 'contrapposto' is a final flourish that provides
aesthetic—if not moral—fulfilment. Indeed, in all Last Judgements prior
to Michelangelo, there is usually a contrast between the saved on
Christ's right, who are static sentinels sheathed in stiff clothes, and the
naked damned on Christ's left, who adopt dynamic postures ultimately
inspired by classical art: 'classical corporeality is a sign of fallen flesh.'[2]
For many christian moralists, it is the supreme beauty of the left side
that makes it so dangerous and potentially evil; when they single it out
for chastisement, they are attempting both to destroy and purge that

beauty. During the Renaissance, however, artists increasingly attempt to suspend time, and to eternalize what should only be a fleeting moment of supreme, unscarred beauty: Death and the Devil are held in abeyance. The left side is idolized.

In this chapter, I would like to look in more depth at some celebrated Italian and antique sculptures in which a 'risky' exposure of the left leg/side is central to their beauty. My first example is Donatello's marble statue *Saint George* (*c.*1416) (Fig. 27), one of the pioneering works of the Florentine Renaissance.[3] The statue was commissioned by the armourers' guild, and was placed in a gothic-style niche on Or San Michele, the headquarters of the city's guilds. A low relief of a blessing God the Father surmounted the statue, while below, as a predella, was a long narrative relief depicting St George killing the dragon. The niche is very shallow, and St George's left foot overhangs the front ledge. Vasari admired the statue for being very 'vivid and proud; the head shows the beauty of youth, the brave spirit of the warrior, a true-to-life quality terrifying in its fierceness, and a marvellous sense of movement within the stone. Certainly among modern statues there is none in marble with such vivacity or spirit as nature and art achieved by the hand of Donatello in this'.[4] Equally enamoured was the author of an imaginary mid-sixteenth-century dialogue in which St George asks a sculptor from Fiesole: 'Why do you resent my beauty? It was impossible that Donatello should represent me otherwise than I am.'[5] The statue was also admired by the burlesque poet Anton Francesco Grazzini (1503–84): he called Donatello's *Saint George* his beautiful Ganymede, and proclaimed that the statue was far superior to any living boy friend.[6]

One of the most original aspects of St George's pose is the way in which he pushes out his left leg, with his weight resting on it, while at the same time drawing back his shield.[7] The knight has pushed his shield across his body with his left hand so that it now rests on the ground and protects his withdrawn right side. His left hand, broad but with long elegant fingers, seems to be insouciantly stroking rather than nervously grasping the top of his shield, which is emblazoned with a cross. The removal of the shield enables him to push his left leg forward, and roll the toe of his left foot over the front edge of the pedestal. His head and especially his eyes are turned to the left, and the implication is that the danger is coming from this direction. He seems to be defying an enemy to strike even though he is now unshielded on that side.[8]

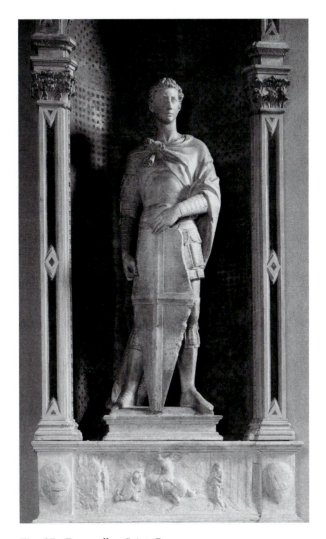

Fig. 27: Donatello, *Saint George*

At first sight, this would appear to be a neat illustration of a point made by St Bernard of Clairvaux in his *Sermon on Psalm XC: 'qui habitat'*, which we cited in the chapter on 'Darkened Eyes'. Here St Bernard insists that whereas 'worldly soldiers only wear their shields on their left side', spiritual soldiers should wear their shield on their right—the point being that they should protect their (right) spiritual side rather than the (worldly) left side.[9] St Bernard was, of course, being

235

metaphorical as such a switch was a practical impossibility, unless a right-handed knight was prepared to hold his weapon in his left hand. We do find the peerless knight Galahad (who is in many ways a literary counterpart to St George) fighting without a shield at the beginning of *The Quest for the Holy Grail* (c.1225) and defeating all-comers to great acclaim, but he soon receives a magical 'spiritual' shield that has a red cross on the outside, and an image of the crucified Christ on the inside, which he wears in the usual way.[10]

So it still seems rather strange that St George is pushing aside a shield that, like Galahad's, is emblazoned with a cross. But here Donatello may have been influenced by a contemporary chivalric fashion for fighting while disarmed in some way. In Christine de Pizan's extremely popular *Letter of Othea to Hector* (c.1400) Othea warns Hector never to 'undertake arms foolishly', and uses the example of Ajax, the 'very proud and overweening Greek knight' who 'through pride and gallantry undertook arms with his arm naked and uncovered without his shield, so he was pierced through and through and overthrown dead. Therefore it is said to the good knight that such performances are not from any honour, but are also reputed foolish and proud, and are too perilous.'[11] There is no evidence from classical texts that Ajax fought like this (rather, he committed suicide by falling on his sword),[12] but the ferociousness with which Othea disapproves, suggests that Christine de Pizan is using Ajax as a vehicle for objecting to a contemporary knightly fashion—a sort of chivalric equivalent of Russian roulette. There are plenty of reports throughout the fifteenth century of knights 'disarming' themselves to prove their prowess or virtue. During the Hundred Years War, English knights vowed to cover up one eye with a patch or blindfold until they had defeated the French; Philippe Pot vowed to keep his right arm bare during a crusade against the Turks (his proposal was dismissed by the Duke of Burgundy as unbecoming); and the young Dukes of Berry and Bretagne wore imitation armour of satin with gilded nails while on campaign with Charles the Bold.[13]

The spirit of Donatello's St George comes closest, I think, to an episode recounted in Malory's *Morte d'Arthur*, first published by William Caxton in 1485, where a disarming of the left side is both a noble gesture by the finest knight in the world and an expression of love for a lady. Sir Lancelot fights the evil Sir Meliagrance in single-combat to save Queen Guenevere from being burnt at the stake. Meliagrance

has treacherously accused the Queen of adultery, but Lancelot defeats him. The vanquished knight appeals for mercy, so Lancelot 'looked up to the Queen Guenevere, if he might espy by any sign or countenance what she would have done'. She nods her head as if to say 'Slay him' and Lancelot 'bade him rise for shame and perform that battle to the utterance'.

Meliagrance refuses to get up, so Lancelot makes him an offer he cannot refuse: 'I shall proffer you large proffers, said Sir Lancelot, that is for to say, I shall unarm my head and my left quarter of my body, all that may be unarmed, and let bind my left hand behind me, so that it shall not help me, and right so shall I do battle with you.' Meliagrance agrees, but Lancelot still defeats him, neatly cutting his helmeted head in two. As a result of this daring exploit, the king and queen 'made more of Sir Lancelot du Lake, and more he was cherished, than ever he was aforehand'.[14]

Lancelot's exposure of his left side is as much for Guenevere's sake as it is for Sir Meliagrance's benefit, for he 'exposes' his heart and therefore his love. When Donatello's St George exposes his own left leg, it is exposed to a beautiful lady as much as to a potential enemy, for his left foot is precisely aligned with the Princess in the marble relief below. The *Golden Legend* already treats St George as a figure of romance, an errant knight who just 'happened to be passing by and, seeing the maiden in tears, asked her why she wept'.[15] She is the only daughter of the King of Silena, a Libyan city that has been brought to the brink by a dragon that eats one man or woman each day, the victim decided by the drawing of lots. Now it is the unlucky Princess's turn.

In Donatello's relief she stands before an elegant portico whose columns recede perspectivally, in a vertiginous rush. We see the princess's body from the left, a billowing mass of diaphanous robes that seem to mirror the fluttering of her heart. The toes of her left foot delicately peek out from beneath her robes. Her dainty foot seems to echo the movement of the left foot of the statue above, and suggests that their 'heart' sides are working in concert. This lends a distinct romantic gloss to the ensemble. It is even possible that Donatello's statue depicts the moment when St George first sets eyes on the weeping princess.

It might seem odd—even subversive—to show a knight sidelining his shield in a work commissioned at great expense by the armourer's guild.

Yet when Donatello made this statue, knights no longer used shields on the battlefield.[16] Knights did, however, have ornamental shields for use in parades and jousts, and the unwieldy size of St George's shield suggests it is a shield of this sort. Its symbolic function would have been immediately recognized—and its pointed base is perfectly aligned with the mounted St George in the relief below, spearing the dragon that attacks from his left. The shield seems to offer symbolic protection from on high.[17]

On the battlefield, mounted knights were now 'shielded' by a pauldron, a circular steel plate fixed directly to the armour of the left shoulder. This reinforcement freed up the left hand to concentrate on holding the reins (if mounted) or another weapon, such as a mace (if on foot). In both the statue and the relief, St George seems to wear the same armour, but judging from other depictions of similar kinds of breast plate,[18] it is unlikely that Donatello intended his St George to be protected by a pauldron (a cloak obscures the left shoulder of the statue, but there is no pauldron-like protrusion). Donatello implies that his St George has renounced the most modern armour over his 'heart' area, and trusts instead in God, and in the love and prayers of a princess. The cloak of the mounted St George rears up behind him, denuding him still further while answering the flutter of the princess' robes. In subsequent Florentine images of St George, by Donatello's contemporary Uccello, a state-of-the-art steel pauldron is clearly visible.

* * *

MICHELANGELO'S *DAVID* (1501–4) IS often compared to Donatello's *St George*, with both statues being seen as consummate depictions of youthful vigour, vigilance, and physical perfection. However, the *David* is even more flamboyantly and recklessly left-sided.

Michelangelo's statue is the first colossal nude marble statue since antiquity, and the first depiction of the Old Testament hero to show him completely nude (Donatello had kitted his bronze *David* out in kinky boots and hat). The young shepherd boy is the standard biblical model for an 'unarmed' combatant triumphing over seemingly impossible odds. When David fights the heavily armed giant Goliath he refuses Saul's offer of his own armour, and merely takes a wooden staff, and a sling with five smooth stones. Goliath taunts him for his youth and his lack

of arms, and David replies: 'Thou comest to me with a sword, and with a spear, and with a shield: but I come to thee in the name of the Lord of hosts, the God of the armies of Israel, whom thou hast defied' [1 Samuel 18:45]. However, this does not mean he is naked, and by introducing nudity Michelangelo introduces the crucial idea that beauty is also a weapon because of its capacity to disarm.

The nudity of Michelangelo's *David* is most intensely felt on the left side of his body. This is because it is the more open side, and the one which Goliath is approaching. David's head, with its furrowed brow, twists sharply to the left to observe his quarry. While we have a magnificent full frontal view of David's torso, his notional enemy would be presented with an outstretched left leg and foot, and bent left arm. This is, of course, a natural fighting position—as Giocanni Bonifacio later pointed out in his treatise on gestures and body language, *L'Arte di Cenni* (1616): 'We put the left foot forward when we want to offend someone, because we do this when we want to attack an enemy'—and he cites a passage from Virgil's *Aeneid* in which Lucagus prepares to battle with Aeneas with 'left foot advanced', and for his trouble receives a fatal spear-thrust through the left side of his groin.[19] Lucagus' fate neatly serves to underline the risk involved in exposing one's 'weaker' side, however momentarily, even if armed. David's left leg and arm cantilever out obliquely, almost in parallel, like unsecured flying buttresses. Seen from the left, he looks especially diffident and—despite his concentrated gaze—off guard. He seems naked twice over.

By way of contrast, the right side is static and closed. The right leg is the standing leg, supported from behind by a tree stump. The huge right arm hangs heavy, and the right hand, apparently unemployed, rests on the right thigh. We could easily assume he was left-handed, for his left hand keeps the pouch of the sling in place, draped over his left shoulder, his arm bent like a shot-putter's. Only when we inspect the back of the statue do we realize the right hand is actually holding the end of the sling, and will therefore have the leading role.

The distinction between the sides of *David*'s body has been compared with a line in the Psalms, which we cited earlier in relation to Dürer, where David says 'I have set the Lord always before me: because he is at my right hand, I shall not be moved' (16:8).[20] But whereas in this passage, the left side scarcely seems to exist, and David appears to be totally orientated to his right where God is situated, in Michelangelo's

statue the eye is eventually drawn to the left side. The two sides work together in tandem: the stasis and (to the enemy) invisibility of the right side is complemented and made possible by the splendidly louche abandon of the left.

David appears to be teasing his heavily armed enemy, drawing him ever deeper into a deadly honey-trap by a feigned lefthandedness and by total exposure of his 'weaker' side.[21] It is as though he were treating Goliath like Pietro Bembo treats his lover, and were fearlessly inviting him to 'feast' with his eyes on his whole left side—before ambushing him. Thirty years later Michelangelo would punningly refer to his teenage lover Tommaso de' Cavalieri in a sonnet as a 'cavalier armato' [armed cavalier] by whom he has been taken prisoner, and Cavalieri, no less than the David, is armed with beauty. Cavalieri is an homme fatal, luring in the Goliath-like Michelangelo, making him beg for the fatal blow of destiny that leaves him 'nudo e solo' [naked and alone].[22]

*　*　*

IN THE MALE IMAGINATION, few things have proved more exciting than the idea of a beautiful woman who suffers, for suffering is fondly believed to intensify beauty. The ne plus ultra of this sensibility is Dante's love of Beatrice, and Petrarch's love of Laura, both of which flourished after the early deaths of these women. Their verbal idolatry could never have taken wing without their deaths.[23] As Oscar Wilde said, 'each man kills the thing he loves'.

For both Dante and Petrarch, the death of the beloved involved the 'purging' and rejection of what Dante, in a slightly different context, termed 'la sinistra cura'—literally, 'left-sided concerns', but really meaning bodily and worldly concerns.[24] It is Michelangelo, however, who most succinctly encapsulates how female beauty may be intensified by a fatal left-sided attack. This he does in two poetic epitaphs written in the early 1540s, not long after finishing the Last Judgement, in which he revisits Lorenzo de' Medici's cult of the lady's left hand. Michelangelo sent the two epitaphs to the poet Gandolfo Porrino in 1543 after the death of Porrino's lover Fausta Mancini Attavanti, who was also called Mancina: they were probably a partial compensation for having declined Porrino's request that he do her portrait.

Here Michelangelo suggests that her supreme physical and moral beauty was embodied in the name Mancina, for 'mancino/a' is 'left-handed':

In noi vive e qui giace la divina
beltà da morte anz'il suo tempo offesa.
Se con la dritta man fece' difesa,
Campava. Onde nol fe'? Ch'era mancina.

[In us there lives and here there lies the divine beauty struck down by death before her time. If she had defended herself with her right hand, she would have escaped. Why did she not do this? Because she was left-handed].[25] Some critics have assumed Michelangelo is criticizing her morals here, using 'mancina' in its literal sense of 'crooked' or 'lacking'. If this were the case, then Michelangelo would be voicing the same sentiment that lay behind standard 'Death and the Maiden' images. This would then have to be one of the most insensitive poems of condolence ever sent, on a par with the vicious satires penned in the age of Alexander Pope.[26] It has also been called a 'graceless pun'.[27] However, as Porrino was a friend (one who had written praising the *Last Judgement*), and as Michelangelo wrote two epitaphs exploring the same conceit, it is clear he is saying that Mancina's beauty was unrivalled precisely because it was 'left-handed'; and that this kind of beauty rendered her as vulnerable to death as she had previously been to Porrino's noble love. There is something here of Isidore of Seville's definition of the 'left hand' which we cited earlier: Isidore believes the left hand is so called 'as if it "permitted" something to happen, because *sinextra* is derived from "permitting" [*sinere*]'.[28] Here, the left hand is the hand that always gives permission, and is hospitable—even unto death.

Mancina's left-handedness renders her too weak to hold on to life: it makes her not just unworldly but otherworldly. One is reminded of the fate of Chloris in Botticelli's *Primavera* (*c.*1482). Chloris is a classic 'mancina'. Depicted on the far right of the picture, she looks up helplessly over her left shoulder at the wind God Zephyr who is about to rape her. Flowers already stream forth from her mouth, as she is immediately reborn as Flora, whom Botticelli has depicted alongside, dainty left foot forward, scattering flowers. We are hardly being asked to feel sorry for Chloris's death, for from it an even greater beauty is born. In nineteenth-century Italian opera, a typical 'mancina' would be the beautiful young girl who dies of consumption, her pain sublimated into the most angelic of songs.

In Michelangelo's second epitaph for Mancina, a sonnet, she becomes a martyr to her noble 'left-handedness':

La nuova alta beltà che 'n ciel terrei
unica, non c'al mondo iniquo e fello
(suo nome dal sinistro braccio tiello
il vulgo, cieco a non adorar lei),
per voi sol nacque . . .

[The fresh, noble beauty that I would deem unique in heaven itself, not just in this evil and treacherous world (the common people named her after her left arm, being blind not to adore her), was born for you alone.][29] The mob could not appreciate her rarefied, left-handed beauty, but attacked her for it. Michelangelo here seems to be making a distinction between 'mancino' and the sinister-sounding 'sinistro'. Those same people who named her after her 'sinistro braccio' [left arm] failed to appreciate that she was a gorgeous 'mancina'. Michelangelo turns her death into an iconoclastic act of sacrilege.

Michelangelo may have seen signora Mancina as a modern counterpart to Cleopatra, whom he had depicted in a sultrily tragic presentation drawing from the early 1530s, which he gave to Tommaso de' Cavalieri. Michelangelo's depiction of the suicide of the doomed Queen of Egypt was one of a series of 'ideal heads'. This was probably the kind of 'portrait' Porrino had in mind for his lost beloved. Michelangelo depicts Cleopatra from the left, with her head sharply turned to her left so we see her two mournful eyes. All we see of her upper torso is the naked left shoulder and pneumatic left breast, which the lethal snake is biting. The breast, with its prominent circular nipple, has an ocular bulbousness and delicacy: the body of the snake encroaches on the breast from above and below, curling round the nipple like a pair of heavy eyelids, closing it down, sending her body permanently to sleep. The super-long snake has evidently chosen the place to bite her with consummate connoisseurship, for although its starting position was far beyond her right shoulder, it has sidled all the way up and around her back. Its movement is mirrored by that of Cleopatra's own pig-tail, for this too, from a starting position near her right ear, has been dragged round the back of her neck and draped over her left shoulder. The left side is evidently the softest and most sensitive—and the most permissive. All roads lead here.

* * *

St Teresa of Avila is the most high-profile 'mancina' of them all—
and in Bernini's sculpture, *The Ecstasy of Saint Teresa* (1645–52, Santa
Maria della Vittoria, Rome), one of the most beautiful. It was completed
thirty years after her canonization in 1622.[30] In her autobiography
(*c*.1561), as previously noted, two left-sided spiritual crises precede her
vision of Christ's left hand. In the first, an angel successfully assails her
from the left, and in the second a devil makes an unsuccessful assault
from the same side. By virtue of having been first consumed by divine
love, St Teresa is then empowered to triumph over death and the devil:
this is because love is the most effective shield of all.

The first of St Teresa's left-sided crises is her most famous vision: 'I
would see beside me, on my left side [lado izquierdo], an angel in bodily
form, such as I am not in the habit of seeing except very rarely...He
was not tall but short, and very beautiful; and his face was so aflame that
he appeared to be one of the highest rank of angels, who seem to be all
on fire...In his hands I saw a long golden spear [dardo] and at the end
of the iron tip I seemed to see a point of fire. With this he seemed to
pierce my heart several times, so that it penetrated to my entrails. When
he pulled it out, I felt that he took them with it, and left me utterly
consumed by the great love of God. The pain was so severe that it made
me utter several moans.'[31]

The 'long golden spear' that pierces her heart is a new version of
Longinus' spear. It wounds the left side of her body, and as it enters it
burns up her entrails. The beauty of the angel is intensified by virtue of
being 'all on fire', and the implication is that Teresa's left side becomes
beautiful by virtue of being consumed by the fire of God's love. The
angel's use of a spear (rather than a Cupid-style arrow) and the angel's
position is probably influenced by chivalric jousts, which were still very
popular in St Teresa's time, and lovingly parodied by Cervantes in *Don
Quixote* (1605/15). In jousts, when the knights tilted at each other,
the opponent was invariably on the left. St Teresa was imbued with
the chivalric ethos, for her spiritual guide, *Interior Castle* (1577) is a
mystical version of that standard theme of medieval art and literature, the
allegorical 'Siege of the Castle of Love', where would-be male lovers try
to storm a castle defended by women. She likens the soul to a castle with
many rooms, protected by guards, and these get progressively harder to
enter the deeper one penetrates. The implication is that St Teresa's own
castle has been stormed by her Lord. In one of her poems, St Teresa calls

Christ the 'sweet huntsman from above' who leaves her lying on the ground wounded.[32]

The chivalric aspects of her vision are quite evident in Bernini's *Ecstasy of Saint Teresa*. Art historians often insist on the 'theatricality' of Bernini's mise-en-scene, for on each side wall of the chapel he inserted a balcony filled with 'spectators' (four in each) who are senior male members of the family of the patron, a Venetian Cardinal, Federico Cornaro (1579–1653). Seven (including Federico) had been cardinals, while the eighth had recently been Doge of Venice. Most were long since dead. The balconies have been compared both to theatre boxes, which were just coming into vogue, and to *coretti*, the galleries in the choir from which VIPs watched church services.[33] That said, none of the 'spectators' is actually looking at the main event, and they are arranged in very informal and varied poses. In each box, one pair of figures debates some issue with vigorous gestures. They are presumably engaged in theological argument and thought, but they might equally be the spectators of a jousting tournament, and these events, watched over by people standing in balconies and windows, or seated in specially constructed stalls, were a traditional subject for art.[34]

In a general way, the structure of the chapel is comparable to that of the *Interior Castle*. The 'spectators' recall the many souls 'who remain in the outer court of the castle, which is the place occupied by the guards; they are not interested in entering it, and have no idea what there is in that wonderful place, or who dwells in it, or even how many rooms it has'.[35] The members of the Carnaro family are not exactly uninterested, but they are certainly not yet fully in the know—they have not attained a state of pure, unmediated contemplation, for otherwise they would gaze enraptured at St Teresa. The patron, Cardinal Francesco Cornaro actually looks away from his own altarpiece into the nave of the church. This must be to signal his own humility in relation to divine truths: it says—in pretty relaxed fashion, it must be admitted—'I am not worthy'.

The rooms of Teresa's 'interior castle' are not arranged in a row, as in a normal house, but are clustered around a central room, both above and below, as well as to the sides.[36] The central room is akin to an 'orient pearl'.[37] This too is how Bernini's chapel is designed with compartments on either side for 'spectators', and zones above and below (for respectively, angels and a relief depicting the Last Supper).

The dazzlingly lit 'central room' of Bernini's confection contains the 'victorious' angel delivering the coup-de-grâce to St Teresa.

The saintly 'mancina's' outstretched left side is nearest to the viewer, her daintily limp left hand and foot completely exposed, her head tilting left towards us, with eyes closed and plump-lipped mouth wide open. This enables us to have a ring-side view of the transfixing of her heart by the Angel who is to all intents and purposes a knight thrusting his spear into her side, his face tilting lovingly to his left, and with a melting glance. His left hand daintily lifts and pulls aside her tunic. St Teresa is not of course mounted on a horse, but on a rolling bank of clouds, from which she appears to topple (a contemporary accused Bernini of having 'pulled Teresa to the ground and made this pure Virgin into a Venus, not only prostrate, but prostituted').[38] A major difference from St Teresa's narrative (apart from the fact that she was in real life a plain, middle-aged woman) is that the angel does not stand to her left, but this has been done in order to keep her 'heart' side fully exposed to the worshipper. Her robes billow, crumple and flow in a glistening white liquefaction. We cannot tell if we are witnessing a sloughing off of bodily flesh and fluids, or their unleashing; a shedding of petals or their unfurling. It is both.

The encounter recalls the ecstatic 'death' of Clorinda in Tasso's crusader romance *Gerusalemme Liberata* (1575), written at the same time as St Teresa's autobiography, and which Bernini would surely have known. Here, the presence of numerous female warriors on either side means that there are plenty of opportunities for lovers to fight each other, knowingly and unknowingly. The Christian hero Tancredi mistakenly slays his beloved Clorinda in battle. He drives his sword into her beautiful breast, and it thirstily drinks her blood [sangue avido beve]; a 'hot river' of blood flows over her breasts and clothes, and her feet give way 'languidly' [languente]. As she falls, the pagan warrior is infused with a new religious feeling, and having forgiven Tancredi—'Amico, hai vinto: io ti perdon'—asks to be baptized so her sins can be washed away. This he does, and as she dies, Clorinda is transfigured by a white floral beauty:

> D'un bel pallore ha il bianco volto asperse,
> Come a' gigli sarian miste viole,
> E gli occhi al cielo affisa, e in lei converse
> Sembra per la pietate il cielo e 'l sole;

E la man nuda e fredda alzando verso
Il cavaliero in vece di parole
Gli dà pegno di pace. In questa forma
Passa la bella donna, e par che dorma. [12:69]

[Her white face was sprinkled with a beautiful pallor, like that of lilies interspersed with violets, and her eyes pointed to the sky, and the sky and sun seemed out of pity to look down on her; and as a substitute for words, she raised her naked and cold arm up towards the knight as a pledge of peace. And so the beautiful woman passed away, and it seemed that she slept.][39] This is precisely the kind of cultural framework within which we should situate St Teresa's own vision and Bernini's statue.

Bernini's St Teresa tilts her head over to the left. Giovan Battista della Porta, writing in his treatise *Della Fisonomia dell'Uomo* (1610), had repeated the traditional belief that a neck leaning to the left meant that that person was adulterous and lacking in modesty [adulteri e di nulla pudicizia].[40] Bernini's sculpture would never be bereft of accusations of immodesty, and of inspiring immodest thoughts, and twenty years later, he made a similar sculpture for the Chapel of the *Blessed Ludovica Albertoni*, in which the Franciscan nun lies prostrate on a mattress convulsed in religious ecstasy. However, he reversed the orientation, showing her from the right, with her head tilted to her right, and this seems to be in keeping with the more restrained and contained feel of the sculpture: there are no dangling or akimbo limbs here, and her robes carefully cocoon her body and sheathe her face.[41]

* * *

THE CULMINATION OF THIS cult of fragile beauty occurs in a celebrated description of the ancient statue of *Laocoon* in Winckelmann's *History of the Art of Antiquity* (1764), one of the foundation stones of historiography in general, and of neo-classical taste in particular. Prior to Winckelmann, most discussion of antique sculpture had been coolly antiquarian in nature, with little attention paid to aesthetic or psychological issues, or to the wider social and political context. As Goethe wrote in his *Italian Diary* on the 28th January 1787: 'It was Winckelmann who first urged on us the need of distinguishing between various epochs and tracing the history of styles in their gradual growth and decadence.

246

Any true art lover will recognize the justice and importance of this demand.'[42]

Winckelmann's set-piece descriptions are by turns forensic and mystical: as a student in his native Germany, he had studied both theology and medicine. But what gave his narrative its urgency was his messianic and holistic sense of historical development. Winckelmann believed that the entirety of Ancient Greek art and society represented the apogee of human development, and he urged his contemporaries to emulate it. Whenever he talks about individual works of art, they are invariably figures in a larger landscape; indeed, because so many of his descriptive metaphors derive from natural phenomena, above all water, the greatest statues often literally become surrogate forms of landscape.[43]

In his rapturous account of the *Laocoon*, Winckelmann concurs with Pliny's judgement that the statue surpassed all other artworks, and he treats the Trojan priest, who incurred the gods' ire by warning the Trojans not to take the wooden horse into the city, as a saintly hero, struggling to master his pain, and concerned above all with his sons. Winckelmann surveys Laocoon's body with a breathtaking attention to the anatomical and emotional landscape:

As the pain swells his muscles and tenses his nerves, his fortitude of spirit and strength of mind are manifested in the distended brow. The chest strains upward with stifled breath and suppressed waves of feeling, so that the pain is contained and locked within. The fearful groan he draws in and the breath he takes empty the abdomen and hollow out the sides, exposing to our view the movement of his entrails, as it were. Yet his own suffering seems to concern him less than the agony of his children, who turn their faces towards their father and cry out for help. The father's heart is manifested in the wistful eyes, and his compassion seems to float over them like a cloudy exhalation.

This is one of the most celebrated descriptions in art history; and it rolls on magisterially, until towards the end he homes in on the snake bite, and stops the reader in their tracks:

The nature that the artist could not embellish, he has sought to make more developed, more strenuous, and more powerful. Thus, there where the greatest pain is placed, the greatest beauty also manifests

itself. The left side, into which the snake's raging fangs pours forth its poison, is the one that through its close proximity to the heart appears to suffer most intensely, and this part of the body can be called a wonder of art.[44]

This part of Winckelmann's account is rarely quoted or discussed, even though it is the climax, aesthetically as well as descriptively—not just of this particular account of the *Laocoon*, but of his entire project.[45] One of the reasons why it has been ignored is that it seems to go against the grain of what we might term the neo-classical strand of Wincklemann's aesthetic, which is predicated on 'unity and perfection' of parts, and concepts like 'noble simplicity'—this last was used to describe the *Laocoon* in the short work that made Winckelmann's name, *Thoughts on the Imitation of Greek Works in Painting and Sculpture* (1755), and which was written before he had even visited Rome. His inordinate praise of Laocoon's left side (in fact, the snake is about to bite Laocoon's hip bone, though Goethe claimed that the snake's head had been incorrectly restored, and would originally have bitten 'above and just behind the hip')[46] implies that the sculpture's beauty may be unevenly spread, and so not quite so simple or unified: Winckelmann clearly views Laocoon, with his left side thrust forward, and with his 'weaker' left hand grasping the snake, as an honourary 'mancino'.

Even in the early essay, however, Winckelmann writes like a pagan devotee of the Cult of the Sacred Heart. He asserts that 'truth springs from the feelings of the heart', and that modern man needed to be as familiar with Greek art 'as with a friend'. One is reminded here less of any antique sculpture than of Cesare Ripa's allegorical image of 'Friendship' who 'has her left shoulder and chest bare, and points to her heart'.[47] In a similar vein, Winckelmann had also noted that one of the key ways whereby the Greek artist familiarized himself with 'all the beauties of Nature' was by watching nude dancers: 'The fairest youths danced undressed on the theatre; and Sophocles, the great Sophocles, when young, was the first who dared to entertain his fellow-citizens in this manner...During certain solemnities the young Spartan maidens danced naked before the young men.'[48] Presumably he believed that Greek dancers led off on the left foot, thus exposing the whole of their left side.

Winckelmann moved to Rome in 1755, having converted to Catholicism when working as a librarian to Cardinal Passionei in

Dresden. While domiciled there, he continued to work as a librarian, initially for Cardinal Archinto (a descendent of Cardinal Filippo Archinto), whom he had known in Dresden, and then, after Archinto's death in 1758, for Cardinal Alessandro Albani, who had one of the finest libraries and collections of antiquities in the city. Albani was the nephew of Pope Clement XI, who had given tacit support to the Cult of the Sacred Heart of Jesus by publishing a Bull in 1713 condemning Jansenist attacks on the validity of mystical visions.[49] It is now that Winckelmann explicitly begins to worship the supreme beauty of the 'heart' side—though we should not forget that a 'heart-centred' mysticism was already flourishing in radical Protestant circles in Germany. As a student of theology, he had been powerfully affected by Pietism, a self-avowed 'heart-religion'[50] which advocated spiritual rebirth and passionate personal relationships with God, and which drew on the mystical strands in Luther's thought.

Winckelmann would also have been excited by Hogarth's timely praise of the heart in *The Analysis of Beauty* (1753): it is the only one of the internal organs 'having the least beauty, as to form...which noble part, and indeed kind of first mover, is a simple and well-varied figure; conformable to which, some of the most elegant Roman urns and vases have been fashioned'.[51] Hogarth's love of the heart was expressed in his painting of Boccaccio's *Sigismunda* (1759). Sigismunda's father, having killed her lover Guiscardo, sends his heart to her in a goblet whereupon she fills the goblet with poison and drinks it. Hogarth's Sigismunda clutches with her left hand a golden goblet from which protrudes Tancred's bulbous heart, and draws it to her bosom, actually touching it with her left forefinger (initially her fingers were covered in blood, but the patron disapproved of this detail). Winckelmann may have seen Hogarth's print of this picture.

In an essay from 1759 on the Belvedere Torso, Winckelmann praises the left side of the famous marble fragment in emphatic terms, commenting that if you 'Ask anyone who has knowledge of the most beautiful living human beings, whether they have ever seen a flank to compare with the left flank [of the Belvedere Torso]'.[52] Winckelmann doesn't repeat this in the account he gives of the Torso in his *History*, but he may have felt it was redundant as his account of it there appears only a few pages after that of the *Laocoon*.[53]

Much earlier in the *History* he had already extolled organs located on the left side of the body in a thoroughly 'left-field' section on the

beauties of the various body parts: 'Even the parts of the genitals have their special beauty. Of the testicles, the left one is always larger, as it is found in nature: it has been remarked that the left eye sees things more sharply than the right.'[54] The imaginative leap—from balls to eye-balls—is disconcerting, to say the least, but it has the merit of consistency.

Winckelmann's observation about testicles was largely correct in relation to Greek statues, but not to nature: in Greek statues, the left testicle is usually larger (and lower) than the right testicle (though not in the *Laocoon*). But in nature it is vice versa, with the right testicle usually being higher and larger.[55] The Greek sculptors may have reversed the position and size of the testicles because of the belief that the blood on the left side of the body contained more water, and on the right side more air; but Winckelmann's evident appreciation of this reversal of nature may be because, for him, the left side of the body contained most of the heart, and thus it made emotional sense for the left testicle also to loom larger.

Winckelmann's observation about the superior sharpness of the left eye further demonstrates his preference for the left side, for although Giovanni Alfonso Borelli had claimed this in 1673 (he thought the left optic nerve may have a better blood supply through its proximity to the heart), the advocates of the left eye were far outnumbered by the advocates of the superior acuity of the right. In 1593 Giambattista della Porta had discovered that each person has a dominant eye, usually the right eye for right-handers, and the dominant eye is the one instinctively preferred for looking through a telescope, magnifying glass, or the sighting mechanism of a gun.[56]

As the *History of Ancient Art* was written in Rome, it is tempting to believe that Winckelmann may have read a manuscript copy of Orfeo Boselli's unpublished *Observations on Antique Sculpture* (1650s), which is now known in four manuscripts, two of which are conserved in Roman libraries. Winckelmann was extremely well-read, though he did not always credit his sources, and if he was aware of Boselli's work, he could not have failed to find it germane to his own work, for Boselli is unusually alert to aesthetic issues. Boselli (*c*.1600–67) was a pupil of the classicizing sculptor François Duquesnoy, but spent most of his time restoring antique sculptures. He was appointed principal of the Accademia di San Luca in Rome, and his treatise is probably based on lectures which he gave there in the 1650s. One of his most interesting

and original points concerns the orientation of the heads of antique sculptures:

> One must also observe that the faces of antique sculptures more often look to the left than to the right, either because that side is the guardian of the heart, or because the figure is more graceful on that side. The shoulder is always somewhat higher on the side towards which the head looks because it seems that these parts love to be united.[57]

It is certainly true that many of the most famous antique sculptures which were then in Rome— *Laocoon, Apollo, Venus de' Medici, Meleager, Cleopatra,* the *Torso* and the *Farnese Hercules*—all look or turn to their left; but this predilection is less marked in portrait busts, though the sharp leftward turn of the celebrated bust of *Caracalla*, with its furrowed brow, was believed to express this ruthless emperor's fury as he condemned some poor subject to death.[58] But Boselli, no less than Winckelmann, was seeing antiquity through heart-shaped spectacles—a bias that was no doubt underpinned by the recent canonization of Saint Teresa, and the fuss that surrounded the completion of Bernini's Cornaro Chapel in 1652.[59]

13. Leonardo and the Look of Love

LEONARDO'S PORTRAITS ARE AMONG the most important symptoms and catalysts of what I have called the 'left turn' in Renaissance culture. Of the five painted portraits by Leonardo that survive, and which are most widely accepted as autograph, four of the sitters look to their left (this is true too of the portrait drawing of *Isabella d'Este*). It seems that Leonardo came to regard a sharpish leftward turn as an essential component if a portrait was going to appear fully animated and engaged: the 'motions of the mind' could only be truly manifested in the deportment, gestures, and facial expression of his sitters if they turned to their left.[1] It was to be one of his most original and influential insights, and we noted earlier how even his celebrated drawing of *Vitruvian Man* (*c.*1490) shows a marked twist to the left in the lower body and feet.[2] Leonardo's finest portraits make the sitters in most previous portraits look like puppets or prisoners looking out of the window of their cell. He achieved both intensity and freedom of movement, but this didn't appeal to everyone—male patrons above all. The most dramatic and reckless of these portraits is undoubtedly that of *Cecilia Gallerani* (1490–1) (Fig. 28), the mistress of the Duke of Milan. But Leonardo was never asked to paint the Duke, who opted for a schematic profile image as his prime state portrait. This standardized image was reproduced as required, like a 'carte-de-visite'.[3]

Before we discuss this revolutionary portrait in more detail, we need to explore Leonardo's development as a portrait painter. His earliest surviving portrait depicts *Ginevra de'Benci* (*c.*1474–8), who had married the Florentine Luigi Niccolini at the age of sixteen in 1474. This is the most static of his portraits, and it has much to do with the fact that the sitter turns her head to the right.[4] The panel has been cut down at

the bottom, but Ginevra would have probably been even more imposing and sentinel-like if her hands had been visible. Ginevra's head is framed and pinned in place by a dense and prickly halo of juniper leaves (juniper symbolizes chastity, and is *ginepro* in Italian—a pun on Ginevra). Her eyes seem to look through and beyond us. It is only far away in the background to her left where we have any sense of transcience: here we get a glimpse of a delightfully watery and hazy landscape. To her right, there are two small gaps in the juniper bush, one above the other, that reveal the sky, but these are so narrow and prickly they make one think of the narrow, difficult path of virtue.[5]

The portrait may have been painted for the humanist Bernardo Bembo, who was the Venetian ambassador to Florence in 1475–6 and 1478–80. He seems to have become Ginevra's 'platonic lover', perhaps publicly for the first time at a chivalric tournament organized by the Medici in January 1475, shortly after his arrival. Poems were written by Lorenzo de' Medici and others to celebrate their relationship. Bembo's emblem of a wreath of laurel and palm is painted on the reverse, together with a sprig of juniper, all entwined by a scroll bearing a Latin inscription meaning 'Beauty Adorns Virtue'. It is tempting to think that the watery part of the landscape is meant to evoke the small section of her heart that is forever Venetian: the water is certainly contiguous with the zone of her heart. Dante refers to the 'lake of the heart' in the *Inferno*, and so too does Leonardo in his scientific writings.[6] That is what I think we have here, though there is no indication of any emotional depths or tremors in Ginevra's primly impassive face. Her austere clothing further suggests her mind is preoccupied with matters of the soul, not of the body; with eternity, rather than with time.

In Milan, where Leonardo lived and worked from around 1482, his sitters look to their left and there is a consequent increase in animation and immediacy. The so-called *La Belle Ferronière (Portrait of a Woman of the Court of Milan)*, painted in the 1490s, is almost a reversed Ginevra. She is just as hieratic, but now she stands nearly side-on to the viewer, her left shoulder in the foreground and her head turned sharply to the left. The eyes seem to make contact with ours, though the mouth is still set firm as if she is probing us a little suspiciously from behind the parapet running along the base of the picture. Intensifying our sense of a leftward orientation is the fact that she is not placed in the centre of the picture, but pushed to her left so that her left shoulder nearly abuts the vertical edge of the panel. Unlike Ginevra, you feel she is about to make

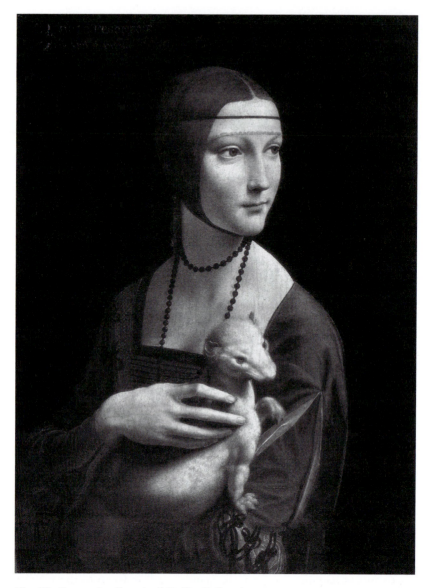

Fig. 28: Leonardo, *Portrait of Cecilia Gallerani*

a momentous choice: the nocturnally dark, blank background isolates her from everything except her own thoughts about the viewer.

Cecilia Gallerani (1490–1) is the most celebrated of Leonardo's Milanese portraits, and the most animated. Her body turns in an elegant serpentine spiral that culminates in a most energetic turn of the

254

head—to the left. Cecelia was the mistress of Ludovico Sforza, Duke of Milan, and it is usually assumed that she is turning towards him as he enters the room. It is not an 'invitation to dance' portrait, however, but a declaration of undying love and fidelity. She presses a live, squirming ermine to her heart with the unnaturally elongated fingers of her right hand; the animal also looks inquisitively to Cecelia's left, and almost seems to pull back the edge of her 'slashed' left sleeve with its raised left paw. The ermine has multiple meanings. It was a symbol of purity because it was believed not to soil itself (which is presumably why Cecelia is prepared to cradle it while wearing her finest clothes); its Greek name, *galee*, was a pun on the sitter's family name; and it was a heraldic emblem of the Duke.

It has been assumed that Cecilia's 'lack of political standing must have been a crucial factor in allowing the artist to experiment with the role of the body in portraiture'.[7] Yet not only was she a member of a noble family, she was also the accomplished authoress of Latin letters and Italian poetry, and a celebrated patron of the arts. Her standing increased enormously by being the Duke's mistress, and by the birth of their son Cesare Sforza Visconti in May 1491. Cecilia may well have been pregnant when the portrait was commissioned and painted, and the (outsized) ermine which she cradles could then also stand for the 'purity' of the imminent new arrival. The social status of illegitimate offspring depended almost entirely on the recognition given by the father, and Cesare gained ample recognition.[8] The Duke immediately gave his son extensive lands and property which Cecilia had the use of.[9] The presence of the ermine legitimizes the relationship and any offspring.

It was customary for bastards to have a 'bend sinister' or 'bendlet sinister' as a mark of distinction on their coat of arms, generally a line passing from the top right corner of the shield (from the viewer's perspective) to the bottom left, and the body of the ermine does create a kind of 'bend sinister' across Cecelia's torso, and it does raise its 'sinister' paw; she herself is performing what we might call a 'turn sinister'.

What I think Leonardo is doing here above all is visualizing what he regarded as Cecilia's peculiarly feminine charms and energies, an aspect to which he was especially responsive. One of the striking things about Leonardo's portraits is how many of them depict women. Only one sitter is a man, and he is one of unusual sensitivity—the so-called *Portrait of a Musician* (mid-1480s) shows a man with cascading curly locks

holding a sheet of music inscribed with words in his right hand; he looks up and to his left, as if suddenly struck by a beautiful thought—or more likely, a beautiful *sight*. In his writings on art, Leonardo asserted the superiority of painting over the 'aural' arts of music and poetry (most poetry was still read or sung out loud), despite himself being an accomplished musician. To prove his point he tells a story about a King who puts down a book of poetry when a painter gives him a portrait of his 'beloved lady'. The poet bridles at this, and so the King counters:

> Be silent, O poet. You do not know what you are saying. This picture serves a greater sense than your [poetry], which is for the blind. Give me something I can see and touch, and not only hear, and do not criticize my decision to tuck your work under my arm, while I take up that of the painter in both hands to place it before my eyes, because my hands acted spontaneously in serving the nobler sense—and this is not hearing.[10]

The man in Leonardo's portrait (who could just as well be a singer or poet) has probably just seen or imagined something that is *visually* beautiful, whether created by nature or art, and it has struck him with the force of a revelation. He will no doubt soon be grasping it with those same hands that have held the sheet of music.

This was an era when relatively few portraits were painted of women, and when women were portrayed, it was usually as part of a double commission to paint a betrothed or married couple. The portrait of *Mona Lisa* was commissioned by her husband, but there is no indication that there was another commission to paint him. Indeed, there is no evidence that any of Leonardo's female portraits had a male companion. No wonder they seem so independent.

It may be that Leonardo was peculiarly interested in female portraiture, and in ideas about female beauty and femininity. His own sexual orientation, and his left-handedness, may have directed his attention to his own 'feminine' side, and he was certainly noted for his elegance and beauty. One of the best sources for traditional ideas—or clichés—about the different characteristics of men and women was treatises on physiognomy, and Leonardo must have read many of these because he vociferously attacked what he termed 'false physiognomy' in his writings.[11] However, his main objection seems to have been to chiromancy (palm-reading), and he certainly believed that the face 'shows

some indication of the nature of men, their vices and complexions'.[12] To this end, he gave heroic warriors a 'leonine' countenance, and his innumerable caricatures exploit physiognomic lore.

If the portrait of *Cecilia Gallerani* is read in relation to a passage from a well-known antique physiognomic treatise from which we quoted in the opening chapter, and which was then attributed to Apuleius, author of *The Golden Ass,* we can sharpen our understanding of her body-language. It sheds valuable light on the increased bulk and presence of Cecilia's left side, achieved by unnaturalistic expressive distortions as much as by foreshortening:

> sorts of appearance which we have assigned to the masculine type occur in the feminine . . . if some part on the right is larger, in what-ever body, be it eye or hand or breast or testicle or foot, or if the top of the head leans more to the right, or if from two or three points the large is on the right, all these indications are assigned to the masculine type. If some part on the left is found to be larger, it is assigned by these indications to the feminine type. And if the top of the head is turned more to the left or out of two or three points the left is the larger, it will be assigned to the feminine type. But also the nose and lips, when they are turned more to the right, announce the masculine type, when they are turned more to the left, the feminine type.[13]

The mere fact that the left side of the body is pushed further forward than the right enlarges it through foreshortening. But Leonardo goes much further. The presence of the ermine and of Cecilia's right hand on the left side of her torso, with both pushing leftwards, aggrandises this side. The left hand, which pushes right, remained unfinished, possibly because Leonardo realized the finished hand would unduly bolster the right side. The lighting from the sitter's left means that only Cecilia's left side is brightly lit, and so it appears bigger (because more radiant) than the right side, which dissolves into darkness. In fact the left side *is* bigger: an impossibly pneumatic contour passes from the left shoulder to the neck, and the corresponding feature on the right side is much lower and shorter. The left side of the face also seems fuller because of the way the dark cap edits and flattens the right side of the face; similarly, the left side of her mouth lifts and pulls leftwards into a smile, and even her nose is turned slightly leftwards. It lends a genetic urgency to her leftwards lurch. The line that articulates the left side of her body is not just what

Hogarth would later call the 'line of beauty'. It is a line of *pregnancy* and beauty.

The *Mona Lisa*, who also turns to her left, exhibits this strategic disproportion too. Her face is distorted so that the distance from the bridge of her nose to the furthest corner of her right eye is about two-thirds that of the distance to the corner of the left eye. The mouth extends about twice as far to the left as it does to the right. There is more 'embodiment' on the left than the right; and conversely, more 'disembodiment' on the right than the left.[14]

Leonardo is definitely the poet laureate of the feminine type.

14. Prisoners of Love

Se la saetta, Amor, che'l lato manco
M'impiaga in guisa ch'io languisco a morte,
Fosse dolce così com'ella è forte,
Direi:—Pungi, signor, il molle fianco'...

[If the arrow, Cupid, that wounds my left side so that I weaken to the point of death, was as sweet as it is strong, I would say: 'Strike, sir, the soft side'...]

<div align="right">Torquato Tasso (1544–95), Sonnet[1]</div>

SINCE THE HEART IS located on the left side of the body, it has been common practice to symbolically 'bind' the left side of the body to show that one is in love, and that one's heart is both captive and protected. This is most commonly expressed through rings—whether they be betrothal and wedding rings, lovers' rings, or charms and amulets.

From around the fourteenth century, however, in some of the most sophisticated circles, the symbols of amorous possession and subjection start to become much more invasive, so that the 'weaker' left side of the body seems (symbolically) endangered. The bonds of love are drawn ever tighter and harder, and become punitive rather than merely protective. The lover's ring is now attached to the shaft of one of Cupid's lethal arrows, and thereby becomes an instrument of exquisite torture. At its most extreme, the lover is more akin to an abused slave than a respected servant. Here, the secular code of courtly love seems to collide with the religious demand for bodily denial. Just as flagellants

would parade openly through city streets, so limping lovers now wear their tortured heart on their (left) sleeve, hose, or shoe.

Whereas the Countess of Champagne urged lovers to wear rings on the little finger of the left hand, with the stone discretely hidden on the inside, the Elizabethan courtier Sir Henry Lee has himself depicted with the thumb of his left hand conspicuously and uncomfortably thrust through a gold ring suspended by a cord from his neck. Now love becomes a kind of living death, but the lover revels in his parlous state. His pained pining is strategic, for it shows he is a man of intense feeling. Too weak to try and escape his cruel lady, he expires in her presence. He is to be envied as well as pitied, for like any flagellant, he is tested and transfigured by the unconditionality of his love.

* * *

PETRARCH IS THE CRUCIAL catalyst for these developments. In the *Rime sparse*, which had a huge influence on European lyric poetry until the Romantics, Petrarch gave shape to his peripatetic life and to the vicissitudes of his love for Laura. In toto, the poems offer an exhaustive encyclopedia of love's pains and pleasures. In several, Petrarch exposes his left side to a succession of amorous assaults and impositions. His left leg is the scapegoat, invariably coming off worst. At one point, the poet regrets he did not try to flee Love earlier for it has now immobilized him by making him lame in his left leg:

> et fuggo ancor così debile e zoppo
> da l'un de' lati ove 'l desio mi à storto,
> securo omai; ma pur nel viso porto
> segni ch'io presi a l'amoroso intoppo.

['and I do flee now, even if so weak and lame on one side where desire has twisted me, safe but still in my face bearing scars that I got in the battle of love.']² A damaged left side here symbolizes the torture endured by the ensnared lover. The scars that he still bears in his face are probably also meant to be on the left side, for physiognomists believed that markings on the left side of the face—whether they be lines, moles, warts, or scars—were more ominous than those on the right, and portended bad and immoral things.³ In another poem, Petrarch enters a 'lovely wood' in springtime, but discovers it to be 'thick with thorns' and is made lame.⁴ Elsewhere, he reminisces about his misspent youth:

....il manco piedo
giovenetto pos'io nel costui regno,
ond'altro ch'ira et sdegno
non ebbi mai; et tanti et sì diversi
tormenti ivi soffersi
ch'alfine vinta fu quell'infinita
mia pazienzia, e'n odio ebbi la vita.

['... when I was young I placed my left foot in [Love's] kingdom, whence I have never had anything but sorrow and scorn; and I have suffered there so many and such strange torments that at the end that infinite patience of mine has been vanquished and I have hated life.']⁵ [5]

The idea that a young lover might place his 'left foot' in Love's kingdom is at least in part an allusion to a dance-step. Petrarch probably believed that no-one really entered Love's kingdom before their first dance with the beloved—not least because the first dance may well involve the first physical contact. But in Petrarch's case his 'weaker' left foot does stumble, and so his right foot is forced, as the dance theorist Thoinot Arbeau would say, 'to succour it'. In this case, though, his catastrophic loss of balance is due to the deceit of his dance partner as much as his own impetuousness. An illustration to a dance treatise by the great Italian dance master Guglielmo Ebreo (1463) which we mentioned earlier shows three supremely elegant dancers—a young man flanked by two women—holding each other by the little finger, accompanied by a harpist. They are located in a Garden of Love, a grassy meadow peppered with knee-high plants, but some have prickly leaves. A prickly leaved plant abuts the man's left leg, and a non-prickly plant his right.

Petrarch's lame-leg motif is a tragi-comic variation on the theme we found in St Bernard's meditations on the Psalms where David, having implored God to protect the (spiritual) right side of his body, repudiates his left side and insists it be 'struck with insults and bound with disgrace!' Yet there is also a piquant paradox at play, for lameness is an essential quality in a lover because it means he cannot flee or resist. Thus although in the first passage we cited Petrarch claims to have fled to safety, we assume he must at some level be 'dragging his feet'. Petrarch is the master of sly, self-serving masochism: his scars spell lust as well as Laura's name.

A celebrated example of amorous foot dragging occurs near the beginning of Dante's *Inferno*. We are told that as Dante ascends the

mountain of Hell, he walks so that 'il piè fermo sempre era il più basso (l. 30)' [so that the firm foot was always the lowest]. This statement scarcely makes literal sense, and if it did, would be redundant. It must instead refer to the so-called 'feet' of the soul which, from at least the early thirteenth century, had been divided into right and left, with the latter signifying bodily desires and appetites.[6] Dante's son, Petro Allegherii, interpreted the line in this way in his commentary on the text: 'But, speaking morally, the inferior foot will be that Love which drags itself to lower terrain; and it will be firmer and stronger than the higher foot—which is to say, the Love which aims high'.[7] The last major exponent of this sort of idea would be William Blake, for whom the left foot signifies materialism, while the right foot is spirituality: in 'I Want', the youth starts to climb the ladder to the moon with his left foot, and so falls into the Sea of Time and Space.[8] For Petrarch, the lowest foot is always the left foot.

The 'firmness' of the inferior foot that is 'dragged' is probably also an allusion to the proverbial wisdom that 'the lame man makes the best lecher'. Amazon women supposedly crippled their boys in childhood to improve their sexual performance and to prevent them taking control of the women when they became adult men. This followed the ancient belief, deriving from Aristotle, that lame legs could not receive the same amount of nourishment as healthy legs, and so the 'surplus' nourishment was diverted to the genitals situated just above them, and turned into semen.[9] What Petrarch really fears (and secretly hopes) about his 'lameness' is that it renders him supremely carnal and priapic. This seems to be happening in Correggio's *An Allegory of Vice* (1520s), where a bearded man is bound by his left arm to a tree, and is enthusiastically tortured by three women who put snakes on his skin, blow a pipe into his left ear, and flay him, starting with his left leg, which is swollen by being dramatically foreshortened. But this flaying of the left foot—thereby rendering it lame—only seems to arouse him: a strategically placed piece of blue drapery draws attention to, rather than masks, a substantial erection.

Petrarch may equally have been influenced by an actual artwork when he was imagining his hapless younger self—the then risqué antique bronze sculpture with which he must have been familiar from his visits to Rome, the *Spinario*, or 'thorn-puller'.[10] During the Middle Ages the statue was conspicuously placed on top of a column. A beautiful naked boy is shown seated on a mound of earth or tree stump pulling a thorn

from the sole of his left foot. We know that Petrarch consulted a guide to the marvels of Rome which had been written by Master Gregorius at the beginning of the thirteenth century, and here the sculpture was (mis-)interpreted in a scandalous erotic light:

> Concerning the ridiculous statue of Priapus: There is another bronze statue, a rather laughable one, which they call Priapus. He looks as though he's in severe pain, with his head bent down as if to remove from his foot a thorn that he had stepped on. If you lean forward and look up to see what he's doing, you discover genitals of extraordinary size.[11]

The genitals are in fact of normal size, but for someone of a moralizing cast looking from below, with the sun at the right angle, they must have loomed rather larger.[12]

Some theologians believed Adam had actually trodden on the serpent, and that original sin was the bite of the serpent: while the right foot suffered the wound of ignorance, the left foot suffered that of concupiscence.[13] By the same token, it was popularly believed that if one is possessed of the Devil, he will occupy the big toe of one's left foot: hence the tradition among newly-weds of lying naked on the floor and kissing the big toe on each other's left foot to break any evil spells that have been cast on the couple, especially relating to impotence.[14] It is scarcely surprising if Gregorius interpreted the spinario's lameness as a symbol of concupiscence.

All these ideas and images must have been fed into the imaginative mix when Petrarch was conceiving his lovelorn younger self: when he enters the 'lovely wood' in springtime, but finds it to be 'thick with thorns' that make him lame, it is uncertain whether this makes him a penitent Sir Perceval or a priapic 'spinario'.

* * *

IN THE FOURTEENTH AND fifteenth centuries, clothes adorned with letters, inscriptions and devices became very popular, and personal suffering and shame tends to be advertised by left-sided adornments. The most famous and glamorous is, of course, the garter of The Order of the Garter inscribed 'honi soit qui mal y pense', which we discussed earlier.

In Boccaccio's autobiographical dream poem *Amorosa Visione* (1342/55?) the act of fixing an amorous inscription onto the poet by his beloved is itself the cause of considerable pain—because the

letters are inserted directly into his heart. This is followed by an equally uncomfortable act of mutual shackling:

['As I stood there it seems to me that / the gentle lady seemed to be coming towards me / to open my breast and write within, / there in my heart, placed so as to suffer, / her beautiful name in letters of gold, / so that it might never escape. / She, after a short pause, / placed upon my little finger a ring / which she had taken from her lovely bosom; / to which, it seemed to me, if my intellect / was able to understand, / was linked a small chain / which descended from the lovely lady's breast, / passed into her and held her with its hooks / as firmly as an anchor grips a rock'.][15]

Boccaccio describes all this with quasi-surgical exactitude, so that we cannot be quite sure if it is a dream or a nightmare (the slightest tug on the chain would dislocate his little finger and pluck out her heart). The fact that the lovers are linked by a small chain suggests they may be glued together like Paolo and Francesca in Dante's *Inferno*. The inscribing of the beloved's name echoes the cross that was supposed to be burned into the heart of Franciscans and of the knightly religious orders, and of the monogram of Jesus that Henry Suso gouged into his flesh. A more palatable variation on this theme occurs in the illumination from the 1480s which we discussed earlier showing the Countess of Salisbury in a full-length cloak decorated on the dexter side with her husband's arms, and with her own arms on the sinister side. In her left hand she holds a golden chain whose other end is held in the gloved left hand of her fully armed husband. The implication here is that the chain ties their hearts together—though he looks more than a little distracted.

One of the wittiest amorous inscriptions was flaunted by Berhhard von Rohrbach of Frankfurt in 1464. This knight is said to have worn hose with a scorpion and four 'M's embroidered on the left leg, and four 'U's embroidered on his cloak (the 'U's presumably continued up the left side). They attested to his ill-starred affairs of the heart for the letters signified Mich Mühet Manch Mal Untrun Unglück und Unfall [Sometimes do disloyalty, unhappiness and misfortune pursue me].[16] There's something wonderfully witty about that 'Manch mal' [sometimes], with its suggestion that Bernhard is slightly disappointed that he is not *always* pursued by the four 'U's. Being only sometimes depressed makes him even more depressed. However, by sewing them onto his cloak he partially remedies the situation because it means the four 'M's

and 'U's now dog his every step like the Furies of Greek Tragedy. The letters are particularly appropriate, because their appearance is redolent of pincers and jaws.

A study of elaborate courtly costumes of the 1430s emanating from Pisanello's workshop gives us some idea of what Berhhard von Rohrbach might have looked like, taking into account the differences of period and place. It shows a young male courtier of elfin delicacy with a gruesome device depicted on his voluminous left sleeve. It is a wooden clamp with protruding nails, like a schematic crocodile's mouth, held together by cross pieces made from sticks. It has been compared with a 'bootikin', an instrument of torture made from wood and iron that was fastened round the foot and leg, and then gradually compressed by hammering in wooden wedges until flesh was crushed and bones broken. It has also been related to one of the individual *imprese* of Borso d'Este called a 'plank with nails fixed underneath', for which no explanation has been found.[17]

Borso's device seems more conventional, akin to a bed of nails, and perhaps therefore symbolizing patience in the face of adversity. But the sleeve is eminently Petrarchan, a vicious trap for the left leg (and arm) of the unwary lover: in the drawing the courtier's left foot is indeed raised as if he is about to take a step forward. The device is akin to an inverted 'A', perhaps an allusion to the way in which Amor turns the world—and lovers—upside down. It nestles amidst a pattern of floral tendrils, as if concealed in a garden of love, but these too are slightly alarming because they have been brutally cut at the base, and at the bottom of the sleeve there are three 'flayed' twigs. There is no sign of the man's left hand or arm, for it is completely engulfed by the sleeve. The design has not been repeated on the right sleeve, because although the tendril on the left sleeve continues round the back, no tendrils emerge from the right sleeve. Several similar devices are found in a coloured woodcut by Casper von Regensburg, *Venus and the Lover* (*c*.1485), where a love-lorn man prays to Venus surrounded by nineteen hearts that are being subjected to various kinds of torture and punishment. The 'heart' side of Venus and of the man are most exposed to our view, and their left hands are both extremely active: the man presses his left hand against his own heart, while Venus holds a huge sword which she presses down mercilessly onto a heart.

Nicholas Hilliard's exquisite miniature *Young man among Wild Roses* (*c*.1587) is a much later variation on this theme, for the thorny roses

grow up primarily around the wistful lover's left side, hemming that side in. They seem to adhere to his black cape, artfully draped over his left shoulder so that the whole of his left arm is concealed (he wears the colours, black and white, of Queen Elizabeth 1, and the rose too may be her symbol). The cape is in reality too small to cover the whole of his left arm, but we don't really notice its being edited out, for the two main stems of the rose now describe and stand in for his arm—albeit an arm that has been flayed and reduced to two arteries, like an illustration to Vesalius' great anatomical treatise.

The young man leans his right side and his head against a column-like tree trunk, a typical symbol of fortitude. A Latin inscription in gold letters curves around the top of the oval miniature, creating an arching halo around the top of the poor boy's head, a verbal pergola. The inscription is taken from the first line of a poem by Statius: 'Dat poenas laudata fides', which means something like 'my praised faith punishes me'. The miniature effortlessly secularizes St Bernard's psalm-inspired antithesis between a strongly supported right side and a weak and overwhelmed left side: no doubt the lover wants to give the object of his affection the impression that his is a pure love. Yet the fact that his right side is supported by a tree—rather than by God—suggests that his love is wholly natural and perhaps even a force of nature that is even more powerful than the rose.

We shall never know how his beloved responded when she received the miniature, but the miniature's survival in good condition suggests she looked favourably on his elaborate suit.

* * *

IF LOVE'S FRONTLINE WEAPONS are arrows and thorns, then the clothes of any self-respecting lover should really be torn, or depict wound-like marks. During the Middle Ages, flagellants did not have a monopoly on torn clothing, for there was a long tradition of knights wear-ing torn clothing as a love symbol. A knight might fix his lady's veil, scarf, ribbon, or detachable sleeve to his helmet, arm, or shield before participating in a tournament in which he had agreed to fight on her behalf.[18] In this case, the pains suffered by the male lover were only too real: he won his lady's favour by defending her hon-our against all-comers on the battle field. If he survived and won, the knight would return the article of clothing in triumph to the lady.

The shield was evidently the most thrilling and erotic place to mount the sleeve, for here it was most likely to be shredded during the course of combat (and this is why ladies tended to give the 'cheaper' right sleeve). The knight is goaded into ever more heroic action by the thought that each blow to his shield violates and wounds his lady (and tears at his own heart strings directly below). The full sado-masochistic potential of this procedure is gleefully exploited in Wolfram von Eschenbach's *Parzival* (*c.*1210). When Sir Gawain agrees to be the champion of a girl called Obilot, he nails her right sleeve to his shield, and after the joust returns it 'pierced and hacked though it was at its middle and end'. Obilot is overjoyed—'Her white arm had been left bare, and she quickly fastened it over'—but her sister then teases her by asking 'Who did this?' whenever she sees her.[19] Duke William IX of Aquitaine was less subtle and had the image of his mistress painted on his shield because 'it was his will to bear her in battle, as she had borne him in bed', and he too would have been fired up by every sacrilegious blow that landed on his heart-protecting shield.[20]

From the late fifteenth century, there was a unisex fashion for elegantly 'slashed' clothing (especially sleeves), which allowed white shirts to puff up suggestively through the slits and, after around 1515, an even more provocative fashion for elegantly 'torn' leather gloves, worn by women as well as by men. These artificially distressed gloves were luxury items, usually changed once a week and perfumed, and they were particularly suited to those who loved rings because the jewels could peek up through the holes.[21]

In Titian's celebrated portrait *Man with a Glove* (early 1520s) a torn glove is worn on the man's left hand as portentously as Obilot's shredded sleeve nailed to Gawain's shield. Various suggestions have been made for the identity of the sitter, none of which is entirely convincing. The pose of the sitter may have been influenced by Raphael's marriage portrait of *Agnolo Doni*, which is paired with a portrait of his wife. Doni's left arm rests on a stone parapet, while here the left arm of Titian's young man rests on a roughly hewn stone block. The similarities end there, but Titian does want us to wonder if this is one half of a diptych, and the orientation of the wistful young man certainly suggests this. He looks to his left, and seems to gesture in that direction with the outstretched index finger of his bare right hand. One might therefore assume that there was once an accompanying female portrait, towards which he is turning. But the portrait speaks as much of the absence as of the presence

of a woman, and this is how we should understand it: as one half of an impossible and therefore non-existant diptych. Either the woman is dead, or (and this is more likely) she is *difficult*.

Since there is no matching female portrait, and it is unlikely there ever was one, our gaze is directed towards a void and, once we have finished meditating on the possible contents of that void, we turn to what is closest to the void and to us—the gloved left hand resting on the rock. The leather peels back to reveal bare skin and some white linen lining. The other glove is held disconsolately in this same hand, and could be dropped at any moment. Its empty fingers line up alongside the filled fingers of the left glove, adding considerably to the atmosphere of dessicated torpor.

In a sense, Titian *has* depicted this young man's beloved, for the rough rock makes one think of Dante's *rime petrose* [stony poems] in which the poet's beloved exasperates him by exhibiting a rock-like obduracy and cruelty—and irresistible beauty. In one of these poems, he says that he has no armour that she cannot split [spezzi], and she bites through his heart layer by layer with her bare teeth; but Love has struck him 'under the left arm so violently that the pain rebounds through my heart', and his heart is cut to pieces.[22] The tattered gloves, which may have been a gift from a lady, suggest he is being flayed alive and that this is the state of his own heart.[23] The index finger of his right hand points decisively and even accusingly to the left, its patrician authority augmented by a large bejewelled ring. But it is unclear whether it points 'accusingly' to the notional woman, or to the left hand, as if despairing of the antics of his 'heart' side. The hand gesture recalls that of John the Baptist pointing to the crucified Christ. The portrait is thus a sexily etiolated secular counterpart to the one of Cardinal Archinto, with the rock being his gloved hand's Golgotha: it has been cut, emotionally at least, to pieces.[24] Things might have been very different if the young man had followed the advice about couture given in Sannazaro's pastoral romance *Arcadia* (1504): 'whoever wears the skin from the snout and genitals of a hyena tied to his left arm, will immediately be followed by any shepherdess who looks at him.'[25]

* * *

THE MOST ELABORATE IMAGE of a 'prisoner of love' is Giambattista Moroni's *A Knight with his Jousting Helmet ('The Knight with the Wounded Foot')* (*c*.1554–8) (Fig. 29).[26] The knight (probably the Brescian

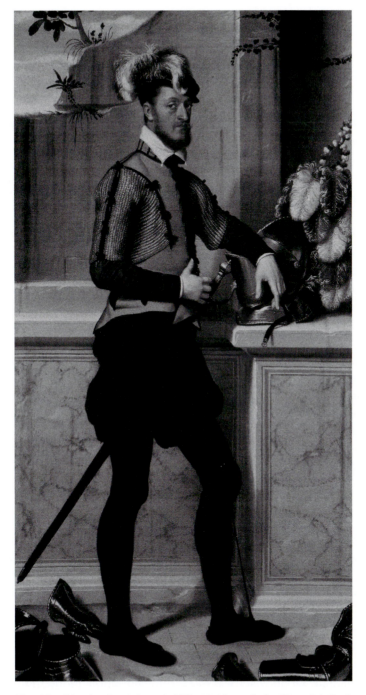

Fig. 29: Giambattista Moroni, '*The Knight with the Wounded Foot*'

nobleman Conte Faustino Avogadro) is shown standing side-on before a wall, his left arm draped with melancholy nonchalance over the visor of a magnificent jousting helmet that has been placed on a ledge. The rest of his armour is strewn on the floor at his feet—an unprecedented feature in portraits. No less remarkable is the fact that his left foot is depicted with a foot brace, which would mean he is suffering from 'drop-foot', a 'fairly common disorder caused by a failure of the ankle muscles due to inflammation or disease of the nerves controlling them'.[27] Various explanations have been offered for the iconography, but this must surely be an emblematic portrait of a love-stricken knight, whose lady is making him suffer and/or perform great deeds on her behalf.

It has been suggested that the brace is an *impresa* similar to the slave's manacle and gold chain worn on the left leg of the Sicilian knight Jean de Boniface, who in the 1440s jousted his way through Lombardy, Burgundy, and Savoy, gaining fame and fortune.[28] This is undoubtedly correct, but the *impresa* has been wrongly interpreted as 'a device intended to shame fellow courtiers in the service of the Duke of Milan'—presumably because of their and Jean's 'enslavement' to their Aragonese rulers.[29] A political reading is expressly contradicted by a contemporary account of how the Sicilian knight introduced himself on his arrival in Antwerp: 'I, Jean de Boniface, knight, native of the Kingdom of Sicily, make it known to all princes, barons, knights and gentlemen without reproach, that in order to serve my beautiful lady [belle dame] and to win a reputation for prowess, and thanks only to the leave granted me by the most excellent, most powerful and most victorious prince the King of Aragon and of Sicily...I lay down a challenge...'.[30]

Jean de Boniface was here secularizing a device that was associated with the chivalric brotherhood, the *Fer de Prisonnier*. Founded by the French Duke of Bourbon and sixteen other French knights in 1415, they solemnly agreed to wear 'on their left leg a prisoner's iron hanging from a chain, emblems which will be made of gold for the knights, and of silver for the esquires, every Sunday for two whole years'.[31] The brotherhood was expected on a regular basis to arrange battles on foot against an equal number of like-minded opponents. They were high-class versions of those groups of football hooligans who agree to meet for pitched battles, though these fights did provide crucial training for warfare. The Virgin Mary was the patron saint of the brotherhood, and

a special chapel was dedicated to her with an altarpiece. The iron of any member who died during the two-year period had to be placed before her in the shrine. However, she wasn't the only woman they worshipped: 'every one of us shall undertake to do everything possible to maintain the honour of all ladies and women of good birth ... whenever widows, virgins and ladies have need of our aid and assistance, each of us shall be compelled to give it.'[32]

Jean de Boniface's chained left leg shows his servitude to his lady, and so too does Avogadro's foot-brace. However, his left leg is lame after being placed in the kingdom of Love, and the way in which the knight's left arm rests on the helmet's visor suggests he has been blinded by love. His plumed cap is soulfully tipped down over his left eye, as if trying to shut out the antics and predicament of his left side. Only the armour for his *left* shoulder, arm, and hand, and for his chest, is depicted,[33] underscoring the complete disarming of his 'heart' side.

The scattered armour further recalls images of Mars when the God of War has been seduced by Venus. This myth was often used to illustrate the idea that love conquers all, even the most battle-hardened of warriors, as in Botticelli's celebrated panel painting where a naked Mars slumbers, his outstretched and dramatically foreshortened left leg bent awkwardly under his arched right leg and the left foot trapped in a pink sheet, while Venus and various *putti* look on. The Venus and Mars story was cited in Marsilio Ficino's celebrated treatise *De Amore* (published in Latin in 1484): '[Venus] seems to make Mars more gentle and thus to dominate him, but Mars never dominates Venus.'[34]

However, the fact that Avogadro stands alertly to attention and still wears his sword, points to an equally popular theme, that love and war are mutually sustaining.[35] This is the meaning of a marble relief by the Venetian sculptor Antonio Lombardo from around 1512 where an alert and expectant Mars sits naked on a stone block, surrounded by his armour. A Latin inscription carved on the block explains: 'I, Mars, do not conduct war well unless I have taken off my clothes.'[36]

At the time when the portrait was painted, Avogadro was a married man, and at first sight it seems strange that he should admit in such a formal and public way that he is suffering the pangs of love. Yet it was standard practice even for married men to offer their 'service' to

another woman, usually one of higher rank. That said, his own wife, Lucia Albani, whom he married in 1550, was a distinguished Petrarchan poet, and two of her poems were included in an anthology published in 1554. She does not mention lame left legs, but the pains—and chains— of love loom large.[37] She may even have come up with the idea of the foot-brace (Lucia was also painted by Moroni, though without any indication that she was a poet).[38] As such the portrait (which remained in the Avogadro family until the nineteenth century)[39] would have been a witty and affectionate tribute to Lucia's very own Venusian charms that have kept him, albeit temporarily, from going off to do a man's business. She may be symbolized by the ivy that creeps across and clings to the marble pilaster in the background.

The Holy Roman Emperor, Charles V of Spain, had encouraged a cult of chivalry in this very period,[40] and jousting tournaments, full of pageantry, symbolism, and bad allegorical poetry, were very popular. The publication of Ariosto's *Orlando Furioso* (1516; revised edns. 1521 and 1532) and its international success, attests to the continuing fascination of chivalric romance. In Brescia, a gentleman's company was founded in 1562 with the express purpose of organizing 'virtuosi et honorati' entertainments, among which was the famous 'giostra all'anello' [joust of the ring],[41] a form of jousting in which the jouster's lance had to pass through a suspended ring. The sexual connotations of this practice had been lampooned by Rabelais. From 1561 a series of hugely ambitious and literary chivalric spectacles were held in Ferrara, but it is likely that similar if more modest events were being put on there in the 1550s.[42] In the Renaissance, dances often preceded the jousts, thus making a direct link between prowess in amorous and martial pursuits, and more dances followed the evening meal.[43] Avogadro may even have worn his foot-brace at a tournament.

An iconographically similar, yet much more pained and claustrophobic portrait was painted in 1568 by the Utrecht-born artist Antonis Mor of Sir Henry Lee (Fig. 30). Here the knight's bondage is expressed by the many rings which are tied to him, mainly on the left side of his body. Sir Henry was for many years Queen Elizabeth I's Champion for the Accession Day Tilts, which meant that he had to organize the ceremonial jousts that took place annually on 17th November, the day of her accession to the throne.[44] These tournaments, with their triumphal entries of knights attended by squires, pages, and liveried servants, followed a pattern that was popular throughout Europe in the

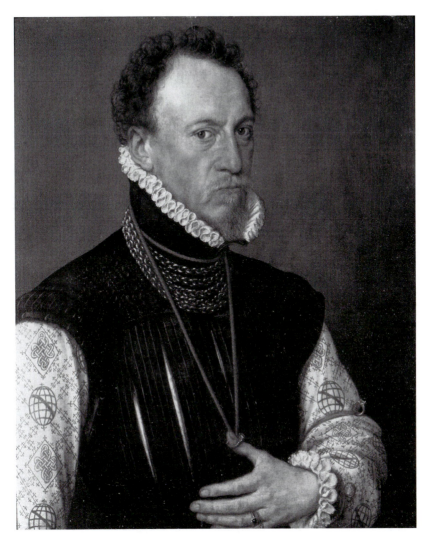

Fig. 30: Antonis Mor, portrait of *Sir Henry Lee*

second half of the sixteenth century. Lee had to lay down his gauntlet in the Queen's defense before each tilt, dress up in symbolic costume, and give wittily romantic speeches. In the half-length portrait, painted before he became Champion, but when he must already have been an enthusiastic participant at the Tilts, Lee wears the Queen's personal colours, black and white. He was eminently qualified to be master of ceremonies for he had been an expert in the chivalric language of love

from childhood, as he was brought up in the household of his uncle Sir Thomas Wyatt, the most distinguished petrarchan poet in England, and the first sonneteer in English.

It was the custom for lovers to exchange rings,[45] but as the size of finger rings could not then be easily adjusted, the recipients often fixed them to their fingers with string, or hung them from their neck, or tied them to their sleeve. This became an excuse to make spectacular and highly confessional fashion statements: the string often became a symbol of the lover's willing enslavement, as we see here.[46] Lee puts the thumb of his left hand through a ring suspended from his neck by a (blood) red 'noose', pulled tight around his neck like a choker. The ring itself has a red stone. In love poetry, Cupid was often blamed for causing a disappointed lover to hang himself, and this possibility is alluded to here. Erasmus' *Adages*, a massive compendium of sayings compiled in the early sixteenth century, included 'they flee from the reddened cord', a reference to a rope dipped in red paint with which the Athenian authorities herded up the citizens to perform their public duties—any shirker who bore a red mark from contact with the rope was forced to pay a fine.[47] But Sir Henry cannot flee from this red cord. It is a precursor to the grimly symbolic red neck scarves worn during the French Revolution.

Lee's impudently phallic thumb looks as though it is being crushed in a thumb-screw (a standard instrument of torture at the time). It is a staged tightness, of course, because the ring would presumably fit on any of his fingers, but it may be meant to allude to a popular superstition that if a ring was too small, it was inauspicious.[48] He is a lover down on his luck, an unjustly treated 'jouster of the ring'.

The gesture is clearly very rude. In 1598, Christopher Marlowe would publish an elegy to a ring which the poet has given to his mistress, and which she wears on a finger of her left hand. He imagines that he becomes that ring, and eventually gains access to her more intimate zones ('hide thy left hand underneath her lap'), whereupon the ring is transformed into a dildo: 'But seeing thee, I think my thing will swell, / and even the *ring* perform a man's part well.'[49] Here Lee seems to be imagining that the ring given to him by his mistress is a kind of vagina dentata, the cause of the most exquisite pain. Two other rings are tied round his left arm and wrist by red cord, and they echo the gold pattern of 'true lover's knots' that adorns his white sleeve. His immobilized left arm looks as though it is in a sling. His right arm hangs

limply by his side, and is depicted only above the elbow. This makes him seem even more defenceless. It has been said that the portrait shows him 'staring out full of confidence',[50] but his lips are surely pursed with grim determination. Many years later, Lee would appear as the Enchanted Knight at the Accession Day Tilts, unable to do battle because 'his arms be locked for a time' after a spell cast by the Queen of Fairies—an allegorical counterpart to Queen Elizabeth.[51]

The scenario in the portrait is comparable to that expressed in a sonnet written by Lee's uncle, a translation from Petrarch (from which we quoted earlier). In the 'Complaint upon Love, to Reason', Sir Thomas Wyatt remembers his misspent youth:

> And thus I sayd: once my left foote, Madame,
> When I was young, I set within his [Love's] reigne:
> Wherby other then fierly burning flame
> I never felt, but many a grievous pain.
> Torment I suffred, anger and disdain.
> That mine oppressed pacience was past,
> And I mine owne life hated, at the last.
>
> (ll. 8–14)

Mor's portrait was painted when Lee was in Antwerp, working as an agent of the Crown. He was thirty-three, the same age at which Christ endured his Passion and Crucifixion. We can perhaps see this image as a representation of the courtier's own deliciously masochistic Passion. It remained in his own collection at Ditchley Park, Oxfordshire, and was presumably meant for the private delectation of his mistresses, and of the visiting Queen Elizabeth. At only 25¼″ × 21″, this cabinet picture would have been rather overshadowed and even crushed by the later and far better known 'Ditchley Portrait' of *Queen Elizabeth I* (*c*.1592; 95″ × 60″), which Lee commissioned from Marcus Gheeraerts the Younger as a peace offering to the Queen after he had secretly married his mistress (they both now hang together in the National Portrait Gallery in London). This picture too features elaborate left-right symbolism. Here Elizabeth bestrides a map of England in full regalia, the heel of her shoes planted firmly on Oxfordshire. The sky behind her left shoulder is tempestuous and striated by lightning, and on the right, is bright and sunny. A sonnet inscribed on the canvas, which must have been devised, if not written by Lee, explains that the sun reflects her glory, and the

thunder her power. In his political and sexual relations with women, Lee evidently relished a bit of both.[52]

* * *

THUS FAR, OUR 'PRISONERS OF LOVE' have been men. This is scarcely surprising as women's roles were much more narrowly defined, and they were more rarely depicted in portraits. It is also far easier to be entertained by the idea of your own subjugation or lameness when you are master of your own house, with total control of the purse strings. It was taken for granted that women were the weaker sex, so there was probably less need to imagine their subjugation or fantasize about it. It may be symptomatic that it is the male Cupid, rather than the female Venus, who gets tied up, blindfolded, and whipped (usually by women) as punishment for making people fall in love.

Nonetheless, there are examples of women who seem to be enthusiastic prisoners of love. Raphael's scantily clad seated portrait of his young lover, *Portrait of a Nude Woman (the 'Fornarina')* (c.1518), is a classic prisoner of love. The 'heart' side of her naked torso is orientated towards us, and she places the fingers of her right hand over her left breast, as if about to squeeze it. The gesture suggests both fertility and sexual availability, and the exposed left breast is found in other renaissance images of 'loose' women.[53] She sits in front of a spray of myrtle, quince, and laurel leaves that also suggest fertility. She glances to her left too, with a faint smile on her lips.

However, her left side is adorned with 'protective' charms and jewels. A blue armband on which Raphael's name is prominently inscribed in gold has been tied around her left arm above her elbow (the same position as the Order of the Garter when worn by women, and the same colour scheme), showing both that her heart is given exclusively to the knight-artist, and that he will defend her. She also wears what could be a wedding band on her ring-finger, and a large tripartite pendant brooch attached to the left side of her turban, so that it hangs down over her jet-black hair.[54] In lapidaries (treatises on jewels with magical powers), wearers of such stones are more often advised to wear them on the left side of the body than on the right, especially those stones that ensure healthy pregnancies.[55] In this context, the squeezing of the left breast may signify she is pregnant—by the artist.[56] The purpose of all these baubles would be similar to a medieval ring brooch recently found in Essex, England, with an admonitory inscription in French:

JEO SUI FERMAIL PUR GARDER SEIN
KE NUS VILEIN N'I METTE MEIN
[I am a brooch to guard the breast / So that no knave may put his
hand there][57]

This would clearly raise a smile both in the wearer and the predator, and
would thus perhaps defuse any potentially compromising situations—so
long as the predator could read and understand French.

The blatant sexiness of Raphael's picture (it was probably exhibited
behind shutters in the artist's bedroom) should not distract us from its
tact and decorum. We see nothing below the breast, and the left arm
seems inbued with unusual power. In a breathtaking sleight of hand, the
position of the left arm and hand, the turn of the head and glance of the
eyes, and her upright posture seem to have been inspired by Donatello's
St George, which Raphael had drawn when he was in Florence in
1504–5.[58] It is thus inserted into a chivalric context. She seems to say,
'I am blessed by the love of the divine Raphael and you violate me at
your peril'.

15. Lovelocks

> the wearing and nourishing of the Love-lockes is not from
> God...therefore they must needes bee from the Devill.
>
> William Prynne, *The Unlovelinesse of Love-Locks* (1628)[1]

FROM THE END OF the sixteenth century until well into the seventeenth century, the most popular and dashing way of showing that one was a prisoner of love was to wear a lovelock. A lovelock was a lock of hair which was allowed to grow much longer than the rest, and hung down over the shoulder, usually the left so that it was near the heart. It might be curled, wavy, or straight, loose or plaited, and terminated by a bow or rosette. The lovelock broadcast the wearer's affection, whether for a lover, or for a spouse. It was the sexiest of all asymmetrical fashions, and drew attention to the emotional afflictions of the 'heart-side' like no other.

The originator of the primarily aristocratic style is usually considered to be the ultra-chic soldier and courtier, Honoré d'Albert, Duc de Chaulnes (1581–1649), who became Maréchal de France, and was often known as Seigneur de Cadenet. In much of seventeenth-century Europe the lovelock was called the 'cadenette'.[2] However, this fashion was popular long before de Cadenet's heyday. In John Lyly's *Midas*, first performed in London before Queen Elizabeth I in January 1590 (that is, when Cadenet was nine years old), Motto the Barber reminds his protégé of the 'phrases of our eloquent occupation'. Key questions to be asked of the customer include: 'Your lovelocks wreathed with a silken twist, or shaggy to fall on your shoulders?'[3] If there were lovelocks on either side of the head, the hair would usually be arranged so that the

lovelock on the left hung in front of the left shoulder, while that on the right was swept behind.

Judging from the visual evidence, England is the spiritual home of the bona fide lovelock which cascades over the left shoulder. This is perhaps not so surprising when one considers that English monarchs still awarded the Order of the Garter: the 'silken twist' that 'wreathed' many a lovelock was in many respects a garter for a (prosthetic) leg or arm of hair. The erotic potential of the lovelock is beautifully expressed in two portraits of Henry Wriothesley, the third Earl of Southampton (1573–1624). In Nicholas Hilliard's exquisite portrait miniature of 1594, a spectacularly shaggy lovelock tumbles down over the left shoulder of this beardless youth of twenty.[4] The cascade of loose hair seems to rise as well as fall, erupting from the region of the heart like spouts of auburn flame. The folded crimson curtain in the background turns the heat up even higher, with the folds adding to the sense of refined neurotic tension. A horizontal fold in the curtain passes behind Wriothesley's head at eye level, while a vertical fold cuts asymmetrically across just above his left shoulder, forming a cross. Here, love is very much the cross he has to bear. Through it all, the pale-skinned youth gazes out with a kind of spell-bound intensity. The miniature was presumably given to his lover and worn next to her—or his—pounding heart.

Wriothesley had Italianate tastes, and was already the patron of many poets, including Shakespeare who dedicated *Venus and Adonis* to him in 1593, and in the following year, when Hilliard painted this portrait, *Lucrece*. Some scholars believe he may be the mysterious 'WH' to whom the sonnets are addressed (WH being a reversal of his own initials). Shakespeare makes an amused and amusing reference to a lovelock in *Much Ado About Nothing* (1598). It occurs when two simpleton watchmen misunderstand a conversation between the devious henchmen Borachio and Conrade. First of all, Borachio laments the ever-turning wheels of fashion: 'Seest thou not, I say, what a deformed thief this fashion is, how giddily 'a turns about all the hot-bloods between fourteen and five-and-thirty' (3, 3, 130–2). He then goes on to describe the sexual shenanigans he has just orchestrated on behalf of his master Don John.

Having overheard all this, the first watchman sounds the alarm: 'Call up the right Master Constable. We have here recover'd the most

dangerous piece of lechery that ever was known in the commonwealth'. Whereupon his sidekick helpfully suggests: 'And one Deformed is one of them; I know him, 'a wears a lock' (3, 3, 166–70). Here, a lovelock signifies the most deformed kind of libertinism—albeit, in the opinion of a half-wit.

Fig. 31: Unknown English Artist, *Portrait of Henry Wriothesley, the third Earl of Southampton*

A second portrait of Wriothesley by an unknown artist (Fig. 31) was until recently assumed to be a portrait of a woman. It is thought to have been painted earlier than the Hilliard. Here he presses an even longer lovelock to his heart with the exquisitely elongated fingers of his right hand. The lovelock seems to emanate directly from his heart like a major artery that leads directly to the left side of his head where we find an elaborate earring hanging from his left ear lobe. It consists of two interlocking red and black double-bows studded with tiny jewels. As Wriothesley wears a black doublet, we may assume that the red bow stands for his beloved. But the great thing about this lovelock is that it obviates the need for a lover. The hand caressing the lovelock is eminently masturbatory, and the feminine associations of long hair give the wearer of a lovelock a refined androgeny. In some respects the lovelock is a fetishistic woman-substitute, a 'live' counterpart to the locket of hair traditionally exchanged by lovers. Renaissance images of hermaphrodites usually confine the female side—and the long hair—to the left.[5] This kind of masturbatory lovelock is the pre-cursor to the penis sprouting from the left side of Marie-Thérèse Walter's head in Picasso's *Dream*. Wriothesley and his aristocratic contemporaries implicitly understood that the left side of the face was the 'wish-face'.

In seventeenth-century England, the left-sided lovelock came to signify the most noble form of love in royal circles. Isaac Oliver, a student of Hilliard, became miniature painter to the wife of King James I, Queen Anne of Denmark, in 1605, and at some time after around 1610 painted a miniature of the *Head of Christ*, in which the redeemer sports an ebulliently shaggy lovelock. It is an extraordinary image whose purpose and patron are unknown. Painted in the soft-focus manner of Coreggio, Christ turns to look meltingly over his left shoulder, though his eyes appear to be closed in sensuous abandonment. As he is clothed, and he may in fact be looking down towards the ground, it is possible that this is supposed to be a 'Noli me Tangere', where Mary Magdalene kneels before Christ and tries to touch him after his resurrection (and this too might explain the spectral quality of the lighting). If this is correct, then the owner and wearer of the miniature is likely to have been a woman. Christ's eyes may appear closed to the viewer, but his cascading locks here suggest the boundlessness of his love (as indeed does the left-ward spurt of blood in Cranach's crucifixions).[6] As we cannot see the 'right' side of Christ's head, we do not know if Oliver intended him to have

equally long hair,[7] but he was too aware of the significance of lovelocks for this to be a visual accident. His miniature of an *Unknown Lady* (1605–10) shows a beautiful woman in male hunting attire provocatively fingering the end of a long phallic lovelock, 'wreathed with a silken twist', implying that her own heart/hart has been successfully 'hunted' down by her male lover, and vice versa.

The fashion for lovelocks may have been inspired in part—or at least given an alibi—by a reference to hair in the *Song of Songs* where the Bridegroom says: 'You have wounded my heart, my sister, with one of your eyes and with one hair of your neck' (4:9).[8] St John of the Cross glosses this passage evocatively in his *Spiritual Canticle* (early 1580s). The *Spiritual Canticle* opens with a poem in which the protagonists are the Soul (the Bride) and God (the Bridegroom). At one point, the Soul-Bride says:

> With flowers and emeralds
> Chosen on cool mornings
> We shall weave garlands
> Flowering in Your love,
> And bound with one hair of mine.
>
> You considered
> That one hair fluttering at my neck;
> You gazed at it upon my neck
> And it captivated You;
> And one of my eyes wounded You[9]

St John of the Cross glosses it as follows: 'The eye refers to faith in the Incarnation of the Bridegroom, and the hair signifies love for this very Incarnation'.[10] Although he does not specify which eye, the fact that it signifies faith in Christ's Incarnation would suggest it is the left eye. The hair too is likely to be on the left side, near the heart.

Elsewhere, John of the Cross specifies that the hair signifies the love the Soul has for God, and like a thread in a garland, it 'fastens and sustains the virtues in the soul'. He seems to be advocating—or imagining— a plaited lovelock, similar in kind to the one described by Motto the Barber, 'wreathed with a silken twist'. John clearly felt a single or tied hair better suggested a monogamous passion, whereas a shaggy lock was too suggestive of a love that is free and indiscriminate. He writes that the virtues 'were held with only one hair, and not with many, in order to

point out that now her will is alone, detached from all other strands of hair, that is, from all extraneous loves'.[11] The consequence of all this is the eternal union, the mutual captivation of the Soul and God: 'Consider the joy, happiness, and delight the soul finds in such a prisoner, she who had been for so long His prisoner.'[12] The imaginary lovelock is here a stairway to Heaven.

The apogee of the shaggy lovelock was to occur at the court of King Charles I of England, and the King wore one from early in his reign.[13] A luxuriant lovelock hangs over King Charles' left shoulder in all thirteen portraits painted by Van Dyck, and is central to their iconography.[14] The first of Van Dyck's portraits, painted in the weeks following his arrival in London in 1632, depicts the King with Queen Henrietta, and their two eldest children, Charles, Prince of Wales and Mary, Princess Royal. The picture is frankly romantic. The Queen gazes tenderly across at her husband—or rather, at his voluminous lovelock which broadcasts the depth of his love for her (and perhaps, too, the size of his libido). The marriage was, by all accounts, extremely happy—not least, because it was fecund—and was celebrated as such in contemporary masques and verse.[15]

Lovelocks became a focal point for puritan opposition to the regime. The most exhaustive broadside was penned by the puritan minister William Prynne, who was later imprisoned and had both ears cut off for publishing a tirade against the theatre in which he criticized productions at which the King and Queen had been present. The uncompromising nature of Prynne's tract is obvious from the title: *The Unlovelinesse, of Love-Locks, or A Summarie Discourse, prooving: The waering, and nourishing of a Locke, or Love-locke, to be altogether unseemely, and unlawfull unto Christians* (1628). At one point Prynne credits the French with the monstrous invention. He complains about Englishmen of all ranks who 'would imitate some Frenchefied, or outlandish Mounseir, who hath nothing else to make him famous, (I should say infamous) but an Effeminate, Ruffianly, Ugly, and deformed Locke'.[16] This may have been because Honoré d'Albert, the Seigneur de Cadenet, had been sent by the French King to England in 1621 as ambassador extraordinary. The purpose of his mission was to put King James I on his guard against Protestant reformers, and to propose (successfully) the marriage of the French King's sister, Henrietta Maria, to Charles, who was then the Prince of Wales and heir to the throne.[17] But where lovelocks were concerned, the English needed no guidance from the French.

Since Prynne is determined to establish that lovelocks are the devil's work, he eventually comes up with a non-Christian source for the style taken from Samuel Purchas' recently published collection of travellers stories, *Hakluytus posthumus or Purchas his pilgrimes* (1625). Prynne announces that:

> the wearing and nourishing of the Love-lockes is not from God (no, nor yet from any of his Saints and Children, with whom they were never in use as we can read of) therefore they must needes bee from the Devill: And that they were so indeed, wee have the expresse authoritie of a learned, late, and reverend Historian, who informes us in expresse tearmes . . . : 'That our sinister, and unlovely Love-lockes, had their generation, birth, and pedigree from the Heathenish and Idolatrous Virginians [Native Americans], who took their patterne from their Devill Ockeus; who usually appeared to them in the shape of a man, with a long blacke Locke on the left side of his head, hanging downe to his feete.'[18]

A Native American from Virginia had apparently visited England and 'blamed our Englishmen for not wearing a long locke as they did: affirming the God which we worship, to bee no true God, because he had no Love-locke, as their Devill Ockeus hath'.[19] They must have had similar beliefs to the Zuni, a tribe located in western New Mexico, who we mentioned in the introduction: for them the two sides of the body were brother Gods, with the left being the elder and 'reflective, wise, and of sound judgement'. Prynne believed the only purpose for a lovelock was as a sort of diabolical love-handle—'to give the Divell holdfast, to draw us by them into Hell: a fitting place for such vaine, Effeminate, Ruffianly, Lascivious, Proud, Singular, and Fanatique persons, as our Love-locke wearers for the most part are'.[20] If there is any truth in this anecdote, it would be the first example of North American influence on European fashions.

The Puritan attacks seem to have had little effect, but in Van Dyck's double portrait of *Thomas Killigrew and (?) William, Lord Crofts* (1638) (Fig. 32),[21] in which Killigrew sports one of the longest and bushiest of lovelocks, there is indeed a strong suspicion that it is meant to appear excessive—the symbol of a despairing love that could drag him down into Hell. The portrait was painted shortly after the death of Killigrew's wife of two years, Cecelia Crofts. Much speculation surrounds the identity of the second sitter, seen from the back with his face in profile,

Fig. 32: Anthony Van Dyck, *Thomas Killigrew and William, Lord Crofts*

but the most plausible suggestion is that he is Killigrew's brother-in-law, William, Lord Crofts, who had lost two sisters in the same year. Killigrew was a royalist poet, playwright, and wit, and Van Dyck shows him leaning up against a broken column (symbol either of mortality or fortitude), his head resting on his left hand, in a classic pose of melancholia. His wife's wedding ring is tied by a black band around his left wrist. The cascading lovelock, pinned to Killigrew's cheek by his left hand, is almost an extension of his tears. A large white highlight in his left eye suggests he may have been crying; no such highlight appears in his right eye, as though the tears primarily fall from the left eye. Here the blatant 'effeminacy' of Killigrew's lovelock deftly signals the female cause of his misery.

At the same time, however, he looks to his right; and the right side of his body—or at least his right arm—suggests that Christian faith will help him to come to terms with his loss, and get over his grief. Not only is a dazzlingly radiant silver cross inscribed with his wife's initials pinned

to his sleeve, the two 'C's attached to the top of it like a pair of wings, but his right hand seems to be about to drop a piece of paper onto the floor. The sheet is in shadow but we can just make out a sketch of a pair of statues of female mourners. This is usually interpreted as being a sketch for a pair of allegorical statues in a funerary monument, but if they were drawings of such important and expensive things, it is hardly likely that Killigrew would hold the drawing upside down in such a diffident manner, in the lowest and darkest part of the composition—unless, that is, he had decided to forego an elaborate tomb (plans for such a tomb have never been found).

The two statues of mourners were never, I believe, meant for a tomb. They stand instead for William Killigrew and Lord Crofts. The drawing is effectively being discarded, showing that they will not allow their grief to become immoderate: they will never permit themselves to become 'pictures' of grief. The grieving female allegories now almost start to look like sinners being cast into the depths of Hell, since the drawing is being thrust by Killigrew down to the lower left. They are being supplanted in the sitters' consciousness by a brightly lit blank piece of paper that is being held up by Lord Crofts, and which is strategically positioned directly above Killigrew's own sheet of allegorical sketches.

Crofts points to the top of the blank sheet with his right index finger, and at first sight this gesture seems strange since there is nothing to see or read. As Killigrew was a writer himself, the blankness must have some significance—especially when compared with the shadowy *orror vacui* of the other sheet. The most likely explanation is that Crofts is saying to his brother-in-law that they must both trust in God and turn over a new leaf in the book of life. By pointing to the top of the sheet, he suggests that a fresh narrative is about to begin. The paper has the same fresh bluey white tonality as their own beautiful shirts, and as the sky on the far right of the composition, and this too suggests a new day is about to dawn. Having discarded the drawing of the mourning women, one suspects Crofts will go and get a haircut as well: his weighty-looking lovelock, which now drags him down like a ball and chain, seems to hang precariously from the finger-tips of his left hand, and will shortly go the same way as the drawing.

The vulnerability that is sometimes implied by extravagant lovelocks may explain the reception given by Bernini to Van Dyck's *Triple Portrait of Charles I* which was sent to him in Rome in 1635 so that he could carve a portrait bust. Many years later, and long after the execution of

the King, English visitors to Rome were informed that Bernini believed the portrait to be prophetic. John Evelyn wrote that Bernini detected 'something of funest and unhappy' in the countenance of the King and 'so many cross-angles in the physiognomy of him for whom it's cut'.[22] The portrait is certainly atmospheric, with its background of cloudy sky, and the different directions in which Charles looks makes one think of brooding images of those who look to the past, present, and future. Bernini's thoughts may also have been prompted by the fact that the King was not a Catholic, but clearly yearned to become one. The agent of the Duke of Modena was hugely impressed by Bernini's (now lost) bust, but on examining the lines and marks on his forehead, quipped that 'from the nature of the marble, there still remain some little spots, and one man said that they would disappear as soon as His Majesty shall become a Catholic [literally "immaculate"]'.[23] But Bernini may too have been surprised, even at a time when men wore their hair long, to see a monarch sporting a lovelock. Did the radical asymmetry of hair-style stimulate the sculptor's propensity to detect 'cross-angles' in his physiognomy?

Undoubtedly, the hair on the left side is more unruly than that on the right: the King seems most composed in the portrait that shows him in right profile, and so with none of the left side visible. From copies of the bust, lost in a fire at Whitehall in 1698, Bernini carefully delineated the King's lovelock—the only time in his career that he was called upon to depict a male haircut of such portentous asymmetry.[24]

16. Honorary Left-Handers

Then the [High Priestess of the Temple of Venus] had [Polia] curl the fingers of her left hand and extend the ring-finger, then draw in the sacred ashes certain characters, with care and precision just as they were painted in the volume of pontifical ritual.

Francesco Colonna, *Hypnerotomachia Poliphili* (1499)[1]

IN THE VISUAL ARTS, conspicuous images of left-handers are extremely rare[2]—so long as we exclude the legion of 'accidental' left-handers found in reproductive prints where the copyist has failed to reverse the source image. From around the 1520s, the makers of reproductive prints, for which there was a rapidly increasing demand, frequently depicted the source image in reverse, because it was much harder and more time-consuming to make a print that would show the source image the right way round: for that to happen, counterproofs and offsets had to be made, and these were invariably fainter and less crisp than the original.[3]

During the Renaissance, however, we do start to find images of what might best be termed 'honorary' left-handers—those who conspicuously espouse left-handedness in order to perform certain actions that are usually carried out by the right hand. In these artworks, the espousal of left-handedness is an expression of love, or of an openness to love; and it is often underpinned by a politics of love.

Michelangelo's unfinished statue of *Apollo* (*c*.1530) (Fig. 33) is perhaps his most beguiling work; it is also one of the first positive and dynamic images of left-handedness. These two factors are inextricably linked. The youthful sun-God reaches over his right shoulder with his left hand to take an arrow from his quiver. This means that he must technically be a left-hander. It can scarcely be an accident, for not only do left-handed archers appear in two other works by Michelangelo from

Fig. 33: Michelangelo, *Apollo*

the 1530s, but this same iconography occurs in relation to Apollo in antiquity. The Delian Apollo, together with the Bridegroom in the *Song of Songs*, are some of the first positive representations of left-handed actions.

289

The Delian Apollo (so-called because his principle shrine was on Delos) was a benign, loving image of a god famed for his ruthlessness. In ancient literature, Apollo is almost always firing off lethal arrows, and in the Homeric Hymns is known as the 'Far-Shooter'. The super-cool assassin is the God presented to us in the *Apollo Belvedere*. The Delian Apollo, whose image is featured on Greek coins, is very different: he holds a bow and arrows in his left hand, and the three Graces in his right. According to Macrobius, writing in the *Saturnalia* (*c.* AD 400), by holding his weapon in his 'weaker' left hand, Apollo demonstrated that he was 'slower to do harm'; and by holding the Graces in his 'stronger' right hand, he showed he was more ready to do good.[4] The Delian Apollo offers love more readily than death, and this aspect of Apolline ethics has been seen as a precursor to Christian ideas of divine forgiveness: 'the god is even waiting for man's repentance that would save him from punishment'.[5] The Delian Apollo is depicted in a large relief by the Florentine sculptor Agostino di Duccio in the Tempio Malatestiano at Rimini, dating to around 1450.[6] He is shown in left profile, and holds his bow and an arrow in his left hand.

The apparent left-handedness of Michelangelo's statue has not been discussed, partly because of the controversy surrounding the title of the work, which has taken up a great deal of interpretative energy. The unfinished statue is dreamily voluptuous, and depicts a naked boy who seems not fully conscious of his movements: he leans back, swaying, his head turned sharply aside to the left. We feel the somnolent weight of the head as in no other Michelangelo sculpture. He is further unbalanced by the position of his right foot, resting on a semi-spherical mound, which makes his right knee jut forward. The statue would work almost as well as a restless recumbent figure, placed on its back.

Vasari, in the first edition of the *Lives of the Artists* (1550), describes it as a statue of the archer-God Apollo, but another source, a Medici inventory of 1553, calls it David, presumably because the compiler thought the mound was the head of Goliath. Some scholars think it started out as a statue of David, and that he held a sling in his left hand, and a stone in his right.[7] However, a contemporary drawing after the figure clearly shows the quiver on his back, which suggests he was an Apollo from the outset.[8] The mound may be his attribute of a sun; or a globe, symbol of his universality; or just a rock.[9] There is no indication that Michelangelo's Apollo is holding anything in his right hand, but the action of the left arm, and the extraordinary slow-motion, sleep-walking

feel of the whole figure, is quite sufficient to make the point about his being an Apollo who is 'slower to do harm'. The bow is omitted, not only because it is difficult to carve a bow in marble, but also for aesthetic reasons (in the *Last Judgement*, St Sebastian 'mimes' the action of drawing a bow, and so do the figures in the presentation drawing *The Archers*).

The Delian Apollo is the first, but certainly not the last time that 'left' in political terms is associated with tolerance and benign justice. The somewhat arcane iconography makes perfect sense when we realize that Michelangelo carved the statue for Baccio Valori, the victorious commander of the Medici-supporting army that had besieged Florence and overthrown the Republic. Valori was immediately appointed Regent of Florence, and remained in this post from 1530 to 1531. Michelangelo carved the statue, Vasari relates, so that Valori could mediate between the artist and the Medici, thus enabling him to make his peace with them. In the second edition of the *Lives* (1568), Vasari simply wrote that Michelangelo carved it to get on friendly terms with Baccio [per farsi amico].

Michelangelo certainly needed to curry favour with Valori and the Medici, as the artist had been a key figure in the defense of republican Florence. He had been one of the nine members of the Council of the Militia, and was Governor and Procurator of Fortifications. Michelangelo even made a series of extraordinary designs for fortifications, but there was no time for anything so elaborate to be built. Instead he just seems to have reinforced some existing bastions, and he successfully covered the walls of the strategically important bell-tower of San Miniato with mattresses to protect it from cannon balls. After taking control of the city, Valori took savage reprisals, and issued an order for Michelangelo's assassination, but the artist could not be found because he had gone into hiding, and was eventually saved by a pardon from the Medici Pope Clement VII. Valori's ruthlessness is all too evident in the portrait painted by Sebastiano del Piombo in 1530, which we mentioned earlier: lit sharply from the left, so that the right side of his face is swallowed up in shadow, he is as calculating as he is pitiless.

The fact that Michelangelo made what is perhaps his most entrancing and weightless sculpture for a man who was not just a vicious brute but who had just destroyed Florentine liberties, has perplexed and disappointed some scholars, and has further contributed to its critical neglect.

But as soon as we realize its true subject, it becomes one of the most courageous works of political art ever made. It suggests in no uncertain terms that Valori and the Medici should temper their cruelty. As such, the text that comes closest to accounting for its spirit is Philo's *On the Embassy to the Emperor Gaius* (AD 39–40), where the Jewish author describes how the Emperor masqueraded as Apollo, 'wearing a crown like [sun] rays, the Graces in his right hand, since it is fitting to hold out good things willingly and that they should occupy the better place to the right, but keeping the bow and arrows in the left hand, since it is fitting to hold back retribution and that it should be allotted the inferior place on the left'.[10] His statue seems to imply that Baccio and the Medici should act in this sort of way. However, he seems to have stopped working on the statue when Baccio left Florence in 1531, and the statue remained unfinished in Florence when Michelangelo emigrated to Rome in 1534. It was never publicly displayed and ended up in Duke Cosimo I Medici's private apartments, alongside Michelangelo's statue of *Bacchus*, whose own movements had been evocatively 'slowed' by the effects of drink.

But how can we be certain that Michelangelo and his Florentine contemporaries knew about the myth of the Delian Apollo? It does indeed seem to have been a rather rarefied theme, and Agostino di Duccio's relief is the only known Renaissance depiction prior to Michelangelo. However, a Latin edition of Marcrobius' *Saturnalia* was published in Florence in 1515 (and in Venice in 1528), and Michelangelo did move in extremely erudite circles. The Delian Apollo was depicted and discussed in iconographic manuals published from the 1550s onwards,[11] and was already a conversation topic at a dinner-party held by a poet friend of Michelangelo's in 1543 (to which we will return in a moment), so it may well have been 'in the air' in 1530. More importantly, the basic concept of the 'loving' left hand that is 'slow to do harm' had been used before specifically in relation to Florentine politics and society, and this would explain its relevance to Michelangelo and to the new Medici regime in Florence.

Boccaccio had begun his biographical *Treatise in Praise of Dante* (1351) with a variation on this theme, using it to criticize the Florentine government that had banished Dante, its most celebrated citizen, for his political affiliations. Michelangelo, as a celebrated devotee of the poet, would almost certainly have read Boccaccio's biography, not least because it was usually appended to collections of Dante's shorter poems.

In his *Treatise*, Boccaccio urged the erection of a statue commemorating Dante (an honour accorded to worthy men in antiquity), and in 1519, when the Florentine Academy petitioned the Medici Pope Leo X to repatriate the poet's remains from Ravenna, where he had died in exile, Michelangelo had offered to erect a 'worthy monument' for the 'divine poet' in a prestigious location in the city.[12]

Boccaccio does not mention Apollo, but in the opening to his treatise he instead credits Solon, the politician who drew up the Athenian constitution, with having made a comparable political distinction between the left and right feet of the body politic. The treatise begins:

> Solon, whose breast was said to be a human temple of divine wisdom, and whose sacred laws are to men of today an illustrious witness to the justice of the ancients, was, according to some, in the habit of declaring that every republic walks and stands, like ourselves, on two feet. In his mature wisdom he affirmed that the right foot consists of not letting any crime that has been committed remain unpunished, and the left of rewarding every good deed. He added that whenever either of these two things was neglected, whether by corruption or by carelessness, or was not well seen to, then the republic must without doubt be lame. And if, by some great misfortune, it sinned on both counts, then it was almost inevitable that it could not stand at all.[13]

Cicero records Solon as saying that 'republics are maintained by two things, rewards and punishments', but it seems that Boccaccio devised the rather strange metaphor of the dispensing left and right feet, which would be more appropriate for a monkey.[14] If his metaphor was initially inspired by the Delian Apollo, about whom he may have read in either Macrobius or Philo, he may have assumed that a metaphor associated with the unpredictable pagan god Apollo, rather than with the venerable Solon, would have cut little ice with his Florentine contemporaries. However, Apollo does make a benign appearance later on in his treatise, as the patron of poets and the inaugurator of a tradition whereby poets are crowned with laurel leaves.[15] So Boccaccio may simply have been combining aspects of Solon with the Delian Apollo.

Boccaccio's trope differs from that of the Delian Apollo insofar as the left and right feet are equal partners, with contrasting functions. He advocates a carrot and stick approach in the ideal republic, with the left foot being responsible for distributing the carrots. But Michelangelo is

likely to have seen Boccaccio's metaphor filtered through the ideas of Lorenzo de' Medici. In a commentary on another poem in which his lady's left hand is praised, Lorenzo would give the left hand priority in a way that comes much closer to the spirit of the Delian Apollo—though once again, Apollo is not specifically mentioned. The sonnet in question is worth quoting in full:

> O mano mia suavissima e decora!
> 'Mia' perché Amor, quel giorno ch'ebbe a sdegno
> Mia libertà, mi dette te per pegno
> Delle promesse che mi fece allora;
>
> Dolcissima mia man, con quale indora
> Amor li strali onde cresce il suo regno!
> Con questa tira l'arco, a cui è segno
> Ciaschedun cor gentil che s'inamora.
>
> Candida e bella man, tu sani poi
> Quelle dolci ferrite, come il telo
> Facea, com'alcun dice, di Pelide.
>
> La vita e morte mia tenete voi,
> Eburnee dita e 'l gran disio ch'io cello,
> Qual mai occhio mortal vedrà né vide.[16]

[O gentlest and most decorous hand of mine! / 'Mine' because Love, that day when he disdained / my freedom, gave you to me as a pledge / for promises that he then made for me. / Sweetest hand of mine, with which Love gilds the arrows that increase his domain, / and with which he draws the bow which makes a mark / on each gentle heart that falls in love. / White and beautiful hand, you then heal / those sweet wounds, as reputedly did the spear / of Peleus. / You hold my life and death / in your ivory fingers, and you also hold the great desire that I conceal, / and which no mortal eye sees or will ever see.]

In the commentary Lorenzo explains that Love shoots his bow with his left hand, guided by his lady's left hand. The tips of Love's arrows cause only temporary pain, like the javelin of Peleus and Achilles which was able to heal the wounds it had inflicted. Just as the Countess of Champagne had insisted in Capellanus' *Art of Courtly Love*, this great love is kept concealed from everyone except the beloved: other men 'cannot

see my most noble desire', Lorenzo says, because 'not having been made noble by her, they are inadequate'.[17] The immediate impact of the left hand is here very limited and exclusive (Lorenzo alone receives its benefits), but in the commentary Lorenzo proceeds to universalize it. First of all, he has to turn anthropologist and explain why the right hand is usually given the leading role in so many transactions:

> It is common and ancient custom among men in every contract and transaction, to touch, as a more efficacious sign of our heart and will, with our own right hands the right hand of him with whom the pact is made, and commonly it is done when peace is restored after some war and related injury. Similarly, when in such cases or in others someone takes an oath, the right hand is its instrument and officer. I believe such a custom as this to have been introduced from the cause that we shall next explain. Whatever peace or similar pact and promise has been given that was interrupted or not observed must have been broken by some new injury that, most of the time usually is begun and administered by the right hand, for it is that which strikes and in most men is very quick and ready to give offence. And therefore, the right hand is used in the above mentioned covenants as a witness and confirmation of that which is performed, for it seems to put under obligation the thing that can first and most easily violate the pact.[18]

Having established the domineering and volatile nature of the right hand, Lorenzo concludes by calling for a cultural revolution:

> Now, in order not to leave in confusion whoever has read something in our preceding commentary that seems *prima facie* a contradiction, we shall next make a major declaration. We have indicated that this hand so much praised and loved by me was the left one, yet all the examples that we have given (either of the pledge that I had from Love by means of it, or of the gilding of the arrows, or drawing the bow or healing, etc.)—[all these] more aptly refer to the right hand. To alleviate this confusion, then, one must understand that the left hand is naturally more worthy and stronger than the right because it is nearer the heart, which is the author of its power and force. It is true that human use, as with many other things, has indeed corrupted this natural power, and therefore, if the right hand has more worth or power, it is owing rather to custom than to nature. And custom

ought not to prevent that from being worthier which by its nature is more worthy.

Those who are truly intelligent will prize the left hand above the right, and reassert the natural order of things:

And therefore good intellects like my lady's—perverse custom notwithstanding—wish in this as in other things to be most excellent among others. And having to demonstrate to my heart the pity and disposition of her heart, she did so by that instrument that was more natural and that, by being nearer the heart, merited more faith. Beyond this, gilding the arrows, pulling Love's bow, and tending the amorous wounds are offices of the left hand because, if indeed its beauties bind tightly, the heart of the beloved binds much tighter, and so heals much better. And all these manual works, which have to symbolize those of the heart, are much more fitting to the left hand because of its aforesaid proximity. And therefore what men commonly do is in error, rather than the choice of this member [the left hand] by my lady.[19]

This is potentially very radical indeed. Lorenzo seems to believe that the first men were naturally left-handers, and regards the later adoption of the right-hand as a symptom of their fall from grace. In the opening chapter, we saw how Plato assumed that handedness was acquired culturally, blaming the fact that one hand effectively 'limps' on 'the folly of nurses and mothers'. He thereby implied that we were originally ambidextrous rather than left-handed.[20] So Lorenzo goes even further than Plato, and this primeval left-handedness underpins his vision of a new golden age of universal peace and love. He makes no mention of the obvious fact that if the left-hand is trained up and exclusively used, it will become just as 'rough' as the right hand. For Lorenzo, the left hand is intrinsically more beautiful and peace-loving.

Lorenzo's conviction about this was probably intensified by the Pazzi conspiracy in 1478, when he and his handsome younger brother Giuliano were attacked while attending Mass in the Cathedral, and both were wounded, Giuliano fatally. This attempted coup was brought about because of the Medici's increasingly authoritarian grip on power, which involved regular siphoning off of public money. In the immediate aftermath, Pope Sixtus IV (who had backed the conspirators) declared war on Florence.

Angelo Poliziano's *Stanze per la Giostra di Giuliano* (1475–8) had been written to celebrate Giuliano's participation in a jousting tournament in 1475, but remained unfinished because of his death. It is in many respects a celebration of the triumph of left-handed values. Its hero is Giulio, a hunter who loathes women, but who then falls hopelessly in love with a nymph whom he sees in a meadow: he is struck in the heart by Cupid's arrow, which he shoots left-handed:

> La man sinistra con l'oro focoso,
> La destra poppa con la corda tocca [40: 5–6]

['The left hand holding the fiery golden arrow, touching his right breast with the bow-string']. Lorenzo may have viewed the Pazzi conspiracy as a hateful 'right-handed' plot against the loving 'left-handed' Medici. Politically, then, Lorenzo's promotion of a pacifist agenda might be seen as a way of maintaining the status quo and thus safeguarding Medici interests, both in Florence, Italy, and Europe.

But one can adduce other reasons too. Many other Italian city-states, were ruled by professional soldiers. Milan, Florence's traditional enemy, was ruled by a succession of *condottieri* with 'unconquerable right arms'. Lorenzo, however, was from a banking family, and this may be one of the reasons why he venerates the 'loving' and 'truthful' left hand above the 'quarrelsome' right hand. Indeed, for the purposes of counting and memorizing, the left hand was crucial, for the index finger of the right hand pointed to the 'five fingers' of the left hand in turn, as we see in images of 'Christ disputing with the Doctors', and in depictions of 'memory hands'.[21]

Lorenzo does not primarily think of himself as a financier or business-man, however, but as a physician who heals wounds. This is because the family name, Medici, means 'doctors'. Innumerable puns were made on the Medici name by their supporters, always implying that the family kept the Florentine republic—and even Italy—in good health. The patron saints of the Medici were the two early Christian doctors, Cosmas and Damian, who reputedly never charged their patients. Lorenzo's vision of a left-handed physician would have made his contemporaries think of healers endowed with magical powers, for they were believed to mix potions and to cast spells with their left hands.

The closest we seem to get to a contemporary illustration of Lorenzo's political worldview is Botticelli's *Pallas and the Centaur* (*c.*1482), a paint-ing which, like the *Primavera*, was made for Lorenzo di Pierfrancesco de'

Medici, possibly at the behest of Lorenzo de' Medici. It was probably hung alongside it in his Florentine palace. Pallas Athene, Goddess of Wisdom, stands to the left of a centaur, holding him by the hair with her right hand. In her left hand she holds a huge halberd, and her upper body and arms are entwined by olive branches, symbols of wisdom and peace. Her diaphanous dress is decorated by the Medici symbol of three interlinked rings. The picture is usually interpreted as the triumph of wisdom and/or chastity over lust, and Pallas is clearly meant to symbolize the Medici family, and their rule over Florence, the new Athens.

Yet Pallas is very much a 'left-handed' custodian, for she holds her halberd in her left hand, and she takes hold of the centaur's hair surprisingly gently, between her thumb and forefinger. The centaur is not unequivocally bad, either, for not only does he seem quite soulful, a potential object of pathos, but he is also a left-handed archer since he holds the bow in his right hand and reaches for his arrows, or for his bowstring, with his left hand, elegantly bending the middle finger.[22] His pose is not dissimilar to that of Michelangelo's *Apollo*.

This centaur reminds us that not all centaurs were bad. Chiron, the centaur who nurtured and taught Achilles—the great warrior who had a spear that healed as well as wounded—was renowned for his wisdom. Like Botticelli's *Venus and Mars*, Pallas and the Centaur are in many respects complementary rather than incompatible. They seem to be idealized reincarnations of an earlier, gentler age. Their encounter takes place in a meadow overlooked by a crumbling rock face. In the background is a rickety fence, and beyond lies a tranquil bay with a moored ship. Scholars usually say that the damaged fence is a sign that the centaur has broken into forbidden territory, but there are no broken fragments of fencing lying on the ground. It is more likely that the fence has just been allowed to decay over a considerable time through benign neglect. The elegiac mood of the picture implies this is a world where nothing is completely closed off, and where people, animals, gods, and ships come and go. The Medici symbols of interconnected rings suggest a fundamental unity rather than strife, and so does the urbanity of Pallas' reprimand.

There was at least one aspect of Lorenzo's domestic arrangements that seems to have challenged left-right hierarchies. Condivi, in his life of Michelangelo, records a peculiar aspect of Lorenzo's seating arrangements for meals:

[Lorenzo] arranged that Michelangelo be given a good room in his house, providing him with all the conveniences he desired and treating him not otherwise than as a son, both in other ways and at his table, at which, as befitted such a man, personages of the highest nobility and of great affairs were seated every day. And as it was the custom that those who were present at the first sat down near the Magnificent, each according to his rank, without changing places no matter who should arrive later, it quite often happened that Michelangelo was seated above Lorenzo's sons and other distinguished people, the constant company in which that house flourished and abounded.[23]

Here, to an extent, a more democratic order was introduced. It was standard practice in the fifteenth century for the lord—and sometimes his wife—to eat alone at a high table on a daily basis, but to permit guests of the highest estate to sit at the high table on special occasions.[24] Usually, the most distinguished guest would sit directly to the right of the lord at the high table. If there were two lower tables, placed either side of the high table and at ninety degrees to it, the most prestigious place was at the top of the right hand table.

Lorenzo was probably trying to emulate the egalitarian principles of the Arthurian 'round table', even if he never actually ate at a round table, except perhaps at a tournament. The Round Table had been created, according to one legend, because Arthur's knights bickered about who should occupy the most prestigious seat at his high table: 'This Round Table was ordained of Arthur that when his fair fellowship sat to meat their chairs should be high alike, their service equal, and none before or after his comrade. Thus no man could boast that he was exalted above his fellow, for all were seated alike, and there was none outside . . . '[25] The order of the knights' names that were inscribed on the famous Winchester 'Round Table' in around 1516 is relevant here. A medieval 'fake' which was probably constructed in the mid-thirteenth century, and when not in use the painted table top was probably hung on a wall. From the inscriptions, we know that the three most prestigious and celebrated knights—Sir Galahad, Lancelot, and Gawain—were seated directly to the *left* of King Arthur. These knights are given priority in the lists of Arthur's knights drawn up by writers such as Malory, and those on the King's right—Sir Mordred, Alynore, and Lybyus—are the last on these lists.[26] Of course, the seating runs in a clockwise fashion

(1, 2, 3 . . .), but what would have struck a contemporary viewer would have been the reversal of the seating hierarchy deployed with a rectangular high table.

The establishment of a new, punitive Medici regime in Florence in 1530 must have reminded Michelangelo of his first patron's own special contribution to political philosophy, and encouraged him to use it as a stick with which to beat Lorenzo's descendants and successors; in the dark days of 1530, Michelangelo must have looked back with fond nostalgia to a Medici regime that had been well-disposed towards him, and which had lived up to the family name, with all its life-saving connotations. Michelangelo's appreciation of the Medici name comes to the fore in a poem written in Rome to the poet Francesco Berni in around 1534.[27] Here he refers to the Medici Pope Clement VII as the 'greatest doctor of our ills' [Medico maggior], and to Cardinal Ippolito de' Medici as the lesser Doctor [Medico minor]. Insofar as the Pope had eventually pardoned him and so saved him from Valori, he certainly was the 'Medico maggior'; in addition, both Pope Clement and Cardinal Ippolito gave him succour by being great patrons of the arts.

* * *

IN 1537, ANOTHER LEFT-HANDED archer features in a work made for another man whom Michelangelo had good reason to fear, Francesco Maria della Rovere, Duke of Urbino. The Duke was the nephew of the late Pope Julius II, and he was responsible for ensuring that Michelangelo completed his uncle's much delayed tomb, which had first been commissioned in 1505. Francesco Maria was a professional soldier with a reputation for extreme violence: he had murdered his sister's lover, and had stabbed to death Cardinal Alidosi, one of his uncle's closest confidantes.[28] In 1537 Michelangelo designed a silver salt-cellar for him, which would have been executed by a goldsmith in Rome. Its appearance is known from a drawing by Michelangelo, and a description by the Duke's Roman agent during the course of manufacture.[29]

Alessandro Farnese had been elected Pope Paul III in 1534, and according to Michelangelo's biographer Ascanio Condivi, he had immediately summoned Michelangelo and asked him to remain in his service. When Michelangelo replied that he was under contract to the Duke of Urbino to complete Pope Julius' tomb, the Pope replied angrily: 'It is some thirty years that I have had this wish, shall I not satisfy it now I am Pope? Where is the contract that I may tear it up?'[30]

In 1535 the Pope issued a special decree appointing Michelangelo Supreme Architect, Painter, and Sculptor to the Vatican household, and in the following year he started the *Last Judgement*.

In the drawing, the legs of the salt-cellar (which is really a tureen) consist of a pair of lion's feet surmounted by a grinning satyr's head. Protruding from the edge of the lid are two falcons' heads, and this lid is surmounted by a statuette of Cupid, balancing precariously on his left leg and drawing his bow-string with his left hand. A description of the salt-cellar while it was being made suggests that the falcons' heads were replaced by foliage, probably of the oak tree, the Rovere symbol ('rovere' means oak tree). Nonetheless, the initial inclusion of falcons, a bird which one associates (in the wild) with mountain ranges, suggests he envisaged Cupid as standing high up on a summit.

The basic conceit is similar to that of the left-handed Cupid in Poliziano's poem, and Michelangelo knew the poet well since it was he who proposed the subject of Michelangelo's unfinished relief, *The Battle of the Centaurs* (*c*.1492). However, Michelangelo's mise-en-scene is even closer to a sonnet by Lorenzo de' Medici in which he describes the moment when Amor (Cupid) came to his aid:

> Amor, in quel vittorïoso giorno
> che mi rimembra il primo dolce male,
> sopra al superbo monte lieto sale;
> le Grazie seco e i cari fratri andorno.
> Lì l'abito gentil, di che era adorno,
> Deposto, dette a me la benda d l'ale,
> allei l'arco in la destra et uno strale
> nella sinistra, e la faretra intorno.[31]

[Amor, on that victorious day / which reminds me of the first sweet pain, / climbs on top of the lofty and happy mountain; the Graces and his dear brothers were with him. / There, having put down the lovely robe that he was wearing, and having given me his blind-fold and wings, / he took up his bow in his right hand and an arrow / in his left, and put his quiver around him].

In Lorenzo's sonnet, Amor *climbs* up onto the mountain ('al superbo monte lieto *sale*'), and perhaps Michelangelo intended this too as there is a nice pun in Italian on the verb 'sale' [climbs], and the noun 'sale' [salt]. Certainly the bitter taste of salt (and tears) might be regarded as one of the components of love, and then perhaps too one might metaphorically

rub salt into the wounds caused by Amor's arrows. In the drawing, Michelangelo mischievously—or absentmindedly—shows an arrow in flight, something which no goldsmith could ever depict.[32] The arrow is fired to the viewer's left, as if aimed at the heart of whoever uses or looks at the salt-cellar.

Not only would this salt-cellar have been the centrepiece of Francesco Maria della Rovere's dining table, it would have undoubtedly stimulated conversations about love, and about the way in which a host shows love by his generosity to his guests (salt itself was a great luxury). We get a good sense of how this might happen from a letter of the 26th July, 1543, written by Claudio Tolomei, a Sienese poet and a friend of Michelangelo's. Tolomei describes a dinner party at which another man named Michelangelo had compared the host to the Delian Apollo, 'wounding' with arrows of love rather than of retribution.[33] No doubt he was in large part moved to say this by the host's surname, Belluomo [beautiful man], for it is not clear why any host would want to 'wound' his guests with arrows of retribution. Michelangelo's salt-cellar would gently remind Francesco Maria that the great artist needed to be cherished rather than punished.

Michelangelo would have probably preferred his intermittently psychotic patron, with his murderous right arm, to resemble the beautiful young swordsman in Moroni's *Portrait of a Left-Handed Gentleman with Two Quartos and a Letter ('Il Gentile Cavaliere')* (c.1565–70).[34] He is both a Delian Apollo and a 'belluomo', for his sword is suggestively fastened to his right hip. One might assume that he is left-handed, yet here the right hand, which holds a letter, is the more active and 'seems to deny what the position of his sword asserts'.[35] The left hand rests passively on two books. The letter is presumably a love-letter, and the books are probably love poetry, perhaps one of the portable editions of Petrarch. Another Moroni portrait, *Portrait of a Gentleman [The Unknown Poet]* (c.1560), features two quarto books with 'Del Fine d'Amore' and 'Dell'Amicitia' inscribed on their spines. The moody sensuousness of his lovely face has often been remarked on,[36] and it is the left side of his upper body—the heart side—that confronts the viewer, and seems to dilate before our very eyes.

* * *

WE HAVE SEEN HOW Lorenzo de' Medici had a vision of an ideal society in which everyone is physically and spiritually 'left-handed'.

For Lorenzo, the fall from grace occurs when 'right-handedness' first appears, and proceeds to take over. As such, we presume that his beloved lady is just about the sole surviving 'left-hander', and it is she who reminds him of the glories of the golden age that has been lost.

Not altogether surprisingly, it is Michelangelo who provides a magnificent image of the tragic decline and fall of left-handedness, and the only collective image of left-handers. At around the time that Michelangelo was carving the *Apollo*, he depicted a small army of left-handed archers in the presentation drawing *The Archers* (*c.*1531), which he may eventually have given to Tommaso de' Cavalieri, whom he met in Rome the following year. It is the most satisfying of all his multi-figure presentation drawings, and so perhaps the greatest drawing ever made. Here, an airborne and prone troupe of nine naked archers (seven male and two female) shoot arrows at a stone herm whose torso is protected on the right side by a shield. All except for one male archer shoot left-handed. Cupid lies asleep on the ground in the foreground, while two other 'amoretti' fan the flames of a fire so they can heat up the arrow-heads. Despite all this attention, the herm is immovable and impassive, and their arrows stick to the shield or the stone base. No arrows have penetrated any part of the 'heart' side of his torso, even though it is unshielded. Cupid is presumably asleep because he has given up.

Scholars have interpreted the archers' left-handedness as a 'bad' moralising feature that proves they are slaves to physical passions.[37] To this end, the herm would be a symbol of chaste and spiritual love. Seen in the context of Michelangelo's statue of *Apollo*, however, the drawing takes on a tragic political light. It would represent the failure of a boundless love offered by a collective group to move an individual. The right-handed archer would then be a sign that their love is turning into hate, and that a rebellion is in the offing: he has had enough, and wants to fire off arrows of retribution. Here, however, the fact that Michelangelo has not depicted their bows, and has them mime the actions of archery, makes the hopelessness of their task seem even more apparent: they are more doomed 'mancini'. As such, they might even be an allegorical representation of the 'mancini' of republican Florence, or even of the nine members of the republican Council of the Militia, to which Michelangelo had belonged.

Michelangelo's imaginative sympathies undoubtedly lie with these beautifully and painstakingly delineated archers.[38] The herm—an

unbending bollard—could hardly be more marginalized in the drawing. He is placed near the edge of the composition, and seems even more marginalized by virtue of being a ghostly, lightly sketched presence. At the centre we find the melée of archers. The dead centre of the composition is located at a point between the buttocks and upper thigh of the archer who pirouettes on his right leg. The heaving, yearning crowd of male and female supplicants take centre-stage and most completely absorb the artist's attention.

<p style="text-align:center">* * *</p>

THUS FAR IN THIS chapter, we have been exploring symbolic uses of weaponry. However, during the sixteenth and seventeenth centuries, symbolic left-handers are also furnished with non-martial implements and tasks. Writing performed with the left hand was essential for making love-centred spells. Insofar as the left hand is the 'messenger of the heart', it made sense for it to write such messages. Near the climax of Francesco Colonna's dream romance, *Hypnerotomachia Poliphili* (Venice, 1499), Poliphilo's beloved Polia is told by the High Priestess of the Temple of Venus to sprinkle the ashes of a sacrificial offering—dried myrtle twigs and a pair of white doves—onto the step of the altar: 'Then the learned director had her curl the fingers of her left hand and extend the ring-finger, then draw in the sacred ashes certain characters, with care and precision just as they were painted in the volume of pontifical ritual'. This unfathomable ceremony 'exorcized all those things that served as obstacles and harms to pious love'.[39] It is nearly impossible to extend the ring-finger while curling the other fingers in, and even a left-hander would be hard-pressed to write with it, let alone with 'care and precision'. But Polia's achievement is meant to attest to the superhuman suppleness and dexterity of the 'courtly' left hand. It is enchanted as well as enchanting.

This procedure may have had some basis in reality. In Jean-Baptiste Thiers vast compendium of popular beliefs, *Traité des Superstitions qui regardent les Sacrements* (1777), we are informed of a superstition regarding marriage. If someone wants to be married within a year, they must draw blood from the ring finger of the left hand, and use it to write 'some dishonest words on an unconsecrated Host'. This must then be placed on an altar, under the cloth, and a priest must be prevailed upon to pray for the desired outcome. Half the host should then be eaten, and the other half pulverized and given to the person one wants to marry.[40]

Two painted self-portraits in which the artist holds his brush and chalk-holder in his left hand suggest that this kind of symbolism could be applied to art-making as well. The first self-portrait, *Portrait of the Artist painting a Portrait of his Father* (c.1580), is by the leading Genoese artist Luca Cambiaso (1527–85) and is known in two versions.[41] Luca's father Giovanni was a painter, and they collaborated on commissions, both frescoes and altarpieces. Giovanni had died in 1579, and his death is probably what prompted the portrait. Luca stands before an easel painting an imposing bust-length portrait of his father, at a slightly larger scale than life. He looks over his left shoulder, presumably at his 'live' father sitting for his portrait in his son's studio. So far there is nothing especially unusual about the picture. However, not only is he holding his brush in his left hand, but the brush is painting his father's mouth and seems to rest on it. Luca was celebrated for being able to paint simultaneously with both hands, and one of his drawings contains the inscription 'Luca Cambiaggio dipingeva con due mani'.[42]

Still, the intimate placement of the brush between the father's lips suggests this is more than simply an advertisement for Luca's amazing ambidextrousness. There is something both comical and touching about Luca's gesture. It looks as though the old man is very much alive—sucking a straw or smoking a pipe. The position of the brush suggests that Luca is a magician literally attempting with his left hand to cast a pictorial spell and reanimate his father by making a 'breathing likeness'; alternatively, the father is, as it were, breathing on the son, and passing on his own ability to paint, so that the brush is a sort of umbilical cord between them. It was then customary for men to greet each other by a kiss on the lips (as we see in countless images of Judas kissing Christ when he betrays him), and this is an impassioned kiss between father and son, and between painters. The brush is a prosthetic vein that begins in Luca's heart, then passes down his left arm and through his fingers.

The second painted self-portrait is by the Rome-based French artist Nicolas Poussin, who was right-handed. *Self-Portrait* (1649) (Fig. 34) was painted for the artist's patron and friend, the Parisian banker Jean Pointel. The commission came about because Pointel and another important Parisian patron and friend, Paul Fréart du Chantelou, had been repeatedly petitioning him for a self-portrait. Poussin wears a black toga, but its sobriety is belied by the informality of his pose, with his head tilted back, and the tousled hair, rosy complexion, and pensive smile. His right

Fig. 34: Nicolas Poussin, *Self-Portrait*

arm stretches right across the front of the picture so that he can grasp the
top edge of a book, propping it up on his lap at an angle. Meanwhile
the left hand, elegantly holding a chalk-holder, is pushed towards the
viewer. It is supported at the wrist by the right arm, which functions
like the painter's maul-stick. Poussin holds the chalk as if he means to
use it.[43]

306

This gesture is unusual, to say the least, for a painter who prided himself on his respect for classical proprieties and on his archaeological approach to resuscitating classical culture. Orators such as Quintilian and Cicero disapproved of gestures made with the left hand, and Michel le Faucheur's *Traité de l'action de l'orateur* (1657) encapsulates this tradition. He insists that only the right hand—the hand of power—should be used for gesturing: 'You must make all your gestures with the right hand; and if you ever use the left, let it only be to accompany the other; and never lift it up so high as the right. But to use an action with the left hand alone is a thing you must avoid for indecency'. The exceptions to prove the rule include 'when Jesus Christ commands the faithful servant to cut off his right hand'. [44] It is easy enough to conceal the left hand in a portrait (and some classical actors hid it beneath their coat),[45] and Poussin's foregrounding of it seems unlikely to be accidental. It is certainly true that the Greek statesman Demosthenes had practiced oratory by looking in a mirror, which reversed his gestures, but there is no good reason why Poussin should have wanted to depict himself for his most important patron as someone who is, as it were, in rehearsal.

Poussin had recently made some drawings to illustrate an anthology of Leonardo's writings on art, and it is tempting to interpret his half-smile and his simulated left-handedness as a homage to the Renaissance master. But the context in which the portrait was painted suggests otherwise. The commission occurred in a climate of jealousy amongst Poussin's patrons, and protestations of love and loyalty from the artist. In a letter of the 24th November 1647, Poussin tells Chantelou: 'Believe me when I tell you that I have done for you what I would do for no other living soul, and when I say that I will always continue to serve you with all my heart. I am not a fickle person, given to switching my affections, when once I have committed myself. If the picture of *Moses discovered in the Waters of the Nile* in Monsieur Pointel's collection generates feelings of love in you, is that proof that I painted it with more love than I did the pictures I painted for you?'[46] He immediately painted another self-portrait for Chantelou, in which the love element is more marginalized. Poussin stands portentously erect with his right hand resting on a book, and his left hand invisible. All warmth is confined to the background where an allegorical female figure of Painting, seen in left profile and with a rosy complexion, is embraced by the naked arms

of Friendship. Poussin reassured Pointel by insisting this was the better self-portrait.

The first self-portrait—with its smiling and left-handed sitter—is a more intimate and emotional expression of Poussin's affection for his patron. But here he also expresses his admiration for a sculptor friend, François Duquesnoy, who had died in 1645. The left-handed painter stands in front of a stone tablet framed by garland-carrying putti that closely derives from a tomb in Rome designed by Duquesnoy. It is death, as well as love, that makes 'mancini' of us all.[47]

MODERNITY

Part 5
Rethinking Left and Right

By the late eighteenth century, Enlightenment attacks on religion and astrology were gradually eroding the cultural significance of traditional left-right distinctions. Even more important was the emergence of aesthetic theories that advocated the total fusion of the viewer with the object of sight. These new theories were brought to bear on the increasingly important genre of landscape painting, and there is no left and right in nature.

That's not to say that some of the old ideas did not continue to thrive. One of the most enduring of the old ideas is the belief in the greater susceptibility and beauty of the 'heart' side. The popularity of the Cult of the Sacred Heart throughout the nineteenth century meant there was no shortage in Catholic countries of images of the crucified and dead Christ seen from the left, and no shortage of images of beautiful naked women seen from the left. These two strands come together in the painter Delacroix's double sale to a Belgian collector M. Van Isaker on the first day of the 1847 Salon of a Crucifixion scene (1846, Walters Art Gallery), with Christ seen from the left, and of a reclining naked odalisque, with her left arm and leg pushed towards the viewer.[1] Even more remarkable are the compositional similarities between three radically left-sided bodies painted by the 'French Correggio', Pierre-Paul Proud'hon—*Christ on the Cross* (1822), *A Young Zephyr* (1814), and the entombment-style *Psyche carried off by the Zephyrs* (1808).[2] But because Proud'hon paints the naked flesh with a white-hot, uninflected intensity, these wonderfully fleshy bodies seem to be purging themselves before our very eyes.[3]

New left-right distinctions did emerge, however, the best known being political left and right. The origins of this lie in the seating plan of the new National Assembly in France in 1789, where the radicals sat on the left, the moderates in the middle and the conservatives on the right of the presiding officer.[4] However, this did not immediately translate into art. Jean-Baptiste Regnault's *Liberty or Death* (1794–5), the larger version of which hung in the Council Hall of the Five Hundred, showed the winged genius of France flanked by a skeletal figure of Death on his lower left, and a female figure of Liberty on his upper right.

Where the visual arts are concerned, the most important development in left-right symbolism—and the one on which I will be focusing—is the way in which the left hand is increasingly cultivated for its access to the most radical and unsettling truths—whether intellectual, political, sexual, or psychological.

17. 'To Err Forever'

Possession makes inactive, lazy, and proud.

Gotthold Ephraim Lessing, *A Rejoinder* (1778)[1]

WINCKELMANN'S WRITINGS, AND IN particular his credo that 'truth springs from the feelings of the heart', was to have a huge influence on romantic-era aesthetics. But whereas the great antiquarian had seen the left side of the human body as the pre-eminent domain for authentic feeling, his successors tended not to localize it in this way, and saw the whole body as the projector and receptor of feeling. The viewer both possesses and is possessed by the object of sight. As a result, an aesthetic that may have started out with the apotheosis of the left side ended up bypassing not just left-right distinctions—but almost all distinctions.

Wilhelm Heinrich Wackenroder's *Confessions from the Heart of an Art-Loving Friar* (1797) was a crucial catalyst.[2] For Wackenroder (1773–98), who spent most of his short life in Berlin, and who only pretended to be a friar for the purposes of this publication, genuine art had to be created with feeling rather than reason:

> *Art* is to be called the flower of human emotion. In continuously changing form amidst the manifold zones of earth it rises up towards heaven, and only *one* united perfume comes forth from this seed for the Universal Father, who holds in His hand the earth with all that is upon it.[3]

Wackenroder does not identify which of God's hands holds the earth (traditionally, Christ held the world in his left hand), because that would be both too precise and too divisive: an indissoluble unity is what this friar is after. Similarly, with the assertion that art is the 'flower' of human

313

emotion, we enter the domain of nature imagery, in which left and right play no part. A flower may be said to have a top and bottom (the flower head and the roots) but it has no left and right.

Wackenroder's ideal artist had a priestly role, and by surrendering his mind to God he could receive unimpeded the mystic stream of the universe. The spectator also partakes in this transcendental pantheism by surrendering himself to the work of art, and identifying himself wholly with it, so that experiencing a great work of art becomes a kind of mystic union—with nature and with God, and with the soul of the artist.[4]

The revelation that results collapses time and space: 'We, sons of this century, have had fall to our lot the advantage that we stand on the peak of a high mountain, and that many countries and many ages lie spread out around us and at our feet, open to our eyes. Therefore, let us make use of this good fortune and wander about through all the ages and peoples with clear vision and always strive to discover *the human element* in all their manifold sensations and products of sensation.'[5] In the Bible, the Devil takes Christ to the top of a mountain and offers him the whole world: our art-loving monk mirrors that temptation scene and offers us '*the human element*' with no sense of irony.

For all the relativism of these panoramic pilgrimages, there is one place and time that Wackenroder wants to visit above all: Nuremberg *c.*1500, when 'my beloved Dürer' presided over the artistic culture of the city, and over a vigorous native school of art: 'German art was a pious youth, raised in simplicity within the walls of a small city amidst intimate friends'.[6] The intimacy is not exclusive, however. Nuremberg almost seems to have been waiting for Wackenroder, and is laid out to receive him: 'How I liked to wander through your quaint streets; with what childlike love I gazed at your antiquated houses and churches, upon which the permanent trace of our early native art is imprinted! How deeply I love the structures of that age, which have such a robust, powerful and true language.'[7]

Wackenroder is equally in awe of Dürer's great contemporary Raphael, and this enables him to assert the existence of a border-crossing brotherly bond between the German and Italian artists: 'Are not Rome and Germany situated on *one earth*? Has the heavenly Father not made *pathways* from North to South as from West to East across the globe? . . . Are the Alps insurmountable?'[8] He sees paintings by both artists in a picture gallery: 'It pleased me very much that they both

present to our eyes so clearly and distinctly mankind in the fullness of soul, so simply and straightforwardly, without the ornamental digressions of other painters'.

Later that day Wackenroder falls asleep and has a dream in which he returns to the gallery and finds the two artists standing in front of their pictures: 'and behold! There, apart from all the others, *Raphael* and *Albrecht Dürer* were standing hand in hand in the flesh before my eyes and were silently gazing in friendly tranquility at their paintings, hanging side by side. I did not have the courage to address the divine Raphael; a mysterious, reverential fear sealed my lips. However, I was just about to greet my Albrecht and pour out my love to him;—but, at that moment, everything became disarranged before my eyes with a great din and I awoke with a violent start'.[9]

For all its mention of piety and reverence, Wackenroder's aesthetic ideal is a totalizing one that brooks few barriers or pedestals. Nothing must be withheld from the right-feeling viewer. Art must express 'fullness of soul', and the viewer is entitled to inhabit the same space and world that is embodied in the picture. The viewer also fraternizes with the picture's creator, who is himself just another viewer. The heraldic conception of picture-making is in peril, and now everything is orchestrated around eliciting the viewer's empathy. Here the visual world—whether a landscape surveyed from a mountain-top; a historic town seen from street-level; or a picture viewed in an art gallery— must be *hospitable*. No genuine friar would gaze with 'childlike love' at 'antiquated houses and churches', for not only does Wackenroder place churches in a list *after* houses, his admiration for them is that of a tourist or antiquarian—he likes the fact that they are 'antiquated'.

* * *

WACKENRODER'S ART-LOVING MONK marks the culmination of a trend in eighteenth century art criticism whereby the critic imagines himself being transported into the artwork, participating and walking about in it, experiencing an encyclopaedic range of feelings and events: Diderot's forty-page pilgrimage through some of Joseph Vernet's landscapes exhibited at the Salon of 1765, accompanied by an Abbé, is the most famous.[10] The Pygmalion myth was also very popular and can be seen as a manifestation of the same trend insofar as the strength of feeling of the artist/spectator ultimately causes Venus to bring the beloved artwork to life.

The Dresden-based landscape painter Caspar David Friedrich (1774–1840) was nominally a feelings-led artist of this sort—hardly surprising, considering he knew theologians who made personal feeling and pantheism the basis of their religion: one of them, the priest and poet Ludwig Theobul Kosegarten, even built a chapel on the coast in northern Germany and held services on the beach for his fishermen parishioners.[11] 'The divine is everywhere', Friedrich said, 'even in a grain of sand'.[12] He further believed the artist's soul should be ever-present in the picture: 'The painter's task is not the faithful representation of air, water, rocks and trees, but his soul, and his feelings should be reflected therein'. Indeed, the 'superficial knowledge of cold facts' is 'sinful ratiocination, for it kills the heart, and when heart and mind have died in a man, there art cannot dwell'. Friedrich, who was brought up a Lutheran, urged the true christian painter to 'follow the voice of your inner self unconditionally, for it is the Divine in us and does not lead us astray'.[13]

Yet in Friedrich's best and most original work we admire the way the landscape and its human subjects appear to prevent rather than invite immersion, and to give the sense of human existence that *has* gone astray. In order to do this Friedrich uses a variety of means to blockade space,[14] and by so doing he rejects the conventional landscape structuring with its seamless passage from foreground to middleground and background. Feelings are undoubtedly expressed, but they are feelings of frustration, dispossession, and loss. It is tantamount to Wackenroder turning up in fifteenth century Nuremberg to find the main gate locked, and the town overrun by plague. For Friedrich, the past and the present are indeed another country. His most compelling methods of blockading space are in certain respects deeply reactionary for they seem to have been partly inspired by the liturgy and left-right symbolism of the pre-Reformation church.

The space in his first great landscape, *The Cross in the Mountains* (1808) (Fig. 35), is split in two by a dramatic deployment of left-right symbolism. Friedrich seems initially to have made this altarpiece speculatively for the Protestant King Gustav IV of Sweden (on the basis that Sweden still owned the part of Pomerania from where the artist came). But when Gustav was deposed in 1809 after an unsuccessful assault on Napoleon's French forces, the picture was acquired by Count Franz Anton von Thun-Holstein, ostensibly to be used as the altarpiece for his private chapel at Schloss Tetschen in northern Bohemia (it is now

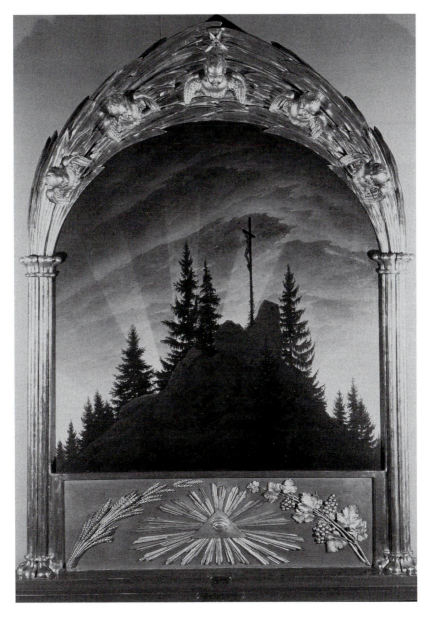

Fig. 35: Caspar David Friedrich, *The Cross in the Mountains*

commonly known as the *Tetschen Altarpiece*). Unbeknown to Friedrich, his altarpiece would end up in the countess' bedroom with a large framed engraving of Raphael's *Sistine Madonna*, the original of which was in the Dresden Gallery.

In this arched altarpiece, a rugged, fir-clad mountain-top is silhouetted against a red-tinted evening sky. The sun is evidently setting behind the mountain and its rays are thrown up in prismatic sections like the beams of modern searchlights. The diminutive wooden cross, with its bronze effigy of Christ, stands on the top of the mountain, but it is turned away from us so that we see Christ's body from the left, and slightly from the back. One of the beams of light strikes the body of Christ, making it softly glow like embers. Our viewpoint is from very low down, near the dark base of the mountain, though we seem to be further cut off from the mountain by the garishly gilded frame which Friedrich designed for the picture, and which was decorated with a range of Christian symbols.

Wayside crosses were a common feature of the local landscape, but the position of Friedrich's cross is unusual, to say the least. It superficially recalls the cross in Lucas Cranach the Elder's print *The Law and the Gospels* (*c*.1529), but whereas Cranach's Christ looks over to the viewer, and his blood spurts considerately and charitably towards us, Friedrich's small-scale Christ seems to be turning his back on humanity. We are, it would seem, being accorded the same fate and position as the bad thief.

In many respects, the silhouetted mountain fulfils the function that, in pre-reformation churches, was performed by the choir- or rood-screen. These decorated stone screens, surmounted by a large crucifix (rood means cross), were first introduced in the twelfth century. They bisected the nave at the entrance to the choir, forming a barrier that separated the clergy and the High Altar from the lay congregation. A second High Altar, an Altar of the Holy Cross, was set up before the screen, and the celebrant at this altar turned his back to the lay congregation.[15] Rood-screens, and turned priestly backs, were an immediate casualty of the Protestant reformation, and rood-screens were subsequently removed from most catholic churches during the counter-reformation. In Friedrich's painting, which is really an 'Altar of the Holy Cross', Christ's cross stands on a 'natural' rood-screen made from a mountain, and seems to turn away from us like the celebrant of a pre-reformation mass.[16]

On first being publicly displayed the altarpiece caused a sensation. Maria von Kügelgen, the wife of one of Friedrich's painter friends, reported: 'Everyone who came into the room was as moved as if they were entering a temple. Even loudmouths like Beschoren spoke seriously and in quiet tones as if they were in a church'.[17] The neo-classical critic Wilhelm Basilius von Ramdohr immediately realized the danger to academic standards and religious convention that it posed, and published his criticisms in four successive issues of the journal *Zeitung für die elegante Welt* between the 17th and 21st January 1809. Ramdohr was equally appalled by its form and content. He castigated the lack of smooth transitions between foreground and background and the absence of aerial perspective. He ridiculed what he took to be its nebulous mysticism that eschewed conventional allegorical and narrative conventions; and he dismissed the flagrant flouting of genres whereby the art of landscape has 'crept into the church and crawled onto the altar'.[18]

Friedrich was moved to respond. His response came in the form of a letter written to Professor Johann Schulze, who was then in Dresden working on the Weimar edition of Winckelmann's writings. A shortened version of the letter was published in the *Journal das Luxus und der Modens* in April 1809. Having described his picture, Friedrich explained the epochal turning point that was depicted:

> It is quite true that the picture possesses an allegorical meaning, even if that meaning is not immediately clear to the Secretary! [Ramdohr] It is quite deliberate that Jesus Christ, nailed to the cross, is turned away towards the sinking sun, itself an image of the all-seeing and all-life-giving Father. An ancient world came to perish with the teachings of Jesus, a time when God the Father still walked visibly upon the earth, when he spoke unto Cain . . . when he delivered amidst thunder and lightning the tables of the Law, when he spoke unto Abraham . . . The sun sank down, and the earth could no longer grasp the departing light.[19]

This 'ancient world' in which even God 'walked visibly upon the earth' is similar to the charmed, effortlessly interactive one that is inhabited by Wackenroder's art-loving monk. Friedrich moves far beyond that. Although he points to the 'hopeful' aspects of the picture—'The cross stands forth, unshakeably firm, upon the rock, like our own faith in Jesus Christ. The fir trees, evergreen through the ages, stand about the cross,

like our own hope in Him, the Crucified One'—these feel like very small mercies, for Friedrich's Christ faces away from us, and seems to abandon us to outer darkness.[20]

* * *

TO APPRECIATE WHAT FRIEDRICH is really up to I think we need to turn to a short theological treatise published by the writer Gotthold Ephraim Lessing in 1778. Throughout the 1770s, Lessing had been publishing extracts of Hermann Samuel Reimarus' *Apology or Defense of the Rational Worshippers of God*, the manuscript of which had been left to Lessing on Reimarus's death in 1768. Reimarus's treatise was the most detailed attack on the historical truth of the Bible that had ever been written. Reimarus accused the Apostles of inventing the story of Christ's resurrection and divinity to increase their worldly power. This rejection of the sole authority of Scripture, which Lessing himself described as 'bibliolatry', denied the central principle of Lutheranism. The anonymous publication of Reimarus' tract caused the 'greatest controversy in German Protestantism in the eighteenth century', and Lessing's responses to critics had a significant influence on the subsequent course of German theology.[21]

Lessing wrote *A Rejoinder* (1778) in reply to a furious broadside from a senior clergyman. He 'magnanimously' argued that if the evangelists' accounts of the resurrection are full of contradictions, these inconsistencies cease to matter if the Bible is treated like any other historical document. Such contradictions are inevitable when different people describe the same event. For Lessing, revelation was gradual and partial, and the rational content of revealed truths becomes progressively manifest over time, eventually superceding the original revelation.[22] Lessing clinched his argument with a statement that was to become one of his most celebrated:

> Not the truth which someone possesses or believes he possesses, but the honest effort he has made to get at the truth, constitutes a human being's worth. For it is not through possession of truth, but through its pursuit, that his powers are enlarged, and it is in this alone that his ever-growing perfection lies. Possession makes inactive, lazy, and proud—
>
> If God held ever fast in his right hand the whole of truth and in his left hand only the ever-active quest for truth, albeit with the proviso

that I should constantly and eternally err, and said to me: 'Choose!', I would humbly fall upon his left hand and say: 'Father, give! For pure truth is for you alone!'[23]

That Lessing could even consider the idea of God offering something positive and energizing with his left hand must have been due to the influence of the Cult of the Sacred Heart, and to those images of Christ proffering his flaming heart in his left hand. At the same time, however, Lessing seems to be reacting against the assumption that once we have access to the 'heart-side' of God, we have, as it were, made it. For Lessing, the offering in God's left hand is a stimulus to further action—to 'show heart' and to embark on those quests that make the heart beat faster. Of course, a 'life of eternal erring' would be many people's idea of hell, and so this offering is not entirely distinct from the traditional gesture of damnation made by the left hand of God: one might almost say that the left hand of Lessing's God offers us a broken heart.

Lessing's attitude towards truth can also be seen as an extreme response to the confusion relating to the Choice of Hercules that we found in Lord Shaftesbury's treatise, and which Lessing had surely read. Shaftesbury had tried to humanize the right hand path by rejecting the idea that it leads to a 'Fortress, or Palace of Virtue, rising above the clouds'. But for Lessing there can be no fudging compromise: the only place the 'whole truth' can exist *is* above the clouds, well out of human reach. This leaves man to operate far below, in the sublunary world. Lessing's 'choice' is, at the very least, exhilaratingly clear-cut.

The Cross in the Mountains can be seen to mark the moment of dispossession, when the light of pure truth (aligned with Christ's right hand) disappears behind the mountain. We are left with the gloomy and unscaleable left-hand side, and are forced to embark on a sisyphean 'ever-active quest for truth' in which we will 'constantly and eternally err'. God no longer walks the earth as he once did, or blesses it with his light, and so there is not even any opportunity for the consolations of pantheism: no charming miniaturist botanical detail is visible on the base of the mountain in the foreground. If anything, the altarpiece is about the impossibility of pantheism in the present age.

This kind of left-right duality was central to Friedrich's art, and his spiritual restlessness is clearly manifested in a number of 'Zecharian'

self-portrait drawings in which the left or right eye is occluded or shadowed, as if he were trying out different types of monocular vision for size. One of these, in which the illuminated right eye is placed at the centre of the piece of paper, has been said to have a 'dichotomous, schizoid character'.[24] Friedrich knew what artists should strive for: 'Close your physical eye, so that you see your picture first with the spiritual eye. Then bring what you saw in the dark into the light, so that it may have an effect on others, shining inwards from outside.'[25] But the truth that Friedrich's pictures bring forth is both incomplete—and rather chilling.

Friedrich often made pictures as contrasting/complementary pairs, which force the viewer to jump back and forth continually, rather than offering repose for the eye. One of the finest is a pair of sepia drawings, *View from the Artist's Studio, Left Window / Right Window* (1805/6), each of which is viewed from a slightly different position. Next to the right window is a mirror that in its bottom right corner reflects back to us the top of the artist's head, and one and a half eyes. Some scissors hanging on the wall below suggest this is a world of piecemeal and cut-off vision.

A coda to Friedrich's great altarpiece is provided by the pair of small complementary pictures entitled *Winter Landscape* (1811).[26] One shows a bent figure of a man with a crutch or stick standing in a snow-covered wasteland filled with dead trees and tree-stumps. The pessimism of this picture is not so much qualified as contextualized by the second picture in which a man has dropped his crutches while walking across a desolate snowscape towards a crucifix that nestles in a clump of fir-trees. We see Christ from the left, in a similar position to the Cranach woodcut, but there is little sense that a miracle will take place, and that the cripple will get up and walk. The abandoned crutches show that he has evidently crawled his last few steps towards the cross, and he now leans back against a snow-covered rock to pray. The fir-trees that surround the cross make a dense natural 'rood-screen'. The cripple may not have seen what lies beyond[27]—a wall, behind which rises up the giant stage-flat silhouette of a gothic cathedral. These are more 'rood-screen'-style obstacles which the man will not surmount until after death. In this figure of the cripple, Friedrich was surely also remembering Ramdohr's complaint that with *The Cross in the Mountains* the art of landscape has 'crept into the church and crawled onto the altar'. He is suggesting that

creeping and crawling are central to the Christian condition: the 'ever-active search for truth'.

Friedrich's aggressive spatial symbolism both rehabilitates and recasts left-right distinctions. The seriousness with which Friedrich regarded one's orientation in relation to a wayside cross is borne out by the very different mood of *Morning in the Riesengebirge* (1810–11), where we see a cross placed on a mountain in the middle distance. This time, we see Christ from front right—the most 'privileged' position. The cross's greater accessibility is implied not just by the gentler terrain (it is almost at our eye level), but by the fact that a young couple have just climbed up to it, and the woman, in a diaphanous white muslin dress, holds the cross with her right hand while helping the man up with her left. Here, with a cloying sentimentality that must have made the picture a highly commercial proposition, God and Nature seem to redeem the woman, and she in her turn redeems the man. As Hugh Honour has written: 'The spiritual turbulence of *The Cross in the Mountains* has been quelled in this serene windless landscape . . . a majestic aerial view in which the purity of light and infinity of the horizon seem close to God . . . but [it] lacks the strange power of the earlier picture to move and trouble the soul.'[28]

* * *

NOT SURPRISINGLY, THE UBER-NATURALIST Goethe had little real sympathy for the more extreme manifestations of Friedrich's 'mystical' art—a final rift occurred in 1816 when Friedrich refused a commission to make a 'cloud-atlas' of different cloud types.[29] Goethe, in one of the most impudent of his *Venetian Epigrams* (1790), had already expressed a brisk enlightenment impatience with arcane religious concepts of left and right:

> 'Goats, go and stand on my left!' so the Judge at the last day will order.
> 'And as for you, little sheep, come to my right, if you please.'
> Excellent! But let us hope he will make one further announcement:
> 'Now, you men of good sense, face me, and stand straight ahead!'[30]

Goethe is pouring scorn on Christ's account in Matthew 25 of what happens at the Last Judgement. But for all his worldly *sang froid*, Goethe is in fact cannibalizing a celebrated Old Testament passage, Deuteronomy

323

5:32 (and similar sentiments are expressed in Deuteronomy 17:11 and Isaiah 30:21).[31] Moses has just revealed the Ten Commandments to the Israelites, and those who obey them will be saved: 'Ye shall observe to do therefore as the Lord your God hath commanded you: ye shall not turn aside to the right hand or to the left.' For the Christian father Origen, this passage did indeed become a credo for a face-to-face meeting with God: 'But when I shall stand upright before Him and shall be crooked in nothing, when *I turn aside neither to the right hand, nor to the left*, but *make straight the paths for my feet, walking* before the Sun of Justice *in all His justifications without blame*, then He who is Himself upright will look on me, and there will be in me no crookedness, nor any cause for Him to look askance at me.'[32] Goethe is thus turning the Old Testament against the New.

In a second version of *The Cross in the Mountains* (1811–12), Friedrich did indeed allow the viewer to confront the crucifix head on, but even here it seems out of reach—wedged in between red, larval rocks on the other side of a boggy pool and its base hemmed in by a thorn bush. Christ's head does not face us but tilts to its left, on which side another large thorn bush blocks the way. The fact that Christ's head seems to face the bush (a reminder of his crown of thorns) just serves to draw even more attention to it.

The painting could almost be an illustration of a vivid metaphor used by Lessing to express his doubts about the truth of Christ: 'This, this is the broad and ugly ditch which I cannot get across, no matter how often and earnestly I have tried to make the leap. If anyone can help me over it, I beg and implore him to do so.'[33] Friedrich is the visual poet of the blocked and crooked path.

* * *

BUT THE FUTURE OF nineteenth century art in general and of landscape art in particular belonged not to Friedrich's divisive and humiliatingly prohibitive spaces. Towards the end of his life he wrote: 'Art should spread joy; that is what fashion wants. A few years ago, a painting of the severity of winter could give pleasure, but not any more . . . mist and winter are in the doghouse now, and who would guarantee that the same fate might not also threaten harsh, death-foretelling autumn before too long . . .'.[34]

In 1873 the pantheistic identification of the viewer with the view was given the new name 'empathy' [Einfühlung—feeling-in] by the

German aesthetician Robert Vischer.[35] Vischer said that we have the marvelous ability to 'impute our own shape to an objective shape', and a 'pantheistic urge' to make ourselves part of the object we see. In viewing a specific object 'I wrap myself within its contours as in a garment'.[36] A French theorist of empathy, Victor Basch, would write in 1896: 'Aesthetic sentiments are above all sentiments of fellowship.'[37] Wilhelm Wackenroder would have heartily approved.

18. Picasso and Chiromancy

'What strange times!' continued Durtal, as he walked Des Hermies to the door. 'At the precise moment Positivism reaches its height, mysticism awakes and a mania for the occult begins.

J-K Huysmans, *Là-Bas: a journey into the self* (1891)[1]

IN THE EARLY SPRING of 1913, Picasso made an elaborate assemblage in the corner of his Paris studio on the Rue Raspail (Fig. 36).[2] It consisted of one, possibly two pieces of white-primed canvas fixed to a large rectangular stretcher that was placed at knee height across the corner of the studio. It was probably propped on a chair, and fixed at the top by rope suspended from the ceiling. Onto the canvas he drew, either in pencil or charcoal, a meagre cubist armature showing a life-size standing figure playing a guitar. Most of the lines were ruled, and the only substantial shading was situated behind and around the guitarist's head.

Thus far, it was little different from his recent Cubist works, in which guitarists and mandolin players—female as well as male—loom large. But what made this assemblage so extraordinary was that the guitarist's upper arms and hands were made from strips of newspaper—probably several layers glued together. The top of each arm was pinned to the canvas using dress-makers' pins supplied by Picasso's then partner Eva Gouel,[3] and cantilevered out so that they could 'hold' a real guitar suspended from the ceiling by string. Below the guitar was a real table on which real still-life props were arrayed: a bottle, a pipe, a cup, and a newspaper.

The assemblage, which is the largest and most ambitious Picasso ever made, no longer survives. It is not clear precisely what happened to it or why.[4] Picasso may have dismantled it because it took up too much space, or because it had served its polemical or 'experimental' purpose.

326

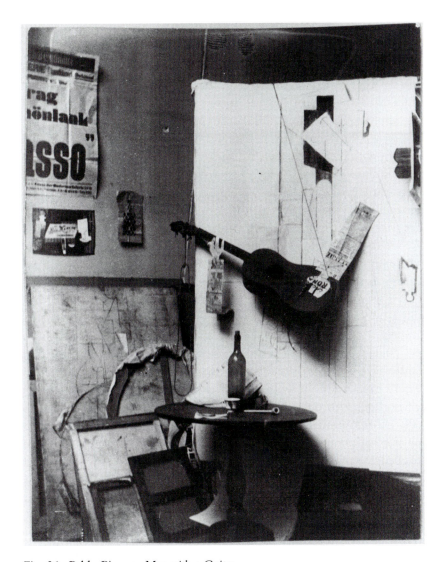

Fig. 36: Pablo Picasso, *Man with a Guitar*

Alternatively, the outbreak of war in the following year may have sealed its fate. We only know about it because Picasso took a photograph of the installation from which he made four prints, each of which is strikingly different. The most complete print shows the whole assemblage as well as a substantial area of the studio to the (viewer's) left, with stretchered canvases casually propped on the floor and, fixed to the wall, a poster

327

for a Picasso exhibition in Munich, a *papier-collé*, and a drawing of a bottle. Their inclusion in the photograph suggests that Picasso regarded it all as what we would now term an installation, and one in which it is unclear where 'art' and 'reality' begin or end. A second print is cropped to focus on the area of the canvas, and Picasso then drew over it with ink, applying a spiky network of straight and curved lines. In the other two prints, Picasso manipulated the printing process by masking various sections with pieces of paper, which appear as abstract white voids.

This mise-en-scene, which seems to prophesy a vast amount of avant-garde twentieth-century sculpture and installation, is all the more amazing when we consider that Picasso's first mixed-media work, *Still-Life with Chair-Caning* (May 1912), had been made only a year before. We are dealing, then, with one of the most innovative moments in the whole history of art. Yet one of its most radical and hitherto unnoticed features is that the guitarist holds his guitar as if he were left-handed. This is very striking for, with a few significant exceptions to which we will return, Picasso's many paintings of guitarists usually show right-handers. It can hardly have been a mistake, for when positioning a real guitar, rather than a very abstract depiction of one, Picasso could hardly have been unaware of the unusual orientation.[5] What makes this feature even more intriguing is that this guitarist is in some respects a self-portrait. Not only does the neck of his guitar point to the name '(PIC)ASSO' printed in bold capitals on the exhibition poster; but a self-portrait photograph also exists in which Picasso sits in front of the stripped down canvas. It has been said that his hands 'seem to be holding an invisible guitar'.[6] Needless to say, the position of Picasso's hands is that of a left-handed guitarist. As he was right-handed, this is strange, to say the least.

* * *

PICASSO WOULD, I BELIEVE, have seen the guitarist's left-handedness as a significant component of the assemblage's radicalism, for left hands had loomed large and portentous in Picasso's three most ambitious paintings of the previous decade: *La Vie* (1903), *The Saltimbanques* (1905), and *Les Desmoiselles d'Avignon* (1907). He evidently felt that these magisterial left hands imbued his large works with a whole new disconcerting dimension of power and profundity.

In order to understand fully his interest in left hands we need to go back to the first years of the century, around the time when Picasso came

into the orbit of the Jewish poet, painter, critic, drug addict and occultist Max Jacob (1876–1944).[7] He first got to know Jacob after he had left an admiring notice at the Vollard Gallery in Paris where the twenty-year-old artist was exhibiting in 1901. They soon became close friends and, although Jacob was homosexual, and clearly besotted, they shared a room—and its single bed—for a few months in 1902. Due to their extreme poverty, they operated a shift system whereby Picasso would sleep in the bed during the day (he liked to work at night), and Jacob during the night.

Because Picasso did not at first speak French, and Jacob did not speak Spanish, they initially communicated using sign language. Jacob was a brilliant mimic, as Fernande Olivier, Picasso's mistress from 1905–12, later attested: 'He would improvise scenes in which he always played the lead, and I have seen his imitation of a barefoot dancing girl at least a hundred times... His attempts to be graceful as he took tiny steps and pointed his toes were a perfect caricature that always made us laugh.'[8] When Picasso was getting to know Jacob, hand gestures in his pictures became far more prominent and stylized, as if the protagonists were actors in a symbolist silent movie. Fingers become increasingly attenuated and double-jointed, taking on an expressive life of their own.

Picasso, who was already extremely superstitious, was given a thorough grounding by Jacob in many aspects of the occult, which was hugely fashionable at the time. There had been an occult revival throughout Europe, Russia, and America in the second half of the nineteenth century, particularly amongst the intelligentsia, and it was a crucial catalyst for the whole Decadent movement. It tends to be seen as a reaction to the scientific rationalism of the period, and yet the many competing occult sects were only too keen to broadcast the scientific basis of their creeds. Indeed, new scientific discoveries and inventions were pounced on as evidence to support the idea that there was a spirit-world. In J-K. Huysmans' best-selling succès-de-scandale *Là-Bas: voyager en soi-même* (Down there: a journey into the self, 1891), an astrologer has no doubt about the scientific basis of the occult: 'Space is swarming with microbes, is it any more surprising that it should also abound in spirits and spectres? Water and vinegar are teeming with amoeba, the microscope reveals them to us, so why shouldn't the air, invisible to human sight or scientific instruments, also be seething, like the other elements, with more or less corporeal beings, with more or

less developed germs of life?'[9] Magnetism, electricity and photography were all roped in to lend support to the idea of a spirit world. Jacob himself attended a conference on 'The scientific origin of the occult sciences'.[10]

Jacob's particular forte was astrology and palm-reading (chiromancy), which he practiced on a part-time basis to make some much needed money (he never failed to ask people on first meeting their date of birth). Despite converting to Catholicism in 1915 (with Picasso acting as his godfather), his occult interests continued unabated, and in 1949 his *Miroir d'Astrologie*, co-written with Claude Valence, would be posthumously published. Here Picasso is listed with other famous Scorpios, all of whom have a 'very powerful sense of good and bad, of what is on the right and on the left'.[11] This restatement of the 'Choice of Hercules' draws on Madame Blavatsky's theosophical notion of the right and left hand paths: inspired by Buddhist ideas about the path to Nirvana, Madame Blavatsky (1831–91) believed that the 'left hand path' is the source of all evil and black magic, and the 'right hand path' the source of all good.[12] However, in the period before the First World War, these traditional polarities were being vigorously contested, with many believing that the left hand was on the side of good and gave access to the most profound and liberating truths.

Jacob tried to teach Picasso the rudiments of hand-reading early on in their relationship, and it is this aspect of the occult that has the clearest impact on his major works. Hand-readers preferred to examine the left hand, both because its lines were clearer, and because of its proximity to the heart. Two pieces of paper survive, which have been dated to 1902,[13] on both of which is drawn an outline of Picasso's left hand. Around one of these, Jacob has written an explanation of palm reading, and around the other he has given a reading of his friend's hand. Picasso has an 'ardent temperament', but will be plagued by ill-health and die aged 68. All the lines stem from the base of the fate line, 'like the first spark of a firework'—something that only occurs in the hands of predestined individuals. The base of the hand is 'broad [carrée], square', a sign of 'sensuality but also frankness and honesty'. The thumb is short: 'no will power'. The line of the heart

> is magnificent, love affairs will be numerous and warm... disappointments will be cruel—they alarm me...love will play too large a role in this life. Notes: aptitude for all the

arts—greed—energetic and lazy at one and the same time—religious spirit without austerity—a cultivated mind—sarcastic wit without malice—Independence.

'Independence' may allude to another quality associated with the left hand—political *gauchisme* [leftism], even if Picasso showed little overt interest in politics until the 1930s.[14] Picasso kept these drawings with him for nearly the whole of his life, until donating them to the museum in Barcelona in 1970. Jacob also made him a talisman from a quarter of a kilo of leather covered in cabalistic signs and formulae, which Picasso carried round in a pocket for decades.[15]

Picasso metaphorically offered up his left hand to Jacob in a letter written while the artist was staying in Barcelona in early 1903. He 'signed' the letter with a drawing of an outstretched left hand, the palm a tangled network of scrawled lines, like a clump of barbed wire. He was clearly extending the 'transparent' and 'truthful' hand of friendship for the parting words are: 'Adieu my old / Max I embrace you / your brother Picasso' followed by the date '1 May 1903'—and then the drawing of the hand at the bottom. The introduction to the standard book on chiromancy, Adolphe Desbarrolles' *Les Mystères de la Main* (first edition 1859), which was republished in numerous editions, helps us to understand what Picasso is trying to express in this drawing. Jacob is likely to have studied this book, and would have been impressed by its intellectual ambitions—even if he would have been dismayed at the laudatory chiromantic profiles of academic writers and painters, such as Meissonier. Its frontispiece illustration shows Desbarrolles sitting on a sofa in a haut bourgeois sitting room reading the left hand of the lady of the house. It is meant to be as respectable and reassuring as a doctor taking a patient's pulse.

Desbarolles, in prose that is at once flowery and constipated, claims that physiologists have shown that the palm of the hand, 'which burns during fevers, bronchial illnesses and irritable disorders', is a kind of 'foyer of the instinctive life of the soul'. The 'agents of communication' of this 'exuberance of the instinctive life' are the 'hillocks [monticules] of the palm and the great piles of *corpuscules paciniques* on the nerves that are found there'. There are between 250 and 300 of these corpuscles, and they are 'condensers of *innervation* [nervous stimulation], the particular property of the hand, by the exercise of magnetism'. They are thus '*reservoirs of electricity*', and they give the hand '*an inestimable sensitivity*'.[16]

He later draws on Doctor Reichenbach's *Lettres Odiques-Magnétiques* to assert that the left side of a man is 'electrified positively' and the right side negatively.[17] In Picasso's sketch, the tangled networks of lines that fill and form the palm suggest its vast *'reservoirs of [positive] electricity'* as well as its *'inestimable sensitivity'*.

* * *

NOW LET'S TURN TO the first of Picasso's great paintings in which left hands play a leading role, the Blue period masterpiece *La Vie* (1903) (Fig. 37), which was painted in Barcelona over a previously used canvas. Here Picasso tries to make a grand statement about the relationship between man and woman—or rather, about the position of women and children in relation to artists. He also makes an important point about artistic process and style.

The painting has been interpreted in many different ways, not least because of the survival of so many preparatory drawings that suggest Picasso changed his mind about the precise subject. It was preceded by a number of drawings in which a naked woman reveals to her naked bearded partner that she is pregnant, and he responds in various ways— by denying responsibility; by begging forgiveness; by pointing accusingly at her; and by beating her. The final compositional drawings for *La Vie* retain the naked standing couple, the woman with her arms around his neck, but she is no longer so obviously pregnant. The scene has changed to an artist's studio, with a picture in the middle. They stand to the right of an easel, and are looking across to their left at an old man standing on the other side of the easel.

In one of these preparatory drawings, the male lover (who now resembles Picasso) points across to the old man with the index finger of his left hand, and points upwards with the index finger of his right hand. This gesture has been associated with an occult saying attributed to the legendary magician Hermes Trismegistus: 'Whatsoever is below is like that which is above as all things are made from one'.[18] Yet if this were the case, one might expect the left hand to point down rather than across to the old man;[19] and anyway, the image itself suggests rupture rather than continuity or smooth transit from above to below. The artist's left hand seems rather to be pointing out the old man to his female companion, and encouraging her to listen to what he says. The artist's upraised right hand suggests that what the old man is talking about is eternity—eternity in relation to artistic fame.

332

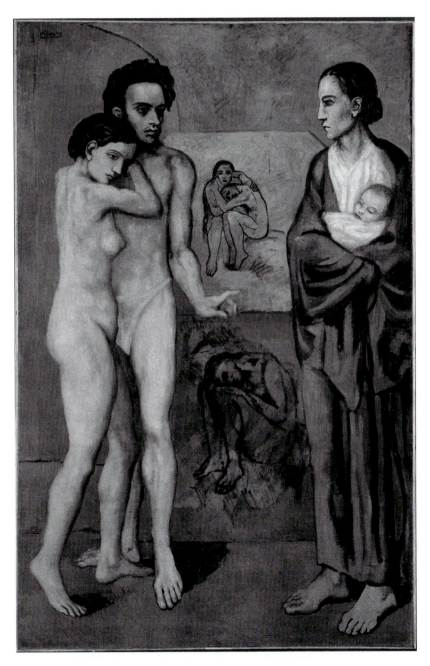

Fig. 37: Pablo Picasso, *La Vie*

In the painting, the upraised right arm is completely excised, and the gesturing left hand thereby becomes the animated focal point of the entire composition. The index finger is impossibly extended, like the portentous finger of the man-creating God of the Sistine Ceiling though the other fingers and thumb droop like those of Michelangelo's Adam. Even more attention is drawn to it because the hand itself is twisted back and up almost to the point of dislocation. This time, however, the artist points across to a slightly older woman with large feet who cradles a baby. She is the furthest forward of the three protagonists, and stands stage left (Picasso's interest in left and right is at its most intense in his most 'theatrical' and 'staged' paintings). Here the artist's left hand is the chiromantic hand of fate, signalling to his clingy partner what life holds in store. The artist's hand also hovers over one of his paintings—one of two square canvases placed in the centre of the picture, one above the other.

It was a cliché at the time that sexual activity entailed a loss of creative energy.[20] The internationally famous social scientist Cesare Lombroso pointed out in *The Man of Genius* (first edition 1863) that 'many great men have remained bachelors; others, although married, have had no children'.[21] Baudelaire put it succinctly: 'the harder a man cultivates the arts the fewer his erections.'[22] Professor Rubek, the sculptor in Ibsen's *When We Dead Wake* (1899), is convinced that if he touches his model, or even desires her sensually, his artistic vision will be lost, and even the priapic Rodin believed that ejaculation entailed the loss of creative energy. In Zola's *The Masterpiece* (1886) the painter Claude Lantier, who instinctively distrusts women, slaves away for years on his masterpiece with its glorious centrepiece of a nude female bather, and his wife is horrified when she realizes her husband loves only 'that strange, nondescript monster on canvas'. One day the artist, in a frustrated rage, punches a hole through the canvas where his idol's breast is, and he is distraught that he has killed 'what he loved best in the world'.[23] He repairs the damage—'with just a faint scar over the heart'—and his passion revives.

This belief was clearly something to which the rampantly promiscuous Picasso could only, at best, pay lip service (a 1902 drawing of a female nude is inscribed with the libertine motto 'When you feel like f******, f***!').[24] However, it has been suggested that Picasso, a regular brothel-visitor from an early age, may have caught a venereal

disease in 1901. He made several visits to the women's prison of Saint-Lazare in the late summer or early autumn, where he drew the inmates (and their children), many of whom were whores. This was thanks to the good offices of Doctor Louis Jullien, a venereologist who did work at the prison, so there is always a possibility that Picasso was one of his patients. Max Jacob's prediction of ill-health, and his fearfulness about Picasso's love-affairs, may have been related to this.[25] The fate of Picasso's unsuccessful and impotent Spanish artist friend Casagemas may also have turned his thoughts to the role of women (and sex) in the artist's life. Casagemas had committed suicide in Paris in February 1901 after his lover Germaine had refused to marry him (not least because of his impotence).

Picasso's picture, then, is intensely topical. The picture implies that real women must be peripheral to the man of genius if he is to be creatively fulfilled. The artist (who now has more resemblance to the willowy and soulful Casagemas) wears a kind of hermetically sealed jock strap-cum-chastity belt, and this seems to insulate him from the predatory thrust of the (unpregnant) woman's left leg between his thighs. The older woman, like most bringers of bad news, comes from stage left, and is perhaps saying to the young girl—'don't expect anything much from the man of genius. It is we who end up holding the baby'.

The two squarish canvases propped up between them tell an even sorrier tale. The top one shows two naked girls, perched on a rock, huddled together forlornly. They seem distraught, abandoned, and must be 'bathers' of sorts. This is even more the case with the solitary crouching girl in the picture below. Stylistically, they recall Gauguin and early van Gogh, but they also seem inspired by Michelangelo's forlorn female 'ancestors of Christ' in the spandrels of the Sistine Ceiling, shoehorned into gloomy triangular spaces.[26] The corners of the top canvas have been cut away, as if it were going to be a mural installed in an arched or roofed space.

They are extraordinarily roughly painted—'strange, nondescript monsters'—and there is the sense here that female suffering and isolation is the great modern subject: if the modern artist cannot desire Woman sensually, he has to punish and brutalize her in his art until she has been put beyond desire. J-K. Huysmans, in an essay on the Decadent Belgian pornographer Félicien Rops, said there is nothing more obscene than chaste people because their starved imagination runs riot: 'It is

therefore likely that the artist who treats carnal subjects violently is, for one reason or another, chaste.'[27]

* * *

THE PROMINENCE OF THE artist's left hand in *La Vie* does not only underscore the profound and prophetic truthfulness of what we see before us; it also, I think, tells us something about the type of artist Picasso was trying to be. For the index finger of his left hand is poised just in front of the lower middle part of the top canvas, where a milky blue zone abuts a darker blue zone. The implication is that this artist finger-paints with his left hand—in other words, from the depths of his tormented soul.

This notion was current in relation to Leonardo da Vinci, one of the few Italian Old Masters for whom Picasso had a kind word (he may have felt some camaraderie as both artists had emigrated north to work in France). In an article published in the leading art journal *Gazette des Beaux Arts* in December 1867, the collector and critic Émile Galichon wrote about one of his own Leonardo drawings. The article concluded with the astounding claim that Leonardo was in fact ambidextrous, and that he had used each hand for different types of drawing: 'It would seem, to whoever closely studies his drawings, that his left hand more willingly obeyed the flutterings [battements] of his soul and his right hand to the lights [lumières] of reason. If he needed to translate the feeling that had made his heart palpitate; if he had followed for a whole day a man whose bizarre or expressive physiognomy had struck him, his left hand would quickly capture the emotion or the memory on the paper.' But for 'definitive studies' (and presumably for his painting), Leonardo used his right hand.[28] Galichon's estimation of the left hand's linkage to the heart was no doubt influenced by the craze for hand-reading.

It has been observed that in France in the 1860s, right-handed artists of Manet's generation started to make painted and drawn self-portraits without correcting the reversed mirror image, so that they ended up appearing to hold the brush or pencil in their *left* hand. This 'embrace' of mirror reversal has been credited to 'a new commitment on the part of artists such as Fantin-Latour, Whistler, Manet and Degas [and others] to painting or drawing exactly what they saw'.[29] But perhaps, too, it came from a sense that the left hand—like that of Galichon's ambidextrous Leonardo—might be better at capturing 'the emotion

or the memory', as well as asserting the avant-garde artist's status as an outsider. Politically, the 'right' were in the ascendancy. Parliamentary government had been overthrown by a coup-d'etat in 1853 which led to the establishment of Napoleon III's second empire. Parliament would only be restored in 1870. During the 1860s the political term *gauchisme* was applied for the first time to left-handers. A fictional dialogue in the satirical magazine *Le Charivari* ridiculed Fantin-Latour's bohemian appearance in a 'mirror image' self-portrait shown at the Salon of 1861: 'Wow! There is an artist with a really hairy face! And he's a lefty [gaucher]'—a clear pun on his left-wing credentials and his depiction as a left-hander.[30]

Manet actually painted a 'left-handed' guitarist, variously known as *Le Chanteur Espagnol* and *Le Guitarero* (1860; The Spanish Singer and The Guitarist).[31] By 1884, the picture was often called *Le Gaucher*.[32] It was one of many by Manet which exploited the vogue for Spanish styles and subjects, which were the height of exoticism, and it brought him his first public success at the Salon of 1861. Theodore Duret, in his book on Manet first published in 1902, claimed the guitarist was a singer who belonged to a Spanish troupe of musicians and dancers, though the anomalies in costume and pose would suggest otherwise.[33] Manet shows a left-handed singer perched on a bench playing a guitar strung for a right-hander. On having his 'mistake' pointed out to him, Manet apparently dismissed it as irrelevant—what mattered was the speed and boldness of the execution.

Ambidextrousness seems to have appealed to other quick-fire drafts-men of the time. The great cartoonist Grandville (1803–47), who was a leading light of *Le Charivari*, 'trained himself to draw with his left hand as well as with his right, and we have seen him alternate between one and the other to improvise, while chatting, an incredible variety of characters and comic scenes'.[34] The implication is that Grandville felt his left hand was better suited to the kind of improvisatory and almost unconscious drawing that he wanted to do. Grandville's example may have partly inspired Gallichon when he imagined his ambidextrous Leonardo—an artist who also chatted while he worked, and who drew caricatures. The idiosyncratic practice of the naturally left-handed German artist Adolph von Menzel (1815–1905) was probably also influenced by this kind of notion: 'When I paint in oils, [I do so] always with the right; drawing, watercolour and gouache always with the left.' His paintings reveal right- and left-handed strokes, though his drawings do seem

predominantly left-handed.[35] Two gouaches of 1864 showing close-up images of his right hand holding a paint dish, and a book, make the point that his left hand is doing the work—as does the rawness of the images.[36] Menzel had a high reputation in France from the 1860s.

Another right-handed artist who cultivated ambidextrousness is the novelist and believer in the spirit world Victor Hugo. He was a prolific draftsman (four thousand drawings survive) and is known to have drawn left-handed, as a way of opening up his unconscious. His ink drawing *The Dream* consists of an energized yet disembodied left arm, shirt unbuttoned at the cuff, thrust upwards with fingers outstretched and palm open towards a turbulent, smoky sky, as if demanding to become a lightning-conductor for cosmic electricity.[37] His Paris home, with his collection of drawings, opened as a museum in 1902, the centenary of Hugo's birth. The French psychiatrist Pierre Janet (1859–1947), who is often credited with being the real founder of psychoanalysis rather than Freud, was fascinated by spiritualist trances and must have known about Hugo's drawing methods. Beginning in the 1890s, Janet routinely distracted his patients with an activity involving one hand while getting them to draw with the other, the object being to elicit subconscious images.[38]

Gallichon's ambidextrous Leonardo was given far greater currency by being cited in later editions of Lombroso's *The Man of Genius* (1863). This was published in French translation in 1889, and subsequently reprinted and revised several times. Left-handedness is included in the section dealing with 'Other degenerative traits' of men of genius: 'Gallichon says that Leonardo drew rapidly with his left hand the images that had greatly struck him, and with his right drew those that were the fruit of sufficient reason . . . Now it is proved that left-handedness is an atavistic and degenerative trait.'[39] For the French Leonardo scholar Eugène Muntz, writing in 1899, his left-handedness was 'a sort of infirmity'—a nod in the direction of those who said Leonardo only used his left hand because of an injury sustained by his right.[40]

It has been said of *La Vie* that here, for the first time in a finished painting, Picasso deliberately juxtaposed 'variant styles'.[41] The cult of the 'two-handed' artist may have pointed the way to that kind of goal. The head of the artist is perhaps painted in the most detailed manner, while the two internal canvases over which the 'artist's' left hand hovers are exceptionally raw: here the paint is sometimes dabbed and stabbed

on, and sometimes built up out of slashed zones of parallel hatching, so that each individual brush-stroke is visible. There are many *pentimenti* [corrections]. The vehemence is such that one imagines he has from time to time, like Zola's Claude Lantier, torn the canvas. It is a painting that is meant to express strong and immediate emotions, and the flutterings— or *shiverings*, since it feels so cold—of the human soul. In fact, so 'badly' painted are these pictures, they may not just be metaphorically painted with the left hand.[42]

* * *

IN PICASSO'S NEXT BIG tilt at artistic immortality, *Les Saltimbanques* (1905) (Fig. 38), his own left hand is given an even more crucial creative role. That year, the twenty-four-year-old artist made many pictures of the transient groups of acrobats, clowns, and musicians that came to perform in Paris. These figures frequently cropped up in romantic and symbolist art and literature, often as alienated outsiders, sometimes enchanting, sometimes sinister. The poet Guillaume Apollinaire, whom Picasso had met in 1904, and who claimed to have been taught magic by elves, was probably instrumental in turning his attention to the 'saltimbanques'.[43] Picasso often shows his performers in unlikely domestic settings, the men still in costume, and sometimes holding babies, but there is usually little sense that the domesticity can last.

A preparatory drawing for *Les Saltimbanques* shows an outline drawing of the palm of Picasso's left hand next to a group of four naked perform- ers bunched together, standing bolt upright. The heights of their heads follows that of Picasso's fingers.[44] Picasso may have envied acrobats and circus performers their ability to deploy their left hand as much as their right when performing juggling and somersaults: a gouache of a weight- lifter made in Paris in 1905 shows him lifting a woman up with his left arm.[45] Here Picasso is, as it were, a weight-lifter who can hold four people in the palm of his left hand.

In the finished painting, with its pervasive blue-pink tonality, there is a group of five figures in a featureless landscape, and it has been suggested that the little girl with her back towards us leaning on the handle of a basket 'can be seen as a thumb', with the four others as the fingers.[46] We are slyly alerted to the origins of the composition by the fact that the tall harlequin with his back towards us (often taken to be a self-portrait) twists his left arm behind his back in an ungainly manner, with his thumb pinioned in his belt, so we can clearly see the palm of his outstretched

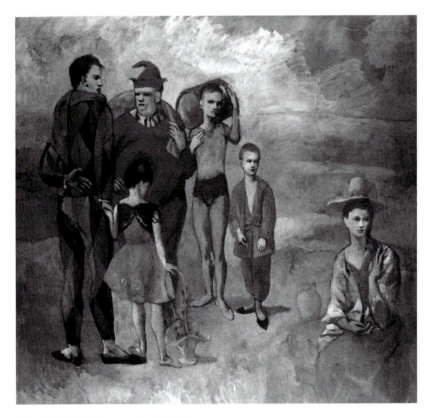

Fig. 38: Pablo Picasso, *Les Saltimbanques*

hand. The position is like a self-inflicted arm lock.[47] Apollinaire, in a poem of 1909 entitled 'A Ghost of a Cloud', describes the 'purplish pink' costume of the 'saltimbanques' as being both revelatory and fatalistic. It is 'a pink full of betrayal' and it is as if a man 'wore the livid colour of his lungs on his back'.[48] Picasso puts the (pink) palm of his hand on his back, and it is meant to be even more revelatory about the troubled state of his soul. The left arms of naturally left-handed children were still often tied behind their backs with a belt to force them to use their right hand.[49] Here, it feels as if we are being permitted to see feelings which are usually repressed.

As in *La Vie*, the closest figure to us, and the oracular key to the composition, is a woman placed at front stage left. She is an impassive, sphinx-like beauty, fully clothed. The harlequin looks sharply across at her, and his left hand seems to be pushing in her direction. She sits on

the ground, with ramrod straight back and neck, and gazes slightly to her left with the far-away look of a Michelangelo Madonna. The wide brim of her straw hat provides her with a halo of sorts. The only movement she makes is to play with the hair that falls over her left shoulder with the long fingers of her left hand. Is this an answering, or absent-minded echo of the harlequin's left hand? The abiding sense is that whereas in *La Vie* the man was putting 'Woman' out of reach, here 'Woman' is putting herself out of reach—and is all the more desirable as a result. It is a picture about male frustration rather than renunciation.

In the next chapter, we will look at the pivotal role of a left hand in *Les Demoiselles d'Avignon* (1907), and after this we should be able to make a more complete assessment of the left-handed guitarist in Picasso's studio construction.

19. Picasso and Satanism

I have made a pact with Prostitution to sow disorder in families
Isidore Ducasse (Le Comte de Lautréamont), *Maldoror* (1868)[1]

LES DEMOISELLES D'AVIGNON (1907)[2] marks the apogee of Picasso's explorations of the portentous power of the left hand. But here we find something altogether different: the fateful left hand of the hand-readers becomes indistinguishable from the transgressive and liberated left hand of the Satanists. Before examining the picture's gestation in detail, we need to discuss the 'rise' of Satanism during the course of the nineteenth century, and its early influence on Picasso.

* * *

THE LEFT HAND WAS not just favoured by hand-readers. It was the preferred hand of occultists and black magicians, in large part because the right hand was pre-eminent in orthodox religions. Whereas the blessing in the catholic mass was performed by the priest's right hand, in black masses it was the left hand. Satanism had become fashionable during the course of the nineteenth century because of the romantic cult of the persecuted and repressed outsider.[3] Shelley's celebration of Milton's Satan in *A Defense of Poetry* (1821) is perhaps the most famous example: 'Nothing can exceed the energy and magnificence of the character of Satan in *Paradise Lost.*' The 'Divine Marquis' (de Sade) and the 'Satanic Lord' (Byron) were perhaps the most influential of the sublime transgressors.

In late-nineteenth-century France, a key figure (and the inspiration of Huysmans' *Là-Bas*) was the self-styled Abbé Boullan (1824–93), a catholic priest who became increasingly unorthodox—and

energetic—after undertaking the spiritual education of a novice Adèle Chevalier in 1856.[4] In 1859, by which time they were lovers, they were granted permission to found a penitential religious community called L'Oeuvre de la Réparation, under whose banner they developed all kinds of scandalous thaumaturgic practices. When one of the community fell ill, Boullan got them to ingest anything from consecrated hosts covered in blood and sperm, to urine and faeces. In 1860, in a thoroughly Byronic gesture, he is thought to have killed his and Adèle's newborn baby (Byron told his pregnant wife he would immediately strangle their newborn, and he greeted its birth with the inimitable words: 'The child *was* born dead, wasn't it?').[5] In 1861, Boullan and Adèle were jailed for three years for embezzlement and indecency.

Boullan's idea of reparation—which became more overt after he was excommunicated in 1876, and established a new community in Lyon—was a form of exorcism whereby his followers took on the 'burden' of performing certain sins so that others outside the community would not need to. Boullan also encouraged those who experienced diabolical obsessions to exorcize them by imagining they were having 'astral sex' with saints or Jesus. He believed that the Fall was caused by a sinful act of love and that it could only be reversed by acts of love accomplished in a religious environment. Sex with a superior being was supposed to raise one's spiritual status—something which, in a perverse parody of St Francis' love for animals, even justified bestiality.

To an extent, Boullan was swimming with the tide, for anti-clericalism was rife and helped fuel a fascination with all manner of priestly and saintly vice: in 1879 a *Bibliographie Clerico-Galante* was published cataloguing erotica supposedly written by priests, and a related publishing house, the *Bibliothèque Clerico-Galante*, was founded. In 1882, they published a work by a 'defrocked priest' J-B. Renoult, *Les Aventures Galantes de la Madone avec ses Dévots, Suivies de celles de François d'Assise.* [The romantic adventures of the Madonna with her devotees, followed by those of Francis of Assisi.] It had first appeared in 1701, and was an attack on 'the great goddess of the Papacy' who in 'mystic marriage' with her devotees granted them favours that were as debauched as those granted by the great pagan 'goddesses of prostitution', Venus and Flora.[6]

Boullan went further than most, however. He was even prepared to have astral sex with incubi, succubi, and half-human creatures in

order to raise them to a fully human form.[7] There must have been a queue all the way from Lyon to Neptune since Boullan claimed to be the reincarnation of St John the Baptist—a choice that must have been determined by the Romantic fascination with the circumstances of his death, engineered by the 'she-Devil' Herodias. In Heinrich Heine's *Atta Troll* (1841), which popularized the theme in France, Salome is the classic *femme fatale*, and there is a powerful sense in which the 'dead' Baptist is somehow complicit in his fate: is it the Baptist's head, or Salome, who kisses with fervour?

> In her hands she carries ever
> That sad charger, with the head of
> John the Baptist, which she kisses:
> Yes, the head with fervour kisses.[8]

Boullan's thaumaturgic doctrines were publicly exposed by the poet and occultist Stanislas de Guaita in his deeply critical book *Le Temple de Satan* (1891), but a more sympathetic portrait appeared in *Là-Bas* (1891). Huysmans befriended Boullan while researching his novel in the hope that he would give him the inside story on Satanism. Boullan did not let him down, but he seems to have pretended to be an opponent of Satanism rather than its leading light. In the novel, Huysmans obligingly made him the model for the kindly Docteur Johannès (perhaps a nod to Heine's *Johannes des Täufers*—John the Baptist), the heroic opponent of the disgusting Satanist Canon Docre. Even when Huysmans realized that Boullan was not so saintly, it did not impair their friendship: he probably knew all along that Boullan was the real Canon Docre. In 1892, Boullan was condemned for the illegal practice of medicine, and as he was dying in 1893, he blamed his death on the black magic of his opponents. He left all his papers to Huysmans.

Boullan had a pentagram (a five-pointed star) tattooed at the corner of his left eye,[9] thus transforming it into an evil eye, and a cross tattooed to the sole of each foot so he could trample on Jesus Christ (in *Là-Bas* Canon Docre is given these tattoos). The climax of Huysmans' novel is a Black Mass conducted by Canon Docre before an altar surmounted by an obscene effigy of (Anti-)Christ, grinning wickedly and with an erection. Canon Docre wears a scarlet biretta 'from which protruded two bison horns of red cloth'. Underneath his sacrificial

robes he is naked, except for black stockings and garters. He praises his master:

> The hope of virile members and the Anguish of barren wombs, Satan, you never demand useless proofs of chaste loins or extol the madness of fasts and siestas, you alone grant the carnal supplications and petitions of poor, greedy families. You convince mothers to prostitute their daughters, to sell their sons, you encourage sterile and forbidden loves.[10]

After Canon Docre finishes his sermon he blesses his congregation of mostly women and boys 'with a sweeping motion of his left hand'. They get off fairly lightly. A little earlier we are told about Black Masses where the officiating priest (or the Devil) makes the congregation 'kiss his left hand, his member and his backside', before giving them the defiled host.[11] Then Canon Docre signals the start of the orgy to end all orgies.

Picasso's *Nude Self-Portrait* (1902–3), a pencil drawing made in Paris when he was in his early twenties, suggests he may have attended a Black Mass—or at least, fantasized about attending one. It is a full-frontal image of the naked artist standing to attention, his right hand placed over his heart, and his left raised to head height, as though he were swearing a diabolical oath of allegiance. His left upper arm is drawn in deep shadow. It is tempting to assume it is just a mirror image that shows his raised right arm in reverse, but the nudity suggests otherwise, as do other drawings from the period.

The grinning *Simian Self-Portrait* (1 January 1903) shows him crouching down, scratching himself with his left hand. A tail protrudes from his bottom while paint-brushes sprout from behind his ears giving him a distinctly diabolical look. The fact that this was drawn on New Year's Day suggests the sacreligious birth of a new kind of artist. Soon after, Picasso drew *Crucifixion and Embracing Couples* (1903), in which the head of the crucified (anti-)Christ tilts to his left, as do his feet. He is surrounded by groups of embracing, naked couples, some of indeterminate gender.[12] Two earlier drawings, now both erroneously known as *Allegory* (1902) show the young artist kneeling naked and tumescent before a naked woman lying on the ground who opens her arms to embrace him. They are both contained between the outstretched arms of a naked winged deity (no doubt a fallen angel, partly inspired by

Aubrey Beardsley's 'Mirror of Love') who stands behind them—male in one drawing, female in the other.[13]

These drawings recall two crucifixion prints by Félicien Rops, *Calvary* and *The Lover of Christ*, in which a naked woman enthusiastically embraces the cross. A satyr with an erection is nailed to one cross; a smiling black man, whose whole body is being bandaged by the woman, hangs from the other cross. The heads of both tilt to the left and the black 'Christ' has a large wound in his left side. A more bourgeois literary version of this theme is the imaginary courtship ritual described by a male lover in a sonnet published in the decadent literary magazine La Plume by J. Clozel in 1890, *Les Mystiques*. The lover imagines sitting with his beloved on a sofa 'in a pale, rose-tinted room, at dusk', lit by an incense burner. He begins to undress her, whereupon a great 'black' Christ stretches out his arms to bless them both. The lover fetches an ancient Bible:

> I shall read out the sweet, sweet Song of Songs
> And kiss your breasts—the Bible on your thighs.[14]

Picasso would return to all these ideas in the scabrously orgiastic, surrealist-era painting and drawing of *The Crucifixion* (1930). In the painting, a smiling cartoon-figure sun literally stands to the left of the cross, with a crescent moon face to the right. In the drawing, which principally focuses on the area to the left of Christ's cross, he is sexually assaulted by Maenad-style female 'mourners', while a creepy priest figure points across to them with the outstretched index figure his left hand; the left edge of the composition is filled by the gigantic extended left arm and hand of the man who has just nailed Christ to the cross, and who is coming down his ladder (this is the only part of his body we see).[15]

The writer Alfred Jarry, whose 'pataphysical' scientific theories appealed to Picasso and the poets in his circle, encapsulates this cultural moment in the frontispiece lithograph illustration to his poetic drama, *César Antechrist* (1894). A man stands before us, holding a black banner in his left hand, naked except for a voluminous cloak that covers his shoulders: to his left is a large plus '+' sign, and to his right a minus '−'. This Christ may even be a portrait of Boullan, and Jarry explains it in fashionably heretical terms: 'Not only are the signs plus and minus identical but so too, ultimately, are the concepts of day and night, light

and darkness, good and evil, Christ and Antichrist'.[16] Here, the 'positive' left side is the first among equals.[17]

It has been said that from around 1870–1914 public and official hostility towards left-handers reached a peak, with all sorts of punitive measures being taken to prevent children who were naturally left-handed from using that hand. In addition, innumerable social scientists such as Lombroso were on hand to 'prove' that left-handers were more likely to be criminals, prostitutes, perverts, homosexuals, insane, retarded, and murderers (both Jack the Ripper and Billy the Kid were assumed to be left-handed, the latter thanks to a photograph printed in reverse). One explanation that has been given for France is that from the 1860s the political term *gauchisme* started to be applied to left-handers, as if to suggest they too were a danger to the political establishment.[18] This is undoubtedly a component, but even more important, I would suggest, is the fact that the Satanists and occultists had a cult of the left hand, and so natural left-handers were tarred by the Satanist association. As the Catholic Church was a bastion of the political right in France (it was a seamless transition: the clergy had traditionally sat to the right of the French King in meetings of the Estates General), the symbolism was hard to resist.[19]

Few of Picasso's early self-portraits show him in the act of drawing or painting. The most important exception to this rule is a charcoal drawing made in Horta de Ebro, Catalonia, in 1898, in which the young artist stands almost in right profile, naked from the waist up, with his drawing pad propped on his upraised left thigh, with the charcoal in his left hand. No doubt this was done with a mirror, but the whole of Picasso's left arm, face, and front is cast into such deep shadow, and the area of shadow is given such pointed, flame-like contours, that one wonders if this too is not a self-portrait of a diabolical artist.[20] Another creepy left-hander features in his first etching, a picador with a spear in his left hand and an owl at his feet, *El Zurdo* (1899/1900, 'the left-hander'). Critics usually assume that the left-handedness was the mistake of a novice etcher, unaware that the image on the engraving plate would be reversed.[21] However, the owl is only explicable if he is meant to be a 'sinister' picador, a harbinger of bad things and of death. His face is in almost complete shadow, and the print as a whole is fatalistically gloomy. He is a more potent version of Don Gonzales, the sexually ambiguous creep in Francisco de Quevedo's play, *El Zurdo Alanceador* (1624, 'The Left-handed Lancer').[22]

All of these works are of modest scale, and mostly made for private delectation—just like the stream of pornographic drawings which were a lucrative side-line in Picasso's early days. Some of these heretical ideas were explored on a larger scale in his mock-Entombment painting, *The Burial of Casagemas (Evocation)* (1901), in which the dead man, as his 'soul' rides upwards on a white horse, turns to his left with arms outstretched to be embraced by a naked whore—an obvious reprise of all those erotic crucifixions.[23] But the painting is generally regarded as a failure, in which Picasso desultorily goes through the libertine motions. There may be a left-right component—the arrangement of all but one of the eighteen 'mourners' to the left of the corpse—but this doesn't redeem the picture in the slightest. It was only with *Les Desmoiselles*

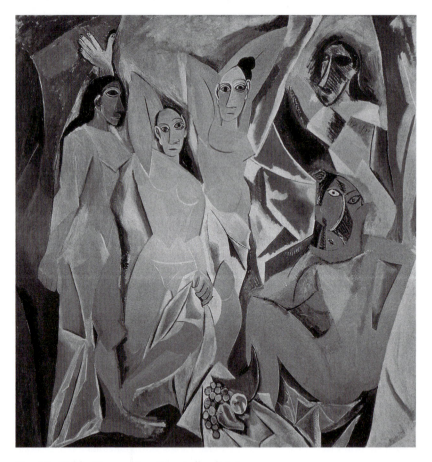

Fig. 39: Pablo Picasso, *Les Demoiselles d'Avignon*

d'Avignon (1907) (Fig. 39) that he would find a way to make great art on a grand scale out of transgressive eroticism.

<center>* * *</center>

THE FINAL FORM OF the composition of the *Demoiselles* was only reached after many months of trial and error. Picasso's earliest studies were made in February-March 1907, and feature two clothed men and five naked whores in a heavily curtained, stage-like room. One of the men stood at front stage right, holding a book and/or skull in his right hand, and with his left hand raised to draw back the curtain. In 1972, Picasso identified him as a medical student.[24] The other man—supposedly a sailor—sat at a table piled with fruit in the centre. It is usually assumed that Picasso was envisaging a faintly moralizing picture, with the medical student as a health inspector and latter-day reforming saint. It could almost have been a reprise, this time set in a brothel, of one of Picasso's first major genre scenes, *Science and Charity* (1897), where a bed-ridden young woman—of indeterminate status—is attended by a doctor (who takes her pulse).

Yet the skull-bearing medical student is far more likely to be an aspiring Docteur Johannès than a kindly Docteur Jullien, the venereologist at Saint-Lazare. He is a practitioner of 'alternative' medicine, who would encourage the demoiselles to engage in 'therapeutic' orgies, and save the human race in the process. At the time, the profession of 'medical doctor' was an ever-expanding field, with all kinds of weird practitioners advertising in the back pages of the newspapers.

In *Là-Bas*, one of the Satanists at Canon Docre's Black Mass is described as having once been 'a doctor at the medical school. He has a private chapel in his house in which he prays to a statue of Venus Astarte standing on an altar'.[25] J. Collin de Plancy's *Dictionnaire Infernal* (first edition Paris 1818; sixth edition Plon 1863), says that Astarte is the wife of Astarotte, Lord of Hell, and has a horned heifer's head.[26] This is the kind of woman that Picasso's 'medical student' is here to worship. The skull suggests he is invested with diabolical powers, and it may be a gift for these female deities. Skulls and naked ladies had already appeared in Gustav Klimt's allegorical painting of *Medicine*, executed for Vienna University and first exhibited to uproar from the medical profession in 1901. The central figure is Hygeia, Greek goddess of health, who holds up a gold goblet in her left hand from which a long snake drinks. Rising up behind her and to her left is a writhing column of naked women and

<center>349</center>

skeletons, and at the outer edge of the column two left arms cantilever out over a void.[27] References to conventional medicine and cures are conspicuous by their absence.

It has often been supposed that the student and sailor are surrogates for Max Jacob and Picasso (and vice versa), and there may indeed be a biographical element. However, Picasso soon turned the student into a woman, and then got rid of the sailor altogether. Finally, he dispensed with a seated woman, and so reached the famous five women of the final picture.

* * *

THE WOMAN WHO SUPPLANTED the medical student is in many respects the Mistress of Ceremonies in the final painting. We see her hieratically, in quasi-Egyptian right profile, her right leg planted slightly forward, clad in coarsely angular yet diaphanous robes that leave her breasts exposed. Her body below the neck has a warm, pinkish tonality. Picasso repainted her from the neck upwards at a very late stage in darker shades, and more primitivizing style, with the right eye looking straight out at us. This must have been to make her look suitably portentous, and even masked. The raised left hand, with its splayed fingers and thumb, seems to sprout directly from her head, and is almost equally dark.

We can see her as an omniscient chiromantic priestess—a sort of Madame de Thèbes. This was the egyptianising pseudonym of Anne-Victorine Savigny, a comedienne and sometime student of Desbarolles, who had become a professional chiromancer at the urging of her playwright friend Alexandre Dumas, son of the more famous historical novelist. He arranged for her to read the palms of a dozen co-members of the Académie Francaise, and this she did faultlessly, correctly recognizing each aspect of their ineffable genius. It was variously reported that she did this from behind a curtain, or with a sack of coarse cloth over her head. From this same material she later made a kind of mendicant friar's robe.[28]

Madame de Thèbes' book, *L'Énigme de la Main* (first edition 1900; other editions 1901 and 1906), is particularly interesting in relation to the *Demoiselles* because there are some fascinating photographs and *trompe-l'œil* line drawings of the *back* of various female left hands, mostly raised vertically in the air (Fig. 40).[29] The back of the hand was studied for the purpose of chirognomy, a reading of personality through the shape and size of the hands and fingers. The author identifies four

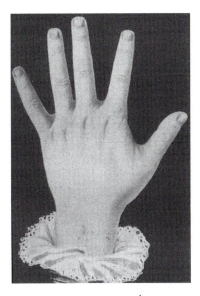

Fig. 40: 'Main carrée' from *L'Énigme de la Main*

types of hand—including Picasso's, the square 'main carrée'. In 1937, Picasso made a number of life casts of open hands, some of which were cast in bronze, all of which were installed and/or photographed with the fingers pointing up in the air, like medieval hand reliquaries. These followed the Victorian tradition of taking casts of the hands of great men. Five were of the palm of Picasso's own hands, and two are of the left hand (if bronze casts are included, there are four versions of each hand).[30] He also made a life cast that shows a 'chirognomic' view of the back of the left hand of his current lover Dora Maar.

The 'chirognomic' hand that sprouts from the head of Picasso's 'priestess' is like a heraldic blazon on a medieval helmet, showing exactly who she is. No practical function is served by having the fingers splayed for she cannot grip or pull the curtain: it is largely symbolic. For Desbarolles, writing in *Les Mystères de la Main*, the hand is vital both for communication and for sensory exploration, especially at night: 'During the night, the hand becomes the brain itself.'[31] Here hand and brain are fused together. As in *Les Saltimbanques*, the shape of the proffered left hand loosely echoes that of the composition: the four fingers correspond to the four standing women, while the thumb corresponds to the crouching woman at front stage left. She is still a medical student of sorts—only she dispenses diagnoses about erotic life and death. For

351

Madame de Thèbes, the left hand means 'Fatalité',[32] and this is what the raised left hand seems to means in the *Demoiselles*, for not only is aggression directed out towards the viewer, via the wide-eyed frontal stare of the women, but aggression is also channelled internally, between the two pairs of prostitutes.

For the scene which the 'high priestess' presents before us is a stunning variation on the theme of *Death and the Maiden*, in which death usually comes from the maiden's left. Despite their primitivizing features, the two central girls—a hybrid of Iberian sculpture and Michelangelo's *Dying Slave* in the Louvre—are clearly meant to look attractive and vulnerable: they are 'far more prepossessing than any other female figure painted by Picasso in all of 1907'.[33] Three of their four arms are raised and jack-knifed behind their heads, concealing their hands, and this too heightens the sense of torso exposure.[34] The enormous slice of melon, placed on a table that juts in to the left of where the central girl's feet are placed, is a witty allusion to their 'innocence' for it echoes the position of the crescent moon on which Murillo's *Virgin of the Immaculate Conception* stands in several paintings that Picasso must have seen in the Prado and the Louvre, which had two such paintings at the time.[35] Of course, the melon and the rest of the fruit (grapes, apple, pear) is also a reference to forbidden fruit.

For the faces of both these girls, the eyebrow sits far higher above the left eye than the eyebrow over the right eye, which merges seamlessly with the line of the nose. This too gives the sense of greater openness, sensitivity, and alarm on the left side, and suggests they may be aware of the monsters that lurk to their left. The jagged, mask-like faces of the two women to their left, their snouts pushing forward remorselessly like the prows of asymmetrical ships, were also repainted at a late stage, influenced in part by African and Oceanic masks seen on a recent visit to the Trocadero in Paris (these are always regarded as the faces that launched cubism). The repainting was an attempt to rescue what would otherwise have been a 'one-face-fits-all' composition. The left eye of each is darker than the right, and that of the crouching figure has slipped disconcertingly: they are surely meant to be especially evil eyes. Desbarrolles, in a section on astrology, reiterates the belief that the left eye is the domain of the moon, adding that it then becomes '*the eye of the gettatore*, the *evil eye*. Never kiss anyone on the left eye, says the wisdom of nations.'[36] The Italian 'gettatore'—the caster or thrower of spells—was an important figure of Romantic superstition, and Freud

later referred to it in his 'Essay on the Uncanny'. At the heart of the composition, the 'Iberian' women abut the 'African' women like racial tectonic plates, creating extraordinary friction.

Picasso was certainly aware of the *Death and the Maiden* tradition. In 1906 he had made an ink drawing, *Young Girl and Devil*, in which the Devil stands to her left offering jewels. At the same time, he made *Young Girl Between Devil and Cupid* in which the girl twists her left leg round so that it is pointing to the Devil.[37] In *The Call of the Virgins* (1900), a drawing reproduced in the magazine Joventut, a naked woman deliriously turns to her left towards an ithyphallic apparition of a man.[38] The Prado contained a large diptych by the great specialist in *Death and the Maiden* imagery, Hans Baldung Grien: *The Three Graces* coyly adorn the left hand panel, while the right panel features an utterly desolate image, *The Three Ages of Woman and Death* (151 × 61 cm), in which a scantily clad young beauty stands before a blasted tree in a moonlit wasteland. She turns to her left because she is being threatened by a monstrous duo: a grotesque old hag, who stands at her shoulder, is pulling at the diaphanous veil which covers her midriff; and the old woman in her turn has her left arm pulled by a skeletal figure of death who holds an hour-glass and a broken spear. On the ground, by the feet of the old woman and Death, lies an abandoned (and presumably female) baby; and an owl stands in front of the maiden. In Picasso's picture, the two monstrous women are not clearly marked out as evil, diseased, battered or past their sell-by date—but they do suggest some of the more 'sinister' and potentially fatal aspects of the profession in which the two more fresh-faced central 'graces' are engaged.

The crouching figure in the *Desmoiselles* has been intriguingly compared to Diana, the nude goddess of chastity seated at the far right of Titian's *Diana and Actaeon*: she looks over her left shoulder to stare witheringly at a male intruder Actaeon, who will shortly pay for this crime with his life.[39] This certainly helps account for the woman's power and aggression, but it does not explain the stylistic differences between the various women in Picasso's picture, or the flagrant iconoclasm of the woman and her squatting pose. For some of this, we might turn to the disgusted and disgusting figure of a man who squats defecating in the bottom right corner of Rembrandt's drawing, *Satire of Art Criticism* (see Fig. 18, p. 158), and who twists his head sharply towards the viewer, staring at us with his single (left) eye.

This sketch was included in an unillustrated descriptive catalogue of Rembrandt's drawings published in Haarlem in 1906 (it was then in a Dresden collection) but I do not know whether Picasso could have seen a reproduction of such a ribald image.[40] It certainly fits the mould-breaking mood of the *Demoiselles*, though both artists are, to an extent, working with a pictorial archetype which I have identified in this book. It has been said the pose for Picasso's figure may have been inspired by seeing Fernande Olivier squatting on a chamber pot, but I doubt she ever squatted with the devil-may-care, iconoclastic gusto of Picasso's and Rembrandt's figures.[41] The brown patch of paint below her buttocks, and the fact that her right arm merges with her right thigh, making it look as if her right hand is reaching down to wipe her bottom, makes it a distinct possibility that coprophilia is part of the erotic mix.

Some recent critics have described Picasso's two monstrous females as the harbingers and symbols of syphilis, and this disfiguring disease may be part of the picture's meaning.[42] Against this, it has been pointed out that none of Picasso's friends died of the pox, and that his pornographic drawings hardly expressed any preoccupation with it.[43] Indeed, his women scarcely look weak or in pain: for better or for worse, their deformity has empowered them, and they add immeasurably to the jolting exuberance of the picture.

Picasso's friends were, for the most part, horrified by the *Demoiselles* when he first showed it to them, and thanks to their dismay it was first exhibited a good nine years later, in 1916. The painter André Derain thought that one day Picasso would be found hanging behind the canvas: this was a reference to Claude Lantier, who hangs himself after a frenetic episode of painting his nude's legs and torso like 'some infatuated visionary driven by the torments of the real to the exaltation of the unreal'.[44] The ladder from which he hangs himself is positioned directly in front of the female nude in his incomplete masterpiece so he can gaze into this woman's eyes while he dies. Braque reckoned that to paint like that Picasso must have been 'drinking petrol and spitting fire'.[45] The critic André Salmon seems to have dubbed it *Le Bordel d'Avignon*, and *Le Bordel Philosophique*, and then, at the 1916 exhibition which Salmon organized, the more demure sounding *Les Demoiselles d'Avignon*—the *damsels* of Avignon.[46] It only became *the* seminal work of modern art after being bought by the Museum of Modern Art, New York, in 1939 from the heirs of Jacques Doucet, who had bought it from Picasso in 1922 on the understanding he would give it to the Louvre.

Picasso professed to hate this title, but it does point to the ambiguous status of the two 'sacrificial victims' at the centre. And why Avignon? One explanation was that Max Jacob's grandmother lived there and they joked that she ran a brothel. But the only reason they would assume she ran a brothel there is because ever since Avignon had been the refuge of the papal court in the fourteenth century, it had had a reputation for sleaze. Petrarch had been dismayed by the luxury and debauchery of the papal court, grown rich on the sale of benefices and other new taxes, and called it the new Babylon. Petrarch's denunciation had been cited with relish by the Marquis de Sade. Other European cities called streets in red-light districts after Avignon (Rome's via degli Avignonesi, for example). The reception in the Hospital Saint-Lazare, where many women suffering from sexual diseases were incarcerated, was known as the Pont d'Avignon.[47] No doubt Picasso and Jacob fondly imagined that fourteenth-century Avignon had been full of Abbé Boullan's spiritual ancestors.

Salmon published the first extensive discussion of the painting in 1912. He is more than a little confused. He credits Picasso and his picture with supernatural powers, but in the next breath tries to exclude them, because he wants the *Demoiselles* to be the crucible of Cubism, which he regarded as a supremely rational artform. When Picasso 'attacked the faces' of the two figures on the right, Salmon writes, the 'apprentice sorcerer was still seeking answers to his questions among the enchantments of Oceania and Africa'. No orthodox medical student he—more like a trainee witch-doctor. But elsewhere Salmon draws back: 'Those who see in Picasso's work the masks of the occult, of symbolism or mysticism, are in great danger of never understanding it.'[48] Since few had properly seen the picture since 1907, this may mean that this was how it was first received by Picasso's friends—as an exploration of the wildest frontiers of the occult.

But what did Picasso think he was up to? He had clearly been provoked by Matisse's *Bonheur de Vivre* (Joy of Life), which had caused a huge stir at the Salon of 1906, and the *Demoiselles* can be regarded as a raucous, claustraphobic riposte to that picture's ecstatic pastoral vision— 'hard' primitivism instead of Matisse's 'soft' primitivism (Matisse thought Picasso's painting was 'an outrage, an attempt to ridicule the modern movement'). He clearly wanted to cause a stir, as did the youthful Comte de Lautréamont in his *Chants de Maldoror* (1868) when the satanic hero announces: 'I have made a pact with Prostitution to sow disorder in

families.'[49] Picasso may have been introduced to this toxic novel by Max Jacob.[50]

In the 1930s, Picasso would tell André Malraux about his first visit to the Trocadero to see tribal art, at the time he was working on the *Demoiselles*. The labels in the museum indicated the ailments that these artefacts cured and the evil spells from which they gave protection. Picasso said that they were 'weapons—to keep people from being ruled by spirits, to help free themselves ... If you give spirits a shape you break free of them. Spirits, the unconscious ... emotion, they're all the same thing'. As such, the *Demoiselles* was his 'first exorcism picture.'[51]

Yet Picasso would have first encountered the idea that orgiastic sex, real or imagined, could exorcize demons and expiate sin in relation to the Abbé Boullan—that is, long before he ever visited the Trocadero. Where the two women with the brutally repainted faces are concerned, we should not forget that Boullan and his followers practiced redemptive 'astral sex' with incubi, succubi, and half-human creatures. The 'chirog-nomic' left hand of the priestess is thus painting for us a picture of an erotic world in which the distinction between fantasy and reality, desire and disgust, sickness and health, love and death, man and beast is being eroded. It is a predicament for which no conventional doctor will ever find a cure.

* * *

FROM 1909 ONWARDS, MALE and female guitar and mandolin players are one of the key subjects during the development of Cubism. In addition, there are numerous still-lives in which one or other of these stringed instruments (and occasionally a violin) lie on a table. Picasso was clearly drawn to the subject of guitar-players because of the anthropomor-phic qualities of a guitar, and because the guitar requires skilful tactile manipulation by both hands. In 1901, an article on 'La Psicologia de la Guitarra' appeared in a Barcelona magazine, *Arte Joven*, for which he provided illustrations. Here the guitar was compared to a woman which a man tries to play.[52] In 1907, the poet W. B. Yeats wrote in a more elevated vein that a guitar player 'can move freely and express a joy that is not of the fingers and mind only, but of the whole being'.[53]

Until the winter of 1911, all the players seem to be right-handed (though some pictures are extremely hard to read). It was then that he painted *'Ma Jolie'* (1911–12) (Fig. 41) with the lower, left hand of the musician plucking the strings, with the right hand placed above.

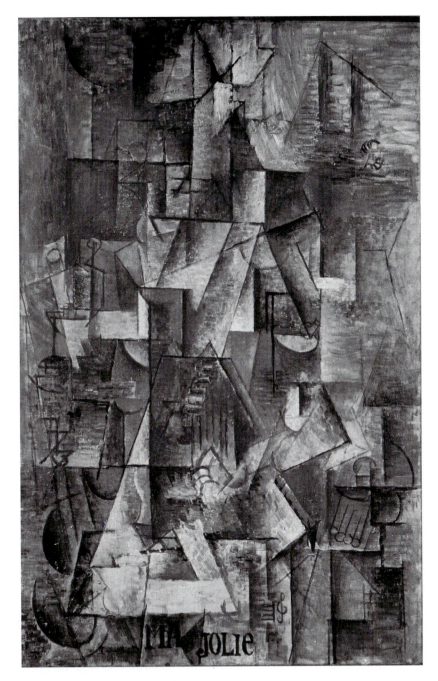

Fig. 41: Pablo Picasso, *Ma Jolie*

The instrument (which could equally be a zither) is held vertically upright, and both hands appear directly above the inscribed letters 'MA JOLIE', a phrase from a popular song 'O Manon, ma jolie, mon coeur te dit bonjour!'

Picasso hardly ever gave titles to his pictures, and this is no exception. It now tends to be assumed that the picture is a portrait of Picasso's new (and very secret) love, Eva Gruel, for Picasso later refers to her as 'ma jolie'. If it is Eva, then her left-handedness might be a symbolic allusion to the clandestine yet deceitful nature of their relationship, for no contemporary says that Eva was left-handed. The relationship certainly involved a great deal of subterfuge, for Eva was a friend of Picasso's then mistress Fernande Olivier, and was herself the mistress of the painter Lodwicz Markus (who soon changed his name to Marcoussis). In May 1912 Picasso ended his relationship with Fernande, and he eloped with Eva. They planned to marry, but she was diagnosed with cancer in 1913 and died in December 1915.[54]

So the idea that the picture is the first visual record of their clandestine relationship adds greatly to its biographical appeal. Yet it is far from clear that the musician in this most abstract of cubist paintings is female, for there are no obvious indications of breasts, female attire or hair. It could just as easily be a male guitarist, singing a song about his love, 'ma jolie'. A broad smile has been detected in the semi-circle placed two-thirds of the way up the picture, but this is hardly gender-specific. It is just as likely to be Picasso as Eva singing a love song 'straight from the heart'.

The sudden appearance of a left-handed musician, who is possibly smiling, in Picasso's work at the end of 1911 may rather have been prompted by the theft of the *Mona Lisa* from the Louvre in August 1911. This is because the left-handed Leonardo was an accomplished and famous lute-player and, according to Vasari, musicians played during his portrait sittings, and this musical accompaniment is what kept 'La Gioconda' smiling. The proportions if not the sizes of *Ma Jolie* (100 × 65 cm) and the *Mona Lisa* (77 × 54 cm) are quite similar, and so too are their subdued tonalities.

Picasso became indirectly involved in the *Mona Lisa* scandal because in 1907 he had come into possession of some Iberian heads stolen from the Louvre by Apollinaire's secretary, the Belgian con man Géry Pieret. These he still possessed. When the *Mona Lisa* was stolen, Pieret boasted falsely to a newspaper that was offering a reward for its return that he had stolen the painting in order to expose the museum's lack of security.

He then sold the newspaper his most recent theft, an Iberian head that had been displayed on Apollinaire's mantelpiece, to prove he was a bona fide art thief capable of the crime.

Picasso and Apollinaire knew they could soon be in big trouble, and tried to dispose of the remaining Iberian sculptures by throwing them into the Seine. Having signally failed to do this, Apollinaire instead took them to the newspaper under a pledge of secrecy. On the 7th September, Apollinaire was denounced to the police, arrested and imprisoned for a week. The poet implicated Picasso, but on being questioned, Picasso seems to have denied ever knowing Apollinaire, and was released— presumably after pulling strings.[55] The painting was only redisplayed in the Louvre in January 1914, having been stolen by an Italian who claimed he wanted to 'repatriate' it.

The left-handed musician in Picasso's picture could just as well be Leonardo singing about the theft of 'ma jolie (Joconde)'. In 1911, street singers had sung a specially written ditty, 'L'as tu vu la Joconde?', while selling postcards of the picture. But regardless of who the sitter is supposed to be, *Ma Jolie*, with its big smile and indeterminate gender, could easily be an attempt to paint a Cubist rival to *La Joconde*. In November 1911 a poet (probably Apollinaire) using the pseudonym 'Le Satyre masqué' published a poem entitled 'Le Vol de la Joconde' in which he claimed that she had in fact already resurfaced in cubist form: he didn't identify any particular Picasso picture, but *Ma Jolie* is the best contender.[56]

Picasso subsequently made a number of other left-handed guitar-players. A drawing of 1912, *Woman with Guitar*, is, certifiably female, and so too is the painting of the same title from 1913–14. A drawing of a left-handed *Guitar Player* (1913) is of indeterminate gender, while the painting *Man with Guitar* (1913) is definitely male.[57] These 'reversals' undoubtedly deepen the effect of 'defamiliarization' that is central to cubist art, insofar as cubism seems to turn the visual world inside out. This is also implicit in those many cubist still-lives featuring a guitar or mandolin laid on a table, for in the vast majority of cases where the instrument is placed horizontally, it is in a position in which it can most naturally be picked up by a left-hander rather than by a right-hander (i.e. with the body of the guitar to the left, and the neck to the right). They might almost be designed to induce *allochiria*, a term used by the psychiatrist Pierre Janet to describe a condition in which his patients confused the two sides of the body.[58]

Last but not least, there is the starting point of the last chapter: *Construction with Guitar* (1913). Picasso had initially been inspired to make works from combinations of unorthodox materials by his co-author of cubism, Braque, who made his first paper sculptures in the summer of 1911. The following year Braque added sand and metal filings to his paint and simulated the appearance of wood grain and marbling with a house-decorator's comb. Then in September 1912, he had glued woodgrain wallpaper to a piece of paper, thus making the first *papier-collé*. He later said that he had always had a desire to 'touch the thing and not only to see it... It was this very strong taste for material itself that led me to consider the possibilities of material. I wanted to make of touch a form of material.'[59] Braque, however, had no interest in pursuing the implications of his paper sculptures, and he left this field to Picasso. His left-handed cubist guitarist certainly does make of touch 'a form of material': it reaches out to us, both in body and soul, yet at the same time, remains unreadable and unreachable.

But the construction would also have been inspired, I feel, by Manet's painting of a 'left-handed' Spanish guitarist, which was mentioned earlier. The painting was displayed at the Durand-Ruel Gallery in Paris in 1906 as part of the Faure collection.[60] A 'still-life' of a water jug and some onions sits in the bottom corner. Picasso may well have identified with this key picture by one of the founders of the modern movement, and have seen himself as a recklessly 'gauche' Spanish guitarist.

In 1909 the French anthropologist Robert Hertz, in his pioneering essay on *The Pre-eminence of the Right Hand*, had asserted:

> The power of the left hand is always somewhat occult and illegitimate ... Its movements are suspect; we should like it to remain quiet and discreet, hidden if possible in the folds of the garment, so that its corruptive influence will not spread ... A left hand that is too gifted and too agile is the sign of a nature contrary to right order, of a perverse and devilish disposition: every left-handed person is a possible sorcerer, properly to be distrusted.[61]

Picasso, the 'apprentice sorcerer', knew this all too well.

20. Modern Primitives

Right-handedness is the price to pay for a more perfect and accomplished civilization; this is why left-handedness seems to be an archaicism, a return to the primitive state.

Anonymous, 'Left-handedness', *Medical Record*, New York 1886[1]

IN THIS CHAPTER I want to look at the various ways in which 'left-handedness' and the 'left-hand path' were romanticized from the 1920s onwards, and their impact on art. 1934 is something of an *annus mirabilis*, for it saw the publication of an essay by the French art historian Henri Focillon, and of an engraving by Salvador Dalí, both of which explored the idea of left-handedness and/or ambidextrousness. As the Focillon essay is more congenial than the Dalí engraving (which is deliberately disgusting), it is perhaps best to begin with that.

* * *

IN 1934 HENRI FOCILLON published *Éloge de la Main* [In Praise of the Hand], an essay that would appear in English translation in New York in 1948 appended to *La Vie des Formes* [The Life of Forms in Art], a much longer essay on aesthetics to which it forms a fairly natural conclusion. *In Praise of the Hand* is a poetic meditation on the human hand which is informed as much by the insights of hand-readers as by more high-brow sources such as the philosopher Henri Bergson, or the English champion of gothic, John Ruskin.[2] For Focillon, hands have their own very distinct physiognomy—a physiognomy which we need to understand far better:

Hands are almost living beings. Only servants? Possibly. Servants, then, endowed with a vigorous free spirit, with a physiognomy.

361

Eyeless and voiceless faces that nonetheless see and speak. Some blind persons eventually acquire a touch so sensitive they can identify playing cards by the infinitesimal thickness of the shapes printed on them. But those who can see also need their hands to see with, to complete the perception of appearances by touching and holding. The aptitudes of hands are written in their curves and structure. There are tapered slender hands, expert in analysis, with the long and mobile fingers of a logician; prophetic fluid hands; spiritual hands whose very inactivity has grace and character; and tender hands. Physiognomy, once diligently practiced by those who were expert in it, would have benefited by a knowledge of hands.[3]

One discerns the influence of Desbarolles. In the introduction to *Les Mystères de la Main*, he praises philosophers such as J-G. Herder who, in his theoretical treatise *Sculpture* (1778), had insisted on the primacy of the sense of touch, and its superiority to the sense of sight: 'Without [the sense of touch] the qualities of the other senses would be useless and powerless', he writes. Hand gestures are also supremely expressive: 'The hand is the speech of the poor deaf-mute. It alone alleviates his isolation and reunites him with humanity.'[4] Desbarolles' praise of the sense of touch coincided with the new approach to children's education espoused by the kindergarten movement, which put a strong emphasis on direct tactile apprehension by both hands of a wide variety of different materials and shapes. In the first decade of the twentieth century, as part of children's sensory education, the Italian educational reformer Maria Montessori even got pupils to perform these exercises while blindfolded.[5]

Focillon does admit that when reading the hand, it may not be able to tell us *precise* details about our lives: 'activity has left marks in the hollow of the hand, and one can read there, if not the linear symbols of things past and things to come, at least the pattern and as it were the memories of our lives otherwise lost to us, and perhaps as well some even more distant inheritance.'[6] Hands are most revealing when left to their own devices:

> Watch your hands as they live their own free life. Forget their function, forget their mystery. Watch them in repose; the fingers are lightly drawn in, as if the hands were absorbed in reverie. Watch them in the sprightly elegance of pure and useless gestures, when it seems that they are describing numberless possibilities gratuitously in the

air and, playing with one another, preparing for some happy event to come...Sometimes it happens that, first raised, then lowered, one after the other in invented rhythms, the fingers trace, nimble as dancers, choreographic bouquets.[7]

These kinds of 'free' gesture seem to prophesy Giacometti's post-war stick figures, with their spindly arms and outsized hands, though Giacometti's figures could hardly be said to be 'preparing for some happy event to come'.[8] Having discussed hands in general, Focillon then proceeds to distinguish between left and right, showing a decided preference for the left hand:

> The hands are not a pair of passively identical twins. Nor are they to be distinguished like younger and older children, or like two girls with unequal talents, one trained in all skills, the other a serf dulled by the monotony of hard work. I do not believe altogether in the eminent dignity of the right hand. Deprived of the left, it withdraws into a painful, almost sterile solitude. The left hand, which signifies unjustly the evil side of life, the 'sinister' portion of space, the side from which one must not come upon a corpse or enemy, or a bird— the left hand can be made to perform all the duties of the right. Fashioned like it, it has the same aptitudes, which it renounces in order to assist its partner. Does it clasp any less vigorously the tree trunk or the handle of an axe? Does it clutch an adversary's body with less force? Has it less power when it strikes? Does not the left hand form the notes on a violin, attacking the strings directly, while the right hand merely projects the melody with the bow?[9]

There had been a vogue for ambidextrousness in the years before the First World War, especially in England and the United States, because it was believed that by training the left hand equally with the right, it would give huge advantages to the individual and to industrial society. In 1903, the Englishman John Jackson had founded the *Ambidextral Culture Society*, and in 1905 Robert Baden-Powell, the ambidextrous future founder of the scout movement, wrote a preface to Jackson's inelegantly titled *Ambidexterity or Two-handedness and Two-brainedness* (1905), signing it with two identical signatures, one written with the right and the other with the left hand.[10] The movement had lost impetus even before 1914, however, and had little impact in the inter-war years, but what probably supplanted it in the public consciousness was the need to train up the

left hands of right-handed war veterans whose right hands had been damaged or lost—something which helped to reduce significantly the institutional hostility shown to natural left-handers.[11] This is part of the context against which Focillon praises the left hand.

However, Focillon is not interested in the left hand aspiring to the condition of the right hand, and being trained up; rather, he wants the right hand to learn from the 'untrained' left:

> We are fortunate in not having two right hands. How else would the diversity of tasks be apportioned? Whatever is 'gauche' about the left hand is indispensable to an advanced culture; it keeps us in touch with man's venerable past, with a time when he was not over-skillful, and still far removed from being able to create; with a time when he was, as the popular phrase goes, 'all thumbs'. Had it been otherwise, we should have been overwhelmed by too much virtuosity. No doubt we should have forced the juggler's art to its farthest limits—and probably have accomplished little else.[12]

For Focillon, there is a utopian aspect to the 'gaucheness' of the left hand, which keeps us in touch with our primitive selves. Here, the distinction between left and right gives us a true sense of proportion and of historical consciousness.

The left hand also gives greater access to a world that is perceived by touch: knowledge of the world 'demands a kind of tactile flair' because sight 'slips over the surface of the universe': 'I seem to see primitive man inhaling the world through his hands, stretching his fingers into a web to catch the imponderable.'[13] Children have this capacity too, but it is only the artist who 'prolongs the child's curiosity far beyond the limits of childhood'.[14]

Gauguin, the great modern primitive who painted and carved and modelled, is exemplary: 'Is not Gauguin an example of those ancients who live among us, dress like us, and speak our own language? . . . Not only painting but all sorts of hand work draw him, as if he were avenging the long inactivity of his own hands which civilization had enforced.' He is an artist who seems to have been ruled by his left hand:

> This man of subtle sensibility combats that very subtlety in order to restore to the arts an intensity long submerged in too much refinement. At the same time, his right hand forgets all its skill, to learn from

the left an innocence that never outstrips form. For the left hand, less 'broken in' than the other, not so expert in automatic virtuosities, travels slowly and respectfully along the contours of objects. With a religious charm blending the sensual and the spiritual, the lost song of the primitive man now breaks forth.

Victor Hugo is also cited as being 'one of the greatest of these visionaries' one whose hand 'is not the mind's docile slave. It searches and experiments for its master's benefit; it has all sorts of adventures; it tries its chance'.[15]

Focillon was primarily a medievalist, the author of important books on Romanesque sculpture and on medieval art. As such, his celebration of the human hand can be seen as a variation on a theme that had been famously espoused by Ruskin in his chapter 'On the Nature of Gothic' in *The Stones of Venice* (1851–3). Having described the degrading 'slavery' in which the modern worker lives, Ruskin urges his reader to 'go forth again to gaze upon the old cathedral front, where you have smiled so often at the fantastic ignorance of the old sculptors'. They should take another look at 'those ugly goblins, and formless monsters, and stern statues, anatomiless and rigid'. But they should not mock them, 'for they are signs of the life and liberty of every workman who struck the stone; a freedom of thought, and rank in scale of being, such as no laws, no characters, no charities can secure'. The variety and imperfection of gothic sculpture is evidence of the sculptors' freedom, and of their ability to express 'their weaknesses as well as their strength'.[16] Ruskin would have been horrified to see his ideas about artistic authenticity, and about the importance of expressing 'weaknesses', underpinning a modern cult of the gauche and cack-handed. But this is what they ultimately did.

* * *

FOCILLON IS CLEARLY AWARE of some of the more extreme and dangerous implications of his argument. When he refers to the left hand as being 'not so expert in automatic virtuosities', and travelling 'slowly and respectfully along the contours of objects' he is probably attacking the ultra-fashionable surrealists as much as 'academic' artists, for it was they who had pioneered 'automatic' writing and drawing, and these methods, while exalting the 'gauche', did not exactly encourage them to move their hand 'slowly and respectfully'. Far from it: surrealist 'psychic

automatism' was in most respects cavalier about objects, deforming them according to the dictates of the free-flowing unconscious. Thus Focillon is trying to rein in his argument, and still maintain a modicum of Ruskinian piety.

The *ne plus ultra* of automatism was published in 1934 by Editions Surréalistes, the same year as Focillon's essay. It was a long poem by Georges Hugnet entitled *Onan*, with an unusual frontispiece engraving by Salvador Dalí. Onan appears in the Book of Genesis. When Onan's bad elder brother Er dies, slain by the Lord, his father Judah tells him to marry his sister-in-law and so 'raise up seed to thy brother', but Onan does not want to fill in for his brother and so 'he spilled [his seed] on the ground'—for which 'crime' the Lord slew him too [38: 7–10]. Onan's act has traditionally been interpreted as masturbation rather than coitus interruptus.

Hugnet's Onan lives in 'voluntary seclusion' where he is able to love all the better:

> Il se tait et le silence découvre son corps.
> Il touche avec la main cette main étrangère
> Qui est la sienne et remonte le long du bras.

[He is quiet and the silence reveals his body./ He touches with his hand this strange hand which is his and climbs the length of his arm]. It is not clear whether the 'strange hand'—or 'estranged hand'—is actually his hand or his penis. But there is clearly an erotic frisson in the otherness of the various parts of Onan's own body: self-touching becomes as exciting as an encounter with a total stranger.

The poem is mainly remembered now because of Dalí's frontispiece (Fig. 42).[17] This carried in its bottom right corner a scrawled, graffiti-style inscription in block capitals:

ESPASMO-GRAPHISME' OBTAINED WITH THE LEFT HAND WHILE MASTURBATING WITH THE RIGHT UNTIL BLOOD UNTIL BONE UNTIL SCAR!

Dalí is clearly a man who is prepared to suffer for his art. The etching is a blizzard of scratches and scrawls, with the densest configuration concentrated in the bottom left corner. The inscription, perhaps written with the right hand, is in the bottom right corner, and the orientation of word and image seems to reflect scientific theories about the various capacities of the left and right brain (the language faculty is located in

the left hemisphere, which controls the right hand; the visual faculty is located in the right hemisphere, which controls the left hand). A dark, round-ish stain fills the centre of the top half of the 'composition'. The picture is defiantly non-representational, but the stain occupies a similar position to a head—or a brain—in a portrait. Dalí was probably aware of Freud's beliefs about writing with the left hand, articulated in a letter to Wilhelm Fleiss at the turn of the century: it is 'a symbolic gesture motivated, if not stimulated, by fantasies which are forgotten, repressed and repudiated by the speech community'.[18]

Dalí was very keen on masturbation, and made many porno-graphic drawings illustrating the act. Here, however, he seems to be taking surrealist automatism to the point of no return—and of parody.

Fig. 42: Salvador Dalí, frontispiece to *Onan*

He had dabbled in automatic drawing in the late 1920s, but by 1934 he was deeply critical of the practice, regarding the method as too passive, and the results as monotonously stereotypical.[19] His engraving has none of the elegant, free-flowing calligraphy we find in most surrealist automatism—and as far as we know, the core Surrealists did not themselves ever use their left hand to make automatic drawings.

Nonetheless, André Masson, the great surrealist pioneer of automatic drawing in the 1920s and the artist most closely associated with the procedure, did regularly allude to the idea of left-handedness and of ambidextrousness in his works. Masson was right-handed, yet disembodied hands frequently loom large and active in his work of the 1920s, and these are just as likely to be left as right hands. In his ink *Portrait of André Breton* (1925),[20] in which the sleeping head of the leader of the Surrealist movement is shown in left profile, it is a left hand that hovers over him, and because lines of ink seem to flow into and out of this hand, forming a cursive cacoon around the poet, it feels as though the left hand is here the creating hand. These generative hands recur frequently in the drawings. In the important painting *Card Trick* (1923), in which the unconventional designs on the cards have been called 'signs and talismans wherein are condensed all the obscure forces of the future',[21] three of the five disembodied hands are left hands. Some of Focillon's descriptions of 'dancing' hands, living their own 'free life', may well have been inspired by Masson's paintings and drawings.

Masson's tumultuous painting *The Labyrinth* (1938) (Fig. 43) can be considered the culmination of these ideas about the human hand. Mythological themes were increasingly popular amongst the Surrealists in the 1930s, and in 1933 Masson had convinced the publisher Skira to call his new review (which was in large part a showcase for Surrealism) *Minotaure*. It has been said that the attraction of the myth was that a labyrinth could be understood in a Freudian way as the mind, at whose centre resides the Minotaur, half man half bull, symbol of irrational impulses; Theseus' quest, aided by Ariadne's thread, might therefore be seen as 'an allegory of the conscious mind threading its way into its own unknown regions'.[22]

In Masson's painting the labyrinth is transposed into the stomach/chest of a stony structure shaped exactly like a minotaur standing on its hind legs in a rocky wasteland, with its skull-head seen in left profile. All the creature's inner workings, and the intestinal labyrinth, are revealed because the masonry has been cut away from the front

Fig. 43: André Masson, *The Labyrinth*

of the torso. Of crucial importance is the fact that the entrance to the labyrinth is through the monster's left hand and up the arm, which is cut away to reveal a stepped passage-way. At the shoulder the notional 'Theseus' would turn left down into an aorta-style passage, and then at the end of this passage, turn left again into the labyrinth—over which hovers a spidery red heart. The paramount importance of the left hand is reinforced by the fact that this minotaur lacks a right arm (Masson had been injured during the First World War, and his minotaur suggests a 'mutilé'). From this, we can infer that Masson believed that the notional idealized 'left hand' not only gave access to the labyrinth of the human mind, but was the implement with which the artist expressed his inner being. In respect to this, his lack of a right arm empowers him.

It is also, of course, a very literal-minded depiction of the 'left-hand path'—insofar as a 'path' runs right up the left hand and arm. Wilhelm Stekel, from whose *The Language of Dreams* (1909/22) Freud derived his own ideas about left and right (he quotes him verbatim in *The Interpretation of Dreams*), believed that the 'right' path in dreams was straight, while the left path was crooked, winding and even spiralling.[23] Masson's image is also a modern version of ancient ring lore, whereby the ring is placed on the fourth finger of the left hand because it is connected directly to the heart by a nerve or vein. In Masson's painting, the 'entrance' to the left hand is surmounted by a ring-like arch, a bit like a vulva, and another larger ring is situated above it. Thus Masson inscribes this traditional belief into the Minotaur's own anatomy.

* * *

THE ARGENTINE WRITER JORGE Luis Borges would have drawn on these same ideas when he wrote his philosophical murder mystery, *The Garden of the Forking Paths* (1941), one of his best known and most emblematic short stories. Here the 'left hand path' opens up an endless array of possibilities, and their plurality is both exhilarating and life-threatening, the stuff of dreams and nightmares. The story involves a kind of automatic writing insofar as the plot loops back on itself repeatedly so we feel that almost anything can happen. Written during the Second World War, it may in part reflect the turmoil of the time.

The story revolves around a Chinese man working for the Kaiser as a spy in England during the First World War, who believes he has been exposed. He first considers trying to flee—'I am a cowardly man'—and then decides in the short time left to him to do something that will

certainly lead to his capture, yet will at the same time enable a crucial bit of information to be passed to the Germans. He will kill a man whose surname is identical to the secret codename of the town which the Germans have to attack. Having located his victim, Stephen 'Albert', by looking through the phone-book, he catches a train and alights at the nearest station:

> A lamp enlightened the platform but the faces of the boys were in shadow. One questioned me, 'Are you going to Dr. Stephen Albert's house?' Without waiting for my answer, another said, 'The house is a long way from here, but you won't get lost if you take this road to the left and at every crossroads turn again to your left'. I tossed them a coin (my last), descended a few stone steps, and started down the solitary road. It went downhill, slowly. It was of elemental earth; overhead the branches were tangled; the low full moon seemed to accompany me... The instructions to turn always to the left reminded me that such was the common procedure for discovering the central point of certain labyrinths.[24]

The Chinese spy knows this last bit of information because he is the great grandson of Ts'ui Pěn, a governor of Yunnan 'who renounced worldly power' to write a novel *The Garden of Forking Paths*, and to construct a labyrinth in which 'all men would become lost'. However, he was shot thirteen years later without completing his work. Stephen Albert turns out to be a sinologist working on Ts'ui Pěn's chaotic papers and (just before he himself is shot) he encapsulates Ts'ui Pěn's ideas:

> In contrast to Newton and Schopenhauer, your ancestor did not believe in a uniform, absolute time. He believed in an infinite series of times, in a growing, dizzying net of divergent, convergent and parallel times... We do not exist in the majority of these times; in some you exist, and not I... Time forks perpetually towards innumerable futures. In one of them I am your enemy.[25]

In Borges' story, we seem to have turned left into a Pythagorean wilderness of the 'unlimited' (this is the first term on the list of opposites that also contains 'left', 'bad', and 'dark'). Eventually the spy commits what appears to be a cold-blooded murder against a defenseless victim:

> I replied, 'but I am your friend. Could I see the letter again?' Albert rose. Standing tall, he opened the drawer of the tall desk; for the

moment his back was to me. I had readied the revolver. I fired with extreme caution. Albert fell uncomplainingly, immediately. I swear his death was instantaneous—a lightning stroke. The rest is unreal, insignificant.[26]

The killer is arrested and sent to the gallows, but when the Germans read in the English newspapers about the sinologist's murder by their spy (he is now named for the first and only time as Yu Tsun) they work out which city to bomb: 'I have won out abominably', Yu Tsun concludes. The story is a sort of Nietzchean updating of the 'Choice of Hercules', in which Yu Tsun is both hero and anti-hero: there is no either/or here. The left hand path takes us into an open-ended world that is somehow beyond morality.

We are never told whether Yu Tsun is left- or right-handed (presumably he can be both, depending on which 'future' he is in), but for right-handers, turning left is indeed more disorientating and 'unnatural' than turning right. During the course of a day, most people turn more in one direction than another, clockwise if they are right-handed, and anti-clockwise if they are left-handed.[27]

Not altogether surprisingly, Borges admired Lessing's remarks about the left hand of God, seeing it as a valid credo for any kind of intellectual endeavour. He discussed Lessing in an interview in 1981:

The important things are the ethical instinct and the intellectual instinct, are they not? The intellectual instinct is the one that makes us search while knowing that we are never going to find the answer. I think Lessing said that if God were to declare that in His right hand He had the truth and in his left hand He had the investigation of the truth, Lessing would ask God to open His left hand—he would want God to give him the investigation of the truth, not the truth itself. Of course he would want that, because the investigation permits infinite hypotheses, and the truth is only one, and that does not suit the intellect, because the intellect needs curiosity. In the past, I tried to believe in a personal God, but I do not think I try anymore. I remember in that respect an admirable expression of Bernard Shaw: 'God is in the making.'[28]

* * *

FROM THE 1950s, AS scientific and popular interest in brain lateralization increased, some artists grew interested in the distinct capabilities of their

two hands. The dubious notion of 'hemisphericity' became fashionable, which had it that most people use only one side of the brain for solving a problem—usually the 'computational' left side of the brain, which controls the movements of the right side of the body. With proper training, it was thought, the right side of the brain could be activated, thus helping us to solve problems in a more creative and relaxed way.[29]

The best known statement to this effect is by the sculptor Barbara Hepworth, and was recorded in *A Pictorial Autobiography* (1970): 'My left hand is my thinking hand. The right is only a motor hand. This holds the hammer. The left hand, the thinking hand, must be relaxed, sensitive. The rhythms of thought pass through the fingers and grip of this hand into the stone. It is also a listening hand. It listens for basic weaknesses or flaws in the stone; for the possibility or imminence of fractures'.[30] The statement accompanies a photograph from 1959 of Hepworth's hands, though the same thought presumably inspired her to make a cast of her left hand in the mid-1940s. There's no obvious left-right symbolism in Hepworth's work, but she may have seen a notional 'ambidextrousness' as underpinning her modernist ambition to make sculpture that is fully 'in the round', and that engages the whole of the sculptor's body.

Other (right-handed) artists drew simultaneously with their left and right hands.[31] From the mid-1960s, the German artist Dieter Roth made a series of drawings in which he first folded a large piece of paper in half, and then drew an 'identical' image on each half. In all he made several hundred of these *Two-Handed Speedy Drawings*, and many were made into prints. Some were 'self-portrait' skulls, while others were hybrid bodies combining male and female, animals and objects. The drawing technique was very schematic, and the 'skill' level of the right hand was only marginally higher than that of the left. Both sides were, from an academic viewpoint, primitive. It was as though, to cite Focillon, Roth's right hand 'forgets all its skill, to learn from the left an innocence that never outstrips form'. In 1970, the Italian artist Alighiero e Boetti made a filmed performance in which he wrote the date on a gallery wall with his right hand and, starting simultaneously from the same central point, wrote the mirror image of the same date with his left hand. As his hands stretched out further and further, control was lost, though more so in the left hand (hardly surprising since it had to do the mirror writing). More recently, the British artist Claude Heath made a series of two-handed

drawings of pot plants on two separate pieces of paper which he could not see because it was either placed horizontally under the table, or on the far side of an upright panel (2001).[32] Heath's automatist scrawls feel like a profound inversion—as though we were seeing a cross-section of the plants' roots. He may have been influenced by the major American purveyor of automatic writing, Cy Twombly. In the 1950s Twombly drew at night, with the lights out, and approached his canvases from oblique and contorted angles, explaining to a critic that 'fearing slickness, he drew as if with his left hand'.[33]

Roth and Boetti would probably have been aware of the then still fashionable French writer Paul Valéry (1871–1945), and his 1943 essay 'Some Simple Reflections on the Body'. For Valéry, the body was both alien and unknowable:

> The thing itself is formless: all we know of it by sight is the few mobile parts that are capable of coming within the conspicuous zone of the space which makes up this *My Body*, a strange, asymmetrical space in which distances are exceptional relations. I have no idea of the spatial relations between 'My Forehead' and 'My Foot', between 'My knee' and 'My Back'... This gives rise to strange discoveries. My right hand is generally unaware of my left. To take one hand in the other is to take hold of an object that is not-I. These oddities must play a part in sleep and, *if such things as dreams exist*, must provide them with infinite combinations.[34]

Just as Dalí's left-handed etching was a parody of Surrealist Automatism, the 'asymmetrical symmetry' and 'uneven even-handedness' of Boetti and Roth's drawings, can be regarded as a parody of the 'all-over' abstract mural described by Clement Greenberg in his essay *The Crisis of the Easel Picture* (1948):

> the 'decentralized', 'polyphonic' all-over picture which...repeats itself without strong variation from one end of the canvas to the other and dispenses, apparently, with beginning, middle, and ending... this sort of painting comes closest of all to decoration—to wallpaper patterns capable of being extended indefinitely... The 'all-over' may answer the feeling that all hierarchical distinctions have been, literally, exhausted and invalidated; that no area or order of experience is intrinsically superior, on any final scale of values, to any other area or order of experience. It may express a monist naturalism for which

374

there are neither first nor last things, and which recognizes as the only ultimate distinction that between the immediate and the un-immediate.[35]

Roth and Boetti imply through their technique that they are jettisoning the very last 'hierarchical distinction' that operates in modern art—that it should be made using a single 'dominant' hand. They imply that if Jackson Pollock had been true to himself and to his totalizing 'all-over' method ('I am nature', he claimed) he should have dripped paint from brushes held in both hands, rather than simply using his left hand to hold the can of paint. Roth's body and especially Boetti's body still stubbornly get in the way, and make the left hand more wayward than the right.

Art education was to be influenced by those popular psychology books which contain a table comparing the different functions of the two brain hemispheres. The best known example of this is Betty Edwards' drawing manual, *Drawing on the Right Side of the Brain* (first edition 1979), which urged the aspiring artist to unlock the right side of their brain, and teachers to develop 'thinking strategies suited to the right brain'.[36] The right brain (which controls the left hand) is 'the dreamer, the artificer, and the artist'.[37]

However, Edwards is in fact aesthetically conservative, firmly opposed to 'expressive gauchisme'. She doesn't advocate the method used by some art teachers who 'recommend that right-handers shift the pencil to the left hand', so that they can have 'more direct access to the R-mode'.[38] This is because 'the drawing is just more awkward. Awkwardness, I regret to say, is viewed by some art teachers as being more creative and interesting. I think this attitude does a disservice to the student and is demeaning to art itself. We do not view awkward language, for instance, or awkward science as being more creative and somehow better.'[39] There's an element of truth to what Edwards says—after all, the 'gauchist' works of Dalí, Roth, and Boetti are aesthetically slight, and do not rank with their finest achievements. But they remain important as symbols of an attitude and of an approach. The only contemporary style of which Edwards seems to approve is academic naturalism, which suggests she in fact has no time at all for dreamers or for automatism. She's an L-brainer in disguise.

One of the most dramatic 'left turns' in contemporary art has been accomplished by the American minimalist sculptor Richard Serra. His

labyrinthine sculptures made from huge panels of rusted steel, sometimes flat and sometimes curved and tilting, seem to slice through space. A recent series called *Torqued Ellipse* consisted of elliptical slabs of slightly twisted steel, anything up to 14 ft high, precariously balanced on the floor, with an opening through which the viewer could walk. The most disconcerting of all featured two torqued ellipses, one inside the other.

The critic David Sylvester asked Serra whether he had 'an instinct to go clockwise or counter-clockwise' when he first walked inside them. Serra replied that he 'started walking them naturally counter-clockwise', and Sylvester said he found himself 'walking counter-clockwise almost every time, and had to make a deliberate effort to go clockwise'.[40] Later on, Serra observed of *Double Torqued Ellipse II* (1998) that it is 'less destabilizing to walk the passage clockwise . . . I think it's a natural impulse to walk to the right'.[41] Thus his previously stated 'natural' impulse to walk left, in a counter-clockwise direction, must have been prompted by a very modern—and therefore *un*natural—desire to be destabilized:

> It's the most unsettling and unknowable of the three *Doubles*. Walking through its corridor . . . makes you feel uneasy, and entering the inner ellipse does not give you any relief. You're contained in a space that doesn't reveal itself readily, you still feel like you're caught up in the drama of how it is unfolding. You can't assimilate this *Double*. You never get rid of your vertigo. It's the most unstable.[42]

Or as Borges might have put it, the leftward, counter-clockwise journey 'permits infinite hypotheses'.

CODA

21. God Save the Queen

... in nine cases out of ten "it is the sitter's left side that possesses most charms.

Richard Penlake, *Home Portraiture for Amateur Photographers* (1899)[1]

I WANT TO CONCLUDE by briefly exploring some of the more traditional left-right distinctions that have continued to influence the creation and the reception of visual images, especially in relation to photography.

The most prevalent, perhaps, is the continued belief in the superior beauty and susceptibility of the left side. When Courbet's close-up crotch-shot *The Origin of the World* (1866), commissioned by a Turkish diplomat, was unveiled by the Musée D'Orsay in 1995 after its acquisition from the estate of the psychoanalyst Jacques Lacan, it was striking how many of the press photographers positioned themselves slightly to the right of the picture (that is, to the 'sitter's' left). This was made abundantly clear by those press photographs taken from further back which included the photographers, all of whom were male.

The photographers were in part taking their cue from the picture itself, for Courbet viewed the woman slightly from her left, and she tilts her torso over to her left (he even gave her sex a decided 'bend sinister'). Most of Courbet's depictions of solitary pretty women are viewed from the sitter's left, and his portrait from the same year of the red-headed Irish woman Joanna Hiffernan, *La Belle Irlandaise* (1866), who is often thought to be the model for *The Origin of the World*, shows her almost in left profile, with her left hand raised in the foreground to hold a mirror, while her right hand ruffles her abundant hair.

No doubt Courbet (and the photographers at the Musée D'Orsay) would have agreed with the observations made by Richard Penlake in *Home Portraiture for Amateur Photographers* (London 1899), though Courbet probably wouldn't have made the pseudo-scientific distinction between left- and right-handers:

> Every face has, artistically speaking, two sides and several views, and to select the best side we must judge of several features, and employ that side with the majority. It is a well-known fact that one side of the face is always better looking than the other. Usually it is the sitter's left side that possesses the most charms, unless he or she be a left-handed person, in which case their right side is usually the best. Do not, however, take this for granted, but try it, and in nine cases out of ten 'it is the sitter's left side that possesses most charms.[2]

* * *

PENLAKE IS RATHER TYPICAL of his profession in his attempt to give studio photography a quasi-scientific grounding. This is due both to the novelty and the commercialism of photography: professional photographers are keen to shore up their commodity with historical and theoretical ballast that will assure customers they are buying a reliably flattering product. Studio photographers have been concerned not just to exploit tradition but to identify archetypal modes that can be followed efficiently and without hesitation. Thus ever since the invention of photography, photographers have been only too keen to emulate and pastiche the Old Masters, and this is particularly so in relation to photographic portraits. As such, most portrait photographers have been moved to consider issues of left and right—and especially in relation to lighting.

The celebrity photographer Annie Leibovitz (b. 1949) recently made some fascinating portraits of a real Queen and a fictional Princess that in their lighting and composition exploited some archetypal left-right conventions. Her portrait photographs of Queen Elizabeth II of England, taken to mark her State Visit to the United States in May 2007 to honour the 400th anniversary of the founding of Jamestown, are classics of their kind—or brilliant clichés.[3] Leibovitz is known for her photographs of celebrities published since 1970 in magazines such as *Rolling Stone* and *Vanity Fair*, and she was the first American photographer to be invited

to take formal photographs of the Queen. Four photographs were taken and made available to the public.

Two of the photographs showed the Queen sitting next to a window in the White Drawing Room at Buckingham Palace. These are the most interesting because they were taken from different directions, with the cool March light falling onto her face from opposite sides. The two images are almost textbook examples of everything we have been saying about lighting conventions in Renaissance portraits.

The first image, in which the Queen sits directly in front of us in what (by Royal standards) is a modest chair, is a classic Zecharian image. This was the first and most important image released to the press. The Queen turns her head quite sharply to the right so that the right side of her face is brightly illuminated, while the left side is substantially cast in deep shadow. She looks towards a French window, both doors flung (unseasonally) wide open to reveal a stone balustrade on the balcony, and beyond that, the bare tree-tops in the Palace garden. The photograph was taken on an overcast day in March, but the reflection of the sky in the open glass door gives the light a brittle glacial intensity it would not otherwise have had.[4] The Queen is not in the centre of the composition, and the visible space to the Queen's right is far larger than that to her left. This gives a greater, and more epic sense of *distance* between the Queen and the object of sight. The picture is a symphony in silver-grey, enhanced by the Queen's white dress and ermine, and by her diamond-encrusted crown. A white (right) slipper peeks out from under the dress and this gives a slight but unmistakable sense of restlessness, as though she's keen to move towards the window.

Reviewing the picture, an art critic intriguingly compared the composition and the mood of this image to a well-known portrait in the National Gallery by Sir Thomas Lawrence of *Queen Charlotte* (1789), wife of King George III—who happens to have been the last Queen of America.[5] This Queen sits in a silvery-blue dress surmounted by a halo of white hair, and looks slightly to her right where a full-length open window gives a view of an autumnal landscape and of Windsor College Chapel (Queen Charlotte is seated in Windsor Castle). Queen Charlotte's listless and slightly melancholy appearance has usually been put down to the recent onset of King George III's madness (and to the potentially even more alarming onset of the French Revolution). Queen Elizabeth II also reputedly has 'reasons to brood in her late years', making the visual echo of Lawrence's portrait of her forebear

even more appropriate.[6] A major difference, however, is the even and bright illumination of Queen Charlotte's face—as had always been the case in Royal portraits, especially of Queens. Scarcely less than in the *Ditchley Portrait* of Queen Elizabeth I, shadows are relegated to the area behind the Queen.

The shadow-scarred face of Queen Elizabeth II in Leibovitz's portrait does have precursors, though the facial shadows are not of the same intensity. The *Diamond Jubilee Photograph* of the famously mournful Queen Victoria, taken in 1893 by the firm W. & D. Downey and issued in 1897, has a comparable mise-en-scene, with a seated Queen, head turned slightly to the right. The illumination is from an unseen window on the Queen's right, though the facial shadow on the left side of the head is lighter. The photograph was reproduced in Frances Diamond and Roger Taylor's *The Royal Family and Photography 1842–1910* (1987), where Liebovitz could have seen it.[7]

It seems that for Leibovitz, the head turned to the illuminated right side by a subject who is closer to the right edge of the picture signifies yearning. In an ongoing campaign for Walt Disney to promote their *Year of a Million Dreams* (it started in 2007 but has been extended into 2008), Leibovitz inserted various celebrities into Disney-style scenes. The first celebrity to be commissioned was Scarlett Johansson as Cinderella, and hers was the first portrait to be published in March 2007. Liebovitz explained that Cinderella was a favourite of her five year old daughter and so 'princesses had to be dealt with'. The resulting portrait paved the way for the Royal picture, which was released only two months later.

Johansson wears a flowing pale blue ballgown and a Harry Winston diamond tiara worth $325,000 ('she couldn't wait to put it on', says Leibovitz). She rushes down some steps to our right, and tilts her head up and to her right to glimpse for the last time the Royal castle (it's 'Cinderella's Castle' at Disneyworld), and the specially made Steiben glass slipper which she has accidentally left on a higher step. Both the castle and slipper are brilliantly lit by spotlights, which stroke the right side of Cinderella's face.

Our Princess and our Queen both seem to be yearning and dreaming of higher things—Cinderella yearns to leave her cleaning job and step up the social ladder into the arms of her Prince; Queen Elizabeth yearns to move beyond worldly cares—or as Dante would say, 'la sinistra cura'. The second idea is both sentimental and impertinent for it implies that

the reigning monarch and 'defender of the faith' yearns to abdicate her responsibilities, and has her thoughts on the beyond.

In Leibovitz's second seated image of Queen Elizabeth II, almost everything is reversed, including the mood. The Queen sits close by a window alcove (we do not actually see the window), and this time the window is on her left. The left side of her face is strongly lit, and the right side is in deep shadow. It verges on being 'hatchet' lighting, the technical term for side lighting that seems to split the face or subject in half. This photograph is far more immediate and grounded, with no sense of yearning—she is close to the light source. The Queen looks directly out at us, and the dark heavy folds of her black train roll far away to her right and towards us, keeping her earthbound, like an anchor. No slipper is visible: she is not going anywhere, she will not be moved. There is even the glimmer of a confident smile. This is a portrait about authoritative presence rather than about flaky absence.

Leibovitz is singularly uninteresting when she speaks or writes about her work—her introduction to *A Photographer's Life* (2006) largely consists of biographical trivia. All one can really say is that her Jewish background may have made her more aware than most of the left–right distinctions found in the Old Testament and in cabalistic commentaries on it. By the same token, one would not be altogether surprised if she had consulted *Light and Film* (1970), part of the Life Magazine Library of Photography, when she was learning her trade. Here, the Life photographer Henry Groskinsky made a series of six portrait photographs of a craggy, besuited middle-aged man holding a pipe. Each picture was taken with a single light from a different position. Four of these lights are on the sitter's right, and two on the left. Leibovitz did something similar in 1971 when she made a series of bust-length mug-shots of Daniel Ellsberg, who had leaked some compromising Pentagon papers relating to the Vietnam War (the effort to smear him eventually led to Watergate). Leibovitz made Ellsberg rotate in bright sunlight with a neutral wall as background, photographing him from the back as well as from the front.[8]

In *Light and Film*, we are informed that the light which is placed at 45 degrees above and to the right of the subject has 'long been the classic angle for portrait lighting, one that seems most natural for the majority of people'.[9] It's not in the least bit natural, but it certainly is classic, and in the more extreme form adopted by Leibovitz, is 'natural' only for those who have a dream. 'Hatchet' lighting from the left 'can

be useful in emphasizing rugged masculine features or in revealing the texture of skin or fabrics'.[10] Bruce Pinkard would expand on this last point in *Creative techniques in Studio Photography* (1979): a side light from the sitter's left 'has something of a heroic, optimistic mood, drawing form as well as texture. This is an excellent key light to use for single important subjects with strong form, or in masculine portraiture.'[11] The Queen certainly does look more heroic and optimistic in the second portrait, even if she is reduced in scale by occupying the middleground rather than the foreground: perhaps Leibovitz can't quite allow herself to let the Queen look as though she could reconquer America.

* * *

THROUGHOUT THIS BOOK, I have been arguing that left-right symbolism is a key that helps us to understand some of the greatest works of Western art. The fact that so many of the best artists found it a creative catalyst of great power and subtlety speaks, I think, for itself. By the same token, the totalizing nature of so much recent art and theory, and the glib rejection of all hierarchies in relation to the arts, may account for the bland and banal uniformity of so much of it.

I wouldn't argue that we can or must return to heraldic modes of vision, or indeed to dualistic social structures; or to the academic dualism of Annie Leibovitz's royal portraits. Indeed, the fact that Leibovitz deploys left-right symbolism in her portraits of female royals suggests it is a quaint archaicism only really useful when dealing with the Ancien Regime.

But by understanding the importance of left-right symbolism to the art of the past, we may yet develop new artforms that make bold and profound distinctions—distinctions that not only disturb, but also detain the viewer.

Notes

Introduction

1. Laurence Sterne, *Tristram Shandy*, ed. M. and J. New, London 2003, vol. 3, ch. 2, pp. 142–3.

2. J. J. Winckelmann, *History of the Art of Antiquity*, trans. H. F. Mallgrave, Los Angeles 2006, pt 1, ch. 4, p. 213.

3. My own previous books have explored these areas. *The World as Sculpture: the changing status of sculpture from the Renaissance to the present day*, London 1999, has two chapters (4 & 11) dealing with theories of touch in relation to sculpture; the title of *Michelangelo and the Reinvention of the Human Body*, London and New York 2005, speaks for itself.

4. T. Eagleton, *The Ideology of the Aesthetic*, Oxford 1990, p. 7. He is referring to 'new historicism'.

5. The few exceptions to this—or at least, the ones of which I am aware—are cited in the notes.

6. It is apparently easier to distinguish between top and bottom than right and left. R. Arnheim, *Art and Visual Perception*, London 1974, p. 33; C. McManus, *Right Hand, Left Hand: The Origins of Asymmetry in Brains, Bodies, Atoms and Cultures*, London 2002, pp. 66ff.

7. P. Gay, 'Introduction', in *Sigmund Freud and Art: His Personal Collection of Antiquities*, ed. L. Gamwell and R. Wells, London 1989, p. 16. See also G. Pollock, 'The Image in Psychoanalysis and the Archaeological Metaphor', in *Psychoanalysis and the Image*, ed. G. Pollock, Oxford 2006, pp. 1–29.

8. R. Ubl, 'There I am Next to Me', *Tate Etc.*, 9, Spring 2007, p. 32: 'In art historical literature on modern and contemporary art the hierarchy of verticals and horizontals and the orientation of an image

have long been examined, but study of the distinction between right and left has, by and large, been neglected'.

9. C. Greenberg, *The Collected Essays and Criticism*, ed. J. O'Brian, Chicago, 1993, vol. 4, pp. 80–1. The idea that an artwork should be taken in at a glance derives ultimately from Leonardo, but he was thinking primarily of small-scale works like portraits: *Leonardo on Painting*, ed. and trans. M. Kemp and M. Walker, New Haven 1989, pp. 22–32.

10. S. Schama, *Simon Schama's Power of Art*, London 2006, p. 6.

11. Madame Blavatsky, *The Secret Doctrine*, vol 3, London 1897, pp. 215–16 & 330, & passim.

12. R. Hertz, *Death and the Right Hand*, trans. R. and C. Needham, intro. E. E. Evans-Pritchard, London 1960. Most usefully read as R. Hertz, 'The Pre-eminence of the Right Hand', in *Right & Left: Essays on Dual Symbolic Classificiation*, ed. R. Needham, Chicago 1973, pp. 3–31. For Hertz, see C. McManus, *Right Hand, Left Hand*, op. cit., pp. 16ff. The journal *Laterality* is devoted to all things left and right.

13. R. Hertz, 'The Pre-eminence of the Right Hand', op. cit., p. 19.

14. R. Needham, 'Introduction', in *Right & Left*, op. cit., p. xii.

15. R. Hertz, 'The Pre-eminence of the Right Hand', op. cit., p. 12.

16. Ibid., pp. 18–19. He does not mention the Chinese, who regard the left as the honourable and male side, though their system as a whole is 'endlessly complicated'—for which reason I too do not discuss it: M. Granet, 'Right and Left in China', in *Right & Left*, op. cit., pp. 43–58.

17. C. McManus, *Right Hand, Left Hand*, op. cit., p. 35.

18. J. A. Laponce, *Left and Right: The Typography of Political Perceptions*, Toronto 1981, p. 43.

19. P-M. Bertrand, *Histoire des Gauchers*, Paris 2001, p. 119. J. Steele & S. Mays, 'Handedness and directional asymmetry in the long bones of the human upper limb', *International Journal of Osteoarchaeology*, vol. 5, no. 1, 1995, pp. 39–49.

20. C. de Tolnay, *Michelangelo*, vol. 5, New York 1960, p. 59. The same variation in the position of the hands appears in a later crucifixion drawing: C. de Tolnay, *Corpus dei Disegni di Michelangelo*, Novara 1975–80, vol. 5, no. 225. For an unconvincing but more interesting attempt to moralize the right and left sides of *David*, see C. de

Tolnay, *Michelangelo*, New York 1943, 1, pp. 95 & 155. He was inspired by J. Wilde: 'Eine Studie Michelangelos nach der Antike', in *Mitteilungen des Kunsthistorisches Institutes in Florenz*, IV, 1932, p. 57.

21. *Vita di Raffaello da Montelupo*, ed. R. Gatteschi, Florence 1998, pp. 120–1.

22. The earliest example occurs in Genesis 48: 13–20, when Jacob crosses his arms to bless his youngest son Ephraim who stands on this left: W. Stechow, 'Jacob Blessing the Sons of Joseph, from Early Christian Times to Rembrandt', *Gazette des Beaux-Arts*, no. 23, 1943, pp. 204ff.

23. U. Deitmaring, 'Die Bedeutung von Rechts und Links in Theologischen und literarischen Texten bis um 1200', in *Zeitschrift für deutsches Altertum und deutsche Literatur*, 98, 1969, pp. 265–92. Nigel Palmer kindly drew my attention to this fundamental essay. Deitmaring may have been influenced by Vilma Fritsch's relatively nuanced *Left and Right in Science and Life*, London 1968, which was first published in German in 1964.

24. N. Elias, *The Civilizing Process: The History of Manners*, vol 1, Oxford 1969, and *The Civilizing Process: State Formation and Civilization*, vol 2, Oxford 1982. It was first published in German in 1931.

1. Avoiding the Beer-Cellar: Left–Right Conventions

1. G. Cardano, *The Book of My Life*, trans. J. Stoner, New York 2002, p. 144. See *Collected Works of Erasmus*, trans and ed. R. A. B. Mynors, Toronto 1992, vol. 33, p. 209, 2:4:37, 'My Right Eye Twitches', for more examples from Pliny and Lucian.

2. S. Freud, *The Interpretation of Dreams*, trans. J. Strachey, Harmondsworth 1976, pp. 73–4. He subsequently realizes the 'beer-cellar' is based on a restaurant he had glimpsed on his left on the road in Padua that leads to Giotto's Arena Chapel.

3. Aristotle, *Metaphysics*, trans. H. Lawson-Tancred, London 2004, p. 20: A 5 986a. G. Lloyd: 'Right and Left in Greek Philosophy', in *Right & Left: Essays on Dual Symbolic Classificiation*, ed. R. Needham, Chicago 1973, p. 171 and p. 182 n. 15.

4. C. McManus, *Right Hand, Left Hand*, London 2002, p. 25.

5. Ibid., p. 213.

6. G. Lloyd: 'Right and Left in Greek Philosophy', op. cit., pp. 172–7.

7. PA 666b 6ff. Ibid., pp. 174–5.

8. M. Pastoreau, *Heraldry: Its Origins and Meanings*, London 1997, pp. 58–9. They were originally leopards.

9. This doesn't operate in the same way if two heraldic beasts are arranged laterally as a symmetrical pair.

10. *The Little Flowers of St Francis* (anon. 14th cent.) ed. Fr H. Mckay, London 1976, pp. 39–40.

11. J. Braun, *Die Reliquiare des Christlichen Kultes und ihre Entwicklung*, Freiburg 1940, pp. 388–411: of 28 arm reliquaries in the illustrated catalogue, only 2 (nos. 445 and 463) are left arms. *Suppellettili Ecclesiastica*, ed. B. Montevecchi and S. Vasco Rocca, Florence 1988, vol. 1, pp. 190–5.

12. Ptolemy, *Tetrabiblos*, trans. J. Wilson, London 1828, pp. 60–1, # 2:2. See also Ptolemy, *Tetrabiblos*, trans. F. E. Robbins, Cambridge Mass. 1940, pp. 124–5.

13. *Seeing the Face, Seeing the Soul: Polemon's Physiognomy from Classical Antiquity to Medieval Islam*, ed. S. Swain, Oxford 2007, p. 561, # 7. First published by Du Moulin in 1549.

14. C. McManus, *Right Hand, Left Hand*, op. cit., p. 292.

15. S. Coren, *The Left-Hander Syndrome: the Causes and Consequences of Left-Handedness*, London 1992, p. 33.

16. Plato, *Laws*, ed. R. G. Bury, Cambridge Mass. 1968, vol. 2, 794e. Cited by C. McManus, *Right Hand, Left Hand*, op. cit., p. 157.

17. 614c. f. G. Lloyd, 'Right and Left in Greek Philosophy', op. cit. p. 171.

18. See, for example, Giovanni Boccaccio, *Il Filocolo*, trans. D. Cheney, New York 1985, pp. 43 (bk. 1:39), 51–2 (bk. 2:7), p. 165 (bk. 3:20). See also his *De Casibus Virorum*.

19. J. Chelhod, 'A Contribution to the Problem of the Pre-eminence of the Right, based upon Arabic Evidence', in *Right & Left*, op. cit., p. 240.

20. C. McManus, *Right Hand, Left Hand*, op. cit., p. 32.

21. S. Battaglia, 'Mancino', in *Grande Dizionario della Lingua Italiana*, vol 9, Turin 1975, p. 71, no. 7. He cites (without full references) two examples from fifteenth- and sixteenth-century Venice.

22. Einhard and Notker the Stammerer, *Two Lives of Charlemagne*, trans. L. Thorpe, Harmondsworth 1969, pp. 95–6.

23. Ibid., p 85.

24. C. McManus, *Right Hand, Left Hand*, op. cit., pp. 60–4.

25. Ibid., pp. 21–3.

26. T. Klauser, *A Short History of the Western Liturgy*, Oxford 1979, pp. 143–4. Initially the façade was at the east end of the church; from the middle of the fourth C. it was switched to the west end. For left-right in relation to north, south, east and west, U. Deitmaring, 'Die Bedeutung von Rechts und Links in Theologischen und literarischen Texten bis um 1200', in *Zeitschrift für deutsches Altertum und deutsche Literatur*, 98, 1969, pp. 284–6. Circular world maps placed 'East'—and the Garden of Eden—at the top.

27. L. Gougaud, 'Eastward Position in Prayer', in *Devotional and Ascetic Practices in the Middle Ages*, London 1927, p. 45.

28. John Donne, *The Complete English Poems*, ed. A. J. Smith, Harmondsworth 1973, p. 144, ll. 180–1. The mandrake in 'The Progress of the Soul' thrusts out his right arm 'towards the east,/ Westward his left'. Ibid., p. 181, ll. 141–2.

29. S. Coren, *The Left-Hander Syndrome*, op. cit., p. 13.

30. I am grateful to Jennifer Montagu for this information.

31. C. Stewart: *Demons and the Devil: Moral Imagination in Modern Greek Culture*, Princeton 1991, p. 177.

32. W. Sorell, *The Story of the Human Hand*, London 1968, p. 116.

33. Letter ccxxiv, 2nd November 1769. *Lord Chesterfield's Letters to his Godson*, ed. Earl of Carnarvon, Oxford 1890, p. 296.

34. C. McManus, *Right Hand, Left Hand*, op. cit., p. 254.

35. Ibid., p. 235.

36. Ibid., p. 217.

37. Ibid., p. 87.

38. Ibid., p. 8.

39. C. Colbert, 'Each Little Hillock Hath a Tongue: Phrenology and the Art of Hiram Powers', *Art Bulletin*, June 1986, p. 298.

40. C. McManus, *Right Hand, Left Hand*, op. cit., pp. 10–13, 172ff.

41. Ibid., p. 194.

42. Ibid.

43. Ibid., p. 180.

44. J. Z. Young, cited by M. Corbalis and I. Beale, *The Psychology of left and Right*, Hillsdale 1976, p. 101.

45. D. Parfit, *Reasons and Persons*, Oxford 1984, p. 246. Cited in *The Mind*, ed. D. Robinson, Oxford 1998, p. 334.

46. C. McManus, *Right Hand, Left Hand*, op. cit., pp. 196–7.

2. Heraldic Images

1. *A Grammar of Signs: Bartolo da Sassoferrato's 'Tract on Insignia and Coats of Arms'*, ed. and trans. O. Cavallar, S. Degering and J. Kirsher, Berkeley 1994, p. 154. Cited by L. Campbell, 'Diptychs with Portraits' in *Essays in Context: Unfolding the Netherlandish Diptych*, ed. J. O. Hand and R. Spronk, New Haven 2006, p. 37.

2. For some Netherlandish exceptions, ibid., pp. 36ff. In the same collection, see also H. van der Velden, 'Diptych Altarpieces and the Principle of Dextrality', pp. 124–53.

3. *Mercanti Scrittori: Ricordi nella Firenze tra Medioevo e Rinascimento*, ed. V. Branca, Milan 1986, pp. 303–11. Cited by P. Rubin, *Images and Identity in Fifteenth-Century Florence*, New Haven 2007, pp. 181.

4. *Meditations on the Life of Christ* (*c.*1300) trans. I. Ragusa, Princeton 1961, p. 334.

5. L. M. Parsons, 'Imagined spatial transformations of one's hands and feet', *Cognitive Psychology* 1987, 19: pp. 178–241.

6. *The Early Kabbalah*, ed. J. Dan, trans. R. C. Kiener, New York 1986, p. 129.

7. C. McManus, *Right Hand, Left Hand: The Origins of Asymmetry in Brains, Bodies, Atoms and Cultures*, London 2002, pp. 192–3.

8. S. Settis, *Laocoonte: Fama e stile*, Rome 1999, p. 176.

9. Ibid., pp. 118–21. Winckelmann cites Sadoleto, but focuses entirely on Laocoon himself in his celebrated account in his *History of Ancient Art*.

10. M. Pastoreau, *Heraldry: Its Origins and Meanings*, London 1997, p. 25.

11. R. Arnheim, *Art and Visual Perception*, London 1974, pp. 35–6.

12. Ibid., p. 35.

13. H. Ziermann, *Matthias Grünewald*, Munich 2001, p. 93.

14. Ibid.

15. E. Bevan, *Holy Images*, London 1940, p. 126. See C. M. Chazelle, 'Pictures, Books and the Illiterate: Pope Gregory I's Letters to Serenus of Marseilles', *Word and Image*, vol. 6, no. 2, April–June 1990, pp. 138–53; ibid., 'Memory, Instruction, Worship: Gregory's Influence on Early Medieval Doctrines of the Artistic Image', in *Gregory the Great: A Symposium*, ed. J. C. Caradini, Notre Dame 1995, pp. 181–215; L. G. Duggan, 'Was Art Really the 'Book of

the Illiterate'?', in *Word and Image*, vol. 5, no. 3, July–September 1989, pp. 227–47.

16. M. Aronberg Lavin, *The Place of Narrative: Mural Decoration in Italian Churches, 431–1600*, London 1990, pp. 6–10 and passim. See also F. Deuchler, 'Le sens de la lecture: a propos du boustrophédon', in *Etudes d'Art Mediéval offertes à Lousi Grodecki*, Strasbourg 1981, pp. 250–8.

17. L. Bellosi, *Duccio: The Maestà*, London 1999.

18. Ibid., p. 22, for a plausible reconstruction with numbered panels so the order can be discerned.

19. For more on this, M. Schapiro, 'On Some Problems in the Semiotics of Visual Art: Field and Vehicle in Image-Signs', in *Simiolus*, vol. 6, no. 1, 1972–3, p. 13. The images in the sixth-century illuminated codex, the Vienna Genesis, start as left to right and return in the second register from right to left. For multiple 'reading' trajectories of Giotto's Arena Chapel in Padua, see J. Lubbock, *Storytelling in Christian Art from Giotto to Donatello*, New Haven 2006, pp. 39–83.

20. C. McManus, *Right Hand, Left Hand*, op. cit., pp. 236ff.

21. For scrolls, see M. Camille, 'Seeing and Reading: Some Visual Implications of Medieval Literacy and Illiteracy', *Art History*, vol. 8, no. 1, March 1985, pp. 26–49.

22. For a full description, R. Jones and N. Penny, *Raphael*, New Haven 1983, p. 56.

23. *A Grammar of Signs: Bartolo da Sassoferrato's 'Tract on Insignia and Coat of Arms'*, op. cit., p. 154.

24. M. Camille, 'Seeing and Reading', op. cit., p. 30.

25. It may initially have been painted for San Lorenzo, Florence. See *Fra Angelico*, exh. cat. L. Kanter and P. Palladino, Metropolitan Museum of Art, New York, 2005, pp. 81–3.

26. For reversed inscriptions in medieval art, M. Schapiro, *Romanesque Art*, London 1977, pp. 160 & 259–60, n. 75.

27. Cited in *Dictionnaire d'Archéologie Chrétienne et de Liturgie*, vol. 6, Paris 1924, col. 664, 'Gauche'. In the entry for 'Droit', in Ibid., vol 4, Paris 1921, col. 1549, we learn that 'first of all left and right were judged in relation to Christ, later in relation to the spectator'. No reasons or dates are given.

28. G. Ciampini, *Vetera Monimenta*, vol 1, Rome 1690, p. 203.

29. As far as I know, no study has been made of the history of the use of this terminology. The beginnings of the 'change-over' can be discerned in Poussin's description of his painting *The Israelites Gathering Manna* in a letter of 1639 to his patron Chantelou: 'if you look at the picture as a whole, I think you will have no difficulty in recognizing those people who are starving, those who are full of wonder or compassion, those displaying charity, those manifesting desperate need or ravenously eating, those consoling others, for you will find everything I have just described in the first seven figures starting from the [viewer's] left, the rest being in similar vein: read the story and picture thoroughly to see if each detail is appropriate to the subject.' A. Mérot, *Poussin*, London 1990, p. 310. However, the picture itself is articulated heraldically, with those to the right of the central figure of Moses (including the people mentioned by Poussin) being more dignified and uplifting than those to his left, who scrabble around looking for food.

30. M. Schapiro, *Romanesque Art*, op. cit., n. 215 pp. 98–100. The issue is discussed in Molanus, *De Picturis et Imaginibus Sacris*, Louvain 1570, bk. 3 #9: *Traité des Saintes Images*, trans. F. Boesflug, O. Christin, and B. Tassel, Paris 1996, pp. 398–401.

31. G. Ciampini, *Vetera Monimenta*, vol. 2, Rome 1699, p. 162.

32. R. W. Lee, *Ut Pictura Poesis: The Humanistic Theory of Painting*, New York 1967; J. Hagstrum, *The Sister Arts: The Tradition of Literary Pictorialism and English Poetry from Dryden to Gray*, Chicago 1958; for sculpture and language, see J. Hall, *The World as Sculpture: the Changing Status of Sculpture from the Renaissance to the Present Day*, London 1999, ch. 5.

33. S. H. Monk, *The Sublime*, Ann Arbor 1960.

34. Diderot is the most famous, above all for his description's of Vernet's landscapes: *Diderot on Art II: the Salon of 1767*, trans. J. Goodman, New Haven 1995, pp. 86–123. R. Wrigley, *The Origins of French Art Criticism*, Oxford 1993, p. 300 n. 71, gives more examples and says it was a 'commonplace of criticism'. The popularity of the Pygmalion myth in the period is a comparable phenomenon.

35. M. Craske, *The Silent Rhetoric of the Body: A History of Monumental Sculpture and Commemorative Art in England 1720–1770*, New Haven 2007, p. 80, and ch. 2 'The Decline of Heraldry'.

3. Fair Game

1. *Nicene and Post-Nicene Fathers: Sulpitius Severus, Vincent of Lerins, John Cassian*, Second Series vol. 2, ed. P. Schaff, Peabody Mass., 1995, p. 356, pt. 1, ch. x.

2. *The Life of Saint Teresa of Avila By Herself*, trans J. M. Cohen, Harmondsworth, 1957, p. 222, ch. 31.

3. One could also cite the antique statue of the *Dying Gladiator*, who has a fatal wound in his right side and seems intensely noble.

4. *Hypnerotomachia Poliphili*, trans. J. Godwin, London 1999, pp. 71–2.

5. *Secretum Secretorum: Nine English Versions*, ed. M. A. Manzalaoui, Oxford 1977, vol 1, p. 53, 'Of the maner and wise of slepyng'. It was popular into the eighteenth century and beyond.

6. *Tiziano*, exh. cat. Palazzo Ducale Venice 1990, no. 40, pp. 267–9. Titian later painted the *Venus and Adonis* for King Philip, and he wrote explaining that he depicted Venus from the back to contrast with the more frontal image of Danae, with which it was to be displayed. But in that picture Venus' left side is most exposed to the viewer, while her right side is clamped unavailingly to Adonis' resistant right side. Note also the suggestive vulva-like slit in the left arm of the woman's dress in Titian's *Woman with a Fur Wrap* (*c.*1535). I am not convinced by Rona Goffen's argument that the orientation of Titian's reclining nudes is determined by the medical belief that women hoping to conceive a male should turn onto their right side during or immediately after intercourse: 'Sex, Space and Social History', in *Titian's 'Venus of Urbino'*, ed. R. Goffen, Cambridge 1997, p. 78.

7. Quoted by D. Rosand, 'So-And So Reclining on her Couch', in ibid., p. 38.

8. S. Wilson, *The Magical Universe: Everyday Ritual and Magic in Pre-Modern Europe*, London 2000, p. 422.

9. Ptolemy, *Tetrabiblos*, trans. F. E. Robbins, Cambridge Mass. 1940, pp. 155, #3:17; p. 321, #3:12.

10. A. G. Clarke, 'Metoposcopy: An Art to Find the Mind's Construction in the Forehead', in *Astrology, Science and Society: Historical Essays*, ed. P. Curry, Woodbridge 1987, p. 181. Girolamo Cardano, *Lettura della Fronte: Metoposcopia*, ed. A. Arecchi, Milan 1994, p. 27.

11. *Collected Works of Erasmus*, trans. and ed. R. A. B. Mynors, Toronto 1992, vol 33., p. 209: ii.iv.37.

12. Bernardino da Siena, *Prediche Volgari sul Campo di Siena 1427*, ed. C. Delcorno, Milan 1989, vol I, pp. 127–8 & 130.

13. L'Abbé Banier and le Masiner, *L'Histoire Générale des Cérémonies et Coutumes Religieuses de Tous les Peuples du Monde*, Paris 1741, vol I, pt 2, ch vii, 'Des Vêtements': p. 89 # x, p. 103 # iv, p. 104 fig. 3.

14. *Nicene and Post-Nicene Fathers*, op. cit., pp. 193–7.

15. Ibid., pp. 356–7. Ambidextrousness was not always respected. In Giovan Battista della Porta's treatise *On Human Physiognomy* (1601), which is a summation of traditional ideas on the subject, the ambidextrous are said to be 'even worse than those who only use their left hand'. Ismael Sofi, an ambidextrous King of Persia, was 'ardent in his cruelty' and 'lustful'. G. B. della Porta: *Della Fisionomia dell'Uomo*, M. Cicognani (ed.), Parma 1988, ch. 39, p. 291.

16. Migne, *Patrolinea Latina*, vol. clxxxiii, cols 205ff; see also *Meditations on the Life of Christ*, trans. I Ragusa and R B Green, Princeton 1961, # xxxvi, p 216–7, where the passage is quoted. This immensely popular thirteenth-century 'biography' gave St Bernard's writings a very wide diffusion.

17. Bernardino da Siena, *Prediche Volgari*, op. cit., vol. I, pp. 127–8 & 130.

18. N. Largier, *In Praise of the Whip: A Cultural History of Arousal*, trans. G. Harman, New York 2007, p. 79: L. Gougaud, 'The Discipline as an Instrument of Penance', in *Devotional and Ascetic Practices in the Middle Ages*, London 1927, pp. 179–204.

19. Henry Suso, *The Life of the Servant*, trans. J. M. Clark, London 1952, ch. 23, p. 70–1. Two of Fra Angelico's frescoes of the *Crucifixion* in San Marco, Florence, show kneeling flagellants beating their left side, as does St Dominic as he kneels to the left of Christ, tied to the column for his own flagellation.

20. Ibid., pp. 49–50, ch. 16.

21. *The Quest for the Holy Grail*, trans. P. M. Matarasso, London 2005, pp. 129–30.

22. *The Etymologies of Isidore of Seville*, trans. S. A. Barney et al., Cambridge 2006, p. 238, XL.i.118.

23. Gertrude d'Helfta, *Oeuvres Spirituelles*, vol. 2, ed. & trans. P Doyère, Paris 1968, pp. 66–7.

24. Ibid., p. 279.

25. Ibid., vol. 3, ed. & trans. P Doyère, Paris 1968, pp. 18–19. Christ's punitive action partially recalls that of the Sabine warriors in relation

to Tarpeia. In return for betraying Rome, Tarpeia demands the golden bracelets they wear on their left arms, but when she asks for *the things they wore on their left arms*, they throw their shields as well as their bracelets at her, thus crushing her: Plutarch, *Life of Romulus*, xvii.

26. Gertrude d'Helfta, *Oeuvres Spirituelles*, vol. 3, op. cit., pp. 313–19.

27. E. J. Sargeant, 'The Sacred Heart: Christian Symbolism', in *The Heart*, ed. J. Peto, New Haven 2007, pp. 109–10.

28. S. Settis, *Laocoonte: Fama e stile*, Rome 1999; F. Haskell and N. Penny, *Taste and the Antique*, New Haven 1981, pp. 172–3, no. 18; J. Hall, 'Agony and Ecstasy', *Art Quarterly*, Summer 2006, pp. 44–7; *Towards a New Laocoon*, exh. cat., Henry Moore Institute, Leeds, 2007.

29. S. Settis, *Laocoonte*: op. cit., pp. 192–3.

30. Ibid., figs. 54–8.

31. Ibid, p. 201.

32. Cesare Ripa, *Iconologia*, ed. P. Buscaroli, Milan 1992, p. 106.

33. Ibid.

34. Ibid., p. 201.

35. Ibid., p. 373.

36. *The Zohar*, trans. and ed. D. C. Matt, Stanford 2004, vol 1, pp. 288–9.

37. Cesare Ripa, *Iconologia*, op. cit., p. 14.

38. N. Boothman, *How to Make People Like You in 90 Seconds or Less*, New York 2000, p. 14.

39. H. Wine, *National Gallery Catalogues: The Seventeenth Century French Paintings*, London 2001, pp. 324–33.

40. T. J. Clark, *The Sight of Death*, New Haven 2006, p. 166 (cites Laocoon).

41. Cesare Ripa, *Iconologia*, op. cit., p. 263.

42. In *Landscape with Orpheus and Eurydice* (*c.*1650), the deed is already done and Eurydice twists round to her right to see the snake slithering away. She is supposed to have trodden on the snake. Whether the snake attacked from her right or was concealed in the knocked over flower basket that is to her left, is unclear. The position of the snake's tail suggests it was slightly to her left.

43. H. Wölfflin, 'Über Das Rechts und Links Im Bilde', in *Gedanken Zur Kunstgeschichte*, Basel 1940, pp. 82–90.

44. This is my revised version of a translation made by Johanna Friederike Breyer for Daniel Chandler.

45. M. Fried, *Absorption and Theatricality: Painting and Beholder in the Age of Diderot*, Berkeley 1980. Fried does not mention left-right distinctions in this stimulating but ultimately unconvincing book, though he does discuss 'left-handed' self-portraits in a later book on Manet.

46. G. van der Osten, *Hans Baldung Grien*, Berlin 1983, Nos. 1, 10, 24, 44, 48, 54, 87b, 90, 93, 109.

47. Pierre de Ronsard, *Amours*, 1:56. Cited by P-J. Bertrand, *L'Histoire des Gauchers*, Paris 2001, p. 31.

48. Marsilio Ficino, *The Book of Life*, trans. C. Boer, Irving 1980, p. 57, bk. 2, ch. 11.

49. In Holbein's great 'Dance of death' series, *Les Simulachres & histoires faces de la mort* (Lyon 1538), nearly two-thirds of the images show death positioned on the victim's left, and these are usually the ones that are reproduced: O. Bätschmann and P. Griener, *Hans Holbein*, London 1997, pp. 56–9.

50. *The Etymologies of Isidore of Seville*, trans. S. A. Barney et al., Cambridge 2006, xl: I: 68, p. 235.

51. The fact that woman in Degas's *Interior (The Rape)* (c.1868–9) exposes her left shoulder contributes enormously to our confusion about her status. It has been called Degas's 'most baffling work': *Degas*, exh. cat., Metropolitan Museum New York 1988–9, pp. 143–6, no. 84. It was reproduced in the standard books on Degas, so Wölfflin might have known it.

52. N. Powell, *Fuseli: The Nightmare*, London 1973, fig. 7 for the second version. *Gothic Nightmares: Fuseli, Blake and the Romantic Imagination*, ed. M. Myron, exh. cat. Tate Britain 2006, cat. no. 1.

53. C. Frayling, 'Fuseli's The Nightmare: Somewhere between the Sublime and Ridiculous', in ibid., p. 12.

54. A term coined by J. Berger, *Ways of Seeing*, London 1972, p. 61.

55. S. Freud, *The Interpretation of Dreams*, trans. J. Strachey, Harmondsworth 1976, p. 475. W. Stekel, *Die Sprache des Traumes* (1911), Wiesbaden 2nd edn. 1922, pp. 79–88, ch. 10, 'Rechts und Links im Traume'. Panofsky's study of the Choice of Hercules may also have been prompted by such cultural phenomena: E. Panofsky, *Hercules am Scheidewege* (Leipzig 1930).

56. W. Wolff, *The Expression of Personality: Experimental Depth Psychology*, New York 1943, p. 39, says that combined photographs were first used by Hallervorden in 1912.

57. Benton, quoted by C. McManus, *Right Hand, Left Hand*, London 2002, pp. 327–8.

58. W. Wolff: *The Expression of Personality*, op. cit., p. 154. W. Sorrell, *The Story of the Human Hand*, London 1968, p. 119. It is now thought that the right side of the face 'seems to resemble the whole face more only because of its visual-field position': in other words, because the right brain hemisphere does the visualizing, and operates the left side of the body, it pays more attention to the left side of the visual field. C. Gilbert and P. Bakan, 'Visual Asymmetry in Perception of Faces', *Neuropsychologia*, vol. 11, 1973, pp. 355–62. But could this not be because an attack from our left side, where the right hand of an enemy who faces us is located, is probably more dangerous than an attack from our right, so we have to pay more attention to what goes on there?

59. T-C Sim and C. Martinez, 'Emotion Words are Remembered Better in the Left Ear', *Laterality*, vol 10, no. 2, March 2005, pp. 149–59.

4. Sun and Moon

1. C. Ripa, *Iconologia* (Rome 1603), ed. P. Buscaroli, Milan 1992, p. 54.

2. E. H. Gombrich, *Art and Illusion*, Oxford 1977, p. 229. In his notes, Gombrich cites the perceptual psychologists Metzger and and J. J. Gibson.

3. Cennino Cennini, *The Craftsman's Handbook*, trans. D. V. Thompson, New York 1960, ch. 8, p. 5. Nicholas Hilliard, *A Treatise Concerning the Arte of Limning*, ed. R. K. R. Thornton and T. G. S. Cain, Manchester 1981, p. 70 concurs: 'You must there fore, chose a light or make one, falling from above, that is from a high window, the light descending upon your left hand, and falling towards the right, with soft and gentle shades, and not with hard and strong bright reflexions.' In his paintings, Hilliard eschews shadow, so it is likely he is here talking about the ideal illumination in the artist's studio when a life drawing is translated into a painted image.

4. P. Hills, *The Light of Early Italian Painting*, New Haven 1987, p. 123.

5. Cennino Cennini, *The Craftsman's Handbook*, op. cit., ch. 8, p. 6.

6. T. da Costa Kaufmann, 'The Perspective of Shadows: the History of the Theory of Shadow Projection', in *Journal of the Warburg and Courtauld Institutes*, 38, 1975, p. 260, points to some of the contraditions in Cellini's passage: during the course of the day the window through which the 'dominant lighting' falls may change, as well as its angle and its intensity.

7. C. Gould, 'On the Direction of Light in Italian Renaissance Frescoes and Altarpieces', *Gazette des Beaux-Arts*, xcvii, 1981, pp. 21–5; P. Humfrey, *The Altarpiece in Renaissance Venice*, New Haven 1993, pp. 53–5. Both give a range of other solutions devised by Italian artists in frescoes and altarpieces.

8. F. Ames-Lewis, *Drawing in Early Renaissance Italy*, New Haven 2000, pp. 20–1, fig. 9.

9. P. Rubin, *Giorgio Vasari: Art and History*, New Haven 1995, p. 140, fig. 95.

10. In Vasari's convivial 'portrait' of *Six Tuscan Poets*, the light comes from the sitters' left, which gives it a heightened immediacy. For his own more hieratic *Self-Portrait*, light comes from the sitter's right.

11. *Italian Paintings of the Fifteenth Century*, National Gallery of Art, Washington DC 2003, Miklos Boskovits et al, pp. 230–5, with full bibliography. Most but by no means all high altars were illuminated from the right (i.e. the south). See P. Humfrey, *The Altarpiece in Renaissance Venice*, op. cit., p. 55.

12. There was a revival of interest in the late nineteenth century—something to which we will return in the final section.

13. *Scritti d'Arte del Cinquecento*, ed. P. Barocchi, Milan-Naples 1973, vol 2, pp. 1259ff.

14. Vitruvius, *The Ten Books on Architecture*, trans. M. H. Morgan, New York 1960. Morgan translates 'astrologiam' as astronomy, which is misleading.

15. Leon Battista Alberti, *On the Art of Building in Ten Books*, trans. J. Rykwert, N. Leach, R. Tavernor, Cambridge Mass. 1988, bk. 9, p. 317. I have slightly adapted the translation.

16. A. Grafton, *Leon Battista Alberti*, London 2000, pp. 20, 77, 80.

17. The idea that the artist is a prophet or augur should make us skeptical about reading off the age of a sitter from their portrait—they may be depicted at an ideal age, whether older than they actually are (Leonardo da Vinci's proposed self-portrait drawings) or younger than they are (many female portraits).

18. Leon Battista Alberti, *On the Art of Building*, op. cit., p. 257.

19. R. and M. Wittkower, *Born under Saturn*, New York 1969, pp. 102ff.

20. Ascanio Condivi, *The Life of Michelangelo*, trans. A. S. Wohl, University Park 1999, p. 6.

21. M. Hirst in A. Condivi, *Vita di Michelagnolo Buonarroti*, ed. G. Nencioni, Florence 1998, p. xix, n. 46.

22. Manilius, *Astronomica*, trans. G. P. Gould, Cambridge Mass. 1977, 2:150–54 & 453ff.

23. Ptolemy, *Tetrabiblos*, trans. F. E. Robbins, Cambridge Mass. 1940, pp. 319–21.

24. A more even-handed approach to the problem is found in an astrological treatise copied down in the second century AD: 'The face is the miracle of the human form and the whole head is like the tabernacle of the Sun and Moon. The Sun is responsible for the faculty of knowledge, and the Moon is concerned with mutability and with sensible impressions... And just as one still recognizes the face of a man through the changes and varied experiences that he undergoes, so one still recognizes the Moon through its changes of colour, illumination, and emanation...' J. Garrett Winter, *Papyri in the University of Michigan Collection*, Ann Arbor 1943, vol 3, no. 149, pp. 67, 108–9. Quoted by G. Bezza, *Arcana Mundi: Antologia del Pensiero Astrologico Antico*, vol. 2, Milan 1995, p. 681.

25. A. Bouché-Leclerq, *L'Astrologie Grecque*, Paris 1899, pp. 321–3.

26. Op. cit., p. 322 n. 3. In the Persian creation myth, the first man is created in the likeness of the universe and 'his two eyes are like sun and moon': F. Saxl, *Lectures*, London 1957, vol 1, p. 58. In the Chinese and Japanese creation myths relating to Pangu and Izanagi, the left eye is the domain of the sun, the right of the moon.

27. S. L. Montgomery, *The Moon and the Western Imagination*, Tucson 1999, pp. 50 & 65.

28. J. Reil, *Die Frühchristlichen Darstellungen der Kreuzigung Christi*, Leipzig 1904; G. Gurewich, 'Observations on the Wound in Christ's Side, with Special reference to its Position', in *Journal of the Warburg and Courtauld Institutes*, 20, 1957, pp. 358–62; *Picturing the Bible: The Earliest Christian Art*, exh. cat. J. Spier et al., Kimbell Art Museum, Fort Worth 2007, pp. 227–32 (F. Harley).

29. 'Epistle to the Ephesians', in *Early Christian Writings: The Apostolic Fathers*, trans. M. Staniforth, Harmondsworth 1968, p. 81.

30. *Perceforest*, ed. G. Roussineau, Geneva 1987, pt 4, vol. 1, #xxvi, p. 559. It was first printed in 1528.

31. Henry Cornelius Agrippa, *The Books of Occult Philosophy*, London 1987 bk I, chs 22 & 23, pp. 48–53.

32. Gian Paolo Lomazzo, *Scritti sulle arti*, ed. R. P. Ciardi, Florence 1974, 2: p. 383.

33. Henry Cornelius Agrippa, *The Books of Occult Philosophy*, op. cit., pp. 50 & 54–5.

34. Giambattista della Porta, *Della Celeste Fisionomia*, Livorno 1991, p. 312.

35. *Scritti d'Arte di Federico Zuccari*, ed. D. Heikamp, Florence 1961, p. 228 (p. 8 in the original treatise): 'Se il Sole, & la Luna, ecco gl'occhi'.

36. A. Bouché-Leclercq, *Histoire de la Divination dans L'Antiquité*, Paris 1882, vol. 4, pp. 20–3; F. Guillaumont, 'Laeva prospera: Remarques sur la droite et la gauche dans la divination romaine', in *D'Héraklès à Poseidon: Mythologie et protohistoire*, ed. R. Bloch, Geneva 1985, pp. 157–99.

37. L. Campbell, *The Fifteenth Century Netherlandish Schools*, London 1998, pp. 174–211.

38. Ibid., p. 201.

39. Ibid., p. 200.

40. E. Panofsky, *Early Netherlandish Painting*, New York 1971, vol. 1, pp. 147–8: 'The strongest of these symbolical laws...was the positive nature of the right and the negative nature of the left. The ray of divine illumination must strike the person blessed with this illumination from his or her right; and such is the case, for example, in Jan van Eyck's "Annunciation" in Washington, where a distinction is made between the ray divine that comes from the Virgin's right and the natural light that comes from her left.' See also pp. 416–17, n. 2.

41. L. Campbell, *The Fifteenth Century Netherlandish Schools*, op. cit., p. 200.

42. This characterization has recently been challenged by E. Pilliod, *Pontormo, Bronzino, Allori: a Genealogy of Florentine Art*, New Haven 2001.

43. Ibid., p. 11.

44. J. Welu, 'Vermeer's Astronomer: Observations on an Open Book', *Art Bulletin*, June 1986, lxviii, 2, p. 263.

45. *Johannes Vermeer*, A. Wheelock et al., exh. cat. National Gallery of Art, Washington and Mauritshuis, The Hague, 1995, p. 170. After an observation by J. Welu, 'Vermeer's Astronomer: Observations on an Open Book', op. cit., p. 264.

46. It may be an attempt to visualize the Aristotelian contention that heaven is only an animal of the higher kind and that it therefore has a right and a left side: the east is the right half of Heaven and the west the left half.

47. K. Thomas, *Religion and the Decline of Magic*, Harmondsworth 1973, p. 323.

48. Most of the pictures of Orazio Gentileschi (1563–1639) are lit from the protagonist's left. There is no indication that he was a left-handed artist. The most likely reason is that he specialized in women and in female-centred subjects—*The Lute-Player*, *The Finding of Moses* etc. *David with the Head of Goliath* is also lit from the left, but David seems unusually sensitive. The more rugged *St Francis held by an Angel* is lit from the right: he has just received the stigmata.

49. S. Foister, *Holbein and England*, New Haven 2004, p. 174.

50. Ibid., pp. 206–14.

51. D. MacCulloch, 'Review of Holbein Exhibition', *Times Literary Supplement*, October 27 2006, p. 7.

52. S. Foister, *Holbein and England*, op. cit., p. 210.

53. Ibid., p. 208.

54. *The Winter's Tale*, ed. J. H. P. Pafford, London 1966, p lxxxviii: 'a modern interpretation...of the description of Paulina with, simultaneously, "one eye declined" and "another elevated" could easily treat the account as ludicrous and might even lead to jocular comment on Paulina's ocular gymnastics. But this would be wrong interpretation of a phrase which simply meant "with a mixture of grief and happiness". '

5. Darkened Eyes

1. Henry Suso, *The Life of the Servant*, trans. J. M. Clark, London 1952, p. 105.

2. The poem continues: 'Some search the Corpses of all Philosophie, / And ev'ry Nerve and Veyne so scribble on, / That where it should be Truths Anatomie, / They make it Errors rightest Skeleton.' ll. 137–44.

3. *The Anchor Bible: Zecharaiah 9–14*, ed. and trans. C. L. Meyers and E. M. Meyers, New York 1993, p. 26: 'It is within this period [515–445 BC], particularly towards its end, that we assign the collection of oracles and utterances that constitute Zechariah 9–14.' Ibid., p. 53 for suggested dates.

4. Ibid., p. 52.

5. See the examples cited in A. Solignac, 'Oculus (Animae, Cordis, Mentis)', in *Dictionnaire de Spiritualité Ascetique et Mystique*, vol. 11, Paris 1982, cols: 591–601; G. Schleusener-Eichholz, 'Auge', in *Lexicon des Mittelalters*, vol. 1, Lief 6, 1979, cols. 1027–1209; P. Rousselot, 'Les yeux de la foi', *Recherche de Science Religieuse*, vol. 1, Paris 1910, pp. 241–9 & 444–75.

6. R. Newhauser, 'Nature's Moral Eye: Peter of Limoges' in *Man and Nature in the Middle Ages*, ed. S. J. Ridyard and R. G. Benson, Sewanee TN 1995, pp. 125–36.

7. P. Lacepiera, *Libro de locchio morale e spirituale vulgare*, Venice 1496, n.p., ch. vii, 'De lo ammaestramento spirituale secondo dodici proporieta trovate nel occhio corporale: Seconda proprieta del occhio'. Zechariah xi is again cited in ch. viii: 'Quarta differentia del occhio dela accidia'.

8. Gertrude d'Helfta, *Oeuvres Spirituelles*, vol. 3, ed. & trans. P Doyère, Paris 1968, pp. 18–19.

9. Cambridge University Library MS Gg. 1.1, fol. 490v. P. Jones in P. Binski and S. Panayotova, *The Cambridge Illuminations*, London 2005, pp. 298–9 and no. 151, pp. 315–16; *The Medieval Craft of Memory: An Anthology of Texts and Pictures*, ed. M. Carruthers and J. M. Ziolkowski, Pennsylvania 2003, pp. 120–3; E. Clark and K. Dewhurst, *An Illustrated History of Brain Function*, London 1972, p. 29 fig. 39. The contents are listed in *M.R.James' Description of Cambridge University Library Gg. 1. 1*, available from the library.

10. M. R. James.

11. P. Jones, in *The Cambridge Illuminations*, op. cit., pp. 315–16.

12. E. Clark and K. Dewhurst, *An Illustrated History of Brain Function*, op. cit., pp. 20–1, figs. 23 and 24.

13. *Fergusson's Scottish Proverbs*, ed. E. Beveridge, Edinburgh 1924, p. 56. It is first noted in the early sixteenth century but probably long predates it: fickle Fortune in Chaucer's *Book of the Duchess* is 'ever laughynge / With oon eye, and that other wepynge'. ll. 632–4. 'To

cry (look down) with one eye and laugh (look up) with the other'
is in proverbial use at least since 1520—M. P. Tilley, *A Dictionary of
Proverbs in England in the Sixteenth and Seventeenth Centuries*, London
1950, E248. It is apparently widespread and was in use in the
nineteenth century—'en pleurant d'un oeil pour le passé et en riant
de l'autre pour le present', E. Souvestre, *Le Foyer Breton*, Paris 1864,
I: 178.

14. Obituary of Baron Guy de Rothschild, *The Independent*, Monday
18 June 2007, p. 34.

15. On the reverse of the self-portrait Dürer drew a *Holy Family*, and it
is interesting to note that later in his treatise, Peter of Limoges tells
a tale of a monk who prays for the Virgin to appear before him, and
who uses his hand to open and close his eyes: P. Lacepiera, *Libro de
locchio morale e sirituale vulgare*, Venice 1496, ch. xiiii. She sends an
angel to inform him that she will visit him, but if he sees her, his
eyes will be blinded by her beauty. He agrees, but then decides to
cover one eye, so that he does not go completely blind. However,
her beauty is such that he uses the hand that is covering one eye
to open the other eye even wider. He loses the sight in that eye,
but prays to see the Virgin again, even if it means losing the sight in
the other eye. She reappears, but rewards his devotion by restoring
his blind eye. In the self-portrait on the same sheet of paper Dürer
is too haunted, and even wary, for him to be having a comparable
vision of the Virgin, but his troubled state of mind strongly suggests
he is here concerned with the moral implications of vision.

16. D. Morris et al., *Gestures: their Origins and Distribution*, London
1979, pp. 69–78. For its depiction in Dutch art, W. Franits, *Dutch
Seventeenth Century Genre Painting*, New Haven 2004, pp. 194 & 292
n. 35.

17. The woodcut is reproduced in M. Baxandall, *Painting and Experience
in Fifteenth Century Italy*, Oxford 1972, p. 103, fig. 58, but Baxandall
does not discuss it, or left-right symbolism.

18. D. Ekserdjian, *Parmigianino*, New Haven 2006, pp. 82–7.

19. G. C. Garfagnini, 'Savonarola e l'uso della Stampa', in *Girolamo
Savonarola: L'Uomo e il Frate*, Spoleto 1999, p. 324.

20. Girolamo Savonarola, *Prediche Sopra Amos e Zaccaria*, ed. P. Ghilieri,
vol. 3, Rome 1972, no. 48, pp. 396–401.

21. Girolamo Savonarola, *Prediche Sopra Ruth e Michea*, ed. V. Romano,
vol. 1, Rome 1962, pp. 91ff., esp. 99–100. The first edition was

published in Florence in *c*.1499, and there were successive Venetian editions in 1505, 1513, 1520, 1539, and 1540.

22. G. Lüers, *Die Sprache der Deutschen Mystik des Mittelalters im Werke der Mechthild von Magdeburg*, Munich 1926, pp. 129–31, 'ouge'; see also essays cited in note 4.

23. *Le Siècle de Titien*, exh. cat., ed. M. Laclotte, Paris, Louvre 1993, no. 31, as by Giorgione (but with no catalogue entry).

24. *Vita di Raffaello da Montelupo*, ed. R. Gatteschi, Florence 1998, pp. 120–1.

25. Ludovico Ariosto, *Orlando Furioso*, trans. G. Waldman, Oxford 1983, canto 13: 32–6.

26. Like most people, I am not sure what is going on in Savoldo's *Shepherd with a Flute*. Both eyes are in shadow, though the bright light on his right cheek and his solemn expression might suggest he is more of a good than a bad shepherd.

27. P. Humfrey, *Lorenzo Lotto*, New Haven 1997, pp. 102–4, notes the connection.

28. *Painters of Reality*, exh. cat., ed. A. Bayer, Metropolitan Museum, New York 2004, no. 82, pp. 188–9.

29. Gian Paolo Lomazzo, *Scritti sulle arti*, ed. R. P. Ciardi, Florence 1974, 2: p. 383.

30. Cesare Ripa, *Iconologia*, ed. P. Buscaroli, Milan 1992, p. 191.

31. *www.york.ac.uk/teaching/history/pjpg/heron.pdf*. The translation is not credited.

32. In costume books of the late sixteenth century unmarried girls from Ferrara are depicted with a veil masking the right side of their face: could it be that they were regarded as somehow spiritually incomplete until they married, just as the Earl of Salisbury would be until his mistress 'opened' his right eye by agreeing to marry him? See J. J. Boissard, *Habitus Variarum Orbis Gentium* (1581), Paris 1979, p. 16; Petri Bertelli, *Diversarum Nationum Habitus*, Padua 1594–6, 'Virgo Ferariensis', np [Illustrated in E. Welch, *Shopping in the Renaissance*, New Haven 2005, p. 10]; C Vecellio, *Vecellio's Renaissance Costume Book* (1590), New York 1977, p. 61, no. 202.

33. A Latin edition of the *Institutes* and *Conferences* was published in Venice in 1491.

34. That Giorgione's *Laura* exposes her right breast (to her husband?) may be proof of her chastity. H. Usener, *Götternamen*, Bonn 1896,

p. 191 (no references) says the Cappodocian saint Kanides refused the left breast of his mother when he was a baby!

35. Jacobo Sannazaro, *Opere Volgari*, ed. A. Mauro, Bari 1961, pp. 61–2, 'Arcadia' # viii, 53–5. Left-right symbolism is also used p. 72, # ix, 32–4; p. 80, # x, 10.

36. P. H. D. Kaplan, 'The Storm of War: The Paduan Key to Giorgione's *Tempesta*', *Art History*, ix, 1986, pp. 405–27. See also D. Howard, 'Giorgione's Tempesta and Titian's Assunta in the Context of the Cambrai Wars', *Art History*, vol. 8, 1985, pp. 271–89. I don't think there is any need to connect the picture with the 1509 revolt by Padua (it was recaptured by the Venetians 42 days later). Padua was presumably a good butt for Venetain humour, as Ireland used to be for the English. Most scholars date the picture long before 1509, anyway.

37. P. H. D. Kaplan, 'The Storm of War', op. cit., p. 414, says it is an egret, but as this bird appeared on the walls of Troy, and was taken by the Greeks as a good omen, it has a similar resonance.

38. Guillaume de Lorris, *The Romance of the Rose*, trans. F. Horgan, Oxford 1994, p. 121, ll. 7857ff.

39. B. Borchhardt-Birbaumer, 'On the Topicality of Tolerant Dialogues: Giorgione and Ramon Lull', in *Giorgione: Myth and Enigma*, exh. cat., ed. S. Ferino-Pagden and G. Nepi Scire, Vienna Kunsthistorisches Museum 2004, p. 74: 'Is it an allegory of his vita voluptuaria, is he perhaps standing at the crossroads between vita activa and vita passiva, between virtus and fortuna?'

40. Origen, *The Song of Songs: Commentary and Homilies*, trans. and ed. R. P. Lawson, London 1957, Bk 2, # 2, pp. 110–12.

41. *Theologica Germanica*, trans. B. Hoffman, London 1980, p. 54.

42. Ibid., pp. 24ff.

43. Ibid., p. 68.

44. G Copertini, 'Un Ritratto del Coreggio nella Galleria d'Arte di York?', *Parma per l'arte*, 1962, p. 125.

45. D. Franklin: *The Art of Parmigianino*, New Haven 2003, p. 96.

46. *Parmigianino e il Manierismo Europeo*, exh. cat. ed. L. Fornari-Schianchi and S. Ferino-Pagden, Parma, Galleria Nazionale and Vienna Kunsthistorisches Museum, 2003, p. 196.

47. D Ekserdjian, 'Parmigiianino and Michelangelo', in F. Ames-Lewis and P. Joannides (eds), *Reactions to the Master: Michelangelo's Effect on Art and Artists in the Sixteenth Century*, Aldershot 2003, pp. 53–67.

48. Juan de Padilla, 'Retablo de la vida de Cristo', *Coleccion de obras poéticas españolas*, vol. xix, Madrid, 1842, p. 435a. Quoted in M. T. Olabarrieta, *The Influence of Ramon Lull on the Style of the early Spanish Mystics and Santa Theresa*, Washington DC 1963, p. 88.

49. Dürer's *Artist Depicting a Reclining Nude* (*c.*1525), a woodcut that was later used in his *Treatise on Measurement*, shows a 'sighting mechanism' in action in the studio. J. L. Koerner, *The Moment of Self-Portraiture in German Renaissance Art*, Chicago 1993, pp. 444–5, discusses its moral function, protecting the artist 'from the lure of the object'; however, he does not mention the use of the right eye. Giuglielmo della Porta was the first to offer experimental proof of eye-dominance in 1593: N. J. Wade, 'Eye Dominance' in *A Natural History of Vision*, Cambridge Mass. 1998, pp. 284–7.

50. The book he holds has been identified as a lavishly illuminated manuscript of religious texts, but it is closed, and seems to be included here for its sumptuous velvet and silver binding. D. Ekserdjian, *Parmigianino*, op. cit., pp. 121–4.

51. Ibid., p. 87.

52. P. Joannides, *The Drawings of Michelangelo and his Followers in the Ashmolean Museum*, Cambridge 2007, no. 22, pp. 137–40.

53. The pose has often been compared to a drawing of the 'Madonna Lactans' with St Anne, usually dated to around the time of the Sistine Chapel: P. Joannides, *Michel-Ange: élèves et copistes*, Paris 2003, no. 16, pp. 107–13. The left side of the Virgin's face is occluded by shadow, and almost all of St Anne's. Lines from the opening of Petrarch's sonnet 129 have been written next to the drawing, and the shadows here may be an attempt to express something similar to lines 9–11: 'my face, which follows wherever my soul leads, is clouded and made clear again [si turba et rasserena], and remains but a short time in any one state.' *Petrarch's Lyric Poems*, trans. R. M. Durling, Cambridge Mass. 1976, pp. 264–5.

54. P. Joannides, *The Drawings of Michelangelo and his Followers in the Ashmolean Museum*, op. cit., no. 34, pp. 185–90. In Michelangelo's only surviving portrait, a drawing of a Florentine youth, *Andrea Quaratesi* (*c.*1532), the teenage boy's floppy cap hangs lower over his left eye, which is in shadow, thus enabling him to smoulder with 'soulful' melancholy.

55. V. Colonna, *Rime*, ed. A. Bullock, Rome-Bari 1982, pp. 167, no. 164, ll. 9–11.

56. Gertrude d'Helfta, *Oeuvres Spirituelles*, vol. 1, ed. & trans. J. Hourlier and A. Schmitt, Paris 1967, 'Introduction' and 'Appendix 1', p. 52.

57. For the Petrarchan symbolism of 'lame' left legs, see chapter xv, 'Prisoners of Love'.

58. J. Pope-Hennessy, *The Portrait in the Renaissance*, Princeton 1989, p. 138.

59. Bacon's striations are more akin to Nietzche's 'Apollonian' veil in the process of being torn away to reveal the Dionysian depths. *Francis Bacon and the Tradition of Art*, exh. cat. W. Seipel et al., Kunsthistorisches Museum Vienna and Fondation Beyeler, Basel, 2003–4, pp. 133ff. The critic was Lawrence Alloway.

60. R. J. Betts, 'Titian's Portrait of Filippo Archinto in the Johnson Collection', *Art Bulletin*, xlix, 1967, pp. 59–61. This dating of the portrait is interesting in relation to the Latin translation of *Theologica Germanica*, which was published in 1557.

61. In Titian's *Saint Sebastian* (*c.*1575) four arrows stick into the martyr's left side and arm, and only one in his right side (this is in a similar position to the wound in Christ's side caused by Longinus' spear, and is the only wound that drips blood).

62. *Decrees of the Ecumenical Councils*, ed N. P. Tanner, London, 1990, vol. 3, pp. 666–7.

63. Ibid., p. 672.

64. C. M. Woolgar, *The Senses in Late Medieval England*, New Haven 2006, p. 30.

65. For this in relation to Raphael's *Disputa*, and the Sistine Ceiling prophets and sybils, see J. Hall, *Michelangelo and the Reinvention of the Human Body*, London 2005, pp. 120–1. On the north portal of Chartres cathedral, a group of contemplative women are shown. Those at the beginning are shown reading a book; but at the highest stage, the contemplative woman no longer reads but gazes upwards. See also the Donne poem quoted at the end of my Rembrandt chapter.

66. D. Scarisbrick, *Rings: symbols of wealth, power and affection*, London 1993, p. 20. Although marriage was not a sacrament, the church seems to have prefered wedding rings to be worn on that finger too. In 1576, at the fourth Provincial Council of Milan, it was decreed that the wedding ring should be placed on the left hand. Jean-Baptiste Thiers later lamented that they thereby 'fell into the super-stition of vainglorious practice': *Traité des Superstitions qui regardent*

les Sacrements Avignon, 1777, p. 455. Could it be that the conduct of wedding ceremonies was already a bone of contention in Milan, and that Archinto's prominently placed ring shows his preference for the right hand?

67. Quoted by S. Clark, *Thinking with Demons: the Idea of Witchcraft in Early Modern Europe*, Oxford 1997, p. 63.

68. *Petrarch's Lyric Poems*, op. cit., no. 233, pp. 390–1.

69. I believe Titian's *Young Woman at her Toilet* (1514–15) plays a similar game: she turns away from the round convex mirror on her left that might encompass the entire world, to a small mirror on her right that will crop her face; Giovanni Bellini's *Lady with a Mirror* (1515) may also explore these themes.

70. H. Langdon, *Caravaggio: A Life*, London 1998, pp. 340ff.

71. Ibid., p. 351.

72. W. Franits, *Dutch Seventeenth Century Genre Painting*, op. cit., p. 72, figs. 66 & 7.

6. The Choice of Hercules

1. *Dante's Lyric Poetry*, ed. and trans. K. Foster and P. Boyde, Oxford 1967, no. 71, pp. 146–9.

2. E. Panofsky, *Hercules am Scheidewege und andere antike Bildstoffe in der neueren Kunst* (Leipzig 1930) Berlin 1997.

3. When the Pythagorean 'Y' is depicted, the 'thicker' line—and the virtuous path—is usually on the viewer's left. These images are unusual in being oriented in relation to the viewer, but this may be because they are supremely typographic and therefore designed to be 'read'.

4. W. Harms, *Homo Viator in Bivio*, Munich 1970.

5. *The Quest for the Holy Grail*, trans. P. M. Matarasso, London 2005, ch. 2, p. 66.

6. Ibid., ch. 3, pp. 70–1.

7. Plotinus, *The Enneads*, trans S. MacKenna, London 1991, I.1, p. 13.

8. M. Baxandall, *Giotto and the Orators*, Oxford 1971, pp. 88–90.

9. E. H. Gombrich, 'Aims and Limits of Iconology', in *Symbolic Images*, Oxford 1978, p. 2. See also G. Duggan, 'Was Art really the 'Book of the Illiterate'?', in *Word and Image*, vol. 5, no. 3, July–September 1989, pp. 227–47, esp. pp. 242ff.

10. E. Panofsky, *Hercules am Scheidewege*, op. cit., p. 164. Translation by T. E. Mommsen, 'Petrarch and the Story of the Choice of Hercules', *Journal of the Warburg and Courtauld Institutes*, 1953, p. 190.

11. Ibid; 'Letter from Emma Edelstein to Theodor Mommsen', in E. Panofsky, *Hercules am Scheidewege*, op. cit., pp. 85–9; W. Harms, *Homo Viator in Bivio*, op. cit., passim.

12. Camillo has defended Queen Hermione from the charge that she has committed adultery.

13. *Raphael: from Urbino to Rome*, exh. cat., London National Gallery 2004, H. Chapman, T. Henry, and C. Plazzotta, nos. 35 & 36 (preparatory drawing), pp. 138–43; *Renaissance Siena: Art for a City*, exh. cat., National Gallery London 2007, L. Syson et al., no. 78, pp. 262–7.

14. E. Wind, 'Virtue Reconciled with Pleasure', in *Pagan Mysteries in the Renaissance*, London 1967, p. 82. In the landscape behind Raphael's Virtue we find a road with a fork in it, and three mounted riders at the fork. They may loosely symbolize Contemplation, Action, and Pleasure.

15. *Dante's Lyric Poetry*, op. cit., no. 71, pp. 146–9. *Renaissance Siena: Art for a City*, op. cit., p. 265; the sonnet's relevance to the picture was pointed out by A. Unger.

16. P. Joannides, *Titian to 1518*, New Haven 2001, pp. 185–93; *Titian*, exh. cat. ed. D. Jaffé, London National Gallery 2003, no. 10, pp. 92–5.

17. P. Joannides, *Titian to 1518*, op. cit., p. 187.

18. *Orlando Furioso*, trans. G. Waldman, Oxford 1983, p. 164. Canto 15, 90–9.

19. For both pictures, see P. Humfrey, *Lorenzo Lotto*, New Haven 1997, pp. 7ff.; *Lorenzo Lotto: Rediscovered Master of the Renaissance*, D. A. Brown et al., exh. cat. Washington National Gallery of Art, Bergamo (Accademia Carrara di Belle Arti), Paris (Galeries National du Grand Palais) 1997–99, nos. 2 & 3, pp. 73–80, with bibliography.

20. L. Campbell, *Renaissance Portraits*, New Haven 1990, pp. 65–7. The backs of portraits were also decorated with inscriptions etc.

21. P. Humfrey, *Lorenzo Lotto*, op. cit., p. 11.

22. Ibid., p. 10.

23. A portrait medal made in *c.*1519 shows only the right side of his face, and the skin is very smooth. A painted terracotta bust from

*c.*1520 attributed to Riccio in the Duomo at Treviso appears to be much more naturalistic, but depicts pimples randomly distributed on both sides of the face. The medal is reproduced in *Lorenzo Lotto: rediscovered master of the Renaissance*, op. cit., p. 73, fig. 1; for the terracotta bust, see L. Coletti, 'Intorno ad un nuovo ritratto del vescovo Bernardo de' Rossi', in *Rassegna d'Arte*, 12, December 1921, pp. 407–20.

24. *A Documentary History of Art*, vol. 2, ed. E. G. Holt, New York 1958, p. 256; ch. 5, # 13.

25. Lord Shaftesbury, *Characteristics of Men, Manners, Opinions, Times*, ed. L. E. Klein, Cambridge 1999, p. 20.

26. E. Panofsky, *Hercules am Scheidewege*, op. cit., pp. 113ff.; *Gli Uffizi: Catalogo Generale*, Florence 1979, p. 559, no. P178 (attributed to Jan van den Hoecke).

27. See also F. Colonna, *Hypnerotomachia Poliphili*, trans. J. Godwin, London 1999, pp. 134ff. The lover Poliphilo comes across three doors of which the right is dedicated to divine glory (gloria dei), the left to 'worldly' martial glory (gloria mundi), and the central door (the one Poliphilo chooses) to erotic love (mater amoris). Effectively, the left path is split into two between human love and war.

28. Oxford, Ashmolean; Leeds, Temple Newsam House; Munich, Alte Pinakothek. An engraving by Gribelin after Matteis' painting was included with the essay in the third volume of the revised edition of Shaftesbury's *Characteristics of Men, Manners, Opinion, Times* (1714). Most of the essay is found in *A Documentary History of Art*, op. cit., pp. 242–59.

29. *A Notion of the Historical Draught or Tablature of the Judgement of Hercules*, London 1713, p. 42.

30. Ibid. The brown fabric which is draped over a branch of the tree echoes the hang of Hercules' lion skin.

31. *A Documentary History of Art*, op. cit., p. 254; ch. 5, # 10.

7. Double Vision

1. Cited by A. Solignac, 'Oculus (Animae, Cordis, Mentis)', in *Dictionnaire de Spiritualité Ascetique et Mystique*, vol. 11, Paris 1982, col. 593.

2. Plato, *Symposium*, trans. W. Hamilton, Harmondsworth 1951, pp. 63–4, # 192e.

3. M. Keen, *Chivalry*, New Haven 1984, p. 152.

4. 'transitoria sinistro intuentur oculo et dextro caelestia'. Thomas à Kempis, *The Imitation of Christ*, trans. E. Daplyn, London 1978, p. 119, Bk 3, # 38. From a manuscript of 1441. Thomas à Kempis, *De Imitatione Christi*, F. Eichler (ed.), Munich 1966, bk 3, ch. 38, p. 312.

5. A. Venturi and A. Luzio, 'Nuovi documenti su Leonardo da Vinci', *Archivio storico dell'arte*, 1, 1888, p. 45: 'certi belli retracti de man di Zoanne Bellini'. R. Goffen, *Giovanni Bellini*, New Haven 1989, p. 265, n. 27.

6. Galleria dell' Accademia, Bergamo. F. Bologna: 'Un ritratto del doge Leonardo Loredan', *Arte antica e moderna* 5 1959, pp. 74–8; R. Goffen, *Giovanni Bellini*, op. cit., pp. 205–9.

7. L. Campbell, *Renaissance Portraits: European Portrait-Painting in the 14th, 15th and 16th Centuries*, New Haven 1990, p. 30: 'most facial expressions are fleeting, and portrait painters have rarely chosen to give their sitters fixed and well-defined expressions. Many have either avoided marked facial expressions altogether or rendered expressions of a subtlety difficult to define'. He goes on to say that some portrait heads 'appear to change expression as they are examined: here the artists have made an effort, conscious or instinctive, to achieve a certain mobility in static images by varying slightly the expressions of the eyes and mouths so that, when attention is focussed elsewhere, another expression takes its place'.

8. Ibid.

9. R. Goffen, *Giovanni Bellini*, op. cit., p. 21: '...his mouth seems almost to smile. This is intended to suggest that he is alive—like the famous smile of Leonardo's *Giocondo*.'

10. L. Campbell: *Renaissance Portraits*, op. cit., p. 27.

11. 'Ioanni Bello Bellino Pictori Clarissimo. / Qui facis ora tuis spirantia, Belle, tabellis / dignus Alexandro principe pictor era'. J. Fletcher, 'The Painter and the Poet: Giovanni Bellini's portrait of Raffaele Zovenzoni rediscovered', *Apollo* 134 (1991), p. 158; B. Ziliotto, *Raffaele Zovenzoni: la vita, i carmi*, Trieste 1950, p. 78, no. 28.

12. G. Savonarola, *Prediche sopra Ezechiele*, ed R. Ridolfi, Rome 1955, vol. I, p. 132.

13. J. O'Reilly, *Studies in the Iconography of the Virtues and Vices in the Middle Ages*, New York 1988, pp. 265ff.

14. *Dialogus de acerba Antonini, dilectissima filii sui, morte consilatorius…* (1438). Cited by G. W. McClure, *Sorrow and Consolation in Italian Humanism*, Princeton 1991, p. 108.

15. E. R. Curtius, *European Literature and the Latin Middle Ages*, trans. W. R. Trask, London 1953, pp. 417–35; M.A. Screech, *Laughter at the Foot of the Cross*, London, 1997; A. Trimble: *A Brief History of the Smile*, New York 2004.

16. For the Loredan family tree, *Palazzo Loredan e l'Instituto Veneto di Scienze, Lettere ed Arte*, ed. E. Bassi and R. Pallucchini, Venice 1985, p. 23. Leonardo Loredan's uncle was also called Lorenzo.

17. J. de Voragine, *The Golden Legend*, trans. W. G. Ryan, Princeton 1993, vol. II, pp. 66–7.

18. E. Cicogna, *Delle iscrizioni veneziane*, Venice 1827–34, vol. 2, p. 283.

19. Livy, *History of Rome*, 2: 12–13.

20. *The Currency of Fame: Portrait Medals of the Renaissance*, exh. cat., S. K. Scher ed., Edinburgh, National Galleries of Scotland 1994, pp. 110–11, nos 31 and 31a. Entry by M. Wilchusky. It is assumed that this refers to a wound sustained while fighting papal troops in 1509, after which he was held prisoner for six weeks. Pietro Contarini, in his recollections of illustrious men published in 1541, wrote evocatively of his captivity: 'And there sat Jocopo Loredano, who, being castellan at Brisighella, burned a hand in battle and the scar improbably remained, testifying to his love for his country.' We cannot be certain that Jacopo was wounded in precisely this way, for Contarini may well have been influenced by the medal, and Jacopo had anyway died in 1535.

21. M. Baxandall, *Giotto and the Orators*, Oxford 1971, pp. 88–90.

22. J. Pope-Hennessy, *The Portrait in the Renaissance*, London 1966, pp. 321–2, n. 9. A. Ravá: 'Il 'Camerino delle Antigaglie' di Gabriele Vendramin', *Nuovo archivio veneto*, 39, 1920, p. 169. 'Un altro quadreto con il retrato de Zuan Bellini et de Vetor suo dixipulo nel coperchio.'

23. The only inscription to feature on the painting is Bellini's signature, written in Latin on a tromp-l'oeil piece of paper that has itself been in the wars, crumpled and folded several times. It is appended to the parapet, just to the (viewer's) right of the mid-point of the Doge's face. The folds in the paper may here suggest the storms

which Bellini himself has triumphantly weathered (the same form of signature appears on two 'portraits' of martyr saints). This meticulously painted portrait would not only attest to Bellini's fortitude, but also to his patience.

24. S. C. Chew, *The Pilgrimage of Life*, New Haven 1962, pp. 116 ff. I am grateful to Elizabeth McGrath for this suggestion.

25. M. Sanuto, *Diarii*, Venice 1879–, 4, col. 144. 'sempre in coleio le opinion sue, et in pregadi, è stà estimate.'

26. R. Goffen, *Private Lives in Renaissance Venice*, New Haven 2004, pp. 32–4.

27. E. Langmuir, *The National Gallery Companion Guide*, London 1994, p. 23.

28. *Palazzo Loredan e l'Instituto Veneto di Scienze, Lettere ed Arte*, op. cit., p. 14. 'Io non mi curo, purché io ingrassi et mio fiol Lorenzo.'

29. E. Gombrich: 'The Mask and the Face: The Perception of Physiognomic Likeness in Life and Art' (1970), in *The Image and the Eye: Further studies in the psychology of pictorial representation*, Oxford 1982, p. 118: 'The arrested smile is certainly an ambiguous and multi-valent sign of animation and has been used by artists to increase the semblance of life ever since archaic Greece. The most famous example of its use is of course Leonardo's *Mona Lisa*, whose smile has been the subject of so many and so fanciful interpretations.'

30. Giorgio Vasari, *Lives of the Painters, Sculptors and Architects*, trans. G. du C. de Vere, London 1996, vol. 1, p. 636.

31. *The Essential Erasmus*, ed. and trans. J. P. Dolan, London and New York, 1964, p. 99. Democritus was paired with Heraclitus, who was referred to as the 'crying philosopher' because he was reputed to be melancholic.

32. M. Kemp, *Leonardo da Vinci: the Marvellous Works of Nature and Man*, Oxford 2006, p. 150. The most popular puns in court circles were *morus*, Latin for mulberry, and *moro*, Italian for mulberry and black man.

33. Cited by D. Arasse, *Leonardo da Vinci: the Rhythm of the World*, New York 1997, p. 408. A. Firenzuola, *On the Beauty of Women*, trans. and ed. K. Eisenbichler and J. Murray, Philadelphia 1992, p. 59. A. Firenzuola, *Opere*, ed. D. Maestri, Turin 1977, p. 778.

34. A. Firenzuola, *On the Beauty of Women*, op. cit., p. 54. A. Firenzuola, *Opere*, op. cit., p. 773.

35. M. Kemp, *Leonardo da Vinci*, op. cit., pp. 257–8; J. Roberts, 'Catalogue of the Codex Hammer', in *Leonardo: the Codex Hammer and the Map of Imola*, Los Angeles 1985, p. 53 (Codex Hammer 9A).

36. *The Etymologies of Isidore of Seville*, trans. S. A. Barney et al., Cambridge 2006, p. 237, XL: i: 90.

37. D. Arasse, *Leonardo da Vinci*, op. cit., pp. 388–9 & 393.

38. A. E. Popham, *The Drawings of Leonardo da Vinci*, London 1946, no. 105, p. 117. For Prudence, see E. Panofsky: 'Titian's Allegory of Prudence: A Postscript', in *Meaning in the Visual Arts*, London 1970, pp. 181–205.

39. *Leonardo da Vinci: Master Draftsman*, exh. cat. ed. C. Bambach, Metropolitan Museum New York 2003, no. 54, pp. 400–3; A. E. Popham, *The Drawings of Leonardo da Vinci*, London 1946, nos. 107 & 108, pp. 117–19.

40. Plato, *Philebus*, D. Frede (trans), Indianapolis and Cambridge 1993, pp. 56–7, # 48b–d.

41. A. Chastel, *L'Illustre Incomprise*, Paris 1988, pp. 116–20.

42. L. Campbell, *Renaissance Portraits*, op. cit., p. 25.

43. For an eighteenth-century example, see Allan Ramsay's *Mrs Mary Adam* (1754) and the analysis by T. Lubbock in *The Independent*, 'Friday Review', 10 March 2006, p. 30: 'This face divides. Look at the right side [sitter's left]. Here, things are friendlier, the eye and cheek muscles contract, smilingly. Now look at the left [sitter's right]. Things are colder, the mouth shorter and straighter, cheek flatter, eye clearer.'

44. Cited by S. Battaglia (without full references), 'Mancino', in *Grande Dizionario della Lingua Italiana*, vol. 9, Turin 1975, p. 71 # 6.

8. Rembrandt's Eyes

1. The broadly grinning *Study in the Mirror* (*c.*1630), which is lit from the right, would partially disprove my thesis, but its attribution is contested. E. van de Wetering, *A Corpus of Rembrandt Paintings iv: Self-Portraits*, Dordrecht 2005, pp. 165ff, where it is attributed to Jan Lievens. If it is by Rembrandt, it may have been a study for an etching of the same subject, which would explain the 'reversal' of the lighting; the same may be true of the similarly lit, but more

thoughtful and plaintive, *Laughing Soldier* (1629–30, Mauritshuis, The Hague): ibid., fig. 128, p. 168.

2. *Rembrandt by Himself*, exh. cat. C. White (ed.), London National Gallery 1999, no. 43, p. 159.

3. Ibid., no. 82, pp. 216–19; *A Corpus of Rembrandt Paintings iv: Self-Portraits*, op. cit., IV 25, pp. 552–61.

4. C. Grössinger, *Humour and Folly in Secular and Profane Prints of Northern Europe 1430–1540*, London 2002, pp. 107–29; *Bilder vom Alten Menschen in der Niederlämdish Deutschen Kunst 1550–1750*, exh. cat. Braunschweig 1993, p. 18.

5. Girolamo Cardano, *Lettura della Fronte: Metoposcopia*, ed. and trans. A. Arecchi, Milan 1994, p. 41, fig. 51.

6. *The Robert Lehman Collection vii: Fifteenth- to Eighteenth-Century European Drawings*, Metropolitan Museum of Art, New York 1999, no. 70, pp. 219–28, entry by E. Haverkamp-Begemann.

7. *Rembrandt by Himself*, op. cit., nos. 22 & 23, pp. 127–8.

8. C. Wright, *Rembrandt as an Etcher*, New Haven 1999, p. 113.

9. Thus the red chalk drawing *Self-Portrait with Beret* (c.1635–8) is more sedate and unsmiling than the etching; the oil-sketch *Portrait of Ephraim Bueno* (1647) is more solemn than the frankly jovial etching, and the painting *Portrait of Arnout Tholinx* (c.1656) is more meditative than the print. *Rembrandt by Himself*, op. cit., nos. 44 & 45, pp. 160–1. *Rembrandt the Printmaker*, E. Hinterding et al., exh. cat. Amsterdam Rijksmuseum, 2000, pp. 58–9 & ct. 82.

10. *Rembrandt by Himself*, op. cit., no. 73, pp. 200–3; *A Corpus of Rembrandt Paintings iv: Self-Portraits*, op. cit., IV 18, pp. 498–507. In a few early self-portraits, both eyes are in shadow, which P. Chapman claims to signify a man of melancholic temperament: *Rembrandt's Self-Portraits: A Study in Seventeenth Century Identity*, Princeton 1990, pp. 25 & 30–1. Titian's *Self-Portrait* (c.1546–7) in which he turns to his left and is lit from his left, has a heightened immediacy, and his luxurious clothes and gold chain point to his worldly success; conversely, the later *Self-Portrait* (c.1560) in which he is shown in left profile, lit from his right, is much more sober, somber, and static. They are not Zecharian portraits, insofar as the meaning is conveyed by orientation, dress, and illumination rather than by the eyes; but they are antithetical in a similar way.

11. *Rembrandt by Himself,* op. cit., no. 17, pp. 120–1.

12. Ibid., no. 79, p. 211; *A Corpus of Rembrandt Paintings iv: Self-Portraits,* op. cit., IV 19, pp. 508–16. The National Gallery *Self-Portrait* (1669) originally showed him with paint brush in hand: ibid., IV 27, p. 571 (x-ray image).

13. C. and A. Tümpel, *Rembrandt: Images and Metaphors,* London 2006, pp. 252ff.

14. *Rembrandt: the Master and his Workshop vol 1: Paintings,* exh. cat. C. Brown et al., London National Gallery 1991, pp. 284–7, no. 49; *Rembrandt by Himself,* op. cit., no. 83, pp. 220–3; *A Corpus of Rembrandt Paintings iv: Self-Portraits,* op. cit., no IV 26, pp. 562–9.

15. See note 14 for references.

16. J. A. Emmens, *Rembrandt en de regels van de kunst,* Utrecht 1968, pp. 174–5.

17. This argument has been partially rejected (*A Corpus of Rembrandt Paintings iv: Self-Portraits,* op. cit., p. 566) because what we see is the edge of the canvas rather than a ruled dark line, but this strikes me as pedantry: at some stage in the construction of the canvas/stretcher, a ruler had to be used to get that straight line; and Rembrandt needed to paint a ruled line to depict the edge.

18. Vasari's letter of 1570 to Martino Bassi. Quoted by D. Summers, *Michelangelo and the Language of Art,* Princeton 1981, p. 370; see also pp. 352–79. The 'compasses in the eye' are cited in Van Mander, *Den grondt der edel-vry schilder-const,* Haarlem 1604, III, 15 (in margin), and in the life of Michelangelo in *Het Schilder-boeck,* Haarlem 1604, fol. 171 v. The story of Zeuxis dying of laughter also appears in Van Mander, but not in an obvious place—it's in the addenda at the end of the Lives, not in the life of Zeuxis. So either Rembrandt, or his contact, knew the book well. The 'compasses in the eyes' are cited three times by Rembrandt's pupil Samuel van Hoogstraten, *Inleyding,* Rotterdam 1678, pp. 35, 36, 63. A further, possibly fanciful, reference occurs in Jacob Campo Weyerman, *De Levens-Beschryvingen der Neder-landsche Konst-Schilders en Konst-Schilderessen,* part 1, The Hague 1729, p. 311. The story is taken from the life of Van Dyck. Rubens' pupils, we're told, used to gather round the master's paintings when he'd left the studio to go home for the night, and they would try to work out the mysteries of his technique. While

they were doing this one evening one of them slipped and fell against the wet paint of a Madonna, smearing her arm and face. They decided that Van Dyck would have to repaint the damaged section: Next day Rubens came up to continue painting, and he contemplated that arm and face with unusual attention, according to the report of one of Van Dyck's fellow pupils, and after he had compared those figures with the other figures, using the sure compass of his eye, he cried out happily, 'That certainly isn't the worst thing I painted yesterday afternoon!' I am grateful to Paul Taylor for all these references.

19. G. Lomazzo, *Trattato dell'arte de la pittura*, Milan 1584, pp. 262–3. Trans. by D. Summers, *Michelangelo and the Language of Art*, op. cit., pp. 371–2.

20. In the illustration to Ripa's 'Teoria', the female allegory has the compasses projecting from her head like a pair of horns!

21. For Rembrandt's possible interest in astrology, in relation to the etching traditionally called *Faust*, see *Rembrandt: the master & his Workshop: Drawings and Etchings*, exh. cat. H. Bevers et al., London National Gallery, 1991, no. 33, pp. 258–60; H. Th. Carstensen and W. Henningsen, 'Rembrandts sog. Dr. Faustus; zur Archäologie eines Bildsinnes', *Oud Holland*, 102, 1988, pp. 290–312.

22. C. Hill, *The World Turned Upside Down*, Harmondsworth 1975, p. 91. See also, K. Thomas, *Religion and the Decline of Magic*, Harmondsworth 1973, ch. 13: 'Ancient Prophecies'.

23. C. Hill, *The World Turned Upside Down*, op. cit., p. 91.

24. A. C. Fix, *Prophecy and Reason: The Dutch Collegiants in the Early Enlightenment*, Princeton 1991, pp. 165 ff. Fix quotes Christopher Hill on p. 165.

25. Three German versions of *Der Weg zu Christo* were published in Amsterdam in 1635, 1656 (?) and 1658. A Dutch translation appeared in 1685: *Der weg tot Christus, in negen bocken vervat*, Amsterdam 1685. The passage appears in #6 'Van't boven-zinnelijhe leeven', dialogue 2. The perennially popular *Imitation of Christ* was published together with the *Theologia Deutsch* for the first time in 1621, and this combination, which featured two left-and-right 'eye of the soul' metaphors, gave rise to a Dutch edition in 1631, and a Dutch translation in 1644 with an attractive frontispiece illustration of an open book placed over a cushion-like heart.

G. Baring, *Bibliographie der Ausgaben der 'Theologia Deutsch' 1516–1961*, Baden-Baden 1963, no. 69. Earlier editions: 54, 55, 56, 61, 62 (Amsterdam 1630).

26. *Rembrandt's Late Religious Portraits*, exh. cat. A. K. Wheelock et al., National Gallery of Art, Washington, 2005, no. 11. The frowning quizzicality of this portrait can be compared to Michelangelo's prophets Isaiah and Jeremiah.

27. Menasseh ben Israel, *Piedra Gloriosa o de la Estatua de Nebuchadnesar*, Amsterdam 1661, pp. 134, 164, 182, 220, 241, 243.

28. They are reproduced and discussed in C. and A. Tümpel, *Rembrandt: Images and Metaphors*, op. cit., pp. 112–15.

29. C. Nordenfalk, *The Batavian Oath of Allegiance: Rembrandt's Only Monumental Painting*, Nationalmuseum Stockholm 1982.

30. Tacitus calls him Julius Civilis.

31. 'An Anatomy of the World', in John Donne, *The Complete English Poems*, ed. A. J. Smith, Harmondsworth 1973, p. 277, ll. 263–4; 268–70.

32. *A Selection of the Poems of Sir Constantijn Huygens*, trans. & ed. P. Davidson and A. van der Weel, Amsterdam 1996, for the Donne translations.

33. John Donne, *The Complete English Poems*, op. cit., p. 225. See also *John Donne's Sermons on the Psalms and Gospels*, ed. E. M. Simpson, Berkeley 1963, p. 60: 'There are Indies at my right hand, in the East; but there are Indies at my left hand too, in the West.'

34. B. McGinn, 'Love, Knowledge and the Unio Mystica in the Western Christian Tradition', in *Mystical Union and Monotheistic Faith*, ed. M. Idel and B. McGinn, New York 1989, pp. 63–4.

9. The Death of Christ 1: Crossing Over

1. St Bernard of Clairvaux, *On the Love of God*, ed. and trans. E. G. Gardner, London 1916. ch. 4, # 12, pp. 57–9.

2. *The Life of Saint Teresa of Avila By Herself*, trans J. M. Cohen, Harmondsworth, 1957, ch XXXIX, para 1, p. 295. *Escritos de Santa Teresa*, Don Vicente de la Fuente (ed.), Madrid 1952, I, p. 120.

3. J. Reil, *Die Frühchristlichen Darstellungen der Kreuzigung Christi*, Leipzig 1904; V. Gurewich, 'Observations on the Wound in Christ's Side, with Special reference to its Position', in *Journal of the Warburg and*

Courtauld Institutes, 20, 1957, pp. 358–62; *Picturing the Bible: The Earliest Christian Art*, exh. cat. J. Spier et al., Kimbell Art Museum, Fort Worth 2007, pp. 227–32 (text by F. Harley); pp. 276–82 for Rabbula Gospels; see also F. Harley, *Images of the Crucifixion in Late Antiquity* (forthcoming).

4. Both these episodes will be discussed in the next chapter.

5. PA 666b 6ff. G. Lloyd: 'Right and Left in Greek Philosophy', in *Right & Left: Essays on Dual Symbolic Classificiation*, ed. R. Needham, Chicago 1973, pp. 174–5.

6. J. Freccero, 'Dante's Firm Foot and the Journey Without a Guide', in *Harvard Theological Review*, 52, 1959, p. 253.

7. *Dictionnaire d'Archéologie Chrétienne et de Liturgie*, Paris 1932, vol. 10:2, cols. 1891–3: 'L'Anneau Nuptial'. For a sixteenth-century reiteration of these views, G. B. Cavaccia, *L'Anello Matrimoniale*, Milan 1599, pp. 63ff.

8. *La regola sanitaria salernitana*, trans. F. Gherli (1733), Salerno 1987, no. cix. It is a Latin poem of the thirteenth century.

9. Miguel de Cervantes, *Don Quixote* (1614), trans. C. Jarvis, Oxford 1992, p. 826, bk 2, ch. 43. Cervantes had a crippled left hand after being wounded at the battle of Lepanto.

10. Cited by J-P. Bertrand, *Histoire des Gauchers*, Paris 2001, p. 68.

11. R. Horie, *Perceptions of Ecclesia: Church and Soul in Medieval Dedication Sermons*, Turnhout 2006, pp. 2 & 80.

12. Jacopo de Voragine, *The Golden Legend*, trans. W. G. Ryan, Princeton 1993, vol. 2, p. 392. See also his sermon, ' Sermones de tempore et de sanctis', in R. Horie, *Perceptions of Ecclesia*, op. cit., p. 228; M. Aronberg Lavin, *The Place of Narrative: Mural Decoration in Italian Churches, 431–1600*, London 1990, p. 58. One wonders whether the extraordinary 'x' crossing at Wells Cathedral, which provides structural support, was not meant to allude to this.

13. F. Deuchler, 'Le sens de la lecture: a propos du boustrophédon', in *Etudes d'Art Mediéval offertes à Lousi Grodecki*, Strasbourg 1981, pp. 250–8. Almost all the ones he cites are cycles of Christ's Passion. M. A. Lavin, *Piero della Francesco*, London 2002, pp. 115–84 & p. 177 fig. 113.

14. C. R. Sherman: *Writing on Hands: Memory and Knowledge in Early Modern Europe*, Seattle 2000, p. 20.

15. *The Etymologies of Isidore of Seville*, trans. S. A. Barney et al., Cambridge 2006, p. 137; VI.ii.20.

16. *The Complete Works of Saint Teresa of Jesus*, trans. and ed. E. Allison Peers, London 1946, vol. 3.

17. H. Oliphant Old, *The Reading and the Preaching of the Scriptures in the Worship of the Christian Church*, vol. 4, Grand Rapids 2002, p. 275.

18. M. Luther, *In Cantica Canticorum . . .*, Wittenberg 1539.

19. *Il Beneficio di Cristo*, ed. S. Caponetto, Turin 1975, ch. iv, pp. 47ff.

20. Parashat Va-Yetse in *The Zohar*, ed. and trans. D. C. Matt, Stanford 2004, vol. 2, p. 413. See also pp. 251, 261–2 & vol. 1, p. 270.

21. Hayyei Sarah in ibid., p. 251.

22. Origen, *The Song of Songs: Commentary and Homilies*, trans. and ed. R. P. Lawson, Westminster 1957, bk 3, #9, pp. 200–3; Second Homily, #9, p. 297.

23. St Bernard of Clairvaux, *On the Love of God*, op. cit., ch. 4, #12, pp. 57–9.

24. *Meditations on the Life of Christ*, trans. I Ragusa, Princeton 1961, p. 257, ch. xlix, 'Of the Exercise of the Contemplative Life'. For other examples and interpretations, U. Deitmaring, 'Die Bedeutung von Rechts und Links in Theologischen und literarischen Texten bis um 1200', in *Zeitschrift für deutsches Altertum und deutsche Literatur*, 98, 1969, pp. 270–6.

25. *Vita*, pl. 13. I. Lavin, *Bernini and the Unity of the Visual Arts*, New York 1980, vol. 2, fig. 255. I have not been able to consult the original book.

26. L. Steinberg, *The Sexuality of Christ in Renaissance Art and in Modern Oblivion*, London 1984, pp. 113–15, Appendix III, discusses the passage in *Song of Songs* in relation to the gesture of the so-called 'chin tuck'. In an otherwise pretty comprehensive discussion, he does not mention Leonardo.

27. P. Lacepiera, *Libro de locchio morale e spirituale vulgare*, Venice 1496, 'Decimo mirabile nella vision del occhio'.

28. For Suso, J. F. Hamburger, *The Visual and the Visionary: Art and Female Spirituality in Late Medieval Germany*, New York 1998, chs. 4 & 5. E. Jager, *The Book of the Heart*, Chicago 2000, pp. 97ff.

29. J. F. Hamburger, *The Visual and the Visionary*, op. cit., pp. 258–9, fig. 5.14. For a colour illustration and brief discussion, B. Newman, 'Love's Arrows: Christ as Cupid in late Medieval Art and Devotion', in *The Mind's Eye: Art and Theological Argument in the Middle Ages*, ed. J. F. Hamburger and A-M. Bouché, Princeton 2006, p. 279.

30. Henry Suso, *The Life of the Servant*, trans. J. M. Clark, London 1952, ch. 7, p. 32.

31. Heinrich Seuse, *Deutsche Schriften*, ed. K. Bihlmeyer, Stuttgart 1907, p. 24.

32. Henry Suso, *The Life of the Servant*, op. cit., ch. 5, p. 29.

33. For more on the heart in the middle ages see N. F. Palmer, '*Herzeliebe*, weltlich und geistlich: Zur Metaphorik vom 'Einwohnen im Herzen' bei Wolfram von Eschenbach, Juliana von Cornillon, Hugo von Langenstein und Gertrud von Helfta', in *Innenräume in der Literatur des deutschen Mittelalters*, ed. B. Hasebrink, H.-J. Schiewer, A. Suerbaum and A. Volfing, Tübingen 2007, pp. 199–226.

34. *Pisanello: Painter to the Renaissance Court*, exh. cat. L. Syson and D. Gordon, London National Gallery 2001, pp. 156ff. D. Gordon, *The Fifteenth Century Italian Paintings: vol 1*, London 2003, pp. 310–24.

35. In the portrait medal of *John VIII Palaeologus* (*c*.1438–43), a similar scenario is enacted, but the mounted Palaeologus only passes a barely visible cross. See *Pisanello: Painter to the Renaissance Court*, op. cit., pp. 31 and 163.

36. *The Currency of Fame: Portrait Medals of the Renaissance*, exh. cat., ed. S. K. Scher, Edinburgh, National Galleries of Scotland 1994, pp. 50–2, nos 6 & 6a.

37. Chrétien de Troyes, *Arthurian Romances*, trans. W. W. Comfort, London 1975, 'Yvain', p. 243, ll 4821ff 'And she made her way straight toward the sound [of the horn] until she came to a cross which stood on the right side of the road'. *The Quest of the Holy Grail*, trans. P. M. Matarasso, London, 2005, pp. 157, 166, 194–5.

38. *A Life of Ramón Lull*, trans. and ed. E. Allison Pears, London 1927, pp. 21–2. For an intricate allegory of an insolent mounted huntsman passing a friar on his left (and thereby pushing him into a ditch), see *Dives and Pauper* (*c*.1405–10), ed. P. Heath Barnum, Oxford 1976, pp. 186–7.

39. *Pisanello: Painter to the Renaissance Court*, op. cit., pp. 87–93, 96–8.

40. *Pisanello*, exh. cat. D. Cordellier and P. Marini, Paris Louvre 1996, no. 186, pp. 287–9.

41. *Pisanello: Painter to the Renaissance Court*, op. cit., p. 96.

42. Plutarch, *Alexander*, 4. 1–7. Passage reprinted by A. Stewart, *Faces of Power: Alexander's Image and Hellenistic Politics*, Berkeley 1993, p. 344.

43. W. J. van Bekkum, 'Alexander the Great in Medieval Hebrew Literature', *Journal of the Warburg and Courtauld Institutes*, 1986, 49, pp. 218–26. Cited by I. C. McManus, 'The modern mythology of the left-handedness of Alexander the Great', in *Laterality*, 2006, 11:6, p. 570.

44. Ibid., pp. 566–72.

45. *Seeing the Face, Seeing the Soul: Polemon's Physiognomy from Classical Antiquity to Medieval Islam*, ed. S. Swain, Oxford 2007, ch. 23, p. 413.

46. Ibid., p. 505, # A10.

47. Ibid., p. 527, # B21.

48. Ibid., p. 659.

49. A. Stewart, *Faces of Power: Alexander's Image and Hellenistic Politics*, op. cit.

50. *Seeing the Face, Seeing the Soul*, op. cit., p. 647; p. 527, # B21.

51. *Picturing the Bible: The Earliest Christian Art*, op. cit., p. 227, fig. 2. Text by F. Harley.

52. See the section on physiognomy in Pomponius Gauricus' *De Sculptura* (1504), ed. and trans. A. Chastel and R. Klein, Geneva 1969, pp. 154–5. 'collum in dextram adclinas onrati, prudentis srudiosique, in sinistram adulteri, ac nullius prudentiae.'

53. Giovan Battista della Porta, *Della Fisionomia dell'Uomo*, ed. M. Cicognani, Parma 1988, p. 242. See also Giovanni Bonifacio, *L'Arte di Cenni*, Vicenza 1616, p. 247. A description by Plutarch of another portrait by Lysippos does not specify the direction of the tilt, and this may have caused confusion: 'When Lysippos had finished his first Alexander looking up with his face turned towards the sky (just as he was accustomed to look, tilting his head slightly to one side), someone not inappropriately inscribed the following epigram: "This statue seems to look at Zeus and say: 'Keep thou Olympos; me let earth obey!'"' A. Stewart, *Faces of Power*, op. cit., pp. 342–4. Della Porta may also have been misled by the right-tilting bust erroneously called *The Dying Alexander* which was then in the Medici collection in Florence: F. Haskell and N. Penny, *Taste and the Antique*, New Haven 1981, pp. 134–6, no. 2 (they cite the Plutarch passage).

54. *Love's Labour's Lost*, ed. R. David, London 1968, p. 166, 5:2:561. 'Too right' can mean too straight, but in this context it also implies that his nose tilts to the right. In the footnote to this

line, only North's translation of Plutarch specifies the left side: no side is mentioned in the references to it in De La Primaudaye's *French Academy* (1577) and Puttenham's *The Arte of English Poesie* (1589).

55. *Pisanello: Painter to the Renaissance Court*, op. cit., pp. 182–4. In figs 4.78 and 4.80, Christ looks to his right. In 4.79, the most accurate copy, the crucified Christ is not visible between the deer's antlers.

56. G. Hill, *Corpus of Italian Medals of the Renaissance before Cellini*, London 1930, vol. 1, pp. 10–11, no. 35. Hill lists eleven.

57. J. L. Koerner, *The Reformation and the Image*, London 2004, p. 204.

58. Origen, *The Song of Songs: Commentary and Homilies*, op. cit., Bk 3, #9, pp. 200–3. See also Hugh of St Victor's crucifixion image in *The Medieval Craft of Memory: An Anthology of Texts and Pictures*, ed. M. Carruthers and J. M. Ziolkowski, Philadelphia 2002, p. 45. D. Summers, *Real Spaces*, London 2003, p. 380, erroneously claims that left and right in Holbein's painted version of Cranach's image, which includes explanatory inscriptions, 'is determined by the textual order of reading from left to right, rather than by the left and right of the image itself'.

59. See also Lorenzo Lotto's *Ponteranica Polyptych* (*c.*1525) in which the blood of Christ, who stands on a cloud, pours into a chalice placed to his left. This seems to have been done in part because the polyptych is lit from Christ's left (liturgical south): P. Humfrey, *Lorenzo Lotto*, New Haven 1997, pp. 52–3.

60. M. Luther, *Theologica Germanica*, trans. B. Hoffman, London 1980, p. 67.

61. His left eye is invisible: but there is no need to assume that it too is open.

62. In Holbein's painted version of Cranach's print, *The Old and New Testament* (*c.*1535), the blood is omitted and Christ's head is turned to his right.

63. J. V. Bainvel, *Devotion to the Sacred Heart: Its Doctrine and History*, trans. E. Leahy, London 1924, p. 152; my italics. From the *Exercises on the Life and Passion of our Saviour Jesus*.

64. The love-stricken Mars in *Venus and Mars* (mid-1480s) is also shown from the left. In the bust-length *Portrait of a Young Man* (*c.*1485, National Gallery of Art, Washington), the evidently love-stricken youth places his right hand over his heart, and thrusts his left

shoulder towards us. Two of his attenuated fingers cross, probably an indication of betrothal.

65. They can be usefully compared to Dosso Dossi's left-sided *Lamentation* in the National Gallery.

66. G. Gurewich, 'Observations on the Wound in Christ's Side', op. cit., p. 361. See also V. Gurewich, 'Rubens and the Wound in Christ's Side. A Postscript', *Journal of the Warburg and Courtauld Institutes*, vol. 26 1963, p. 358; A. A. Barb, 'The Wound in Christ's Side', *Journal of the Warburg and Courtauld Institutes*, vol. 34, 1971, pp. 320–1.

67. This, at any rate, is the implication of the diagram and text in A. Hayum, *The Isenheim Altarpiece: God's Medicine and the Painter's Vision*, Princeton 1989, p. 28, fig. 15; and in *Grünewald et le Retable d'Isenheim*, exh. cat., Colmar 2007, Musée d'Unterlinden, p. 48, fig. 2.

10. The Death of Christ 2: 'Not Idle'

1. Julian of Norwich, *Revelations of Divine Love*, trans. C. Wolters, Harmondsworth 1966, ch. 51, pp. 141ff.

2. *Meditations on the Life of Christ*, trans. I. Ragusa, Princeton 1961, lxxix, p. 336.

3. Ibid., pp. 336–7.

4. Conversely, if the Christ child is sleeping, or holding a pomegranate, then this prophesies his death.

5. The last edition was Cologne, 1607.

6. Bernardinus de Busti, *Mariale*, Milan 1492, pt. 3, sermon 6, # Q–R; cited (and refuted) by Molanus, *De Picturis et Imaginibus Sacris*, Louvain 1570, bk 4 # 8: *Traité des Saintes Images*, trans. F. Boesflug, O. Christin and B. Tassel, Paris 1996, p. 501.

7. J. Hall, 'Saga in Stone: the Taddei Tondo', *RA Magazine*, Spring 2005, p. 85.

8. W. Stechow, 'Jacob Blessing the Sons of Joseph, from Early Christian Times to Rembrandt', *Gazette des Beaux-Arts*, no. 23, 1943, pp. 204ff. The scene was rarely depicted in the late Middle Ages and early Renaissance, but it is included in Pontormo's *Joseph with Jacob in Egypt* (probably 1518) one of a series of panels on the Life of Joseph painted for a Florentine banker; ibid., p. 202.

9. Julian of Norwich, *Revelations of Divine Love*, op. cit., ch. 51, pp. 141ff.

10. The celebrated asymmetry of Titian's *Madonna di Ca'Pesaro* altarpiece of 1519–26 may have been motivated by similar considerations: the foreground of the picture is the area to the left of the Virgin's elevated throne. The Christ Child raises his left leg as if he is about to jump down into the world (here populated by St Francis and the secular members of the Pesaro family), while overhead a cross borne by putti tilts sharply to the left. In Tintoretto's *Virgin and Child with the Infant Baptist and Sts Joseph, Elizabeth, Zacharias, Catherine and Francis* (1540, Private Collection), the Christ-child throws himself to his left (and towards St Francis) with his arms outstretched, making a clear cross-shape, and the Virgin crosses her legs, which probably alludes both to her virginity and to the crucifixion. See T. Nichols, *Tintoretto: Tradition and Identity*, London 1999, pp. 34–5, with comparison to Michelangelo's *Medici Madonna*.

11. See, most recently, H. Chapman, *Michelangelo: Closer to the Master*, exh. cat., London British Museum, 2006, p. 212.

12. F. Hartt, *The Drawings of Michelangelo*, London 1971, p. 215, no. 298, believes it is Christ's soul, but the position, direction, and lack of theological precedent, makes this implausible.

13. C. de Tolnay, *Corpus dei Disegni di Michelangelo*, Novara 1975–80, vol. 1, p. 80, no. 87, believes the greater proximity of the cross means he is the good thief.

14. J. Hall, *Michelangelo and the Reinvention of the Human Body*, London 2005, pp. 174ff.

15. D. Ekserdjian, 'Parmigianino and the *Entombment*', in *Coming About: A Festschrift for John Shearman*, ed. L. R. Jones and L. C. Matthew, Cambridge, Mass. 2001, pp. 165–72; D. Franklin, *The Art of Parmigianino*, New Haven 2003, pp. 153–60.

16. The figure of Christ is comparable to Tintoretto's drawing of *Christ on the Cross* in the V&A, which is squared up for transfer. Christ looks to his left, and has his left foot placed over his right—as occurs in the Scuola di San Rocco *Crucifixion*.

17. *Peomatum Hadriani Iunii Hornani Medici*, Lugduni 1598, p. 90. Cited (and refuted) by Molanus, *De Picturis et Imaginibus Sacris*, op. cit., bk. 4 #9: *Traité des Saintes Images*, op. cit., pp. 504–6.

18. M. Hirst, *Michelangelo and his Drawings*, New Haven 1988, pp. 117–18. *Il Carteggio di Michelangelo*, ed. P. Barocchi and R. Ristori, Florence 1965–, vol. 4, pp. 101, 104–5. In the third letter, she expresses her delight that the angel on Christ's right is more beautiful than that on his left, for St Michael will place Michelangelo himself on Christ's right on the Last Day.

19. Christ looks up to his left in the Crucifixion scene of the *Antwerp-Baltimore Polyptych* (*c*.1400), with an inscribed scroll coming out of his mouth—'My God, My God, Why hast Thou Forsaken Me?' God is shown above the cross to Christ's right. Christ's orientation does help to 'lead into' the neighbouring scene of the Resurrection. H. van Os, *The Art of Devotion in the Late Middle Ages in Europe 1300–1500* exh. cat. Rijksmuseum Amsterdam 1994, pp. 137–50, no. 43c. Text by H. Nieuwdorp.

20. It was made for Santissima Annunziata in Florence. C. Avery, *Giambologna*, London 1993, p. 202 & pl. 226; p. 264 no. 95.

21. Michelangelo, *The Poems*, trans. C. Ryan, London 1996, no.162, ll. 1–6.

22. C. de Tolnay, *Corpus dei Disegni di Michelangelo*, op. cit., vol. 5, nos. 224, 226, 227, 229, 230.

23. A. Condivi, *The Life of Michelangelo*, op. cit., p. 103.

24. W. Harms, *Homo Viator in Bivio*, Munich 1970, pp. 97ff. Both 'arms' are the same width, however.

25. V. Colonna, *Rime*, ed. A. Bullock, Rome-Bari 1982, p. 103, no. 36.

26. Gertrude d'Helfta, *Oeuvres Spirituelles*, trans. and ed. J-M Clément, Paris 1978, vol. 4, pp. 164–6. Cited by N. F. Palmer, '*Herzeliebe*, weltlich und geistlich: Zur Metaphorik vom 'Einwohnen im Herzen' bei Wolfram von Eschenbach, Juliana von Cornillon, Hugo von Langenstein und Gertrud von Helfta', in *Innenräume in der Literatur des deutschen Mittelalters*, ed. B. Hasebrink, H.-J. Schiewer, A. Suerbaum, and A. Volfing, Tübingen 2007, pp. 220–1.

27. Gertrude d'Helfta, *Oeuvres Spirituelles*, op. cit., vol. 4, pp. 62–7, where, by way of contrast, the right side of Christ is the best place from which to feel his heart: St John positions himself on the left side of Christ, and positions Gertrude on the right, because she needs to look through the wound in his side to see the heart. St John's greater sanctity means he can 'see' through Christ's skin.

28. For an erotic reading of the 'slung leg', L. Steinberg, 'The Metaphors of Love and Birth in Michelangelo's Pietà', in *Studies in Erotic Art*, ed. T. Bowie, New York 1970, pp. 231–85.

29. The left arm of *Night* in the Medici Chapel is also missing.

30. Sir Thomas Browne, 'Of the heart', *Pseudoxia Epidemica*, ed. R. Robbins, Oxford 1981, bk. 4, ch. 2.; see also ch. 3: 'Of Pleurisies'; ch. 4: 'Of the Ring finger'; ch. 5: 'Of the right and left hand.'

31. *The Collected Works of St John of the Cross*, trans. K. Kavanaugh and O. Rodriguez, London 1966, frontispiece illustration, and pp. 38–9, 'Note on Drawing of Christ on the Cross'.

32. A view of the crucified Christ, seen from the left, but from below, was included in Pedro Fernández' *Altarpiece of St Helen* (1519–21), in Gerona cathedral.

33. Salvador Dalí also saw the drawing, and his Glasgow *Christ on the Cross* is influenced by it. However, he centralized the composition, making it symmetrical, and classicized Christ.

34. *The Collected Works of St John of the Cross*, op. cit., p. 499.

35. Ibid., pp. 499–500.

36. Ibid., p. 500.

37. St Gertrude had a vision in which a crucifix above her bed tilted towards her, and Christ explained that the love in his heart drew him towards her: Gertrude d'Helfta, *Oeuvres Spirituelles*, vol. 3, ed. & trans. P Doyère, Paris 1968, ch. 42, p. 193.

38. J. Brown, *Velázquez, Painter and Courtier*, New Haven 1986, pp. 158–61.

39. Lope de Vega, *Obras Poéticas*, ed. J. M. Blecua, Barcelona 1983, pp. 371ff; P. J. Powers, 'Lope de Vega and Las lágrimas de la Madalena', in *Comparative Literature*, VIII, 1956, pp. 273–90.

40. *Obras Poéticas*, op. cit., p. 411, ll. 129 ff.

41. Ibid., p. 323, sonnet xvi, l. 10.

42. In one of his early genre pictures, *Christ in the House of Martha* (*c*.1619) Velazquez had shown Mary Magdalene crouching on the ground in front and to the left of a seated Christ. His left forearm rests on the arm of his chair, and the palm of his hand is raised.

43. *Meister Eckhart: the Essential Sermons, Commentaries, Treatises, and Defense*, trans. E. Colledge and B. McGinn, Mahwah 1981, p. 193: sermon 22: 'Ave, gratia plena'; B. McGinn, *The Mystical Thought of Meister Eckhart*, New York 2001, p. 124.

44. A. K. Wheelock, *Johannes Vermeer*, exh. cat., National Gallery of Art, Washington, 1995, pp. 190–5, no. 20.

45. D. Arasse, *Vermeer: Faith in Painting*, trans. T. Grabar, Princeton 1994, p. 86.

46. Ibid., p. 85, believes the cross is excluded for formal reasons: 'a cruciform reflection might have excessively accentuated a burst of light at this spot in the work.' This is unlikely in the seventeenth century.

47. A. K. Wheelock, *Johannes Vermeer*, op. cit., p. 192.

48. L. Gougaud, 'The Beginnings of the Devotion to the Sacred Heart', in *Devotional and Ascetic Practices in the Middle Ages*, London 1927, pp. 75–130; C. M. S. Johns, 'That Amiable Object of Adoration: Pompeo Batoni and the Sacred Heart', in *Gazette des Beaux Arts*, vol. 132, 1998, pp. 19–28; E. J. Sargent, 'The Sacred Heart: Christian Symbolism', in *The Heart*, ed. J. Peto, New Haven 2007, pp. 102–14.

49. C. M. S. Johns, 'That Amiable Object', op. cit., p. 20. Father Joseph de Gallifet, *The Adorable Heart of Jesus*, London 1887, p. 14.

50. M. M. Edmunds, 'French Sources for Pompeo Batoni's 'Sacred Heart of Jesus' in the Jesuit Church in Rome', in *Burlington Magazine*, cxliv, Nov. 2007, pp. 785–9.

51. Gallifet, *The Adorable Heart of Jesus*, op. cit., p. 72.

52. Ibid., pp. 119, 121, & 134.

53. Ibid., p. 73.

54. Ibid., p. 80. One wonders if Gallifet knew of Dryden's *Fables, Ancient and Modern* (1700), which includes a revised version of Boccaccio's tragic tale of Sigismunda, in which the heart of her lover, whom she has secretly married, is sent to her in a golden goblet by her outraged father: 'oft (her Mouth apply'd / To the cold Heart) she kiss'd at once, and cry'd.'

55. C. M. S. Johns, 'That Amiable Object', op. cit., p. 21.

56. Ibid., p. 19.

57. It looks deliciously eucharistic, good enough to eat: I can't help thinking of a Christmas pudding all aflame.

11. Courtly Love

1. G. Cardano, *The Book of My Life*, trans. J. Stoner, New York 2002, p. 18, #5.

2. *Andreas Capellanus on Love*, ed. and trans. P. G. Walsh, London 1982, Bk 2, xxi, #50, p. 269.

3. Augustine, *City of God*, trans. H. Bettenson, Harmondsworth 1984, bk. 22, p. 1074. Her choice of the little finger was an interesting one, to say the least, since the Latin for little finger is 'auricularis', and Isidore of Seville claimed in his *Etymologies* that this was because 'we use it to scrape out the ear (auris)'! *The Etymologies of Isidore of Seville*, trans. S. A. Barney et al., Cambridge 2006, xl: i: 71, p. 235.

4. S. Rapisarda, 'A Ring on the Little Finger: Andreas Capellanus and Medieval Chiromancy', *Journal of the Warburg and Courtauld Institutes*, 2006, pp. 175–91.

5. C. Richter Sherman, *Writing on Hands: Memory and Knowledge in Early Modern Europe*, exh. cat. Seattle 2001, p. 20.

6. Ibid., pp. 20 & 208.

7. Gottfried von Strassburg, *Tristan*, with the surviving fragments of the *Tristan* of Thomas, trans. A. T. Hatto, Harmondsworth 1960, p. 315, ch. 32.

8. Ibid., ch. 28, p. 282. In its right hand it held 'a scepter with a bird perched on it that beat its wings like a live bird'—perhaps a symbol of the human soul.

9. Ibid., ch. 32, p. 316.

10. In the *Roman de Tristan* (*c.*1240), two fisherman who rescue the King of Cornwall from a river know he is of noble stock because of his fine physique and his ring: 'On the little finger of his left hand, he wore a gold ring, which was very expensive and very beautiful, with a precious stone.' *Le Roman de Tristan*, ed. R. L. Curtis, Cambridge 1985, vol. I, p. 55, #43. Cited by S. Rapisarda, 'A Ring on the Little Finger', op. cit., p. 176.

11. R. Schoch, M. Mende, and A. Scherbaum, *Albrecht Dürer: Das Druckgraphische Werke*, vol. 1, Munich 200, no. 18, pp. 65–7. They cite Panofsky's argument that the ring refers to the story of 'Venus and the Ring', in which a young man took a ring from the finger of a statue of Venus. Titian's *Danae* has a ring on the little finger of her *right* hand: her left hand is invisible to us. In Titian's images of Venus, when both hands are visible, the ring is placed on the goddess's left hand.

12. D. Franklin, *Painting in Florence 1500–1550*, New Haven 2001, p. 225, fig. 179.

13. See also Bronzino's *Portrait of a Young Man* (Metropolitan Museum, New York) and *Study of a Young Man* (Chatsworth).

14. D. Ekserdjian, *Parmigianino*, New Haven 2006, pp. 129–32.

15. M–C. Pouchelle, *The Body and Surgery in the Middle Ages*, Cambridge 1990, p. 119.

16. P. Cunnington and C. Lucas, *Costume for Births, Marriages and Deaths*, London 1972, p. 117.

17. J. Herald, *Renaissance Dress in Italy 1400–1500*, London 1981, p. 185.

18. Ibid. See also E. Welch, 'New, Old and Second-hand Culture: the Case of the Renaissance Sleeve', in *Revaluing Renaissance Art*, ed. G. Neher and R. Shepherd, Aldershot 2000, pp. 101–20. Welch does not, however, discuss *left* sleeves, though they are mentioned in some of the inventories she cites.

19. J. Woods-Marsden, 'Portrait of the Lady', in *Virtue and Beauty*, exh. cat. Washington National Gallery of Art, 2001, p. 69.

20. R. W. Lightbown, *Mediaeval European Jewellery*, London 1992, pp. 96–100.

21. S. Coren, *The Left-Hander Syndrome: the Causes and Consequences of Left-Handedness*, London 1992, pp. 13 and 17. R. Hertz, 'The Pre-eminence of the Right Hand', in *Right & Left: Essays on Dual Symbolic Classificiation*, ed. R. Needham, Chicago 1973, p. 12.

22. F. Colonna, *Hypnerotomachia Poliphili*, trans. J. Godwin, London 1999, p. 167.

23. J. Woods-Marsden, 'Portrait of the Lady', in *Virtue and Beauty*, op. cit., p. 69.

24. J. Huizinga, *The Autumn of the Middle Ages*, trans. R. J. Payton and U. Mammitzsch, Chicago 1996, pp. 42ff.

25. For more on this, E. Gombrich, 'Ritualised Gesture and Expression in Art', in *The Image and the Eye*, Oxford 1982, pp. 63–77.

26. La Curne de Sainte Palaye, *Mémoires sur l'Ancienne Chevalerie*, Paris 1759, vol. 2, pp. 188–9 & note 'C'; J. Paviot ed., 'Les États de France d'Éléonore de Poitiers', *Annuaire-Bulletin de la Société de l'Histoire de France*, Paris 1998, pp. 86 & 82 (for commentary); idem., 'Les Marques de Distance dans les Honneurs de la Cour d'Aliénor de Poitiers', in *Zeremoniell und Raum*, ed. W. Paravicini, Sigmaringen 1997, pp. 91–6. Paviot concurs with La Curne's interpretation of the gesture.

27. Paviot states that the 'au-dessous' position was only honorific if occupied by a woman; if a man had the woman on his right it merely demonstrated her superior status. Ibid., p. 93.

28. *Mémoires d'Olivier de la Marche*, Paris 1885, vol. 3, pp. 120–1; 200.

29. Oresme does not exactly approve, either, and adds: 'Right is more noble than left'. R. Mullally, 'Reconstructing the Carole', in *On Common Ground 4: Reconstruction and Re-Creation in Dance before 1850*, Proceedings of the Fourth Dolmetsch Historical Dance Society, ed. D. Parsons, London 2003, pp. 80–1. Mullally argues that the *carole* was only a circular dance, but illustrations also show dancers in a line.

30. I am grateful to Françoise Carter for this information. Guillaume de Lorris, *Le Roman de la Rose*: 'Deduis la tint parmi le doi / A la carole, et elle lui' (ll. 836–7). The translation is from Chaucer, *The Romaunt of the Rose*, ll. 352–3.

31. Perhaps this convention lies behind the affectation of drinking tea with the little finger of the cup hand outstretched.

32. The nearest equivalent I have found to the gestures of the Arnolfinis occurs in Lorenzo Ghiberti's roughly contemporaneous panel of *Solomon and Sheba* for the second set of Baptistery doors. Solomon faces the Queen of Sheba and greets her by holding her right hand in his left; she places her left hand over her heart.

33. *Illuminating the Renaissance: The Triumph of Flemish Manuscript Painting in Europe*, exh. cat, eds. T. Kren and S. McKendrick, J. Paul Getty Museum Malibu, 2003, pp. 215–16, no. 51.

34. Lorenzo de' Medici, *Comento de' Miei Sonetti*, ed. T. Zanato, Florence 1991, vol. 2, no. CXXXVII, ll. 9–11.

35. *The Autobiography of Lorenzo de' Medici the Magnificent: A Commentary on my Sonnets*, trans. J. W. Cook, Binghamton 1995, p. 123. I have slightly adapted some of these translations.

36. Macrobius, *The Saturnalia*, bk. 7:13:8, p. 498.

37. *The Etymologies of Isidore of Seville*, trans S. A. Barney et al., Cambridge 2006, p. 392, xix. xxxii. 2.

38. Francesci Barbaro, *De Re Uxoria*, Florence 1533, bk 1, ch. 8. I am grateful to Beverly Louise Brown for this reference. See also her essay, 'The Bride's Jewellery: Lorenzo Lotto's Marriage Portrait of Marsilio and Faustina Cassotti', in *Apollo*, forthcoming 2008. The ring is placed on the bride's left hand here and in Lotto's paintings of the mystic marriage of St Catherine.

39. The paintings include Fra Angelico, *Marriage of the Virgin* (1425–6), Prado, Madrid; Rosso Fiorentino, *Marriage of the Virgin* (1523), Florence, San Lorenzo. C. Klapisch-Huber uses these pictures as illustrations to an article claiming that the ring was placed on the right finger: *Women, Family and Ritual in Renaissance Italy*, Chicago 1985, pp. 196–209.

40. A. Bouché-Leclercq, *Histoire de la Divination dans L'Antiquité*, Paris 1882, vol. 4, pp. 20–3; F. Guillaumont, 'Laeva prospera: Remarques sur la droite et la gauche dans la divination romaine', in *D'Héraklès à Poseidon: Mythologie et protohistoire*, ed. R. Bloch, Geneva 1985, pp. 157–99.

41. One wonders too if he knew anything of the Chinese system of etiquette in which left is usually aligned with the east and is the honourable side. See M. Granet, 'Right and Left in China', in *Right & Left: Essays on Dual Symbolic Classificiation*, ed. R. Needham, Chicago 1973, pp. 43–58.

42. J. Paviot, 'Les Marques de Distance dans les Honneurs de la Cour d'Aliénor de Poitiers', in *Zeremoniell und Raum*, op. cit., p. 93.

43. H. van Os et. al., *Netherlandish Art in the Rijksmuseum 1400–1600*, Amsterdam 2000, no. 2, pp. 50–1; L. Cambell, *Renaissance Portraits*, New Haven 1990, p. 61, no. 70.

44. In the next century Antonis Mor depicted several beautiful women facing to their left with their left arms extended and adorned with jewels and flowers. *Dynasties*, exh. cat., ed. K. Hearn, London, Tate Gallery 1995, no. 21. A British full-length 'double' portrait, probably of Sir George Delves (1577), shows him squeezing with his right hand the bared left hand of a lady whose face is concealed by a myrtle branch, symbol of Venus. She wears a signet ring on the little finger. Ibid., no. 56. Titian's *Venus with a Mirror* was painted over a double-portrait of a couple in which the woman stands to the man's right.

45. T. D. Kendrick, 'A Flemish painted shield', *The British Museum Quarterly* 9, 13: 2, 1939, pp. 33–4.

46. G. Cardano, *The Book of My Life*, op. cit., p. 18, #5.

47. Caravaggio's fortune-tellers are 'old school', and read the palm of their male clients' right hand: could this indicate that they are charlatans?

48. Girolamo Cardano, *Lettura della Fronte: Metoposcopia*, ed. and trans. A. Arecchi, Milan 1994, p. 28. The three male heads in Titian's

Allegory of Prudence follow this disposition, and are lit by a cool 'lunar' light from the left. However, it is only the old man, and the grizzled allegorical lion, who have 'marks' on their forehead.

49. Lorenzo de' Medici, *Comento de' Miei Sonetti*, op. cit., pp. 123–9. There are eight manuscript versions of the 'Comento'. The poems were first published in 1554; the 'Comento' in 1825.

50. *The Autobiography of Lorenzo de' Medici*, op. cit., pp. 123–5.

51. Cf. the exquisite dancing couple in the heart-shaped *Chansonnier de Jean de Montchenu* (*c*.1475); Lo Scheggia's *Cassone Adimari* (1440s), with its five pairs of doting dancers.

52. *Renaissance Florence: The Art of the 1470s*, exh. cat., P. L. Rubin & A. Wright, London National Gallery, 1999, pp. 338ff, no. 91, p. 341.

53. In *Parzival*, Wolfram von Eschenbach breezily comments on the lax morals of Arthur's knights: 'The whole Table Round without exception were at Dianazdrun with Arthur the Briton...I would most certainly not have brought my wife to such a concourse— there were so many young bloods there! I should have been afraid of jostling strangers. Someone or other would have whispered to her that her charms were stabbing him and blotting out his joy, and that if she would end his pangs he would serve her before and after. Rather than that I would hurry away with her.' Wolfram von Eschenbach, *Parzival*, trans. A. T. Hatto, London 1980, ch. 4, p. 116.

54. They had probably also been egged on by the *Art of Courtly Love*, for here we are breezily informed that 'Love is nothing other than an uncontrolled desire to obtain the sensual gratification of a stealthy and secret embrace. Now I ask you: what stealthy embrace could take place between a married couple...?' *Andreas Capellanus on Love*, op. cit., bk 1 # 368.

55. M. Keen, *Chivalry*, New Haven 1984, no. 27.

56. Lorenzo de' Medici, *Comento de' Miei Sonetti*, op. cit., p. 212.

57. R. Strong, *Artists of the Tudor Court: the portrait miniature rediscovered 1520–1620*, exh. cat., London, Victoria & Albert Museum, 1983, p. 75, no. 83, says it has never been 'satisfactorily explained or translated'.

58. T. Lubbock, 'Great Works: Portrait of an Unknown Man Clasping a Hand from a Cloud', *Independent*, 2 June 2006, p. 30 of the review.

59. Thoinot Arbeau, *Orchésographie* (1588), Langres 1988, p. 26.

60. *Trattato dell'arte del ballo di Guglielmo Ebreo Pesarese*, ed. F. Zambrini, Bologna 1873, pp. 65–8. Cited by M. Baxandall, *Painting and Experience in Fifteenth Century Italy*, Oxford 1972, p. 78.

61. Lorenzo de' Medici, *Opere*, ed. A. Simioni, Bari 1914, vol. 2, p. 211.

62. 'Specchio d'Amore dialogo di Messer Bartolomeo Gottifredi nel quale alle giovani s'insegna innamorarsi' (Florence 1547) in Giovanni della Casa, *Prose*, ed. A. di Benedetti, Turin 1970, p. 606. In addition, the lovers are encouraged to communicate using secret signs, such as re-arranging the left sleeve of their shirt.

63. Veronica Franco, *Rime*, ed. S. Bianchi, Milan 1995, no. 2, L 145–50, p. 60.

64. T. Nichols, *Tintoretto: Tradition and Identity*, London 1999, pp. 90–3. The positions are reversed in the version of *c*.1550 in the Louvre: we see Susanna's right side, and it is much less physically alluring than the left side of the Vienna Susanna. Further lowering the temperature is the cool stare that Susanna throws at us. The elders get a full view of her left side, impeded only by her hair, which is being combed. This may be the Italian picture to which Diderot twice refers in his Salons: 'This picture takes considerable liberties, but no one is offended by it.' *Diderot on Art*, trans. J. Goodman, New Haven 1995, vol. 1, p. 13 & vol. 2, p. 50. The held up hair does, at first sight, look like clothes.

65. *Le Siècle de Titien*, exh. cat. Paris Louvre 1993, no. 43, pp. 340–8.

66. Thoinot Arbeau, *Orchésographie*, op. cit., p. 8.

67. P. Bembo, *Prose e Rime*, ed. C. Dionisotti, Turin 1960, p. 509.

68. J. Campbell, 'NB', *Times literary Supplement*, 22 June 2007, p. 32. Campbell is objecting to the recommendation of a style guide to outlaw the phrase: 'It is rarely the right foot.' C. Howse and R. Preston, *She Literally Exploded*, London 2007.

69. J. Boulton, *Knights of the Crown*, Woodbridge 1987, ch. 4, pp. 96ff.

70. J. Vale, *Edward III and Chivalry*, Woodbridge 1982, pp. 76ff.

71. 'les garters qe bien me seoient a mon avys—qe gaires ne vaut'. Henry of Lancaster, *Livre de Seyntz Medicines*, ed. E. J. Arnauld, Oxford 1940, p. 72. Cited by C. M. Woolgar, *The Senses in Late Medieval England*, New Haven 2006, p. 77.

72. Boulton, *Knights of the Crown*, op. cit., p. 157.

73. Ibid., p. 158.

74. Cited by C. W. Cunnington and P. Cunnington, *Handbook of Medieval Costume*, London 1969, p. 92, # 4.

75. Boulton, *Knights of the Crown*, op. cit., p. 142.

76. C. M. Woolgar, *The Senses in Late Medieval England*, op. cit., pp. 158–9. Woolgar cites Isidore of Seville on the colour of horses.

77. *The Autobiography of Lorenzo de' Medici*, op. cit., p. 119.

12. Fragile Beauty

1. Johann Joachim Winckelmann, *Kleine Schriften, Vorreden, Entwürfe*, ed. W. Rehm, Berlin 1968, p. 171.

2. M. Camille, *Gothic Art*, London 1996, p. 89.

3. The most complete account is H. W. Janson, *The Sculpture of Donatello*, Princeton 1979, pp. 23–32. I am not convinced by Janson's argument (which is followed by some others) that he held a bronze sword in his right hand: I don't believe the marble could have supported the weight, and St George usually holds a sword after he has mortally wounded the dragon with his lance, whereas Donatello's St George is not yet engaged in battle. If he held a weapon, the most likely is a broken spear: this is what he is given in a depiction of the statue on a majolica dish from the early sixteenth century. This is reproduced in J. Pope-Hennessy, *Donatello Sculptor*, New York 1993, p. 47. Pope-Hennessy discounts any bronze props.

4. H. W. Janson, *The Sculpture of Donatello*, op. cit., p. 24.

5. J. Pope-Hennessy, *Donatello Sculptor*, op. cit., p. 48.

6. H. W. Janson, *The Sculpture of Donatello*, op. cit., p. 24.

7. B. A. Bennett and D. G. Wilkins, *Donatello*, Oxford 1984, p. 199, note the strangeness of the pose.

8. The designer of a majolica dish depicting St George in the early sixteenth century was evidently flummoxed by this for he placed the shield much closer to the left foot. J. Pope-Hennessy, *Donatello Sculptor*, op. cit., p. 47, fig. 39.

9. *Oeuvres complètes de Saint Bernard*, ed. and trans. M. L'Abbé Charpentier, Paris 1873, vol. 3, p. 139.

10. *The Quest for the Holy Grail*, trans. P. M. Matarasso, London 2005, pp. 42–3, 51, 53ff.

11. *Christine de Pizan's Letter of Othea to Hector*, trans. J. Chance, Cambridge 1997, p. 115, # 94.

12. For Ajax, see B. Kennedy, *Knighthood in the Morte d'Arthur*, Woodbridge 1992, pp. 299–301. In *Lancelot of the Lake*, trans. C. Corley, Oxford 2000, p. 345, Guinas boasts he would not even need his shield to defeat Hector, but loses, and then loses again when armed. Classical writers said that Ajax committed suicide after losing out to Odysseus in the (verbal) contest to inherit the armour of the dead Achilles. Some claimed he went mad first, but Ovid says he immediately stabbed himself in the heart with his sword. This may be where Christine got the idea that he exposed his 'heart' side in battle.

13. J. Huizinga, *The Autumn of the Middle Ages*, trans. R. J. Payton and U. Mammitzsch, Chicago 1996, pp. 102 & 115.

14. *The Works of Sir Thomas Malory*, ed. E. Vinaver, revised P. J. C. Field, Oxford 1990, vol. III, bk 19: 9, pp. 1139–40 & see note p. 1611. Already in bk 6: 17, Lancelot had offered to disarm himself except for his sword in order to fight Sir Pedivere, who was trying to kill his own wife but was now begging for mercy. For both incidents see B. Kennedy, *Knighthood in the Morte d'Arthur*, op. cit., pp. 123–4 & 299–301.

15. Jacobus de Voragine, *The Golden Legend*, trans. W. G. Ryan, Princeton 1993, vol. 1, p. 239. The focal point of the Order of the Garter was St George's Chapel at Windsor Castle, which Edward III refounded and rebuilt on a lavish scale.

16. M. Keen, *Chivalry*, New Haven 1984, p. 206.

17. A parallel might be drawn with Donatello's *Marzocco* (1418–20), the heraldic lion of Florence which he carved immediately afterwards. The shield bearing the Florentine coat of arms is propped up on the ground beneath the lion's right paw, while the lion looks inquisitively to his left.

18. See, for example, the armour in the contemporaneous relief of *The Judgement of Solomon* on Palazzo Ducale, Venice: J. Pope-Hennessy, *Italian Gothic Sculpture*, London 1996, p. 219, pl. 221. Janson called for the armour to be properly studied by an expert but this has not happened, except for brief comments by R. W. Lightbown, *Donatello and Michelozzo*, London 1980, vol. 1, p. 85.

19. G. Bonifacio, *L'Arte di Cenni*, Vicenza 1616, p. 413, 'Piede sinistro avanti'; *Aeneid*, bk. 10.

20. J. Wilde, *Michelangelo*, Oxford 1978, p. 39.

21. In the Louvre study for the bronze David, we see the exultant David from the left, and because his left hand is withdrawn behind his buttock, his whole side is opened up to inspection.
22. Michelangelo, *The Poems*, trans. C. Ryan, London 1996, no. 98, p. 93.
23. Vittoria Colonna wrote a series of amorous justificatory sonnets in memory of her husband, the Marquese di Pescara, after his early death.
24. In Dante's *Paradiso*, St Bonaventura tells the poet that during his life he paid less attention to remedies for the body [la sinistra cura] than for the soul: 'nei grandi offici/ Sempre posposi la sinistra cura' [12: 128–9].
25. Michelangelo, *The Poems*, op. cit., no. 177.
26. Michelangelo, *Rime*, intro. G. Testori, ed. E. Barelli, Milan 1975, p. 238, n. 1.
27. C. Ryan, in Michelangelo, *The Poems*, op. cit., p. 306, n. 177.
28. *The Etymologies of Isidore of Seville*, trans. S. A. Barney et al., Cambridge 2006, xl: I: 68, p. 235.
29. Michelangelo, *The Poems*, op. cit., no. 178, ll. 1–5.
30. I. Lavin, *Bernini and the Unity of the Visual Arts*, New York 1980, vol. 1, pp. 75–140.
31. *The Life of Saint Teresa of Avila By Herself*, trans. J. M. Cohen, Harmondsworth, 1957, ch. XXIX, paras. 12–13. *Escritos de Santa Teresa*, ed. Don Vicente de la Fuente, Madrid 1952, I, p. 89.
32. *The Complete Works of Saint Teresa of Jesus*, trans. and ed. E. Allison Peers, London 1946, vol. 3, p. 282, poem III, 'Yo todo me entregué . . .'.
33. I. Lavin, *Bernini*, op. cit., pp. 93–4.
34. The Museo di Roma in Palazzo Braschi holds a number of seventeenth-century paintings of tournaments.
35. *The Complete Works of Saint Teresa of Jesus*, op. cit., ch. 1, p. 203.
36. Ibid., ch 2, pp. 207–8.
37. Ibid., ch. 2, p. 205.
38. I. Lavin, *Bernini*, op. cit., p. 121.
39. Translation from M. Praz, *The Romantic Agony*, trans. A. Davidson, Oxford 1970, p. 48, n. 19.
40. Giambattista della Porta, *Della Fisonomia dell'Uomo*, ed. M. Ciconani, Parma 1986, p. 242. 'Dal Collo', ch. 22. A neck inclined to the right signifies prudence and studiousness [prudente e studioso].

41. By this time it had become more acceptable to situate Christ's wound on the left of his torso, or shown from the left, as Bernini did in his lost painting of the *Vision of the Blood of the Redeemer* (*c.*1670), known from an engraving. The cross hovers in mid-air, over a sea that has been created by the blood streaming from all five wounds. The wound in his side is on the right side, but the focus of the entire composition is on his left side. Christ is illuminated from the left, and the left side of his chest has become the dazzling centrepiece of the composition. In the late seventeenth century, a large painting of the Crucifixion was installed over an altar in Bernini's church of S. Andrea al Quirinale, and the wound was placed on the left. V. Gurewich, 'Observations on the Wound in Christ's Side, with Special reference to its Position', in *Journal of the Warburg and Courtauld Institutes*, 20, 1957, p. 362.

42. J. W. Goethe, *Italian Journey*, trans. W. H. Auden and E. Mayer, Harmondsworth 1970, p. 167, 28 January 1787.

43. For water metaphors, B. M. Stafford, 'Beauty of the Invisible: Winckelmann and the Aesthetics of Imperceptibility', *Zeitschrift für Kunstgeschichte*, 43, 1980, pp. 65–78.

44. J. J. Winckelmann, *History of the Art of Antiquity*, trans. H. F. Mallgrave, Los Angeles 2006, p. 314, pt 2.

45. A. Potts, *Flesh and the Ideal: Winckelmann and the Origins of Art History*, New Haven 1994, p. 142, quotes it but then misreads it.

46. Goethe, 'On the Laocoon Group' (1798), in *The Collected Works, Volume 3: Essays on Art and Literature*, ed. J. Gearey, Princeton 1986, p. 18.

47. Cesare Ripa, *Iconologia*, ed. P. Buscaroli, Milan 1992, p. 14.

48. All quotes from Henri Fuseli's 1765 translation, reprinted in full in *Winckelmann: Writings on Art*, ed. D. Irwin, London 1972.

49. C. Johns, 'That Amiable Object of Adoration: Pompeo Batoni and the Sacred Heart', *Gazette des Beaux Arts*, 132, 1998, p. 20. Cardinal Albani had published his uncle's letters, briefs, and bulls in 1727.

50. F. E. Stoeffler, *German Pietism During The Eighteenth Century*, Leiden 1973, p. 153. The phrase is that of the leading Lutheran reformer Nikolaus Ludwig von Zinzendorf (1700–60).

51. William Hogarth, *The Analysis of Beauty*, ed. R. Paulson, New Haven 1997, p. 64, ch. xi.

52. J. J. Winckelmann, *Kleine Schriften Vorreden Entwürfe*, op. cit., p. 171.

53. J. J. Winckelmann, *History of the Art of Antiquity*, op. cit., pt 2, p. 323.

54. Ibid., pt 1, ch. 4, p. 213.

55. The only exception occurs on the rare occasions when the heart is on the right side, a condition known as 'situs inversus': the left testis is larger. C. McManus, *Right Hand, Left Hand*, London 2002, pp. 226, 291–2.

56. N. J. Wade, 'Eye Dominance' in *A Natural History of Vision*, Cambridge Mass. 1998, pp. 284–7.

57. Orfeo Boselli, *Osservazioni sulla scultura antica*, ed. A. P. Torresi, Ferrara 1994, ch. xviii, p. 212.

58. F. Haskell and N. Penny, *Taste and the Antique*, New Haven 1981, pp. 172–3, no. 18.

59. The cult of fragile beauty espoused by Winckelmann and Boselli may have influenced the restoration of what is perhaps the most erotic large scale antique sculpture, the *Barberini Faun*, a fragment of which was found in the moat of Castel Sant'Angelo in 1627, and which was first restored by Cardinal Barberini's sculptor, Arcangelo Gonelli. It has always been viewed and reproduced from the left. The Marquis de Sade called it this 'sublime statue grecque', and Edmé Bouchardon made a full scale copy that is now in the Louvre. Almost exactly the same viewpoint was adopted by Gustave Courbet for his equally explicit painting of a reclining female nude, *The Origin of the World* (1866), though the format of the painting crops her body in a way that is remarkably similar to the fragmentary *Belvedere Torso*. Most of Courbet's solitary depictions of pretty women, both naked and clothed, show them from their 'heart' side, but none exhibit such radical anatomical distortion and cropping. For the *Barberini Faun*, J. Montagu, *Roman Baroque Sculpture: the Industry of Art*, New Haven 1989, pp. 163–9; F. Haskell and N. Penny, *Taste and the Antique*, op. cit., pp. 202–5, no. 33.

13. Leonardo and the Look of Love

1. J. Pope-Hennessy, *The Portrait in the Renaissance*, Princeton 1979, ch. 3 'The Motions of the Mind', pp. 101ff.

2. As far as I know, this has not been commented on. No other image of Vitruvian Man exhibits a comparable asymmetry.

3. This is what Leonardo essentially provided for Isabella d'Este, the Marchesa of Mantua—albeit awkwardly tacked onto a twisting torso.

4. D. Alan Brown, *Leonardo da Vinci: Origins of a Genius*, New Haven 1998, pp. 101–22.

5. The portrait is often compared to Verrocchio's *Lady with a Bunch of Flowers*, by which it was probably influenced, but Verrocchio's lady looks slightly to her left and is more relaxed and approachable.

6. *Leonardo on Painting*, ed. and trans. M. Kemp and M. Walker, New Haven 1989, pp. 144–6.

7. J. Woods-Marsden, 'Portrait of the Lady', in *Virtue and Beauty*, exh. cat. Washington National Gallery of Art, 2001, p. 76.

8. A. C. Fox-Davies, *A Complete Guide to Heraldry*, London 1969, ch. 32, 'Marks of Bastardy', p. 389.

9. C. A. Bucci, 'Cecelia Gallerani' in *Dizionario Biografico Italiano*, vol. 51, Rome 1998, pp. 551–3.

10. *Leonardo on Painting*, op. cit., pp. 24–6.

11. E. Gombrich, 'Leonardo and the Magicians', in *Gombrich on the Renaissance 4: New Light on Old Masters*, London 1986, p. 67.

12. Ibid. Codex Urbino 109r and v.

13. Anonymous Latinus, *Book of Physiognomy* (probably end of fourth century). *Seeing the Face, Seeing the Soul: Polemon's Physiognomy from Classical Antiquity to Medieval Islam*, ed. S. Swain, Oxford 2007, p. 561, #7. First printed edition by Du Moulin in 1549.

14. In an innovative portrait attributed to Fra Bartolomeo, *Costanza de' Medici* (*c.*1490), the sitter boldly pushes her left elbow, which rests on a table, towards the viewer. On the table are sewing implements, so here, in a very direct way, the projection of the left side underscores her femininity.

14. Prisoners of Love

1. Torquato Tasso, *Aminta e Rime*, ed. F. Flora, Turin 1976, vol. I, p. 99, no. xxxvii.

2. *Petrarch's Lyric Poems*, trans. and ed. R. M. Durling, Cambridge, Mass. and London 1976, pp. 190–1, no. 88, ll. 5–8.

3. A. G. Clarke, 'Metoposcopy: An Art to Find the Mind's Construction in the Forehead', in *Astrology, Science and Society: Historical*

Essays, ed. P. Curry, Woodbridge 1987, p. 181. Girolamo Cardano, *Lettura della Fronte: Metoposcopia*, ed. A. Arecchi, Milan 1994, p. 27.

4. *Petrarch's Lyric Poems*, op. cit., pp. 368–9, no. 214, ll. 23–4.

5. Ibid., pp. 560–1, no. 360, ll. 9–15.

6. J. Freccero, 'Dante's Firm Foot and the Journey Without a Guide', in *Harvard Theological Review*, 52, 1959, esp. pp. 261ff.

7. 'Sed, moraliter loquendo, pes inferior erat amor, qui trahebat ipsum ad inferiora terrene, qui erat firmior et fortior adhuc in eo quam pes superior, idest amor qui tendebat ad superna'. Cited in Dante Alighieri, *La Divina Commedia*, ed. G. A. Scartazzini, Milan 1911, p. 6, n. 30.

8. S. Foster Damon, *A Blake Dictionary*, Hanover 1988, p. 140, 'Foot'. J. Wicksteed, *Blake's Vision of the Book of Job*, London 1910, 'Appendix'.

9. *Collected Works of Erasmus*, trans. and ed. R. A. B. Mynors, Toronto 1992, vol. 34, II: ix: 49, pp. 108–9.

10. F. Haskell and N. Penny, *Taste and the Antique*, New Haven 1981, pp. 308–10. Its subject is still unclear.

11. Master Gregorius, *The Marvels of Rome*, trans. J. Osborne, Toronto 1987, ch. 7, p. 23.

12. L. Barkan, *Unearthing the Past: Archaeology and Aesthetics in the Making of Renaissance Culture*, New Haven 1999, p. 152.

13. J. Freccero, 'Dante's Firm Foot', op. cit., pp. 259ff.

14. Jean-Baptiste Thiers *Traité des Superstitions qui regardent les Sacrements* Avignon 1777, p. 516, #6.

15. Boccaccio, *Amorosa Visione*, trans. R. Hollander et al., Hanover NJ 1986, canto xlv, ll. 10–24.

16. R. W. Lightbown, *Mediaeval European Jewellery*, London 1992, p. 368.

17. D. Cordellier and P. Marini, *Pisanello*, exh. cat. Louvre Paris 1996, no. 102, pp. 182–4; *Pisanello: Painter to the Renaissance Court*, exh. cat. L. Syson and D. Gordon, National Gallery London 2001, pp. 70–1.

18. cf *The Death of King Arthur*, trans. J. Cable, Harmondsworth 1971, #14, p. 30. The vavasour's daughter says to Sir Lancelot: 'My Lord, I thank you. Do you know what you have granted me? You have promised to wear my right sleeve on your helmet at the tournament, instead of a plume, and to bear arms through love for me.' Fileno

ties Biancifiore's veil to his helmet in Boccaccio's *Il Filocolo*, trans. D. Cheney, New York 1985, bk 3, p. 155.

19. Wolfram von Eschenbach, *Parzival*, trans. A. T. Hatto, London 1980, ch. 7, pp. 193 & 200–1. Wolfram was evidently very excited by the idea of a beautiful woman in rags. Prior to the sleeve episode, Parzival comes across the lady on a horse who has been humiliated by her husband because he believes she colluded with Parzival when he robbed her of her ring, and had even allowed herself to be raped: 'It was no more than a net of rags that she was wearing. Where this served as cover for her body, dazzling whiteness met Parzival's gaze. Elsewhere she had suffered from the sun. Wherever she had it from, her lips were red, their colour was such that you could have struck fire from them. From whichever quarter you might have had at her it would have been on the open side!' [Wolfram von Eschenbach, *Parzival*, op. cit., p. 136]. The 'open side' is the side of a fully armed knight that is not protected by his shield.

20. M. Keen, *Chivalry*, New Haven 1984, p. 30.

21. R. Levi Pisetzky, *Storia del Costume in Italia*, Milan 1966, vol. 3, pp. 166ff. See also E. M. Dal Pozzolo, 'Sotto il Guanto', *Venezia Arte*, vol. 8, 1994, pp. 29–36.

22. *Dante's Lyric Poetry*, trans. and ed. K. Foster and P. Boyde, Oxford 1967, no. 80, pp. 171–5.

23. One thinks too of the poem in which Michelangelo offers to clothe his 'cavalier armato' [Tommaso de' Cavalieri] in a gown and shoes made from his own flayed skin. Michelangelo, *The Poems*, trans. C. Ryan, London 1996, no. 94.

24. In Titian's *Portrait of a Young Man in a Red Cap* (*c.*1511), the melancholy young man holds the hilt of his sword with his (tattered) gloved hand, and looks sadly away to his right. The sword is held almost vertically, forming a cross shape, as if he were imagining Sir Perceval's penitential stabbing of his left thigh. According to P. Joannides, *Titian to 1518*, New Haven 2001, p. 210, 'the gaze seems to be one of regret', while the hand is held on an 'unusually prominent sword, rare in portraits not explicitly martial'.

25. Jacobo Sannazaro, *Opere Volgari*, ed. A. Mauro, Bari 1961, p. 72, #ix, 32–4.

26. N. Penny, *The Sixteenth Century Paintings, volume 1: Paintings from Bergamo, Brescia and Cremona*, London 2004, pp. 200–5; M. Gregori,

'Giovan Battista Moroni', in *I Pittori Bergamaschi: Il Cinquecento 3*, Bergamo 1979, p. 273, no. 123.

27. N. Penny, *The Sixteenth Century Paintings*, op. cit., p. 200.

28. By Stella Maria Pearce (Newton) in the National Gallery dossier. Ibid., p. 200 & p. 205 n. 6.

29. Ibid.

30. *Oeuvres de Georges Chastellain*, ed. Baron K de Lettenhove, Brussels 1866, vol 8, p 79ff. A description appears on pp. 69–70.

31. Statutes published in *Society at War*, ed. C. T. Allmand, London 1973, pp. 25–7.

32. Ibid., pp. 26–7.

33. N. Penny, *The Sixteenth Century Paintings*, op. cit., p. 200. The foot-brace of course makes it impossible for him to wear any armour on his left leg: hence its omission from the pieces on the floor.

34. Marsilio Ficino, *Commentary on Plato's Symposium on Love*, trans. Sears Jayne, Dallas, 1985, p. 97; see also Boiardo, *Orlando Innamorato* (1492/3), trans. Charles Stanley Ross, Berkeley 1989, Canto I, 2.

35. Richard W. Kaeuper, *Chivalry and Violence in Medieval Europe*, Oxford 1999, p. 224.

36. *The Genius of Venice*, exh. cat., ed. J. Martineau and C. Hope, Royal Academy of Arts, London 1983, p. 364. One might compare this with Vasari's description of the Giorgione painting in which a warrior takes his armour off, so that all sides of his body are reflected by it. It was a polemical picture painted to show the ability of painting to show objects from all sides, like sculpture. Giorgio Vasari, *Lives of the Painters, Sculptors and Architects*, trans. G. du C. de Vere, London 1996, vol. 1, p. 644.

37. *Rime di Lucia Albani*, ed. A. Foresti, Bergamo 1903.

38. N. Penny, *The Sixteenth Century Paintings*, op. cit., pp. 221–3.

39. The National Gallery simultaneously bought from the Avagadro family another portrait by Moroni's teacher, Moretto da Brescia. Painted in 1526, it may depict Conte Faustino's father, Gerolamo II Avogadro, and is the earliest independent Italian full-length portrait. There is a colour contrast here that may be symbolic: the left leg and shoe is a funeral black, while the right is mauve.

40. E. Langmuir, *The National Gallery Companion Guide*, London 2004, pp. 142–3, makes this point in her entry on the picture.

41. *Enciclopedia dello Spettacolo*, Rome 1955, vol. 2, col. 1075, 'Brescia'.

42. E. Pavoledo, 'Le theatre de tournoi en Italie' in *Le lieu theatral à la Renaissance*, ed. J. Jacquet, Paris 1964, p. 101.

43. R. C. Trexler, *Public Life in Renaissance Florence*, New York 1980, p. 235.

44. R. Strong: *The Cult of Elizabeth: Elizabethan Portraiture and Pageantry*, London 1977, pp. 129–61.

45. R. W. Lightbown, *Mediaeval European Jewellery*, op. cit., p. 73.

46. *Dynasties*, ex. cat., ed. K. Hearn, London, Tate Gallery 1995, no. 20, pp. 60–1. A damaged picture of similar size and format depicts Edward, 3rd Lord Windsor, who accompanied Lee in Antwerp. He has his right thumb squeezed through the ring, and this, I think, is in keeping with the far more subdued nature of the picture: the cord is mostly concealed within his doublet, and he carries no other lover's symbols.

47. I, ii, 67. *Collected Works of Erasmus*, op. cit., vol. 31, p. 209.

48. P. Cunnington and C. Lucas, *Costume for Births, Marriages and Deaths*, London 1972, p. 120. They cite Letter 50 of Dorothy Osborne's 'Love letters . . . to Sir William Temple', written in 1653.

49. Elegia XV: Ad anulum, quem dono amicae dedit.

50. R. Strong, *The Cult of Elizabeth*, op. cit., p. 129.

51. Ibid., p. 139.

52. In 1594 Lee probably devised the symbolism for a portrait by Gheeraerts of his cousin *Captain Thomas Lee* (Tate Gallery), which remained at Ditchley Park. Captain Lee's left hand is scarred and hangs limp. The obvious explanation for this is that it refers to Gaius Mucius Scaevola's immolation of his right hand in a sacrificial fire after being captured by the Etruscans: Scaevola's own words— Facere et pati Fortia (both to act and to suffer with fortitude is a Roman's part)—are inscribed on the painting. However, the fact that Captain Lee's left hand is damaged, and that his left leg is pushed towards the viewer also suggests a Petrarchan manifestation of his love and loyalty—presumably for his Queen?

53. Jean Fouquet's *Virgin and Child with Angels* (*c.*1450), where the Virgin is probably Charles VIII's mistress, Agnès Sorel; Titian's *Flora* (*c.*1518); Licinio's *Young Woman with a Mirror and an Aged Lover* (*c.*1530); Michelangelo's presentation drawing of *Cleopatra* (*c.*1534).

54. M. dal Poggetto, 'I Gioielli della Fornarina', in *La Fornarina di Raffaello*, L. M. Onori (ed.), Milan 2002, p. 96, says that the

turban suggests high social status. Raphael's *Donna Velata* (*c*.1514) has a similarly placed pendant brooch, a bracelet on her left wrist, and touches her left breast with her right hand; her necklace is asymmetrical and seems to have been pulled over onto her left shoulder.

55. J. Evans, *Magical Jewels of the Middle Ages and the Renaissance*, Oxford 1922, p. 201, 'de Etite' (prevents miscarriages); p. 220 'Dyamans' (ensures children with healthy limbs).

56. It can be compared with the later portrait of *Gabrielle d'Éstrées and her Sister in the Bath* (*c*.1595), by an unknown French artist, where Gabrielle's breast is daintily squeezed by her sister. See H. Zerner, *Renaissance Art in France*, Paris 2003, pp. 209–16.

57. R. W. Lightbown, *Mediaeval European Jewellery*, op. cit., p. 100. *The Age of Chivalry*, exh. cat., Royal Academy of Arts 1987, p. 484, no. 644.

58. *Raphael: from Urbino to Rome*, exh. cat., National Gallery London 2004, H. Chapman, T. Henry, and C. Plazzotta, no. 47, pp. 166–7. See also P. Joannides, *The drawings of Raphael with a Complete Catalogue*, Oxford 1983, no. 87r.

15. Lovelocks

1. W. Prynne, *The Unlovelinesse, of Love-Locks*, London 1628, p. 4.

2. R. Corson, *Fashions in Hair*, London 1965, pp. 206–9.

3. *The Plays of John Lyly*, ed. C. A. Daniel, London 1988, Act 3, Scene 2, l. 43.

4. R. Bayne-Powell, *Portrait Miniatures in the Fitzwilliam Museum, Cambridge*, Cambridge 1985, p. 114, no. 3856. Bayne-Powell says the hair 'is in a fashion the Earl is believed to have initiated, though it was little followed'. Certainly judging by the literary record, neither of these statements is correct.

5. See Jan Gossaert, *The Metamorphosis of Hermaphroditus and Salmacis*, 1523.

6. We are offered Christ's 'heart' side in Oliver's cabinet miniature of the *Entombment* (1616, completed by 1636). All the women, including the Marys, are on Christ's left side, and one of them kisses his outstretched left hand.

7. In Oliver's *The Entombment* Christ's head is tilted to his right, and we only see a long lock of hair on the left side.

8. This follows the Vulgate: 'in uno crine colli tui'. The King James' Bible translates it as 'with one chain of thy neck', but this was probably understood in the same way: 'one necklace of thy neck' would be rather absurd and meaningless.

9. *The Collected Works of St John of the Cross*, trans. K. Kavanagh and O. Rodriguez, London 1966, p. 414, stanzas 30 & 31.

10. Ibid., p. 438; stanza 7, #3.

11. Ibid., p. 530; stanza 30, #9.

12. Ibid., p. 534; stanza 31, #10.

13. J. Peacock, 'The visual image of Charles I', in *The Royal Image: Representations of Charles I*, ed. T. N. Corns, Cambridge 1999, p. 180.

14. S. J. Barnes et al., *Van Dyck: A Complete Catalogue of the Paintings*, New Haven 2004, nos. IV, 45–58.

15. M. Butler, 'The Stuart masque and the invention of Britain', in *Europe and Whitehall: Society, Culture and Politics 1603–1685*, ed. M. Smuts, Cambridge 1996, p. 80.

16. W. Prynne, *The Unlovelinesse of Love-Locks*, op. cit., p. 27.

17. M. Prevost, in *Dictionnaire de Biographie Française*, Paris 1959, vol. 8, col. 849.

18. W. Prynne, *The Unlovelinesse of Love-Locks*, op. cit., p. 4.

19. Ibid., p. 6.

20. Ibid., p. 7.

21. *The Queen's Pictures*, exh. cat. C. Lloyd, National Gallery London, 1991, no. 41.

22. J. Evelyn, *Numismata*, London 1697, p. 335. S. J. Barnes et al., *Van Dyck: A Complete Catalogue of the Paintings*, op. cit., p. 465; no. IV. 48.

23. C. Avery, *Bernini: Genius of the Baroque*, London 1997, p. 225.

24. The bust of Thomas Baker, carved at the same time, features a ribbon tied to the left lock of hair, but the hair is the same, shoulder length on both sides.

16. Honorary Left-Handers

1. F. Colonna, *Hypnerotomachia Poliphili*, trans. J. Godwin, London 1999, pp. 227–8.

2. S. Coren and C. Porac, 'Fifty Centuries of Right-Handedness: the Historical Record', *Science*, no. 4317, 1977, pp. 631–2, examined over a thousand artworks in which there was unimanual tool or

weapon use, and found left-handedness depicted in around 7 per cent., regardless of historical era or geographical era. This would thus be a 'normal' distribution. As Coren and Porac cite no concrete examples of left-handedness in actual artworks, it is impossible to assess their findings. From my own (unsystematic) survey of Renaissance art, the number of left-handers is far less. Their results may have been distorted by the inclusion of sculptures and drawings: the former are often reversed when copied or cast; the latter are sometimes drawn in reverse for transfer.

3. D. Landau and P. Parshall, *The Renaissance Print 1470–1550*, New Haven 1994, p. 130: the earliest Italian reproductive prints rarely reversed the source image. But from around the 1520s, prints were more frequently made in reverse of the drawings they follow. For an explanation of counterproofs, L. Pon, *Raphael, Dürer, and Marcantonio Raimondi: Copying and the Italian Renaissance Print*, New Haven 2004, pp. 111–13; P. Goldman, *Looking at Prints, Drawings and Watercolours: A Guide to Technical Terms*, London 1988, pp. 22 and 45. Titian collaborated closely with print-makers over more than six decades, yet virtually every print made after one of his drawings or paintings reverses the source image: C. Karpinski, 'Lights Always at Play with Shadows: Prints in Titian's Service', in *The Cambridge Companion to Titian*, ed. P. Meilman, Cambridge 2004, pp. 96–7.

4. Macrobius, *Saturnalia*, I: 17; R. Pfeiffer, 'The Image of Delian Apollo and Apolline Ethics', *Journal of the Warburg and Courtauld Institutes*, no. 15, 1952, p. 21.

5. Ibid., p. 32.

6. Ibid., p. 28.

7. C. de Tolnay, *Michelangelo*, vol. 3, New York 1948, pp. 96–7.

8. J. Pope-Hennessy, *Italian High Renaissance and Baroque Sculpture*, London 1996, p. 435.

9. Michelangelo depicted God creating the sun on the Sistine ceiling, and surrounded Christ with a sun in the *Last Judgement*. In the presentation drawing *The Dream*, the 'dreamer' leans on a globe.

10. R. Pfeiffer, 'The Image of Delian Apollo and Apolline Ethics', op. cit., pp. 21–2.

11. V. Cartari, *Le Imagini de I Dei de gli Antichi* (1556; illustrated ed. 1571), ed. G. Auzzas et al., Vicenza 1996, pp. 53–4.

12. J. Hall, *Michelangelo and the Reinvention of the Human Body*, London 2005, p. 21.

13. Giovanni Boccaccio, *Life of Dante*, trans. J. G. Nichols, London 2002, p. 5.

14. Albert S. Cook, 'The Opening of Boccaccio's Life of Dante', *Modern Language Notes*, vol. 17, no. 5, May 1902, pp. 138–9.

15. Giovanni Boccaccio, *Life of Dante*, op. cit., ch. 11, pp. 54–5.

16. Lorenzo de' Medici, *Comento de' Miei Sonetti*, ed. T. Zanato, Florence 1991, p. 214; *The Autobiography of Lorenzo de' Medici the Magnificent: A Commentary on my Sonnets*, trans. J. W. Cook, Binghamton 1995, pp. 125–7.

17. Ibid., p. 131.

18. Ibid., p. 127.

19. Ibid., p. 131.

20. Plato, *Laws*, ed. R. G. Bury, Cambridge Mass. 1968, vol. 2, 794e. Cited by C. McManus, *Right Hand, Left Hand*, London 2002, p. 157.

21. For memory hands, which started in the eleventh century with the Guidonian hand of Guido d'Arezzo (*c.*992–1033), see 'The Hand as the Mirror of Salvation' in *Origins of European Printmaking*, exh. cat., P. Parshall, R. Schoch et al., National Gallery of Art Washington, 2005, no. 92, pp. 292–5.

22. R. Lightbown, *Sandro Botticelli*, vol. I, London 1978, pp. 83–4.

23. Ascanio Condivi, *The Life of Michelangelo*, trans. A. S. Wohl, University Park 1999, p. 13.

24. S. Jervis, 'The Round Table as Furniture', in *King Arthur's Round Table*, ed. M. Biddle, Woodbridge 2000, p. 35.

25. J. V. Fleming, 'The Round Table in Literature and Legend', ibid., p. 10. The passage occurs in Wace's *Le Roman de Brut*.

26. *King Arthur's Round Table*, op, cit., pp. 276–7, for a table of these lists.

27. J. Hall, *Michelangelo*, op. cit., p. 68.

28. *Michelangelo Drawings: Closer to the Master*, exh. cat., H. Chapman, London 2005, pp. 122–3.

29. Ibid., pp. 247–9. P. Joannides in *L'ombra del genio: Michelangelo e l'arte a Firenze 1537–1631*, exh. cat., ed. M. Chiarini, A. Darr, and C. Giannini, Palazzo Strozzi Florence, 2002, pp. 324–5.

30. Ascanio Condivi, *The Life of Michelangelo*, op. cit., p. 128.

31. Lorenzo de' Medici, *Canzoniere*, ed. T. Zanato, Florence 1991, vol. 2, no. CLI, ll. 7–8.

32. *Michelangelo Drawings*, op. cit., p. 249.

33. G. G. Bottari and S. Ticozzi, *Raccolta di Lettere*, Milan 1822–5. vol. 5, pp. 101–7. D. Summers, *Michelangelo and the Language of Art*, Princeton 1981, pp. 12–3 and pp. 462–3 n. 21. Summers mistakes this Michelangelo for Michelangelo Buonarrotti.

34. N. Penny, *The Sixteenth Century Paintings, volume 1: Paintings from Bergamo, Brescia and Cremona*, London 2004, pp. 232–5; M. Gregori, 'Giovan Battista Moroni', in *I Pittori Bergamaschi: Il Cinquecento 3*, Bergamo 1979, pp. 276–7, no. 127.

35. N. Penny, *The Sixteenth Century Paintings,* op. cit., p. 232.

36. M. Gregori, 'Giovan Battista Moroni', op. cit., p. 277: 'la naturalità aggressiva e sensuale del viso che trova un equivalente...solo in Velazquez.'

37. M. Hirst, *Michelangelo and his Drawings*, New Haven 1988, p. 111. A. H. Popham was apparently the first to notice this, in the 1920s.

38. J. Hall, *Michelangelo*, op. cit., pp. 180–4.

39. F. Colonna, *Hypnerotomachia Poliphili*, trans. J. Godwin, London 1999, pp. 227–8.

40. Jean-Baptiste Thiers, *Traité des Superstitions qui regardent les Sacrements,* Avignon 1777, p. 414.

41. B. Suida Manning and W. Suida, *Luca Cambiaso*, Milan 1958, pp. 101, 136, 157; J. Woods-Marsden, *Renaissance Self-Portraiture*, New Haven 1998, pp. 235–6.

42. B. Suida Manning and W. Suida, *Luca Cambiaso*, op. cit., p. 190 & fig. 200.

43. Baccio Bandinelli holds a piece of chalk in his *Self-Portrait* (early 1530s), but only so that his right hand can be freed up to point dramatically to his drawing of Hercules.

44. English translation: Michel Le Faucheur, *An Essay upon the Action of an Orator*, London 1702, pp. 196–7. Cited by P. Goring, *The Rhetoric of Sensibility in Eighteenth Century Culture*, Cambridge 2005, p. 50.

45. Ibid., p. 122.

46. A. Mérot, *Nicolas Poussin*, London 1990, p. 311.

47. Rembrandt draws with his left hand in the etching *Self-Portrait with Saskia* (1636), which probably illustrates the Dutch proverb 'Love brings forth art'. He seems to be doing an absent-minded doodle of a heart. In no other print does Rembrandt have someone drawing or writing with their left hand: *Rembrandt by Himself*, exh. cat., ed. C. White, National Gallery London 1999, no. 46, p. 162.

Part 5. Rethinking Left and Right

1. H. Honour, *Romanticism*, Harmondsworth 1979, makes this point. L. Johnson, *The Paintings of Eugène Delacroix*, Oxford 1986, vol. 3, nos. 372 and 433; vol. 4, plates 188 and 241. Although Delacroix says that Isaker bought both pictures, it is not clear if the sale of the Crucifixion scene went ahead, or if Isaker swiftly sold it on, because the picture was soon in the hands of another collector. See ibid., vol. 3, p. 221, n.1.

2. *Pierre-Paul Proud'hon*, exh. cat., S. Laveissière, Metropolitan Museum New York 1998, nos. 211, 182, & 185.

3. This is explicit in *The Soul breaking the Ties that Bind it to Earth* (1823), ibid., no. 221, for the naked body of the female soul is shown in left profile. It is akin to looking into Turner's Venetian suns.

4. J. A. Laponce, *Left and Right: The Typography of Political Perceptions*, Toronto 1981, pp. 47ff.

17. 'To Err Forever'

1. G. E. Lessing, *Philosophical and Theological Writings*, ed. and trans. H. B. Nisbet, Cambridge 2005, p. 97.

2. W. H. Wackenroder, *Confessions and Fantasies*, trans. M. H. Schubert, University Park 1971.

3. Ibid., p. 109.

4. M. Barasch, *Modern Theories of Art 1: from Winckelmann to Baudelaire*, New York 1990, p. 294.

5. W. H. Wackenroder, *Confessions and Fantasies*, op. cit., p. 111.

6. Ibid., pp. 115–16.

7. Ibid., p. 112.

8. Ibid., p. 112.

9. Ibid., pp. 116–17.

10. *Diderot on Art II: the Salon of 1767*, trans. J. Goodman, New Haven 1995, pp. 86–123. R. Wrigley, *The Origins of French Art Criticism*, Oxford 1993, p. 300 n. 71, gives more examples and says it was a 'commonplace of criticism'.

11. W. Vaughan, *Caspar David Friedrich*, London 2004, pp. 18–25, 72–4.

12. J. L. Koerner, *Casper David Friedrich and the Subject of Landscape*, London 1990, p. 16.

13. W. Hofmann, *Casper David Friedrich*, London 2000, pp. 271 & 269.

14. For the phrase 'blockaded space', used in relation to Anthony Caro and other modern sculptors, see P. Fisher, *Making and Effacing Art*, New York 1991, p. 44.

15. T. Klauser, *A Short History of the Western Liturgy*, Oxford 1979, p. 148.

16. Friedrich's figures seen from the back evoke this alienating cultural memory, though the figures themselves seem to have reached a dead end. *The Monk by the Sea* (c.1809)—an art-loving friar?— stands alone at the tip of a prow-shaped shore, looking out to the empty sea. He seems to have reached an impasse. So too *The Wanderer above the Mists* (1818). The reintroduction of rood-screen's by the English architect Pugin in the 1830s would cause great controversy: R. Hill: *God's Architect: Pugin . . .* , London 2007, p. 201.

17. W. Vaughan, *Caspar David Friedrich*, op. cit., p. 108.

18. Ibid., p. 109. For texts see *Art in Theory 1648–1815*, ed. C. Harrison, P. Wood and J. Gaiger, Oxford 2000, pp. 1012ff.

19. Ibid., pp. 1025–6.

20. The picture with which the form and content of *The Cross in the Mountains* can be most usefully contrasted is Claude Lorrain's *The Sermon on the Mount* (1656). The composition is similar, but the message is hopeful and pantheistic. Friedrich is unlikely to have known of it, however, as it was unpublished and in a private English collection.

21. H. B. Nisbet, 'Introduction', G. E. Lessing, *Philosophical and Theological Writings*, op. cit., p. 8. For Lessing's influence on Friedrich Schleiermacher, often cited as an influence on Friedrich, see R. Crouter, 'Introduction', F. Schleiermacher, *On Religion: Speeches to its Cultured Despisers*, Cambridge 1988, pp. 8, 10, 32.

22. G. E. Lessing, *Philosophical and Theological Writings*, op. cit., p. 5.

23. Ibid., p. 97.

24. J. C. Jensen, *Casper David Friedrich*, London 1981, p. 12.

25. W. Hofmann, *Casper David Friedrich*, op. cit., p. 270.

26. *Caspar David Friedrich: Winter Landscape*, exh. cat., J. Leighton and C. J. Bailey, London National Gallery, 1990.

27. J. L. Koerner, *Casper David Friedrich*, op. cit., p. 18.

28. H. Honour, *Romanticism*, London 1979, pp. 31–2.

29. W. Vaughan, *Caspar David Friedrich*, op. cit., p. 217.

30. Johann Wolfgang von Goethe, *Selected Poetry*, trans. D. Luke, London 1999, p. 91. For further examples of Goethe's glib approach to left and right, see the physiological matching between Ottilie and Edouard in *Elective Affinities*, trans. R. J. Hollingdale, London 1971, ch. 5, pp. 60–1, & ch. 11, p. 246.

31. See U. Deitmaring, 'Die Bedeutung von Rechts und Links in Theologischen und Literarischen Texten bis um 1200', in *Zeitschrift für deutsches Altertum und deutsche Literatur*, 98, 1969, pp. 287–9.

32. Origen, *The Song of Songs: Commentary and Homilies*, trans. and ed. R. P. Lawson, Westminster and London 1957, bk 2, #2, p. 109. It is just possible that the hesitation of Hercules in so many 'choice' pictures is due to the fact that he too would rather take the middle path, but I can see little visual indication of this in the images.

33. 'Of the proof of the spirit and of power' (1777), in G. E. Lessing, *Philosophical and Theological Writings*, op. cit., p. 87.

34. W. Hofmann, *Casper David Friedrich*, op. cit., p. 272.

35. For empathy, M. Barasch, *Modern Theories of Art 2: from Impressionism to Kandinsky*, New York 1998, pt. 2.

36. *Empathy, Form and Space: Problems in German Aesthetics 1873–1893*, ed. H. F. Mallgrave and E. Ikonomou, Santa Monica 1994, p. 25.

37. M. Barasch, *Modern Theories of Art 2*, op. cit., p. 114.

18. Picasso and Chiromancy

1. J-K. Huysmans, *Là-Bas: a journey into the self*, trans. B. King, Sawtree 2001, p. 244.

2. A. Baldassari, *Picasso and Photography*, Paris 1997, pp. 106–21; W. Spies, *Picasso: The Sculptures*, Stuttgart 2000, pp. 78–80.

3. J. Richardson, *A Life of Picasso*, vol. 2, London 1996, p. 254.

4. A. Baldassari, *Picasso and Photography*, op. cit., p. 116, says it was 'destroyed upon completion', but she offers no conclusive evidence, beyond assuming that the photograph in which Picasso sits before the 'bare' canvas was taken after the installation had been dismantled, rather than before. In n. 349, p. 251, referring to this photograph, she says that 'at the spot where the musician's arm was stuck to the canvas is a black mark perhaps left by the string holding the guitar, the outline of which was subsequently drawn onto the canvas'. There is, however, no indication in the other photographs that any string went to this point. Various dates have been proposed for the

self-portrait photograph, both before and after 1913. J. Richardson says it disintegrated.

5. I can't tell which way the guitar is strung.

6. A. Baldassari, *Picasso and Photography*, op. cit., pp. 116–17. Illustration on p. 107.

7. For Picasso and Jacob, *Max Jacob et Picasso*, exh. cat., H. Seckel, Musée Picasso, Paris 1994; J. Richardson, *A Life of Picasso*, vol. 1, London 1991, pp. 203–7 and passim.

8. Fernande Olivier, *Loving Picasso: The Private Journal of Fernande Olivier*, trans. C. Baker and M. Raeburn, New York 2001, p. 204.

9. J-K. Huysmans, *Là-Bas*, op. cit., p. 139.

10. P. Andreu, *Vie et Mort de Max Jacob*, Paris 1982, p. 61.

11. M. Jacob and C. Valence, *Miroir d'Astrologie*, Paris 1949, p. 142.

12. Madame Blavatsky, *The Secret Doctrine*, vol. 3, London 1897, pp. 215–16 & 330, & passim.

13. *Max Jacob et Picasso*, op. cit., nso. 12 & 13, pp. 12–13; J. Richardson, *A Life of Picasso*, vol. 1, op. cit., p. 266.

14. It was after the restoration of the monarchy in 1814 that the terms left and right started to be commonly used in relation to French politics.

15. *Max Jacob et Picasso*, op. cit., p. 13.

16. A. Desbarrolles, *Les Mystères de la Main*, 20th edn., n.d., Paris, xxii–xxiv.

17. Ibid., p. lii.

18. J. Richardson, *A Life of Picasso*, vol. 1, op. cit., p. 274.

19. The gestures in the drawing *Harlequins with Raised Hands* (1907) seems closer to this, and Richardson's comparison of it with the preparatory study for *La Vie* (ibid., p. 274) only serves to underline the difference. In the Tarot Juggler card which Richardson uses to illustrate the occult unification of heaven and earth, it is the left hand that is raised and the right hand lowered. Richardson, I believe, exaggerates the importance of Tarot cards as a visual stimulus for Picasso.

20. J. Hall, *The World as Sculpture*, London 1999, ch. 13 'Loving Objects'.

21. Cesare Lombroso, *The Man of Genius*, New York 1984, pp. 13–14.

22. J. Pierrot, *The Decadent Imagination 1880–1900*, trans. D. Coltman, Chicago 1981, p. 125. Charles Baudelaire, *Oeuvres Complètes*, Paris 1951, p. 1219.

23. Emile Zola, *The Masterpiece*, trans. T. Walton, Oxford 1993, pp. 124 & 284.

24. J. Richardson, *A Life of Picasso*, vol. 1, op. cit., p. 244.

25. However, there was a literary fashion for hospital settings, according to M. Praz, *The Romantic Agony*, Oxford 1970, p. 279: 'There was a tendency towards the end of the century to substitute a hospital background for the background of Oriental lust, cruelty, and magnificence against which the superwomen of Gautier had been painted'. He cites Ivan Gilkin's 'L'Amour d'Hôpital' from *La Nuit* (1897).

26. I am thinking in particular of the woman who looks straight out and who was, until the 1980s restoration, believed to be blind. The frescoes were, of course, far gloomier in Picasso's day, long before the 1980s restoration. Picasso evidently looked quite closely at Michelangelo. The black chalk study for *Evocation* (1901) in the Musée Picasso is very closely modeled on Michelangelo's black chalk drawing *The Resurrection of Christ* (*c.*1532–3) in the British Museum.

27. M. Praz, *The Romantic Agony*, op. cit., p. 319.

28. E. Galichon, 'Un Dessin de Léonard de Vinci', in *Gazette des Beaux Arts*, vol. 23, 1 Dec. 1867, p. 536.

29. M. Fried, *Menzel's Realism*, New Haven 2002, p. 167; *Manet's Modernism*, Chicago 1996, ch. 5, with extensive further discussions in the footnotes. The daguerreotype and other early direct-positive forms of photography produced 'mirror' images, but by the 1860s they had been superceded by processes that used negatives. See P. Leopold, 'Letter: Pont Neuf', *Times Literary Supplement*, 21 March 2008, p. 6.

30. M. Fried, *Manet's Modernism*, op. cit., pp. 602–3, n. 10. He does not mention any political overtones.

31. *Manet 1832–1883*, exh. cat. Paris 1983, no. 10, pp. 63–7.

32. *Manet 1832–1883*, op. cit., p. 64.

33. T. Duret, *Histoire d'Édouard Manet et de son Oeuvre*, Paris 1902, p. 17.

34. Edouard Charton, 'Grandville', *Le Magasin Pittoresque*, 23, 1855, p. 356. Cited by P-M. Bertrand, *Histoire des Gauchers*, Paris 2001, p. 212, n. 61.

35. C. Bambach, 'Leonardo, Left-Handed Draftsman and Writer', in *Leonardo da Vinci: Master Draftsman,* exh. cat. ed. C. Bambach, Metropolitan Museum New York 2003, p. 34.

36. M. Fried, *Menzel's Realism*, op. cit., pp. 52–4.
37. Reproduced in E. Lucy-Smith, *Symbolist Art*, London 1972, p. 31.
38. P. Janet, *L'État mental des hystériques*, Paris 1911, pp. 88–9. It was first published in 1894. Cited by D. Lomas, 'Modest Recording Instruments': Science, Surrealism and Visuality', *Art History*, vol. 27, no. 4, Sept. 2004, p. 650, n. 60. P. Janet, *The Mental State of Hystericals* (New York 1901), Bristol 1998, pp. 184–5.
39. C. Lombroso, *L'Homme de Genie*, 4th edn., Paris 1909, p. 26, # 10.
40. E. Muntz, *Léonard de Vinci: L'artiste, le penseur, le savant*, Paris 1899, p. 16. P-M Bertrand, *Histoire des Gauchers*, Paris 2001, p. 104, n. 13.
41. E. Cowling, *Picasso: Style and Meaning*, London 2002, p. 103.
42. *Self-Portrait with a Palette* (1906) was preceded by a number of studies in which the artist holds his paintbrush in his right hand, and his palette in his left, with his thumb poking through the hole. In the painting his right hand no longer holds a paintbrush, and is clenched into a loose fist; his left hand holds the palette, but his protruding thumb is reduced to a white blob of paint. This self-portrait seems to celebrate the birth of the radically gauche painter, whose palette is a prosthetic extension of his (left) arm, and whose thumb is pure white paint.
43. Ibid., pp. 118–31. J. Richardson, *A Life of Picasso*, vol. 1, op. cit., pp. 334 ff.
44. Ibid., pp. 382–5.
45. Ibid., p. 371.
46. Ibid., p. 382.
47. Ibid. Other images show harlequins with their hands behind their backs, but not gesturing.
48. Ibid., p. 336.
49. P-M. Bertrand, *Histoire des Gauchers*, op. cit., p. 94.

19. Picasso and Satanism

1. Le Comte de Lautréamont, *Maldoror*, trans. P. Knight, Harmondsworth 1978, ch. 7, p. 36.
2. *Les Demoiselles d'Avignon*, Musée Picasso, Paris 1988, 2 vols. The English version of William Rubin's essential catalogue essay, 'The Genesis of the Demoiselles d'Avignon', later appeared in *Studies in Modern Art 3: Les Demoiselles d'Avignon*, Museum of Modern Art, New York 1994, ed. J. Elderfield, pp. 13–144. See also *Picasso's Les*

Demoiselles d'Avignon, ed. C. Green, Cambridge 2001; E. Cowling, *Picasso: Style and Meaning*, London 2002, pp. 160–80.

3. M. Praz, *The Romantic Agony*, Oxford 1970, ch. 2, 'The Metamorphoses of Satan'.

4. R. Baldick, *The Life of J-K Huysmans*, London 2006. J. Richardson, *A Life of Picasso*, 1, London 1991, p. 503, n. 5, cites Boullan as a possible source for Picasso's 'juxtaposition of the sacred, the mystic and the sexual', but is much more interested in Tarot—a mistake, in my view.

5. M. Praz, *The Romantic Agony*, op. cit., pp. 74–5.

6. J-B. Renoult, *Les Aventures Galantes de la Madone avec ses Dévots, Suivies de celles de François d'Assise*, Paris 1882, pp. x and 53. Renoult spent time in London, having left France and the Catholic Church to become a Protestant Minister. His book was published in Amsterdam, and is heavily influenced by Erasmus' *Dialogues*. Apollinaire owned a copy of this book: *Catalogue de la Bibliothèque de Guillaume Apollinaire*, ed. G. Boudar, Paris 1983, p. 132.

7. R. Irwin, 'Afterword', in J-K. Huysmans, *Là-Bas*, see ch. 18, n. 1 for full reference, p. 327.

8. M. Praz, *The Romantic Agony*, op. cit., p. 314.

9. C. McIntosh, *Eliphas Lévi and the French Occult Revival*, London 1972, p. 181.

10. J-K. Huysmans, *Là-Bas*, op. cit., pp. 251–2.

11. Ibid., p. 243.

12. His knowledge of Boullan and of black magic may have preceded his relationship with Jacob: see, for example, the heavenly whore-house in *The Burial of Casagemas*, and the crosses furnishing his *Portrait of Sabartes ('Poeta Decadente')*. The so-called *Christ of Montmartre* (1904), who stands on a window ledge about to commit suicide, is seen in left profile: J. Richardson, *A Life of Picasso*, 1, op. cit., p. 317.

13. Ibid., p. 243.

14. J. Pierrot, *The Decadent Imagination 1880–1900*, trans. D. Coltman, Chicago 1981, p. 88.

15. J. Richardson, *A Life of Picasso*, vol. 3, London 2007, pp. 395–402.

16. J. Richardson, *A Life of Picasso*, 1, op. cit., p. 366. K. Beaumont, *Alfred Jarry: A Critical and Biographical Study*, Leicester 1984, p. 81.

17. Puvis de Chavannes' preliminary version of *The Beheading of St John the Baptist* (1869, National Gallery, London) shows the Baptist looking to his left at an impossibly elongated, wand-like

cross which he holds in his left hand; this is the side on which Herodias and Herod stand. In the exhibited versions, this 'heretical' motif was excized and the Baptist looks to the front. Puvis was, I believe, suggesting the Baptist's complicity with Herodias's perverse passion—he is turning his lips towards hers, and putting his crucifix on the left-hand side.

18. P-M. Bertrand, *Histoire des Gauchers*, Paris 2001, p. 89.

19. J. A. Laponce, *Left and Right: The Typography of Political Perceptions*, Toronto 1981, p. 53.

20. J. Richardson, *A Life of Picasso*, vol. 1, op. cit., p. 98. It is surrounded by other sketches of hands. A large, powerful 'right arm' appears in the top right corner but the hand is not holding anything. Two more sketches were made by putting the fingers and thumb of his left hand together and then drawing the mirror image; a third is a schematic view from above of his left hand in the act of drawing, for which he must have held the pen in his left hand.

21. J. Richardson, *A Life of Picasso*, 1, op. cit., p. 137.

22. Cited by J-P. Bertrand, *Histoire des Gauchers*, op. cit., p. 68.

23. E. Cowling, *Picasso: Style and Meaning*, op. cit., p. 87, compares the motif with Rodin's *The Old Tree*, and the composition as a whole to *The gates of Hell*.

24. W. Rubin, 'The Genesis of the Demoiselles d'Avignon', op. cit., p. 44.

25. J-K. Huysmans, *Là-Bas*, op. cit., p. 249.

26. J. Collin de Plancy, *Dictionnaire Infernal*, Paris 1863, p. 56: 'Astarte'. See also Dante Gabriel Rossetti's steamy painting, *Venus Astarte* (1877), and his poem *Astarte Syriaca*: 'That face, of Love's all-penetrative spell / Amulet, talisman, and oracle,— / Betwixt the sun and moon a mystery.'

27. F. Whitford, *Klimt*, London 1990, ch. 3. It was destroyed during the Second World War.

28. *www.geocities.com/Athens/Academy/1672/chirorub.htm*. This is the only information I have found on her, and this essay (on the history of chiromancy) has no bibliography.

29. Apollinaire owned a copy of her *Almanach*, Paris 1914, which gave recipes for a happy life. *Catalogue de la Bibliothèque de Guillaume Apollinaire*, op. cit., p. 151.

30. W. Spies, *Picasso: The Sculptures*, Stuttgart 2000, pp. 358, 401, & 403. Picasso's hand: nos. 220 (right), 220a (right), 220b (left), 220c (left),

224 (right). The back of Dora Maar's left hand: 168a. No. 224 illustrated the front cover of D-H. Kahnweiler, *Les Sculptures de Picasso*, Paris 1948.

31. A. Desbarrolles, *Les Mystères de la Main*, 20th edn., n.d., Paris, xxii–xxiv. Desbarolles echoes Herder's *Plastik* in his own celebration of the insights gained by touch: 'Without [the sense of touch] the qualities of the other senses would be useless and powerless.'

32. Madame de Thèbes, *L'Énigme de la Main*, Paris 1900, p. 198.

33. W. Rubin, 'The Genesis of the Demoiselles d'Avignon', op. cit., p. 69.

34. Only two hands in the picture are properly delineated—the 'priestess's' raised left hand and the left hand of the standing girl which holds some drapery. The right hand of the 'priestess' is only schematically delineated, and marginalized by being pushed back. No other hand is depicted in the painting—making that about $2\frac{1}{2}$ hands out of a possible 10! It contributes to the feeling that this scenario is out of control.

35. *Bartolomé Estaban Murillo*, exh. cat., Prado Madrid & Royal Academy of Arts London 1982, nos. 38 and 75. The latter, then known as the *Immaculate Conception of Soult*, was in the Louvre, having been stolen by Marshal Soult in 1813. It was returned to the Prado in 1941.

36. A. Desbarrolles, *Les Mystères de la Main*, op. cit., p. 416.

37. W. Rubin, 'The Genesis of the Demoiselles d'Avignon', op. cit., p. 41.

38. J. Richardson, *A Life of Picasso*, vol. 1, op. cit., p. 155.

39. E. Cowling, *Picasso: Style and Meaning*, op. cit., p. 171.

40. C. H. de Groot, *Die Handzeichnungen Rembrandts*, Haarlem 1906, no. 303. *The Robert Lehman Collection vii: Fifteenth- to Eighteenth-Century European Drawings*, Metropolitan Museum of Art, New York 1999, no. 70, pp. 219–28, entry by E. Haverkamp-Begemann. Aert van Waes' print on a similar subject, *Man Defecating on a Palette and Brushes* was made the following year (p. 220).

41. J. Richardson, *A Life of Picasso*, vol. 2, London 1996, p. 18.

42. By the same token, we should remember that the Renaissance fashion for *Death and the Maiden* images coincided with the first arrival of syphilis in Europe—when it was known as the French Pox.

43. P. Daix, *Picasso: Life and Art*, trans. O. Emmet, London 1993, p. 67.

44. Emile Zola, *The Masterpiece*, trans. T. Walton, Oxford 1993, p. 347.

45. P. Daix, *Picasso: Life and Art*, op. cit., p. 81.

46. J. Richardson, *A Life of Picasso*, vol. 2, op. cit., pp. 18–19.

47. W. Rubin, 'The Genesis of the Demoiselles d'Avignon', op. cit., p. 19.

48. A. Salmon, *La Jeune Peinture Française*, Paris 1912. Trans. E. F. Fry ed., *Cubism*, London 1966, pp. 81–5.

49. Le Comte de Lautréamont, *Maldoror*, trans. P. Knight, Harmondsworth 1978, ch. 7, p. 36.

50. J. Richardson, *A Life of Picasso*, vol. 1, op. cit., p. 287.

51. A. Malraux, *la Tête d'Obsidienne*, Paris 1974, p. 18. W. Rubin, 'The Genesis of the Demoiselles d'Avignon', op. cit., p. 16.

52. J. Richardson, *A Life of Picasso*, 1, op. cit., p. 186.

53. 'The Guitar Player'. Quoted F. Kermode, *The Romantic Image*, London 1957, p. 50.

54. J. Richardson, *A Life of Picasso*, 2, op. cit., ch. 15, 'Ma Jolie'.

55. Ibid., ch. 13. 'L'Affaire des Statuettes'.

56. Ibid., pp. 204–5.

57. Ibid., p. 246; p. 263; p. 272; p. 279.

58. P. Janet, *The Mental State of Hystericals* (1894), Bristol 1998, p. 64.

59. Quoted by C. Poggi, *In Defiance of Painting: Cubism, Futurism and the Invention of Collage*, New Haven 1992, p. 98.

60. *Manet 1832–1883*, exh. cat. Paris 1983, p. 534.

61. R. Hertz, 'The Pre-eminence of the Right Hand', in *Right & Left: Essays on Dual Symbolic Classificiation*, ed. R. Needham, Chicago 1973, p. 16.

20. Modern Primitives

1. *Medical Record*, New York, vol. 30, no. 21, 20th Nov. 1886, p. 579. Cited by P-M. Bertrand, *Histoire des Gauchers*, Paris 2001, p. 57. I have translated Bertrand's French translation.

2. J. Hall, *The World as Sculpture: the changing status of sculpture from the Renaissance to the present day*, London 1999, p. 326; A. Molotiu, 'Focillon's Bergsonian Rhetoric and the Possibility of Deconstruction', *Invisible Culture*, 3, 2000: www.rochester.edu/in_visible_ culture/issue3/molotiu.htm

3. H. Focillon, *The Life of Forms in Art*, New York 1989, pp. 157–8.

4. A. Desbarrolles, *Les Mystères de la Main*, 20th edn., n.d., Paris, xxii–xxiv.

5. J. Hall, *The World as Sculpture*, op. cit., pp. 253ff.

6. H. Focillon, p. 160.

7. Ibid.

8. Giacometti's figures are of course the heirs to Picasso's Blue and Pink period sleepwalkers.

9. Ibid., p. 161.

10. J-P. Bertrand, *Historie des Gauchers*, Paris 2001, p. 153.

11. H. Focillon, *The Life of Forms in Art*, op. cit., p. 157.

12. Ibid., p. 161.

13. Ibid., p. 162.

14. Ibid., p. 167.

15. Ibid., pp. 178 & 180.

16. John Ruskin, *The Stones of Venice*, London 1851–3, vol. 2, ch. 6, # 14 & 22.

17. D. Lomas, 'Modest Recording Instruments': Science, Surrealism and Visuality', *Art History*, vol. 27, no. 4, Sept. 2004, pp. 645–7.

18. *The Complete Letters of Sigmund Freud to Wilhelm Fliess 1887–1904*, ed. J. S. Masson, Cambridge mass. 1985, pp. 292–3. Cited C. McManus, *Right Hand, Left Hand*, London 2002, p. 35.

19. D. Lomas, 'Modest Recording Instruments', op. cit., p. 645.

20. W. Rubin and C. Lanchner, *André Masson*, New York 1976, p. 32.

21. Ibid., p. 99. The quote is taken from M. Leiris, 'Eléments pour une Biographie', in *André Masson*, Rouen 1940, p. 10.

22. W. Rubin and C. Lanchner, *André Masson*, op. cit., p. 47. Illustration on p. 53.

23. W. Stekel, *Die Sprache des Traumes* (2nd edn.), Wiesbaden 1922, pp. 84–5. This is in ch. 10, 'Rechts und Links im Traume'. In 1925 Freud recanted and described Stekel's other interpretations as 'reckless' and unscientific: S. Freud, *The Interpretation of Dreams*, Harmondsworth 1976, pp. 466–7 & 470.

24. J. Luis Borges, *Labyrinths*, ed. D. A. Yates and J. E. Irby, London 1970, p. 47.

25. Ibid., p. 53.

26. Ibid., p. 54.

27. C. McManus, *Right Hand, Left Hand*, London 2002, p. 167.

28. 1981 interview with A. Barili, 'Borges on Life and Death', http://southerncrossreview.org/48/borges-barili.htm

29. C. McManus, *Right Hand, Left Hand*, op. cit., pp. 298–9.

30. Barbara Hepworth, *A Pictorial Autobiography* (1970; revised edn. 1978), p. 79.

31. R. Ubl, 'There I am Next to Me', *Tate Etc.*, vol. 9, Spring 2007, pp. 30–5.

32. See '*What is Drawing?*', The Centre for Drawing, Wimbledon School of Art 2001–2, ed. A. Kingston and I. Hunt, pp. 19–25, 33–5, 153–55; www.claudeheath.com.

33. R. Pincus-Witten, 'Learning to Write', in *Cy Twombly: Paintings and Drawings*, Milwaukee Art Centre 1968, n.p.

34. P. Valéry, *Aesthetics*, trans. R. Mannheim, New York 1964, p. 36.

35. C. Greenberg, *The Collected Essays and Criticism*, ed. J. O'Brian, Chicago, 1986, vol. 2, pp. 222–3.

36. B. Edwards, *Drawing on the Right Side of the Brain*, London 2001, p. 41.

37. Ibid., p. 40.

38. Ibid., p. 45.

39. Ibid.

40. D. Sylvester, *Conversations with American Artists*, London 2001, p. 309.

41. Ibid., p. 322. Cited by C. McManus, *Right Hand, Left Hand*, op. cit., p. 24.

42. D. Sylvester, *Conversations with American Artists*, op. cit., p. 322.

21. God Save the Queen

1. R. Penlake, *Home Portraiture for Amateur Photographers*, London 1898, p. 38.

2. Ibid., p. 38.

3. 'Photographic Portraits of the Queen taken by Annie Liebovitz': *www.britainusa.com/sections/articles_show_nt1.asp*. Having been quoted a fee of £10,000 per photograph, it has proved impossible to reproduce any.

4. Whenever I see this glass door, which has two panes of glass bisected horizontally in the middle, I can't help thinking of Duchamp's *Large Glass*, whose full title is *The Bride Stripped Bare by the Bachelors, Even*.

5. J. Jones, 'Annie Liebovitz', http://blogs.guardian.co.uk/art/2007/05/annie_leibowitz_one_of_the_mos.html

6. Ibid.

7. F. Diamond and R. Taylor, *Crown & Camera: The Royal Family and Photography 1842–1910*, Harmondsworth 1987, p. 68.

8. *Masters of Contemporary Photography: The Photojournalist: Mary Ellen Mark and Annie Leibovitz*, London 1974, pp. 25–8. The pictures are displayed on their contact sheets. In the text by A. Marcus, the only comment is: 'The back connoted mystery, the unseen face.'

9. *Life Library of Film: Light and Film*, New York 1970, pp. 194–5. They don't explicitly specify the right, but throughout the book this is the preferred position: see pp. 196–7.

10. Ibid.

11. B. Pinkard, *Creative Techniques in Studio Photography*, London 1979, p. 51. See also pp. 53 f and h; pp. 64f.

Index

Figures, notes, and tables are indexed in bold.